BLACK ANGEL

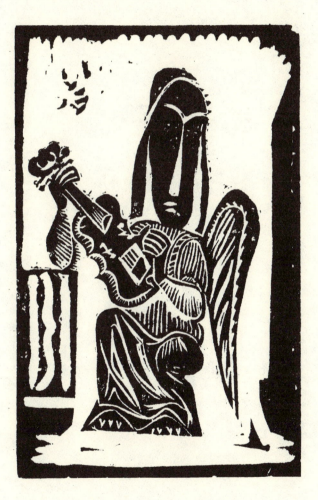

By the same author

Xenakis

40.00

Cen

Black Angel

The Life of Arshile Gorky

Nouritza Matossian

92
GORKY, A

THE OVERLOOK PRESS
WOODSTOCK & NEW YORK

First published in the United States in 2000 by
The Overlook Press, Peter Mayer Publishers, Inc.
Lewis Hollow Road
Woodstock, New York 12498
www.overlookpress.com

Library of Congress Cataloging-in-Publication Data

Matossian, Nouritza.
Black angel : the life of Arshile Gorky / Nouritza Matossian.
p. cm.
Includes bibliographical references and index.
1. Gorky, Arshile, 1904–1948.
2. Artists—United States—Biography. I. Title
N6537.G65 M38 2000 759.13—dc21 [B] 99-059584

Manufactured in the United States of America
First Edition
1 3 5 7 9 8 6 4 2
ISBN 0-58567-006-5

For Hagop, Vahakn and Rolf

Thanks to Agnes Gorky Fielding for kind permission to reproduce works and text by Arshile Gorky.

And gratitude to Archbishop Khajag Barsamian, the Diocese of the Armenian Church of America, for permission to quote from the translations and publications by Karlen Mooradian and to reproduce works of the Mooradian Estate.

Special thanks are due by the author and publishers to the Vatche and Tamar Manoukian Charitable Foundation for their generous sponsorship of the illustrations.

The author and publishers are also especially grateful to the Armenian General Benevolent Union and Louise Manoogian Simone for their financial assistance.

Contents

Illustrations x

A Writer's Journey: Introduction xi

PART I ARMENIAN CHILDHOOD 1902–20

Prologue 3

1 The Angel of Birth 5

2 *Hayrig*, Father 17

3 The Village School 25

4 Pilgrim 31

5 Van 41

6 Rainbow Line 54

7 The Heroic Defence of Van 63

8 Beat the Drum 77

9 City of Death 85

10 The Face of Famine 93

11 Second Flight 100

PART II REHEARSING FOR GENIUS 1920–34

12 Ellis Island 113

13 The Watertown Years 127

14 The Big Apple 140

15 Grand Central School 150

16 Papa Cézanne 157
17 Beautiful Sirun 167
18 A Dangerous Muse 183
19 The Troubadour 192
20 Nighttime, Enigma and Nostalgia 199
21 *Mayrig*, Mother 213
22 Poor Art for Poor People 219

PART III FLYING 1934–40

23 Happy Tappy Girl 231
24 A Driving Force 238
25 Dance of Knives 247
26 Child of Eden 255
27 Elevation of the Object 260
28 *Argula* 270
29 The World's Fair 277
30 Blitzkrieg 284
31 Fantastic Fancies 291

PART IV THE RED AND GOLD WORLD 1940–47

32 Seventh Love 299
33 Out West 307
34 Blithe Spirit 317
35 The Waterfall 324
36 White Angels, Black Angels 331
37 Skybaby 340
38 Papa Breton 351
39 The Glorious Summer 358
40 In a Biddy Whirlpool 369
41 Good Hope Road 376
42 Rollercoaster Living 385
43 My Little Pine Tree 392
44 Burning Easel 399
45 Rearranged Body 407
46 Life on a Leash 413

Contents

47 Catastrophe Style 421
48 City Pastoral 429

PART V THE SONG OF A SINGLE PERSON 1947–48

49 Full-Blooded 439
50 The Crumbling Earth 447
51 Darling Gorky 455
52 Agony 464
53 Goodbye My Loveds 471

PART VI THE GIFT

54 Summer Funeral 479
55 Life after Death 490

Appendix 496
Notes 499
Chronology 543
Select Bibliography 553
Acknowledgements 559
Index 561

Illustrations

Colour plates between pages 272 & 273

Black & white plates:
 Section 1 between pages 144 & 145
 Section 2 between pages 432 & 433

Maps:
 Armenia and Vaspurakan 6
 Khorkhom 28
 Van 44
 Defence of Van 67
 From Van to Yerevan 81

Part titles:
 The Angelic Violin, 1940 i
 I *Armenia's Khorkhom Dream*, 1939 1
 II Self Portrait, 1926 111
 III Study for *Organisation*, c. 1935 229
 IV Untitled, c. 1944 297
 V Untitled, detail, c. 1946 437
 VI *Anatomical Study*, c. 1931–2 477

Introduction

A Writer's Journey

The name Arshile Gorky meant nothing to me as a teenage student from overseas. In the Tate Gallery, London, I was transfixed by the staring eyes of a woman. She sat square and solid, like my Armenian grandmother in an old photograph. A boy carrying flowers hovered beside her. His dark eyes were like my young brother's. There were other small canvases. Curving, vibrant shapes nestled like ripe fruit in sculpted hollows. Next door, huge abstracts hung with drifts of jewel colours in mysterious, shifting forms. Some of the patterns recalled the Armenian alphabet I'd learned as a child.

Turning to the catalogue I read,

> Arshile Gorky (Vosdanig Manoug Adoian), born October 25, 1904, in Van, Armenia ... Mother from long line of Apostolic priests ... Armenians driven out by Turks. Gorky with his mother and sister and thousands of refugees walk ... many dying of cholera ...

Gorky was Armenian. He had shared the fate of my family, had survived the major genocide of 1915–1920 when the Ottoman Turks had tortured, slaughtered, and uprooted two million Armenians. Like many immigrants to America, branded 'starving Armenians', he had discarded his name. A famous Russian had inadvertently provided him with the armour to continue.

> 1948 Commits suicide ...

I recalled photographs of Armenians hanging from gallows in public squares with idle Turkish soldiers leaning on their rifles. Had Gorky punished himself for some dreadful crime? Had a personal event swept away the scaffolding he'd built up for himself with this momentous body of work?

So began my fascination with Arshile Gorky. On that rainy London afternoon, an obsession was born. My first stop was New York City. In three of America's finest museums I saw his drawings and paintings progress from the figurative through Cubism, Abstraction, Surrealism into a final synthesis of their own. His famous double portrait, *The Artist and His Mother*, haunted me. Gorky had deliberately left it unfinished, like a fragment of an ancient fresco whose history had been violently interrupted. I noted with pride that his work hung alongside the modern American contemporaries: De Kooning, Pollock, Gottlieb, Rothko. How strange that so little had been published on him. I tracked down two early biographies, by Ethel Schwabacher and Harold Rosenberg, but neither answered the question of his origins.

Back in London, I delved into the Armenian illuminated Bibles at the British Museum. Bold reds, blues, golds and oranges glowed like Gorky's paintings. I projected slides of these miniatures onto my wall, then enlarged and pushed them out of focus across the ceiling. The Virgin, robed in blue and pink surrounded by red, dissolved into an oval of embedded colours. Saints, animals and landscapes atomised into Gorky's animistic forms. On the same page, the scripts meandered through an enveloping space punctuated by flames of colour. This attempt to abstract the illuminations arose from my need to see them through the eyes of a child. Later, I discovered that Gorky had indeed seen such Bibles as a boy. It was the first of many hunches which would then be confirmed in research to reassure me that I was on track. Why had such a leading artist been neglected? De Kooning had acknowledged Gorky as a master. A whole generation, from Pollock to Rauschenberg, had taken stock of Gorky's innovations. A prime mover, in changing the course of twentieth-century American art, it seemed, was virtually unknown in Europe.

Years later, hearing of my interest, Marina Warner introduced me to Gorky's widow, Mogooch Fielding, who told me I had an Armenian face that Gorky would have painted. When I asked her if a new biography of her husband had come out, she replied, 'No, would you like to write it? I'll help you all I can.'

Thrilled by the coincidence, I accepted at once. Mogooch had been visiting London when we met, but her home was in Spain. Natasha, Gorky's younger daughter, and I went to Andalucia where I began a series of interviews (which continued over a fifteen-year period). Mogooch supplied letters, documents, books and photographs. Gorky slowly fleshed out in my mind as a dark giant with compelling eyes, with an overwhelming vocation and a sense of humour. He had adored his young Bostonian wife, and two daughters. He was befriended by Fernand Léger, André Breton, Marcel Duchamp, Joan Miró. The man whose work had galvanised me as an impassioned teenager came into focus, as Mogooch continued, close to tears. There were still many unanswered questions.

I was overjoyed to meet the only living person who had shared Gorky's childhood, his beloved sister Vartoosh Mooradian. In Chicago, this fierce old lady with tarnished, silver hair and her mother's dilated, dark eyes fished out old boxes of letters from under her bed. The rhythmic strokes and flourishes of Gorky's Armenian script revealed the hand of a cultivated man. Together, we deciphered his economically inverted characters. I had in mind the books edited by her son Karlen Mooradian, containing the published translations of Gorky's correspondence on wide-ranging topics from Armenia to Cubism and Surrealism. But there was no sign of those didactic letters, nor anything like them. When I mentioned that some must be missing, Vartoosh held up her transparent fingers to her face. 'I guarded these letters like my life,' she protested. 'They were my gods.' She insisted that there were no other letters. I was bewildered. Could the most frequently quoted of Gorky's correspondence be lost? Karlen, Vartoosh's son, who had previously refused to let me visit his mother, had recently died.

As the only person outside his family, and certainly the only writer, to be granted access to these original letters, I needed to work fast to discover the truth. A comparison led me to realise that twenty-nine of the letters to his family which Karlen had published in English were missing from Vartoosh's collection and could not be traced. As I studied the easy affectionate style of Gorky's writing in the original Armenian, full of news about the family and his longing to be with them, I came to a shocking conclusion. Those missing letters were not Gorky's words at all. Karlen must have faked them and then inserted them among the genuine correspondence in his book. No doubt his reason for embellishing Gorky's life and opinions had been the rage and frustration his family felt with the art

world's neglect of his uncle. In an attempt to legitimise Gorky's status and contribution to twentieth-century art and to Armenian history, Karlen's so-called 'letters' embroidered reality with opinionated quotations and romanticised memories of the family and friends. Manoug Adoian had assumed the name Arshile Gorky for reasons of survival, when he became disenchanted with politics. Then Karlen had broadcast Gorky's voice from the tomb as a nationalist and even a Stalinist. I dared not tell anyone about my discovery. I recognised it as a watershed.

By then, I had conducted so many of my own interviews with family members, Armenian friends and other artists, that my focus was no longer affected by others' writings on Gorky. Since none of his biographers before 1978 could read Armenian, most of their judgements had to be based on secondary sources and previously published material. There was no evidence of the artist's attempts to come to grips with the cataclysmic childhood which would catch up with him in later disasters. The truth about Gorky, distorted from the first by miscomprehension and the publication of Karlen's letters, could only be untangled by going back to source material in Armenia. Seeing the situation with more clarity, I now approached the raw material of his life with new insights. Harry Rand's book, the only theoretical account written in the seventies, argued that Gorky, an inveterate liar, had used abstraction to conceal and disguise the truth. In fact, Gorky was often missing from volumes on Abstract Expressionism and Surrealism because art historians confessed that they had avoided him, since they knew so little about his background. Only a trickle of interesting articles and catalogues had analysed his art: those by Diane Waldman, William Seitz, Robert Goldwater, Jim Jordan, Dore Ashton, Meyer Schapiro and Melvin Lader.

Then came a breakthrough on the mystery of Gorky's suicide. Mogooch had no light to throw on it since she had been hundreds of miles away at the time. She allowed me to read her letters but not to quote from them. The brunt of the blame for his death had been aimed at her and the artist Matta. Both had denied responsibility for his distress. 'We meant him no harm,' she told me. 'Matta loved him.' Her response laid emphasis on Gorky's increasing mental agitation and her helplessness as a younger, inexperienced woman.

At last a key witness was located. I flew to Arizona, to meet Muriel Levy, wife of Gorky's art dealer. Tearfully she took me through those final

days, after Mogooch had left him, concluding, 'To go through the path life took him, with all its pain, ordeals and nightmares . . . you'd have to be a saint to survive these things.'

Ten years after I began my research, I felt that, as an Armenian well-versed in the tragedies of my own people, and with knowledge of the language and culture, I had unearthed an epic artist's life. Gorky's art could be understood through a life of turmoil, like Van Gogh's. His work had to be examined for the clues it gave about his history. Yet his struggle to survive and to triumph in modern art had been rewarded by a paradoxical neglect. I needed to redress this. By 1992, I had pieced together my fragments into a 1,300-page manuscript. Yet something was still missing.

I decided that the heartbeat could be found only in Armenia, and in particular during four mysterious years of Gorky's adolescence. Perhaps some relatives might remember the terrible years of 1915–20. Arriving in Armenia's capital city, Yerevan, I was thrilled to hear from the museum director that Gorky's elderly cousin, Azad Adoian, was still alive. With Mount Ararat in sight, I imagined Gorky among thousands of refugees, seventy-seven years ago, marching through two hundred miles of parched and rocky terrain into the famine-stricken town. Azad Adoian's home, in a street of rickety wooden houses and hidden under rambling vines, was filled with Gorky's relatives who were just as curious about me as I about them. At first, the eighty-four-year-old Azad claimed great memory loss for those early years. But then, slowly, as in a trance, he began to doodle and slowly a map emerged of the Western Armenian village of Khorkom, Gorky's birthplace by Lake Van. He labelled each house and orchard, as though he'd been there only yesterday. His skilled engineer's hand drafted out a shared past, but also my future visit to Gorky's home. Surrounded by the faces and voices which represented a true link to Gorky, it was one of the most emotional moments of my research.

It was time to face the journey I'd always avoided. My childhood had been filled with terrible tales of atrocities in my grandparents' birthplace, Gorky's birthplace, our communal homeland. I had postponed my plans to go several times, warned that Kurdish-dominated eastern Turkey – the Armenia of my grandparents – was a remote and dangerous place, where tourists had been attacked. But I ignored reports of terrorism; fired by Azad's description of the beauty of Lake Van, and my longing to see Gorky's birthplace, I set off. Dilapidated villages, barren fields and ruined

stone churches (now used as stables and toilets) went on for miles as we approached. I glimpsed fields of pink and purple wild flowers against fresh green, gushing canals, the spectacular turquoise lake. For the first time, I understood completely how much a race of Armenians had lost: not just vast tracts of land, cities and lives, but the rape of history, the loss of memory. If I could tell Gorky's true story, I might retrieve a tiny part of that obliterated history. I had memorised Azad's sketch so as not to be mistaken for an heirloom hunter! It helped me to track down a hamlet, no longer called Khorkom. Crows wheeled overhead in the poplars, just as Ado had described. In Gorky's village, I stood on the arid path where the mud brick houses of the Adoians had been turned into hovels. The smell of burning wood, dung, dust and baking flat bread filled my nostrils.

The final step of my pilgrimage was a short boat trip which took me from Gorky's village to the tiny historic island of Aghtamar in Lake Van. A deserted, tenth-century church, decked out with biblical sculptures, had miraculously survived. Angels fluttered between stone windows. Under the dome of the hushed, derelict shrine, fellow Armenians stood in the rubble singing a prayer. The frescoes of saints who had stared down severely at a boy over eighty years before now glared just as harshly at us; their monumental figures almost washed out by the rain, but their dark eyes still seeing.

I gazed from the church to the lake, at the pure blue of the religious illuminator Toros Roslin; the blue of Arshile Gorky. The domes of snow-streaked mountains circled the water in an unbroken chain. I was standing in Gorky's painting, *They Will Take My Island*. Gorky's canvases were stretched across this landscape, its fresh colours, its iridescent light. My circle of journeys was complete; I had found him. I touched a carved stone cross warmed by the sun. There had been another sunny morning in a cemetery far away in Connecticut, where Gorky lay in foreign soil. I scooped up a handful of white sand from the shore of Lake Van, knowing that there now remained a book for me to write.

PART I
ARMENIAN CHILDHOOD
1902–20

PREVIOUS PAGE *Armenia's Khorkhom Dream,* 1939. Ink, $7\frac{1}{2} \times 10\frac{1}{2}$" (Diocese of the Armenian Church of America)

Prologue

The small boy climbed a poplar tree, his bare legs and arms wrapped around the white trunk. One hand over the other, he inched up, without looking down. Twenty feet up, crows circled the top of the tree, dived, and flapped black wings – 'Kra⁄a⁄k! Kro⁄o⁄k!' The scarecrow boy had a mess of twigs on his head.

The row of poplars in bright sunlight were laden with nests. He perched on a forked branch, which dipped under his weight. One wrong move and he would fall. The nests looked like scribbles in the sky; they were full of eggs. He wanted to paint on the eggs and give them to his mother. He stretched to steal a few and slip them into his sweater. Crows dived for his face, but the crown of thorns protected him.

He swung in the treetop, exhilarated by the motion. Storks' nests were even higher up but he wouldn't touch those. His house was down there among the patchwork of flat mud roofs of Khorkom. Mountains reared up their snowy peaks, Mount Sipan higher than the rest. The turquoise lake shone in the sun, and further out, the rocky island of Aghtamar hunched like a turtle, on the edge of Lake Van. The tip of the church dome pointed at the sky. He was alone on top of the world.

1

The Angel of Birth
1902

In the early years of the twentieth century, Khorkom was a small village by Lake Van, in the province of Vaspurakan, Western Armenia. Armenians had lived continuously on the rugged highland plateau since pre-Christian times. The plateau was edged with lava fields, cut through with rivers. One third of it was taken up by Lake Van, 5,500 feet above sea level. In the Lower Valley of the Armenians, Vari Hayotz Dzor, the lake had risen, flooding fields and squeezing out the people. The Turks, under whose authority the Armenians had lived in the Ottoman Empire, also oppressed them.

The village still stands, under another name, although the original inhabitants have been wiped out. Arshile Gorky was born Manoug Adoian. His large, patriarchal family was one of the wealthiest in the poor village, which lived off the land and the lake. A high bluff, with a church standing on it, overlooked the lake, protecting the village, which nestled in a hollow behind. In fact, *khor* means 'deep', and *koum*, 'stable', in Armenian.

The people of Khorkom were Christians but their rituals and way of life originated from ancient cults of nature. They believed that at the birth of a baby, angels and demons waged war over him. As the boy grew up to become a man, he would feel that demons and angels were never far away.

His mother, Shushanig, went into labour in a mud-brick house smelling of farm animals and manure. She was twenty-four and this was her fourth labour. Her long face had filled out in pregnancy. Her large almond eyes were bright. She lay by a fire in the central room on bedding laid out on the floor. Her husband and all other men had left the house.

5

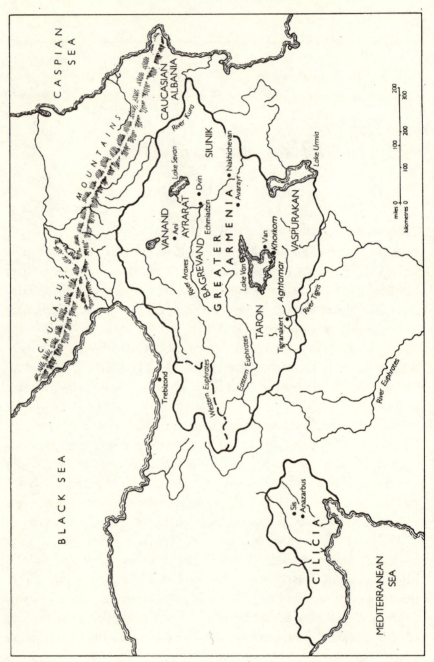

Historic map of Armenia and Vaspurakan showing Gorky's birthplace, Khorkom.

Babies were delivered by a midwife who had to perform ceremonies to protect the mother and child. First, she picked up a long metal skewer and blackened its point in the fire. On each wall of the room, she drew the sign of the cross to keep the devil away. Then she gave the skewer to the mother with a prayer. Childbirth was dangerous. Many women died, and fewer than half the infants survived until the age of two. The elder sisters-in-law were on hand to guide her:

'When labour starts, the angel comes down and takes all your sins and puts them in a bag and hangs them over your head. When the baby is born, the angel will return and sprinkle all your sins back on to you.'

This was the signal for elderly aunts and young women to come forward. 'Please, now you are pure, bless us. Please, bless us!'

After three daughters, Shushan prayed for a son. A woman on either side of her, at her elbows and knees, supported her back.

'A boy! God bless him. A boy!'

Long limbs and a mass of damp black hair. The baby's eyes were black.[1]

The umbilical cord had to be cut while a healthy woman was nearby, the blood smeared across the baby's wax-covered face so that he would have red cheeks, then the afterbirth and umbilical cord were taken in a white cloth for burial in the churchyard so he would be a fine singer in church.

The midwife beat some salt and a couple of eggs into warm water, and gave the infant his first frothy bath. She put salt on his dark head, under his arms, feet and hands, and swaddled him. He would remain swaddled for the next forty days. The children rushed out with sweets, to pass on the news to the village.

Prayers and ritual verses were said. The midwife asked the mother as she brought her the swaddled baby, 'Girl, am I light, or are you?'

'May it pass lightly,' Shushan had to reply.

Three times they repeated the response, then the baby was laid into the crook of her right arm. He was thin, with long fingers. She saw the faces of her dead father and her brother.

'Eyes open, *Atchke patz*. He's smart.' Her relatives praised him and congratulated her, spitting '*tout, tout*' in between words to fool the evil eye. His mother-of-pearl eyelids were fringed with dark lashes. She whispered, 'My little black one.'

Her husband, Setrag Adoian, rugged, over six feet tall, had to stoop to get through the low doorway. He was handed his son with ceremony and

7

blessings. His previous marriage had ended sadly with the death of his first wife, Lucy Amirkhanian, leaving him with a son and a daughter. He was forty, and he and Shushan had one daughter together, Satenig, but this was their first boy.

Shushan was supposed to stay indoors for forty days to protect herself. The boy was christened after Setrag's father, Manoug Adoian, but his mother nicknamed him Vosdanig after her home town. From birth the boy had two names, one from each side of his family. He answered to both, as though he were two separate people, until he later adopted a third name.

His date of birth was subsequently lost; in the turmoil of events, all family and official records were destroyed. Gorky would later give his birth date as 1902, then as 1903 and 1904. His elder sisters and cousins maintained that he was born in 1902 or 1903, in October. Vartoosh, his younger sister, insisted it was 22 April 1904. The year 1902 is the most probable one, and corroborated by other boys of his age.

His mother was the daughter of a priest in the Apostolic Orthodox Church belonging to the early Eastern tradition. Sarkis Der Marderossian was head of Saint Nishan Monastery on the slope by Vosdan overlooking the lake. Her name meant 'lily' and she was named after a martyred saint. She married into a farming family but her own background was very different. As an eighteen-year-old widow, after her husband's murder, Shushan had been forced to give up one daughter, Sima. Widows who remarried usually left their children with their own parents, but she had not been able to do this. She kept the younger girl from that earlier marriage, Akabi, now seven. The eldest, she had entrusted to an orphanage in the nearby city of Van in the tradition noted by H. F. B. Lynch, the scholar and traveller who wrote one of the finest accounts of the area at the turn of the century: 'A widow, about to marry again, will bring her young child to the feet of the missionaries, beseeching them to bring it up and educate it in her place, as their monument − for so she puts it − before God.'[2]

Setrag's son by his first wife lived with them. Young Hagop saw the baby put to sleep in a cradle on rockers or in a kelim strung up between ropes for a hammock. While Shushan breast-fed him, she sang and talked to him. Hagop was jealous of the intruder, and grew up into a rough, angry character, quick to push his young stepbrother around. Shushan had entered the marriage of convenience not only to support herself and her children, but also for physical protection. In the archetypal Armenian home, the mother-

in-law ruled supreme and the bride was 'an uncomplaining servant under the grandmother', waiting for permission to speak to her elders. Sometimes this did not come until the bride was in her sixties.[3]

Setrag's elder sister, the widow Yeghus, called *Dadig*, Grandma, because of her age, was also above Shushan in the pecking order. She controlled the household stores and assigned Shushan work and chores. The unhappiness of a young woman in a loveless union went unremarked by elders who arranged them for convenience. Shushan conformed, 'always wore a scarf on her head, was very quiet and never sang out loud. She was modest and hardly spoke,' her nephew Ado remembered. But in a crisis she could show her mettle.

His grandfather Manoug Adoian had three sons, named after Shadrak (Setrag), Mishag and Abednago, whom Nebuchadnezzar had cast into the fiery furnace, but had then seen 'walking in the midst of the fire' in the Old Testament. A resourceful man, Grandfather Manoug had gone to labour in Greece to earn money for a team of ploughing oxen and some fields. Farming his fields, cutting poplar trees for lumber and growing most of the fruit and vegetables, he struggled to make a living out of land that was constantly being claimed by the rising waters of the lake. Setrag, his eldest, was born in 1863.

All families lived cheek by jowl in the small houses. Manoug's young cousin recalled the home:

The Adoians had one house. When you came in, to your right was Setrag with his family and to your left was Krikor [the family's name for Abednago]. In the centre was a large room with two windows where they received guests. In this room was the *tonir*, a very big oven where they made bread and cooked. Behind the house was a storeroom where all kinds of fruit and vegetables were kept.[4]

Manoug grew up in a house by the lake with a dirt floor, unpainted walls, hardly any furniture. He wrote later, 'The walls of the house were made of clay blocks, deprived of all detail, with a roof of rude timber.'[5] The heart of the house was the hot red fire in the ground. Flames flickered out of the *tonir*, a clay pot sunk into the earth. Everything pivoted around the central fire and out of it the women pulled bread and food. Smoke went through a hole in the centre of the roof, and the ceiling was always black.

Women sat around this fireplace cooking, or when it was empty and cold, covered it with a lid.

His father was busy with the huge, lumbering animals. Gorky's earliest memories were of oxen and bullocks, horses and sheep. They were stabled right next to the house and as important to him as the human members of his family. All around the house, shoulder-high mud walls enclosed the animals. They were not so much built as moulded from packed mud and straw, with smoothly rounded tops and a rough, dusty surface. The whole village was earth-coloured. The only bright shades were fresh green trees and grass, abundant wild flowers, and the mysterious lake changing from blue to fuchsia and dark purple.

Shushan woke first each day, and while the family slept, she sat by her favourite rose bush, where nightingales perched. Her son used to hear her sing softly as she brushed her hair. Quickly she tied it in a scarf, before the men saw her, and left for the fields and orchards. While she worked, the older women and girls cared for her children. Shushan kept seven horses and was happiest riding. The family had many animals to tend: three hundred sheep of the large-tailed variety used for buttermilk and cheese, twenty goats, two horses for transport. There were four water buffaloes for labour, four oxen for ploughing, three cows for cow milk and dairy products which the people of Van considered inferior to products of sheep milk. Setrag had a *khan* (warehouse) in Constantinople for import and export. The family owned forests in Van and cut lumber which they transported with their own large sailboat to Adeldjevas in exchange for wheat.[6]

As the toddler grew up, he was drawn to the animals, the sound of baaing sheep and lowing oxen, their dusty odours, the smell of drying dung, as his father herded them around the yard. His mother fed and watered the sheep, and also milked them. Chickens pecked the ground. His father shouted 'Ho-yez!' at the oxen; his mother repeated their names for her boy. But though he reacted to her voice, he did not echo her words, and Shushan grew anxious.

Young Manoug was often woken by bellowing oxen. Then he heard waves beating on the lake shore, and hoarse, shouting men. His father Setrag and his uncle Krikor yelled and fought daily, and the small house shook with their rage.

Setrag's two younger brothers had gone to America in 1896. They had

laboured for long hours in dangerous conditions, living cooped up with other men in unsanitary boarding houses, but they did not get rich, and the youngest brother, Mishag, had died of tuberculosis. The thousand dollars in insurance money was the main cause of strife between the two remaining brothers.

Krikor bragged on his return, 'America is a miracle come true. A dream! They have tall buildings like towers with clocks that chime every hour.' The open-mouthed villagers noticed that he was still wearing the same worn-out suit.

In 1904 a severe famine struck Van. Grain was scarce owing to bad crops. What little remained was stockpiled by the corrupt Ottoman administrators. Prices were pushed up, while thousands died of starvation. The Armenians were on the whole careful farmers who cultivated their land, growing cereals, tobacco, vegetables and fruit, in contrast with their nomadic neighbours, the Kurds, whose wandering herds stripped the land. There were a number of settled Kurdish villages, but the Armenians were extremely poor and their farming methods were still primitive, relying on wooden ploughs and threshers. The people were described as undernourished, even in normal times, by the excellent anthropologist, Yervant Lalayan from Tiflis:

> They harvest the wheat fields by hand, crawling on their hands and knees. Men and women are slow to walk and weak, a sign of bad nourishment. Their heads are bowed, they lack enthusiasm and are slow to talk. After centuries of living in the sight of greedy eyes, they appear like beggars in rags and without shoes. Famine is frequent. It is typical of Vanetzi men to emigrate for years all over the world and work, while their families stay in Van.[7]

Manoug grew up within a community of subject people. For three centuries, Armenians had endured the tyranny and corruption of the Ottoman Empire. Armenia had been divided, with the West falling under the Ottoman, and the East under the Persian Empire, until 1828 when Russia annexed Caucasian Armenia. With the final decay of the Ottoman Empire at the end of the nineteenth century and early twentieth century the Christian Armenians became scapegoats for the Turkish pashas, always on the lookout to impose ever more crippling taxes in addition to customary

exactions taken by Kurdish overlords. Manoug's cousin, Azad, remembered
the hardships:

> The Turkish government had tax gatherers who came to the village, very evil
> people who took away one tenth of the best crops. Their demands were hard
> on the villagers, who wept on those days.[8]

Shushan escaped the noisy arguments in the cramped house by taking
Manoug out to the fields. In the orchards of pears and apricots, she worked
while his sisters played with him. She made toys for him out of bits of wood
and cloth. He watched her take a cork and a few feathers, work them with
her long fingers and suddenly, a bird was flying above his head on a string.
Manoug loved to twirl the bird, thrilled with his mother. He told a friend
years later in New York that her handiwork was as fine as the sculptures
Picasso assembled out of found junk, and that it was his mother who first
encouraged his love of art. He buried his face in her apron as she sang and
told him tales: a shepherd played a trick and was imprisoned in a rock,
spirits inhabited trees, giants fought and wrestled, then turned into
mountains – 'See Mount Sipan over there?'

Even in his second year, Manoug still made no effort to speak. The
children started calling him *lalo*, Van dialect for mute. Shushan made
pilgrimages to churches; she took him to the sacred rocks, springs and trees
where people flocked for healing. She was a strong believer and he later
evoked a strong memory of going with her to a mysterious part of their own
garden. Thirty-five metres from their house, the only needle tree in the
village, just two metres tall, twisted and turned dry branches for thirty metres
along the ground. They called it *Khatchdzar*, the Tree of the Cross. Ado, his
cousin, recalled, 'If a snake or spider bit someone, they would tear off a bit
of clothing and fasten it to the branch. The *Khatchdzar* had hundreds of
strips of cloth on it. There were ten or so apple and pear trees in that garden
and in autumn, when their leaves covered the earth, snakes would come and
make their homes.'[9]

Every Wednesday and Friday people came to light candles on the huge
rocks out of which the tree sprouted and wrap a strip of cloth around a
branch with a prayer. Shushan lit candles and prayed fervently for her son to
speak. His older sister Satenig remembered that men had once dug
around the tree, and found 'a huge Bible, ancient script on parchment, not

Armenian, an older script. The writings were decorated with birds and flowers. The cover was gold and the edges of the pages were gilded.' Her uncle Krikor stopped the digging in case the Turkish officials found out and caused trouble.[10]

For children the place was a magnet. Later, as an artist, Gorky was exercised by the potency of tree, rock and water. He appeared to be under the sway of the forms and spaces; he drew from nature as though it exerted a force over him. For him, landscape had the function to transform life. He came to write about the Tree of the Cross only after releasing locked-up memories in his late series of paintings entitled *Garden in Sochi*. Sacred trees still exist in Armenia and the Middle Eastern countries, by a church, shrine or spring. Rags of different colours flutter in the wind, fading into white, and the tatters of people's wishes cling like dead flowers on bare branches. Those forms would surface in Gorky's late drawings when he had plenty of reason to make wishes, but had lost the courage to form them.

As soon as Manoug could hold a pencil, he had started to draw. Akabi, his elder half-sister, remembered that he drew all the time. Shushan cajoled and bullied Manoug, but he refused to speak. In every other respect he seemed bright and lively and the women tried remedies: they pressed to his mouth the little finger of a child who spoke; they rubbed the key of St Nishan Church on his lips three times with prayers.[11] Then Shushan resorted to shock tactics. One day she walked with him to the top of a crag and showed him that unless he spoke to her, she would throw herself off the edge. As she hurtled to the cliff's edge to jump off, the boy cried out:

'*Mayrig*! Mother!'

It became his template for dealing with crisis in adult life.

All his relatives remembered her efforts. She did not give up, but asked the help of her nephew Kevork Kondakian, her sister-in-law, Dadig's son. Kevork was a fourteen-year-old boarder at Aghtamar seminary who came home at weekends. He played with Manoug and tried to encourage him to speak a few words, without results. One day in the middle of a game, Manoug picked up a long stick and threatened his cousin. Kevork grappled to take the stick away, but the little boy was fast, and nimbly darted up a ladder to the roof of the house. Over-excited, he whacked Kevork, who

yelled out in pain and pretended to be badly hurt. This stopped Manoug instantly. Kevork howled, as he realised the effect he was having. The little boy peered at Kevork and made incoherent sounds.

Kevork cried, 'You hurt me, Manoug! I'm crying now. *Al gou lam.* Manoug. *Al gou lam.*'

Manoug's face went scarlet, his eyes dilated and he repeated the words. '*Al gou lam? Al gou lam?*', crying and running downstairs.

The women rushed to him. Kevork had a healthy fear of Shushan: 'a very, very good woman, but when she got angry nobody would stand in her way. I was frightened she would be angry with me and I ran away.'

Gorky would use an echo of his first words as a title, *Argula*, in later years, just when he found his own voice as a mature artist.

Akabi, the eldest sister, however, maintained that he stayed mute even longer. According to her, he did not speak until one day he had gone to swim in the lake and no one could find him. There was great commotion and his mother and aunts feared that he had drowned. They were crying when he returned home. He ran to his mother and said, '*Yes, hos em.* Here I am.'[12]

All the stories associated his first break into speech with anguish, words ripped out of him. Manoug suppressed his reaction to the violent and brutal outbursts at home, between his uncle and father, by a total shutdown. He could keep his equanimity until a moment of crisis, when the outburst could throw him into violent rage and loss of control. It was to remain a characteristic of Gorky. He held the attention of others with his silence, keeping them on tenterhooks. In his artistic life too, people became impatient, he tantalised them with his skill, testing himself, and delayed his flowering until they lost patience.

Satenig, Manoug's sister, born in 1901, was his constant companion. She was finely wrought, with full dark eyes, but at the age of two or three she had caught smallpox and her family feared that she would die. They treated the toddler by burying her in hot mud up to her waist, believing that the heat would enter her bones and chase out the smallpox. She escaped from the sand bath, so they tied a heavy weight between her legs to keep her in place. The child survived, but pockmarked and bow-legged. She remained frail and melancholy, often taking to her bed later in her life. Only a year or two older than Manoug, she was closest to him during his infancy. She

found it very difficult later to talk about her childhood, and sometimes broke down in conversation, but her recollections were vivid:

To fetch water we put the jugs on our heads and went to the spring. We went to the fields and we had a lot of gardens. The Turks used to come there to sit. It was a lovely place. Full of pear trees. It was on a high slope and looked down onto the lake of Van. We could see Vosdan from our door.[13]

Shushan's birthplace was within their view. All the children later talked with longing of their beautiful village in its magnificent setting. Small children roamed freely from house to house in the village. Satenig's recollections of her brother were mostly set outdoors.

We had an orchard which was just near the lake and I was only eight years old. Gorky and I used to go to the slope and slide down it to swim in the lake. He found a fish. A dead one. It often happened because we had a lot of fish. The lake had thrown it up and brought it onto the sand. He put it on the sand and started to draw the shape of the fish. Then he drew it again and then again and again. The same fish on the sand. He said, 'I can also draw our pear tree.' It was a pear tree, right there on the slope. It had three branches. He drew it exactly and the fish under it. He was about five years old.

In this anecdote his elder sister captured what Gorky achieved in his late and freest works when he dared to reach back to his childhood. He could draw a fish and a pear tree together without contradiction. As an artist he would work to perfect his draughtsmanship. Even aged five, he was not satisfied with the first fish he drew. He went on looking and drawing, again and again. The lake shore was their favourite playground where small children could also feel frightened. She recalled:

Gorky and I were little and we had gone down from our orchard right near Van Lake to swim. We took off our clothes and put them there on the sand. Out of the water a red snake came and hid in Gorky's clothes. I remember this from my fright. We got out of the water. Gorky pulled his clothes and the snake jumped out and slipped into the water. We got home and told our mother.

'Oh, did you see the snake's head? Was there something shiny on its head?'

We said, yes. 'That snake doesn't bite people. You should have caught it. That was a diamond jewel on its head.'

Local lore was full of poetic images which Shushan passed on to her children. Nothing should be taken at face value, because it could be a disguise for the supernatural. She taught her children to identify nature and find magical meanings even in potential dangers.

In one of the key myths Manoug was taught, a great hero, Vahakn, is born out of an apricot-coloured sea surrounded by reeds, a full-grown boy with golden beard and two suns for his eyes.[14] He is a protector of the people, a slayer of dragons and snakes, a mythical sun god and Dionysian divinity. A fragment of a poem from the ninth century BC locates the myth by Lake Van; and Manoug's name was also associated with the myth. It means child, and was sometimes prefaced with *Alek* ('good') or *eghek* ('reed').[15] He learned that his name and the lake had a place in the central creation myth. At sunset the lake flared up in a sheet of fire; apricot and blue strands of cloud criss-crossed the sky; the reeds stood out by the water's edge, black and rigid.

2

Hayrig, *Father*

Manoug became his father's silent shadow. The mute, observant child with hungry eyes followed the tall farmer, sat on his shoulders as he strode about, watched him as he dug, planted, harvested and harrowed. He loved to watch as Setrag fed and yoked oxen and buffalo to the heavy wooden plough. His father guided the animals, yelled out whinnying, yodelling calls, and often belted out a ploughing song as they churned through the rich soil. The little boy begged to stand on the flat part of the plough. His father picked him up with callused hands, covered in soil and dirt. Those were the times that Manoug felt closest to his *hayrig*, father, part of a world of labouring men. They bumped through clods and soil, eyes level with the huge hindquarters of the beasts. The boy smelled the earth as it turned over and the steaming odour of the animals.

Later in life, Gorky imitated his father. He moved into the country, dirtied his hands, grew vegetables, surrounded himself with cows, bulls and dogs, all of which he drew. He escaped the claustrophobia of the city to find the big sky and wide open spaces of his childhood. Khorkom's lakeside fields, with mountains enclosing the horizon, would give Gorky's paintings their distinctive layout. He drew enlarged close-ups of plants, insects and animals, haunches and udders, from the viewpoint of a small boy. The distant curving screen of folding mountain ranges shaped Gorky's honeycombed space in late canvases. One painting that springs directly from this experience he called *The Plough and the Song*.

His father also took him on board the large sailing boats which transported goods. The Armenian sailors sat him on the poplar logs or sacks

of wheat; they hoisted the vast lateen sails to coast along the shore, sailing to Van and Adeldjevas. On misty mornings the clouds appeared to fall on the lake, while the boats and mountains floated through them. Later, in America, Gorky's favourite topics of conversation with his aged father were the farm, fields, animals and boats, as though, his sister Satenig recalled, they would return and find them unchanged. Gorky's transparent washes, mists of fresh blue, pink, lilac, seem to rise from the lake of Van, the iridescent light on the mountains when the sun is low. A distant sail boat emerging through billowing mists can be seen in *Charred Beloved*. The mother-of-pearl sheen of the lakeside and skies informed the gossamer texture and light of his mature paintings.

Manoug's late breakthrough into speech reassured his worried parents. But there is a discrepancy between the idyll of primitive rural life he is supposed to have enjoyed and the mutism which points to disturbance and deep emotional trauma. The outside world was also threatening. A new catastrophe would cause a severe setback for the child and his family.

At the end of the nineteenth century, Britain, which from the late 1820s had been the ally of Ottoman Turkey, was intent on propping up 'The Sick Man of Europe' as it was called. Disraeli prepared to pounce on India and dreaded the rival Russian Empire. The European powers had in 1878 committed themselves to guaranteeing the protection of the Armenians, by the Treaty of Berlin. Britain rebuffed the only neighbouring state interested in helping them, Russia, and denied her that right. Instead, the Armenian territories came under the special protection of Great Britain, which was in secret league with Turkey. The defenceless Armenians became the Sick Man's whipping boys: robbery, pillage and rape of the Armenians had always been justified since they were infidel, *giaour*. British editor W. Llewellyn Williams reported:

> First of all Armenians were despised if not actively hated as Christians; then they were treated as beings of an inferior order – maltreated, denied justice, robbed by lawless Kurds and equally dishonest tax-gatherers. They were ground between the upper millstone of religious bigotry and the nether millstone of official injustice and oppression. The State would not defend them. They were forbidden to defend themselves. To carry or even possess

arms was punishable by death. To suffer injuries was the Armenian's duty – in person, honour, goods; to resent them was to deserve and receive punishment. Life was cheap, and long-continued unchecked exercise of power made the Kurd or Turk insensible to the cruelty inflicted upon, and the suffering borne by, his helpless, unresisting victim.

Even at the beginning of the 19th Century, at Constantinople, a Mussulman could very well stop a Christian in the street, and calmly behead him, in order to test that his sword was in good condition. The *rayahs* (Christian minority) were obliged to carry a special handkerchief to wipe the shoes of a Mussulman in the streets at the least sign that he wished it done.[1]

Armenians looked to European countries for protection, but in vain. Russia's success in carving up the collapsed Ottoman Empire made the Turkish sultan even more vicious after he lost the Balkan states. Armenians formed revolutionary secret societies to defend their people's security, demand basic justice and civil rights. The sultan later armed Kurdish tribesmen, the Hamidiye, in imitation of the Russian Cossacks, to terrorise the Armenians together with his secret police. Armenians looked to European countries for protection, but in vain. Even Russia ceased to be interested when the St Petersburg autocracy grew ultra-reactionary in 1896.

In Van, orphanages had to be founded to care for four hundred children left destitute by Sultan Hamid's massacres in 1895 and 1896 to which European governments turned a blind eye. American, German and British church missions had been set up to bring relief. But in less than a decade another massacre was being unleashed on the Armenians by Sultan Hamid.

In 1908 a terrible massacre of the Armenians took place in the city of Van, just a short ride away from the Adoians' village. Panic spread through the villages. A close friend of the family, Dickran Der Garabedian (nicknamed Kertzo Dickran after his village Kertz), was a student at the Aghtamar Seminary and a member of a resistance group. He brought news of the grim events:

There was a critical situation in Van ... the government had seized our secret arms depots, confiscating our rifles, bombs, ammunition, and books and papers. There were searches made in the villages, especially in the Hayotz Dzor district ... searching for weapons and jailing the revolutionists and

other suspects became common. The torturing, ransacking and destruction became unbearable. People tried hard to bear even rapings.[2]

In 1908 Manoug's home was a safe house, sometimes used by the freedom fighters. The children were startled in the middle of the night by desperate-looking men talking in hoarse whispers. 'They had faces like wolves,' his elder sister said. 'My mother used to give them food, and talked to them, then they slipped out as silently into the dark as they had come.'[3]

The Armenians in Van were in peril. According to the American missionary physician Clarence D. Ussher, the Turkish governor of Van, Ali Bey, 'used every means in his power to incite the Armenians to revolt in order to have a pretext for massacring them'.[4] Shushan worried for her daughter Sima – the unlucky older child of her first husband, now a tall, lovely fourteen-year-old, whom she had left in the American orphanage. Sima had witnessed the killing of her own father during the last massacre and had to relive the horrific events of Van among strangers and destitute children. An Anglican minister, the Reverend Noel Buxton, and his brother, Harold Buxton, a Member of Parliament, were travelling in the area and gave eyewitness reports of the horror that struck the city in April 1908:

> The terrors began early in the morning. Some women fled panic-stricken down the street; shots were heard – this was the first warning. Then a crowd of fugitives gathered into the little courtyard, hoping for protection from the British Consulate near by. Our friends already made up their minds to go. They slipped out at the back, crossed a narrow passage and gained access to one of those gardens, surrounded by high mud walls which are attached to almost every house in this quarter of the town. So from one garden to another they hastened, expecting to be overtaken at any moment – while the awful butchery proceeded. They saw many cut down. A group of little boys fled down a lane in the same direction; in a few moments they might have reached safety, when round a corner Turkish soldiers appeared. The little boys were caught in a trap. In a minute or two, Turkish swords had done their work, and, bloodstained, were seeking further prey. Meanwhile the fugitives were providentially spared, and reached the American Mission. Here were gathered some scores of fugitives. The compound and building were a very harbour of refuge. Yet even under American protection life was not secure.[5]

He described Sima's school in graphic detail:

> During the night, the crowded schoolrooms and outhouses were raided, and some of the best-favoured both of boys and girls, never to be seen again by their relatives. The horrors of those days have never been told before. House after house in the Armenian quarter was ransacked, and every valuable removed and the building committed to flames. For those who were not butchered in the streets worse tortures were reserved. In some cases horseshoes were riveted on to men's feet; wild cats were attached to the bare bodies of men and of women so that they might tear the flesh with their claws; many were soaked in oil and burnt alive in the streets.
>
> With such memories in the minds of all, can we wonder that the position of the Armenians should be described as intolerable?

Panic spread to the surrounding villages. Then word reached Shushan in Khorkom that Sima had died. Manoug's sister Satenig simply said that she died of a broken heart. Grief and guilt overwhelmed Shushan. 'My mother never talked about her. She couldn't bring herself to mention her.' Satenig understood that she blamed herself and her husband's family for the death of her child.

The ferocity of the attack left most Armenians in no doubt that a wholesale massacre was planned. But among the Adoian brothers there was constant disagreement. Krikor was more ambitious, and kept pressing Setrag to leave for America, where they could work together to send money back home. He argued that if they stayed they would surely be recruited into the Ottoman army. Setrag refused to leave the family behind with their elderly father, and only Shushan to look after the farm and business.

Once when Setrag and Krikor were shouting at each other as usual, little Manoug suddenly jumped up and yelled, '*Para! Para! Inch para!* Money! Money! What money?'

He grabbed his father's hand and pulled him out of the house to a willow tree, where he asked him to cut off a branch and whittle it into a pipe – the only way he knew to distract his father. His cousin Kevork told the story to show how the outbursts upset the small boy.

Setrag continued to worry about the explosive political situation, but his fears were allayed later in 1908, with the new constitution (written by an Armenian) forced on Sultan Hamid by the 'Young Turks'.[6] It introduced civil and religious liberties for all Ottoman subjects and parliamentary

representation for the different nationalities within the empire, freedom of speech and press, amnesty for thousands of political prisoners. New Armenian representatives sat in the Chamber of Deputies in Istanbul and, for the first time, Armenians were permitted to arm themselves for self-defence – a trap into which they fell easily, anxious to believe in the new dawn of the 'Daybreak in Turkey' movement.[7]

From Khorkom, the children watched fireworks and rejoicing on the nearby island of Aghtamar across the lake on 11 July 1908.[8] The Young Turks had lowered the high cost of passports and removed other prohibitive taxes and restrictions to rid Turkey of Armenians. Optimistic for the future at last, Setrag planned to travel to America with Krikor, joining a stream of three thousand Armenians.[9] Setrag was forty-four. Shushan had lived with him for eight years, and given him another daughter, Vartoosh, in 1906. She now lost her second husband as well, and was left to look after the children and the farm, unprotected.

Manoug never forgot the day his father left. Setrag took his own three children, Satenig, Manoug and Vartoosh, sat them on his horse and led them to his huge wheat field by the lake. 'Just twenty feet away,' Satenig recalled, 'the lake beat against the field, and icy water gushed out from a spring.' Shushan had packed a breakfast of boiled eggs and *poghint*, a local dish of whole wheat roasted with butter and mixed with honey. They sat on the grass by the spring, ate the food and drank the cold spring water.

Setrag kissed them one by one and said, 'Can I be sure of seeing the three of you again?'

That picture of their father remained a fixed point of Gorky's life, the only story he told about his father. All three repeated it like a refrain with variations. Satenig did not even notice that she repeated her story with a different ending:

'Then we left and came home. When we came home our father was not there, so it must have been about the time he left.'

Manoug clung to a parting gift from his father, a pair of pointed red shoes, made in Van, *sabok*, Russian for 'sabots' made of wood, and sometimes called *drekh*. A soft leather sock, ankle-high, was worn inside the wooden clog. This footwear is common in photographs of both children and adults of the region. Gorky mentioned the shoes in conversation and later would bring their distinctive form into his *Garden in Sochi* paintings.

Akabi, his eldest sister, and Vartoosh, both said that Manoug was not

speaking at the time. Apparently he relapsed into mutism after the shock of the 1908 massacre, followed quickly by parting from his father. He would never forgive Setrag for abandoning them. Throughout his adult life Gorky would not allow his immediate family to reveal that his father was still alive. Perhaps after the difficulties of his childhood he detached himself from this father who had proved a disappointing and unreliable figure. In Gorky's drawings, a shadowy male figure is persistently depicted from the back, disappearing through doorways, walking out of drawings, even hanging by the neck, like the father who disappeared from his horizon.

For the rest of his childhood, Manoug came under his mother's influence, the only boy among three sisters. Shushan became the head of the little family, showing her strength and some dominant qualities as well. The boy became particularly attached to his father's horse, a chestnut with a white star on its forehead called *Asdgh*, 'star', and a long-haired dog he named Zango.

Manoug found solace and total absorption when his hands were busy. His prodigious talent showed itself early to his friends. He drew with such a passion that Akabi, his half-sister, retained an odd memory: 'He used to draw in his sleep. You could see his hand moving.'

Even when the children went swimming in the lake, Manoug's hands were never still. The clay deposit on the sand, used by villagers to make pots, became his play dough. Manoug patiently made little soldiers out of the clay, six or seven with sticks in their hands, lined up in the sun to dry. He called them the 'Persians'. The half-dozen he made with a headdress he called the Armenians. Then he set them out in battle formation. Every child knew of the battles between the Armenians and Persians. Especially in this region, St Vartan, the commander, was a hero who had defended the Christian faith against the heathen in AD 451. His exploits were chronicled by Yegishe, also a local hero, who had written the history in Manoug's family monastery, St Nishan.

Ado, his cousin, also recalled that 'he sculpted incredibly delicate dogs and Van cats. We were amazed since none of us could make them.' Manoug carved and whittled as soon as he was allowed to hold a knife. His friend Yenovk (Enoch) Der Hagopian recalled:

In Van we didn't even have a knife to carve with. We were afraid of the Turks and Kurds, all Armenians were, especially the kids. They were fighting us. Our parents were fighting. Sometimes if we carried a knife with us they said, 'Don't carry the knife because if they take you, they think that you'll make trouble.' I don't know who got hold of a knife. In spring we used to cut those willows, we used to cut branches and take the skin off, make a whistle. A flute. I don't remember whether it was mine or his, but we only had one knife.[10]

Manoug soon became so skilful that he whittled flutes for the other children and he carved a special one for himself with a face on one side and an animal on the other.

Another boy, Paregham Hovnanyan, saw a darker side to Manoug: 'a very deep boy and very good. When he did naughty things, he did them secretly. He didn't show them to anyone. He beat the boys, he beat us.'

Shushan recognised herself in her son's tempestuous character. He threw himself into play with unreserved passion. She watched this boy who kept nothing back and constantly got himself into scrapes, and feared that he would never be able to temper the extremes of his nature. She called him her Black One, but that was also the name by which the villagers called the Devil. Manoug, the 'good boy' with unpredictable moods, became the prototype for the man. Broody, handsome, intelligent, he retained the same ruggedness, the love of manual work and, as far as he could reproduce it, his father's masculine image.

3

The Village School 1907

'Lord, admit the boy
Let his flesh be yours
And his bones be left to us.'

The five-year-old Manoug had heard these words from his mother as she handed him over to the headmaster of the village school. Hand in hand, the small boy walked with his tall, slender mother, she dressed in headscarf and long skirt, down the dirt track, along the lake, to the neighbouring village of Koshk. He was lucky to be able to attend school, she told him, few families could afford the fees. 'Look at the poorer children who labour in the fields and house.' He must obey his teachers, work hard to read and write, so he could become a teacher. The primary school stood next to the church. The headmaster had absolute authority over his education, discipline and moral upbringing. Shushan believed, like other Armenians, that the only salvation from misgovernment by Ottoman rulers was education. Once Setrag had left for America, the children's upbringing became her responsibility.

Manoug carried a little slate on which he copied letters and numbers with a nub of white limestone. Paper was precious and the slate was a prized possession. He discovered that he could draw on it. Often, in class, he became so engrossed that he hardly heard the teacher, but his talent made the teachers reluctant to punish him. One day the master, Mr Mihran, noticed Manoug hunched over his slate at the back of the class.

'Bring your slate here,' he ordered.

On the slate, with just a few lines, he had drawn two savage dogs snarling and biting while six children stared aghast. Manoug waited.

'What miracle is this, my boy? Surely you will become a painter!' exclaimed the teacher.

'I . . . don't know . . . what I'll become . . .' Manoug stammered, 'but I love to draw.'[1]

Writing and drawing on slate created a lifelong habit. As an artist, Gorky liked to draw on the same piece of paper or canvas, treating the surfaces more like a slate to be drawn on and rubbed out. He left lines only barely erased, the layers showing through. He used surfaces for depth, as though he might just scrub the top layer and start all over again. In particular, his black and white drawings in the series *Nighttime, Enigma, Nostalgia,* reproduced the glossy shine of slate.

The Adoians' house was on the eastern side of the village nearer Koshk. Manoug walked the half-mile to school with his cousin Ado, past their orchard and the springs for drinking water. The clear air at these high altitudes was crisp and invigorating. They ran along a low, swampy area of bamboo and reeds bordering on the river Koshab below and the lake. Ahead, they saw the mountains, Ardos towering above the others, capped in ice. In winter, the ground was covered in snow, sometimes so deep it reached as high as the flat rooftops. The cold never bothered the children on the way to school in the snow, his cousin Azad maintained. 'It was a good winter. The snow was firm and set and we walked around without shoes on it. It was good, very healthy.'[2]

The Khorkom school had been destroyed but villagers were collecting to build a new one. The rural primary school even boasted teachers with knowledge of English from the Van teacher-training colleges. Manoug showed little interest in the school subjects and itched to be set free. He sat on rush mats on the floor with the other children – no seats or desks – writing and drawing on his slate or with a pencil on any scrap of paper.

Ado often saw his exercise book, filled with pictures of horses, buffaloes, and his favourite, a stork standing on one leg in its nest. Manoug quizzed Ado, 'Whose buffalo is this?'

'Kosali Hagop's.'

'How do you know?'

'By his straight and sharp horns.'[3]

The children did not have toys, and spent time contriving playthings for

themselves, while the girls learned to weave, sew and embroider. A favourite pastime for Manoug was making butterflies and tortoises by cutting walnut leaves with scissors. He carefully preserved beautiful butterflies in the pages of his school primer. His cousin Ado commented that even as a little boy, 'the great desire for drawing seemed to make him restless' and that Manoug got into trouble with the teacher for drawing angels' wings into the parchment Bible in Church.[4]

In an adult drawing of a very personal nature, usually dated 1928–32, Gorky has sketched a butterfly with wings outspread. On each wing is an oval with the profile of a man and a woman, his parents united. Next to it, upright on its short stalk, is one huge eye in the centre of a large leaf. The ink drawing combines the butterfly and leaf, those two natural objects which Ado mentioned. In other drawings and paintings, the eye of a butterfly wing, a dark spot spiralling inside an ellipse of bright colour, is a point of punctuation, whirling with energy.

The church and the school gave the community a strong sense of identity. The Armenians in the Ottoman Empire were defined not by their nationality or ethnicity but by their language, culture and especially by their Apostolic religion. They even used their churches to mark their spatial boundaries and terrain as though the spiritual defined the temporal. Almost seventy years after having left the village, Azad, his younger cousin, drew a map, using churches as landmarks, explaining:

> Khorkom is in southeastern Vaspurakan on the shore of Lake Van. A small village of about a hundred houses. That village has neighbouring villages of Koshk and St Vartan. Towards Van people went to St Vartan Church, and on the other side was Koshk, where land and water were mixed together. Wild ducks roamed freely, people never shot or killed them but left them free. Khorkom village is found between the village of Koshk and the lake. From the shore at a distance of half a kilometre, there is a monastery called Vart Badrik on the shore of the lake. It is a historical place about which I don't know a lot but it looks out at Aghtamar church. Aghtamar is in the middle of the lake. On the feast days, especially the Holy Cross, everyone went on sailboats to the island. There they had a feast and returned to the village.[5]

Each day, Manoug was woken up at dawn in the dark to accompany his aunt Dadig to the morning service in church. The boys dressed in cassocks and held candles for the priest. They learned the antiphonal chants and the

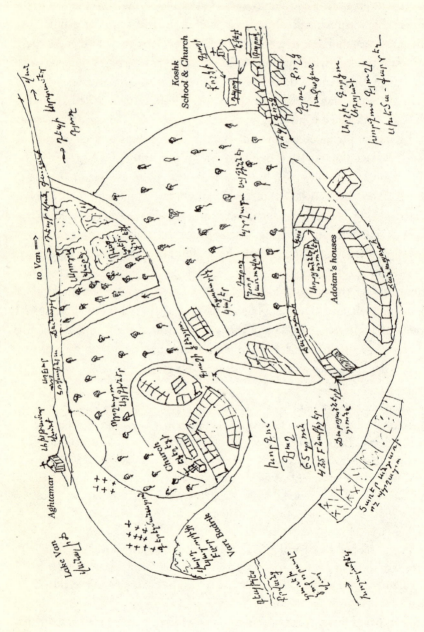

Khorkom, Gorky's village. Map drawn from memory by Azad Adoian.

ancient music, parts of the Divine Liturgy dating from the fourth century. The Armenians had converted to Christianity as the state religion in AD 301, becoming the first Christian nation. Manoug had to memorise the Book of Daniel, texts of dreams and visions which would impregnate his fantasy. The Khorkom church was crude, some of the walls built with mud bricks; Koshk and Ishkhanikom had finer architecture. The village church had a steeple, but bells were forbidden by the Ottoman government. From the roof of the priest's house, he heard the *gochnag*, a slab of walnut struck with two mallets by the sexton, at dawn and sunset each day.

Manoug sang religious music and prayers every day. It was the finest music he heard as a child, along with folk music of the region. The deacon held a long-handled staff mounted with a silver disc surrounded by clusters of little silver bells, *shshoog*, shaking it to frighten away the devil. The boy saw the altar, separated from the body of the church and raised like a stage with a curtain before it. He would map out that space in his mind and draw on it later in abstract works. In grander churches, the vestments and crown of the priests were changed as he passed behind the altar for mysteries and secret prayers, a dramatic moment for a child watching him disappear from view.

The village priest possessed an orchard of apples, so fragrant that they tempted the children. They pinched the apples and ran off to the ruins of Vart Badurik to eat them. They used to stand around the stone altar and intone like the priest. Manoug made darts out of bamboo which he pushed into the uneaten apples, then threw them out into the lake to feed the fish, 'to make the catch better in the morning'.[6]

Later, in America, Gorky's friends heard him chant in a magnificent voice, as though conducting a service. Sometimes he gave a comic version, imitating their uneducated village priest, gobbling words in his hurry to be off.

In Khorkom, political discussion thrived at a clandestine library set up in 1908. Only half an hour's ride from Van with its schools, churches and printing press, and a short boat ride away from Aghtamar, the chief theological centre, Khorkom was downwind of powerful changes which had swept Van in the nineteenth century. The village had a progressive and liberal atmosphere, compared to other villages in eastern Anatolia. Armenian was freely spoken and taught in school, whereas in other provinces it was forbidden.[7]

Manoug grew up in a society in which Armenians were second-class citizens. They were discriminated against, paid extra taxes, were part of a non-Muslim minority. Manoug nevertheless received conflicting messages from the adults about his ethnic identity. Armenians were weak, defenceless, subservient, victims of Kurdish robbery and murder; on the other hand young men were to put their patriotism first, be armed, and fight for their equality and freedom.

Manoug and his friends became aware of the reading and discussion in their library with books and papers from Van, Tiflis (later Tblisi), Baku and America. One friend, Hovnanyan, remembered:

> During the winter days in our house or in Malka's house, the teacher used to read aloud in his free time. People listened to the writings of Toumanian, Aghayan, Raffi, Issahakian and other writers, books and stories. During those gatherings the village shepherd Nohrabed Alexander told wonderful stories from the forty Klhkani Teveri and at the end, he sang and chanted with his beautiful voice those marvellous songs.[8]

Later in New York, Gorky was known as a magical storyteller. He liked sitting together with friends, talked and sang, striking an odd note in the New World. As a child in Khorkom, when deep snow covered the ground, he sat in the evening with several families around the *tonir* filled with hot embers, and a frame spread with a cloth over it. The children tucked in their feet, while on the cloth dried fruits, thin sheets of apricot and sun-dried apple paste, long strings of dried grape paste, nuts and *oghi* (aqua vitae) were passed around. Akabi, Manoug's sister, was often asked for a song; modestly she refused a few times until her mother nodded, then she would sing in a bright voice, her cheeks getting redder. Minstrels, like his friend Yenovk's father, who had travelled all over Armenia learning songs, played the *saz* (a string instrument) and sang ballads.

Storytellers, their own shepherd of Khorkom in particular, had memorised vast epics in verse, and Manoug enjoyed the exciting stories of monsters and princesses, kings and djinn, in the local dialect with its guttural earthquake rumbles. This was the background for his instinctive attraction to Surrealism in New York, and his natural affinity for drawing and painting his fantasy.

4

Pilgrim

Manoug's days were shaped by the changes of season in the farming community, marked by religious feasts. In September he sensed his mother's excitement as she prepared the annual pilgrimage to her father's monastery of Chagar Sourp Nishan. She packed his best clothes and plenty of food, and picked a sheep for the sacrifice. Most of the harvest was complete. The wheat and grapes had been stored, the pears and apples stacked in layers of clean dry sand in bins for the winter, the walnuts sold in the market of Van. A few red and bronze pomegranates still hung on the trees.

The Adoians joined a long procession of people who rode or climbed the flanks of Mount Ardos towards Vosdan, driving sheep and calves. His mother still liked to call him 'Vosdanig', after her birthplace, but little was left of it, except a glorious history.[1] After the 1895 massacres, when two thousand Armenians had been killed or dispersed and the monastery pillaged, all that remained of the town was 'the group of buildings which feature the hillside, the remains of the ancient town . . . the relics of an old castle, the ruins of a church' and the Der Marderossians' home: 'A small church still remains, a memorial of better times, which is said to have existed for many centuries. We could see its plain four walls and small conical dome to the east . . . still attended by a priest.'[2]

Two miles from Vosdan the tree line ended and the solid stone walls of a small monastery had rooted on earlier, chunkier masonry. The small conical dome of stone and the top of the square church could be glimpsed. To one side spread the mountainside and behind fanned out orchards and walnut

trees. Inside the courtyard were two dozen rooms where Shushan's family would sleep. Satenig recalled:

> We used to stay for three or four nights. They gave us a room in the tower. My mother had been born there. Our family had descended from 37 priests. There were more than eight very beautiful *khatchkars*, finely carved. These were very happy times. They did sacrifice, danced and feasted.

Shushan's family, the Der Marderossians, are listed in the annals of the religious centre of Etchmiadzin as priests, keepers of the monastery, going back thirty-six generations.[3] The claim that the family descended from royal blood was made, and Shushan was styled Lady, although such a title does not exist in Armenian.[4] *Der*, Lord, is the title of a priest, appended to his name.

Shushan told her children of their grandfather Der Sarkis, who had lived with his family in the monastery with its two chapels, a mill, two orchards and fields.[5] But her family had been struck by tragedy in this monastery. She had a sister and four brothers. At sixteen the youngest, Nishan, had fallen in love with a Kurdish girl. One night he was brought to the door of the monastery, his body stabbed and cut with knives. Hamaspiur, his mother, had cursed God. Her husband saw a dream in which the Saint ordered him to take his wife away and silence her blaspheming or the family would be cursed for seven generations and their name would disappear. Hamaspiur's rage gave her no peace; she took a torch and set fire to the church. They left the monastery, breaking an uninterrupted line of centuries. Manoug's grandfather was killed in the 1898 massacre while defending his parishioners, his body nailed to the door of his church in Van. The rest of her family dispersed, to a nearby village, Ermerur. Theirs was a bloody history and Shushan filled Manoug's head with terrifying images. The curse upon his grandmother, who had tried to 'murder God', haunted succeeding generations, even a hundred years later in America.

Manoug followed his mother around the monastery where she had played as a girl, among fruit trees and beehives. She told him about St Nishan who seized devils and threw them out of mad people's bellies. The massive carved tomb with the holy relics of St Yegishe was a shrine. He had written the history of the Armenians, and the chronicle of Vartananz as an eyewitness in the fifth century. Shushan drilled into her son the most famous

battle in Armenian history when Christianity was defended. The Saint's pectoral cross kept in the small chapel next to the main church was said to cure the insane.[6] She herself bore the name of Vartan's daughter, a martyr for her faith, who had suffered barbaric tortures. Shushan determined to give her son a sense of their family history and she instructed him from memory.

Shushan had seen her father reading from medieval illuminated Bibles, prayer books and hymnals during liturgy and blessing the sick. She turned the parchment pages and showed Manoug columns and arches with geometric patterns and brilliant colours. In the open spaces between the columns, Armenian letters floated. The boy saw a peacock lifting its crowned head, a row of partridges, a palm tree. Through that painted archway, a believer could pass into another world. The Virgin nursed Jesus protected by an oval frame, the Apostle, robed in red lake and ultramarine, held up a pen, his feet resting on a cushion.

Some figures were no larger than the child's fingers; a prince became a bird, an illuminated letter hovered with the outstretched wings of an angel. Nothing was what it seemed but metamorphosed into another being. In comic-book fashion, these simple pictures told the life of Christ within the confines of the parchment page. The haloed Jesus and his disciples walked over jagged landscape, broke bread, walked over an azure sea teeming with fish; angels swooped out of the sky and hovered with brown feathery wings; devils pushed sinners into the flames of hell.

Squashed between the strong verticals and loops of the Armenian text were trees, cockerels, devils. No distinction was made between image and graphics. Letter and image size grew or shrank to fit the overall composition. Later, a calligraphic quality would often be discerned in Gorky's flowing lines. He would take a detail from a drawing and blow it up. The hybrids filling these pages had freed his pictorial imagination, prising it free to embrace Surrealism.

Outside in the courtyard, the children darted about, animals decked with flowers were blessed and slaughtered, women cooked special foods. Incense from the church ceremonies mixed with the scent from cauldrons bubbling over fires. Lamb simmered with barley until it became soft and creamy covered with spices. An English traveller witnessed such a feast:

> The courtyards of monasteries of churches resound with merrymaking . . . the
> peasant of Armenia is then in holiday mood and gala attire. They come in

from neighbouring villages and assemble for the dance which takes place towards evening . . . The sound of the flute pierced the air with a wild strain, accompanied by the beats of a drum. It had a singular effect of remoteness, simple beauty and pathos. In the falling twilight three slender figures could be seen executing simple rhythmic movements; those soon gave way to one figure – that of a child, dressed in a long white frock, who seemed to hold the crowd spellbound, as she swayed to and fro, giving way as she approached. Presently she vanished, and the men began to dance arm in arm, five or six in a row, reminding one of the wild gypsy dances which have been staged in London in Russian ballets. Of folk dances such as these the Armenian peasants are extremely fond.[7]

Young Manoug joined in. Later the adult Gorky never missed an opportunity to celebrate, sing and dance in his own tradition.

After this feast others followed. There were 150 monasteries in Vaspurakan. Autumn colours were so vivid as to be almost garish, 'trees glowing with colour, from canary-yellow to crimson and madder-red, and mountains, snow-crested and forest skirted tower over all'.[8] These colours would find their way into Gorky's painting years later but there was always the tranquillity of blue to calm their intensity. 'Lake Van, bluer than the blue heavens, with its huge volcanic heights – Sipan Dagh, Nimrud Dagh, and Varak Dagh, and their outlying ranges – its deep green bays and quiet wooded inlets . . . pure green shadows and violet depths'[9] – such a rich palette from nature would spoil Gorky for other landscapes.

Shushan could not leave her house for long, with the animals and crops to care for. But they would not miss the most important pilgrimage to the magnificent Church of the Holy Cross on Aghtamar Island.

The children were thrilled for it meant a trip by sailboat. 'It was the harvest festival, the Adoians and all the villagers went by boat to Aghtamar,' said Ado. 'I remember it well, I was already eight or nine. It was almost seven kilometres from the village. You could see Aghtamar perfectly well from our village, the walls and fortifications.'[10]

Just below Vart Badurik the boats were ready to carry passengers. Setrag owned two such sailing boats, 35 feet long, with a wide prow, used for transporting all kinds of cargo and passengers. A triangular sail hung from the yard at the top of the mast. If the wind was not strong enough, the sailors would have to row with huge oars.

Down from the mountain villages came farmers, scarves wrapped around

their heads, in traditional baggy pants, waistcoats and capacious shirts, the women in long dresses and headscarves. People from the city dressed in Western suits and ties. Crowded among sacks of flour and wheat, baskets of food for the feast, the children looked out.

As they approached, the island grew bigger and the cone of the church pushed into the sky. It was built of stone the same colour as the rocks on which it rested. They could make out the carvings around the outside walls. The lake appeared bluer, more opalescent. They climbed up the stony path, past almond trees, and after a turn, the south wall suddenly came into view – stark, flat, fantastic animals and figures suspended in relief across it. The crisp outlines of the square building were sharpened by the clear light. A giant, deer, a sea monster, saints and angels with folded wings, rose above a flat horizontal band. Deep edges etched dark shadows in the stone, like solid drawings. 'The work of a jeweller rather than of an architect,' commented the traveller H. F. B. Lynch.[11]

'On the outside of the church were sculpted pomegranates and animals with horns,' Ado recalled, 'and the beautiful walls had flowers as though they formed a garland all around the church.'[12] On the western façade of the church was a magnificent relief of King Gagik dressed in Oriental turban holding up a model of the church to Christ, surrounded by angels and seraphim. This prince of Vaspurakan had chosen the island as his capital, and had churches and palaces built by the architect Manuel in 915–21. Aghtamar had been fortified, planted with orchards, laid out with terraced gardens and a palace erected whose gilded dome sparkled in the sun.[13] Now only the church and monastery buildings remained, and Aghtamar became the religious centre of neighbouring towns and villages.

Manoug and his friends picked out soldiers with swords, a sailboat, a winged sea monster with gaping mouth, lions and other carvings.[14] He heard the king's name, Ardzruni Gagik, repeated often, sometimes as Ardzvi Gagik ('Eagle of Aghtamar'). His own later choice, Arshile Gorky, echoes its initials and syllables.

Clutching his mother's hand in the stone interior of the square church, squeezed between adults, he stood beneath the central dome. The church is still standing today. Tall columns and soaring arches rise on four sides. Arched windows cut into the thick stone would have thrown sunlight on the colourful paintings that covered the walls. Christ entered Jerusalem on a donkey; opposite he washed his disciples' feet; a cluster of sorrowful women

draped in cowls clasped their hands. A boy turning his head from side to side would have seen tall, forbidding saints stare down at him, book in one hand and finger raised in warning. Haloes and rounded Armenian eyes, bare feet and hands, made rhythms and patterns against the ascending line of singing. They settled in the boy's memory. The King's Gallery was carved with elephants' heads. Angels hovered everywhere, above the windows of the dome. Cool blue against rich red, brown and ochre, compressed by black outlines. The frescoes were arranged in geometric order: Baby Jesus in a manger, Lazarus in the tight little rectangle of a coffin, a chrysalis, shrouded in semicircles.

Gorky would reproduce this wrapped-up figure as a haunting form in his late drawings, when he himself came close to death. On the walls of Aghtamar, the sandstone texture and lines of masonry showed through peeling colours. He would paint and scrape off layer upon layer, revealing the substance beneath like an archaeologist getting to the substratum of his memory.

It was clear to all the family that since his father left in 1908 Manoug enjoyed a special relationship with his grandfather and namesake, Manoug Agha.[15] He sat next to his *Babi* (grandpa), who smoked tobacco from Vosdan in a *nargile* (hookah). Huge bubbles rose through water in the thick glass flask as he puffed at the mouthpiece and sent up clouds of sweet smoke. They shared a passion for apricots and Manoug picked the first fruit of the season to receive his grandfather's blessing. One day the old man accepted a bet and sent the boy to fill a huge basket with apricots. Manoug Agha ate the apricots and tossed the stones to one side. The children watched almost six kilograms disappear. In an hour, he had finished and won the bet. Next Manoug smashed the apricot seeds while Grandfather ate the kernels. His cousin learned, years later, that the kernels 'have a chemical reaction and destroy the acidity of the apricots so that he could digest them'.[16]

Gorky inherited the old man's bravado. Later, in New York, a friend recalled having a set meal in a restaurant. After dessert and coffee, he ordered the waiter to repeat the meal and ate it again, from soup to dessert.

Manoug grew unusually tall and lanky, with huge feet, long fingers and a peculiar lope which earned him the nickname *oukhd* ('camel'). His friends

sometimes came up against his explosive temper, especially the mild-tempered Yenovk who recalled: 'He was very temperamental. Since we were little, he'd get mad. He could hurt you. He was stronger than I. Couple of times he did hurt me and once I came home with red eyes, crying.' An uncle smoothed over the crisis but for a month Yenovk avoided Manoug.

One day while swimming in Lake Van someone yanked his leg under the water. Manoug bobbed up: 'If you don't talk to me, I'll drown you. I'll drown you!'[17] They became friends again. Manoug did not know his own strength. His sudden eruptions would later have catastrophic results for his relationships. Yenovk would also become an artist and singer, taking a protective role, caring for Gorky through his darkest moods.

They often played below the bluff of Mount Badurik in a cemetery strewn with slabs of stone carved with crosses. These were called *khatchkar*, combining the word *khatch*, 'cross', and *kar*, 'stone'. Yenovk said: 'Neither he nor I knew about art. They were beautiful and we would rub them with our hands.' The stones were rectangular steles inset with a cross, and other patterns: the tree of life, foliage, a bird or fish and inscriptions. These were prime sacred artefacts, which had been carved by Armenians for centuries, probably originating in pagan times when rocks, streams and trees had been worshipped. They were often set in a field or at a crossroad to commemorate a battle or pray for a good harvest.[18] The boys traced the grooves and labyrinths of warm stone with their fingers, and wished they could decipher the stories. Some had been carried down and reused as tombstones by the villagers. Gorky's painting later contained the coiled and springy energy of their curves and angles, and especially the double-ended cusps. That spareness stayed with Gorky; the quality of weathered stone, its dips and hollows would characterise his work as he gouged into his thickly painted surfaces and weighed down canvases with so much paint that no one could lift them. He named paintings after Khorkom, and other myths.

At school the children learned that they lived in a place with a legendary past. Manoug's first lesson in history was the myth which every Armenian schoolboy is taught about the origin of the nation. It began with the Bible and Noah's Ark landing on Mount Ararat, to the north of Khorkom. One of Noah's grandsons, Hayk, son of Japheth, revolted against the giant, Bel, after the destruction of the tower of Babel. He settled his tribe, the 'Hayk', in

the region, the name by which Armenians call themselves. One boy remembered their history lesson:

> In our village there's the river Khoshab, which pours into the lake. South of
> it is an island, Kurvantz, which emerged from the rising level of water on the
> lake, where there are tombstones. According to the tradition, Haig and Bel
> fought there. Haig killed Bel and they buried Bel on Kurvantz where the
> stones are white.[19]

For Manoug and his friends the lake was an unending source of pleasure. Giant turtles came out to nest, laying eggs on the grassy slopes of the mount. The boys tried to stand on their backs for rides. 'We used to bring the eggs to our mothers so they could wash their hair in the yolks to make it soft and strong,' said a cousin. The plentiful wild geese and ducks were not hunted. Cranes flew in and returned each year to their old nests in the poplars surrounding the shore. Storks and seagulls wheeled overhead.

'A marvellous view ... opened from the height of the village onto the peaceful lake,' his cousin recalled. 'The setting sun with its last rays meets the little waves of the lapping waters and the *darekh* fish leap in their dance, flying high into the air.'[20] A new freshwater lake had been formed by the draining of the river Khoshab into a basin cut off by the little islet of Kurvantz. The water rose, just below the Adoians' house, where the fields had flooded, and only bamboo grew there. In summer the fishing rights were sold. Van fishermen and others came with their boats during March and April, to catch the local fish, *darekh*. Manoug joined in, wading to where the fishermen placed barriers in the water at the mouth of the river as it flowed into the salt-water lake. On the other side they held up willow baskets and the golden fish jumped into the baskets. Shushan smoked the largest fish for the winter, and cooked the smaller fresh ones, slapping them onto the side of the *tonir* to be eaten with pilaff rice.[21]

At sunset, the children waited to pinch rowing boats from fishermen and hunted for the eggs of water fowl in nests among the reeds. Manoug stopped other boys from stealing baby chicks from their nests, but if they were lucky enough to find eggs, he hurried home to beg Dadig for a little butter to make an omelette on the fire they had made outdoors. As the sun fell into the lake the water turned an eerie blood red and they were startled by

howling shrieks. The monster in the lake would swallow them, they told one another, and ran home in the dark.

Behind the apparent normality of daily life menacing political events were being planned for the destruction of the Armenians, yet the Armenian leaders could not read the signs. Since the optimistic July 1908 Constitution Declaration by the Young Turks, Sultan Hamid had been deposed in 1909, in favour of his ineffectual brother, Mehmed V. A terrible massacre took place in Adana, Cilicia, in which 30,000 Armenians were slaughtered. Sultan Hamid launched a counter-revolutionary coup against the Young Turks in Constantinople. Talaat, future Minister of the Interior, took shelter with an Armenian parliamentary deputy, Krikor Zohrab, and later to repay his kindness sent him to his death.[22] Massacres were planned in other cities. The Turkish ambush prepared for the Armenian citizens of Van on 26 April 1909 was foiled by a fluke snow blizzard.[23]

Khorkom by then had its share of revolutionaries, splitting the village between rival groups. Children of Manoug's age were influenced by young teachers who instilled in them a sense of national identity through history and secular literature, rather than Church traditions.[24] Manoug's mother, though religious, was sympathetic to new ideas, and keen for him to escape the old fatalism which crushed the hopes and ambitions of her generation.

Independent and hard-working, she cultivated the fields, tended the animals, but with no help from her sister-in-law, Baydzar, Krikor's wife. The family no longer mentioned the grandfather, who probably had died at this period. Gorky sometimes talked about attending a big funeral when he saw the traditional laying out of the body on a bier, the face exposed. His own late painting, *The Orators*, would be interpreted as a flashback to such a scene. Left on their own, the sisters-in-law began to fight over their duties and possibly their inheritance. Grandmother was too old to arbitrate. Shushan remonstrated with Krikor's young wife, Baydzar, for not doing her share of the work.[25]

Letters informed the brothers in America that Baydzar and her family had moved out to Van, taking Grandmother. Shushan was left sole mistress of Khorkom. Krikor returned, and persuaded his ageing mother, who owned the title deeds, to sign everything over to him. Then he stormed back

to Khorkom with his family to evict Shushan. Manoug's family moved into a smaller house. His young cousin repeated his parents' words: 'They were poorer than us and Setrag was lazy. My father took him to America to make money.'[26]

Krikor and Baydzar then decreed the marriage of Akabi, Shushan's daughter by her first husband. Akabi was a hard worker, bright and cheerful, adored by the children.[27] Manoug was drawn to her infectious good humour, in contrast to the more melancholy personalities of Satenig and Vartoosh. Girls were married as early as fourteen to protect them from rape and abduction by the Turks and Kurds. Shushan acquiesced in order to save her from Baydzar's high-handedness and Krikor's beatings. Later in America, Akabi's daughter, Libby Miller, remembered, 'Baydzar and her husband wanted to get rid of her. They married my mother off as soon as she was able. She didn't see him until they got to the altar.'[28]

On 10 February 1910, Manoug stood solemn-eyed, surrounded by his sisters and mother. He watched his tall, fourteen-year-old sister face a short stocky man at the altar. The priest joined their hands, brought their foreheads together until they touched, then placed a wreath on each head, crowning them King and Queen of the day in keeping with the Armenian service. Mgrditch Amerian, the bridegroom, was from the same town and even the same family as Shushan's first husband. 'They had to get dispensation from the church to get married since Akabi and he were first cousins,' Libby explained, for the Armenian church forbade marriage to close kin.

Shushan herself had been married at fourteen to Tovmas Prudian, in 1894. 'Only two years later, three Turkish guards dragged him into the house in Shadagh,' Gorky's sister Vartoosh explained. 'They pulled up her eyelids like this,' plucking hers back to expose the whites of her eyes, 'then the men stabbed him and forced her to watch. He had dared to stand as Mayor of Shadagh.'[29] In that instant she explained Shushan's staring eyes, which would never relax, and would compel her son to draw them all his life.

Shushan wept during her daughter's wedding. Manoug and Vartoosh only remembered scrabbling on the floor for sweets when the bride was showered with them for good luck.

5

Van
1910–12

Tension between Manoug's mother and Uncle Krikor finally reached boiling point. One day Manoug heard them fighting. Outside the house, his mother stood her ground. His uncle lunged and hurled her down on the stones. Shushan was bruised, and that night she suffered internal bleeding.[1] This signalled the end of her resistance. Vartoosh remembered her resolve, 'Even if we have to walk to Van, we must leave this place.'

The cousin who had helped Manoug to talk recalled:

This was a very unfortunate thing in the family and Manoug got impressed by that and he never forgot. As a child he couldn't speak at all. He had a great love for the horse and dog. The dog was very good and he was playing with him mostly. When he left the house with his mother and lost the horse and dog, he felt very, very bad.[2]

Manoug, his mother and two young sisters left home in September, 1910. Shushan took only the barest essentials. She piled a few rugs, eiderdowns, clothing, kitchen utensils and personal belongings on the back of a cart. They bumped along the dirt track out of Khorkom, under poplars and along streams, leaving their fields behind. Van lay about seventeen miles to the north, a slow journey along the lakeside. On Manoug's left the brilliant blue waters glimmered with patches of lavender and pink. On his right, apple, cherry and mulberry orchards hid the mud brick houses of Artemid. Ahead, Mount Sipan rose like the roof of a giant church; tongues of snow cut deep into its folds. Other travellers were headed for Van: barefoot

peasants on foot, men on horseback, wagons and carts. A caravan of camels with loads from Bitlis lumbered along.

Long before they approached the gate of the walled city, they saw the colossal back of a sleeping dragon rear up out of the plain. Van Citadel sat 300 feet high on the long narrow ridge which bristled with the spiky crenellations of medieval walls running for several hundred feet.

The province of Van was the main centre of the Armenian population in the Ottoman Empire, after the Armenian kingdom of Cilicia. It was the only one where Armenians were in the majority. A quarter of a million Armenians had lived there since the dawn of history. The next largest group was 87,000 Nestorians, followed by 52,000 Kurds and a mere 14,000 Turks. In the city of Van lived 53,000 Armenians. 'There does not appear to be any evidence of an actual settlement of Turks in Van or the neighbourhood,' H. F. B. Lynch pointed out.[3]

Van was also a vital cultural centre for Armenians, rivalled only by Tiflis in Georgia. Schools, colleges and even museums were maintained by the church and some prosperous businesses which supported an educated and cultivated community with strong links outside Western Armenia. Two major massacres, constant persecutions and migration had decimated the number of Armenians, but they were still in the majority on their own land, which gave them a confidence few other Armenians possessed under Ottoman rule.

Akabi lived with her husband and mother-in-law in the City, as the walled section was called. Nearby was Shushan's sister, Yeva. The new arrivals found a room to rent in a busy part of town, crowded with churches, mosques and bazaars. The move from Khorkom to Van was an abrupt change of horizon and space, from the open farming land and vistas of blue water to the narrow, crowded streets lined by two- to three-storey buildings.

Manoug's first home was in a Turkish neighbourhood, and his younger sister, aged five, was aware from her mother of tension and danger in the city. 'We rented one room from an Armenian family, the Boudaghyans. They lived together, real Vanetzis in a large house with a room that had a little kitchen we'd put together with a fire for cooking.'

Nothing is left of the walled city now except a few ruined empty shells of churches and mosques of solid masonry. Yet, the accounts of travellers and

Armenian writers give a picture of the thriving city through which Shushan walked her son to school. *Yissusean* (Jesus's), one of the oldest schools, founded over fifty years earlier in the courtyard of Sourp Paulos and Sourp Bedros, St Paul and St Peter, was at the very base of the Rock, their name for the fortress.[4] Shushan may have sent Manoug there because she was unable to pay school fees. It was a better school than Khorkom's, with qualified teachers, some fluent in French and English.

The traveller H. F. B. Lynch described a typical class in one of Van's schools around that time:

> The younger pupils in the primary class will be collected in one vast room, seated on benches or on the floor. They are attired in nondescript and ragged cotton garments; and few even of the older scholars are possessed of suits in cloth. A number of smaller classrooms, with forms and blackboards, are approached from a long passage. Although the windows are all open, an unpleasant odour pervades the air . . . The vast majority (of children) have less pronounced more irregular features common among the youth of Europe. But their eyes are all very dark and bright, shining like big beads. They look extremely intelligent.[5]

Manoug was taught from 'textbooks supplied by the printing presses of the Mekhitarist order in Venice and Vienna'. The subjects were the Armenian language, religion and literature, Turkish and mathematics. The teachers were laymen. Some had trained at college in Van before the government closed it down; others came from Tiflis and Constantinople. The Ottoman government constantly placed obstacles in their way, such as preventing the arrival of books, restricting their choice, banning gymnastics in case 'the boys might be drilled and *rebel*!'[6] Lynch noted that a copy of Xenophon's *Anabasis* had been defaced to erase the name of Armenia from a map. A tax of 2 per cent was levied on the Armenians for education, but was pocketed by the Ottoman officials, and so more money had to be raised for schools.

Manoug hated school. An energetic child, he wanted to be outdoors, running with the boys, swimming in the lake, climbing trees and playing games. The family were cooped up in one room. They longed for their village house, the open expanse of the lake, the freedom to roam and run in the gardens and orchards. Shushan missed setting off on her horse to the

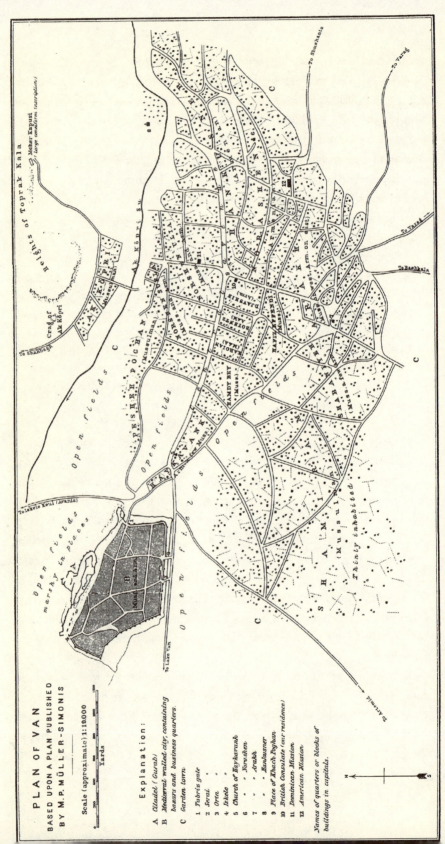

PLAN OF VAN
BASED UPON A PLAN PUBLISHED
BY M.P.MÜLLER-SIMONIS

Scale (approximate) 1:10.000

Yards

Explanation:

A Citadel (Gurab)
B Mediæval walled city, containing
 bazars and business quarters.
C Garden town

1 Tabris gate
2 Serai „
3 Orta „
4 Iskele „
5 Church of Haykavank
6 „ „ Norashen
7 „ „ Arakh
8 „ „ Hankusner
9 Place of Khach Poghan
10 British Consulate (our residence)
11 Dominican Mission
12 American Mission

Names of quarters or blocks of
buildings in capitals.

fields at dawn, and Manoug was miserable without the animals, especially his favourites, the dog, and the horse with a white star on its forehead.

Every morning before sunrise he was woken by the *jamhar*, the town crier, who banged with a wooden mallet on their door to rouse them in time for church. He shouted the words 'All is well', except in times of danger for Armenians, when he would warn them. Manoug and his mother left early to go to school. Stallholders set out little booths, knife grinders, dried fruit sellers, mattress makers, cradle joiners. People were very differently turned out from the peasants and ragged children of Khorkom. Many Armenians dressed in smart European suits. Muslims always wore the fez and sometimes a cloth *sarikh* wrapped around the head; others had long, flowing Oriental robes. In the market were coloured mountains of dried fruit and spices; dried meats hung from hooks; brass trays and silver jugs glinted in the sun.

Manoug and his mother passed a high wall, which led into the courtyard of a church. H. F. B. Lynch wrote: 'You enter through a low door of great weight after hammering with a ponderous knocker. The most interesting of all is certainly Sourp Paulos . . . parts of the chapel date back to an epoch before the advent of St Gregory, when Christianity flourished in Vaspurakan.'[7] The church was of naked stone, unplastered, unpainted. Three huge slabs with cuneiform characters were built into the seven-foot-thick walls.

Inscriptions carved into stone was a common sight for Manoug, both here and on the base of the Rock. Later in the course of his work, Gorky developed a vocabulary of forms, motifs, characters. In one large pen and ink drawing he assembled more than thirty frames, each with a different drawing. It was later named *Alphabet*, and suggested a wall with inscribed slabs.[8]

Most of the twelve churches were dedicated to the Virgin Mary. It was a continuation of the pre-Christian cult of the female goddesses Anahita and Ishtar. Gorky's later reverence for his mother, shown by his painting her portrait as a deity, was undoubtedly affected by these strong female archetypes.

Shushan wrote to her husband that they had been thrown out of their home and deprived of their livelihood by his brother. Surely he would return, as Krikor had done, to take charge. She had lived with him for seven years before he left for America. She had never really loved him, but

had been a dutiful wife and a loving mother. Setrag sent her money which took months to arrive.

Shushan determined to find a safer home. Most Armenians lived outside the walled city in *Aykesdan*, the Garden City, several miles away from the old section. It was set out with wide roads and houses. The Reverend Clarence Ussher, the missionary physician who became a key figure in their lives, gave his impression of the main street:

> This was sixty feet wide, though most of the other streets were extremely narrow. It was bordered by double rows of trees, mostly poplars and willows, with a water-course on each side. All sorts of domestic ceremonies were being performed on the banks of these water-courses: here a Moslem was washing his feet; further down was a woman washing her dishes and cooking utensils; still farther down, another Moslem was rinsing his mouth from the small stream; because it was running water it was considered clean.[9]

Such houses still exist in the outskirts of Van, in dilapidated condition, giving the impression of a once attractive and airy neighbourhood, bordered by streams.

Shushan found rooms in *Chagli*, Young Almond Street, on the outer edge of the plain facing the mountains and monastery of Varak. A high vaulted doorway led to a courtyard. There were balconies with vines climbing up, trees and flowers. Manoug immediately liked the new house, where he could play in the large garden. Behind the house were orchards with quinces, pears, apples, plums, wild cherries, sour and sweet cherries. The bedrooms were upstairs, and downstairs was the sunken oven for baking bread and cooking. Vartoosh also loved this house: 'Our street was very pretty. There were poplar trees and willows. Part of Shamiram canal flowed down our street, two streams flowed through, the other was the drinking fountain. There were streams everywhere in the streets.'[10] Vartoosh often slipped into the present tense as she visualised the house. 'To see the mountains you have to walk out into the fields.'

Shushan was happier, planting spinach, onions, flowers, and tending the fruit trees. She bought a cow so the children could have milk to drink. Their Armenian neighbours made them welcome. Shushan decided to send the children to the American Mission School. Dr Ussher reported, 'At the southern edge of the middle third of the Garden City were the

American premises, situated on a slight rise of ground. They were enclosed by a high mud wall. A great double-leaved wooden gate opened on the street.'[11]

They were awestruck by the large classrooms with windows and desks. The American Mission School introduced Manoug to a different style of teaching and new subjects, including English, which he had never studied until then.[12]

As he grew up Manoug was becoming more of a tearaway. His mother did her best to curb his strong temperament, although she secretly admired it. Shushan had authority enough to cow her relatives but she was overtaxed by looking after three children. Manoug often gave her the slip and went off to play with his friends. One day he came racing back to the house, and begged her to hide him. He had climbed a tree to pick some fruit and some branches had broken. Now the owners were after him. Shushan pushed him into the cold, empty *tonir* and slammed on the lid. Crouched in the dark hole, Manoug heard angry voices and his mother's calm tone. Her son was not at home. She would punish him as soon as he returned. She led the complainants away from the oven. The voices subsided. Manoug waited for her to release him.

Vartoosh recalled that he loved to draw. He always had a penknife and a stick which he whittled, giving it the shape of a pencil. He carved wooden tops, which he liked to spin endlessly, especially when the ground was covered with ice. If he could find money, he bought paper and pencil and drew and drew and drew. Animals, birds, people, anything that caught his eye or exercised his imagination. His mother was severe and expected a great deal of him. But her values were not those of a peasant woman. She always put aside a little money so he could buy drawing paper and pencils.

In spring, the fields around the house were full of wild flowers, and the green orchards were colourful with the blossoms of apple, pear, peach, apricot. Children, dressed in new clothes, carried fragrant bunches and sprays to church. 'At Easter people would dye their eggs and bring them for Gorky to decorate. They'd queue up for him to engrave flowers and birds and trees. He painted beautifully on those eggs. The eggs were taken to church to be blessed.'[13]

They walked to school at dawn, and returned at sunset. In winter, snow covered the ground, and the journey to the American quarter seemed even

longer. The winters were severe and, when the water froze, Manoug and his friends skated on the ice.

It was cold in the house. Shushan wore a long dress with a coat over it. She was a fine cook, often preparing an earthenware pot of meat with quince or apple, letting it simmer all night. She made *herissa*, cooking meat with barley until it was creamy. They ate off specially carved wooden plates. Metal pots were only for cooking and had to be 'tinned' twice a year to prevent the brass turning a poisonous green. Shushan was so meticulous that the neighbours laughed at her for wasting soap on washing metal pots and pans instead of merely rubbing a handful of ash against the metal as they did.

Manoug looked forward to the days the baker-woman came to bake bread once a week. Bread sold from the bakers' ovens was inedible, for they used flour mixed with grit and mud. Government officials created cartels, hoarding cereals to keep the prices high and often creating artificial famines. Shushan managed to get her own supply of flour, which she sieved repeatedly, then kneaded into dough. She smiled at her son as she pressed the sign of the cross on the risen mound of dough. 'May your bride's cheeks be as soft as this dough.' He munched on the first warm bread as the women rolled out dozens of paper-thin pastry rounds with long rolling pins, wrapping the huge circle along the length of the pin. They laid them on a metal dome over a fire for *lavash* bread or slapped smaller ovals on to the clay side of the *tonir*. All week the baked rounds were kept dry, then moistened with a few drops of water for eating. Meat, cheese, eggs, everything was wrapped in the bread.

At night the children loved to sit by lamplight around the fire, feet tucked under the frame covered with rugs and eiderdowns – the most frequent cause of fire in Van. 'First Gorky talked, then Mummy, then Saten. Oh, those were good times.' Vartoosh sighed. 'We four sang constantly. Mother sang, then Gorky, all kinds of songs.'[14]

Shushan rarely left the house, except to attend church every morning and to buy food. There was great excitement over the American Mission's occasional movie shows, which were religious. Manoug went with his sisters and could hardly believe the moving pictures were not real people. Vartoosh recalled their walks by moonlight. 'He had a very good voice. We sang all the way home.'

During the next two years the city became Manoug's stamping ground.

Its influence on him would be very strong. He wandered about the town avidly exploring, a habit he continued into adulthood. His sister did not resent the freedom he enjoyed. 'He would go off with his friends to swim in the lake and come back at night. Mother begged him not to go because there were Turks who might harm him.' At the end of the week he went on long rambles in the fields outside the city.

One day his uncle Krikor appeared, riding *Asdgh*, the chestnut horse which Manoug had particularly loved. The boy stroked its muzzle and talked to it. His sister Satenig remembered:

> Gorky was so incredibly happy. Gorky took it by the reins and he brought it into our garden, in the city, and he led it back and forth, back and forth. It was Gorky's horse, a chestnut with the white star on its face. He was so happy about it. He was too young to ride it and he never rode in Van. In the country we used to sit him on the horse and lead him.'[15]

Her voice broke as she told the story, remembering how much the horse had meant to her brother.

In the Mooradian collection, there is a line drawing in China ink which Gorky sent to his young nephew in the 1930s. A boy and a tall horse face one another. The boy is small and chubby-faced, the top of his head level with the horse's muzzle. He stands squarely in front of the horse's head gazing up into its eyes. They seem transfixed by one another. In a clear and childlike style, the bold drawing evokes an early memory.

The horse made him feel homesick. His mother was not pleased to see her brother-in-law Krikor, nor did she want the fruit and vegetables he had brought. A second sketch catches the drama of the meeting. The boy, seated on the back of the horse, holds the reins. He stretches out a hand to stroke its neck but his way is barred. A tall, slender woman, her hair in a coil around her head, wearing an ankle-length dress and longish apron, faces the horse directly. All three characters are in profile. She leans back, away from the horse, and fixes it with her gaze. Gorky later often drew horses and carved them for his little daughters.

Satenig said he cried that night and asked his mother to send him back to Khorkom. His new, fragile roots in the city were swept away by the familiar

atmosphere his uncle brought. Shushan promised that he could go back for the summer.

The only surviving photograph of Manoug as a boy was taken in Van at about this time and sent to his father. The boy looks around eight or nine years old. Shushan took her son to a local photographer, not bothering to include his sisters. Perhaps she made the decision on the spur of the moment, when she was walking past one of the rare photographers' studios in Van. She sits and he stands beside her, making him appear taller. Her hands are resting on her knees, partly curled. The full frontal pose is common in photographs of this period. The boy is dressed in a formal long coat with dark collar, buttoned-up shirt, long trousers and overshoes. He holds a little nosegay of flowers. This was a common convention of all studio photographers; the flowers were offered as fragrant gift to the recipient. Others hold a pen, a book or even a handful of apricots. Manoug looks prematurely solemn with almond eyes in an oval face, his hair neatly combed down one side. Shushan looks bravely at the camera, challenging her husband with the trials of her life. She was thirty-one. Her face is long, with refined features and heavy lids, a resolute mouth, her hair covered in the traditional scarf. A long apron covers her dress, always wrongly described in subsequent writing as 'embroidered', although it is merely a flower-sprigged print on cotton. The authentic Van embroidered aprons, which Shushan stitched, were patterned squares, finely worked in stars and flowers.

Shushan probably sent the picture to Setrag with her son-in-law, Akabi's husband Mgrditch. He set off for America in August 1911, together with Manoug's half-brother Hagop, to avoid conscription in the Ottoman army. He left behind the two women, the children and his six-month-old baby boy.

In summer, Van became extremely hot and many people went to stay with their relatives in mountain villages. Akabi went to her mother-in-law's in Shadagh, taking her brother Manoug with her. Shushan worried constantly about her son's health. He was thin and very tall. The mountain air would do him good.

High up in the eastern flank of the Taurus mountains, Shadagh nestled in a fertile basin of trees and vineyards at the junction of two rivers, the eastern tributary of the Tigris and the Sevdiguin rivers. The two peaks of the

Arnos, 12,500 feet high, and the slightly lower Ardos towered over the hilly town which Manoug loved. About a thousand people lived in its fortress-like stone houses. A handsome stone bridge spanned the river in a graceful arc. The people here dressed differently; the men in straight, baggy trousers with shirts and waistcoats, their heads wrapped in a large, twisted cotton cloth, like a turban; the women wore baggy trousers and coloured shawls, with white scarves around their faces, always ready to cover their mouths when strangers appeared.

Akabi's in-laws owned many sheep and Manoug went out into the highland pastures with the shepherds and flocks. He ran and played with the sheepdogs, Bashu and Zango. He was thrilled when his sister allowed him to spend the night on the mountainside with the shepherds. After letting the sheep graze on the steep upper pastures, they climbed up the hillsides, keeping a wary eye open for wild pigs and grey bears. Before nightfall, they herded the sheep into caves to keep them safe from wolves and predators. Manoug gathered firewood, the shepherds lit a small fire and sat down with him to eat an evening meal.

As the fire flickered against the cave wall, Manoug listened to stories of their exploits and fighting. He was learning the local dialect with its guttural sounds and spattering of Kurdish. His mother spoke fluent Kurdish for she had lived here with her first husband. The shepherds told him stories of Shero and Chatto, the revolutionary leaders who both died in 1896 defending Shadagh, the capital of the last Armenian Antsevatsik princes.[16] As the young boy listened to the stories, it seemed to him that his whole family and friends were caught in a web of rebellion and death. Only the few who escaped to another place, like his own father or Akabi's husband, could be safe.[17]

One of the men pulled out a flute, and another broke into song. Others joined in the song of the Shadaghtsis, so old its clean, pliant intervals seemed like ancient church music. Manoug watched the men dance their powerful leaping dances, silhouetted against the fire, more vigorous than the songs and dances of the villages down in Van. They encouraged him to join in. 'Learn to dance like a man!' Early in the morning he woke, the sun gilded the flanks of the Ardos peak, brooks gushed down the hillsides. He splashed his face with ice-cold water and, cupping his hands, took a long drink. A shepherd handed him cheese wrapped in *lavash* bread and he sat down with the men to eat breakfast.

A breakthrough in his career as a painter, one of Gorky's great mature paintings, was called *The Waterfall*. He would paint it after spending days standing on a rock midstream, near the Housatonic Falls in Connecticut, on one of his rare trips away from New York. But Gorky's abstract canvas is not of Connecticut. The density of vegetation it suggests, the depth of verdure and earth tones, the powerful diagonal crossing the picture, hint at a wilder vertical mountain backdrop. Each of Gorky's great paintings has a name to be unravelled, a place in his heart. The titles are clues but their origins were so well hidden that they became a source of speculation. Here in Shadagh is Manoug's childhood waterfall.

During that holiday in Connecticut, his friend Schary was surprised to see Gorky return to the river day after day, saying it reminded him of a place back home. Then one night on Schary's terrace Gorky began to weave a dance, his tall, skinny frame silhouetted against the night sky. He sang in an off-key mode, accompanying himself as he spun and danced.[18]

The new wool of the season was being spun and woven in the sixty-odd workshops in town. With very little farming land on these steep slopes, weaving was one of the few sources of income for both men and women. Akabi took Manoug to see her friends, and out came the textiles they had woven during the winter, very fine woollens woven with soft goat's mohair. He touched the soft wools and traced the rich geometric patterns the women wove into their scarves and decorative aprons, light as veils in bright colours. In New York, Gorky would become known for always wearing the finest English tweeds and woollens.

Finally, as the summer drew on, he was able to go down from the mountains, back to his own village of Khorkom until autumn. Manoug's cousins Ado and Azad waited impatiently for him. They were shocked at how tall he had grown. They sparred, wrestled and tumbled. The little hut looked smaller than ever now that he was used to living in a large house in Van. He could almost reach up and embrace Asdgh, his horse, to talk softly in its ear. The village looked dustier and smaller too, but the poplars swished in the wind and challenged him; the crows swooped menacingly as though warning him off. He could climb better this year, his legs were stronger and he could grip tighter on the trunk. His cousin Ado laughed at

the memory, 'My head is covered with deep scratches from the crows. But Gorky had the worst gashes on his head.'[19]

The village was hot and sticky. At night hordes of mosquitoes fell upon them. Manoug's great delight was to sleep with the harvesters in the melon fields. Hammocks woven out of bamboo were hoisted between trees; Manoug filled his with the melons for midnight feasts.

Yenovk, his friend, was also growing up and came to see Manoug. It was autumn, he remembered, 'because it was time to steal pears'. They pinched apricots in spring, pears in the autumn. Yenovk, bursting with pride, announced, 'My father lets me carve on stone.' His father had changed career from a minstrel to parish priest of Ishkhanikom, and carved one *khatchkar* a year. He would ask his son to sit down and carve a stone with him, as Yenovk explained, 'with two chisels and a broken hammer' they produced beautiful crosses like the ones on Vart Badurik.[20]

There was no one in Van who enjoyed making things with him as much as Yenovk. Even as adults, they would continue to paint and sculpt things together. Living in separate cities, they contrived complicated games to meet up and paint together. Gorky tried stone carving several times, but few pieces have survived.

However much Manoug begged to stay, his mother insisted that he return to Van. He savoured his last days, swimming with friends until evening, making the most of his freedom. When his mother and sisters called for him to leave, Manoug was nowhere. They found him at last crouched behind a wall, clinging to a sheepdog's long white fur and rubbing its stomach. The dog Zango was licking his face, while Manoug murmured, 'Oh Zango. Lucky, lucky Zango! You don't have to go to school. I wish I was a dog.'[21]

6

Rainbow Line
1912–14

In autumn Manoug was back in Van and his school friend Arshag Mooradian noticed he could not settle in class. 'He was a couple of years younger than me. We saw each other every day at that American School. He wasn't so good in mathematics. He had a few problems. What he did all day? He had a stick and a knife. He used to carve it all day.'

From 1912 to 1915 they went to the American Mission School. Shushan's connections in Van were far better than in Khorkom, for she had an educated family and friends. But no one could get Manoug to pay attention. Arshag said, 'Shushan was a lovely lady and terribly fond of Manoug.' She often visited Arshag's house to plead with him, 'Help Manoug! Please, help Manoug at school.'[1]

If he was not good at maths, the boy showed other surprising talents. His teacher Jamgochian was astonished when he memorised a map, and reproduced it exactly, drawing freehand on the blackboard. Vartoosh said, 'He predicted that Gorky would make enormous progress in art because he was very advanced for his age.'[2]

The impact of the American missionaries was profound. The mission had opened in 1871 under the protection of the British Consul of Van to provide education, crafts, medicine, and to care for orphans. They ran two American mission schools in Van, one in the walled city and one in Aykesdan. Gorky went to the Aykesdan School with 110 boys. Of the teachers, 95 per cent were Armenian, some trained in American colleges. The overall head of the mission was the Reverend Clarence Ussher, an enlightened physician, perspicacious and experienced in negotiating the

minefield of Ottoman officialdom. He had quickly learned fluent Turkish and Armenian, and employed Armenian nurses in the hospital he founded and built. Ussher noted, 'The tenacity with which the Armenians have clung to their religion has been equalled only by their obstinate patriotism ... the Armenians giving up their lives for the religion the Ottoman Government would compel them to renounce.'[3]

Ussher was valuable as the only American doctor in the city, alongside the Armenian Western-trained doctors who practised there. After travelling and living in Turkey for several years, he had formed the opinion that the Armenians were the most 'progressive element in the Ottoman Empire'. Noting that 'they were the creators of the country's wealth', the financiers, merchants, professionals and skilled artisans', and many were in high positions in government, he considered the banishment and massacre of Armenians 'a suicidal policy'.

He knew the Armenian values. 'Educate, educate – the girls no less than the boys.'[4] The mission took care of 500 orphans and 400 day pupils; 1,100 schoolchildren lived in the buildings and compound. There were two evangelical churches and Sunday schools. Ussher supervised a hospital and two large schoolhouses where children were taught trades as well as lessons. They wove cloth, cured the skins of the oxen and sheep eaten in the mission, and made shoes. The girls learned sewing and baking, helping to cook all the food eaten in the school. The boys went into workshops to learn from carpenters, blacksmiths or locksmiths.

Manoug loved to work with wood. His uncle Aharon was a cabinetmaker and taught him how to handle tools, while his sisters learned to sew, and became excellent seamstresses. Their mother took in sewing to pay for their expenses and supplement the money Setrag sent. She also used a small spinning wheel to weave textiles and carpets. Shushan tried to give the children a new set of clothes every spring, sewing most of them herself. 'Like birds which have new nests in spring, you children must have something new to wear,' Vartoosh remembered her saying. Her mother's favourite colour for a girl's dress was blue.

Manoug still had not come across much painting based on perspective and a central diminishing point. He was fascinated by the figurative art of sculpture and relief, medieval paintings in churches, metalwork and carpet weaving. All were flattened forms and used space as an equally important element of pattern to order the chaos of emptiness. Later on, when

confronting Western art, Gorky would find himself drawn to those painters who were pictorial, flat and non-illusionistic, and particularly to Cubism, which viewed objects simultaneously from different angles. His earliest training began in handicrafts.

Manoug often went to visit Ahko in the carpet workshop where she wove. Up to six girls were knotting on the large loom. Weaving had to be done by the youngest girls with very sharp eyesight and nimble fingers. An older woman checked their work, pointing to a picture of the design drawn by a master weaver. It contained figures and motifs from traditional rugs which he combined with his own colours and patterns. Skeins of wool in red, blue and yellow hung from the frame. The smell of the wool and dye was sharp. They quickly knotted in the stitches following the outer fine black lines and filling in the colours of the designs, flowers, leaves and the straight border. In this district, carpets both with and without pile had been woven for centuries. At home they used flat rugs without pile called *karpet*, for packing away bedclothes, for covers and cushions, even as salt bags. Row by row the cross section built up into a flower, and as one motif was completed another next to it was half done while still another was just beginning. Manoug's attention was drawn by the figure, then by the blue background which itself made another shape in between the patterns. Here was a kind of drawing. It was like his own hand moving over paper with a pencil. The outline was made and the colours filled in. *Kdzel*, 'to draw', also means 'carding wool' in Armenian. The terms evoked the art of painting: *lusakidz*, 'line of light', *tziranakidzn*, 'apricot line', *vosgekidzn*, 'golden line', and *spitagakidzn*, 'white line'.[5] The lines themselves were often edges of colour, not just outlines filled in by another colour. Gorky was later admired for his line and these words applied perfectly to him as he worked repeatedly over the edges of one colour meeting another.

The weavers often repeated, 'Red is the colour of woman, child and joy. Red is the best for the eye.'[6] Gorky would later talk to André Breton about 'cardinal red' when he discussed his most personal paintings.

From an S-shape in the carpet he could recognise the twisting body of a dragon; the zigzag was its tail and the fork its claws. This was his first lesson in abstraction. The sun was in the centre like a disc, trees and flowers were braided along the borders, like the garlands on the church of Aghtamar.

In some of Gorky's paintings the dizzying array of motifs is tightly interwoven but always floats and fills the space. The interplay of

background into foreground, juxtaposing a tiny but complete small motif against a bolder, larger form, balances the difference in scale. Later in New York, Gorky loved to study the Caucasian carpets at the Metropolitan Museum.

In Van, Manoug often used to stand by the open booths of the silver workers and watch them as they worked. 'There were engravers on silver. They worked on little boxes for sweets or rings. *Sevadli* it was called,' Vartoosh remembered. 'It was black underneath and then they carved them. Very beautiful designs. They sat in the window and worked so people could see them.'[7]

The root of the word *sevadli* is the Armenian *sev*, 'black'. As the craftsmen worked, they chipped off silver to reveal a layer of black *niello*. Gorky too was adventurous in the drama of white on black, a master at producing different nuances and colours merely with his application of black. In the *Nighttime, Enigma and Nostalgia* series of drawings, there is a shift from pencil and pen on paper to scraping black to reveal white. He had absorbed the *sevadli* technique when he was a boy in the streets of Van, a craft which developed his sensitivity to chiaroscuro lighting effects.

By January 1913, a military dictatorship was in power in the Ottoman Empire, under a militant faction of the *Ittihad* or Young Turk party. It consisted of Enver, Talaat and Jemal. German officers were in key positions in the Ottoman army. 'The steely eye of the Young Turks was fixed on the land east of Armenia.'[8] A pan-Turanian empire was the ambition: to reunify the Ottoman Empire with Eastern Caucasia and Central Asia. The Armenian tableland was an obstacle in the middle of this scheme and the 2 million Christians living there must be eliminated. Extensive plans were laid by the former telegraph clerk Talaat, who understood the value of fast communication as a tool to be kept out of the hands of the enemy. A network of Ittihadists was spread to the furthest provinces of the empire; each headsman and provincial governor had a committee member at his side to control his every action; in all towns and villages where Armenians lived, governors and police chiefs had been appointed with secret orders giving detailed instructions for the extermination operation. The 'hungry wolves' were activated by fanaticism and greed. The programme of 'Turkey for the Turks' involved the expulsion and murder of all non-Turkish elements, and

seizure of other people's property – even though 'Turkey' was still the multiethnic Ottoman Empire.

The foreign powers, as in the past, ineffectively drew attention to the ill-treatment of the Armenians and an agreement was signed between the Ottoman Empire and Russia in February 1914 to supervise the six Armenian provinces in two administrative districts. Turkey would reunite the *vilayets* (provinces) of Trebizond (now Trabzon), Sis, Erzerum (Erzurum), while Russia supervised Van, Bitlis, Harput and Diarbekir. Each would be supervised by foreign inspector generals (appointed by Turks) to survey the execution of reforms. The aim was to eliminate illegitimate possession of Armenian lands and houses by Kurds and Turks, corruption in administration and tax-gathering, and to maintain law and enforce impartial justice for Armenians. The agreement was probably a cynical cover by the Young Turks while they were secretly preparing their 'final solution' for the Armenians. Inspectors never took up their posts, although the Dutch envoy arrived in Van to start work in the summer of 1914, but soon left.[9]

Manoug's family felt secure because of their connection with the American mission, which seemed to offer a refuge of peace, but it was not always as benevolent as the missionary reports would suggest.

One morning, Manoug was summoned by the headmaster, the Reverend Ernest A. Yarrow, a Wesleyan with four children. He was a missionary with a powerful vision and relentless determination. The tall, blue-eyed American waited in his office. The American flag hung in one corner, and on the wall a blue-eyed Christ with long, blond hair was depicted holding his shepherd's crook with children flocking to him in streaming sunlight. Yarrow rapped out English words which Manoug did not understand and pointed at the boy's shoes. Manoug's hands trembled as he took them off. The Reverend took a rope and tied his ankles tightly together. Manoug was made to lie face down on a table. There was a sharp swish and the cane cut down into the soles of the eleven-year-old boy's feet. The searing pain made him scream. Every time he yelled, another swish stung and shook his body. Manoug writhed on the hard surface, gasping for breath. At last Yarrow flung down the cane and told his victim to go.

Dazed and blinded with tears, Manoug could not stand up. Nor could he fit the swollen lumps of feet, cut and bleeding, into his shoes. Vartoosh wept quietly as she spoke of it:

Oh, I had forgotten that. He came home and was crying very much, very much, because Mr Yarrow, the supervisor, had punished him by tying his feet and beating the soles so much that he couldn't walk. I don't know what Gorky had done. For two or three weeks he couldn't go to school because he had such terrible injuries on the soles of his feet. They call it *palakhgan*.[10]

Shushan could not take him to the doctor for Dr Ussher too was American. She must do her best with her own remedies. *Bastinado* was a favourite torture the Turks practised on Armenians, sometimes beating them so hard their feet burst open. It was hard to imagine this man of God torturing an American boy like that. Armenians were second-class citizens; no matter where they went, they could never be safe. The boy's torture coincided with the imminent bloodbath which would begin with the encircling of Armenians in Van.

On 28 June 1914, Franz Ferdinand was murdered at Sarajevo, and the First World War broke out. On 2 August 1914, secretly, the Young Turks signed an agreement with Germany as it was invading France. In July, a Young Turk mission proposed that, in case of war with Russia, a group of Armenians should instigate a revolt of the Armenians in Russia, as a provocation to justify the entry of the Ottoman army into Transcaucasia. In return they would cede an autonomous state comprising Russian Armenia and several regions from the Armenian provinces of Erzerum, Van and Bitlis. The Vanetzis would have been jubilant at the prospect of an independent Armenia at last, with Van at the centre. But the three Armenian leaders, Vramian, Rostom and Aknuni, suspected a trap to make traitors of Russian Armenians and rejected it. Nevertheless, they agreed that Armenians would be loyal. A quarter of a million Armenians signed up for the Ottoman army. Later, the number of deserters from the army was to be higher among the Turks than the Armenians during the war.

Manoug's maternal aunt Yeva, an active member of a resistance group, was known for riding with guerrillas on horseback. The leader, Levon Pasha Shagoyan, sometimes stayed in Manoug's house.[11] The boy heard snatches of the latest news and understood that they were in real danger. Since Van was a border town of Russia, it was close to the front at Kars

where the Ottoman Empire was mobilising to fight Russia. His family knew that in the Russian army, seven units had been formed of Armenian citizens of Russia. As in the past, the Armenian nation was divided between two foreign empires, and Armenian forced to fight against Armenian on the front lines. This also gave the Young Turks the excuse to persecute the Armenians. Reports soon reached Van of the appalling treatment received by the Armenians who had gone to fight for the Ottoman government. In the early autumn of 1914, Ottoman government officials in Van went on a rampage of requisitioning goods and searching for arms. Conditions became unbearable.

> Fuel could not be brought from other districts, kerosene, sugar, dry goods, could not be imported from Constantinople, because all the means of transportation, pack-animals and ox-carts, had been seized by the Govern-ment. Provisions and clothing had been confiscated. The grain taken from the very threshing-floors, where it was being trampled out by oxen, was made into a coarse, black soggy bread which soon went mouldy. It was then rebaked so hard that it could not be broken with hammer or stone. The families of men in active service were supposed to be given thirty piastres a month, but the families of Armenian soldiers rarely received this.[12]

In December 1914, the Ottoman Third Army, under command of the Young Turks' leader, Enver Pasha, attacked the Russian front. But the Turks were poorly equipped and suffering from typhus and cholera. Unused to the bitter cold of the high plateau, 90,000 men died and 12,000 were taken prisoner. Whole divisions – in total at least 30,000 soldiers – were frozen, standing upright like monuments. Armenian front-line troops personally saved Enver. He wrote to the Armenian Patriarch of Constantinople praising the courage and loyalty of the Armenian troops.[13]

The Vanetzis heard that the Russians had now entered deep into Erzerum and were close. Surely they would make an advance and liberate them? Some groups were prepared. However, enraged by his defeat, Enver turned his troops on Armenian villages, massacring and destroying as they went. The soldiers stirred up the Turkish and Kurdish populations against the Armenians. At the end of January, the Armenian soldiers who had saved his life were disarmed by Enver, forced into battalions of hard labour, or used as packhorses until they dropped or were executed. Armenian

functionaries were suddenly placed under house arrest and their passports withdrawn.

Each day, coming out of the classroom into the mission yard, Manoug saw bedraggled children, orphans and desperate women who had flocked to the only safe haven. Each told a more appalling account of atrocities suffered.

At home, food was so scarce that if Shushan had not grown vegetables and fruit, it would have been impossible to feed the children. She warned Manoug to be careful, for he was growing up and striking out with his many friends; sometimes they truanted from school. His beating had made him lose faith in the Americans who ran the mission. Recently twelve young boys of Ereer had been rounded up to be registered for conscription; instead they were taken away by gendarmes and shot. As Manoug was taller than other boys of his age, he was a likely victim to be press-ganged.

Armenian leaders patrolling streets and villages tried to curb the more spirited youths. They preached peace and tolerance. Despite the torture and killings of Armenians, they argued that it was better to put up with a burned village or two than to give the Turks cause for further massacres.

Just before Easter, a new *Vali* (governor) was appointed to the province. Jevdet Bey (brother-in-law of Enver Pasha) was known for his fanatical persecution of Armenians and zeal in refining methods of torture. One of these earned him the name of the 'horse-shoeing Marshall'. He had horseshoes nailed on to the feet of his victims and forced them to dance a macabre tap-dance until they fell. Jevdet was charming, wily and skilful in his relations with the Consuls of Van; he attended tea-parties with the American missionaries. He swore good will and protection to the Armenian leaders, while plotting to kill them. Armenian leaders parleyed with him, tried to maintain morale and check the youth from retaliating as Armenian villages were burned and ransacked, women and children killed, men tortured. For nine months, they tried to improve relations and restore peace, but Jevdet instigated a reign of terror.

Shushan was helpless to do anything more than keep her family together. Their lives were in danger, and she worried every evening until Manoug came home safely. Every night, she gathered her children, Vartoosh remembered:

In Aykesdan we prayed before going to sleep. We stood, first Mummy, then Gorky, Satenig and I, and looked to the east, *Aghotaran*. We only prayed that

God give peace, that war shouldn't happen, and God guard our lives. Mummy said this aloud and we made the cross and knelt.[14]

7

The Heroic Defence of Van
1915

All his life Gorky would remember the day the sun went black. The year 1915 was the darkest in the history of the Armenian nation. It opened with a sinister omen of nature.

Manoug's mother helped him hold a burning paper to a piece of glass until it was blackened with soot. He was excited, unsure of what to expect. Soon the streets filled with people, holding sooty spectacles and casting anxious glances at the sky. A great shadow fell over them. The sun slowly darkened. The darkness spread until it was blotted out. The tree-lined street disappeared, the people disappeared, everything went dark. A hush fell over the city.[1]

All over the region people were terrified by this eerie event. In Khorkom, Manoug's cousins Ado and Azad had not been warned of the eclipse and recalled that they were driving the oxen at the time. 'In the middle of the day, the sun went dark and out came the stars. We were so scared and didn't understand what was happening. Terrified, we ran home.'[2]

From that moment, the natural order of their lives turned upside down. They were sucked into a whirlpool of hatred and carnage. For Manoug the sudden change from light to dark was a supernatural event which would be remembered in his work *The Diary of a Seducer*, painted in the year of a man-made catastrophe, Hiroshima.

All Armenians knew that by March the power of the Anglo-French fleet had weakened in the Dardanelles. But they did not know that, secretly, the Young Turks put into operation their blueprint for a wholesale massacre of the Armenians. The early declarations of idealism were replaced by a

master-race ideology like the Hitlerian one. Ironically, Enver Pasha was rumoured to be of mixed blood, and Talaat the son of a Macedonian or Bulgarian gypsy. Together they had carefully prepared plans masterminded by Enver Pasha, the telegraph operator, Talaat, and with the help of the German army and advisers, they were put into effect.

Jevdet Bey, the new Governor of Van province, was preparing to send orders to his subgovernors to begin a massacre on 19 April,[3] 'to exterminate all Armenian males of twelve years of age and over'.[4] But first he planned to get rid of their intellectuals and leaders. The same murderous policy was to be executed throughout the Armenian provinces.

In Shadagh, Shushan's village, he arrested a schoolteacher. That night, people demanded his release. Dr Ussher, who had known Jevdet as a boy, was summoned as a go-between. In the office of the *Kasab Tabouri* (Butcher Regiment), as the *vali* called his band of released Turkish convicts, the doctor heard Jevdet command, 'Go to Shadakh and wipe out its people!' and turning to Dr Ussher he shouted, holding his hand below his knee, 'I won't leave one, not one so high!'

The regiment turned into Hayotz Dzor, the Valley of Armenians. Dr Ussher wrote:

Many of the criminals had been bandits and outlaws living by their rifles for years and were crack shots. They were mounted, armed with daggers, automatic pistols, and modern repeating rifles. Where they saw a mother nursing her babe they shot through the babe and the mother's breasts and arm. They would gallop into a crowd of fleeing women and children, draw their daggers, and rip up the unfortunate creatures. I forbear to describe the wounds brought to me to repair.[5]

Dr Ussher's fate became inextricably tangled with the fortunes of the Armenians who looked to him for refuge. Shushan and especially Manoug benefited from his courage. He tried to reason with Jevdet on behalf of the Armenians and also the various consulates whose neutrality should be honoured. But the governor proposed to put fifty soldiers with canon and supplies for ten days in the mission compound, conveniently situated on a hill dominating the Armenian quarter of Aykesdan and the road from the Ottoman barracks on Varak plain. The Armenian leaders refused to allow Turkish military in their quarter. The missionaries knew Jevdet would not

hesitate to kill them, and reiterated their neutrality under protection of the British Consul, asking for time to confer. Meanwhile the Armenians were ordered to prepare for defence under the governorship of their leader, Aram Manoukian. Another missionary, Miss Knapp, noted: 'For some time past a line of Turkish entrenchments had been secretly drawn round the Armenian quarter of the Gardens. The revolutionists, determined to sell their lives as dearly as possible, prepared a defensive line of entrenchments.'[6]

The Adoians lived on the edge of the Varak plain and saw the defence positions going up. The siege of Aykesdan was about to begin. Men, women, even children dug trenches around the neighbourhood. Manoug grabbed a spade from the garden and went out to help. They set up two hundred fortified positions in houses, barricades, walls and trenches where defence posts were organised. The long mud walls of the houses and gardens were formed strong interlaced and terraced positions.[7] Behind the fortified lines, which would prove surprisingly effective against artillery fire, they improvised about 80 *teerk* (blockhouses), to control the field in all directions.

The Armenian leaders of all the parties had received intelligence and had experienced enough massacres to expect the worst. They had to hold Van until the Russian army could get through. They had trained young men and secreted arms in villages where they could be brought down. But conscription and killings had dwindled the numbers of able-bodied men, and now there were no more than 300 with rifles and 1,000 with pistols and antique weapons to defend 30,000 Armenians, over a square mile in Aykesdan and a square mile within the walled city. Meanwhile Jevdet Bey had a full fighting force of 5,000, led by German officers, equipped and supplied with cannon and ammunition.

On the night of Monday 6 April 1915, Manoug was startled by gunfire and blasts so powerful that he was sure the house had blown up. The house stood exactly on the frontline between the Armenians and the Turks, and shells kept exploding on the porch. In the distance could be heard 'the roar of the artillery, which was making the heroic city of Van tremble to its foundations and turning it into an immense cauldron wherein were consumed daily hundred of innocent women and children whose only political offence consisted in being Christians'.[8]

Then they heard shouts and hurrahs and the blast of Armenian bugles. It was a signal of victory from the Friday Stream, the Lovers' Walk, which had now become a defence position. The Turkish infantry charged,

followed by a Turkish mob, but they were unprepared for the return fire from the Armenian defences and had to retreat. The firing continued and from the Castle Rock, the cannon boomed like clockwork. The walled city, with its Armenian population, was cut off from Aykesdan and the rest of the town and repeatedly shelled. Armenians in mixed quarters had taken shelter. That night, Jevdet, incensed by the unexpected resistance from the Armenians, set fire to all the Armenian houses there. Only one was spared, the house of a man called Jidatachian, where Jevdet had lived as a boy. The walled city was cut off and no more news of its inhabitants would arrive until almost the end of the siege. No one knew whether the Armenians there had survived. The sound of distant gunfire and shells kept up all that night. Vartoosh said, 'The shells fell around us, the noises, the bullets, flew past in town.'[9]

For the Adoian family, as for all Armenians, it was the end of normal life. Everyone sensed the terrible danger, but few appreciated its finality. The children reacted to the sudden rushes of terror and excitement, panic and relief. *Aykesdane Ayrevoum E* (Aykesdan is burning) is the title of a famous novel about Van by the Vanetzi writer Kourken Mahari. The conflagration of Van and the defence of the city would become bywords for courage and heroism for years to come.

A provisional government for Van province was set up by the Armenians, with representatives from all parties and the missions. A military council, administration and financial bodies were appointed. The consul of Italy was still in residence. The military council sent a proclamation that their defence was against the governor and not against their Turkish neighbours. Jevdet might be changed and good relations be restored. Distinguished Turkish citizens replied that they shared these sentiments but were being forced to fight against their will.

Rafael de Nogales, the Venezuelan mercenary in charge of the German officers directing the artillery firing line, wrote of his approach into Van, 'To right and left of the road circled screaming flocks of black vultures, disputing with the dogs the putrefied Armenian corpses thrown about on every side,' and noted that, 'The city was in the hands of the Armenians, but the Turks held the height.'[10]

The American mission, at the southern edge the Garden City, was enclosed by a high mud wall. The Adoians joined 6,000 fugitives from Aykesdan seeking refuge under the American flag. One woman told a

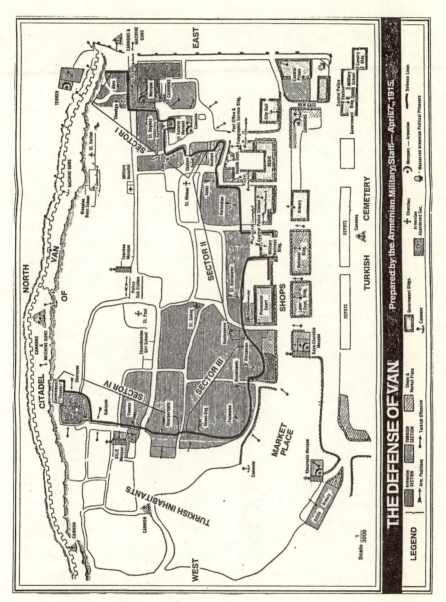

Map of the Defence of Van, prepared by the Armenian Military Staff, April, 1915.

missionary, 'What would we do without this place? This is the third massacre during which I have taken refuge here.'[11] For the Turks who were cynical about honouring its neutrality, it was a prime target. The Americans knew that they had no real guarantees for safety and had best organise to survive the siege. A city government was established with mayor, judges and police. The town had never been so well policed before. Daily rations arrived for the soup kitchen. Dr Ussher saw the Armenians in a new light: 'From the moment these people had known it was to be a struggle to the death they had raised their heads and said, "Better ten days' liberty and then death than to die as the slaves we've been."'

Vartoosh, who was nine, remembered:

The war started, the schools were closed. Our section became a battle front. The men were fighting in the area and they moved us. Akabi came too, her little boy, Gurgen, and Mummy. We moved to the building of the American missionaries. It was a huge place. Gorky was with the men running about. They took ammunition to the soldiers, carried supplies. He was always with the boys. In the evening he came home. We lived and slept there.[12]

The war was to be Manoug's rite of passage to boyhood. Daily proclamations went out from the Armenian command under Aram Pasha.

This struggle is not only for our existence, but a struggle for justice and right!
Be brave! We are victorious everywhere!
The password is: Wheat.

His words were repeated by the boys.

We have not lost a single man, nor abandoned one of our positions.
Economise your cartridges. Victory is ours . . .
You must not insult the religion of the enemy.
In Toprak Kale a young boy of 12 succeeded in getting a hat off the enemy Turkish police; placing it on his head he was able to reach our positions.'[13]

Manoug scoured the ruins together with other small boys, gathering spent shells and cartridges. They scraped them out so that jewellers and

metalworkers could make new ammunition. The orphanage workshops were busy with children making ammunition; 2,000 cartridges and case bullets were made in a day. An Armenian professor made smokeless powder; he even succeeded in constructing three cannon. Men who could not fight dug trenches and built walls within walls. The baked mud proved strong against shell and gunfire. Women made uniforms and cooked. The school band marched about the city playing military airs where the fighting was hottest to drown out the artillery noise, especially the *Marseillaise* and Armenian national songs to infuriate German artillerymen on the Turkish side.

Manoug joined the ranks of the men. It was common for fourteen-year-olds to sign up as volunteers. The boys delivered messages, food and provisions to the fighting men. They ran great risks under fire, running between *teerks*. Plucky by nature, he learned to act coolly. He was fortunate at least in finding himself in the only city where active defence was organised, giving him a sense of hope, pride and confidence. He was bewildered by the violent racial hatred which could only be satisfied by torturing and annihilating his people, but he knew his mother and sisters were safe. The Vanetzis were combative survivors. This was the root experience for Manoug, the making of Gorky, and the secret of his courage in facing crisis later. But its tumult would remain in him all his life; in the words of the poet Daniel Varoujan, 'The Armenian nation wept and roared in me.'[14]

The unthinkable took place on 17 April 1915. Shells exploded in the neutral area of the American church and Dr Ussher's house under the flags of Red Cross and the USA. Vartoush recalled hearing the terrible explosions and felt sure that they were being blasted for the last time. Manoug was not there.

As for the bomb which fell on the American Church, it is no more than a pretext of the American missionaries to support the insurgents . . . if the orphanages, missions, be they American, German, or other, open their doors to the guilty, we will fire on them as well; for it is absolutely necessary to conquer and punish them.[15]

Jevdet Bey wrote this without apology in his letter to the Italian Consul, Sbordone. Two people were killed and many injured. The courtyard was frequently peppered with bullets, despite Dr Ussher's protests that US soil should be respected. Jevdet had tried to occupy the compound with soldiers on pretext of guarding it, but the Americans had held out.

The exchange of letters, carried by unarmed woman volunteers carrying white flags, who were shot for their efforts, gives a vivid insight into the fighting in Van. Jevdet always blamed the Armenians. He even accused them of opening fire on their own side, charged them with treason and with helping the Russians. The mission-school director Ernest A. Yarrow wrote:

> The Armenians never took the offensive, they were too inferior in number and too badly armed; they fought to defend the homes, their honour and their life; also our sympathy naturally was with them. However we were extremely prudent, even though we had given much proof of our neutrality.[16]

Another witness, Miss Knapp, wrote, 'The fact cannot be too strongly emphasised that there was no "rebellion".'[17]

Sbordone was their only link with the US government. He did some plain speaking to Jevdet: 'If the Armenians have recourse to arms, it is because they are convinced that the government, under pretext of military service, wants to exterminate them totally.'

Jevdet accused the consul of negotiating with the Armenians so they could gain time:

> The traitors are working to favour the enemy operations, for they are counting on the imminent arrival of the Russians; but let them know that the Russians will never dare to cross our frontier. I am sorry for the people who must be suffering greatly.[18]

The Armenians sent out an almost jubilant bulletin on the same day:

> 17 April. This morning a lively bombardment started on Aykesdan and on Sahag Bey position, without results. This morning the enemy directed their cannon fire from the fortress onto the interior of the town; after two hours they stopped. This morning cavalry and infantry of about 200 advanced in three columns from the barracks of Bekir towards our positions on Shoushan and

Varag. Before the force of our defence the enemy retired in disorder shouting loudly; they disappeared completely leaving many dead.[19]

Manoug's group was determined to hang on. He had become experienced, doggedly retrieving every empty shell and cartridge. A soon as a shell had fallen, he rushed up with a bucket of water and doused it, while it smoked, digging it up to haul off to the workshops where the metalworkers were turning out 2,000 bullets and cartridge cases a day, helped by a labour force of young boys.[20] Their inventions made the arms more efficient; for example, long needles pierced the mud walls through which Mausers fired up to six shots at the enemy, like machine-gun fire.[21] Manoug preferred his duties outside. He hardened himself to the ceaseless din of gunfire and exploding shells, the booming of the cannon from the top of the castle. He saw injured and dying people, helped to bring them to safety. He watched the mortars explode, lighting up the surrounding buildings and sky. A total of 1,600 shells, for the most part of German manufacture, would be fired upon the town. The British consulate had been bombed. No one could be sure of safety from the Turkish governor who ordered, 'The Armenians must be exterminated. If any Muslim protect a Christian, first his house shall be burned; then the Christian killed before his eyes, then his family and himself.'[22]

That day the Armenians were attacked by his troops; the entire male population of Akantz (north-east of Lake Van) – 2,500 men – was murdered on the same day. By the time his orders had been carried out 55,000 people were dead. 'That Monday all the villages in the province were attacked by Jevdet Bey's soldiers and by Kurds under his command,' wrote Dr Ussher, adding that only in Shadagh and the Moks region did Armenians defend themselves or fled into the mountains and caves. In the compound Shushan and her daughters worked to help the unending stream of wounded refugees staggering in from outlying massacred villages. The survivors' accounts were always horrifying. Sickened by the carnage, Dr Ussher wrote, 'Many of them were horribly mutilated, little babies shattered –! I dressed the wounds of the rest and sent them to houses outside our compound . . .'

The total extermination of all Armenians in the province was Jevdet's intention and delight. '*Ishim yok, keifim chok*. I have no work and much fun'. His chilling words written in a letter were repeated by the missionaries.[23] But

the Armenian leaders, isolated from the rest of Turkey, could not yet know that this was part of a far larger concerted campaign springing into action in every town and village where Armenians lived. On 24 April in Constantinople, 600 Armenian intellectuals – writers, poets, politicians, lawyers and others – were rounded up; some were killed, while others were driven into the desert on forced marches to die. It was the first death knell warning of a wholesale genocide. A further 5,000 men were murdered. From then onwards, the government had ordered the deportation of all Armenians in the eastern provinces, Trebizond, Erzerum, Bitlis, Harput, Sivas. It was part of the national plan. In fact, after Van, Jevdet would continue his bloodthirsty course with his 'Butcher Regiment' massacring in Sairt, Erzerum and Bitlis. After 25 April, eleven days from the start of the siege, he abruptly allowed thousands of fleeing women and children into Van to deplete the dwindling resources of the Armenians and starve them out. He shipped a large number of women and children to a desert island in the lake, where they slowly starved.

The number of refugees rose to 15,000. In the mission compound, where Shushan was staying with her daughters, they cooked, baked, sewed and helped with any work assigned to them. They were sent out to various school buildings, the chapel and temporary shacks. Dr Ussher's house sheltered a hundred refugees. All food was rationed. Neutrality was fierce; not a single soldier carrying arms was allowed through the gate. Even wounded soldiers were treated elsewhere. Dr Ussher was the only American physician and surgeon, helped by Armenian doctors and nurses. An epidemic of measles raged among the children; the refugees brought pneumonia and dysentery. Shushan feared for her children, especially Manoug, who returned in the evening, gaunt and hollow-eyed. She was sure he ate nothing all day. But he had an excited gleam in his eye which had not been there before. He was learning the art of self-defence. His whole bearing was changed.

Each day the fighting continued. There were 12,000 men under command of de Nogales, who ordered that 'artillery fire never cease for an instant from dawn to night' helped by his own invention of 'fifteenth-century mortars',[24] made by filling empty grenades with calibre. On the first day the Armenians had been in control of the walled city and Aykesdan, while the Turks held the castle and the outskirts, 'forming an iron ring' as they

increased their attacks. The seasoned warrior was sobered by the defence which he frequently and grudgingly called 'heroic Van'.

I have rarely seen such furious fighting as took place during the siege of Van. It was an uninterrupted combat, sometimes hand-to-hand or with only a wall between. Nobody gave quarter nor asked it. The Christian or the Moor who fell into enemy's hands was a dead man. To try to save a prisoner during those days would have been almost as difficult as to try to snatch the prey from a starving tiger.[25]

By the fourth week of the siege supplies had run so low that only three weeks' food was left. Still no news of the inhabitants in the beleaguered City where the shells rained, sinking into the massive walls of sun-dried brick. Many Armenian soldiers had died, but the wounded still fought back.

On 30 April, Shushan took advantage of a cease-fire to send Manoug back to the house to fetch food, vegetables and fruit from the garden. He set off on a beautiful spring morning. It was a long walk. The silence was eerie after the uninterrupted din of firing. Only the song of birds could be heard. Varak plain across which the two sides had been firing was a carpet of wild red and purple anemones and poppies, and *zmerzoug*, blue flowers, with a perfume you could smell for miles. On Varak mountain, apple trees were in bloom. The house was pockmarked from bullets and shelling. All was peaceful in the garden. The roses bloomed. Everything had grown since they had left a few weeks ago. While the war raged, fruit and flowers had taken on new strength in the spring. It was eerie inside the empty house again. He stayed in the orchard and picked all the crops.

He staggered back to the mission with his load. Shushan was startled to see him hidden by a bunch of flowers – the first roses from the front for his mother. 'Mummy always loved roses,' Vartoosh said when she was eighty-three, sitting next to a flower painting by Gorky. It was a walk he would remember for the rest of his life.

From the mission windows, a few days later, everyone saw hillside villages being burned. Varak monastery, with its priceless collection of manuscripts and rare printed books, went up in smoke. Manoug had often been there, and pictured with horror the beautiful Bibles and illuminations, over a thousand of them, burning up, the pages curling, their cool silver bindings no longer protecting them. 'God has forsaken the Armenians!' he

often heard people say. But now, God had forsaken his own sacred word. Gorky's paintings, *Charred Beloved*, would also evoke a burned page of a sacred book.

His mother prayed; the Turks kept up their rifle fire with poisoned and explosive bullets, reckless with abundant ammunition. The mission, which was in direct line of the largest barracks, Haji Bekir Kishla, was often showered with bullets. Meanwhile not one of the messengers they sent out had returned. This time they sent twelve men with messages sewn into the lining of their clothes to the Armenian leaders fighting on the Russian front.

To Americans, or any Foreign Consul.
Internal troubles in Van. Government threatens to bombard American premises. Inform American Government American lives in danger.
(Signed) C. D. Ussher
 E. A. Yarrow
Reward messenger.

Ammunition was low. Food was scarce. How much longer could they hold out?

On 16 May, to their amazement the missionaries spied through field glasses a small fleet of boats sailing away. They dared not hope that the Turks were sending away their families. Dr Ussher described it:

Suddenly, late that afternoon our ears were startled by that uncanny shriek, rising to a crescendo which once heard can never be forgotten and a shell from Hadji Bekr's Barracks exploded in our hospital yard. Another brought down the Red Cross flag. Five more followed in quick succession, evidently aimed at the American flag flying above the girls' school building, made a great hole in the roof near the base of the flagstaff. Then – silence!

In the streets people were praying. The defence groups had told them, 'Pray, pray. If God doesn't help us we are done for.'

Kertzo Dickran, the Adoians' friend fighting in the trenches, recalled the day: 'Everyone was on duty including the military headquarters, supply body, trench repairmen, Red Cross, Ladies' Union. As I passed Norashen Church, I found it filled with praying men and women, of unshakeable faith.'[26]

That afternoon forty-five bombs exploded in the American compound,

in a schoolroom and the church. The explosions continued for three hours. Desperate people asked Dr Ussher what would happen next if the Turks had the temerity to fire on the American flag. Dr Ussher replied, 'Do not be anxious; the Turks are saying goodbye. They wouldn't dare to fire on our flag if they weren't planning to run away.' He saw that the Turks in Haji Bekir barracks, loading their packhorses, cattle and sheep, and their heads were all turned to the mountain gate. Word was sent to Aram Pasha: 'The Turks are running away!'

Immediately the strongest Turkish positions were attacked and the barracks at the foot of Toprak Kala Hill and on the summit was taken. Half an hour later both were in flames. For the next two days the Armenians burned the fortress and the Ottoman public buildings, so they should never again be used against them.[27] 'A magnificent blaze it made, and in the light of that the people danced and laughed and sang, almost crazed by the sudden reaction of joy at the very hour when their last hope seemed gone.'[28]

Manoug heard a sound that shocked him. They had not heard the peal of church bells in Van for decades, silenced by the Ottomans. Now they rang all over the town, in every church. He joined people streaming out to dance in the streets. They rushed to the City to find out whether their neighbours had survived. But their jubilant expressions soon turned to horror. Noravank Church had been set alight as the Turks were leaving. Flames and smoke billowed from the wooden interior of the ancient building. The stench of charred bodies was sickening from a church crammed with the corpses of those who had gone for sanctuary. The Turks had knocked through building after building, killing as they went those people who had not died as victims of arson. Bodies were piled up against walls: old men, women, children, mothers clutching babies. A child crouched in the crook of his mother's dead body, howling. People searched desperately for their relatives and friends, men comforted their wives, young soldiers struggled to lift half-hidden bodies to identify comrades. This was their day of victory. Their city of shattered buildings filled with dead Armenians.

Manoug turned and fled, to climb the forbidden rock of Toprak Kala. The fortress had always been barred to civilians. Now the Armenian tricolour, of red, blue and orange, was draped across it. He clambered up vertical walls, past huge chambers hewn out of rock where prisoners had

been chained in the dark for years. The air became cleaner after the putrefying, bitter smoke of the city.

On the summit, excited people stared out and pointed to buildings miles away in the distance. For the first time, they glimpsed the whole of Van from a vantage point 300 feet high; the Old City was a pulverised smoking ruin. Beyond were the indifferent blue lake and snow-topped mountains. Manoug could see where his first home and primary school had been, his own childhood, now buried in the rubble. His friends climbed the Turkish cannon and started to sing a patriotic anthem: 'Hurrah, hurrah, May the sword of freedom shine!'

8

Beat the Drum
1915

Manoug stood by the roadside as the Russo-Armenian regiment marched into Van, behind their commanders on horseback. The soldiers, under orders to occupy the city, halted, amazed by thousands of people advancing towards them, cheering, bearing the traditional welcome of bread and salt. The Vanetzis were proud of having successfully defended themselves without outside help and had prepared a hero's welcome. Manoug and his sisters would never forget the moment the Russian flag was hoisted on the fortress rock next to the Armenian one. 'We went back to our homes. The Armenians were in power,' said Vartoosh.[1] The populace believed that, 'From that day the province of Van was no longer a "province of Turkish Armenia"; it became the first province of Armenia reborn.'[2]

The Adoians were relieved. There was to be a respite. Vartoosh remembered those six weeks like a dream; they became six months in her mind. Foreign soldiers filled the town. 'The Russians were soldiers of the tsar. They were in Van for six months. They came to the orchard to pick fruit. They didn't bother us. They spoke Russian and used sign language. We understood what they wanted.' The children loved to creep out and listen to the soldiers singing around the campfires. Later in New York, Gorky would sometimes speak a little Russian and sing songs that he had picked up from the soldiers in Van.

Neighbours returned and started to rebuild their shelled houses and buildings. Under Russian protection, Armenian leadership would continue. The boys strode about the city. Slowly the extent and brutality of the massacres dawned on the townsfolk. They were unprepared for the sheer

scale of the horror. Squads of Russian and Armenian soldiers discovered entire villages full of dead bodies; 55,000 were discovered in one area, they even choked the rivers. The Armenian soldiers had to cremate piles of bodies, which was against their religion. When Gorky came to see the war paintings of Goya, he would feel a rush of recognition at the stark horror, and in *Guernica*, he would identify the distorted shapes and convulsive movements in Van. Only at the end of his life his own festering memories would be laid to rest in his most ambitious drawing, *Summation* (1947).

The high point of the liberation for Manoug and most of the city was the entry on 3 June of General Antranig riding his white horse with his Armenian volunteers. He and his troops had fought heroically on the Russian side with the intention of restoring the Armenian territories, but the Russians had other plans. General Nikolaiyeff dropped a hint to Mr Yarrow, 'There are three roads out of Van,' but the American was delirious with typhoid. Soon people started panicking, spreading rumours the Turks were coming back.

On 24 May, the Allies had declared the Turkish government and its officials responsible for the massacres. The Turks replied that they had merely been safeguarding their borders and had no obligation to account to any foreign government.[3]

The unexpected self-defence of Van was exploited by the Young Turks as a betrayal of the Ottoman government and a conspiracy by the Armenians in league with the Russian enemy.[4] Jevdet treacherously reported that the Van Armenians were in rebellion. He further declared that the 55,000 slaughtered Armenians had in fact been Muslims massacred by Christians, and attributed to the latter the tortures and atrocities committed by his own men on the Armenian women and children. This charge remained on the records to be repeated and embellished until the present day. 1915 was the start of the most highly organised extermination and deportation of a people from its homeland ever executed by a government. As a result, a million Armenians were murdered, caravans deported, driven across deserts to be tortured, raped and killed. The events were reported and condemned by the *New York Times*, the *Times* in England and press all over Europe to no avail. Henry Morgenthau, the US ambassador to the Ottoman Empire, argued helplessly with the planners of the genocide and later wrote, 'The great massacres and persecutions of the past seem almost insignificant when compared with the sufferings of the Armenian race in 1915.' For

Gorky, as for so many other survivors, the injustice rankled. The cover-up of the Armenian genocide was aided and abetted by the Western powers, Russia and Muslim countries, who saw no advantage in publicising it. Turkey, with the help of Germany, massacred one small nation, stole its land, and also destroyed its history and self-image. But no public trials and no reparation followed for the Armenians. Turkey turned the tables on her victims – denying the killings, charging that the Armenians had massacred Turks, theirs had been a relocation policy, backing up their claims by suppressing and falsifying evidence. This in turn laid the ground later for the Jewish Holocaust. The survivors hid their suffering, despairing of justice. But Gorky subsequently identified his Armenian nationality with persecution and massacre, betrayal and death, when he dredged up and reconstructed the destroyed image of a nation through his paintings.

It was still dark, long before dawn, on 15 June 1915, when the *jamhar* (town-crier) banged on Manoug's door. '*Nahanj!* Retreat!' He ordered the inhabitants to get ready immediately and evacuate the city. It was an order from the government and the Russian army. The Russians were retreating before daybreak. The six weeks of clinging to their burning city, praying for deliverance, had been in vain. The children were terrified.

There were two women, Shushan and Akabi, with young children: Satenig, Manoug, Vartoosh, and Akabi's son Gurgen, just two years old. Thrown into panic, Shushan had the classic refugee response; she and Manoug buried most of their gold and silver in the garden against the day they would return. They took $300 in currency and gold pieces, some blankets and enough bread for a few days. 'The whole town was in an uproar,' Vartoosh said. 'People in the streets, flocking. Everyone saying, "What are we to do? How are we going to go?" Crying and shouting in the street. Gorky was just a boy. What could he do?'

Street by street, evacuation began. Here and there, houses were blazing as people burned their possessions rather than leave them to the Turks. They started to walk out of the city, under guard of Russian and Armenian soldiers. The elderly were hoisted on wagons. They were to take the northern route to Erevan (now Yerevan) which led into Russian Armenia, 150 miles away.

The Adoians left as dawn broke. A distinct memory of that last morning

remained with Vartoosh: 'There was a very beautiful place when we came out of Van and arrived at Diramayr [Mother of God] Church. On one side was the lake and on a height over the sea rose the church. It was morning, early. The sun was coming out at that very point. We went into that church, Mother, Gorky and I. We said a last prayer. It was a place of pilgrimage. I remember it like today, the sun shining on the sea and the church standing there. Everyone prayed in turn and then carried on.'

They marched all day, heading north along the lake, and were allowed to rest only for short periods in the open. At first they tramped on a highway, a straggling stream of humanity. Manoug saw cattle, heavily laden donkeys, and oxen pulling carts piled with household possessions; women with babies in their arms and bundles on their backs; some even used cows and goats to transport light loads. Vast fires could be seen on the hillsides, for many villagers had set alight their grainfields before leaving, so as not to feed the advancing Turkish army.

Over the next few days, as they climbed up the mountains and left the lake behind them, the terrain became rough and deserted. They were forced to walk by moonlight. The scorching sun by day was too dangerous and they had to avoid Turkish soldiers or Kurds on the attack. Manoug walked mechanically, one foot in front of the other, trying not to think about how much his feet ached, his back hurt and his stomach gnawed for something solid to eat. They walked past people who had fallen on the side of the road, dying of exhaustion, thirst and hunger. 'It was a race for life. The sight of those gasping terror-stricken thousands was one never to be forgotten,' wrote Miss Knapp of the ordeal.[5] Akabi had trouble keeping up, as she carried Gurgen. 'She said he was very sickly on the way,' Libby Amerian later remembered. 'There was no food. The waters were all filthy and everyone kept telling her, "Leave him behind!" A lot of people left their children behind. "No. I'll carry him. I'm not leaving him."' Akabi strapped him onto her back.[6] Vartoosh remembered the journey vividly:

Walking night and day for eight days, our shoes were all gone. We clambered over hills and fields. We slept at night a little bit but we had to wake very early to set off because the people who left after us were all killed on the field of Bergri. The Turks attacked them and killed them, almost 40 or 50,000 were killed there. Some went down to Persia but we took the route to Erevan.

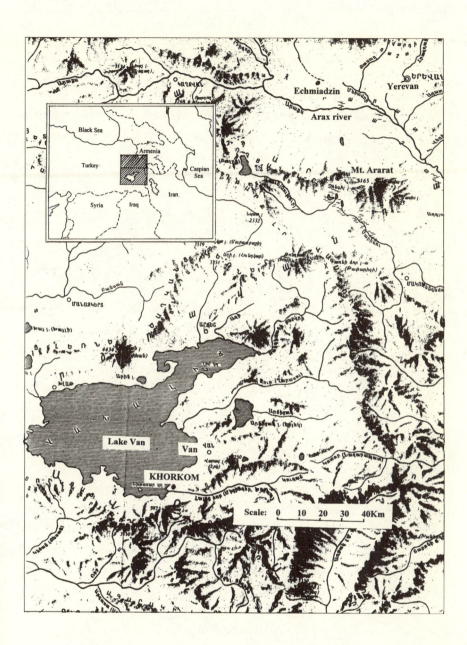

Map of terrain from Van to Etchmiadzin and Yerevan.

They came to the torrential river Bandi Mahoun, which they had to cross. From the heights, Turks and Kurds fired down into the unarmed multitude who were hemmed in between hills and river. Their Cossack guards galloped off to save themselves. The invalid Ussher, who made the journey on a litter hung between two horses, wrote:

> Hundreds threw themselves over the precipice into the river to escape the worse fate of falling into the hands of the Kurds. Fathers and mothers killed their own children to save them from the Turks. But thousands struggled on panting, gasping for mile after mile . . . it seemed an eternity of horror.[7]

Shushan and her family managed to walk over a rickety rope bridge full of holes while the water roared below them and waterfalls rushed down a hundred yards away. Akabi clasped Gurgen even tighter. Many people lost their children on that bridge, and others drove their carts through the water.

They stopped further up on the other side. Vartoosh went off with a silver jug to fetch water from a well. Shushan kept Manoug at her side all the time, because he was the man of the family. When Vartoosh did not return, they went out searching for her, calling out, terrified that she had been attacked or had drowned. At last they found her, lost and crying. From that day Shushan attached a rope to herself and each of them, so they could not be separated.

They continued on over the plain, black lava fields stretching out for miles in every direction. Dark rocks in jagged shapes jutted in sharp angles where Turks and Kurds hid waiting to attack. There was not a tree or a blade of grass. The stony ground tore at their feet. Vartoosh described the journey in hushed tones: 'We had no food or anything. We had no water. We dug to get a little moisture. If there was anything, we gave food to Gorky, because we had to look after the boy, the man in the family. He was thin anyway. Mummy always trembled over him.'

They crossed the steep slope of Mount Taparez and the next day came to Chingli Mountain, 'a steep climb over ditches, boulders, and soft dirt which filled the air with clouds that almost blocked the sun'.[8] It was a foothill of Mount Ararat. Vartoosh said, 'When we saw Ararat, we were amazed. It was the first time we saw such a high mountain. We'd read about it at school but never seen it. We thought Varakavar and Sipan in Van were

high, but that was so much taller.' Its blunt top was covered with snow and, like a reflection, a ring of cloud crowned the peak.

But there was no food. 'Only grass,' Vartoosh said. On the approach to Ararat the local people, Yezidis, brought down bits of ice from the mountain. Shushan bought some for the children to suck in place of water. It was like taking strength from Ararat. 'On that field there were little things like peas, *kalir*. We picked those in the field to eat. We ate green things all the way to Igdir.'

They arrived in the town of Igdir at night. Shushan had made it by willpower alone. She was very sick and collapsed in front of a shop. The image of his mother dragging her children this far, tied to her as if by an umbilical cord, could never be erased. Gorky would feel attached to her all his life. The little family staggered to a halt.

'Akabi, Akabi! Is it you?' a man in Armenian soldier's uniform called out. It was her husband's cousin. He brought them a bucket of water and some bread. Manoug and Akabi bought a melon, but the flesh was rotten. Akabi was so desperate that she stole some cheese. Finally an Armenian family took pity on them and allowed them to stay in their orchard.[9]

For the first time in ten days they rested, bought flour to make bread, washed their clothes and cooked a meal. They were grateful to sleep even outdoors, to rest and look after Shushan and little Gurgen. They stayed there for several days, living mostly on fruit. But the town was filling up; as more and more refugees arrived, they were ordered to move on. They hired a cart on a road, crowded with weary refugees still trudging with animals and carts, all hurrying to safety. It was one long hot day's journey in July. They followed the great Arax River along the fertile plains of Mount Ararat, then crossed the bridge over to Etchmiadzin. With that crossing they left Western Armenia behind them, never again to return to their home and their land.

Ussher came a few days later and saw the full extent of the horror.

Those who travelled with us had come not only from Van *vilayet*, but from Bitlis and Erzerum provinces. We reached Igdir Monday, August 10.

During that week more than two hundred and seventy thousand refugees poured over the border into the Caucasus ... the Erevan plain filled with a shifting multitude overflowing the horizon, wandering aimlessly hither and thither; strangers in a strange land, footsore, weary, starving, wailing like lost and hungry children.[10]

9

City of Death
1915–17

Shushan had pinned all her hopes on reaching Etchmiadzin, the holy city, where they would find shelter and comfort. She had never expected to see it flooded with refugees. Vartoosh said:

> The space between the seminary and the church of Etchmiadzin was filled with refugees — Vanetzis and others. We slept there in the open air. They helped us a little with food and after that they could do nothing. The Jemaran school was flooded with people. They were sleeping outside with no beds and no blankets on the ground. Akabi got sick.[1]

Manoug went to find help. Akabi had a high fever and they feared she had typhoid. Everywhere he saw sick children, women with feet bandaged in rags, old people hardly able to move. People wore rags, so frayed and shredded that they scarcely held together; others had patched the same cloth so many times, it resembled tree bark.

The family was marooned in Etchmiadzin for several weeks. Akabi began to recover, but the overcrowding worsened and food was harder to find. Some 200,000 fugitives, who had lost most of their possessions in Kurdish raids, came through Transcaucasia. The water became polluted, and it was impossible to provide adequate sanitation. Vartoosh said, 'Then cholera came and people suddenly went black and died. People . . . half-alive, they piled up in carts and took away and buried . . . On top of each other.'

The children's courageous aunt Yeva, who had walked from Van, died

of cholera. Manoug acted quickly. Taking some money, he returned with a carriage. 'Gorky saved all our lives by finding this phaeton,' Vartoosh said. 'If we hadn't left then we would also have died.'

The carriage drove them down the thirteen-mile road to Yerevan, past St Hripsime Church, through open fields irrigated by streams. The rocky ridges of the mountain ranges stood out in volcanic profusion behind Ararat. The horses trotted past fields of rice, then cotton, their pods bursting like snow, and miles of orchard.

In 1915 Yerevan was a hot, dusty place. In mid-summer, dust clouds blew through the streets, spreading trachoma. Shushan felt very weak. They had relatives in the city, but had no idea where. They were dumped outside St Sarkis Church, which still stands by the Hrazdan river. 'We got to the doorway and just sat there,' Vartoosh remembered. Here too, every open space was crowded with refugees from Western Armenia. They slept outdoors on the ground for one night. At last, at 14 Milionouritz Street, they found one room. They would live under a roof for the first time in two months.[2]

They were given ration books distributed by the Armenian Apostolic Church Diocese, and stood in line for hours to get a portion of bread. Their money was running out and they needed to find work. It was grape harvest and Manoug, with his elder sisters, stood in the main square every morning and waited. 'They came to hire people for picking grapes,' Vartoosh said. 'They put us on carts and drove us out. We used to pick grapes. You were allowed to eat as much as you wanted but you couldn't take any home with you.' They worked from 8 a.m. to 5 p.m. for one rouble a day in the vineyards. The grapes were almost their only source of food.

They had to move house after two weeks because the Russian soldiers nearby made it unsafe for the women. Satenig said, 'Yerevan had nice streets. We moved to 39 Vagsaltzky Street, near the station, in one room again.' Soon the grapes were finished and they needed other work. Shushan, Akabi and Satenig worked in factories canning fruit and vegetables, while Vartoosh looked after Gurgen.

By then, the catastrophe which had struck the nation had been reported internationally. Charities were set up to send relief to 'the starving Armenians'. In September 1915, the Russian IV Corps and the Armenian units had retaken Van, Vosdan and later Moush and Bitlis. But it was a bitter victory for they reoccupied 'an Armenia without Armenians'. The

Turks had depopulated the lands, driven out and murdered the Armenians. Although Russia had promised to hand over these territories to the Armenians, now they planned to partition the Ottoman Empire and repopulate it with Russian colonists. The Armenians still did not realise that they were pawns in a vast international game.[3]

In Van, the Turks had been the master race; here it was the Russians. In both countries, Armenians were seen as an inferior class. Manoug now lived in what is the centre of modern-day Yerevan. Parts are still unchanged, with rambling single-storey mud houses among orchards and vines hung with grapes.[4] Katanovsky Street led off Astafian Street, now renamed Abovian, the main shopping thoroughfare of Yerevan. The Adoians' landlady at number 18 was a prosperous housewife with property in the north of Armenia. She liked Shushan and was kind to them.

Shushan spun cotton in a factory and Akabi mended rugs, living in a room next to her mother. Vartoosh remembered this year as their best time in Yerevan, for despite poverty and difficulties they were all together. Manoug, still only thirteen, was very resourceful in helping his family. Vartoosh recalled her mother began singing in the evenings again.

> *Manir, manir, im jakharag,*
> *Manir, spitag patilner.*
> Spin, spin, my reel,
> Spin white threads,
> Spin threads, thick or fine,
> So that I may care for my sorrows.

Vartoosh sang her mother's song at the end of her life in Chicago, "'My Dickran walks barefoot". It was her song. She lived such a terrible life. She was always singing that song. It really pictured her own life at that time.'

Shushan recreated their family life, despite difficulties. 'Every evening, Satenig or I read a book aloud,' Vartoosh said. 'Toumanian, Raffi, who wrote in a popular style.' Manoug wanted to find work, but Shushan insisted they go to the diocesan school, attached to St Sarkis, the church where they had first been marooned in Yerevan. The teachers were laymen from European colleges, especially Germany, and used relatively modern methods. Manoug, a tall boy, sat at the very back of the class, lost in a world of his own. After his recent upheaval, he was in a state of shock and hardly

paid any attention. He daydreamed, whittling away with his knife, ignoring everything. One classmate recalled how their teacher lost his temper.

'Why don't you at least pay attention? You might learn something.'

Manoug sat, shaking his head. The movement of his hands absorbed him. He carved a face or an animal, scraping away at the wood to give form to his pent-up feelings. He was being taught a full curriculum, including Russian. In the playground, he was popular, good at sport and ball games. He sometimes went to a football field or took part in other children's games of Yerevan. *Popov Douj Pet* was played with a ball and stick, 'just like hockey,' said Vartoosh. With his long gangly legs, Manoug excelled at leapfrog, easily clearing six people. But he was mostly on the look-out for jobs to bring in a few kopecks.

Every day, after school, he walked half an hour up a steep hill to the American orphanage in the Marash district. Some people from his old school in Van were there: Dr Ussher, a teacher and Vanetzi children who had survived the march. He worked, doing any odd jobs assigned to him. Sometimes he came home with bread for his mother and sisters, saved from his meals. Vartoosh said:

He always wanted to be the man of the house, not in Van but especially in Yerevan. He was always with Mummy. In those days everyone was like that, loving the members of your family and respecting them. He wasn't so old, but he wanted to comfort us.

On 9 October 1916 Manoug went with his mother to Yerevan railway station to say goodbye to Satenig, Akabi and her son Gurgen. Mgrditch, Akabi's husband, had returned to collect his wife and son. Vartoosh remembered how Shushan hugged them and kissed them on the eyes and forehead, then turned away to sit, dry-eyed, by the wall without another word. No doubt Shushan had hoped that Setrag would also come for his family. But he had only scraped together the money for her passage to America. He judged that she was the most vulnerable, for the children would be cared for in the American orphanage until he could bring them over later. Shushan refused. 'Mother would not think of leaving Armenia. She never loved my father. She said she would not go,' Vartoosh said. After losing one daughter, Sima, in the orphanage, Shushan would never leave without her children, but she agreed to let Satenig go with Akabi. Satenig

was sensitive and melancholy; a willowy dark-eyed adolescent of fifteen scarred from smallpox. She did not want to part from her mother and the two younger children.

When they returned home, Shushan did not hold back her tears. Vartoosh recalled Manoug's words, 'Don't think about it, Mother. Don't worry. God is merciful. Something will happen.'

Shushan was convinced she had lost her elder daughters for ever. Something in her broke that day. Vartoosh said, 'Gorky always tried to give her comfort and hope. She loved him so very much. We were very close, our family.'

For Manoug, there was work in the carpentry workshop, supervised by his uncle Aharon. The adolescent excelled at the craft and became very skilled at using tools, joining and sanding wood. The smell and feel of timber reassured him. He built beds, blackboards, chairs, desks and tables for the American missions and orphanages. At night he made combs by heating horn, hammering it flat, pulling it and cutting the teeth. But Shushan's ambitions for him were still high. 'She always hoped that he would become a teacher, always,' Vartoosh said. 'That was a good profession and highly respected.'

Manoug was now old enough to grasp the wider issues affecting them in Yerevan. In his daily search for food and the odd job, he heard rumours of huge political changes, which would tip the balance of the world for decades. The First World War was in its fourth year. Tsar Nicholas II, Emperor of All the Russias, abdicated in March. People huddled in groups around newspapers, heatedly discussing news of strikes, food riots, war. Writers were always on hand to lead public opinion. Armenia had not enjoyed independence for 500 years (since 1375), therefore politicians were virtually unknown. The most exciting news was a decree in April 1917 which permitted Western Armenians to return to their homes. Faced with food shortages and discrimination in Transcaucasia, 150,000 people tramped back home, and 20,000 began rebuilding Van, opening shops and re-establishing themselves, despite the fighting. In May, the Armenians were granted administration over these provinces. Shushan pined for Van but dared not undertake the long journey back.

For the refugee families like the Adoians, conditions worsened after the break-up of the Tsar's administration. They were in the middle of a most

turbulent period with the balance of power shifting at every moment, food shortages and mass riots. The Armenians were now governed from Tiflis by a joint body of the three Transcaucasian countries: Armenia, Azerbaijan and Georgia.

Manoug was startled in the orphanage, one day, by two familiar-looking boys. They were tall, thin and dressed in rags. He recognised his cousins Ado and Azad. They had been separated since long before the siege of Van. Once again Ado and Manoug became inseparable. They found occasional work near the main square at the State Printing Press, off Abovian Street. All newspapers, journals and books were typeset and printed here. Manoug learned typesetting, assembled the metal letters along little racks, turned the huge rollers of the presses and worked as an apprentice. The individual letters he sorted were like little metal soldiers. All books were bound by hand, and he learned this job together with Ado. Each evening, he brought home loose pages, prepared and collated them, then with Vartoosh, bound them through the night. 'We had a little frame and I sewed the pages together. Mother was ill. We made a little money that way. While we worked, we talked about everything.'

Writers also worked at the press: the Vanetzi novelist Gourgen Mahari, and Yeghishe Charentz, the outstanding poet of the revolutionary era. Both writers had fought in the defence of Van. At this period, the political turmoil was electric. The Bolsheviks were recruiting youngsters. Boys, nicknamed *gavroches* after Victor Hugo's characters, were sent out to distribute pamphlets. Ado and Manoug were in daily contact with inflammatory political ideas and overheard much literary and political discussion between writers and political thinkers. They heard poetry about the struggle for cultural identity and freedom.

Manoug's intellectual growth as a teenager was combed through with agitprop literature, the poetry he heard and the Utopian idealism that rang through all political discussion. As Charentz wrote, 'And his song echoed in each fighter's heart, And each heart burned like a red dawn.' Vartoosh particularly recalled him saying, 'One day I want to leave my name for my people so that our people will be proud of me as they are of Dickran and Vartan.'

Manoug was caught up in the cross-currents between the champions of the Western Armenians, on the one hand, and the Bolsheviks, on the other.

Like other uprooted Armenians, sick of being humiliated by the Russian Armenians, he hated being called a 'refugee'.

Young Manoug was trying both to survive and to make sense of the turmoil around and within him. For the lanky teenager with a serious mind and fiery nature, the writers he read and met provided a range of role models from romantic to quixotic, avant-garde to revolutionary. Descriptions of Gorky's behaviour as an artist ring with echoes of the Yerevan poets. The Armenian literati were closely connected with the Moscow of early Cubism and modernist poetry during its most radical and abrasive period. There were key figures in the art world about whom Manoug must have known. Martiros Saryan had studied and exhibited in Moscow with Chagall, Burliuk and Kandinsky. His bold, flat painting with strong, vibrant colours earned him recognition in Russia, and was reviewed by Mayakovsky. Young Manoug gradually began to consider his chances of becoming an artist. The poet or artist was not an outsider or marginal outcast in his country, but revered as *varbed*, master, with a central role in forming public opinion.

Among the intelligentsia, choosing a new name was *de rigueur*. It signalled a new birth, discarding old class origins to become the 'new universal man', who recast himself in the fire of the class struggle. In a more ancient practice in the Armenian Church, deacons and bishops had divested themselves of their secular identity and name, to take a new spiritual one. Manoug knew that Lenin, Stalin and Trotsky had all rejected their family names and adopted new ones. The riddle of Manoug Adoian's later need for a name change becomes clearer in the light of his admiration for Maxim Gorky. The famous writer was a hero among Armenians because he had co-edited the first publication of Armenian poetry in Russian.[6] His own books were translated into Armenian. He had once walked all over the Caucasus from the Black Sea to the Caspian. His first story was published in Tiflis, whose printin g presses and literary circles were run by Armenians. He was a friend of Armenian writers, and his anthology, published in 1916 in the wake of the Armenian Genocide, drew attention to the murder of many great poets by the Turks. Sympathising with the Armenian victims, he acted for the Armenian Relief Organisation led by the national poet, Hovhannes Toumanian. So fascinated was he by the language, that he later came to live in Yerevan, to study Armenian.

Situated on the outer reaches of great Mother Russia, Armenia fascinated Russian poets and writers, much as Italy did the English — with its hot-blooded and artistic people, and its rocky mountains dotted with ancient architecture. Russian writers were also intrigued by the fourth-century alphabet and the originality of the ancient Indo-European language, both in its classic and modern forms.

The Russian poet Valery Bryusov, who worked with Maxim Gorky on the *Anthology of Armenian Poetry*, described its appeal as 'a search for synthesis of the two fundamental sources — the Western and the Eastern — on which all humanity depends and whose interaction has always been so vividly reflected in the history of Armenia'.[7] This synthesis also lies at the root of Arshile Gorky's painting.

10

The Face of Famine
1917–20

In the late spring of 1917, Shushan was very ill and food was scarce. Manoug scavenged for food without success. There was no bread in Erevan. Sometimes he found relief in planing wood, hammering nails, lining up letters, sketching on salvaged paper.

In September, the first Russian Armenian Congress took place in Tiflis. Caucasia was recognised as part of the Russian Federation with administration based on nationality. France approved the defence of the Armenian borders, to be recognised by the Allies in November.

At the beginning of 1918 there was still no hope of peace. Manoug was in Erevan during the most critical year of war and independence, when the existence of Armenia hung by a thread. All hopes of consolidating rule over Western Armenia were dashed when Turkish nationalists demanded Kars, Ardahan and Batum (now Batumi), territories that the Ottoman government had re-ceded to Russia in 1878, and subsequently occupied them with the collapse of the Russian Empire. In May 1918, when peace conferences were still in progress, the Turkish forces pushed into Russian Armenia. They were aiming straight for Erevan. Three years had passed since the siege of Van and Manoug was now old enough to fight as a soldier.

Any minute, the Turks, reinforced by the division from Eastern Transcaucasia (the modern Azerbaijan), could break through. One Turkish force had reached the plain of Sardarabad, a mere seventeen miles west of Etchmiadzin. However, the depleted Armenian defence forces, with

the help of ordinary citizens, succeeded in defeating the Turkish force on 24 May. Suddenly news came of a truce signed in Batum and a cease-fire.[1]

If the Armenian forces had not fought back, Armenia as a country would have been wiped off the map. The force had managed to snatch a strip of land one twentieth of its former size, pushed back into a tiny highland of rocky slopes, unsuited to farming. On 28 May 1918, the First Republic of Armenia was declared, with humiliating terms – all Turkish Armenian provinces were lost. But for the starving people, the political turmoil was forgotten in the daily search for food. Manoug went out with his cousins to find bread; it was no longer safe for Vartoosh to be in the streets. They were horrified at the civil disorder recalled by Azad:

> Armenia turned, supposedly, into an independent country. They broke off links with the Russians. In what is now called Freedom Square, they pulled up their Mausers, broke into shops, burned them, looted them, took money and ran. Armenian against Armenian. There in the square was a small cinema. They killed a man and just took his money. It wasn't politics, just robbery![2]

Poverty and lawlessness had turned Erevan into a wild place. The Bolsheviks were fighting in Baku, and any time they might invade Erevan. The new capital of a new republic, with two-thirds of its territory under occupation and half its population made up of refugees, was unable to cope. The government still sat 100 miles away in Tiflis, until August. Uncle Aharon made a rare visit to his sister in the summer of 1918 and Manoug sensed her alarm when he said, 'The Bolsheviks are coming! You have to leave!'

Aharon insisted, although he had no plans to go himself, that they would be safer in Tiflis.[3] So they set off again with their possessions on their backs. It was August and very hot. The three of them trudged through the outskirts of Erevan and up the hill of Kanaker, but could not get far. 'We couldn't walk. My mother got sick.' Vartoosh later concluded that Shushan must have been anaemic. 'We stayed in the village of Shahab, outside Erevan just twenty or thirty kilometres.' In fact it was seven miles from the edge of Erevan, a village called Shahar, but seemed a lot further to the young girl. They sheltered in a mud hut.

It was harvest time, and from the upper reaches of Lake Sevan peasants

brought grain to be transported to town. Manoug bought a donkey with the remains of their money, drove it to Erevan loaded with grain, and returned with grapes. Vartoosh worked as a maid. Shushan went out to the fields after threshing was over, to pick up any grains off the ground. She cooked them and insisted that her children should eat, especially Manoug. But she was getting weaker all the time, and hardly spoke any more. 'We stayed there for a few months. We realised that mother was getting very bad.' Vartoosh emphasised that they leaned on Manoug, relying on his courage. When their mother's health worsened, Manoug made up his mind: 'Vartoosh, we must take mother back to Erevan.'

They dragged themselves back, though Shushan could hardly walk. They were appalled by scenes of horror on the way. Starving people roamed around, eating grass, desperate for anything to gnaw. 'We returned to Erevan and other people had taken our house,' Vartoosh said. 'The Turks had left, so in their district we found an empty house. A tiny place and we had to stay there. Mother was very, very sick.'

But when they got her to the charity hospital she was refused admittance. 'You have people in the States. You have money.'

Manoug argued that they received no money from America. In fact, unknown to him, Setrag sent money, but it did not get through the bureaucratic chaos.

The winter of 1918–19 is called in Armenia 'Year of the Famine'. There were half a million refugees in Erevan province, of whom 75,000 were in the town of Erevan. The countryside had been stripped of crops and livestock by the withdrawing Turkish army. Turkey had also imposed a blockade on Armenia to starve the people; no supplies could come through on the railway lines. The Tartars had abundant grain but would not sell it; irrigation canals and equipment had broken down.[4] Once again Manoug and his family were locked into a siege. Newspaper articles and reports by relief workers are harrowing to read.

The winter was long and severe. In Erevan the temperature dropped to 30° C below zero. Blizzards raged. It was one of the most ferocious in history. The *Saturday Evening Post* in America reported:

A terrible population! Unspeakably filthy and tatterdemalion throngs; shelterless, deathstricken, milling from place to place; children crying aloud;

95

women sobbing in broken inarticulate lamentation; men utterly hopeless and reduced to staggering weakness, heedless of the tears rolling down their dirt-streaked faces.

Mobs rioted for food:

wide-eyed, eager hands stretch in wolfish supplication; teeth bared in a ghastly grin that had long since ceased to be a smile – an emaciated, skin-stretched grin, fixed and uncontrollable.[5]

A typhus epidemic struck. By January 1920 a total of 19,000 had contracted the disease and 10,000 died. A newspaper reported:

The populace is feeding on the bodies of cats and dogs. There have even been cases when a starving mother has eaten the kidney or the liver from the corpse of her own child ... skeleton-like women and children rummage in the refuse heaps for mouldered shoes and, after cooking them for three days, eat them.[6]

The bread ration was down to four ounces, only for those entitled to claim. Outside Erevan whole villages died and the survivors became skeletons, gnawing rotting bones torn up by dogs. Near Etchmiadzin, Ashtarak, all around Erevan, people were stripping the woodlands and fields; 'the population has fallen upon the fields; it is grazing, swelling, and dying.'[7] By the time the rest of the world began to hear the reports and organise relief, it was too late.

The reason for lack of relief was that most of the American missions had been based in Western Armenia. Turkey had cut off diplomatic relations with the USA in 1917, leaving only a few missionaries. But with the sweep of the Ottoman army into Transcaucasia, Allied officials pulled out.[8] When the first consignment of grain was sent in by the American Committee for Armenian and Syrian Relief in the Near East, in January 1919, it was too late for the thousands who had already perished.

Many of Gorky's later drawings and complex group compositions are strewn with tatters and ribbons of the forlorn people's rags, their figures tracking a hazardous trail across the picture plane. Other paintings in grisaille, interpreted by some commentators as cosy domestic scenes, are

huddled clusters of bodies pushed up against one another, dark beyond hope.

Gorky's experiences during these years could never be retold, for they threatened to overwhelm him. His hidden early life provides keys for his need to form a cast-iron alter ego which would shield him from the memory of the horrific events. In his art, he evolved an abstract style which left him a neutral zone in which to function.

Manoug begged for work at the orphanage again. But every day, he and Vartoosh walked past bodies lying in the street, half dead from cold, their bones sticking out. By the end of the spring of 1919, 200,000 people had died: one-fifth of the total population of the republic. Added to that was the death toll in Western Armenia of 1.5 million through deportation and massacre.

Vartoosh clung to Manoug; they were always hungry, exhausted, half frozen. They had taken shelter in a ruin with no glass in the windows. Shushan could hardly move. 'We used to wrap mother up and put her in the window,' Vartoosh said and wept, 'because the roof was leaking as the snow thawed. We worked until evening. Whatever they gave us to eat in the day I used to save and bring it in the evening to give Mother and Gorky.'

Not far away lived their uncle Aharon, a supervisor in the orphanage, in a comfortable house, but he ignored them. Shushan was too proud to ask for his help. Vartoosh secretly went to him. They received flour, wheat. 'He wouldn't give my mother even one egg. He wouldn't even talk to her. He treated her very badly. Gorky and I used to go out to work. How Gorky worked! The poor boy. But we couldn't manage.'

Manoug saw his mother change day by day, making a slow descent into malnutrition and depression. He had never seen her so dull, listless and sluggish. Her lustrous black eyes were leaden and glazed, sometimes sharpened by pain. Her white skin had lost its radiance to become dry and powdery. Her silky black hair was now always wrapped up in rags. He tried to animate her, but she stared absently without expression. She was debilitated by malnutrition, fighting the awful pangs of hunger, to save her children from seeing her suffering. When he went out, he was afraid of how he might find her on his return. Shushan was thirty-nine years old. He would rush back to sit and talk to her. In New York Gorky would draw

and draw her face, for years. A shrouded, wrapped-up figure, seated, slumped, lying down, would haunt his drawings later.

On 17 March 1919 the head of relief sent out a message to the USA:

No bread anywhere. Government has not a pound. Forty-five thousand in Erevan without bread. Orphanages and troops all through Erevan in terrible condition. Another week will score ten thousand lives lost. For heaven's sake hurry![9]

Around 19 March, 'when the green buds were beginning to sprout', Vartoosh remembered, they were together in the derelict house. Shushan was slumped against the windowsill. Thawing snow was dripping through the holes in the roof. She was debilitated, her stomach was swollen and her long fingers had become spindly. Her eyes were sunken and cavernous, she had sores in her mouth and her lips were coated and furry. She was dictating a letter to her husband. Manoug huddled at her feet, crouched over pen and paper, copying down her words. Vartoosh watched. 'Mummy was speaking. She was saying, "Write that I can never leave Armenia. That I will never come to America. They've abandoned us completely." Then suddenly we saw that mother had died.'

They rushed to her. They felt her face and hands but she was limp. The awful realisation that she was gone for ever stunned them.

On the same day as Shushan summoned her last breath to dictate a letter, in Watertown, USA, her eighteen-year-old daughter Satenig was walking down the aisle in a satin wedding gown. Young pages carried large candles ahead of her. She leaned on her tall father's arm. The guests whispered that Setrag had given her $1,000 for the wedding. The bridegroom was not of her choice. She was slender and poignant, with huge, dark eyes in a fragile, pointed face, covered in a mist of veiling. The church was full of people but her mother, brother and sister were far away. She saw them in her mind's eye, in Erevan.

As she stood before the altar, flames shot up all about her. A candle had

caught her wedding veil. The bride heard a scream, froze and someone ripped off her veil. There was pandemonium in the church. People whispered that it was a bad omen, and Satenig remembered the curse on her grandmother who had set fire to Chagar Sourp Nishan. She did not know that thousands of miles away in Erevan, her mother Shushan had just died.[10]

11

Second Flight
1920

Shushan's death was the end of long struggle. Vartoosh could not stop her tears; Manoug was numb. Vanetzi friends quickly rallied to the children. Krikor Moudoyan Manoug's teacher in Van, informed the authorities. 'Uncle took us to his house,' Vartoosh said. 'After Mother died, he wanted to do something for us. He had never talked to my mother. He had not behaved well towards her.'[1]

With thousands of people dying there was not much ceremony. Bodies were collected in carts and piled into mass graves. After the typhus, cholera had followed, and bodies were quickly dispatched. 'I don't even know if there was a proper burial. I don't know which cemetery she is buried in,' Vartoosh said. 'They just took her away.'

Manoug and Vartoosh were just two out of 13,000 orphans suffering from malnutrition in Yerevan. After the American Committee for Relief in the Near East set up orphanages, a further 30,000 children were gathered. Just three days after Shushan died, Vartoosh remembered, the first supplies of flour arrived. 'What was the use after she had died? What could we do?' She was handed a bag of flour, and a bag of rice weighing 20 pounds. She cooked for her brother. Vartoosh said, 'The American missionaries helped us a lot. Flour had just come from America. Truly, they were kind to us. I made bread. We worked in their orphanage and we ate there. Then the Americans opened the mills so that the people could work.'

The American government voted the Hundred Million Dollar Appropriation to subsidise relief, with Herbert Hoover as head of the American Relief Administration. A chilling account was sent after an inspection in

April 1919. It describes the deaths from starvation and diseases caused by malnutrition and estimates that out of half a million refugees in need of food, about a quarter of a million were still at starvation point, dressed in vermin-infested rags with no hope of any improvement since there were no supplies at any price.[2]

Manoug and Vartoosh had struggled to care for their mother and felt defeated. Vartoosh could not stop the tears flowing down her cheeks. Years later she would have the same reaction to her brother's death. 'The tears just flowed and wet me. I couldn't stop them,' she said. 'Let us go and sit by the lake and weep.'

Manoug held on, trying to make decisions, postponing his grief. He was consoled by their Vanetzi friend Kertzo Dickran. He had married a sixteen year old girl, Vassilouhi Pohanian, and had two sons both of whom died that terrible winter.[3] He took the lead, saying, 'Your father and sisters are in America. There's nothing for you here. Come with me. I will take you as far as Constantinople and put you on a ship to join them in America.'

The children also received notice that $300 sent long ago by their father had finally arrived. But the officials, who had denied their mother hospital because of her husband in America, refused to hand over the money to Manoug. They insisted it could be received only by their mother; a minor could not claim it. The dollars were returned.

'If we can only get to Constantinople, you'll receive the money there,' Dickran consoled him. 'I'll take you.'

Manoug and Vartoosh decided to risk a dangerous train journey, but they would need travel permits from Yerevan to Tiflis. Yerevan seethed with unrest. The young republic was in danger at every moment from Bolsheviks on the one hand and from Kemalist Turks on the other. Civil war split the country. Armenia was at war with Georgia over the northern district of Lori, and rail connections with Georgia had been cut. Manoug went to Commander Dro, the assistant military chief of the republic, in a black stone building on the southern edge of the city. Part of the wall with the outside staircase still stands today. Manoug climbed the flight of stone steps to the office. Seeing the tall boy enter his office, Dro's mind was on his dilapidated army, and he eyed the young recruit. Instead Manoug requested exit papers. Dro pulled a gun on him and yelled, 'You are a traitor! A deserter! You're leaving the country and running away!'

He hit the boy hard with his Mauser. Manoug lost his balance and fell,

rolling down the long staircase to the bottom. He returned home covered in blood. 'He called me a traitor!' he told Vartoosh. 'He said, "You should stay to fight."'

But Kertzo Dickran was a seasoned fighter, an upright, old-fashioned character who served as a secretary in the Ministry of the Interior. He had seen his own village of Kertz ransacked and burned by Kurds, children killed by the sword on their mother's backs, his own father murdered when he was only six. He had survived years of rough living in the mountains and had fought in the defence of Van. Dickran reasoned that the war between the Armenians, Turks, and their neighbours could go on indefinitely, without the return of the eastern provinces. For the past four years they had endured illness, famine and death. It was time to go to America to their father and sisters. He paid for the children's passage. His party included his wife, Manoug, Vartoosh, and Mariam, sister of his comrade in arms, the redoubtable leader Levon Pasha Shagoyan, who was their second cousin.

Before he left Yerevan for the last time, Manoug witnessed one historic event – the political rally of the only independent government Armenia was to have for the next half-century. The day on which a year ago independence had been thrust so unceremoniously on the Armenians, 28 May 1918, was chosen for the first anniversary of the republic and to declare officially the unification of Western and Eastern Armenia. In the main square, opposite the City Hall, soldiers, students, scouts and schoolchildren, including those from various orphanages, were assembled.[4] Manoug and Vartoosh watched the parade. The assembled masses all showed scars of the hideous winter. They gazed at the floats and motor cars, and heard the thirty-gun salute booming.

Since Manoug had failed to get an exit permit, Dickran obtained their papers and asked Dr Ussher for a letter of reference on the journey. After his long experience with the Armenian refugees, Dr Ussher had become head of the American relief effort, fighting for aid and political support of the Armenians. He wrote them a letter to the American Consulate in Tiflis, Georgia.

<div style="text-align:center">

The bearers
Dikran Der Garabedian
Manoug Adoian
and Nazlu Shaghoian

</div>

are worthy Armenians of
good character and ability, personally
known to me. Any
assistance to them in
reaching their relatives
in America will
be appreciated and
will not be misplaced.

<div align="right">C. D. Ussher.[5]</div>

Manoug and Vartoosh set out for the journey from Yerevan in the summer of 1919, taking very little with them. 'We sat on the tramway to leave,' Vartoosh remembered. 'Our uncle came in the carriage and said, "Don't leave. You are little. You will be lost on the journey. You will be killed on the way."'

'We've made our decision. I'm taking my sister and we're leaving. No matter what happens, we are leaving,' Manoug replied.

All he wanted was to leave the chaos and misery behind him. He was becoming conscious that a whole civilisation had been shattered. By the end of the genocide, his people had been butchered, uprooted, driven across deserts, homes and lands abandoned or taken over, churches and schools burned and overrun. Manoug had struggled through each horrific episode, had lost his home, his mother; his childhood paradise was ravaged. He was taking with him a tragedy which filled his heart and against which he would have to battle for the rest of his life.

The train from Yerevan made a half-circle through the Plain of Sardarabad, where only a year ago the terrible battle for Armenia had been fought and won. It continued around Mount Aragatz, through open country on the west of Lake Sevan where layers of black porphyry cut through mountains which led out to the bare rock-strewn heights of Armenia. Chugging across the steppes of the southern Caucasus, it reached a range of mountains guarding the Armenian tableland in the north, running east to west. As the train climbed to Dilijan, the barren hills gave way to slopes covered by dense trees and steep pastures, valleys lush with vegetation. Manoug had

been trapped in Yerevan for four years. Chain against chain of blue mountains on the horizon were a last reminder of Van.

For 200 miles, the ancient train rattled and shunted below looming mountains. The travellers saw Alexandropol, the scene of heavy fighting between Armenians and Turks, then Karakilisa, another battlefield. Many villages and towns lay in ruins. The northernmost district, the magnificent mountains of Lori, was an area the Georgians had fought for but which Armenians had finally been granted in 1918. It was the setting of the opera *Anoush* by Gorky's favourite poet, Toumanian. Distant villages stood out, with stone polygonal domes of Armenian churches. Barren hillsides were strewn with boulders. They passed through beautiful green valleys and hillsides, the district of Borchalou.

After fifteen hours they approached Tiflis, capital of Transcaucasia. Before 1918, it had been the cultural capital of Armenians, home to writers, actors, musicians, Armenian newspapers and other publications, and the best schools and colleges. It had been the seat of government for Transcaucasia, which had included Georgia, Armenia and Azerbaijan until they split up, and afterwards of the Republic of Armenia. Lately the delegates had been expelled. The Armenian population had been driven out of a city in which they once had their own mayor and administrators.

The city stretched out north to south in the valley of the river Koura. The railway station was in the north. Exhausted, two children made their way into town, overwhelmed by the smart people bustling around. They crossed the new town, European in style, with wide boulevards, enormous nineteenth-century buildings, grand houses and fancy shops. They had never seen a city like this before. 'We were scared, sort of huddling the walls in the street,' Vartoosh remembered. 'We went to the Protestants.'

At the American mission, armed with Ussher's letter, Manoug spotted his Armenian teacher from Van. His teacher did not at first recognise him, tall, lean and looking older than his years. Answering questions about his mother and family, a lump rose in Manoug's throat and he could not talk. 'He looked at his teacher and wept,' said Vartoosh. 'That man helped us a lot. He took us in, and gave us clothes, fed us and kept us there.'

Tiflis made a deep impression on them. Manoug roamed about the beautiful city. Perhaps in a fanciful mood as an adult, he told friends that he had met Maxim Gorky, who had given him his name. Three galleried bridges crossed the river. People strolled down the wide boulevards in the

cool evenings. Despite the effects of the war, people appeared optimistic and flourishing. It was shocking after the destitution of Armenia to see handsome, well-fed, beautifully dressed people enjoying themselves. The women were like the nineteenth-century artist Hagop Hovnatanyan's portraits, dark-eyed, wearing a narrow band of lace across the forehead and a tight bodice.[6] Half a million Armenians had left their stamp on the city in banking, commerce, industry and local administration, as well as art and literature. They had fled from Western Armenia to thrive in Tiflis, surrounded by fertile and rich agriculture, and had provided a lead for the Eastern Armenian provinces.

Like Van, the old town of Tiflis was dominated by a great crag. On this sat the citadel of Metekh. Two-storey houses crept up the hills, with red tiled roofs and wooden balconies painted in blue, red, yellow and white and faded into softer tones. Manoug walked down to the Armenian quarter of Havlabar, near the central marketplace where traders set up their stalls and workshops, so different from Yerevan. Mountain people swung long black cloaks, strutted in wide trousers and flat, black hats. Street-porters staggered under enormous loads. Artisans worked on the streets. The shops overflowed with fabrics, ribbons, leather saddles, jewellery, boots, shoes and exotic foods. On the street corners, people ate from stalls giving off smells of roast lamb, fried onions, wine and honey.

Manoug's stay of a few weeks in Tiflis helps to explain his constructed identity. He would say that he was born in Tiflis, that he was Georgian. Today the significance of his allegiance has been lost with historical shifts and the migrations of his people. It was a plausible alias for a boy who no longer wanted to be identified with a birthplace which had been wiped off the map, and preferred a fine city whose culture had dominated his education in Van. In this city called 'the Paris of the East', he came across enamelling on silver, antiquities, and, he later confessed to a friend, the finest oil paintings he had ever seen which left him with a puzzled disquiet.

The travellers finally continued by rail to Batum, on the eastern coast of the Black Sea, for the Georgian authorities had only recently reopened the closed line so that vital supplies could reach Armenia. They travelled over 100 miles through banks of purple mountains. As they approached the Black

Sea, the vegetation grew lusher and more exotic. The district of Batum was safe, held by Allied forces guarding the gateway of Caspian oil to the west.

The Russian-built town with its wide boulevards, massive public buildings and shops impressed them. But it was always raining. The French sailors in the harbour called Batum 'the *pissoir* of the Black Sea'. Brother and sister slept on the floor of a large warehouse at the dock, huddled together with other Armenians, and waited for a cargo ship to Constantinople.

The crossing from Batum southwards to Constantinople was a long journey by cargo ship, stopping at every port on the way to reload. Manoug sat on deck, hypnotised by the waves and the snowy mountain tops along the coast. He had not been in a boat since Lake Van. Vartoosh noticed that even here, he found some paper and pencil to sketch the little towns they passed with their busy ports: Findikli, Pazar, Djayeli. Riza had steep slopes of tea plantations, then came the towers of Trebizond. The sea voyage was a dream which transported him from the horrors of his life in Yerevan. The Black Sea was not a brilliant, luminous blue like Lake Van, but steely and choppy. Clouds floated above the tops of hills, edging the Armenian plateau. Manoug's mother was always with him on this journey. This was his first opportunity to reflect and to mourn her.

He had travelled more than 800 miles along the coastline of the Black Sea and now entered the narrow straits of the Bosphorus, the sea turning from grey to translucent blue. On his left was Asia and, on his right, Europe. Roumeli Hissar reared up on the west coast, with its tower and buttresses spreading up the hill in a triangle. After Tiflis, Constantinople was the city where Armenians had made their greatest impact. If Tiflis was the centre of the Moscow-oriented Armenians, Constantinople was more closely connected with Paris and the other European capitals. The Armenian population numbered about 100,000.

He saw buildings on either side of the water; a fairy-tale skyline of palaces, minarets, domes and churches. Skirting past Dolma Bahche, the ship berthed on the east coast. Their destination was the tall, *schloss*-like railway station of Haydar Pasha where travellers from the east disembarked to travel by rail to Baghdad. From here, large numbers of Armenians had been deported to the interior to join the death marches. The refugee camp for Armenians was packed. Exiles were pouring in, for Mustafa Kemal (later

called Ataturk) was now hammering the Armenians who had survived in French-occupied Cilicia and thousands were on the move again.

At Haydar Pasha camp, they slept in tents with other Vanetzis. The relief missions were better organised. Near Eastern Relief maintained three orphanages and a soup kitchen.[7] The Americans took charge of the Armenians along with the Armenian Patriarchate and community. Vartoosh said:

> We went to the American Ministry of Relief to request our money. One girl there, Musinian, was taking care of Gorky and me. She said, 'Come every day and I will give you food.' She gave us baked beans and that very sweet milk we loved so much. We spread it on bread.

Dickran filled forms to contact their father. It was autumn and a sharp wind whistled through the tents. They were thinly dressed. Manoug tried to find odd jobs, remembering that his mother had taught him that anything was better than a handout. He worked at a cobbler's, repairing shoes. Armenian ladies helped the refugees. Vartoosh, a slender fourteen-year-old with jet-black hair and the gentle eyes of a doe, attracted sympathy from a female doctor, Vergine Kelekian, who offered to house them both in the wealthy district of Bebek. Manoug refused, preferring to stay in camp. Vartoosh went to live in the house, furnished with polished furniture and carpets, a real bed off the floor, and all the food she had dreamed of during the famine. Dr Kelekian pampered Vartoosh: 'She bathed me, cut my hair, dressed me in very nice clothes, treated me just like her daughter. She had a very beautiful home. I would always sing for her.' Dr Kelekian had a handicapped child and begged Vartoosh to stay.

Manoug was relieved of his responsibility as a surrogate parent. At last, he did not have to look after anyone else. The constant search for food was over. He met up with two friends from Van: Yenovk's older brother Parsegh Der Hagopian, and Krikor Moudoyan. Vanetzis stuck together, bewildered by the accents from Erzerum, Moush, Yozgat, Hajin. In the evenings they played music and sang. They told jokes in their own dialect and talked constantly about Van. Manoug climbed trees, explored his surroundings, played games and joked with other boys, eager to catch up on the carefree childhood he had missed.

On Sundays, he crossed by .ferry with some Vanetzi friends, to see

Vartoosh at the Kelekian house in Bebek. On the west were Galata and Pera, the most Europeanised districts where the Armenians lived, and on the south, Stambul, the Turkish section.[8]

Mr Kelekian was a cashier in the Ottoman State Bank. Vartoosh was happy and healthy. She begged her brother to stay, gave him sweetmeats and presents. The contrast between the wealthy middle classes of Constantinople and the Armenians in Van struck them both. Nearly 100,000 now lived there, despite a drop in number since the massacres of 1896, 1909 and 1915. The former were confident about their Armenian heritage and equally at home with Turkish. They loved French literature, music and theatre, and peppered their conversation with French, which Manoug did not understand. They acted as a bridge between Europe and Turkey: the first Ottoman opera in Turkish was composed by an Armenian; the first novel in the Turkish language was written by an Armenian.[9] Their efforts in setting up the Armenian National Constitution had been confined to Constantinople, ignoring the needs of the oppressed peasants in the Armenian provinces.[10] Now they felt safe with Constantinople under Allied occupation with only a nominal Sultan in government.

Manoug's time in Constantinople and the insight this family gave him shifted his perspective. He saw Van, Yerevan and his past in a different light, and the entire jigsaw of the Armenians began to fit together in a new way. Armenians were vulnerable. Only in a new country like America would he be free, no longer an object of ingrained nationalist hatred.

In Constantinople, too, Manoug glimpsed the ornamental tiles that decorated ferry stops and the brilliant colours of Kutahya tiles in the Armenian churches, which had a lasting effect on his painting. The decorative tiles covered large areas of wall, in floral and geometric patterns, cobalt blue against pearly white, repeated outwards in radiating spandrels. They held an inner opalescent light and lustre; some were grounded in turquoise, green, yellow and red. Outlines were often blurred, colour floated over the underlying design marked in dark blue or black with a freedom that enhanced the artisan's touch. These features found their way into Gorky's late drawings and paintings.

The tiles were made by the Armenian ceramicists of the fifteenth century.[11] Etchmiadzin Chapel was also decorated with Kutahya tiles, including a fine series decorated in 1718 by an artist named T'oros, who was probably also a manuscript illuminator. Since Kutahya had been a centre

for Armenian manuscript copying and illumination in the fifteenth and sixteenth centuries, pictorial tiles were linked to illumination, each tile inscribed with a relevant text.[12]

Gorky would make line drawings of animals and figures with a similar robust simplicity. Some of his innovations had their roots in the ceramic traditions. One colouring technique was to paint a surface in cobalt blue, then glaze it over with a semi-transparent yellow to create green.[13] Gorky also liked to expose one colour beneath another. In many drawings he reveals the white paper or canvas under the pencilwork or oil paint. The glazes, too, were an inspiration; Gorky developed a method of drawing with wax crayons onto a pencil drawing, rubbing soft melting wax in a fast elliptical movement applied with pressure, allowing the paper to show through. In black and white drawing with ink he created a glazed patch, similar to the way light falls on a ceramic surface, deepening tones and heightening reflection.

He unconsciously picked up motifs from tiles, carpets, everything that caught his eye at this age: sharp-lobed flowers and leaves; roses drawn as a centrifugal form wrapped around a centre, like the Armenian symbol of eternity, carved on churches and stone crosses. The ceramicists transformed the symbol into an eight-petalled flower or medallion which repeated across a wall with tendrils binding it in place. Gorky developed an entire system of forms whose roots are hidden deep in his childhood, combining drawing and painting techniques.

Later, Gorky was known for having an encyclopaedic visual memory. 'He just knew by heart everything there was in a museum,' said De Kooning, who often walked with him. In America, his friends were amazed at how much he had travelled; they did not know that he had scarcely seen anything of European art.

Months passed without news from their father. The winter worsened. Rain and mud made life in tents hard to bear. Hampartzoum, the Kelekians' son, pressed enquiries through his shipping firm. One day he surprised them – their papers were ready and their passage to America was booked. He had found no difficulty acquiring exit papers; the Turks were making it easy for Armenians to leave in order to confiscate their properties.[14] Manoug also moved in with Dr Kelekian, who 'helped Gorky a great deal', said

Vartoosh. He brightened up the household with his comic stand-up routines of regional Armenian dialects or imitated the Protestant pastors around the camp. The children were in high spirits, and Vartoosh made the rare remark, '*Kef ein anoum*' – they had fun.

They had stayed in Constantinople for almost six months. After Armenian Christmas on 6 January, Dr Kelekian packed winter clothes for their journey. They would be crossing the Atlantic in the cold month of February. She pressed Vartoosh to stay longer, but no one could separate the young girl from her brother.

In the harbour crowded with naval frigates and all kinds of vessels, Manoug embarked on a ship bound first for Greece. He stood on deck with Vartoosh beside him, waving at the family who had taken them to their hearts. The stretch of water cut them off irrevocably. Manoug was leaving Armenia for ever.

PART II
REHEARSING FOR GENIUS
1920–34

PREVIOUS PAGE *Self Portrait*, 1926. Pastel on paper, 13 × 11". (Collection Mr and Mrs Harry W. Anderson)

12

Ellis Island
1920

On board ship, in February 1920, Manoug had few regrets about leaving. In the last five years, he had experienced crushing upheavals and looked forward to a new life. He was probably seventeen, but looked like a man, broad-shouldered and tall, with an alert face.

They berthed in Piraeus and sailed on to Patras, staying briefly in the Greek port with its busy harbour for a few days. They wandered around the town. Vartoosh noticed a nice smell coming from some strange fruit which Manoug bought for her. 'They peeled just like walnuts. So tasty. They were tangerines. And even now, whenever I eat a tangerine, I remember Patras,' Vartoosh said. Her brother met a Greek girl on the boat in Patras. 'A very nice, sweet girl. She did not know Armenian. He did not know Greek. They would go and pick flowers.' Throughout the long journey from Constantinople to New York, he walked on deck with the Greek girl, or sat hour after hour watching the sea. 'She is not going to Boston. Chicago is a very distant place,' he told Vartoosh.[1]

In Naples, everyone was nervous about the medical examination and eye test for trachoma. The children passed, but Kertzo Dickran was declared *no bono*, no good. He must stay for medical treatment. Trachoma in eastern Europe was so common that authorities examined immigrants at their port of embarkation in Italy, to avoid sending them back from Ellis Island. They were sad to be parted from Dickran, who had kept his promise to get them on a boat to New York.

Brother and sister sailed on to Gibraltar and entered the Atlantic, with no further stops until Ellis Island. Manoug became infected with 'America

fever' on the SS *Presidente Wilson*. Surely it was a lucky ship! President Wilson had taken part in negotiations after the war advocating the establishment of a free Armenia.

> The waves were beautiful. Gorky was happy to be on the sea. He sang songs of Van. He liked to sit at the side of the ship, close to the waves. He started to write poetry and he was drawing pictures. He drew boats, the sky, the clouds, he drew all the way to America.

Setrag's $300 had bought them tickets in steerage among the poorest passengers. Manoug slept on a three-tier metal bunk covered in coarse striped ticking in the men's compartment surrounded by 2,000 metal-frame settles crammed into a low-ceilinged dormitory. Vartoosh slept on the women's side, next to the engine rooms. The air below decks smelled rank and stale. A biting disinfectant was slopped on the floors daily to counteract the stench of vomit.

On deck were people such as Manoug had never seen; strange faces from all over eastern Europe. People in city suits; families in peasant outfits. Women with ruddy faces, hair in buns, gold earrings dangling, scowled, smiled, yelled at their children. Wearing overcoats over long, bunchy skirts, and headscarves tied under the chin, they sat clutching their bundles, looking out for thieves. Boys cowered, their jackets safety-pinned together. Old men, with labels attached to their coats, waited. Children ran about yelling and fighting. Mothers pulled blankets over their heads and suckled infants or lay with their heads in each other's laps. The men wore skull caps, prayer shawls, flat caps and even soldier's uniforms. They sat on deck around pieces of sackcloth, playing cards and chess. At night, out came the mandolins, accordions, mouth organs. People sang and danced.

The children wondered what to expect on the other side. The Kelekians had explained that their relatives had been wired and would be waiting. What if they did not recognise their father? Manoug could barely conjure up a picture of Setrag; Vartoosh had not seen him since she was two. She had gazed at a photograph of him seated in a carved chair, a fine gentleman in an elegant suit with a gold chain. He had never seen a picture of his daughter. He had only received one photograph of his family, and that was of Shushan and Manoug, taken long ago in Van. They were both apprehensive about meeting *Hayrig*, Father. In their eyes, he had failed them

and left their mother to starve. Vartoosh harboured residues of anger against him even at the end of her life.

At last, on the twenty-first day of their crossing, the first glimpse of America appeared on the distant horizon. Manoug stood on deck to see everything. Slowly they approached the flat and sandy coastline of Rockhaven Point and Coney Island. Opposite rose the low, smooth hills of New Jersey and Staten Island. Excited people pushed and shoved at the railings to get a view of the promised land, though none of them could feel sure of being allowed to enter.

They sailed through the Narrows into Upper New York Bay. The crowded immigrants gaped at the bristling skyline of Manhattan and the huge piers of the West Side. The Hudson river, a wide swathe of grey-green water, stretched on and on, as the skyscrapers rose on either side of the ship. Huge ocean-going liners were anchored to colossal piers. 'Oh, Vartoosh, what kind of a place is this?' Manoug spoke in his sister's ear in hushed tones. She stood speechless, huddled against her brother's shoulder.

Suddenly a roar went up on deck. Hundreds of fingers pointed, hats were lifted into the air, hands waved. Cries went up around them: *'Libertà! Eleftheria! Azadoutioun!'*

The sight they had all been waiting for – the Statue of Liberty! Manoug spotted a green giantess springing up from the grey water, a star bursting around her head. Some passengers fell on their knees and wept; others crossed themselves.

'My heart was banging against that rail! We just stood there, holding hands,' said Vartoosh. 'We were both crying.'

Instead of sailing to Ellis Island, they berthed at New York pier, but were not let off the ship. Later, ferries would come to take them across to Ellis Island. Only first-class passengers were permitted to disembark. The children waited and stared. The poorest passengers were kept in the hold below.

When their turn finally came, they boarded the ferry. The little island seemed to consist entirely of imposing red-brick buildings, halfway between a castle and a terminal. Ellis Island could not cope with the great flood of immigrants arriving after the war, between 1919 and 1921. The Adoians arrived at its most overcrowded and chaotic.

Their first contact with American soil was to join a long queue winding outside the building. An awning shaded hundreds of immigrants in long

lines. People stood, sat on their cases, tried to control their children, stamped their feet in the freezing cold. Manoug and Vartoosh were ordered to leave their scanty belongings in the baggage hall on the ground floor and walk down a corridor and up a staircase. Step by step they climbed, in single file, while officials on either side scrutinised them. Vartoosh, on the stair below Manoug, became anxious when an officer drew a cross with his piece of chalk on the back of his jacket. Would they send him back? It was only the first of a series of tests for any obvious marks of illness or deformity. At the top of the stairs the two swing doors were flung open and they entered a huge hall echoing with the din and hubbub of anxious people. The ceiling rose as high as a cathedral, for over 50 feet; all around the first floor galleries led to offices. Officials stared down. Thousands of people under that one roof were all talking, crying, shouting, screaming. There was a stench of bad breath, unwashed bodies, stale tobacco and fear. A maze of queues were separated by brass railings. Guards pushed them around. People stood cowed and waiting. Uniformed officials barked orders.

A man behind a desk asked people their names and received mumbled replies. The majority could not speak English, so their names were altered, abbreviated, for the officials did not bother to copy names correctly. Manoug knew enough English to answer simple questions. He and his sister were each given a number and told to wait. Then he was separated from Vartoosh. There were other people with chalk marks on their backs. Vartoosh was scared but an Armenian reassured her, 'Don't worry. He just looks too thin, so they will give him a special medical examination. Make sure he doesn't have TB. Everything will be all right.' After months of living comfortably with the Kelekians, eating good food, Vartoosh looked healthier than her brother.

Manoug was prodded and pushed by doctors. Anyone detained on suspicion of ill-health or other problems was herded into wire cages around the edge of the hall, overcrowded and dirty. Eyes were prised open with a button hook, the eyelid turned sharply back to show the top part of the cornea for trachoma, possibly infecting healthy eyes. Occasionally the doctor dropped the hook into a bowl of methylated spirits. Manoug was so shaken that he needed all his control not to run away from this place.

When Manoug and Vartoosh met again at mealtimes, they huddled together. It could take days to process their papers as new shiploads arrived. They slept in separate dormitories and fed in long mess halls. They had not

seen a single familiar face, and they did not know whether their relatives were outside waiting for them. They were more frightened than they had ever been in Armenia, except here they were more like prisoners. At night they cleaned a little patch of window to stare at the lights blinking on the distant skyscrapers. Manoug whispered to Vartoosh, 'Cry, Vartoosh *jan* [dear]. Cry as hard as you can. Maybe if you cry they'll send us back. Pinch yourself to cry.'

At last Manoug passed the medical examinations. He had to sit with people from his own ship on benches. They shifted forwards bench by bench to the inspector railed off at a large desk with an interpreter at his side. The questions rained.

'What is your name?'

'How old are you?'

'Do you have relatives in this country?'

Manoug tried to answer in English.

'Do you have money with you? May I see it?'

The next hurdle was the literacy test in Armenian. Elderly people who had no schooling stared at the paper blankly. Vartoosh was exempted, because she was under sixteen. Manoug passed. Having passed all the tests, they were handed two boarding cards. Suddenly their agony was over. Dazed, they stared at each other. What next? The interpreter explained that their names would be announced downstairs at the meeting point.

It was their turn to walk to the end of the room to the 'Stairs of Separation'. Manoug faced the flight of stairs, turning his back for the last time on the booming Registry Room, crammed with desperate people. Vartoosh clutched his hand. Ahead stretched out a long corridor with doors on either side. The stairs were wide and smooth. Down there was the New World and Manoug felt he had a right to it. He followed the people in front of him making their way to the 'Kissing Post'. Italians hugged their children; Jews wept over their wives; Slavs locked into bear hugs and thumped each other. They searched all the faces and recognised no one.

'What'll we do?' Vartoosh kept asking him. 'Where will we go?' He had an address somewhere. Suddenly he started shouting. 'Look, Vartoosh! Over there!'

The familiar figure of Akabi's husband, short and stocky, bustled towards them. The children ran forward.

'Mgrditch Agha!' Tears streamed down Vartoosh's face. 'Uncle Mogouch!'

His arms enclosed the children in a rugged embrace.

Manoug was bewildered by his first glimpse of New York. Tall towers thrust upwards into the clouds. Verticals cut razor-sharp angles in concrete and steel. Enormous glossy cars hurtled along wide avenues. Every space was paved, concreted, asphalted, not a tree or mountain in sight. Manoug was filled with a strange horror.

Shaken by the immigration ordeal, he now found himself surrounded by Mgrditch; Vosgian, his godfather; and Hagop Adoian, his half-brother – a menacing giant. But his father had not come. They made their way to Grand Central Station, where a smart, stylish Akabi was waiting. She cried and laughed and squeezed them to her. In the station they stared at the tall ceilings and Egyptian grandeur of the vast hall. The train to Boston had plush seats and heating. Akabi gave them little tablets wrapped in silver paper to eat. The stuff was sweet and melted quickly in Manoug's mouth. 'That is called chocolate.' Akabi laughed at their expressions.

The train ride lasted more than four hours. First they whistled through New York, then countryside called 'Ker-ne-tiket'. Soon they were surrounded by small towns, then the flatter Massachusetts landscape came into view. In Boston they took a bus. Manoug was expecting a fine house, a large car, lovely furniture – an American version of the Kelekian house in Constantinople. Akabi lived in East Watertown, a small town near Boston, populated by Armenians, Jews and Italians. As they approached, the town shrank in scale. Row upon row of small two- and three-decker clapboard and shingle houses replaced the stone-built residences of Boston. The streets narrowed; little shops and businesses spilled out. The people no longer appeared so sharply tailored and clean-cut, more like the immigrants on the ship. They got off the bus and walked down a little street, past a row of shops on Mt. Auburn Street on Coolidge Hill Avenue, to a clapboard house with a small wooden porch.

Manoug entered Akabi's busy kitchen, heated by a corner stove. Around a table adult relatives and children all talked and shouted at once. Little Gurgen, who had walked with them from Van to Yerevan, was a thin and drawn-looking ten-year-old, now called Jimmy. Akabi's daughter, Liberty,

a toddler of three, ran around laughing and chattering. She had brilliant blue eyes and blonde hair. This was the nerve centre of the Van community. Whoever arrived from the old country was invited to stay.

Satenig was lying alone in an upstairs bedroom, her face to the wall. She had just come out of hospital after a miscarriage, and, moreover, she had always felt a burden of guilt about being separated from her mother, brother and sister. Face to face with them, the reality of her mother's death hit her. She could not respond. 'I can scarcely remember their arrival, I was so ill. I wasn't interested.'[2]

Akabi was gutsy and cheerful. She mothered them, fed them her *lavash* flat bread dripping with melted butter, her *pastourmas*, garlicky spiced dried fillet, and Vanetzi cheeses. Satenig's husband, Sarkis Avedissian, was a salty man who joked and laughed. The family had been apart for almost four years with scarcely any communication. Akabi had heard of her mother's death in the most casual way from another immigrant. She was appalled by Manoug's account, not realising how much worse their lives had been after she left. The contrast between the deprived years in Yerevan and the overflowing table in the snug house filled with people raised silent questions. 'Where were you when we were starving? What did you do when Mother was dying?' They said nothing; it was in their eyes. The gap that opened on that first day could never be bridged.

They went to see their father in Providence, Rhode Island. His mother's words rang in Manoug's ears, filling him with bitter and conflicting feelings. At the end, she had cursed him: 'He has abandoned us. He does not care about us. I will never go to America.' If Manoug did not openly reproach him, Vartoosh held him responsible for their mother's death, 'How could we be expected to feel anything for a man we had not seen for twelve years? They told us, "This is your father." There we saw a stranger before us. We couldn't feel anything. We were supposed to love him.' Vartoosh struggled with her feelings. 'My mother did not love him. He could not even read and write. She just married him and he went away.'

Manoug had a hazy memory of an extremely tall, dynamic father, who had ridden with him on his horse. He had to square it with Setrag at fifty-seven, still erect and handsome, with greying hair receding at the temples. He had blue eyes, one of them injured, in a long face with a determined chin and large features. The tall, rangy bone structure of the Adoians had

been inherited by Manoug. Setrag's hands were coarsened from hard labour and his manner was gruff.

For Setrag, the shock was even greater. He had left behind a toddler and a small boy. Now he was faced with two tall, slender teenagers. In Vartoosh he must have seen an echo of Shushan. It was an awkward meeting. Setrag even had difficulty understanding the children's elegant Eastern Armenian dialect.

Brother and sister had no idea how hard life had been for him. He lived with his eldest son Hagop and his family, and both men worked in a foundry, the Iron Winding Company, doing backbreaking work. In America Setrag had scraped to find the money for their passage. When he had first arrived with Daniel, his nephew, in 1908, he had worked in a textile mill in Central Falls. Years later, he was still an unskilled worker.

The hulking figure of Hagop dominated the household. He had married a woman from Kharpert, Heghine Najarian, only four foot tall. They had four children: Lucille, born in 1912; her sister Arshalouys (Dawn) in 1914; Baghdassar Ashot (Charles) in 1917; and George in 1919. There was none of the jollity and light-heartedness of Akabi's home. Lucille was dispassionate, 'My father had a coldness with everyone.' And Gorky's niece Florence found him frightening:

Hagop was a big, big man. He was menacing, the way he looked. There was a meanness in him. A real Adoian with a stubborn streak. He probably raised his hand. You could see that from his children, maybe his wife too. A lot of Armenian men were that way. The women had to be submissive. His wife, Heghine, was meek and mild.[3]

Setrag is the least-known member of Manoug's family, in part because Gorky went to great lengths to hide him. Lucille was very attached to him and was the only member of the family to describe him:

My grandfather was a fine man, even when he was really old. He was nice, very jolly. Whenever people came to visit, they got into a good mood, they would say, 'Setrag sing us a song.' My father would teach us some songs too. They always talked about the old country. Grandfather was kind to my mother because she was a sweet woman. They always spoke Turkish, if they didn't want us kids to understand.[4]

Manoug shocked them with his hopes of going to school; his mother's love of beauty, nature, learning and culture had no echo. He was to stay in Rhode Island with his father and earn his keep. Vartoosh went back to Akabi in Watertown. No school for her either; she was to work in the Hood Rubber Company. Compulsory education had been legislated, but it was impossible to enforce upon the hundreds of immigrant children with strange names who looked alike to the authorities. Many declared themselves to be older than sixteen, so that they could earn a wage. Times were hard and everyone had to fight for survival.

Manoug's arrival in America coincided with an economic crisis which lasted from 1919 to 1924. The first to be laid off work were marginal and unskilled workers like the Armenians. Manoug's father and brother were anxious for Manoug. Rhode Island was populated by foreigners, and as in many east-coast towns the foundry was the chief employer.

They took him to work. It was deafeningly noisy, smelly and hot. Huge furnaces were constantly being shovelled with coal. Acrid smells burned his nostrils. In later paintings, Gorky would evoke the fires and the atmosphere of the foundry in which he worked during his first months. The workplace was rough and full of immigrants. The foremen were Americans and quick to ridicule a 'greener' with a funny name and poor English. Here was another lousy foreigner come to take the work away from honest Americans.

The ground-swell of prejudice against foreigners manifested in such events as the trial of the anarchist Sacco and Vanzetti made Manoug feel unsure of himself and motivated him to change his name. Although he had experienced discrimination by Russian Armenians and smarted under the taunts of 'refugee', he had never been made conscious of the colour of his skin or this strange new defect – his foreignness. He said nothing of this period of his life but it fuelled his resolve to escape from the treadmill.[5]

At home he had to fit into a household ruled by men, where women were subservient. His father and brother came home exhausted and had little to say. Lucille recalled, 'They used to get an Armenian paper every week, *Hayrenik*, and my father used to read it. Whether my grandfather could read, I don't know, to be honest.' The paper was produced in Boston with a wide circulation in the diaspora. Lucille added, 'My father smoked nargile and grandfather too. Father had a beautiful set of pipes.'

Her brother Charles was fond of his grandfather, 'a rough man'. They

thought that he slept in his outdoor clothes and kept his axe under his pillow. Charles remembered him later:

> I was working in the tea-shop and he used to come in every Saturday morning to buy a quarter pound of Brooks' tea. I always waited on him. One day he had a cut in his hand and you could see the meat and the bone. He must have been cutting wood or something. I said, 'Grandpa, come on, I'll take you to the hospital.' 'No,' he says, 'I urinate on it two or three times a day and that's what heals my hands up.'[6]

Manoug found himself in a rough, uncultivated atmosphere. On the dresser was a photograph from the days when the men first came to America, a row of strapping young Vanetzi men in tight-fitting suits with their hair parted in the middle and their whiskers bristling. Several sit with their chests pushed out, right leg swung over left, some holding a folded newspaper on their knee. In the centre, next to Setrag, one holds a nargile pipe to his lip, cord curling down to the bottle at his feet, and his neighbour holds a cigarette. In a line of younger men, each wears a large buttonhole of flowers, at the ends of the row, they hold up little posies of flowers. Two young men hold hands, and one of them places his hand on Setrag's shoulder, another rests a hand on the man in front of him, to indicate that they are blood relatives. It was an echo of his own pose clutching little flowers chest high in the photograph with his mother. A studio photograph represented effort and expense. It was an important souvenir, loaded with meaning and symbolism. The photograph of the twelve men had been sent to the four corners of Turkish Armenia, to families who had not seen them for many years. No one would guess the harsh reality of their lives. Up to one-third of them would die of pneumonia or industrial accidents.

They had laboured in foundries and mills around the clock, working extra hours. Often they were paid less than their American counterparts. Despite a high level of literacy in their own language, the majority knew no English and appeared ignorant of the concept of unions and justice. They were used as strike-breakers.[7] Penned up in factories and cities, they longed for the land they had farmed, their families and communities, the strong bonds of family and village. But the genocide had put a stop to that, and the sudden influx of traumatised refugees placed a new strain on the communities. One brother, Mishag, had died of tuberculosis. Pneumonia also killed a

high proportion of workers. In mills, foundries and rubber companies, the air was thick with dust and lint, or contaminated with chemicals. Not only did the workers labour in unhealthy and dangerous workplaces but they lived in poorly ventilated and crowded quarters. In the early years Setrag, Hagop and Daniel had shared a house with a large number of other workers, where Akabi's husband Mgrditch had joined them in Providence. They had slept in the beds by shift according to their work schedule. Hagop, a good cook, had taken charge of the meals. Manoug saw the pattern of life that lay ahead, if he was to follow his father and brother.

An old friend from Van visited him unexpectedly. Arshag Mooradian, who had been at Missionary school, had taken the same route as Manoug, via Tiflis, Batum and Constantinople to America. 'I saw him again in 1920,' he recalled. 'He'd only just arrived. He had a burn on his foot and he couldn't work.' No other record exists of Manoug's burn. Industrial accidents were common and it was easy for a beginner to injure himself. Arshag was shocked. 'He was just fifteen or so and working in that foundry.' Manoug was not going to sit around the house to convalesce. Instead he seized the opportunity to escape. 'Arshag. Let's go and look around the city.'

They walked around the shops together. A painting of a shepherd with his flock caught their eye, as large as a wall. Manoug stopped his friend. 'You see that? I am going to be a painter one day, better than that!'[8]

This is the earliest mention of Manoug's ambition to become a painter. He paced out the town, looked at paintings, and was not afraid to criticise. He blurted out his confession, frustrated at being forced to work, then injuring himself. He knew that he could paint, even without training. Arshag, a keen and original observer of Gorky, remained his friend and encouraged him.

In the autumn of 1920, Manoug left the foundry and enrolled at the Technical High School of Providence. At last he would acquire an American education. But to his surprise the academic subjects were taught at a lower standard than in Armenia. Car mechanics, engineering, metal turning, and electrical work were popular. There was little opportunity to learn drawing and painting. Inquisitive and shy, Manoug wandered around the little town on his way to school.

One day at the end of a church service, the American pastor stood at the door to shake hands with the congregation.

'And you, young man. Where are you from?'

Manoug replied, 'Armenia.'

'Ohhh! So you are one of "the starving Armenians"?'

Relief societies had done their work since 1915 with emotive terms to persuade people to give. The Armenians were held up as a lesson by mothers across America: 'Finish your dinner. Think of the starving Armenians!' Everyone knew the phrase. Later a friend of Gorky's, Helen Sandow, said, 'I remember as a teenager being told, "You're so thin, you must be an Armenian."' It was the first time she heard the word 'Armenian'. Manoug had fled from the perils of Armenia, but if he hoped to forget the tragic memories, others constantly reminded him. He had only one escape. Hagop's daughter, Dawn, said, 'He used to paint in the park all the time. Lucille was very pretty with dark hair and lovely eyes. He would tell her to sit still, and he would draw her with a pencil or a pen, just her top half.'

Soon he found the Roger Williams Park and spent all his free time surrounded by trees, flowers and water, sketching and painting. He would return home with a large bunch of roses for Heghine, his sister-in-law. One day she asked, 'Manoug, you know these beautiful roses, *keghezig varter*. Where do you find them?'

'Ach! That garden I go to is just full of them.'

'*Mi perer! Mi perer*! Don't bring them! Don't bring them! They'll arrest you!'

This Chaplinesque immigrant story bears Gorky's stamp. Some of the earliest surviving paintings done by Manoug are of flowers and roses. The other blooms look imaginary, but he painted roses in a realistic way. Shushan had sat under her rose bush, outside the village house, singing softly early in the morning. He had walked through the siege of Van carrying her a bouquet of roses. His cousin, Lucille, said, 'He wasn't afraid of being caught. He used to pick the roses because Roger Williams was noted for them. I don't remember him having a job.'

Hagop thought him a sissy and a layabout. No real man would sit painting flowers. Within the Armenian community the attitudes to an aspiring artist could not have been more crushing. Manoug was used to the more art-loving atmosphere of Russian Armenians. The petit-bourgeois

Ellis Island

Ottoman Armenians had known nothing but repression, arriving with no more than the coats on their backs. They thought only of basic survival, scraping and saving to bring other relatives over. The women worked when the men were unemployed. They cooked and sewed, and tried to save money. With no social security, no benefits, no safety net, the families tried as quickly as possible to get out of the factories and start small businesses of their own.

When his father talked of remarrying, Manoug was appalled. The mourning period in Armenian society was three years. Satenig and the children remembered their arguments, part of the family lore, later to be swept under the carpet. Manoug was now in conflict with both his father and brother. The happy family home he had dreamed of in Armenia had already soured. Manoug's sense of alienation increased. Satenig said, 'Most of the time he painted farmhouses, or ducks on water. He did a lot of charcoal. He drew and painted anything.'

At the Technical High School of Providence the teachers recognised his talent. Soon his drawings and paintings were being displayed and the head teacher praised his work. Comments from his peers about his dark looks and odd name irritated him, driving home the realisation that he was just one of thousands of immigrants and no citizen. He made friends with a Ukrainian boy, Mischa Reznikoff, who also liked drawing and later became an artist. Mischa remembered:

He said he was from the Caucasus, that he was Russian. We used to go to cowboy movies, every week. They show you the guy falling off a horse, or being squashed by something. They write, 'To be continued next week'. So we went the next week.[9]

Manoug dropped a clue to his metamorphosis on his first pictures. He signed them by a strange name. There was pressure to shorten names and make them Anglo-Saxon, hanging on to a few syllables of the old one. Manoug composed his own straight out of a Western. He picked Archie, then toyed with the word 'gun' and 'Colt'. He signed himself Archie Gunn. The letters 'Ar' were the clue to his Armenian identity. He would keep the prefix as in Ararat, Armen, Arshag, Artavasd, Artashes, Arpine,

125

and a host of Armenian names, and the initials 'A. G.' even after the name change. With his new signature, he cut himself off from his father, his brother and his painful history.

13

The Watertown Years
1921—24

At six in the morning in the dark, Manoug was outside the tall gates of the Hood Rubber Company, among the long lines of grey workers trudging through the stench of burning rubber. He had come to find work with his sisters in Watertown. They would have to labour long hours and it would be dark again before they got out.

Manoug had stormed out of Hagop's house in Providence after violent arguments about money. Hagop was jealous of the favoured young son and accused Setrag of indulging Manoug, who should go to work instead of school. He took refuge with his sister Akabi, who had bought a house at 86, Dexter Avenue, where the family occupied the second floor, letting out the rest.

Vartoosh earned nine dollars a week and she wanted Manoug with her. He was capable, but his restless hands never stopped. His sister said, 'He drew on everything and anything. Table-cloths, napkins, scraps, pavements.'[1] Akabi's sunny personality gave her home a bright atmosphere. She was spirited – later to be known as the first Armenian woman to drive a car in Watertown; she cooked, set a table groaning with food for ten people every night, joked, and sang. The melancholy atmosphere of other Armenian homes, weeping and lamenting their experiences of the genocide, was absent. They never talked about their childhood or their mother. Her way of coping with the past was by clamping the lid on it. Her children would end up feeling estranged.

Akabi's daughter Libby said, 'All three sisters had their noses up in the air. My mother was not quite a snob.' Fiercely loyal to one another, they

fought and quarrelled. Akabi had handsome, lively features with clear skin and a radiant personality; Satenig was small and slight, with a wistful look in her dark eyes; Vartoosh was slim and willowy, with long dark hair and a heart-shaped face. They tailored their own clothes and men's shirts, embroidered exquisite smocking and lace for the children. Satenig was pregnant again. She gave birth to a baby girl on 13 December 1921, and called her Shushanig (Lillian) after her mother.

'They lived in Dexter Avenue and Mt. Auburn Street, a nice area with a lot Vanetzis', a lodger recalled. 'Most Armenians worked as labourers at Hood's making tyres and sneakers. We had Vanetzi picnics, a big crowd; Florence's father was the best Armenian dancer.'[2] Of Manoug he said, 'His mind was on the painting. He sat in that porch and made skatch after skatch.' Everyone was a model if they would only sit for a few minutes. The children were sometimes snatched up too. Libby said, 'I loved him dearly. He was very warm, very loving. We called him Manoug, not Uncle or anything like that. He was handsome; not very dark. He loved to sing Armenian songs and loved to joke.' He played with children and always called the smallest one *Mogooch* – a term of endearment in Armenian for a plucky, mischievous child.

Manoug was surrounded, as he had been in Khorkom, by the warm rough and tumble of family life, but his aspirations were different. Kevork Kondakian, his cousin who had helped teach him to speak as a child, saw him often:

His sisters were taking care of him just like a child. Especially Vartoosh loved him like he was a seven-year-old. The only brother they had, so they gave him everything he needs. He wanted to do nothing else but art. He had to go after that like a fever. Vartoosh gave him money, everything. The courage to do anything he wants. Satenig was the same way, but Vartoosh more.[3]

Vartoosh felt she owed Manoug her life and that she was in America thanks to a courage beyond the capacity of a young boy. Her passionate belief in his talent was remarked on by their friends with the Armenian expression, 'She put all the world to one side, her brother on the other.' With little schooling, Vartoosh was the most enthusiastic about education. She had a natural instinct for beauty and passed on their mother's ambition for him.

Vartoosh fell in love with Moorad Mooradian, their neighbour and childhood friend in Van, tall, handsome and utterly charming. As a teenager, he had fought in Armenia from 1912 to 1915, then had emigrated to America to join the US army in 1917. While fighting in France with distinction, he had been gassed and discharged. Manoug liked Moorad, but the sisters did not approve of him, for he was merely an employee at Hood Rubber.

Manoug's own stint in the rubber factory was doomed. During lunch breaks he climbed to the top of the buildings and walked around the roofs to escape the stench. Large, uninterrupted roofs, all black, spread out before him. Like some ancient Armenian fresco painter, he drew on them with chalk. Memory and imagination transported him from this miserable factory. Huge pictures appeared on the roof. Back at work, he was hauled up by a yelling foreman who told him to keep off the roof. Depressed and bored by the monotony, he sneaked up to draw compulsively on parts of the roof that might be hidden from below. But the next time he was caught, he was fired.

Freed from the factory, Manoug roamed Boston. The Boston Museum of Fine Art gave him his first experience of a great art collection. The shock of seeing his first Piero della Francesca, his first Rembrandt, his first Degas, made him dizzy. It confirmed his need to paint. At last, he stood face to face with great paintings and he felt sure that the paintings lived and breathed. They had a reality that was far brighter than the outside world.

He discovered the anatomy of art, how the parts of the collections related to each other. Manoug walked down the main corridor, hung with tapestries, then into the different galleries on the ground floor. He could see archaic and classical Greek and Roman statuary. The Old Kingdom Egyptian sculptures and mummy paintings were rivalled only by the Cairo Museum. Medieval sculptures were displayed as well as Indian and Japanese. Closer to home were Persian ceramics, Coptic and Islamic textiles. Their closeness to Armenian textiles struck an echo. He saw Chinese and Japanese prints, English furniture, engravings by Dürer.

The variety and breadth of the museum gave him a broad base on which to build. In New York, when artists remarked on Gorky's vast knowledge, they assumed that he had acquired it in Russia or Europe. In fact he studied assiduously all the contents of the Boston Museum, looking at everything and reading the museum handbooks on painting. In the galleries he was

astonished at students copying the pictures and realised that this was a way to study the masters. He set himself up before Velázquez, Goya, Ingres. The more he sketched, the more his frustration with himself sharpened his resolve to study. The magnificent collection of Impressionists in Boston were puzzling and challenging. There was no Cézanne in the Boston Museum at the time but he did see Monet, Degas and Pissarro.[4]

For Manoug, the early twenties were years of conflict and confusion, shot through with the exhilaration of discovery. He had been uprooted so many times in his young life, that homes had no permanence. Neither boy nor man, he was in chrysalis.

One of the first photographs taken in America shows 'Archie Gunn'. His straight hair is brushed back; he has a resolute mouth, a long straight nose and a chiselled chin. His right eye is open and dreamy; the left is smaller and tensed for action. Instead of a tie, a silky cravat cascading from a white buttoned collar signals that he has become an artist. The young man ponders on his future.

Perhaps he could become an art teacher. He and Mischa Reznikoff discussed their projects and compared work:

At that time he was drawing Caucasian mountains and sunsets, very unlike what he was doing later. What he remembered of his old country. He told me he came from the Caucasus. He was just a beginner, his sentimental period. He always talked of himself as being a Russian rather than an Armenian. I knew that – because when you asked him in Russian, he couldn't speak it. His English was also kind of broken.

Reznikoff opted to study at Rhode Island School of Design. But he recalled that Manoug 'liked the idea of a fine art school – three years in drawing and painting'.[5]

His sister was settling down. Vartoosh was seventeen and could think of nothing but Moorad. Her niece said, 'Oh, Vartoosh wouldn't listen to anyone. She'd sit and brush her long black hair to one side and sigh. "I love him. I love him." Then she eloped.'[6] A Vanetzi wedding with people who had known each other since childhood was held on 8 June 1923. According to a lodger, Kooligian:

Akabi gave the wedding party in her house. We sang and danced a lot that

night. It was a regular Armenian wedding party. Oh, Manoug was in good form. He had a good voice and was such a good dancer. Akabi begged. 'Don't jump so hard. You're gonna bring the house down.'

Later that year his father married a widow, Akabi Shaljian. Manoug teased him, 'Father, you're old already. Why do you want to get married?'

Setrag reasoned, 'My son, if I get a boil on my back, I can't say, "Vartoosh, Satenig, look at my back." But if I had a wife, I'd say, "Look here."'[7]

Satenig said of the bride,[8] 'She knew very good English. She had gone to the school where they had put up all of Gorky's pictures. She was very proud. "My son's pictures are on the wall."'

Manoug was seizing every opportunity to train himself in drawing and painting, taking lessons from a German woman whom Vartoosh remembered as Mrs Bijur. She took him to New York and made him aware of the art world. She told him that an Armenian could not be a painter. Only a Russian or German could keep his name. Manoug's eyes were being opened.

In the winter of 1923, a Russian, 'Arshele Gorky', enrolled at the School of Fine Art and Design in Boston. His maturity, height and dramatic look were noticed by a teacher, Miss Ethel Cooke. 'He came to our school very well equipped. He was an artist.'[9]

Manoug needed a finer name to enter the school than Archie Gunn. Getting to know Boston and New York, he had discovered that while Armenians were 'starving refugees', Georgians were chic, artistic, and posed as princes. Many Armenian artists had lived in Georgia, so like revolutionaries in Russia, he chose a pseudonym to escape detection.

Manoug had admired Maxim Gorky, as a revolutionary artist, and the masterpiece *The Mother* touched him (he would one day celebrate his own mother in a portrait). Maxim Gorky had proved his love of the Armenian language and acted on behalf of the Armenian Genocide victims. With Manoug's distinguished looks and smattering of Russian, he could pass himself off as a Georgian and also acquire an artistic pedigree. He too had grown up without a father, and perhaps in imitation of

Maxim he would pretend that his own father was dead. He wanted to make his assumed identity watertight and an Armenian father was an obstacle.

Maxim Gorky's family name was Alexei Maximovitch Peshkov but his father had called him *gorky* (bitter), for his sharp tongue. Manoug felt bitter about his childhood and his first disappointing years in America. Maxim had changed his name at the age of twenty-four, just before publishing his first story in Tiflis; Manoug now signed his paintings with a distinguished surname. The Christian name Arshele is a greater puzzle. It is close to the familiar Armenian names, Arshag, Artsruni, Arziv (eagle); Achilles the Greek hero with his flaw sounded more European to him.

Maybe the young man fancied that he looked like Maxim. Black and white photographs darkened Maxim's brown hair and blue eyes, and emphasised his slanted eyes, Mongol cheekbones and shaggy moustache. In a photograph with Tolstoy he wore long hair and a voluminous coat which Manoug imitated. In his autobiography, *My Childhood*, the harrowing story of family greed and violence was like Manoug's. The folk tales of Maxim's God-fearing grandmother and her optimism echoed his own life with his brave mother.

Gorky had the panache to transform himself from a poor immigrant to a distinguished young painter using the art school as his first backdrop. He enrolled for evening classes and over the next two years, 1923–25, completed his basic training as an artist. Miss Cooke's accounts shed light on these formative years:

> During the First World War, he came in with boys from Holland and other places from Europe. A person as capable as he was must have had something. It was noticeable right away that he could draw, and knew what he was about. He seemed to just get ahead by leaps and bounds and we were all quite proud of him.

Talent and bravura set him apart from the other students. A fellow student, Katherine Murphy, observed:

> Gorky was very attractive. He had some fire. He was tall. Gangly. Six feet if not more. Among his stories was one that he was the nephew of Maxim

Gorky. That caused considerable embarrassment to the school director who had introduced him as such to a friend of the author. Mr Connah was very fond of Gorky and took him about a good deal.[10]

The school was variously called the New England School of Design, the Museum Guild School and the Museum School of Fine Art and Design, Boston.[11] 'The president, Mr Douglas John Connah, taught painting and Vesper George, design. It was a very good school,' said Miss Cooke. 'We had design, drawing and painting in a two-year course which at a normal school took four.' It was mainstream, yet enlightened, associated with the leading American Realist painters William Merrit Chase and Georges Henri.

Gorky had progressed from Caucasian landscapes to portraits. The received view that Gorky's first great influence was Cézanne is challenged by this account. In Boston he discovered a long and lively tradition in the French Barbizon School, which had influenced American painters such as William Morris Hunt. Monet and the Impressionists had inspired the east-coast painters Theodore Robinson, Thomas Wilmer Dewing and Frederick Childe Hassam.[12] Gorky studied French Realism and Impressionism before he had even seen his first canvas by Cézanne. But his first master was even more improbable.

The great idol of Boston was John Singer Sargent, the first living artist whom Gorky admired and studied. By the early 1920s, Sargent was nearing the end of his life. His portraits of US presidents, European aristocrats and society beauties had made him a celebrity in Britain and America. He was now completing some monumental murals in the academic American Renaissance style for the Boston Museum of Fine Arts. Miss Cooke observed that when Gorky started out, 'he was very fond of John Singer Sargent. He used to carry his book under his arm. I imagine he slept with it under his pillow. He was that sort of a student.' All his life Gorky was in the habit of carrying a book on his current favourite artist and obsession. The books changed, but his hunger for study did not. He learned the Sargent techniques at the school. Miss Cooke said:

Connah had Sargent's old studio in Boston. When Sargent came back to finish off some work, those murals and portraits and the library, he would come to the school. The students went out to the studio on Newbury Street. I

don't know if Gorky ever met Sargent. I was hoping they would meet because Gorky sort of worshipped him.

Gorky learned to paint straight on to canvas, elaborating play of light on planes and developing tonality, rather than drawing black outlines and filling in with colour. Sargent's technique was distinctive:

the places of masses were indicated with a rigger dipped in a flowing pigment. No preparation in colour or monochrome was allowed, but the main planes of the face must be laid directly on the unprepared canvas with a broad brush. These few surfaces . . . were painted quite broadly in even tones of flesh tint, and stood side by side like pieces of a mosaic, without fusion of their adjacent edge.[13]

Gorky tried his hand and later even adopted the rigger, or long-haired signwriter's brush, to the surprise of fellow artists.

He studied Sargent's masters Velázquez and Franz Hals, as well as the French Impressionists. Gorky spent many hours drawing with pencil, charcoal and ink. He adopted Sargent's Spanish themes. A Franz Hals study still remains, but only his niece Libby remembered others:

In our dining-room we had a painting of a Spanish Don, in the manner of Velázquez. He was copying a lot of paintings like that Spanish Grandee. Those paintings later got burned in a fire. He was also painting views and landscapes from nature.[14]

Gorky's oil painting of Franz Hals's *Lady in the Window* was sold to a collector in 1926.[15]

Gorky adopted Sargent's theatrical attack with paint and brushstrokes upon a canvas. He observed Monet, Pissarro and Manet through Sargent's eyes. Gorky was to develop this ability to see one artist through the eyes of another as a method. He developed a bold and penetrating eye for sitters and acquired his facility and fluency in quickly getting down personalities with the same seeming spontaneity. Sargent varied his brushwork to suggest line and texture; wood, silk and flesh were achieved as he turned, twisted and scraped paint. Gorky laid one colour on top of another and scraped it off with a hard bristly brush to reveal the shade below like Sargent. He studied how large forms were broken down into harmonious units and shapes, tonal

contrasts, gradations. He floated glazes and modulated tones.[16] It encouraged Gorky to free his medium.

His teachers praised him, and appreciated his workmanship and talent. At last, his passion for painting was no longer ridiculed. Jack Ferris Connah, the principal's son, became Gorky's closest friend. Jack fed Gorky with Sargent stories from his father; they studied and discussed work and techniques. In 1924 Sargent executed murals for the Widener Library, Harvard.[17] It was an example to the young student of the potential in creating a mural in a large public space; in the 1930s Gorky would carry out a series of monumental murals on a different theme.

In his first known self-portrait, from the period 1923–24, Gorky executed a 'Sargent' of his own head and torso: the epitome of a bohemian young artist in a smock and softly folding bow. Black hair swoops down and the handsome face, lengthened and romanticised, is worked in broad patches set against each other. The face and background are boldly modelled with thick, unblended paint in the accepted Realist method. The portrait bears the Sargent hallmarks of spontaneity and speed. It also resembles the 'Archie Gunn' photograph of Gorky. In oil, the artist has refined his face, letting the hair drop in a dark arabesque over the right temple and added more of his body. The lean, dandified portrait is a European version of Gorky's Armenian face, which would broaden later. As his teacher noted, there is no hesitancy in this early work. It shows confidence, facility and simplicity, remarkable in so young a man. The hand of a mature artist is already tempered by awareness of style, also carrying his mood of dash and optimism.

Gorky's alter ego gave him the freedom to express himself. Everything Russian was chic. The Russian Tea Room in New York was all the rage: musicians, dancers, painters and writers were celebrated there, often claiming to be titled. The Ballets Russes and Diaghilev were adored. Gorky did not have blond hair or blue eyes, but he developed the part. Miss Cooke recalled:

He told us he was Russian, he'd been in a Russian concentration camp or some kind of camp. I didn't get the story straight. He didn't seem to need

money. Perhaps he came with some kind of scholarship. We all thought he had training. He was so accomplished.

The ladies knew little about his part of the world and even less about Armenians. Miss Cooke imagined that a refugee escaping from concentration camp might acquire a scholarship. This made it easy for Gorky to improvise his self-portrait without fear of discovery. Miss Cooke observed:

> He was confident. Very much so. Never afraid to express what he had to say, in art or painting or talking. But he didn't make friends with perfect strangers. Gorky was a very happy person. No melancholy. He never moped around. Of course he had a sad expression, you might say. He looked older than his years.

He showed only his positive side to Miss Cooke, but she glimpsed a shadow. Gorky had put his past behind him in a deliberate act to free himself. He was geared up for an exciting future. Every day brought fresh discoveries about art. He took advantage of the teaching and opportunities. Miss Cooke was emphatic: 'We were fond of Gorky. Everyone there liked him a lot.' They went out to exhibitions and on walks: Frank Cronin, a redheaded Irishman, Jack Connah and Miss Cooke. 'We'd have these wonderful talks about art and how they lived. We'd all go out to eat together in Boston. It was a wonderful life.' Gorky and Jack Connah, who was six foot seven, well set and broad-shouldered, went walking, swimming and exercising. 'They thought a lot about their health,' said Miss Cooke, remembering Gorky's remark, 'You have to be strong enough to plough to be able to paint.'

His pride prevented him from letting Miss Cooke realise how poor he was. He carried off an ease of manner, dress and behaviour. He had learned caution and was able to express himself in English, especially on subjects like art which really interested him. His fellow student Mrs Murphy saw him as:

> a tall, serious young man in his twenties of great ambition who spent most of his free time in museums and washed dishes in the Hayes Bickford Restaurant, about a block from the school. He worked in the kitchen. I imagine that's how he paid for his meals. He worked in the daytime. Afternoons he worked in a small portrait class where he could relax, walking

back and forth with intricate dance steps, telling his long fanciful delightful tales of his boyhood in Russia.[18]

Gorky's love of drawing may have triggered childhood memories of song and dance. He relaxed in class, happy and in control. Murphy noticed that he 'was fairly young, but he seemed much older than the other students. Much older. Very tall, dark and thin. Big eyes, black hair. Very tall.'

Gorky was serious but a playful personality emerged. His paintings from this time also move in large sweeps and rhythmic arabesques, charged with bursts of energy.

His steady purpose was apparent to the staff. Miss Cooke believed, 'He was idealist, to start with. He liked the truth. He wanted to do an honest job. That's an ideal. He loved beautiful things: he never envied anyone anything. He was planning his life, even then.'

Although he saw a lot of her, and continued to in later years, she remained 'Miss Cooke'. Gorky needed to continue the relationships he had enjoyed with his mother and sisters, which had been companionable and respectful. The overt sexuality of American girls was alien to him. When he first came to art school, Gorky was heard to say that he hated women. Helen Remick, a young woman in his painting class, deliberately placed her easel so close to his that when she moved around, she touched him. One day Gorky stormed into the office.

'Miss Cooke! Can't you make Helen behave?'

'Oh, what's she doing now?' Miss Cooke replied.

'Well, she rubs into me.'

Gorky did not tell people about his financial difficulties. No doubt his family chipped in. Vartoosh must have given him part of her wages. In the museum Vartoosh watched him study Uccello, making a telescope out of his hand. He told her, 'This way I can see only the face and concentrate.' He sat and looked for a long time before he drew it, then got an idea for earning money.

Boston had an excellent collection of portraits by Americans: the sixth American president, John Quincy Adams, by John Singleton Copley and the unfinished portrait of George Washington by Gilbert Stuart; Sargent had painted Woodrow Wilson and Theodore Roosevelt.[19] Gorky copied all the portraits in the museum. Visitors were intrigued by the tall young man's lightning sketches. Soon he had memorised five American

presidents, and took his trick to the Majestic Theatre in Boylston Street, Boston. An imposing figure, he stood before a blackboard on stage facing the public during the interval, and sketched a president a minute. Halfway between art and vaudeville, his act was popular. He earned a decent amount of money, which he invested in a good easel and paintbox.

The equipment appears in a photograph of Gorky in Akabi's backyard. Seated before a painting, he is half turned to the camera, a brush in his right hand and a palette in his left. He also carries a *mahlstock* to steady the hand which he has put to use in strong, upward diagonals on his canvas. He poses in a suit, collar and tie; a gentleman artist. The canvas has not survived but shows a dynamic composition with bold diagonals, swordlike leaves and flowers.

Gorky's glimpses of good Bostonian society alienated him from the immigrant community. He was now under strain to keep two halves of his life separate. Above all, the Bostonians must not know that he was Armenian. At home, his paintings and sketches were of no value.

His reputation as a painter spread among Armenians, but their response was discouraging. Gorky sometimes dropped in to a club in the *Hayrenik* building, the headquarters of the local Armenian language newspaper, where he ran up a small bill. Since he had no money, he brought a painting to settle it. The angry manager put his foot right through the picture. The newspaper editor witnessed him rip the canvas and even smash the frame in front of Gorky, to show his contempt. A painter was no better than a brothel keeper, since he painted naked women. Gorky had no place in that community.[20] But he commanded respect from fellow students in Boston. Katherine Murphy recalled:

> During the noon recesses, Gorky used to sketch outdoors and one dull day, he painted a small panel of the Park Street Church. A parishioner passing by offered Gorky five dollars for the painting, if he would make the figures more like Americans and less like peasants. Naturally, Gorky was furious. He told the man where to get off and he took his painting off. He said. 'I'm sorry because I could have used the five dollars.' So I said, 'I'll give you ten dollars for it,' and that was quite a sum to me then.

She acquired and preserved one of the earliest oil paintings by Gorky.[21] A church and some other buildings are painted in a broadly Impressionist

style. The colours, unexpected pale mauves and warm pinks set against touches of green and yellow, presage Gorky's individual colour world. The tones are beautifully rendered and the figures are not crude, but quickly sketched people moving. In the Boston Museum, Monet's *Sur la Cité à Trouville* may have inspired him.[22] The brushwork is laid on in firm diagonal strokes and left unblended. *Park Street Church, Boston*, is signed 'A. Gorky', but not dated, although Murphy remembered it in 1923–4. The view is of the public garden, Park Street Common, with the church on the corner of Sherman Street.

His teachers thought highly of him, and the principal gave him special tuition. He had another job known only to her. 'Gorky used to do work for a dealer on Charles Street. I don't remember the address. He used to do portraits or touch-ups of portraits that had become discoloured. I don't remember the name. The place is gone.'

His technique was solid. Even before completing the school course, Gorky was appointed assistant instructor in the life-drawing class. At last he fulfilled his mother's dream of becoming a teacher, and received Miss Cooke's accolade: 'I tell you, Gorky could draw as well as any Sargent drawing.'

14

The Big Apple
1925

The first snapshot of Gorky in the big city came from his friend Mischa
Reznikoff: 'I went to New York Public Library and here is Gorky,
standing up there on the steps. I was small and he was very tall. He was
wearing a Burberry coat down to his ankles.'

No sooner had they shaken hands than Gorky excitedly began, 'Mischa,
I painted an apple. The walls of the studio are bulging! I am afraid the
studio is going to collapse! It's such a strong apple.'

He whisked his friend off to see it in the studio, at 47A Washington
Square. It was a little bedroom with a metal bed, according to Reznikoff.

> I come in and there's the easel, and he's so big in that studio. It's 16 by 20, a
> little canvas, an apple in the middle. He was under the Cézanne influence. It
> was well painted but it didn't bulge the walls of the studio or anything like
> that. It was his imagination, you see![1]

Gorky had inevitably been drawn to New York after his apprenticeship
in Boston. He told his family it was the artistic capital of America and that
he would support himself by teaching, with encouragement from the
principal, Mr Douglas Connah. Between 1924 and 1926, he found a new
way of life and almost became another kind of painter. Katherine Murphy
was struck by his ambition. Before leaving, he told her, 'If I don't become a
great artist, I don't know what I'll be. A cook, maybe!'[2]

Gorky soon discovered that the New York of the mid-twenties was a
bleak place for artists. Many described it as a wilderness with no art scene

and no recognition for the professional status of the American artist. Gorky observed that impetus in art came from Europe, and only Europeans were considered artists. With rare exceptions, galleries showed only European painters. The political isolationism of the USA, threatened by hordes of ragged immigrants, depressed by the postwar slump, led ordinary Americans to reject their ties with Europe. American artists were demoralised by the backlash of jingoism. Earlier some had been influenced by the Cubism of Paris but now they increasingly rejected it. The National Academy of Design did not include 'Art' or even 'Fine Art' in its title. That august institution, modelled on the British and French academies, was supposed to set standards. The Academy's rejection of young artists had caused the formation of the Breakaway Group in 1908.[3] One of the leading traditional artists of the time, Thomas Eakins, advised American artists

to remain in America, to peer deeper into the heart of American life, rather than to spend their time abroad obtaining a superficial view of the art of the Old World . . . to study their own country and portray its life and types . . . Americans must branch out into their own field . . . They must strike out for themselves, and only by doing this will we create a great and distinctively American art.[4]

Gorky tried to learn from the Renaissance and the nineteenth century, but the Boston Museum had been more liberal in hanging Impressionists than the Metropolitan Museum was. He also scoured the commercial New York galleries on 57th Street to see works by twentieth-century masters. He had to come to terms with not only Cézanne, but also Picasso and Braque. He wanted to swallow the whole of art history, yet he found himself in a city that cared neither for modern art nor for its indigenous culture. Art students headed for Paris. With no citizenship papers or money, Gorky tried to find Paris in conservative New York, examining every museum and collection.

From February to March 1924, major exhibitions of Sargent were held at the Grand Central Art Galleries in New York. Gorky, Miss Cooke and friends went to the show. Moses Soyer, who with his brother Raphael later became Gorky's close friend, characterised their horizons: 'Times were different then. There was hardly any art movement of importance in New York. We were taught that Sargent was the world's greatest painter. Trick lighting and clever painting was our goal.'[5]

The last high point in American art had taken place over a decade earlier, in 1913; the Armory Show was the first major exhibition of modern artists. Modelled on the Salon des Independents in Paris, it had shown hundreds of works by both European and American artists. The broad public was scandalised, but some collectors bought enthusiastically.

The upheaval of the war in Germany and Italy, and less so in France, had produced a desire for stability in an artistic revulsion against Cubism. *Neue Sachlichkeit*, 'the new objectivism', was to express new national identity. In Russia, artists were again painting realistically, even Kasimir Malevitch and Natalya Goncharova. In America, Regionalist and Realist art killed the impetus towards abstraction which had taken place a little earlier.

Douglas Connah from the Boston New School of Design introduced Gorky to the New School of Design in New York, on 1680 Broadway and 52nd Street. It was the address Gorky gave when registering at the National Academy of Design, where he joined Charles Hawthorne's drawing classes. The staid portraitist of the Realist School was described by one commentator as a 'good solid painter, sure of his values and safe in his technique. Paintings a bit stiff, rather removed in effect from actual experience.'[6]

Gorky rejected the National Academy after less than a month, to join the sister school of the Boston New Design School, also set up by Connah. Gorky entered his date of birth as April 1902, and his birthplace as Kazan, Russia, a city associated with Maxim Gorky. One of his students, Mark Rudlovich, recalled that in 1925, 'Gorky came down from Boston with Mr Connah. Gorky was monitor in the class in which I was enrolled.' Later that student also shed his family name, to become Mark Rothko.

During his year as monitor Gorky made an exacting teacher. He was especially demanding of young Rothko, who did not have a natural aptitude for drawing. Indeed, later, Rothko abandoned it for Colour Field work. Rothko had sharp recollections which date some of Gorky's paintings.

At that time, when I first met him, he liked Monticelli. He also made copies of Franz Hals in the Metropolitan Museum. This is not to imply that Monticelli and Hals were necessarily his favourite artists. Not at all. As a teacher, he had to make do with what original works of art were available for viewing by students. It was part of his job to lecture to us and expound on the techniques used by the artists hanging in the Metropolitan.

The impact of Gorky's personality on Rothko was considerable.

> Gorky was head of the class, in charge of it. He taught, as well as saw to it
> that the students were on good behaviour. And he expected good
> performance. He was strict. Perhaps I shouldn't say this, but Gorky was
> overcharged with supervision . . . He always appeared dramatic . . . He was
> an intense, emotional man to whom art was rather like an obsession. But he
> was not at all hard to get along with, provided you had a serious concern
> about art.

Rothko could not get over his deferential attitude, even later on a visit to
Gorky's studio. 'I remember taking out his garbage,' he said. I'm afraid I
still thought of him as my class monitor.'

Judging from the two artists mentioned, Franz Hals and Adolphe
Monticelli, a precursor of Impressionism, whose thick impasto with a palette
knife influenced Cézanne and Van Gogh, Gorky was moving away from
Sargent. When he was not teaching, Gorky worked from hired models. He
tried his hand at different disciplines. 'I especially remember that he did
some sculpture in class, and that's not a very well known facet of his career
– sculpting. He had considerable talent and was not averse to expressing it
vividly in his art of that very early period.' Rothko assumed that Gorky 'had
some experience in sculpture or at least carving in Armenia'. Although he
never became close friends with Gorky, he gives an insight into a period
about which little is known:

> Being an artist he simply accepted the significance of various forms of art . . . I
> don't think there is any doubt that painting was his main love. I remember
> him being an expressive, versatile individual, painting nonetheless remained
> uppermost in his thoughts.

From Rothko, Gorky did not hide his origins, but simply embroidered
them, blurring the facts:

> It was all fantastic and you couldn't believe what he told you, if you were a
> stranger . . . it was difficult to tell where reality ended and imagination began.
> He was always expounding on the unique beauties and poetry of the place of
> his birth. Always insisting that there was no place on earth exactly like
> Armenia.[7]

After moving to New York, Gorky often returned to Watertown, to his sisters, nieces and nephews. There, Vartoosh and Moorad had joined a Communist Party cell. This created friction in the family. She argued and made up with her sisters by turns.[8] When a friend protested to Akabi, 'Why do you let those people hold Commie meetings in your house?', Akabi feistily retorted, 'What business is it of anybody's? My sister does as she pleases in my house!'[9]

Soon afterwards, Vartoosh moved to her own house on Templeton Drive. After the 1924 slump hit the labour market and large numbers of workers were laid off, Gorky's father went to live with his elder son Hagop on a farm in Norwood, Providence. Hagop's son Charles remembered keeping a cow, chickens and ducks, and doing back-breaking farm-work to survive.[10] Gorky loved visiting them with Vartoosh, as a welcome change from New York. He was surrounded by animals and fields, even though the landscape was flat pasture. He rode the horses on the farm. Hagop's children, Lucille, Charles and Dawn, crowded around him. Lucille recalled:

> He'd sit down there and make pictures of the flowers and stuff. I had done a pink cow. He took that. I never saw that again. He had given my family three pictures, one was flowers, one was a nude woman, I think she was standing, I can't remember the third one. When we were moving from Norwood the movers stole it. We never saw them again.[11]

On 1 November 1923, Gorky's best friend, Yenovk Der Hagopian, had arrived in Watertown and his first question was: 'Have you seen Manoug?' Later, he spoke of their first meeting in America with emotion and switched to Armenian: 'He was astonished by me, I was astonished by him. He stared at me, I stared at him. Still, it was a childish meeting.' The feeling between them was unchanged. Yenovk had gone to art school in Tiflis and wanted to carry on studying, so Gorky recommended his own school.[12]

Gorky found a job for Yenovk at his old workplace, the Hood Rubber Company. He told him to take his oil paints and easel, and leave them with the watchman. When Gorky arrived from New York, he went to Hood to leave a message, then chalked a trail of arrows down Arlington street, every fifty or a hundred feet. After work, Yenovk followed them across Coolidge Cemetery until he found Gorky painting in the park. This children's game

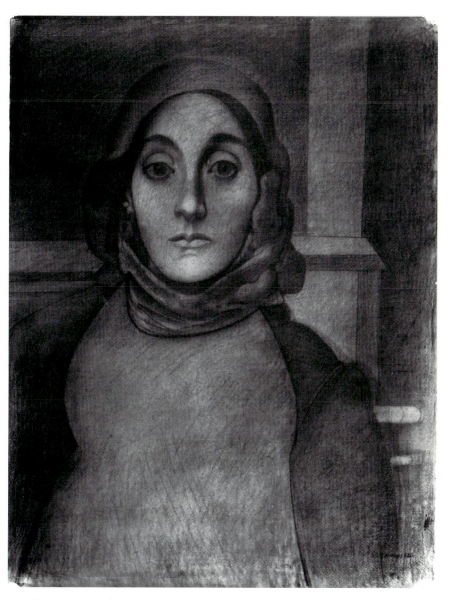

1. *The Artist's Mother*, 1938.
Charcoal, COURTESY OF THE ART INSTITUTE OF CHICAGO.

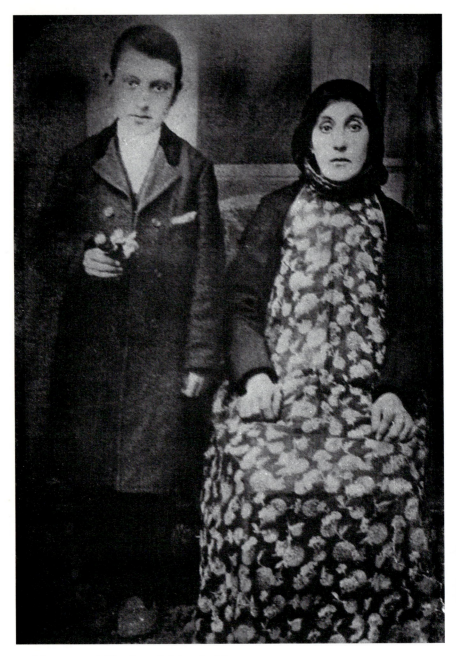

2. Manoug and Shushan Adoian in Van, 1910.

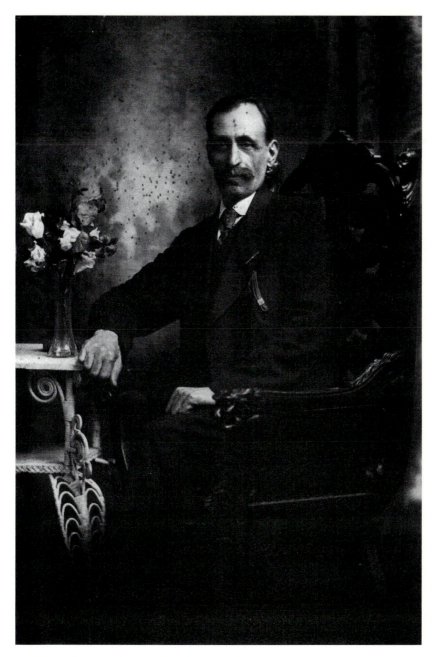

3. Setrag Adoian, the artist's father, Providence, 1910.

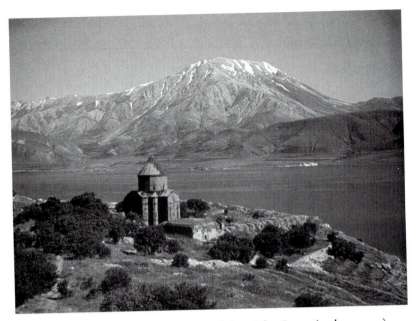

4. Island of Aghtamar and Church of the Holy Cross (10th century).
PHOTO: PATRICK DONABEDIAN.

5. Fortress of Van from Tabriz Gate, 1923.

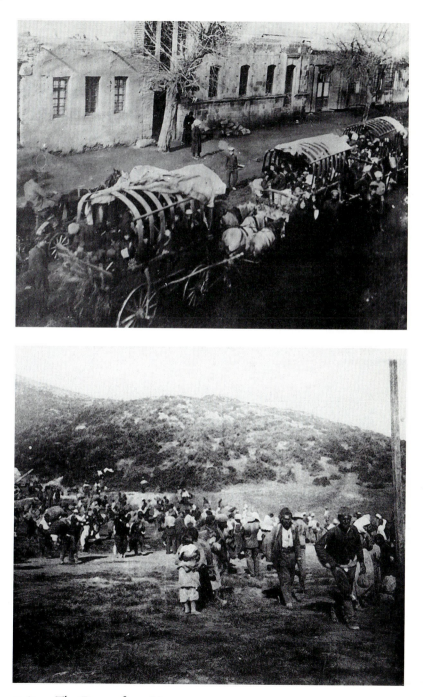

6 & 7. The Retreat from Van, summer 1915.
NUBARIAN LIBRARY, AGBU.

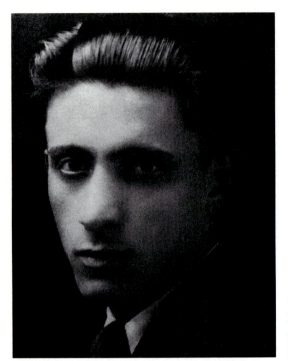

8. Gorky at the Majestic Theater in Boston, Massachusetts, 1924.

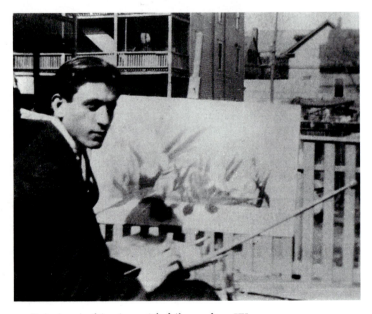

9. Painting in his sister Akabi's garden, Watertown, Massachusetts, 1924/5.

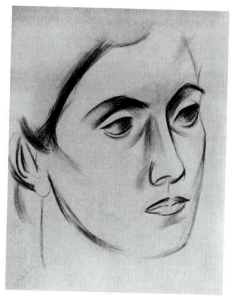

10. Portrait of Vartoosh,
pencil on paper.
Diocese of the Armenian
Church of America.

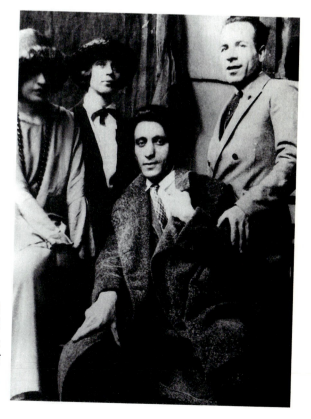

11. (*Left to right*)
Miss Lysles, Ethel
Cooke, Gorky and Felix
Chookjian, School of
Fine Art and Design,
Boston, 1925.

12. Three Forms related to Nighttime, Enigma, and Nostalgia, after 1929.
Pen and India ink. COURTESY OF THE ART INSTITUTE OF CHICAGO.

13. Letter from
Gorky to his sister,
Vartoosh, 1937.

was typical of Gorky and Yenovk, who continued to behave like boys in Khorkom. Once, Gorky set up his easel on a busy intersection by Stuart Street, on the corner of Spring and Arsenal streets.

'Manoug! Are you crazy? There are so many people here.'

Yenovk hid himself in the high grass. Cars rolled past and slowed down, people stared. Finally a police car stopped.

'Hey, where you come from?'

Gorky carried on painting. 'I come from heaven! Where do you think I came from? I'm a man like you.'

'Don't get too wise, I'll take you in!'

'Oh, come on, let's go.' Gorky tucked his picture under his arm and marched off. The police car coasted along beside them.

'May I see your picture?'

Gorky pushed it up to the window.

'Young man, I'm not that ignorant! You have to give me some distance. Looks beautiful. But why don't you go to the golf course on Belmont side? It's a wonderful place.'

'Sergeant, I am from Watertown too. I worked in Hood Rubber. I know golf course, I know every angle in this Watertown. I want to study an interesting spot. Is there any crime in that?'

'No. There's no crime. But when you stop the traffic, accidents might happen.'

Gorky's nerve appalled Yenovk. Their friendship was a riddle to him:

> Until today I think about this. That boy was so strong and I was so weak. If he hadn't loved me, he wouldn't have singled me out like that. We were like kids. Sometimes he would say, 'Prepare a canvas of this size or that size and I'll paint next time I come.'

Often Gorky brought canvas boards, painted on them, and left three or four for Yenovk, who said, 'I still have the paintbox he gave me.' When Yenovk asked Gorky for help, he would reply, 'No. I won't correct them. I prefer to do this subject on another canvas.'

Yenovk was a less adventurous spirit. When Gorky once criticised a painting, he hid it away. Months later Gorky asked how it was progressing, hunted it out, studied it, 'This is beautiful!'

'Manoug, a few months ago you said it's not good, no more than an Oriental khali design. Now you're admiring. What are you doing to me?'

'Don't mind me. Don't ever take any criticism from anybody, and if you take criticism, put your painting away. Don't let them see it.'

※

Gorky still visited his friends and teachers at the New School of Design in Boston. Miss Cooke said, 'He was back in Boston in 1924. He painted a portrait of me which has disappeared. I have a picture of the four of us. He was painting me on the Sunday that photo was taken.'[13]

The only person seated, Gorky dominates the centre of a group of four. Although it is taken indoors, he sports a thick Burberry tweed coat, unbuttoned to show off a suit and patterned tie. He swaggers with left hand in lapel, legs spread wide. His hair is long, his strong chin is clean-shaven. He exudes authority.

Two ladies flank him. Miss Lysles, in a long gown and heavy string of beads, has pulled a fur-edged *cloche* hat down over her forehead, accentuating sultry eyes and a heart-shaped chin. She was an art model Gorky would certainly have painted. A portrait acquired in 1927–29, by Mrs Bijur, oddly called *Portrait of Mogouch*, is very like Miss Lysles, with pointed nose, slender face and dark eyes.[14] The clear-eyed Miss Cooke, with a sharp dark suit and a boyish black bow at her collar, has a black straw brim down to her eyebrows over a pert face. On the wall behind them a swathe of rough sacking is ready for sketching. Another Armenian student, Felix Chookjian, puffs out his chest, one hand resting on Gorky's left arm. Gorky has arrived. He is on equal footing with Miss Cooke now, as a teacher in the associate school in New York.

Gorky was preoccupied with his painting throughout the summer. Merlin Carlock, who hired models for the Grand Central School, befriended Gorky in the spring of 1925. Gorky gave him a painting, *Beach Scene*, at their last meeting.[15] The work was definitely not recently painted; Carlock thought it had perhaps been done on the French Riviera!

Gorky's *Beach Scene* has a striking similarity in subject and composition to *Oyster Gatherers of Cancale*, 1878, by Sargent. Three tall figures occupy the foreground, with two smaller ones behind; Sargent's two figures are also offset by a trio. The sketchy style and bold brushwork of Gorky's early painting *Park Street Church* is evident. Sargent's beach is triangulated and

divides off the water shining on the sand; similarly, a few diagonals on Gorky's sandy beach break up the bottom of the canvas in an uninterrupted surface of sand. His picture is subdivided; figures planted in the centre of the picture occupy a third while the waves begin two-thirds from the base. *The Oyster Gatherers* hung in the Boston Museum: Gorky must have been struck by its 'translucent glow – a quietly dazzling evocation of North Atlantic light . . . a high-speed performance, parts of it executed wet on wet.'[16] Gorky's painting also foretells his later mastery of light and transparency in the use of paint.

By the time Gorky enrolled at the Grand Central School of Art, which was located in the attics of the Grand Central Station building, he had elaborated his curriculum vitae with brio. The Rhode Island School of Design was mentioned, although his friend Reznikoff denied that Gorky had attended it. Gorky went on to chalk up studies in Paris at the Académie Julien under Albert Paul Laurens. He was not challenged.

At the school he made a Greek friend, Stergis M. Stergis. That autumn, they visited the Daniel Gallery for a show of the Blue Four: Lyonel Feininger, Paul Klee, Vasily Kandinsky and Alexei von Jawlensky.

We used to study together at the Grand Central Art School under Nikolai Fechin, a great Russian painter, day and night, through the years 1925 to 1928. Gorky thought Fechin was one of the greatest painters. He had wonderful technique. I have a portrait here [by Gorky]. You'd think it was painted by Fechin.[17]

Fechin also painted in bold blocks of colour, unmixed at the edge, stubbed onto the canvas with vigour. He taught Gorky a rugged approach to portraiture. Gorky attempted, like Sargent, to paint portraits of well-heeled ladies but he had no entry into high society for commissions. He needed work to support himself and to afford a studio. Miss Cooke said:

The Ferragil Gallery was on 57th Street then. A man named Purdy got Gorky to do portraits of these society dames. He did a few of them. I think they offered $1,500 a portrait. It was quite a price. I'm not sure that price is right. Seems like an awful lot. I saw quite a few of them.

But after a time Gorky complained, 'They aren't pretty, Miss Cooke, and I

can't make them pretty and they all fall in love with me.' She later remarked, 'I can hear him say that as plain as anything'.[18]

None of these society portraits appears to have survived, although Stergis gave a lively account of one vernissage:

Knoedler Galleries, I think it was, commissioned him to paint five portraits of different women, The cheapest one, I think, was $1,500 or $2,000 to $3,000. At the time they gave him a very nice studio. He painted one of the women. The most beautiful portrait! She had a black velvet dress with green sash thrown over, from one shoulder down. Very beautiful!

At the unveiling, they had a lot of family friends. The husband remarked to Gorky, taking him aside, 'Would you mind to tone down the lips?'

He had a beautiful bright spot on the lips. Gorky threw up his hands. He start swearing in Russian. He pulled the canvas down. And of course, the result? They had advanced a thousand dollars, which he had spent for canvases and so on. He was eating for a change. That money was gone. He never got the balance of it. He had no place to go. I said, 'Arshile come to my place, until you find another place.'

He moved in with me. He only finished one painting, and that was the unhappy ending of it. He didn't do the rest. The gallery didn't want nothing to do with him.

Other painters were aghast at his stubbornness. Haroutune Hazarian, a collector, introduced an artist who had known Gorky's family in Van and was intrigued by finding an Armenian modernist. Panos Terlemezian later founded the Yerevan Art College, now named after him. It was a meeting of two future Armenian masters of diametrically opposed styles. Gorky showed them his paintings. The visitors were startled by a dramatic portrait of a lady slashed with a knife. Gorky pointed to it.

'Look. I was going to get a thousand dollars for this painting. She like it; I don't like it! So, I'm gonna destroy it!'

'Terlemezian was surprised,' Hazarian recalled. 'He knew Gorky needed the money but he was a man of character, of good taste. So he destroyed it.'[19]

Although he obsessively reworked canvases and kept some over a period of many years, as works in progress, Gorky rarely signed a work. But once he had signed, the painting was finished. He never doubted his judgement on execution and completion.

Gorky's experience of portraiture was even more extensive than has been

supposed. Stergis, who was ignored by biographers, shared his home with Gorky and later pleaded for a truer portrait of his friend.

Books I read on him were real artificial. Not the real Gorky. Gorky was such a character. I really want to see something right on him. I knew Gorky better than anyone. He ate with me and slept with me and lived with me for one year and a half. We had piles of paintings. A few days we went down and burned a lot of them in the incinerator because we got tired of all those canvases. Mine I didn't care about, but probably, we burned a fortune in Gorky's – his early paintings.

15

Grand Central School
1926–27

'Fetish of Antique Stifles Art Here, Says Gorky Kin', ran the headline of
an article in the *New York Evening Post* on 15 September 1926. Gorky's
appointment as instructor in the life class at the Grand Central School of
Art was reported, thanks to his claim: 'The election of Mr Gorky to the art
school gives New York ... a member of one of Russia's greatest artist
families, for he is a cousin of the famous writer, Maxim Gorky. But Arshele
Gorky's heart and soul are still his own.' The reporter was also impressed by
the school on the seventh floor of the Grand Central Station building,
which could be reached by taking an elevator at Platform 29. Then he went
to Gorky's studio on West 50th Street, where he saw propped up against the
walls many 'quiet' still lifes, landscapes and portraits of persons not 'well-
known'. During their interview, Gorky declared, 'Cézanne is the greatest
artist that has lived.' He denounced provincialism in American art, arguing
knowledgeably:

> Your Twachtman painted a waterfall in any country, as Whistler's mother
> was anyone's mother. He caught the universal idea of art. Art is always
> universal. Art is not in New York; art is in you. Atmosphere is not
> something New York has, it is also in you.

John Twachtman (1853–1902), a landscape artist imbued with the spirit of
Japanese art and Buddhist philosophy, blurred his forms, recalling Claude
Monet, in poetic waterfalls and wintry landscapes. Gorky's choices were
prophetic; almost twenty years later, Gorky would paint three canvases

named *Waterfall*, in more abstract style, and complete several pictures of his mother.

The article confirmed to Gorky that he was right to suppress his real identity. He achieved public recognition because of his assumed persona, playing it to the hilt. Even his loose, long coat, imitating Maxim Gorky, was a perfect cover-up and swung dramatically with his long strides. Gorky's provocative interview in the *New York Evening Post* echoed Maxim Gorky's sharply critical articles on life in America on his visit of 1904. His use of the term 'fetish' probably revealed his readings of Freud.

By assuming a famous pedigree, Gorky also aligned himself with the Russian Revolution, Modernism and Europe. He naively believed that this was his passport to America's social and material opportunities, as well as self-realisation. But he condemned the American indifference to 'great modern art': 'Too many artists paint portraits that are portraits of a New Yorker, but not of the human being.' Then he shot out his manifesto:

But a real artist, of course, cares not what he sells any more than where he is. If a painting of mine suits me, it is right. If it does not please me, I care not if all the great masters should approve it or the dealers buy it. They would be wrong. How could there be anything fine in my painting unless I put it there and see it?

Perhaps it read as a young man's idealism, but it was a creed by which he lived all his life.

Gorky became a minor celebrity, and his reputation quickly attracted students. According to one, Arthur Revington, his teaching was not typical of the school.

I took his class which was unusual because Grand Central was rather an academic place and so students immediately divided into two camps: for Gorky and against Gorky. He was a very exciting teacher. You knew immediately that he was a good artist. No question about it. He's simply the best teacher because he made you answer his questions and you had to think about what he wanted to know. In that manner he introduced the whole world of art.

I had at that time never heard of Cézanne. When I went there in 1927, Gorky was already speaking about Cézanne, so we looked at the book by Meier-Graeffe, the German critic who wrote on Cézanne.[1]

Perhaps it was Fechin who provided the bridge with Cézanne. Although not a Post-Impressionist, Fechin could not have developed his chunky, open, rectangular brushwork without knowledge of Cézanne. Gorky inspired and shocked his students. Kenneth Hayes Miller, his opposite number at the Art Students' League, sent out his students to the streets and lowlife of New York for faithful realism. Gorky's own experience of poverty and degradation blocked them out as themes for painting. Art would be his way of transcribing human experience on to a universal and spiritual canvas. He also rejected the academic school of painting, while he admired the 'scientific' Precisionists, like Charles Demuth and Charles Sheeler, for technical virtuosity.

Gorky encouraged students to put passion into their work. He brought a Hungarian violinist into class to play for them. He sent them in odd directions to look at some particular aspect of a painter's work, to analyse and read about it. In class, he drew, painted, and taught by example. Shortly after joining his group, Nathaniel Bijur described how he completed *Tulips*, a still life, in just two hours, as a classroom demonstration. Bijur bought it from Gorky for $100 in 1926.[2]

On his occasional trips to Boston during the years 1924–27, Gorky met George Yphantis, a student. In the Boston Museum of Fine Arts, they had heated discussions and to prove a point, Gorky offered to paint a portrait in oils in a single sitting. The student recalled, 'We met on the next Saturday morning at the studio of the New England School of Design for this purpose. It had been agreed that I provide all the necessary materials and that the portrait remain in my property permanently.'[3] He became the owner of a wonderful portrait in the early style, with a breath of Fechin in its close-up immediacy and rectangles of unblended colour.

Gorky struggled with portraiture, landscape and still life in 1926. His students thought him overworked by the school, yet he toiled by himself. Reznikoff said, 'He worked like a madman. Always really worked hard. If he didn't have confidence, he wouldn't work so hard. It was crazy.'[4] From this period date several portraits and self-portraits.[5] He kept some pictures for longer than twenty years and continued to work on them roughly in the same style and spirit as he had begun, even though his current approach might be in stark contrast.

The Grand Central School of Art held exhibitions of students' and teachers' work, and though some of Gorky's paintings were lost, they were

documented in catalogue illustrations. One was of a female nude sculpture.[6]
A vital clue was given by Gorky's friend Stergis:

> I have a painting he did at the Metropolitan Museum of a Rodin statue, *The
> Poet and the Model*. The Rodin Gallery was right at the main entrance . . . He
> set up his easel, had to pick up his belongings and take them to the locker at
> four o'clock. Well, he forgot the time. The guards got annoyed. 'Either stop
> at the right time and pick up all those things or we won't let you in!'
>
> So, he goes and buys himself an alarm clock. He was quite a character.
> Tall, long hair. He used long brushes – one of those thirty-inch long brushes.
> He put paint on canvas and walked back again. People were attracted and
> stood around watching him instead of going to the gallery. There was quite a
> crowd over there, every day, when he was painting. Finally, at four o'clock
> the alarm clock would go off! And then, he'd take the stuff to store. That is
> the canvas I have over here.[7]

Gorky viewed the sculpture as a springboard, not as a subject for copy. He
held a brush a yard long by the tip, as calligraphers do, using the shoulder
rather than the wrist for fluid movement. In years to come the calligraphic
element in Gorky's work would became distinctive. He could see the whole
of his subject as well as all the canvas, including its edges, without having to
step back. Gorky constantly danced back and forth between his pictures. He
was fascinated by different tools and techniques of commercial sign-writers,
whose ability to draw a long straight line he envied and respected. A
scientist friend, Warren McCulloch, observed him:

> When he painted, he generally stood, and he painted well out in front of
> him, not close up to his face. He behaved like a man whose natural focal
> point was about two to three feet from his face, rather than up close.
> Anything up to thirty feet is pretty much in focus; you don't need to shift
> from that. Much inside two, three feet you get big shifts, and you lose scale
> very badly that way. He liked big canvases and he liked to get in as much as
> he could.[8]

His student Arthur Revington recalled paintings of subjects unusual for
Gorky:

> The very first painting I ever saw by Gorky could have been in the

Renaissance, a head framed by a door looking out over a landscape . . . Then there was one of a crucifixion. What became of those paintings? I don't know. I never saw them again and have never seen them in a show at the museums. But I never forgot them either.[9]

No such paintings survive. Only a reproduction in the Central School catalogue showed a Gorky on a religious theme: Christ in *Pietà*, on the Virgin's lap, flanked by two women, done in bold Cézanne idiom with highly defined planes and strong outlines is attributed to 1927–30.[10] Gorky had a strong interest in the early sixteenth-century painter Mathias Grunewald and the medieval wood sculptor Tilmann Riemenschneider. He owned reproductions and books on them and would return to the Crucifixion theme in very late abstract works. Revington remarked, 'In those days people thought of him as an accomplished draughtsman rather than a painter.'

Gorky did life-drawing, cast and portraiture in a series of family portraits, knowing that Cézanne had started his large cycle of family portraits early, often returning to the same sitters, his father, mother, sister and their servants. But Gorky's models were often displeased. Satenig's daughter Shushik sat. Vartoosh recalled the pink charcoal sketch. 'It was very beautiful. The neck was very long. I think that's why they didn't like it and somebody ruined it.'

Another model, Akabi's daughter Libby, was ambushed: 'One Sunday afternoon on Dexter Avenure in 1926, when I was eight, he said, "Go get your coat." I had a little red coat with a fur collar and a boyish bob.' Gorky prepared his easel and paints while his friends John Hussian and Yenovk chatted. Libby giggled whenever Yenovk pronounced his name, 'Gurky'. She fidgeted. 'Manoug, I'm getting awfully tired.' She never called him uncle. He finished in one sitting. His niece was disappointed. 'But he made my eyes brown!' she said seventy years later, her grey hair still in a boyish bob and her eyes a startling cornflower blue. She held up an oil painting of a little girl which had never been exhibited or photographed. 'No one knows about this,' she said. *The Portrait of Libby* might have been a companion piece to Gorky's *Self-Portrait at the Age of Nine*. The girl in a wooden chair wears a coral coat and a high squirrel collar. Her face is painted with broad brushmarks and warm colours edged in dark paint. Behind the chair is a framework, a dark oblong, part of a desk,

and to the right a coppery greenish vertical. He painted her blue eyes the colour of his father's. Perhaps Gorky felt that to introduce blue would have spoiled the colour harmony.

Gorky took photographs of the family, remarkable for their stark composition. The tiny black-and-white prints are fine portraits by a practised eye, using natural light in the yard. He posed them in a frontal arrangement, chair and sitter equidistant to the camera and background, offset by a mass of wall, like his painted portraits.

In Akabi's house, Gorky often mused over the photograph of himself and his mother, taken in Van, next to the one of his father in a carved chair. He loved looking at his mother, but the image of Setrag beside her upset him. He longed to paint his mother. One day he asked Akabi, 'Let me take this photograph, and I'll bring it back.'

'That's the only picture I have of Mother. I don't want to lose it,' Akabi replied.

Gorky insisted he'd return it. His experience in copying drawings and paintings in the museum had familiarised him with the process of transforming a finished image into another medium. Libby said, 'He brushed grandfather off and he painted the picture.'[11]

Gorky borrowed the photograph in 1926, the same year he spoke in the *Evening Post* of Whistler's *Mother*, a subject he had been pondering. He made drawings of the photograph in a variety of styles and techniques which catalogue his versatility as a draughtsman. This was the start of his lifelong quest to repossess his mother.

Unknown to his New York circle, Gorky was actively involved in Armenian life. In 1927, recognised as an artist and personality by the large Armenian community, Gorky was asked to address a gathering in Worcester, Massachusetts. He went with his sister Vartoosh and her husband Moorad to a fund-raising fair of the Harachtimagan. This was a thinly veiled communist organisation sending aid to Armenians under the Soviet regime. Vartoosh recalled his words of solidarity and sympathy, ending: 'The grief and suffering of the Armenian people has ploughed a furrow across their brow.' It was a figure of speech in Armenian, *jagadakir*, words written across the forehead meaning 'fate'. Survivors of the Armenian Genocide often talked about their *jagadakir*, giving a fatalistic twist to the

tragedies which had struck them. Gorky used it to articulate his favourite work metaphor of ploughing.

Although Gorky gave the impression of a confident New York artist, the terrors of his early experiences had not receded. For the rest of his life, he would oscillate between the twin poles of his personality. In November 1926, the Grand Central School of Art Quarterly published a poem.

Thirst

My soul listening to the death of
 the twilight
Kneeling on the far-away soil of
 suffering, my soul is drinking
 the wounds of twilight and of
 the ground and within, it feels
 the raining dawn of tears.
And all the stars of slaughtered
 lives, so like to eyes grown dim
 in the pools of my heart this
 evening are dying of despair
 and of waiting.
And the ghost of all the dead to-
 night will wait for the dawn
 with mine eyes and my soul,
 perhaps to satisfy their thirst
 for life, a drop of light will fall
 upon them from on high.[12]

Only those who knew his real origins could identify 'the far-away soil of my suffering' and 'all the stars of slaughtered lives' as the murdered Armenians of his homeland. He had a vocation as a painter, 'with my eyes and my soul', to paint his tribute to their memory so that 'a drop of light will fall upon them from on high'.

His success would draw the attention of the world to his nation's tragedy and help him to vindicate the dead. That drop of light never did fall, however, either for the nation or for himself. Every effort by Armenians to seek justice, to enlist representation from western governments, fell on deaf ears. The *Evening Post* interview was Gorky's conscious message; but the poem remained his subconscious one.

16

Papa Cézanne
1928

Gorky grew a shaggy moustache, beard and long hair in 1928, when other men shaved clean, wore the thinnest moustaches and pomaded their hair flat. He had grown to a full six foot four, with a broad frame. His dark colouring and coal-black eyes gave him the look of a smouldering hero of the silent movies. Proud of his physique, he invited men to punch his stomach when he was off his guard. It was hard as a board. 'He looked like Rasputin. A real Armenian! Robust and a man of principle,' said Hazarian.

'His sister Satenig quizzed him gently about his appearance. 'Gorky, why do you have a beard?'

'I want to paint myself as Christ, with long hair and a beard.'

She commented, 'I don't think he was religious. He just wanted to paint himself like that.'[1]

Whenever he sat on the porch to draw or walked out, the street kids followed. 'Hey! Here comes Jesus Christ!'

He told another friend who was horrified by his beard, 'I am painting myself, looking in a mirror. When I finish, it's going to be one of the best portraits in New York!'

In one striking self-portrait, from 1928, Gorky looks more like a French sailor with a beard and a green bateau shirt, a distant cousin of a Matisse self-portrait.

His friend Mischa Reznikoff recalled visiting the Metropolitan Museum with him:

Certainly he looked more like an artist than I did. At that time he was nuts about Rembrandt. Gorky comes forward and takes a look. Goes back to a little bench. He said, 'Forget the face. Just look at the background. Very loosely painted.'

At that time he was painting loose too. We're looking and there's a middle-aged woman staring. He had a beard. Big eyes. She says to him, 'Pardon me, but you look like our Lord, Jesus Christ!'

Gorky stood up. He was insulted!

'Madam. My name is Arshile Gorky! Mischa, come on to the El Greco Room!'[2]

Perhaps he wanted to look like his chosen master, Cézanne. Roger Fry's essay on Cézanne had been published in 1927 and Gorky's copy was one of his favourite books, judging from its well-thumbed appearance.[3] He considered it the most intelligent analysis of Cézanne's painting and referred to it often in teaching. Cézanne the visionary, explorer and inventor in art, a misunderstood loner, appealed to Gorky trying out different roles. He told an artist friend, Saul Schary:

In the old days you went into an artist's studio, and you worked under him. Inevitably you came out painting like him. Nowadays, you don't work in an artist's studio, but inevitably you do adopt a master of your own and you work as an apprentice to that man.

Saul Schary added:

Gorky told me that he was very slow. He didn't speak, he said, until he was seven. You always have to take what he told you with a grain of salt. He had a bit of the actor in him and if he could make a point by exaggerating, he would. By the same token in his art he developed slowly in each one of his periods, which is the way it should be.[4]

Cézanne had suddenly turned to a systematic study of the still life in a single year (1873). Gorky acquired the discipline too. In 1928, Gorky painted as many as forty still lives, as well as numerous portraits and landscapes. Much of this work was created while Gorky was sharing an apartment with his friend Stergis, but at the end of 1928 or in early 1929 Stergis prepared to leave New York and Gorky had to move.

He rented a loft in the Village, bought second-hand tables and easels. At the time he was interested in Degas, and he always carried books on Cézanne. He had bought a lot of vegetables and flowers and fruit and set up still lives around the studio. He had twenty or thirty settings over there, and a canvas in front of each one. He started painting kind of an assembly line. When I went to say goodbye to him, the fruit and vegetables had rotted, but he was still painting from one of them.[5]

Gorky collected only Cézannesque objects – green apples, pears, peaches, aubergines, a long loaf of bread with a bone-handled knife to stick in it, simple jars, bottles, plates, a skull, a ginger jar. He even found a small wooden table with overhanging top and small drawer just like the one that appears in several Cézanne still lives. He reconstituted the master's studio as though painting alongside him and tackling the same artistic problems. He studied Cézanne's method of setting up a still life; the cloth slightly draped upon the table, fruit arranged in contrasting tones, one against the other, making the complementaries vibrate, the greens against the reds, the yellows against the blues, tipping and turning, the fruits, using coins of one and two sous for the purpose. Gorky too arranged them with infinite care, as the artist Raphael Soyer observed:

> Washington Square studio . . . on a sloped table was arranged a still life, so beautiful, so artistically arranged . . . looked like a wonderful kind of painting . . . looked as if it was unnecessary to paint it. A musical instrument, a guitar, sheets of music – that was the time he painted still life – arrangement was so faultless I have a very distinct memory of the quality of that composition. It was a work of art in itself.[6]

Gorky never talked about money but his friend Will Barnett saw how poor he was when he visited Gorky in the studio: 'He had painted a still life with a piece of cheese which attracted mice or rats. One of them chewed off a piece of the cheese. He was furious! It was a still life with collage.'[7]

Gorky taught his students composition of spatial organisation and juxtaposition of volumes. He encouraged them to paint and to analyse the volumes in geometric terms, to grasp that for the creation of space, line and plane are fundamental. He drummed into them Cézanne's dictum that one must first of all study the cone, the cube, the cylinder, the sphere. Only after painting form and plane could real painting begin. His feeling for intrinsic

geometry stemmed from his childhood, when he had lived close to Armenian architecture of the finest period, based on the arrangement of the cube, circle, cylinder and cone and their sections according to the golden mean. The proportions and pure forms had educated his taste.

Gorky selected a spot in Central Park, with red rocks and pine trees, for his Cézannesque landscape. Placing himself at the pond opposite the Plaza Hotel, he stood in a flat cap and suit, feet comfortably wide apart, his whole body concentrated on the low easel, a large tree in the foreground. Oblivious to inquisitive strollers, he worked until dusk, then he returned home to compare his day's work with the reproduction he had memorised.[8]

His students had to observe. Arthur Revington remarked:

You had to give Gorky your attention. He cared nothing at all about what you were doing. The way you learned was to follow him around and learn from what he did. That is absolutely the best teaching in the world. The best of the best ... He made it difficult, very hard. As it should be with any artist, Gorky's own work was absolutely the first and most important thing. The students were very secondary. You just sweated it out.[9]

Gorky saw himself as an apprentice to a greater master. He became so immersed that he even introduced Cézanne's jokes in class, according to Revington:

Gorky had a certain humour. He got a big kick out of things Cézanne did in his paintings, like the donkey rearing up when coming across a party of all these ladies sitting in the woods. But Gorky wouldn't laugh. He had a very curious tooth-formation ... His teeth were spaced very far apart.

A circle of friends had grown up around Gorky, including some of his students. Rook McCulloch (the daughter of a student, Mrs Metzger) often invited Gorky to the country where she was building a house. Gorky tackled carpentry for the first time since Yerevan and amazed the McCullochs by his aptitude with new, complicated tools and his physical strength. They talked about art, and McCulloch said, 'He always insisted that the crucial thing was the draughtsmanship. The drawing had to be well executed. "Skatch after skatch." The hand had to do what the mind intended.'[10] And Rook McCulloch observed:

He used to see things that interested him by way of composition in the most unlikely objects around him. Things that were lying haphazardly on the table or parts of architectures. As he was walking along the street and he was struck by it, he would point it out. This was very noticeable in him that he could see a space and relationships without being particularly interested in what the objects themselves were.

In 1926 he had completed the painting *Antique Cast* with pale Venetian rose red, the body in cream with black accents. Gorky used a palette knife to smooth it and he would continue until it felt like a brush in parts. He often urged his students in the class, 'Bring that cast alive. Bring it alive.'[11] He would take a pencil and with a few lines correct the drawing. Cézanne had said:

Pure drawing is an abstraction. Line and modelling do not count; drawing and outline are not distinct, since everything in nature has colour . . . By the very fact of painting, one draws. The accuracy of tone gives simultaneously the light and shape of the object, and the more harmonious the colour, the more the drawing becomes precise.[12]

Modern American art opposed drawing against modelling, as though the two were diametrically contrary. Only by setting up a system of blocks of colour, or small colour planes from cool to dark, could the light on an object be revealed. Gorky understood that both line and plane were coexistent and each performed a function. Sometimes the line was not completed but interrupted, so that the neighbouring area of colour contiguous to it could be allowed to eat away at the shape or contour by a contrast in dark to light or warm to cool colour tones. McCulloch noticed, 'He painted the same thing in a dozen different kinds of colour to get the right ones to bring it out.' Interacting planes came into play, one pushing the other forward or back. At the end of his life Gorky succeeded in placing drawing and painting on a continuum until the distinction became artificial.

Gorky was a chameleon. He could work simultaneously on a portrait using the techniques of Fechin, a sculpture in Impressionist style, and a still life in the manner of Cézanne. He painted in the personality of different artists, just as he changed his physical disguises. He also found time for his first romance. The affair was known to Stergis.

Nancy was brunette, light brown hair. American girl. She was his sweetheart. They were very much in love. Her father was a retired captain on big liner. She lived on Staten Island but her father wouldn't let her see him. It was quite a pathetic thing! Gorky never used to want her to be alone. That was his first love. She used to come and visit him, meet him in New York. We used to take her back to Staten Island, leave her a few blocks away from her home . . . I have a portrait he didn't finish of her with a violin. The portrait I am looking at right now is of Nancy. If you didn't know that it was painted by Gorky you would think it was painted by Fechen.

Gorky became deeply involved with Nancy and wanted to marry her. But he did not have enough money to satisfy her father and was forced to stop seeing her.

Despite making great strides in his work in 1928, Gorky felt lonely, with both Nancy and Stergis gone from his life. He had been used to living with a friend, and disliked the empty studio, silent meals, solitary nights. The Village could be a bleak and callous place, at a time when Scott Fitzgerald wrote, 'All gods dead, all wars fought, all faiths in man shaken.' Gorky saw the bright young things recklessly living it up without a thought for the future. Flappers wore straight dresses, two strings of beads, and bangles on their wrists. Hems shot up from ankle to knee-high, flesh-coloured stockings were rolled below the knees and galoshes unbuckled. The girls pulled a tight-fitting felt hat over bobbed hair. Gorky disliked the painted faces with bright clown circles rouged on to cheeks, the 'kissproof' lipstick and long cigarette holder clenched between the teeth. Many women worked, drank in speakeasies, rejected old-fashioned models of behaviour. Freud was freely interpreted – the natural sexual urges had to be satisfied, or ignored at terrible cost. The only way was 'letting oneself be carried along by the mad hilarity and heartbreak of jazz, living only for the excitement of the evening'.[13] In the Village Gorky came across artists, writers, bohemians, who thronged amongst the local Italian, Irish and Jewish traders. The 'continuous present' was in and its high priestess Gertrude Stein pronounced: 'The future is not important any more.' Nothing mattered except having a good time, being amused or amusing. The journalist George John Nathan asserted in the influential magazine *American Mercury*:

If all the Armenians were to be killed tomorrow and if half of Russia were to starve to death the day after, it would not matter to me in the least. What

concerns me alone is myself, and the interests of a few close friends. For all I care, the rest of the world may go to hell at today's sunset.[14]

Gorky's studio had an entrance at 47A Sullivan Street and overlooked Washington Square. He saw speeches made, and great parades start, then swing down 5th Avenue. He often sat on a bench looking at the crowds. Coming from a slower pace of Armenian community life where people sat in parks playing chess and cards, reading newspapers, where poets recited and discussed politics, he felt isolated without people around. On Sundays he went to classical concerts at the Metropolitan Museum with his childhood friend Arshag, who recalled sitting in the park afterwards one autumn afternoon, when an old black lady passed, then stopped.

'Oh my, my, my, mister! You look like our Abe Lincoln!' She bent to kiss Gorky's hand.

'No, I'm not! He was the best man America ever had. I wish I was half as good.'[15]

Gorky knew his solitude was necessary and he stoically endured poverty. One day his sister turned up with her friend Shnorig Avedissian.[16] 'It was winter. He had a scarf tied around his neck. His place was cold. When he opened the door he was quite yellow. We took him by surprise. He got mad at her.'

'Why did you come all the way here in this cold?'

It was a beautiful room, but dilapidated and unheated. Vartoosh made him lie down on a couch which was falling apart, a slab of wood covered with cloth. She made his favourite soup, *tanabour*, barley and vegetables thickened with yoghurt. She rubbed his neck with liniment. The friend went walking around the shops to let him sleep and talk with his sister. The women slept on the floor. He was too ill to paint and had no oils. Shnorig observed, 'He was kind of a person, you couldn't fool around. Imagine when he was sick! Vartoosh was the only one who could go near him.'

As he began to recover, the colour came back to his face. Shnorig teased him, 'Gorky, did you put that up right? Is it upside down? What is it supposed to be?' He sometimes tacked Photostats of paintings or his own drawings upside down.

'*Toun inch kides?* What do you know? Keep quiet!'

'Gorky, this looks pretty good.'

'If you want that, I'll give it to you.'

'I don't want those crazy things. I wouldn't hang them in my bathroom!'

He replied, suddenly serious, 'My drawings will be valuable one day and you'll regret not taking it.'

Gorky often pressed his friends to take a work, even if they did not appreciate it, confident that it would be valuable in the future. He never cared about money for himself. He often said, 'I don't care what they think about me. I know what I am. They don't have to give me credit. That's nothing.'[17]

His private lessons were recalled by a student of 1928, Herluf Svennigen, who took three evening classes a week, including the Antique Model, paying $15 to $25 per month.[18] Every week Gorky chose the best painting. He praised powerful lines, not caring for a finished look. Once, he burst out, 'If you're going to stand around looking at that painting much longer, take a knife and slash it up!'

His student said, 'You'd think of him in the same class like Cézanne and the rest of them. He was bohemian. Jet-black long hair. He didn't care much for the average person. He was very clear. He loved Picasso.'

Gorky's acquaintance with Picasso's work was becoming noticeable. That year, 1928, Gorky went to see Miró at the Valentine Gallery, works by De Chirico, Stuart Davis, Kandinsky, Klee and Léger. No doubt the most exciting show for Gorky was the *Paul Cézanne Loan Exhibition of Paintings*. He spent hours looking at pictures, commenting to his students. He was outspoken, larger than life, and instantly attracted an audience.

A short young man with blue eyes and shabby clothes was trying to get acquainted. After a couple of rebuffs, he finally plucked up the courage in Union Square.

'Nice to see you again,' he said to Gorky, who replied in a friendly way. 'Some day, if you don't mind, I'd like to come to your studio.'

'Why don't you come right now?' Gorky suggested.

The stranger had a candid face and thick Dutch accent. He recalled:

So we went to his place. I was very taken with it. It had a marvellous atmosphere. It was immaculately clean. I was terribly impressed. All this work and strong paintings. Enormous amount of paints, brushes, all in order. An enormous number of postcards, of other paintings. He had ways of discovering details of paintings. He liked Léger, Mondrian, Ingres,

enormously. That's why he was such a remarkable man. I didn't know he was a painter. He was a great storyteller.[19]

If he did not know that Gorky was a painter, why did he ask to visit him? Gorky's neighbour in the 1930s, Balcomb Greene, commented, 'Because of his spectacular appearance, he easily became a celebrity. He was better known than his paintings were.'[20] This was the beginning of a long relationship which would have numerous ups and downs, but the young man determined to follow Gorky, certain that he had some knowledge to impart. 'I attached myself to him,' said Willem de Kooning, then an unknown commercial painter; 'he just knew it by nature'. De Kooning was born in Rotterdam in 1904, studied there, then stowed away to America in 1926. Despite his classical training, he felt Gorky had a superior instinctive knowledge. 'It isn't technique, it's like concept, getting the right ideas.' He became Gorky's shadow, accompanying him to galleries, helping him stretch canvases, even decorating his studio. 'He understood everything and had insight. He understood everything in nature, in painting; Chinese art, Japanese art, Greek, all art, he had a point of view about it. I don't know if it was always correct. He didn't look up the books. He didn't care. But I know he was very correct for me. He got the point.' De Kooning behaved like an apprentice to a master. He tried to see art through Gorky's eyes, to paint like him and learn not only his techniques but also his quirky aphorisms. He studied the same subject matter, drew from the same masters, attempted similar techniques of still life and portraiture. 'The line is beautiful, it's personal. Not necessarily a concept like the Cubists.' Later the misapprehension grew up that they shared a studio but they never lived or worked together. As Gorky discovered Uccello, Ingres, Cézanne, he explained to De Kooning what interested him; Matisse as well as Picasso. Musem director Diane Waldman wrote, 'De Kooning interpreted Ingres' vision through Gorky's eyes in portraits of the late 1930s and 1940s.'[21] Sometimes Gorky grew weary of being imitated but nothing seemed to humiliate or discourage De Kooning.

Although art historians have attempted to date Gorky's work in chronological sequence according to style, first Cézanne, then Picasso and so forth, the memories of his friends and relatives raise doubts about a linear progression. Gorky's still lives show a variety of styles from Cézanne to Braque and the Cubists and certainly at least one painting, *Still Life with*

Guitar, dated by Gorky 1927, suggests that he may have looked at Cézanne because of Picasso's interest in him.[22] His student Arthur Revington noticed the shift to Picasso:

> Cubism had just begun to make an appearance and Gorky was well aware of it. He possessed an immediate instinct. We all started to do these many different kinds of work, all rather unusual for the period. We had hardly known about Cézanne. The same is true for Matisse also, but he never seemed to like Matisse much.

Gorky often went to Staten Island to teach landscape painting. He took a class of young women to paint there and a set of photographs show Gorky, a wild look in his eye, in double-breasted suit and long hair, clowning like a Marx brother. He leapfrogged with gangly legs, wore his jacket back to front and struck silly silent-movie poses.[23]

His own paintings of Staten Island bear the hallmarks of euphoria, perhaps because it was the home of his sweetheart Nancy. One such landscape shows a solitary tree at the curve of a road between some boulders and a cluster of trees sweeping to the right with flame-leaves and branches. The pine soars into the sky, creating a rainbow of colour around it. The trunk rises in a strong vertical, branches span the surface horizontally. Parallel brushmarks of thinned paint barely cover the canvas with a feathery texture in warm terracotta, dark cypress greens and soft reds and ochres. Top and bottom are cropped. The title, *Landscape in the Manner of Cézanne*, is not Gorky's but posthumous. The work has been identified as one segment of the landscape *Rocks in the Forest*.[24] His disposition of planes and bluntness of brush marks went beyond Cézanne, as though he had seen the early Mondrian painting *Flowering Tree*, 1912, a natural grid. By now, he had discovered Cubism and was extracting its structural elements.

On the day Manoug was born, his father had planted a poplar sapling. As he grew up, the little boy lovingly tended it.[25] As though reminded of the tall trees he had climbed, he now painted it high up, eye-level with the nests. He borrowed from Cézanne in order to extend his scope. Gorky's current raid was upon the masters of modern art.

17

Beautiful Sirun
1929

One evening, as he prepared to leave Grand Central School, Gorky glanced into the life class. A tall model was surrounded by students sketching at their easels. Gorky stopped wiping his hands and stared. The girl was slender; her fine features were chiselled in clean lines. She had large eyes and a high forehead framed by golden brown hair rippling down her shoulders. He sauntered over to a student and studied his sketch, then said in a loud voice, 'Here you have a beautiful white Arabian horse! And you make a mess of dirty socks.'

He hovered while she collected her things. His friend from Providence, Mischa Reznikoff, waiting in the hall to go out with Gorky heard her say, 'Thank you for calling me a beautiful Arabian horse.'

'Oh, that's nothing.'

She mystified Gorky. He sensed something familiar about her. 'Are you Armenian?' he blurted out.

To his amazement she replied, 'Yes.'

'Where were you born?'

'Van!'

'It was like the sun had risen after a million years,' she said years later.[1] Even the girl's name fitted into Gorky's dream – Sirun Mussikian. *Sirun*; 'beautiful' in Armenian. She had fair skin and slanting light brown eyes. The fine bone structure of her face was an invitation to an artist. She had been born in Van in 1910, the year he had gone to live there, and he felt she had been created for him. He couldn't get over the coincidence.

She agreed to join him for a coffee. Sirun was modelling, but she had plans to study, and like Gorky she had an assumed name, Ruth French.

The next evening, he waited after class to take her to dinner with Mischa and his girlfriend. After the meal, Gorky offered to walk her home.

When Sirun invited herself to his studio, Gorky was startled. Sirun was bright and independent. That night, she said, 'It's too late to go home.'

'Why don't you just stay over here? You sleep on the bed and I'll stay on the rocking chair.'

The next evening, she returned. Again, he offered her his bed.

'Why would I go to a man's studio if I was not going to spend the night with him?'

In the early hours of the morning, Mischa, who lived by Central Park uptown, heard banging at his door. He looked at his watch: 3 a.m. Dressed in pyjamas, he opened the door to find 'Gorky standing outside looking like Jesus Christ. He was extremely upset.'

'Mischa, I'm in love with this girl, Ruth. She asked me to come to bed with her.' Mischa waited, 'I bit her!' Gorky blurted out.

They sat down to talk man to man.

'Look here, Gorky, some girls like to be treated rough and some like to be treated very gently, delicate-like.'

Gorky looked perplexed and miserable, then his eyes lit on the drawing pad on the table. 'Well, draw me some positions.'

Mischa complied. Warming to his theme, he sketched naked bodies in different positions and explained them. Gorky sat unusually silent, completely absorbed. Suddenly he interrupted, 'Pardon me, Mischa!' Mischa was in full flow. Gorky placed his long index finger on two entangled bodies. He pointed to a thigh. 'Pardon me, Mischa, but that line is not very well constructed!'

Mischa threw him out.[2]

Sirun stayed. Gorky was the star of Grand Central School, a well-known figure in the Village, striding in a black coat buttoned up to his chin and wearing a huge hat. She called him 'a Beverly Hills Rasputin'. Many girls at the school were infatuated by him; others were terrified. He had at last found someone of his own kind and could not bear to be away from her. With her Gorky no longer had to pretend to be someone he was not.

After receiving a windfall of $200 insurance payout from Vartoosh, Gorky took the vast studio in Union Square. He was a little further uptown

and once more overlooking a large public square where political events occurred. Balcombe Greene, who lived nearby, saw the move:

His moving was symbolic. The previous painter to occupy this immense studio facing on 16th Street was an academic craftsman who had pulled his battered belongings into a hall room, letting this gigantic Modern sweep into his quarters. Gorky swept in with his bolts of canvas, his mountain for an easel, his many packages of brushes, his cases of pigments, his stentorian commands to the movers, his indifference to me crowding past in the hallway. I could not yet know him.[3]

Gorky immediately transformed the vast studio for work, cleaned and bleached the floor. He set up his paintings on racks and positioned his large easel. He had inherited the Vanetzi cleaning obsession from Shushan.

He was scrupulously clean. He had this enormous studio and it had an oak floor. He used to scrub that goddamn floor every week until it actually looked like the deck of a ship. There wasn't a drop of varnish around. The boards were white and clean.[4]

Then he persuaded Sirun to move into his studio. She brought few possessions. Later she remembered it vividly.

You went up these stairs and turned right in the door and on the second floor was the enormous studio, you turned right up a couple of stairs to the bedroom. It was big enough for a double bed and that was all. Down here was another door at the other end of the studio was a tiny closet-like kitchen.

His furniture was second-hand: a couch for models, a couple of easels, a table for paints and brushes, a dresser pushed against the wall. No telephone or radio. His only passion besides his paints and brushes was his clothes. He had wonderful taste and told her that he loved brown, 'a very sophisticated colour'.

They were extremely poor but so were most of their friends. She recalled:

It was cold. I don't remember any kind of heat. That bedroom was miserable. Everything was miserable. He didn't even see it, didn't even feel it. Nothing affected him. I don't think he even knew what he ate. Perhaps if he

was eating Armenian food he'd know if it was good. But otherwise, he didn't know if something was crappy or not.

Many artists lived in cold-water flats without heating in a bohemian part of town. Gorky paid the $75 rent, Sirun bought food. They cooked on a tiny stove in the dark cubicle where the main activity was the fastidious washing of Gorky's hundreds of brushes, first rinsed in turpentine, then washed with soap and water. Sirun continued to pose at the school for $1 an hour or $75 a month although he did not approve. Gorky was making $200 a month with his teaching job and private students and it gave him a security that other painters did not have. Every month he bought over $100 worth of paint and brushes; after the rent, he was left with $25 for everything else. Sirun said:

> He never asked the price of paint or brushes. Windsor & Newton, the most expensive beautiful sable brushes. He squandered his money on paint. He squeezed that stuff out of the tube by the mile! Nothing was going to make him stop. Nothing! He bought all colours. He talked a lot about ochre, yellow ochre was a favourite. He used them all. Sometimes straight and put them on just with a palette knife as thick as can be, and other times, he was very delicate.
>
> He could have no more not painted, than he could have stopped breathing!

When he wasn't painting, he drew endlessly. He had rolls of canvas, stacks of paper from the best to the poorest, like newspaper. He was capable of making a hundred drawings in a night.

Gorky's ability to support himself was no mean achievement. Very few dared call themselves artists; they taught, drew commercially, designed and did odd jobs. They only took off the summer months to paint, in cheap temporary accommodation, while their wives supported them. Gorky had set himself up as an artist in a professional studio. Vartoosh continued to help. Despite being married and having expenses, she admired his courage, and had an unshakeable vision of his success.

He enjoyed Sirun's companionship. The cold space lit up with her presence. He sketched and painted her endlessly. Gorky was teaching Nathaniel Bijur, who came faithfully to the studio every Saturday. Sirun said, 'He was painting my whole body. It was beautiful, too. I posed for

both of them, and Gorky was painting a huge nude. He also did a beautiful head of me.'

Gorky teased her during the modelling sessions, quoting Cézanne: 'Women should be like cabbages. When they sit still they should not move.'

Sirun laughed. 'He was kidding of course. I was sat for twenty-five minutes, then rested for five. There was nothing sadistic in modelling for him.'

One of Gorky's largest paintings from 1929 is *Reclining Nude*. The woman lies on a makeshift couch or roll-up bed, resting her arms behind her head on two pillows, with the gesture of Ingres's *Les Baigneuses* and Manet's *Olympia*, but in Gorky's pose the knees are bent, covering the pubic area, right ankle tucked under the left. The model, previously unidentified, has a shapely slim body and long legs, an oval face and long hair.[5]

Sirun's report that Gorky painted 'an enormous nude' is the vital clue here, because he generally used relatively small canvases at the time. The era of enormous canvases was yet to come and, despite his extravagance in materials, he was limited by his income. As if in celebration of his love, he painted an unusually large canvas, measuring $34\frac{1}{2}$ by 44 inches, well over one square metre.

Sirun's description of the roll-up bed where she posed on a couple of pillows also matches the painting. He captured her rangy looks, even though the face is not painted in detail. Like Picasso, who refused to part with certain canvases, Gorky kept this painting for himself. He did not show it or offer it to buyers. The companion piece, *Seated Woman with Vase*, also resembles Sirun, with an open face, strong jaw line and noble contour from eyebrow to nose, and full sensuous lips. Two further portraits – *Portrait of a Girl*,[6] dated around 1929, and, particularly, *Portrait of a Woman* – are probably of her too. They also remained in his private collection. The former is compared with Matisse's *Jeune Femme*, 1918, with 'blank almond eyes', illustrated in the *Cahiers d'Art*, volume 2, 1927, which Gorky undoubtedly saw. The sitter is most likely to have been Sirun, for her long involvement with Gorky was kept a secret, except from close friends and family, and subsequently it has not been taken into account. Both portraits share the same reflective pose, a woman with her right hand cupping her cheek. Just as Gorky was noted for drawing the same still life in different styles, he painted the same pose in different styles too. The arch of her eyebrows and slightly off-centre parting match a photograph of Sirun. He

would later paint his second wife in a progression of styles. But he did not identify Sirun, for reasons which will soon become clear.

Gorky was deeply involved with the Armenian girl, confiding in his friend Yenovk that she was the only woman, after his mother, who came close to his ideal. However, Roselle Davis, Mischa's girlfriend, detected a strain in the relationship:

> She was tall and had a look that he regarded highly. He kept describing her as 'the wild horse'. He put her on a pedestal and she didn't care very much for that. She wanted to be treated as a woman. His love for this girl was not so much of her as a human being, as his love of his image of her. So there were conflicts between them constantly. She had beautiful features, dark hair, wonderful pigment. He never gave the impression of being a Don Juan. Never out to impress women on that count, because he was so serious in his own interests. Women had a great regard for his intellect.[7]

Gorky had achieved an artist's dream; he was in love with his model and living with her. He scrutinised her every feature and felt elated by the act of painting her. She made herself totally available to him, and he possessed her in the act of painting more completely than at any other time.

He stopped only to teach. He went to bed late, and got up early to paint. He painted at night while she was asleep. He sensed her indecision about what to study and tried to interest her in art. She confessed to being ignorant, but she was young and in love, and she listened: 'He explained everything to me about his work. He talked a lot about cubes and cones and cylinders but I can't remember beyond abstract things. He really did want to share.'

Gorky felt there was something predestined about their love. She straddled both his worlds, she sounded American and held her own with his New York friends, yet she was Armenian. Together, they could build up a relationship based on their roots:

> He really was living in Armenia in Greenwich Village. That was his fascination with me. It certainly wasn't my intellect. I mean why would a man as accomplished as he fall in love with this little nobody? Except that I was very good looking. Really, it was an absolute mad passion with him and the only reason? I was Armenian.

For the first time he took a girlfriend to meet his sisters and family. 'One of

the biggest things in his life was that whole family up in Boston, especially Vartoosh. He took me up there right away.' He also took her to the farm on Norwood, Rhode Island, where his half-brother, Hagop, lived, but did not tell her he had a father. His niece Lucille remembered the visit of 'the girlfriend he brought in 1929. The preacher's daughter. She was beautiful, very fair, reddish brown hair. They slept in our room. He took her everywhere, gallivanting, during the day and stayed almost a week.'[8] Gorky wanted her to feel a part of the family. But she held something back from him, telling him with reluctance that her father had been a minister in Van and her mother, also Armenian, had separated from him. She perceived him differently from others: 'I had never known anybody more Armenian than Gorky. He loved it, was proud of it. He felt that they had more soul. They were superior. The look of the people which he loved as a painter. The eyes. There's real soul there.' He took her to Armenian restaurants on Lexington and 28th Street, to Armenian movies. 'He made great efforts to see these and was very, very moved by them.' Gorky could not understand her apparent indifference to films of the Armenian Genocide. She wanted to be American, to integrate and forget about her past. He struggled to break down her barriers. But with his other friends, he was no longer Armenian.

> He was ambitious and an opportunist, he felt that the Armenians were very persecuted like the Jews, he felt he could get where he wanted much faster being a Russian since Russian was very fashionable then.

With Sirun he dropped all his defences.

> He talked of the wonderful mother. Real gentleness. I don't know whether he imagined it or not. He told me about her death. He really loved her, very, very much. When he talked about her it was magnificent! This Armenian thing was always with him. Probably every woman he painted looked like his mother.

As Raphael, Botticelli and Ingres had sought out and created their own type of woman, Gorky was in the process of creating one. Sirun was the incarnation of the perfect Gorky woman.

On 24 October 1929 Wall Street crashed, sending shock waves throughout

America and the rest of the world. It struck Gorky on an upward swing. He was involved in a passionate love affair; he held a secure teaching job; he was the centre of a group of artists who were beginning to think of him as a leader.

Only a few days later, on 9 November, the Museum of Modern Art was inaugurated on the twelfth floor of 730, 5th Avenue. Three wealthy women collectors, Miss Lillie P. Bliss, Mrs Cornelius J. Sullivan and Mrs John D. Rockefeller, had created it to exhibit modern art in New York and preserve modern American works. Their curator, Alfred Barr, was only twenty-seven. Artists rushed to *The First Loan Exhibition: Cézanne, Gauguin, Seurat and Van Gogh*. Some 50,000 visitors flocked to the museum within the first five weeks. The permanent collection included Edward Hopper, *House by the Railroad*; a bronze by Aristide Maillol, *Ile de France*; one Picasso, and a few works by Charles Burchfield and Kenneth Miller. Gorky and his friends hoped to show there in the future.

Earlier that year Charles Demuth had exhibited his Precisionist machine-era paintings in New York, and Georgia O'Keeffe had shown views of New York from her Lexington Avenue flat on the thirtieth floor. Rothko and Kline were painting in a more traditional vein.

At this period Gorky was painting under the influence of Matisse and had left Cézanne behind, at least in portraiture. His still lives were showing a strong allegiance to Miró and Léger, painters Gorky was studying between 1929 to 1930. He was moving on from the realism of Cézanne to greater abstraction through Braque and Picasso. He even made his only exact copy of a Picasso still life, *Bottle, Playing Cards and Glas* (1914).

Gorky was frequently in the company of the artist John Graham, a White Russian who had changed his name from the Polish-sounding Dubrowsky. Graham was short and ramrod straight; a military man, spruced up in waistcoats and bow ties. He was bald, always wore a hat, and sported a long thin moustache, sharply trimmed over his lips, drooping over the corners of his mouth. Gorky had heard fantastic stories about his origins, that he had been in the tsarist army, either as a cavalry officer or a guard, had fled communism after breaking out of jail and ended up in Paris. This fascinated him when he discovered that Graham had adopted his new name to pass himself off as an American painter, and had become immersed in painting and studying Cubism.

He regaled Gorky with his meetings with Picasso, and the French

Surrealist poets André Breton and Paul Eluard. His home was a storehouse of primitive art of which he was a knowledgeable dealer. Unlike American artists, he stressed that primitive art came from civilisations as great as those that produced European art. Erudite and philosophical, he was a natural foil for Gorky, who was twenty years younger and more actively working through the problems of Modernism. The sculptor Chaim Gross had amassed a vast collection of African bronzes, masks and carvings with his help, and his wife said: 'John Graham? He was a very avant-garde man. He loved women. He loved wine. Graham never cared for money, only for art. After he died, the auction at Parke Bernett went on for five whole days.'

He introduced Gorky to many books, including the influential Henry Focillon's *Life Forms in Art*, from which he translated to Gorky. Focillon had argued that certain forms or types recurred through history and through different cultures. The broad perspective which embraced all cultures and periods, even primitive art, appealed to Gorky, who kept alive within him the art forms of Armenia and the Middle East. He studied ancient forms of art and traditional crafts, considering them just as vital for his artistic maturity as fine art. Graham drew with John Sloan at the Art Students League, while Gorky, in his twenties, was already an established and highly respected teacher. They visited the Folk Art Museum of Harvard, went to the Metropolitan for carvings from the South Pacific, Armenian carpets and Persian miniatures. Together they studied *Cahiers d'Art*, a French art review which, besides articles on the newest art, always introduced the styles of other cultures, even Armenian architecture and sculpture. They traced the influence of African and Pacific arts on the modern masters, especially Modigliani and Picasso. They were convinced that Cubism was the only way forward.

Gorky was paradoxical in his unhesitating impetus towards abstraction while he revered the history of art. He often quoted Raphael, 'In order to become a master one must swallow a master.' Intent on swallowing a master, he also had to swallow the master's antecedents.

In the early stages of their friendship, John Graham's encyclopaedic knowledge appealed to Gorky, who read a great deal and impressed everyone as being extremely educated, although he was mostly self taught. He pored over art books but also loved Dostoevsky and the Russian writers.

Graham appreciated Gorky's talent and intellectual stamina, later describing him as cursed by good taste. There would always be an element of competitiveness between them, when Gorky outstripped him as an artist. Graham was also a collector of gifted people and a discoverer of new talent. He introduced the sculptor David Smith and his friend Dorothy Dehner, then first-year students at the Art Students League, to Gorky.

Their favourite meeting place was Erhard Weyhe's bookstore. Almost every morning Gorky sat there in a special chair and insisted on seeing every new book. He read voraciously, unable to buy. The shop was haunted by artists: George Bellows, Rockwell Kent, Max Weber. Once Gorky became so desperate for an expensive art book that he brought two still lives to Weyhe.

'Can't you sell these paintings?'

Weyhe took them and collared a rich collector. 'You better buy that painting,' he said, and showing the second painting, added, 'I've bought one too.'

Proudly he telephoned Gorky. 'I just sold your painting. Come get your cheque.'

'How dare you sell that painting!' Gorky yelled.

'Look here, the customer didn't buy the painting. I sold it to him! You know the difference? Naturally I can call it off!'

Gorky got his cheque, and made a gift to Weyhe of the second painting. Weyhe related that he sold the work for $750 or $800, which seems a high price for an unknown artist's work. This started him selling drawings and paintings in a small gallery above his shop. Julien Levy, later to play a crucial part in Gorky's life, worked there. Gorky gave Weyhe several drawings, and observed his ruse when selling it to a customer. 'But I gave him a $50 book for it. You can have it for $50.'

Most important at this juncture was Gorky's meeting with Stuart Davis, whom he considered the outstanding modern New York painter, with his bold Cubist style and American idiom. He had just returned from Paris in 1929, funded by Gertrude Vanderbilt Whitney. Gorky respected Davis for taking a stand against the Regionalist backlash. According to Sirun's recollection:

Davis and Gorky got on wonderfully. Gorky's respect for him was untouched. Nobody could have said anything against Stuart Davis! He was a great artist without any qualifications whatsoever! Stuart Davis impressed

me a great deal, even though he hardly talked. He really didn't! Most people were looking up to Gorky – even Davis felt that Gorky was a fine artist too. Everybody around Gorky knew he was the master.

Davis's father had been art editor of the Philadelphia Press, employer of many distinguished artists.[10] As young as nineteen, Davis had exhibited in the Armory Show, and seeing the other paintings there had radicalised his ideas on art.[11]

He was thirty-six, about ten years Gorky's senior. Short, stocky and jowly, perhaps he felt slightly overshadowed by the tall, handsome younger man, for Mischa Reznikoff commented: 'Next to Gorky, why, Davis looked like a plumber!' And he 'talked like a taxi driver'. Gorky learned to talk out of the corner of his mouth, too.

Stuart Davis said they met in 'a fairly decent artistic-type studio on the edge of the slums near Washington Square'. He was amazed at how well equipped it was:

Outside of an art store I had never seen anything like this collection of properties in one place before – nor since, for that matter. The question of how he acquired this truly impressive stockpile and kept it replenished was raised from time to time, but no really clear picture of the feat was ever arrived at.[12]

Gorky admired Davis for forging a clean visual world of his own in tune with modern American design, pushing the flatness of his clean-edged, geometric forms and interchanging planes, and creating puzzles as if to represent a third dimension.

Unlike many others, who could not see more to Gorky than the obvious influences of Léger or Picasso, Davis identified a keen mind wrestling with fundamental questions Here was a kindred spirit working with integrity. Davis had adapted Cubism to his own ends, to make it American. He hit upon the symbols and paraphernalia of American billboards: matchboxes, petrol pumps, sugar packages, nothing was too humble or ordinary. Their bright, often strident colours were effective in his flat and rhythmic compositions. He later wrote of Gorky:

During the period that I knew him, Gorky's work was strongly influenced by certain styles of Picasso. This was apparent to everybody, and there is a

tendency to criticise him as a naive imitator. I took a different view and defended his work at all times . . . It must be remembered that at that remote period the exponents of modern art were much less numerous than they are today, and they needed to maintain a solid front against the Squares of every ilk who were always out to subvert it . . . Under those conditions I would automatically have supported Gorky's work and kept questions of disagreement inside the family circle. But I had no equivocal opinions about it. I took it for what it was — the work of a talented artist in the process of development, and one who had the intelligence and energy to orient himself in the direction of the most dynamic ideas of the time.

In the evenings, Mischa Reznikoff and John Graham would join them, at Ticino's on Thompson Street. The group followed Gorky past the ground floor, where there was a pool table and sawdust on the floor, to the basement. Sirun recalled that it was very simple and clean. The tables were set with tablecloths and marvellous food. They always had the spinach soup. 'I don't remember us eating spaghetti or anything like that. He liked food but he didn't eat that much. We didn't drink.' When she was not present, according to Reznikoff, a different evening developed:

It was during Prohibition, so you had a line down the side, coffee cups with some kind of Prohibition drink in them. After a few bottles of Prohibition wine, Gorky would start singing his songs. 'Aaah, aah, aah!' Like these Armenian gypsy songs. He had a way of snapping his fingers onto his knuckles. Davis liked jazz. He would say to Gorky, 'Jazz it up a little, Gorky! Jazz it up a little!' Gorky could sing and snap his fingers and dance, he could do that in the middle of that miserable tea-room. We used to get loaded.[13]

Then, according to Davis, he would launch into story-telling:

He recited tales of his various exploits with florid embellishments and boastings that held the attention of his listeners, because a good deal of objectivity, of humour was included . . . The studio, the costume and talk added up to a dramatisation of his natural gifts which made him an unforgettable personality.[14]

Too poor to spend money, they walked. On 5th Avenue, they crossed Washington Square under Washington Arch and passed red-brick houses

from the 1830s, some with columns over the entrances. On the East Side at New York University, Gorky often dropped into Albert Eugene Gallatin's Gallery of Living Art, one of the first museums in America of modern art, where he familiarised himself with the first works of Jean Arp, Robert Delaunay, Joan Miró and Piet Mondrian as well as Picasso and Braque.

In Union Square, they watched people play chess. Italians clustered around the nineteenth-century statue of nationalist leader Giuseppe Garibaldi; children kicked balls and rushed around. Gorky pointed out the black people to Sirun: 'After you look at a black person, you can't bear to look at a white person any more.' He told her that they had been abused and martyred like Armenians. Other artists joined him in the square, since they couldn't afford bars and cafés.

For Sirun, the first flush of infatuation was over; they had been living together for a few months in the chilling reality of the early Depression. She remained on the sidelines, a voiceless model, while he occupied centre stage. (Sirun would eventually opt for theatre school and life as an actress.)

In Watertown, Moorad and Vartoosh had become militant communists and were actually planning to return to Armenia. Her sisters were appalled. Sirun perceived them in a different light: 'His relatives were some very left, some very right, and heated argument flared up. Moorad was a handsome man. It was very exciting. They fought and scrapped and screamed. Gorky didn't have much interest.'

They stayed with Vartoosh who decided one day to have her straight black hair curled into fashionable Marcelle waves with heated clips. She asked Moorad to take a snap of them. Gorky, bearded and mustachioed, wearing a suit and tie, has his arms round the sultry Vartoosh and the smiling Sirun. In a second photo they posed as a couple; he looks cautious while Sirun exudes cool confidence. They stand shoulder to shoulder, without contact. Her hands are buried deep in her pockets and his are clasped behind him. As soon as the camera was put away, Gorky began teasing his sister.

'*Agchi! inkzinkt havanoum es?*' (Girl! do you fancy yourself?) He was hiding something behind his back. 'Bend down!'

He chucked a bucket of water over her hairdo. She laughed as she remembered the water fight. 'He always liked natural looks, nothing artificial. He wanted me to have my hair long and simple.'

They visited Sirun's mother who had remarried and lived nearby in Lowell. Gorky was fascinated by her father, wondering whether he might have seen him preach at the mission school in Van, but she refused to answer questions about him.[15] Back in New York, Gorky quizzed Sirun, sensing she was hiding something. He persisted until, in an unguarded moment, Sirun confessed that her father was still alive, but declared that she never wanted to see him again as long as she lived.

One day Gorky went off to Boston alone and was very excited on his return. 'I have met the greatest man! The wisest man!'

She listened to him, 'raving on and on'. Then, he dropped the bombshell. He had been to see her father in a mental asylum. Sirun was speechless. 'My heart just sank.'

Gorky insisted that her father was highly intelligent and deserved a better fate. He had been a brilliant bacteriologist at Chicago University. Such a man should not be locked away! He had been committed by his wife, who had gone off to live with another man. He offered to take her to see him:

> He was just fantastic. I had rejected the Armenian thing because it hadn't been very good to me. My father and mother divorced. I had a wretched childhood. As soon as I was grown up and on my own, I really wanted to forget. He kept bringing it up all the time.

He won her over. Vartoosh and Moorad drove them to the asylum, which by bizarre coincidence was in Watertown. Gorky was by her side.

> It was pretty sad. I had been about twelve years old and now I was twenty. I really didn't want to see him and I only went up because Gorky wanted me to. My father was just as cold and indifferent as he always had been. He was very disappointed with me because I wasn't in college. It all happened around 1930.

The sight of the dignified man trapped among the insane was to leave a lasting impression on Gorky and return to haunt him. He pleaded with Sirun to sign the papers to release him. She refused. Gorky had rejected his own father and kept him a secret from her, but Sirun's father fulfilled his own need. Vartoosh witnessed the battle: 'She refused to sign. They fought. He said she was heartless and godless. Her father was *badveli* (a preacher),

very well educated and very well-spoken. Gorky was heart and soul hoping to get that man out.'[16]

The clapboard house could not contain the shouting and yelling. Gorky flew into a rage, picked up a knife and chased Sirun around the kitchen table. She stood up to him. The love affair turned into a power struggle. Gorky's disappointed anger at his own father, suppressed during the genocide years, was being vented in a scenario displaced from his own situation. He wanted to heal her broken family and replace his own splintered history. Sirun was too disturbed to tell Gorky the whole truth, which she only confessed in old age:

> Father had a terrible persecution complex. He was convinced people were trying to kill him. He was insane. Paranoid. He decided to leave Los Angeles. We waited in the middle of the night for a train. Just me and my elder sister; my brother had stayed with my mother. He walked us along the beach all night long because he was afraid to sit in a room. Finally, we get to Ogden, Utah, and he buys a gun, to protect himself. I was sitting on a twin bed opposite him and he shot me and I fell on the bed. And I got up again. And he shot me again! I saw the blood streaming down and I went to the door and opened it. He said that life was so awful, so terrible, he didn't want me to have any part in it. In his strange way he really did love me. I knew that.

She had been a girl of twelve. Her mother had abandoned them and Sirun survived by escaping them both. She 'never wanted to see my father again because he had shot me. I had almost died. It wasn't just the shooting. It was the years before that . . .' The unfinished sentence hinted at earlier abuse.

Gorky was out of his depth in dealing with a young woman who had suffered abuse so deeply that she could not let him into her pain. She felt the rift between them widen.

> I felt more or less like his servant. But that's not necessarily his fault. I'm not saying he made me his servant. There were certain routines that had to be done and washing his brushes was a big one. I didn't mind that. There wasn't much housework.

Gorky did not give up. It did not occur to him that there was any other

way than to love, and fight, and make up. His strained intimacy with Sirun began to alter into a Cubist perception of her. She was no longer lyrical, but displayed the bold forms and new 'ugliness' of which Picasso spoke. Gorky integrated Cubist discontinuities of planes, breaking up the central focus, putting alternative views and perspectives within a single canvas. The subject itself was abstracted while the pictorial space became the reality. His painting anticipated a crisis he could not foresee.

18

A Dangerous Muse
1930

Early in 1930 the director of the Museum of Modern Art, Alfred H. Barr, was preparing a group show. He visited Gorky's studio to look at his work. Gorky was then represented by the J. B. Neumann Gallery. A show at the Museum of Modern Art was a major step in public recognition.

The two men were both in their late twenties. Alfred Barr had a pinched look to his face with a tight mouth and gold-rimmed spectacles perched on a little nose. He looked at the flamboyant figure of Gorky, his neat studio, and his pictures. 'I was impressed immediately by his seriousness as an artist and his charm as a person. I went back again shortly afterwards to pick out some paintings for our show, an exhibition of works of 46 sculptors and painters under 35 years of age.' On his second visit, 'to be candid I was somewhat put off by his dependence on the painters of the School of Paris such as Matisse, Picasso and Miró.' But he added, 'In spite of his derivative style one felt grateful for his studies of abstract and semi-abstract painting during a decade given over largely to Social Realism and the American Scene.' On receiving Gorky's CV,

Arshile Gorky
Born 1903 Nizhni Novgorod
Studied there and in Tiflis and three months under Kandinsky in 1920
To America
In 1922 lived in New York
81 Still Life
82 Still Life courtesy of J. B. Neumann Gallery, NY

83 Still Life Collection Jonathan Bijur

Barr noted, 'Gorky's listing was somewhat fanciful.' He added, 'I recall that about then or shortly afterwards he let it be known that he was a Georgian Prince. Anyway the misinformation was his fantasy not ours.'[1] Gorky had probably shaved a year off his age and was keen to emphasise his admiration of his latest master, Vassily Kandinsky. In 1929, Barr first used Kandinsky's term 'abstract expressionism' to describe Kandinsky's works from 1910–20.[2] Gorky's identification with the Russian in 1930 is the first hint of the direction he was to take, in detaching himself from Cubism, towards a more fluid and poetic approach over the next decade.

From January to March, the Museum of Modern Art showed *Painting in Paris*, with fifteen Picassos, eleven Matisses, several De Chiricos, Légers and Mirós. Gorky could not keep away. As De Kooning said, 'Gorky was very much influenced; he wanted to be influenced. All over the world people were influenced by Picasso and Braque. They picked up obvious cliché things and their paintings have disappeared. Gorky did it in the right way, in his own way.'[3]

He was particularly struck by the *Seated Woman*, 1927, which he could already have seen reproduced in *Cahiers d'Art*. A young painter, Peter Busa, reported that it was Gorky's favourite painting: 'He would stand in front of it for an hour at a time!' That year Gorky produced his own versions of the painting, first a gouache on cardboard only $12\frac{1}{2}$ by $8\frac{3}{4}$ inches; later he painted a far larger oil. Diane Waldman wrote in 1981, comparing Gorky's painting with Picasso's:

> Significantly, Gorky used Picasso's forms, often quite literally, yet he rejected Picasso's characteristic brutality. Picasso's *Seated Woman* is part human, part predatory animal, part Inquisitor, part Crucifixion; her hooded mask-like visage, the configuration of her nails generate a sense of danger typically terrifying, typically Picasso. In Gorky's *Painting*, however, there is no violence, no brutality: the deformation of the woman is modified, the implicit volume of the figure and thus its physical presence are suppressed, the forms are flatter, simpler, clearer and above all more abstract. The immense power, the severity and intense drama of Picasso's art are absent ... For Gorky's sensibility is exquisite and lyrical. Despite his debt to Picasso, this painting is imbued with the grace and idealism and poetry which mark his lifelong oeuvre.[4]

The Exhibition of Works by 46 Painters and Sculptors Under 35 Years of Age ran from 11 to 26 April. Out of three still lives by Gorky, only one is reliably identified: *Still Life* with a bunch of grapes from 1928. This is more rooted in his Cézanne period – a strong work with elegant lines and colour. Barr did not purchase a Gorky for the museum, but at least on 24 April, as other Armenians were commemorating the Armenian Genocide in churches and public meetings, one Armenian survivor had made it into the Museum of Modern Art. Yet he was there as a Georgian! For Gorky it was a personal triumph.

He was spending time on the double portrait of himself and his mother. Another turning point was his two still lives loosely borrowed from Picasso, in which he introduced a palette and an egg. The palette alternated as a guitar, then a shoe or slipper. The slipper was to become a vital element of the *Garden in Sochi* series; in these still lives are the first stirrings of that autobiographical series. Sirun may have jolted his early memories and emotion so that motifs surfaced unexpectedly. The process of transformation from one motif into another became a major theme of Gorky's work, just as his personality was dynamically reinventing itself.

The Depression had begun to bite, and he saw artists going hungry and homeless, like spectres from his past. With no support or welfare, Gorky worked even harder to support himself. 'We didn't even talk together,' Sirun said. 'That was the terrible thing. He'd get very moody at times and he'd worry about money and then he'd worry about selling his work. Nobody wanted to buy, nobody had any money to buy.'[5]

His friend Arshag knew how much he loved her but saw her as a far stronger personality than she herself realised. 'They were together for a couple of years. But he was very temperamental, and she was also temperamental.'[6]

She was still only twenty and was beginning to find their life together a drudgery:

We'd go to sleep about eleven or twelve and get up early in the morning. He would stay and paint and I would go to work. He was tired too, very tired. The same all through weekends. The only diversion he ever had with me was to go up to Boston to visit his family or walking in Washington Square Park. He loved to walk. I felt I had no life whatsoever. Yet there was no life to share with him.

He didn't smoke. I smoked. Life with him was so stressful for me I started

smoking. Neither one of us were drinkers, and we didn't have any money to drink anyway.

Sirun's attitude to sexual relations was far more modern and frank than Gorky's. Even so, she listened amazed, as Stuart Davis's wife gossiped about her marriage: 'Bessie was such a funny woman. She said she could read the papers and smoke cigarettes while they were having intercourse.'

Gorky had never lived with a young woman before and was sexually inexperienced and inhibited. He often grilled Stuart for tips on improving his performance. She complained:

You know sex wasn't even particularly important to Gorky. No. Really wasn't! I felt that most of Gorky was in his head. It was his romanticism . . . Something no woman probably ever told you about him was that he said, making love to a woman was as much as working an eight-hour day. You can imagine how that made a woman feel!

You thought that at the back of his mind, even while having intercourse he was thinking, 'Oh my goodness! all my strength is going. I should save it up for painting.' [She giggled.] I never forgot that. It was so odd that he would equate this marvellous love expression with a hard day's work.

Gorky invested so much passion in his work that he hardly noticed their incompatibility, while her perception of him shifted hazardously.

He was like my father. If you asked him something, he would give a great big lecture and bore you out. It's not what you wanted. You wanted a little comfort and warmth. In his dogmatic way, he tried to bend you to his will. I'd had that from the time I was born until I was twelve.

Once she had identified Gorky with her father, their relationship was in trouble. 'I think Gorky loved me but if only he'd shown it some other way. If he'd just been tender. I wished he'd married me or given me that kind of assurance or support or love or whatever. That's what I wanted. But he didn't.'

Gorky misread all the signs. She was the only woman who stood up to him, unafraid and pretending not to care about marriage. She decided to run away from him, but Gorky always turned up, a dark phantom in his long flapping coat, turning his piercing, wounded eyes on her.

She took a train to her sister's in Buffalo, where he didn't know the address. She said, 'The next morning there was a knock on the door and there was Gorky. That can drive you crazy.' The more he pursued her, the more closely he resembled her father. 'It was just awful. He was terribly possessive and he was so jealous and he was afraid I was seeing someone.'

Once, after he had followed her all over New York, they ended up on Riverside Drive. He threatened that if she didn't come back, he would drown himself. When she failed to react, he started running towards the river. She screamed to stop him. 'He was such a romantic!' she commented, finding reassurance in this proof of devotion.

As the relationship deteriorated, he grew more agitated. 'If I didn't come and be a good girl and do what he told me to, he was going to commit suicide. He was a tortured man, there was no doubt about it. I recognised his talents. But I didn't feel that I wanted to sacrifice myself for it.' Sirun had given up: 'In a woman he wanted something pleasant to look at like a statue but never to interfere in his mind or soul. Someone he could take sustenance from or worship but never give and take. Never. Never!'

One day, they had a serious row and she stormed out again. He searched her possessions and found an unmailed letter, addressed to a man. His address was near the Cooper Union Museum, in the Village. Gorky found it in the early hours of the morning, banged on the door and burst in. There was Sirun with a handsome young Mexican guitarist. Fernando Felix took one look at the enraged giant who stormed in, with huge hands and black eyes flashing murder, and he darted out of the door, abandoning his lover. 'He dragged me out of Felix's by the hair and made me get in the taxi,' Sirun said. 'My hair was very long. He just dragged me up, pulling it. He was so mad. He was crazy. He brought me back and put his fist in my face. The blood was everywhere.'

That was the end of their relationship for Sirun. She stood up to him bravely and refused to compromise, even when he pleaded that he couldn't live without her. But she emphasised later: 'It only happened that one time! It was a good thing he did that! I would never have had the strength. I really loved him!'

She never saw Felix again; he went back to Mexico.[7] Gorky confided in Raoul Hague, an Armenian sculptor, who would gossip all over the Village that 'he wept like a child'.

He told me about a Mexican dancer. Young. Black. Dark. Would knock any woman off her feet. I think they were having an affair. Gorky found them in a hotel on Broadway. He broke the door down and took her by the wrists. She was naked or in a negligee. He put her in the taxi and took her down to his studio. After that she wouldn't stand for it and that was the end.[8]

Gorky was devastated by the loss of Sirun and by what he had done to her. He went to see his friend Yenovk: 'He came to Watertown. He was starving. We sat at Belmont View near the big pond, or by the Charles River. Talk, talk, talk. Never talked about art. Only about the love affair. We came home at two o'clock in the morning. Broken-hearted. He was broken!'[9] Gorky could not stand the sudden solitude of his studio and begged Yenovk to come and live with him. He felt empty and desolate.

Critics have written that Gorky did not produce many paintings in 1930–31, owing to economic difficulties in the Depression. But the emotional damage of the break-up with Sirun was a major factor. Gorky tried to anchor himself with his drawing and painting, but since he had always worked from his emotions, the long bouts of terror and inactivity short-circuited the flow of ideas. He was now well launched on a more abstract phase. During the love affair, his portraiture and landscapes had harmonised with nature and natural forms. It coincided with the culmination of his Cézanne period and his shift to Cubism. After the violent parting from her, an increasing tendency toward abstraction set in.

In the late 1920s and early '30s, Gorky began a series of Cubist paintings whose flatness and evolution of large shapes and interconnectedness show not only that he was studying the works of Braque and Picasso, but also that the reliefs and carvings of tenth-century Armenia were in the forefront of his mind. He was reappraising what had once been his own culture – the kings and saints, eagles and lions, boats and grapevines, that were carved on the walls of Aghtamar. He spoke to his architect friend Badrik Selian, 'with enthusiasm about the art of Armenia. He gave examples of how they were not representing in a realistic way, like the eagles, lions which are carved on the arches of churches.' Gorky explained how abstract art had roots in Egyptian art in the representation of creatures and animals and people. He

contrasted Armenian sculpture with Greek: 'They are not finished, as Greek art is.'[10]

If Gorky sprang hungrily like a wolf on the synthetic Cubism of Picasso and Braque, it was because he was culturally predisposed to it. As an intellectual tool, he could wield it for analysis. He told a friend he wanted to feel what Picasso felt through his fingertips. By making it part of himself, he could move on, but he brought something of his own individuality and culture to it. Gorky took an independent approach to his Cubist works, added accents of plasticity, tensile line, subtlety of colouring and warmth, all his own. He and John Graham often painted the same subjects and the same shapes. In Los Angeles County Museum, two later paintings by Graham and Gorky hang side by side. Gorky's integration of the subject matter has found a more personal style. He handled paint with more finesse and bravado than Graham, the shapes are more organic and coherent, the proportions and spaces between them have an inevitability that only great masters achieve. His authority showed even at this relatively early stage.

A number of people would pass through Gorky's life at this time, attracted by his intensity and unusual depth of knowledge – artists, gallery owners, friends. Sydney Janis was a wealthy shirt manufacturer who had begun collecting modern art and was keen to educate himself. Gorky became his art guru. He drove Gorky around New York in a cherry-red convertible, entertained him in his stylish flat which boasted the spectacular purchase, Rousseau's *The Dream*.[11] Gorky studied it while he baby-sat Janis's son and pronounced it 'like a big poster'.

Although Gorky was close to some of the key figures of the Social Realist movement in art, he was suspicious of propaganda and party manipulation. In New York, Raphael Soyer, a communist artist and neighbour at 1 Union Square, befriended Gorky.

He was very handsome and very striking. He was an extraordinary looking fellow. If you saw him in the street you would stop and look at him. Very romantic looking. Had the most beautiful hands I ever saw a man have. A melancholy expression. He was melancholy, that was part of him. Very melancholy voice, thin voice, melancholy intonation and melancholy laughter. He wore a brown coat and a red scarf. He shied away from girls, but they didn't shy away from him.[12]

Soyer and his brother were City Scene painters.[13] Gorky deplored the inherent conservatism of their work, but it did not prevent Gorky and Soyer from liking each other, and looking for technical proficiency in one another's work.

During the early 1930s, Gorky completed a great number of drawings as part of his self-imposed tutelage, like Cézanne and Picasso. Gorky called Soyer's attention to different masters: 'Look at this Degas. See how abstract it is! He had a little pocket book of Ingres. He'd often take it out and look at it. Shake his head. He looked like it was a prayer. He was aware of those qualities by many artists, appreciated them and could have been a very great lecturer on art.'[14] Gorky's devotion to Ingres was cribbed from Cézanne and Picasso, his two great teachers, who had revered and plundered Ingres. As a young man, Cézanne had even painted a series on the walls of his father's house and signed it, 'Ingres'. Picasso also returned to Ingres repeatedly, notably in the *Portrait of Gertrude Stein*.[15]

Gorky could not afford models and used to draw in Soyer's studio. His friend maintained:

> He wasn't dogmatic. He enjoyed doing drawings in my studio with great care. He was aware of the fact that people were criticising him, that he is Picasso or Braque and Cézanne. He told me that these painters were his great influences, just like a person has a father and a mother, an artist can have a father and a mother.

An artist in Armenia worked under a *varbed*, a master. In New York, Gorky looked for a master in vain. Had he gone to Paris, his development might have taken a less tortured route. He followed his instinct, at one or two removes from Europe. Sirun noted that although he loved New York city, he often used the word 'vulgar' about America.

In the autumn of 1930, he saw *Picasso Drawings and Gouaches* at the John Becker Gallery, and Miró's first one-man show in America, at the Valentine Gallery. De Kooning and other friends went with Gorky to hear him talk about the work. Will Barnett, a young artist, spoke of Gorky's impact on them all:

> New York was a backwoods in those days. Nobody knew much about art. We were so ignorant. There were the American Scene painters and some

other derivative stuff. Gorky had this knowledge and refinement of European art, he could talk about it like nobody else and he understood it too. He was way ahead of everyone and had the direct knowledge of an ancient civilisation which gave him the leadership. Sure, we all followed him.[16]

By 1930 the early phase of discovery was over and Gorky, through unhappiness, had reached a new stage of maturity.

19

The Troubadour
1931

On 1 January 1931, Gorky attended the opening of the *Special Exhibition Arranged in Honour of the Opening of the New Building of the New School for Social Research* to see the hanging of his work *Improvisation*. The show was organised by Katherine Dreier, an artist who had exhibited at the Armory Show in 1913. She had founded the Société Anonyme as one of the first museums of modern art in New York. Exhibitions of Cubism, Dada, De Stijl, Constructivism, had been organised in different museums, since a permanent museum could not be found. Gorky's appearance in the show, soon after his inclusion in the Museum of Modern Art, was an important sign. The actual painting he showed is not known. No work under the name *Improvisation* survived, although the canvas may have been renamed later. It was probably an abstract or semi-abstract work, for he had begun moving away from the rigorous Cubism of Picasso and Léger, towards the more plastic and figurative approach of Miró and Kandinsky.

Gorky rarely gave titles to his works, but was paying homage to Kandinsky. The Russian artist intended his *Improvisations* to evoke a spontaneous emotional response, whereas *Compositions* required conscious preparation and maturing of an inner feeling, and were more advanced and complex.[1] The titles suggested that he equated sound with colour, musical composition with art. Gorky read and reread Kandinsky's book *The Art of Spiritual Harmony*. Several paintings from 1930 to 1931, such as *Abstraction*[2] and *Sunset in Central Park*,[3] show Gorky already exploring a non-Cubist and more organic imagery. And he often discussed Kandinsky with a friend, the young artist Anna Walinska. 'He did veer toward the early

Kandinsky, 1910–1912, the ones we discussed, before Kandinsky of the geometric form. It was much of what he is saying in his later works – the freedom of the form and the space and the line.[4]

Gorky was struck by similarities between Kandinsky's background and his own. The Russian's earliest works, sparked off by fairy tales and stories, had explored a rich folk ambience. Gorky too had identified the myths and legends of Armenia as a rich source. As De Kooning astutely remarked, 'He was gifted with folk art.' But unlike Kandinsky, he did not illustrate the stories; it was rather that their ethos and fantasy had coloured his childhood and made him a storyteller. One young girl of eighteen, who later married the sculptor Chaim Gross, could not take her eyes off Gorky:

> I used to see him outside the library, 42nd Street Library and 5th Avenue. Biggest one in New York. He always sat on the steps with his hands on his knees. He had jet-black coal eyes. They were piercing when they looked at you. And he has enormous hands, almost like an animal, and huge feet. Everybody loved him, the women especially. He told wonderful tales. We were all sitting on the ground and looking up at him, as though he were Jesus Christ himself, maybe even more! Things about the old country and people and about Armenia and animals and folk tales. He made them up. Imagination. Like he drew fantasy drawings.[5]

She also made the link between his improvised stories and drawings. They were the inner planes of Gorky's mind against which the foreground must be projected. Like a troubadour, Gorky captured his live audience with poetic legends and songs.

Gorky's friends admired his singing. Rook McCulloch maintained, 'It was his main hobby. He'd sing while he was working. He'd sing while he was walking.'[6] Gorky sang folk songs of his region, calling them Georgian, since no one else understood the words. Some had strong dance rhythms and others soaring lines of melisma. As he sang, he could put himself into a frame of mind that brought emotion into the empty studio, making it vibrate with his childhood memories.

Gorky's circle of Russian friends was widening. Lately, a colourful new figure had burst on to the scene – David Burliuk, thickset, with one good eye, a whiskery face and a gypsy earring. He introduced himself everywhere as 'the Father of Russian Futurism!' Just when Gorky needed to hear about

Kandinsky, Burliuk obliged with reminiscences of the Russian group with whom he had exhibited and written essays, alongside Kandinsky. Born in 1886, Burliuk was much older than Gorky, with a first-hand knowledge of the Futurist and Abstractionist movements in Russia. When Gorky was still a child in Armenia, in 1907 and 1908, David and his brother Vladimir had been founder members of the Russian artists' group *Karo Bube*, which included Natalya Goncharova, Michail Larionov and Kasimir Malevich.[7] Burliuk had lectured on Cubism in 1913, and the following year travelled to Tiflis, where he had met Armenian artists. Gorky felt a natural affinity with him, and the added whiff of notoriety about Burliuk, who had dressed and behaved outrageously at an exhibition of modern Russian art in the Brooklyn Museum, commended him even more to Gorky. With many shared ideas and the same humour, Gorky and Burliuk became firm friends.

Gorky interpreted his own work in the spirit of Kandinsky when he told a puzzled friend looking at his *Sunset in Central Park* that 'the red is the lake and the green is infinity'. He never denied that his work sprang from life and nature, but his utterances were cryptic. His innate feeling for colour was satisfied by Kandinsky's views on the harmony of colour tones and their tensions. He was intrigued by the idea that each colour has a distinct character and identity.

In *Sunset*, Gorky's flying forms are anchored in a shallow space, the edges cut cleanly out of the ground with a decisiveness recalling Miró. As for the question of 'influences', Kandinsky himself had answered it:

> If in order to express his inner impulses and experiences, an artist uses one or another 'borrowed' form in accord with inner truth, he then exercises his right to use every form internally necessary to him – a utilitarian object, a heavenly body, or an artistic form created by another artist.[8]

In Gorky's *Still Life* (1931), the fruits have become stylised into formal elements in a composition unified by shape and a hint of perspective. The apples, which years ago 'made the walls of the studio bulge', had flattened.[9]

Paradoxically, as the economic situation worsened with the Depression, Gorky had more opportunities to show his work, but sales did not always follow. The exception was when, in April 1931, the Downtown Gallery at 113 West 13th Street exhibited Gorky's pictures. He may have been introduced to Edith Gregory Halpert, who first opened the gallery in 1926,

by Stuart Davis, a regular exhibitor. Gorky had shown individual works in different galleries, but now he was being presented in a gallery where, for once, American art was championed. During 1931, the Downtown Gallery received seven works, mainly still life and abstract, the prices ranging from $100 to $450.[10] Records were kept for 'Archele Gorki', an early spelling of his name.

Gorky was thrilled when the gallery made a prestigious sale to John D. Rockefeller, Jr., of his still life *Fruit*, from 1928 to 1929, an elegant pyramid of apples and pears against drapery in his Cézannesque style. According to the records, the gallery received it on 13 April 1931, and Mrs John D. Rockefeller, Jr, the daughter of the distinguished collector and a founder member of the Museum of Modern Art, purchased it only a week later for $250.[11] Gorky neglected to sign it, like the majority of works from this period. Having a painting in the Rockefeller collection carried enormous cachet, and Gorky was quick to inform his sister. Yet since the early 1920s, when he did society portraits for several thousand dollars, prices had dropped and there was little hope of improvement. In the next month from 2 to 22 June he exhibited in *Paintings, Water-colours, Drawings, Sculptures by Leading Contemporary American Artists* 'to Sell at $100 and Less'.

On 3 September 1931, an article on Stuart Davis written by Gorky appeared in *Creative Art*, volume 9. Asked for his thoughts on art, Stuart Davis had decided to be interviewed instead, explaining: 'I chose Gorky, which indicated how sure I was of his friendship and sincere liking for my work.' Gorky developed it into one of his rare essays, opening with a clear statement: 'The twentieth century – what intensity, what activity, what restless, nervous energy! Has there in six centuries been better art than Cubism? No. Centuries will go past – artists of gigantic stature will draw positive elements from Cubism.' The essay was full of highly personal insights, such as 'every time one stretches canvas he is drawing a new space'. Gorky criticised the passive approach to pictorial space; 'Stuart Davis realises the invisible relations and phenomena of this modern time, he is the visible point to the progressive mind in his country.' He summed up the aspects of Davis's art that he valued most.

Yet the silent consequences of Stuart Davis move us to the cool and intellectual world where all human emotions are disciplined upon rectangular proportions. Here these relations take us to the scientific world where all

dreams evaporate and logic plays its greatest victory, where the physical world triumphs over all tortures, where all the clumsiness dies, and leaves only the elements of virtue, where the aesthetic world takes new impulse for new consequences.

He takes a new position upon the visible world. This artist, whether he paints eggbeaters, streets or pure geometrical organization, expresses his constructive attitude toward his successive experiences. He gives us symbols of tangible spaces, with gravity and physical law. He, above his contemporaries, rises high – mountain-like! Oh, what clarity! One he is, and one of but few, who realises his canvas as a rectangular shape with two dimensional surface plane. Therefore he forbids himself to poke humps and holes upon that potential surface. This man, Stuart Davis, works upon that platform where are working the giant painters of the century – Picasso, Léger, Kandinsky, Juan Gris – bringing to us new utility, new aspects, as does the art of Uccello. They take us to the supernatural world behind the reality where once the great centuries danced.

Gorky also took the opportunity to lash out at critics of new movements in the twentieth century:

We shall not, contrary to the expectation of these people, hear of the sudden death of cubism, abstraction, so-called modern art. These critics, these artists, these spectators who wait for a sudden fall are doomed to disappointment. They have merely not understood the spiritual movement and the law of direct energy of the centuries ... If they could but realize that energy is a spiritual movement, and that they must conceive of working under a law of universal aesthetic progress, as we do in science, in mathematics, in physics.

The modern masters on Gorky's list were his own strongest influences, an accurate forecast of who would turn out to be considered the century's seminal painters. It is questionable whether other artists of his generation, in 1931, would have made such a radical and sound choice. He also focused on a parallel between mathematics, science and art, a relatively unfashion-able view. Upon it hinged his personal belief that progress is possible in art, and that perfecting different aspects of work contributes to a body of knowledge.

Davis was understandably delighted, for the article set him on a pinnacle – the only American in a panoply of European modern masters.[12] Gorky

was characteristically generous in his praise, although he would later be disappointed in Davis.

From 5 to 25 October, the Downtown Gallery featured *Artists' Models: Figure Paintings by Leading Contemporary American Artists*. Gorky showed *Head*, a Cubist painting with two interlocking heads, one rectilinear on a diagonal axis, and the other curvilinear slotted inwards in a bold, lively composition.[13] Although Gorky was criticised as *avant-garde* for his Cubism, he moved with the pulse which beat through New York architecture, furniture, fashion – the High Deco that would stamp the city.

That year Gorky saw two new landmarks go up in New York; the magical Chrysler Tower and the austere Empire State Building. The latter, with its eighty-six floors, was then the tallest building in the world, with a zeppelin mooring on its roof. Gorky often paced through town with his architect friend Frederick Kiesler. 'They'd read everything, from top to bottom, every store sign, every advertisement, every building,' said Kiesler's wife Lillian.

'In the street you get big shadows from signs,' Gorky pointed out. 'But this is a painting. Look at the shadow. Look at the form.'[14]

In November 1931 the Whitney Museum of Modern Art opened in the guise of a Hollywood *Rose City of Marrakesh*, in pink stucco and white stone lintels with fluted white columns. The intimate museum had natural light, wooden floors and sackcloth-lined galleries. The collection of the heiress sculptor Gertrude Vanderbilt Whitney, built up over twenty-five years, included pioneers of American art.[15] Her offer to build a new wing for the Metropolitan Museum to house 500 works, including Davis and Hopper, had been turned down, so she built her own.[16] The Whitney was to play a vital role in presenting Gorky's work.

Gorky often dropped into a favourite artists' hang-out in the village, romantically named Romany Marie's. It moved premises frequently, but on Grove Street near Sheridan Square it occupied a low building with fake leaded windows. He sat in the semi-basement bar, in heated conversation with friends. Romany Marie, a gypsy, made eastern European dishes like stuffed cabbage leaves and rice for her penniless clientele, cracked jokes and gossiped, tried to make and break love affairs. She attended exhibitions and took paintings as payment for food. The daring innovator Buckminster Fuller loved the place and designed her bar. Gorky came across a couple there who would play an important role in his life: Dorothy Miller, a tall,

dark-haired woman, witty and imaginative, and her boyfriend, Holger Cahill. He gave them painting lessons and Miller remembered that, although Gorky was working on his abstract canvases, the studio was dominated by one painting which mesmerised her: 'He had that marvellous picture of his mother and himself hanging there all through the years. He talked about his mother but he never admitted to being Armenian. He always was from Georgia. But he told us that she had starved.'

In *American Printmakers: Fifth Annual Exhibition* at the Downtown Gallery, Gorky showed three lithographs, *Painter and Model, Mannikin,* and *Self Portrait,* priced at $12 dollars each. There is a striking similarity between an untitled lithograph and an oil painting by Gorky, *Blue Figure in Chair,* from 1931. The same lithograph is also closely linked to *Abstraction with Palette* in its formal composition. Over a span of a couple of years, Gorky worked on a series of paintings and lithographs which developed a basic theme, just as he had painted several versions of the same still life in 1927 to 1929. His focus on his subject shows a systematic, almost scientific method of working, which he was to pursue for the rest of his life. The apples of the earliest still lives are plump and edible. Then they are cut open and become skeletal. At a later stage, a swooping arabesque defines the apples, but the outline itself becomes absorbed, then legible as a breast, a shoe, a wheel. Gorky worked close to his materials, stretching his objects to transform them into a new entity. He showed a mental and intellectual drive and agility that others perceived as verging on the obsessive.

20

Nighttime, Enigma and Nostalgia
1932–34

Gorky entered the dark night of his life when he was scarcely thirty years old. The Central School of Art closed, leaving him without a salary. Never before had Americans experienced poverty and unemployment on such a scale. Artists were close to the brink, with a sudden fall in the prices on the art market. Every time Gorky went out, he saw men standing in long queues just for a crust of bread and coffee. Others hung around restaurant rubbish bins searching for scraps. Around them wealthy New Yorkers in furs spilled out of shiny black cars into theatres, bars and restaurants, hell-bent in the pursuit of fun, while 'Buddy, Can You Spare a Dime?' was plucked on banjos. Some artist friends were on the breadline. Empty shop windows gaped. Gorky walked along the river, past shanty towns called 'Hoovervilles' after the president who refused to provide welfare and resisted federal aid. No charities or relief organisations could cope with over 10 million unemployed.

Vartoosh and Moorad were determined to repatriate to Armenia. Visiting them in Watertown in 1932, Gorky painted one last portrait of Vartoosh, with black hair falling in a swathe down her shoulder. In the previous summer he had painted Vartoosh and Sirun. He mixed his colours and listened to his sister's dreams of going to university, as she pleaded with him to leave with them.

The Soviet dream, Papa Stalin patting beribboned children, had been imprinted on her mind. Their cousin Ado had risen high in the Party. Moorad would import Ford engines into Armenia to start a trucking company and help build a classless society. Only Russia, Vartoosh believed,

had protected Armenia from the vicious jaws of Turkey. Moreover, there was no future for unemployed labourers laid off in a crashing capitalist America, where they were despised. Gorky should take his rightful place among the artists of the Revolution.[1] After a 1920s renaissance in literature and art in the Soviet Union, writers from abroad repatriated to define the new culture. Newspapers urged Armenians to return, giving dazzling economic reports. Akabi reminded them, in vain, of their starvation in Yerevan.

Gorky felt nothing for Yerevan, but yearned for his homeland and for Lake Van, hopelessly out of reach. He was also stateless, still without a US passport. 'You go over,' he told her, 'and I'll join you later, as soon as I have some money.'

They dreaded the departure day. Distance and her marriage had not weakened their bond. Gorky had shrugged off his father and others of his family, but never Vartoosh: 'We wrote to each other every day. Sometimes more than once a day. He was always writing to me to tell me he had a success or a problem,' she said. She always found ways to send money, bring food, buy clothes. Like Van Gogh's brother Theo, she foresaw the day when his life would flow smoothly and he would triumph.

When he finished the canvas, Vartoosh had never seen a more beautiful portrait of herself. 'The painting was as large as a door. It was marvellous.' She did not want to part from it but it was too large to transport. 'When I left, I asked Akabi to look after maybe ten to fifteen paintings he'd done of me and Sirun.' Vartoosh would regret this bitterly. She took with her a smaller portrait, a landscape for Ado and several small drawings.

Gorky took her on a last shopping trip to Boston. To describe it, she slipped into the present tense: 'He has very, very delicate taste in clothing.' He chose a smart Harris tweed coat, mannish, double breasted, belted over a suit. No smart woman went without a hat and gloves. Gorky picked from the display of fancy flowerpot hats a closely fitting helmet with twisting crest.

'Norma Shearer wore it in *Smilin' T'ru*.' Gorky mispronounced, 'I like the hat. I don't know about *Smilin' T'ru*.'

On 10 May 1932 Vartoosh and Moorad boarded a ship which would take them to Bremen for a train to Armenia. Gorky waited on the quay as they waved by the ship's rail. Others threw tape and yelled, but he was a silent lone figure far away below them, a tall man in the crowd.

Painting alone in his unheated studio, Gorky began a series of black and white drawings and studies which summed up his life and state of mind: *Nighttime, Enigma and Nostalgia.* 'Enigma' was a fashionable word and a favourite of Graham's and of course of de Chirico's. 'Nostalgia' was an inspiration for Gorky who reinhabited the places of his childhood.

From 1931 to 1934 he devoted himself to a body of work with strong themes and a structure that would form a matrix for his future work and transform him as an artist. He painstakingly took apart the constituents of form and composition, without the distraction of colour, and forged his grammar of forms.

Nighttime, Enigma and Nostalgia, probably named in retrospect like most of his work, was to be an important series of drawings and paintings in which he explored his themes, thoroughly, examining every possibility and direction. Separated from the two women he most loved, his sister and his lover, Gorky worked in black, and on black, as though in mourning.

The drawings for *Nighttime, Enigma and Nostalgia* intimate Gorky's descent into his unconscious. Inspired by his reading of Freud, he allowed his dreams to enter his drawings, as he became familiar with André Masson's work, together with Picasso's drawings of abstract forms from 1928, at the new Pierre Matisse Gallery. He also saw the first Surrealist show at Julien Levy's new gallery in 1932, with Salvador Dali's, *The Persistence of Memory* – wrist watches slung like washing on a line; Marcel Duchamp's wire bird cage filled with marble sugar lumps, and a thermometer; new works by Picasso and Max Ernst. Gorky had talked about Surrealism to his students as early as 1928, almost simultaneously with his discovery of Cézanne. It was a liberating experience after the drab American Scene paintings of New York.

In January 1933, Gorky executed his own abstraction of concrete forms which he had been studying in drawings. In the final version, on a shallow space, two complex figures interact in seesawing motion. The left side is the male, playful, the right is female, with pointed breasts and head thrown back. The pictures progressively become more violent, and displaced objects – a ball, a bird – begin to evolve. Themes and motifs recur through the series. Once a complex of forms has been set together, parts fuse into new entities always anchored by architectural lines and planes.

Different themes have been listed as points of entry to the final abstraction: 'Cubist standing figure; column with objects; organic abstraction; male

écorché.'² However, his own painting *The Antique Cast*, 1926, a headless cast with modelled musculature reclining on a base, is the likeliest source of inspiration. The male torso, thighs and man's arm, even the curve of a basket can be seen as the basis of curving forms which Gorky dovetailed. Stripped of mass and relief, the simplified symbiotic human forms are superimposed on different drawings as though on a table top. Figurative subjects such as a man hanging from a rope; the fish, with its body eaten away, and only the vertebrae showing; a man on his back, over a plaited loaf of bread, a palette and a letter box on a column, resting on a letter box; a step ladder, and others were later combined in a long horizontal arrangement for a mural. Spatial divisions created simultaneous worlds but were juxtaposed as alternative realities.

Gorky's evident immersion into Surrealism was becoming clear in his attitude to automatic drawing which gave new scope for his inexhaustible appetite for sketching. In the Works on Paper department of the Museum of Modern Art, Gorky drawings are kept in storage. One sketch depicts a cell-like space, where a woman leans over a seated man. In the top left corner is 'some indecipherable writing', pointed out by the curator. Gorky has written *Mayrig*, 'Mother', in Armenian – three times. Perhaps the words hit Gorky like a sudden realisation of what he had drawn; he could be sure nobody would understand what he had written. In an abstracted version of that picture he had drawn the bodies as detached parts. One sketch, *Untitled*, had confused the museum curators and had been framed upside down, but was clearly from the *Nighttime* series. Instead of black on white, it was reversed like a photo negative. Gorky was consciously developing white on black, later to be picked up as a theme by De Kooning working with enamel in 1946.³

Gorky used all the different black and white media from pencils to pens, line drawing and a variety of hatching: 'stippling, diaper patterning, cross-hatching, dense scribbling, flat washes, and spare line – displays Gorky's skilled and sensitive draughtsmanship'.⁴ He hatched with remarkable precision, graded the density and direction of the parallel lines to shift the plane with pencils sharpened to a long point. He practised hatching with a pen for hours, as he talked with friends. Surfaces become plastic. In a frenzy of hatching and cross-hatching lines joined together to make a solid black surface.

He made single-line drawings and pencil sketches of the theme in the

same format in over fifty versions.[5] The black and white drawings glow as though with colour, occasionally with the addition of brown ink. The quality of his penmanship creates a gamut from white to black, textures from solid to diaphanous. They have been compared with André Masson's drawings, but show Gorky's draughtsmanship to be tenser and more cohesive. He would work on a drawing for hours, trying out a new process, scraping with a razor, rubbing, splashing. Once, after a whole night of concentration, he completed a beautiful drawing, then washed it with water. De Kooning was distraught to see it disappear down the drain, leaving phantom traces on the paper. Gorky shrugged.

In the China ink drawings of white on black, the white is scraped out from a black surface like the silver and black metalwork of his childhood in Van. His mastery of pen and China ink produced sensuous black liquorice surfaces. Grooves and indentations capture the eye and guide it across the picture plane from curve to point, from angle to circle. In these black and white drawings Gorky laid out the skeleton of future works. He invented an economic grammar which expressed his despair and set out the bare bones of his depression.

The natural objects of the early sketches get submerged in composition. Pictures within pictures are self-contained. The fish Gorky drew as a young boy on the sand of Lake Van is there, but with the flesh eaten away. The colossal man, his father, turns his back on his family, walks out of doorways, bends over his seated mother. Scenes from his life are a vocabulary of forms. Concrete images are slowly abbreviated and abstracted into the final version, with only one oil painting completed from this series.

In the pile-up of bone shapes and straight lines, two sharply peaked triangles are interpreted as the jutting breasts of a woman. Gorky welded some parts of his life into a harmonious whole, while other fragments disintegrated and became ghostly. He told his friends that nothing he had experienced during the famine and terror in Armenia could surpass the bleak horror and misery of the Depression in New York. When later asked about the significance of the drawing he replied, 'Wounded birds, poverty and one whole week of rain.'

An arresting out-of-focus snapshot catches his mood of despondency. Unusually, he has signed and dated it, 'Arshele Gorky, 1933', with the rhythmic loops and downward strokes of his Armenian script. Gorky sits, hands on knees; strong neck and broad chest protrude from an open-necked

diamond-patterned sweater, tucked into baggy trousers. His face is strained and hollow-eyed. Emaciated cheeks accentuate his Armenian nose with wide drooping moustache. He has composed himself with difficulty. No more poses with bohemian beard, cravats, well-cut suits, brushes and violins. The gentleman artist of the Sargent days has become a welder or mechanic in his workshop.

Behind him, in place of tools, the walls are lined with drawings of *Nighttime, Enigma and Nostalgia*. Roughly tacked-up drawings would one day be worth a fortune, but could not then have bought him a meal. The portrait is as much of *Nighttime, Enigma, Nostalgia* as it is of the artist, his black and white outline absorbed by the harlequin pattern and the even stronger elliptical black and white drawings.

As Gorky went beyond Cubism into a more plastic from of image making, he became more confident and articulate, but he was out of step with the currency of narrowing conservatism. From the early thirties, Gorky was involved with a growing number of admirers and helpers, many of them competitive artists.

His close friend Stuart Davis upheld freedom and abstraction in art, but his Party activities came first. Gorky argued that social theories and the revolutionary spirit should bring greater freedom of expression. The labour movement serving the cause stifled art and produced an upsurge of mural painting, poster art and magazine illustration. Gorky valued freedom in America, yet Soviet cultural and artistic models were imposed by the powerful American Communist Party. Since many artists refused to join, the John Reed Club tried to create Party cadres and instructed them to attract a broader membership. Ferdinand Lo Pinto, an artist and friend, recalled:

> There was tremendous discussion about proletariat art and abstract art. Many guys, now very well known abstract painters, would have slit your throat and hung you, if they had the power. They were that adamant. It was a very hard battle. Gorky was like most of us, a little torn. He had social sympathies on the one side, but his aesthetic impulses were greater.[6]

Lo Pinto shared a studio with Willem de Kooning, and he said:

Gorky was pretty poor, among very poor people. We'd all chip in and buy him a dinner or give him a five-dollar bill we never got back. We complained about America, how the country did nothing for us. Gorky kept telling us how lucky we were to have wooden floors and glass windows. We would kid him. What would we do, live in a sheepskin tent?

He wasn't aggressive in the militant sense. He was like many people in the thirties – disenchanted. They saw slobs living in the fat of the land and they, who had something to contribute, were penniless. He never said anything against the United States.

His friends could afford to complain, but Gorky received censored letters from Vartoosh in Yerevan hinting at poverty, lack of food, political repression and purges. She now begged him to 'make the best' of his life in New York.

Gorky was also appalled by the news coming from Europe. Hitler's rise to power in Nazi Germany gained momentum. By the beginning of January 1933 he became chancellor. Only one month later the Reichstag was burned; civil liberties were suspended. Gorky read in the newspapers that books and art that did not conform to the Nazi view were termed 'degenerate'. Paintings by modern artists he admired were confiscated and stored in cellars or placed on view for ridicule in 'chambers of horrors'.[7] Gorky was campaigning with American artists against the persecution of modern artists in Germany. In Russia, Germany and the USA, artists were forced into a political mould to serve the interests of a party or reacted against political control of art. At no other period in the twentieth century had the status of the artist been so sharply politicised. Stuart Davis completed a fresco for the Radio City Music Hall, which was featured in the Museum of Modern Art mural painting exhibition in the spring of 1933. Gorky was the first to visit any new exhibition. He saw Ben Shahn's protest art at the Downtown Gallery: twenty-three gouaches, *The Passions of Sacco and Vanzetti*. Edward Hopper had a retrospective at the Museum of Modern Art. The Urban Realists, under John Sloane, documented the Depression and its effects at the Art Students' League. Thomas Hart Benton taught a still-life class there, with an unknown art student, Jackson Pollock, as class monitor. Benton's murals for the library of the Whitney Museum, *The Arts Life in America*, were unveiled in 1932. Through his mouthpiece, Thomas Craven, Benton condemned foreigners, the Red Flag, European

influence and Modernism.[8] The artistic isolationism of American art was increasingly identified by journalistic images of Americana. In the long term these would lead to the Pop Art movement. Gorky said, 'Those lousy advertising people are gonna take over.'[9] For the moment, abstract art was parodied as un-American.

With Vartoosh away Gorky missed a family and a home. He met Helen Sandow, a pianist, and her husband, Alexander, who lived near him on Washington Square. Gorky loved to listen to her play Bach. He showed his purist taste in music too, for when she performed a favourite Chopin mazurka, he asked her to leave out trills because they were 'unnecessary'. Gorky was so critical of American painters that on their first visit to his studio, they muttered, 'The way he talks about other painters, he'd better be good.' Gorky pulled down paintings to show them. 'When we saw his paintings we were spellbound. We realised he was a great painter. I got gooseflesh.' Alexander, a physicist, took the photograph of Gorky with his *Nighttime* drawings. When he saw fake mathematical formulas in Gorky's painting he supplied authentic ones. They often went to exhibitions.

He adopted this warm Jewish family and Helen thought he 'seemed incredibly lonely, suffering as though from the break-up of some love affair. But he was so considerate and fine in his manners. He was just a natural aristocrat.'

Once while he dined with them, he painted an impromptu painting on a breadboard; a still life of some fruit in simple firm brushstrokes. They hung it on the dining-room wall. Helen's straight nose, lustrous dark eyes and beautiful long face appeared in many unnamed drawings. She said, 'He always managed to have a pencil in his hand.' He would say, 'I have to keep my hand in.' Gorky was then drawing in pen and ink, in a spare and economical style, practising single-line drawing. In Helen, he again found his favourite type of face, resembling the faces of his mother and sisters. One day, when Alexander walked around to see him draw, Gorky covered the paper with his hand. A fine sketch of Helen's head tilted in a diagonal was balanced by a small breast in a corner of the page, even though she was dressed. As in many sketches from this period, it was a simple half-circle with a dot. Saying goodnight, he left the drawing on the table to save embarrassment.[10] Helen gathered up drawings and doodles each evening, and stuck them in a drawer. She remarked, 'At the Guggenheim Exhibition I felt uncomfortable lending that drawing.'

Gorky was so protective of her that once in a café, when a man made an insinuating remark, he sprang to his feet to punch him.

In March 1933, under the new president F. D. Roosevelt, Congress passed new legislation to start the New Deal programme. It was a great swing towards liberalism. Roosevelt took measures to unify federal, state and local government, to organise relief activities and, most importantly, create employment. Gorky heard him on the radio, explaining: 'Our greatest task is to put people to work'.[11] Artists recognised that they were working people, along with the half-starved unemployed workers. Intellectuals were called the 'forgotten men'. They organised themselves in order to make their demands heard. On 25 September 1933, artists formed the Emergency Work Bureau Group, 'the tiny seed that eventually grew into the first American trade union for artists'.[12] Members of the John Reed Club and the Communist Party were active in the group. The aim was to ensure that artists were eligible for job programmes from which they had recently been excluded. Stuart Davis was always in the forefront of these activities, as were Gorky's other friends. Soon the Unemployed Artists' Group was petitioning the New York State Temporary Emergency Relief Administration. Immediately a further two hundred artists were employed. Those artists who could prove their lack of means ('indigence') were put on the PWAP, Public Works Aid Project, a government agency to aid unemployed artists.

Between 1932 and 1934 mural painting had come to the forefront since the Regionalists (like Benton) and Mexicans (like Diego Rivera and José Orozco) had created many large murals on public buildings. This was deemed an art form in which the masses could take pleasure and edification. A highly public and visible form, potential carrier of all kinds of messages, it was also challenging in scope for the artist. Gorky was one of the first to enlist, on 20 December 1933, in one of the four government programmes set up for art between 1933 and 1934: PWAP for the decoration of public buildings.[13] He submitted a pen sketch, measuring 30 by 123 inches, for a mural with a written proposal:

My subject matter is directional. American plains are horizontal. New York City which I live in is vertical. In the middle of my picture stands a column which symbolises the determination of the American nation. Various abstract scenes take place in the back of this column. My intention is to create

objectivity of the articles which I have detached from their habitual surrounding to be able to give them the highest realism.[14]

It was a return to his first glimpse of New York and the Statue of Liberty rising out of the ocean. The 12-foot drawing was lost.

At Christmas 1933 he went to stay with his sister Satenig, who noticed his hollow cheeks and the holes in his shoes. She sent her husband Sarkis, Gorky and another relative, Armenag, to buy a Christmas tree. They staggered back under the most enormous pine they could find with a trunk one foot in diameter. It wouldn't fit through the door. She stood helpless:

> Sarkis was short, Armenag and Gorky were tall. We lived on the second floor. I see Gorky just dangling from the roof of that porch with one hand, holding up the tree with the other. Armenag pulling. When they got it through the top window, they couldn't get it to stand up. They went off and this time came back with the most enormous nails. They hammered in about twenty of those nails. We had a new carpet. [laughs] Then it was too high for the ceiling, so they had to cut off the top of the tree!

Satenig remembered Gorky as always happy. She made sure that he saw their father, and, unlike Vartoosh, she maintained, 'He loved his father very much.'

They swapped Vartoosh's letters from Yerevan. Gorky feared he might forfeit his place on welfare schemes for artists because of her. But back in the city, he was signed up and assigned $37.38 per week. It was not a moment too soon. He had starved and scraped. Like other artists, he had frequented soup kitchens. He had experienced great difficulty in obtaining materials over the last year, and had not sold many works.

Gorky joined the first 125 artists signing up on the Mural Project, which included Harold Rosenberg, not then a critic. The new administration organised and after ten days, Gorky was handed a cheque. He stared at it suspiciously. Artists did not have bank accounts. He asked the project manager, 'Where can we cash these cheques?'

'There's a bank right across the street.' Gorky looked alarmed. 'And I'll send a boy to identify you.'

With their dollars, a group peeled off downtown to celebrate with a dollar bottle of whiskey on the benches in Washington Square.[15] Gorky rushed straight up to his studio to fire off a series of drawings for his mural.[16]

Refusing to kowtow to 'propaganda art', he started on a set of abstract sketches. His inroads into Cubism and his paraphrasing of Picasso had been accompanied by a handful of friends: Graham, Davis and de Kooning. Now a larger group developed as younger students turned towards abstraction.

> Since the American art was American regional painting, slick and tight, to see Gorky in those early thirties, this was luscious. Bold, luscious, turning towards something we had never known in America before. I didn't and my peers and colleagues had not. There was a very good reason why we should be involved with Gorky.
> The name Gorky was a myth among young avant-garde painters – that he was an exceptional painter – the vanguard of modern art.[17]

The new perspective on Gorky came from Lillian Olinsky, assistant to Hans Hofmann. An exile from Nazi persecution, Hofmann became an influential teacher bringing the European modern tradition into American art teaching.[18] He first taught at the Arts Students' League, then opened his own school in a studio on Madison Avenue between 1931 and 1932, which Gorky often visited. They also met Hofmann with Graham, Kiesler and Davis.[19] 'Mr Hofmann wrote of the present condition of American art and named as the two creative American artists Arthur Carles and Gorky,' Olinsky said. (Arthur B. Carles, one of the earliest and finest of the American abstract painters, was considerably older than Gorky.) Hofmann called Gorky 'an American painter' and discussed the state of American art with him. Hofmann popularised his notion of the 'push-pull' effect of form and colour which created tension in the picture space. Another fashionable concept of the time was the notion of positive and negative space. The space between forms was considered as important as the forms themselves. These were not new considerations for Gorky, who had incorporated them into his work several years earlier. Instead he went against the flow as a student, observed at the Metropolitan Museum:

> There were stories about him all over town. He could get kind of vehement and come out with strong statements. He had a perfectly good sense of humour. Vytlacil [a teacher] was down there and most people were doing pretty modern stuff. Gorky was doing one drawing after another. And Vyt

said, what was his idea of doing these Ingres-like drawings? And Gorky said, 'Just in case! In case the art market dropped!'[20]

Young artists sought him out. Peter Busa met Gorky in 1933 and compared the prevailing teaching philosophy, 'Do your thing. Express yourself', with Gorky's classical approach, 'Apprentice yourself to ideas'. On a first visit to Gorky's studio, he commented that the work was very like Picasso. Gorky retorted, 'Why not learn from the best?' Busa followed him to the Metropolitan on Artists' Days.

> Two or three days a week, he was there religiously, like going to church. He liked the atmosphere. It wasn't a free for all. He often invited friends, students, scholars. He and Bill [de Kooning] would go once a week. Gorky was the leader, the mentor, he was the interpreter. He didn't do it like a teacher, more like one artist talking to another fellow artist. But there was obvious leadership in terms of knowledge, of his interpretation. To hear him talk for an hour about one painting! Where did he get all this? He read a lot.[21]

Busa, short and trim, was an amateur boxer, and Gorky enjoyed sparring with him in the studio. Although he was 'strong as an ox', Gorky couldn't box. Busa stayed close, hitting him at will. Frustrated, Gorky yelled, 'God damn it, Busa!', picked him up and hurled him across the room on to the couch. Part Greek, part Sicilian, Busa was sympathetic to Gorky. In the studio he watched the *Nighttime, Enigma and Nostalgia* series develop, and many very simple and bold abstract still lifes. Gorky also talked about anarchism, telling Busa, 'You would rule yourself. Best government, governs least. It will never come in your time or my time.'

The art scene consisted of many overlapping groups. At the Soyers' studio he met Ben Shahn and the master of political satire, George Grosz, who had immigrated from Germany. An important forum was the Art Students' League. Gorky often dropped in, especially at lunchtime, for intense discussions and meetings with different speakers, such as the influential writer Lewis Mumford, and Dr Alexander, the artistic co-ordinator of the Rockefeller Centre. The latter had commissioned murals because of 'the Orozco myth and the Rivera myth', as Philip Pavia, a young sculptor, reported. 'Gorky was not going to take this without a fight.'

He criticised official art and challenged the director with probing questions. Pavia was a keen organiser who observed:

> Gorky would be in the lunchroom every day, together with Stuart Davis. Davis talked out of the corner of his mouth, and we were kind of scared stiff of him. Gorky was very sure of himself in those days. He had a beautiful, marvellous face. Our president, John Sloan, would come in and look at us in the lunchroom, then he would walk out. It was usual for Gorky to take over. He would talk in his beautiful Armenian accent – very rich. He was a singer in a church and he had this beautiful modulated voice. We would listen to the man all the time.

Gorky's circle of friends was not restricted to the artists in the Village and the Art Students League. Some of his private students were wealthy, professional Americans. Gorky, by taking them on tours of the Metropolitan, explaining paintings, earned a few dollars. They appreciated his wit and invited him to their homes, where he met their family and friends. Mrs Metzger was one such student, and Ethel Schwabacher, wife of a New York lawyer, was another. Generally, Gorky kept them separate from his other friends, occupying the centre of several groups which never intersected.

Gorky often discussed Surrealism with his friends. It was taken more seriously since 1934 with the Museum of Modern Art ambitious show *Fantastic Art, Dada and Surrealism.* Surrealism had seeped into his drawings. After Julien Levy's exhibition of Dali in 1934, Gorky's friend Balcomb Greene had been outraged. 'How can you see this commercial trash?'

'That's not commercial trash,' Gorky retorted. 'If a man can give you one image becoming another, that takes a lot of plastic ability.'

Ironically, the puritanical Greene would later drop his abstract style to paint 'multi-images'.

Busa recalled Gorky's fascination with 'fantastic people' and with Dali. He liked extremes in all things and, on meeting Dali, asked how he became famous. The great showman told him, 'Go to St Mark's Square, announce that you're going to piss against the church, if you want to become famous!'

Gorky tried to attract the attention of Julien Levy, a complex, truculent young man who had worked at Weyhe's bookstore and now ran his own gallery. Son of a wealthy Jewish property owner, Levy's passion was photography and film, and on forays to Paris he purchased early

photographic collections. He had met the leaders of the Surrealist circle – Dali, Breton, Duchamp, Man Ray – enthusiastically adopted their mode of life, thrown himself into their social network, eccentric parties and provocative behaviour. Gorky frequented Levy's 57th Street Gallery where Marcel Duchamp was often playing chess with Frederick Kiesler and de Chirico would drop in for a chat with Lazlo Moholy-Nagy. Gorky sat in the back room reading books, too shy to show his work or ask for a show.

21

Mayrig, *Mother*

Gorky's vast studio was dominated by a single large painting which seemed to float like an altarpiece. More than any other work, this compelling masterpiece has come to symbolise Gorky's love for his mother, and by extension his love for his country. In exhibition it overshadows other paintings with its poignancy.

A dark-haired boy stands next to a seated woman. Her pale oval face, a pallid moon, hangs above the rose and lavender pyramid of her apron and long skirt. The enlarged saintly eyes of the woman and the boy's startled gaze in dark eye sockets are haunting. Her pallor is heightened by the soft shades of her dress. His complexion is darker, his hair and clothes in shades of sienna. The two inhabit separate worlds, hers, the dead, and his, the living. She is ghostly and statuesque with a straight spine; he is hesitant and fearful. Mother and child look straight ahead.

Gorky had studied the sepia photograph which his mother had sent Setrag, the one he had borrowed from his sister Akabi. It was the only image of his childhood and his mother before Van had burned and their world had fallen apart. The formal pose is at odds with their poor provincial dress: the boy's long coat with buttons undone, her thick jacket and long dress covered up by an ankle-length flowery apron, perhaps to hide shabby clothes. Her scarf envelops her face like the cowl of a nun. The boy is awed by her, dutifully holding two little flowers like a pageboy to a queen, an awkward child bridegroom.

Gorky drew from that photograph like a man possessed, using different media to analyse different parts of the image: pencil, pen and ink, crayon

and pastel. He did fine single-line drawings and bold ink sketches with shading. With every stroke of pen and pencil he brought her to life. Each part of the body, the upper and lower arm, the surface of the mother's apron, child's hairline, nose and mouth, became a flat and flowing form. He isolated the image of his mother and drew her and himself alone. He effaced the busy print on the apron. Homing in on her face, her scarf, even the bow of her lips, he simplified it, drawing it obsessively in the margins of other sketches. In one dramatic pencil portrait of her, with her face more rounded, he rubbed out the pencil marks until only an ethereal image floats through the surface. He drew her so often that Raphael Soyer sketched Gorky drawing her. Like a musician, he practised for his virtuoso performance. Another friend, Peter Busa, remembered Gorky urging him to go beyond 'listless copying'.

'You've paid your rent. Now do something else with them. You got to fuck'em up, Busa. You must transform your drawings! You've got to fuck 'em up.'[1]

At last he was satisfied with a drawing combining crisp outlines and shading of drapery in the sleeves, in a classic academic technique which shocked his Modernist friends. He squared off the drawing to transfer it to the huge canvas, but was so nervous his friend Saul Schary had to help him block it in. Later he would continue to transfer even seemingly improvised abstract drawings for painting. Shifting from pencil and ink to oil paint, he obliterated realistic details, historical particularities, to create a timeless image. He simplified basic shapes, streamlined them, until the surface resembled a relief in stone. The figures are bold and frontal, as though suspended high on the wall of a church. By painting over a dark surface with vigorous and bold brushmarks, he created a rugged texture which blends, when viewed from further away. The edges of the limbs and forms of clothing are repeatedly worked over, showing only the merest shadowy edge of the dark paint underneath. The sculptor David Smith said: 'I remember watching a painter, Gorky, work over an area edge probably a hundred times to reach an infinite without changing the rest of the picture . . .'[2]

Gorky had begun this portrait in 1926. There are two different versions of *The Artist and His Mother*; one is in warm rose and terracotta, at the National Museum of Art in Washington; the second is in pale gold, fresh yellow and ochre, livid green and creams glowing, at the Whitney Museum of Modern Art. She sits, pale and withdrawn, with heavy-lidded eyes forlorn, her

mouth a little harder and more bitter. He clings to the flowers. Opinions differ on which of the paintings was the earlier, but it is generally believed that the one at the Whitney is later, resolved after the artist completed a new series of drawings. Since Gorky often worked on several canvases of a given subject, he probably worked on them synchronously, changing them as he progressed. There are subtle differences in the positioning of the figures; the boy moves back; body contact between them is lost as though his left arm wasted away to increase the empty space between them; his feet also turn away.[3] But Gorky left the hands unfinished – his mother had let go of him at the end.

During 1932 the Knoedler Gallery showed an early Cézanne, *Portrait of the Artist's Mother*, 1866–67. Her face is wreathed in a pale headscarf, pallid in eerie yellow lighting. Gorky never missed an opportunity to see Cézanne's work, and that portrait strengthened his iconic treatment of his mother's head. The title also drew attention to the boy as 'artist', as proof that he had fulfilled her dream by becoming a master.

The Artist and His Mother has been likened to Ingres for simplicity of line and smoothness, to Egyptian funerary art for pose, to Cézanne for flat planar composition, to Picasso for form and colour and numerous other Western allusions, some very far-fetched.[4] All commentaries miss his central and most logical inspiration. No other source or influence captures the essence of his double portrait more vividly than the austere frescoes and stone reliefs of the Virgin and saints in the Church of the Holy Cross at Aghtamar. The strong, rigid figures in hieratic postures with their features simplified into geometric patterns, the severe and hypnotic gaze of the huge dark eyes, had caught young Manoug's gaze. In the Aghtamar frescoes, the figures are more frontal, fuller, more geometric than the Byzantine icons to which the work has been compared. Icons do not form part of the Armenian religious painting and their worship is forbidden by the Church. However, in the wall-paintings, shoulders are drawn as cross-sections of a circle, bodies as cylinders, haloes as circles; faces are broader and with large open almond eyes, with subtler and warmer colours. Gorky was known to study the fine portraiture in the medieval Armenian illuminated manuscripts in New York libraries. They highlight 'the general aesthetics of Armenian art based on a frank acceptance of sensuous, material beauty that is unusual in Christian art'.[5] For this pivotal work which detonated from his own roots he combined the Eastern and Western traditions of art he had integrated. The

sculptural quality of both Gorky's portraits is more accentuated in the Washington version, where the blunt brushstrokes fall on the canvas in chiselled zigzags, to look like the pink stone of Aghtamar. On the outside wall, Manoug had seen a masterpiece in the series of carved reliefs, a seated Virgin and Child. Her oval face is encircled by the ellipse of her mantle.

Gorky worked on these paintings from 1927 until 1944. While he lived with his Armenian girlfriend, her features and bearing rekindled the memory of his mother's image. His second wife confirmed that 'he continued painting them in my time' (1941–48). It became Gorky's unfinished symphony. He articulated it later:

> When something is finished, that means it's dead, doesn't it? I believe in everlastingness. I never finish a painting – I just stop working on it for a while. I like painting because it's something I can never come to the end of. Sometimes I paint a picture, then I paint it all out. Sometimes I'm working on fifteen or twenty pictures at the same time. I do that because I want to – because I like to change my mind so often. The thing to do is to always keep starting to paint, never to finish painting.[6]

He shocked his friends with fierce attacks on the canvas. 'Get to the paint when it looks like a Vermeer. Get a Rolls-Royce surface which has 32 coats.' He had revelled in the clean line of Ingres and in his smooth, translucent surfaces. He admired the exaggeration in the length of an arm or a hip which appeared distorted but heightened the pictorial integrity. Realism could be abandoned for the sake of purity and balance of line. Peter Busa often observed, 'Gorky had a great love for realistic painting. He understood the difference between illustration and art. There was always plastic reasoning in his art, interpretation of experience in terms of a transformation, in terms of the factors of art.'

Saul Schary, a more traditional painter, recalled:

> This picture took a hell of a long time. He'd let it dry good and hard. Then he'd take it into the bathroom and he'd scrape the paint down with a razor over the surface, very carefully until it got as smooth as if it were painted on ivory. You look at that picture and you won't be able to tell how he did it because there are no brushstrokes. Then he'd go back and paint it again, all very fine and done with very soft camel-haired brushes. He scraped it and he scraped it and he scraped it. Then he'd hold it over the bath-tub and wipe off

with a damp rag all the excess dust and paint that he'd scraped off. That's how he got that wonderful surface. It's the only painting he ever did that way.[7]

Areas of the canvas are smooth and thin as paper. On the mother's face, the razor blade has shaved away the top surface revealing the canvas weft. De Kooning watched in awe: 'The surface of the painting is like a mirror. Surface is like a metaphor in art. Like metaphysical. The material – he had a terrific surface, like a living thing. Surface control.[8]

The painting was large, but Gorky owned a crank easel. Often he turned it upside down or on its side to scrutinise its formal composition. One friend, David Margolies, saw the canvas as the object of Gorky's passion.

He would take a whole tube of paint, squeeze out the whole thing and scoop it up, put it on with a brush or with a palette knife and then paint with the brush. Sometimes he used a palette knife, sometimes a brush, but with a degree of violence which was emotional. He cranked his large easel up, so most of the time he stood to paint. As he painted he wore sandals, a blue-green smock, sometimes a mechanic's overalls. He strode away from the painting, then swooped back to it, grab the paint and move his brushes with excitement. The brushes had to be the very best, Windsor & Newton and Rubens. Big Rubens brushes. Even his beautiful palette and easel were objects of admiration for other artists.[9]

Gorky applied paint with a delight verging on the sexual. He once said to Raoul Hague, a sculptor watching him in the studio, 'See the excitement of the brush!'[10]

Confident of his expertise at last, he painted in answer to a strong inner need. His homage to his mother was bound to take on a sacred quality. Gorky's experience as a survivor of the Armenian Genocide is at the root of its spiritual power and explains its captivating poignancy.[11] It had been his goal for years. He saved her from oblivion, snatching her at last out of the pile of corpses to place her on a pedestal. He atoned for abandoning his name by recreating her as a goddess. In Armenia relatives frequently sculpt crosses for their loved ones; graveside feasts are held on the Day of the Dead. To be buried in an unmarked grave is the worst fate. Gorky built his monument to her. He painted his mother and himself in shades of the rose tufa of Aghtamar. She is the lost homeland retrieved, the resplendent

Armenian earth and stone. Fearful of losing his childhood and his identity, he placed himself next to his mother and he painted her back to life.

Vartoosh described to me how Gorky warned her before letting her see it for the first time. Then he sat her down, facing the portrait in his churchlike luminous studio, and said, 'Vartoosh dear, here is Mother. I am going to leave you alone with her.' He shut the door.

'Oh, I was so shocked! Mother was alive in the room with me. I told her everything and I wept and wept.'[12]

22

Poor Art for Poor People
1934

On 17 January 1934, Gorky reported to the Public Works Aid Project that his drawing for the mural *1934* was almost finished, and offered to send a complete sketch. At the committee's request, he submitted the following:

Mural design – detail
oil painting
25" × 40"
/For/Port of Authority – New Building
Building for Engineering Purposes
technical universities
Date started: Feb. 16, 1934
Anticipated date of completion: ?
Detail in color of mural drawing titled: '1934'

I agree not to change any detail of the above assignment without consulting the PWAP.[1]

Over the Christmas holidays of 1933, Gorky had evolved the design from the *Nighttime* series, on long rolls of paper (91 by 29 inches), and a second version (71 by 26 inches) in pen and ink, divided into three. He exhibited one sketch in a group show in the Forum in the RCA Building in the new Rockefeller Center. *The First Municipal Art Exhibition* was opened by Mayor Fiorello La Guardia.[2] In addition, an oil painting, *Organization No. 4*,[3] Gorky's great showpiece; a pen and ink drawing, *Nighttime of Nostalgia*; and a lithograph, *Kiss*, were exhibited.

On 2 February 1934 Gorky attended the opening at the Mellon Gallery,

27 South Street, Philadelphia, of his first one-man show. Thirty-seven paintings were exhibited, all dating from 1926–30, but his more recent works of the last three or four years were excluded. Gorky was excited to see so many of his pictures hung together. Stuart Davis, Holger Cahill, Frederick Kiesler and Harriet Janowitz (Sydney's wife, later called Janis) wrote notes for the catalogue. The vibrant and powerful works, with luscious colours, strong lines and subtle tonality, were praised by Holger Cahill who wrote that Gorky showed 'an extraordinary inventiveness and fertility in creating spatial arrangements, both precise and harmonious, and he contributes to contemporary American expression a note of intellectual fantasy which is very rare in the plastic art of this country'.[4]

Gorky's friend Bernard Davis entertained them in his elegant house in Rittenhouse Square, Philadelphia, hung with modern art. Davis purchased several canvases. Gorky's *Still Life* with pitcher and aubergines, in warm apricots, yellow ochres and pale blues, pink and white, became part of his collection, along with three others, based on a more Cubist construction, from 1928–29.[5] But generally there was a lack of critical recognition, and the work did not sell. Worse still, news arrived of a catastrophe.

Only a week after the opening, Akabi's house in Watertown had caught fire and gone up like a tinderbox. Trying to put it out, firemen had drenched the walls with water laced with chemicals. The water had poured down the walls and flooded the cellar, where at least nine Gorky paintings were stored. Libby reported:

I don't know whose paintings they were. I know one was ours – a huge picture of a Spanish Don sitting in a chair – like Velázquez. Van Gogh was on the dining-room wall, the one with the fishing boat when he was copying Van Gogh's style. The firemen went all up and down that house and all those paintings were ruined![6]

Vartoosh would never forgive Akabi for losing 'one large fishing boat on an ocean and one large very, very large portrait.'[7] No record of such works exist. Over a dozen works were lost, executed between early 1920s and 1934, including portraits of Vartoosh and of Sirun, painted when Gorky was in love and in a lyrical mood. The final portrait of Vartoosh, 'as large as a door', and the very early works from Boston were chucked on the rubbish heap. Gorky was furious.

'I'm not going to give you any more paintings. You don't take care of them! Those were the early paintings.'

He was sorry to see his early works disappear. Since he often destroyed or painted over his own work when he needed a canvas, to save them from himself, he gave paintings away. Without a thought of saving the damaged pictures for cleaning, Akabi trashed them along with her burned possessions. She and Satenig were shocked by the fire and attributed it to the curse on their grandmother, who had tried to burn down the family monastery.

Gorky's unlucky streak only got worse that spring. One of his students, Max Stevak, teased him one day, 'Gorky, have you heard? They're throwing all aliens off the Project.'

Gorky, still stateless, was horrified. 'I'm too upset. Let's go look at pictures.'

On 7 March he had sent a report that he was 'carefully, working constantly' on his mural. He submitted drawings to Juliana Force and Lloyd Goodrich at the Whitney Museum of American Art, administrators of the PWAP. Neither was keen on abstract art. On 29 April 1934, he was dropped from the payroll after receiving just eighteen weeks' pay. His hopes were dashed and he was without funds.

He threw himself into organising against cuts and demonstrating for greater numbers to be hired. He was a charismatic and articulate speaker, valuable to the cause. The Unemployed Artists' Group demonstrated in front of the Whitney Museum. Eight more demonstrations would be held here. Juliana Force favoured known artists, instead of registering the needier but lesser known. Stuart Davis was an important figurehead as an established artist who was not an immigrant. Roselle Davis, his second wife (Mischa Reznikoff's former girlfriend), recalled the Committee of Action: 'The artists had no organisation. They all had a common need for a place to hang their work and sell their work. They sought the city fathers for that purpose and they organised a demonstration.'

Their aims were the same as those of other workers' unions: wages and work. Mistrusting the naiveté of Social Realist rhetoric, Gorky argued with Davis, who had given up painting and was pressing him to do the same. Gorky made floats for May Day parades and designed posters but he did not call them art. He joined committees, supported antifascist groups, but refused to stop painting.[8] De Kooning watched him before packed

audiences at the John Reed Club. Busa commented, 'He had a lot of enemies. Anti-intellectual artists hated him! The good ones had great respect for Gorky. He used wonderful language. He was dynamic and very excitable.'[9]

Gorky condemned the communist mural for the Rockefeller Center as backward-looking propaganda which did not advance the development of art. In fact Diego Rivera's mural was destined to be demolished upon completion for its offending portrait of Stalin. Although Gorky's mural project *1934* was axed, he gained experience with a small mural at a speakeasy in Waverley Place, which also later disappeared.[10]

Without his PWAP cheque, Gorky was desperate. He now gave classes twice a week for a mere 50 cents an hour. While others taught naturalism, Gorky advocated Cubism and French Surrealism. Only when he was desperate, he asked his friends to buy paintings from him. Gaston de Havenon teased him by saying: 'I see your paintings every day I visit you. Why should I buy one?'[11]

Clement Greenberg, later to be an art critic, heard rumours that 'he was damn poor. Sydney Janis bought paintings from him ten bucks a drop. He sold pictures for five, ten, fifteen dollars. Small ones it's true.'[12]

His friends the Sandows agreed to buy a work although their entire savings only amounted to $500. Bewildered, they let Gorky pick a Cubist still life for $100. Helen confessed she 'hated it'. 'If only we'd known he was starving. But he was so fine, he often refused to eat.' Once, on a walk in Central Park, they came across him painting rocks and trees. Helen expressed surprise that he could paint such lifelike pictures.

'You like this?'

'I love it,' she replied, preferring it to their abstract.

'It's yours.'

Gorky was thirty-two years old and still living alone. His greatest complaint to friends was not poverty or lack of recognition, but loneliness. No one had replaced Sirun. If he could not find the ideal woman he would paint her, invent her from his desire. A work evolved with the wishful title, *Portrait of Myself and My Imaginary Wife*.

The small painting is unusually short and very wide, $8\frac{1}{2}$ by $14\frac{1}{2}$ inches. Gorky started it on a scrap of cardboard. A self-portrait in sombre, greenish

tones, head hanging, eyes downcast, is painted in a different plane, from a buxom woman with an oval face, large dark eyes framed by bold eyebrows and dark hair scraped back over the forehead and caught at the nape of the neck. The vibrant and fleshy woman's face, in ochre and earth tones, contrasts sharply with the sickly pallor of the man's head, larger and more geometric, alluding to Picasso's African-inspired portraits, especially *Tête de Marin*, 1907. As in his mother's portrait, Gorky painted her light against a golden background, and himself dark, with a monumental face, burnt sienna on a livid green, dark tonsure-like hair in flowing Gorky arabesque, more pliant and graceful than the *Marin*.[13] He hangs his head like a man condemned to death, looking down into Hades. The melancholy painter seems to have lost hope of contact with his surroundings, while a young woman in full bloom appears unconnected to him. Gorky's sense of alienation and distance from women is the hidden theme. His longing for a wife could not conjure up a real one.

In immigrant families the photo bride or groom was common. And when families were separated by physical distance or even death, photographers joined pictures together to form a fictional group whose members could never meet in reality.[14] Gorky had resisted such falsification by severing his father's photograph from his mother and himself. Now he inserted a woman's portrait next to his own – his painted bride was won by collaging two separate portraits, the Picassoesque artist with the Corot woman.

Gorky missed Vartoosh and picked other sitters from his family. Akabi, with her handsome features and glowing skin, gave him a magnificent portrait, which he called during his lifetime, *My Sister, Ahko* (later *Portrait of Ahko*). It is close in feeling and conception to the *Imaginary Wife*. Since it escaped the fire, it was either begun early and taken by Gorky to his studio, or painted after the fire, probably in 1934. Libby had no recollection of her mother sitting for a portrait. Years later Gorky was to sign and date it 1920. Youthful allure in the freshness and posture suggest that Gorky painted her when young. With a white garland in her hair, the regal balance of her head, and huge, expressive eyes, he conjured her up as an Armenian princess in his favourite colours: warm apricot and earth tones, fresh green and light sienna, glossy black and deep terracotta.

Gorky kept a photograph of his sister, taken from 1918, from which, I believe, he painted a very different portrait. The classical pose of her face in three-quarters to the camera shows the clean line from her pronounced

cheekbone to her strong chin, dark eyes, long straight nose and generous lips. The second *Woman's Head* is very like the photograph. The face tilted slightly forward in profile, the hairline swept back, a shadow above her eyes and under her nose are all faithful to the photograph. The colouring of the work is similar to the other portrait with her orange to terracotta dress and warm tones. The portraits share the vibrant colours of Gorky's early Cézanne-inspired still lives, particularly *Pears, Peaches and Pitcher* (1926–27), unlike his portraits of Vartoosh in cool greens, reflecting the sitter's melancholia.[15]

During the summer of 1934, he camped in his sister's porch in Watertown with canvas and brushes. His friend Kooligian sat for three separate portraits. 'He used to come down every summer and paint for a month, then he used to go back to New York.' Yenovk Der Hagopian, John Hussian and Khatchadour Pilibosian kept him company. Gorky relaxed in the camaraderie he missed in New York, for he was still one of them: as Koolikian observed, 'He was a common man.' Gorky entertained them with impersonations of New York art events.[16]

'Rr. e. d, rr.e.d. rr.e.d. Gl.o. o.w w, gl. o.w, gl.o.w,' he intoned in imitation of Gertrude Stein.

Hussian and Yenovk were conventional painters and argued hotly when Gorky maintained that there was no point in doing realistic work which a camera could do better. He silenced them by grabbing a palette knife, whipping on some colours, to turn out a painting in three minutes without a brush.

Around this time the shocking news came that Vartoosh and Moorad wanted to leave Armenia. Could Gorky find a way of getting them back? Their repatriation had coincided with the most volatile and dangerous period. During the two years, 1928 to 1930, collectivisation of agriculture and rapid industrialisation had created an upheaval in population redistribution. Armenia was ending market economy to start on the centralised state-driven economic development. Moorad travelled to the far reaches of Armenia, Zangezour, and saw the havoc wreaked on the efficient peasantry who resisted losing their lands and livestock. They fought the Soviets and slaughtered their own livestock rather than give in. Moorad saw poverty and the inefficiency of the state-enforced system. Enforced collectivisation had produced severe food shortages in Yerevan. A sinister change had transformed the artistic elite. Writers and artists' unions imposed

the official line. When Stalin imposed his Five Year Plan, he summoned the artists to Moscow to announce tight new decrees. In a new mood of militancy, emphasis on proletarian art was prescribed in all the arts. A fearful period of treachery was unleashed as former friends and associates denounced one another.[17] In the 1930s the Soviet Union became highly centralised and any autonomy in Armenia was lost. Vartoosh realised that either in Yerevan or in Moscow, Gorky would be clapped in jail. It was lucky that he had stayed behind.

Gorky's reputation as a leading modern painter drew young artists in New York. As he sat one evening in a small cafeteria on 5th Avenue and 14th Street, older artists surrounded him. David Burliuk was the most prominent with his gypsy earrings. Gorky was recommending the classical method of working directly from the masters in museums. In the thirties, self-expression was the goal, and few cared about old masters.

A stranger butted in from a nearby table, 'I have copied from fifteen masters in the Metropolitan Museum and at the Lennox Collection of the New York Public Library.'

'Oh, have you?' replied Gorky. 'And which ones did you copy?'

'Claude, Rembrandt, Constable, Corot.'

'Good, but you would have learned more from Poussin, Ingres and Cézanne.'

The young man's name, Khanian, sounded Armenian, and was later changed to Jacob Kainen.[18] A 24-year-old painter, he was thrilled to meet Gorky: 'John Graham, Stuart Davis and Gorky were generally recognised by alert artists as the Magus figures in the New York art world. I wouldn't have dreamed of missing an opportunity for association.'

Gorky saw his work on 14th Street and University Place, and gave friendly advice in what Kainen thought was a unique English, switching 'he' with 'she' because Armenian grammar has no gender, omitting definite and indefinite articles. He spoke in resounding paradoxes about the importance of the physical and tangible in paintings, telling Kainen he should get the forms flat, while preserving a sense of mass and volume. Above all, the artist should trust his subconscious.

To Kainen's delight, Gorky asked him to pose. The dark and ramshackle stairs, the black door, were no preparation for the shock of

entering Gorky's vast studio. 'The first memory I have is of the now famous self-portrait of the artist with his mother, unframed, facing me on the distant wall. It exuded a noble, matriarchal calm that seemed to fill the large, clean, well-lighted studio.' From his alcove stuffed with canvases leaning against the wall, Gorky selected one.

'Whose work does this look like?'

Kainen stared at Gorky's *Still Life with Skull*. 'Cézanne!'

'Right!' The artist did not seem displeased and pulled out another. 'Matisse's *Still Life with a Greek Torso*,' with different colours and composition. Again Gorky was pleased.

He posed Kainen in a chair, chin in his left hand, approved his neutral jacket and tie, readjusted the pose. A far cry from the elegant ladies in expensive evening gowns of the twenties. At the end of the session, he left the canvas to dry for a week. Kainen was dumbfounded: 'Gorky sanded down the newly dried surface and applied almost identical colours. By the next week, Gorky would sand it down again and apply another layer of matching colours. This procedure continued until the final eighth pose.'

Gorky sanded, scrubbed, and sighed, 'I want surface smooth, like gla-a-ss!'

Kainen was alert:

Density in painting is very important. He believed in painting layer on layer, refining relationships of colours and shapes and implying a kind of subterranean life for each colour. A dark blue in a Cézanne painting appears solid as a rock, but that final colour and texture can only be achieved through having certain colours underneath. The practice of overpainting also made the edge of the paint areas firmer, more sensitive, more crucial.

Sometimes he found Gorky on his hands and knees making drawings for the *Nighttime, Enigma and Nostalgia* series, and observed his pen and ink technique. 'He would cross-hatch, but it's very difficult to copy his cross-hatch method. Rough but very precise. The line is very fine, but I don't get his insouciance.'

For two months Kainen sat. They sometimes walked together and Gorky pointed out 'texture and pattern on mud-spattered walls; surprising colour combinations on painted surfaces worn by wind and rain; cracks and other vicissitudes on pavements and curbs. Rooftops fascinated him, especially the

hooded tin spouts angled menacingly.' Gorky bent his wrist to imitate the angle and spread out his fingers.

'Look, they're ready to jump.'

His imagination animated the objects, transformed the world around him, 'finding resemblances between the raw materials of everyday life and the raw material of his imagination'. Gorky even noticed a drinks stand, 'a marble-fronted Neddick stand, a mottled broken mosaic of orange and green, the unreadable remnant of a painting of oranges fringed with green leaves'. Gorky swept back to the kerb to get a better view, swooped down and passed his hand over in the painter's gesture without touching the surface.

'What chexchures! What chexchures!'

Kainen's last view of his portrait was 'the crisp dark curve of the hairline and the flaring lapels of the jacket'. Unable to pay his model, Gorky shyly offered two drawings, one from the *Nighttime* series, never knowing whether they would end up in a dustbin. For Kainen they were a marvellous gift.[19]

In New York, that autumn brought to a head many issues and conflicts. Differences between more radical communist artists and conservatives were polarising. In the year since Hitler became chancellor of Germany, Nazi blood purges had begun. Opposition to Nazism galvanised the labour movement involving the artists. Relief programmes employed greater numbers of artists. The Unemployed Artists' Group became the Artists' Union. By the end of 1934, unionising on the New York model had spread nation-wide and local artists' groups had formed in sixteen cities. The Artists' Union own journal, *Art Front*, edited by Stuart Davis, first appeared in November 1934 to 'unite all artists engaged in the practice of graphic and plastic art in their struggle for economic security and to encourage a wider distribution and understanding of art'.

This was the sticking point in Gorky's dispute with Davis. Already artists were encouraged to think of themselves as 'cultural workers'. Did this mean that they would take orders from their employers? Gorky disagreed over thinning down artistic content in 'art for the masses'. Although Davis was adamant in defence of abstract art and Cubism, he was caught in the dilemma of pushing through a political agenda, neutralising opposition from outside, and trying not to compromise. But Gorky's main activity was making art, and he could not be diverted to sitting on committees and

organising. Davis wrote: 'I took the business as seriously as the serious situation demanded and devoted much time to the organisational work. Gorky was less intense about it and still wanted to play.'

One day Gorky gave a lecture at the Artists' League. Frustrated by the dictatorship of mediocrity, he addressed the question of art and the importance of pursuing high standards. While others raved about Rivera and Siquieros, Gorky praised Pierre Puvis de Chavannes, the flatness of his murals and his wonderful treatment of walls. His militant audience wondered who Puvis de Chavannes was. In full flow of passion, Gorky attacked the grim paintings and murals going up by order of bureaucracies and committees, and denounced them in a resounding sentence which split him from the left for ever: 'Poor art for poor people!'

Gorky's phrase summed up the patronising attitude of the right and the manipulative propaganda of the left. 'Poor art for poor people' reverberated around New York to become a stock phrase. Some used it as a weapon against Gorky; others agreed. It was the final blow in his disagreement with Davis and marked the end of an important friendship.[20]

PART III
FLYING
1934–40

23

Happy Tappy Girl
1934

One evening Gorky spotted a young woman standing before his painting for a long time on the opening night of a group exhibition of 'the dull sort'. She was transfixed by 'a powerful abstraction in violent and magnificent colour', unaware of the artist at her side.[1]

'You like it?' he asked.

She turned around and he saw a beautiful face. 'Oh, yes! This is the first *real* painting I've ever seen.'

'Would you like to see more?'

He showed her his work, and she stared at the black and white ink drawings tacked to the walls in preparation for his mural.

'What magnificent forms,' she said.

'You don't ask, "What are they? What do they mean?"' For Gorky, 'love my painting' meant 'love me'. He was bowled over by the tall young woman. Marny George had come down from Seattle in 1933 to study art. She complained that teachers had only taken her 'up to Cézanne' and made her draw from plaster casts. With her radiant complexion and beautiful body, she soon found work as a model in a department store. About fourteen years younger than Gorky, she saw him as a romantic, handsome figure, commanding attention wherever he went. He was fiery and his charm had an irresistible edge of danger. Gorky had no money, so they went for long walks through the Village. He talked in pictures, explained art, even the cracks in the pavement. Marny thought him a hero from another time and place. He sent her a poem with a gardenia tree and repeated to her, 'I am a poet!'

He introduced her to his friends. Mischa Reznikoff was sceptical:

This Marny was a typical happy tappy girl. I thought to myself, Ah ha! This is wrong! What fascinated him about her? She looked exactly like that period of Picasso when he had taken off the walls of Pompeii, women with big rubbery looking fingers and all blown up classical faces. I'm positive that's why he fell in love with her. She had a big handsome figure. Tall and voluptuous.[2]

She incarnated a physical ideal, although Busa thought, 'He was always good at proportions. We'd bring our girlfriends to size them up.' But with Marny he was serious. Gorky wrote to Vartoosh in Yerevan that he was getting married.[3]

In optimistic mood, he designed his mural. His work was shown at the Guild Art Gallery and he was about to have a one-man show. He had been miserable on his own, and now at last a perfect Picasso model had materialised in his studio. He did not know that she was also going out with her boss's son. At dinner, in their Park Avenue apartment, decorated with Italian Renaissance paintings, she asked why they had no work by living painters. Later, at a charity skating show in Madison Square, she sat in their $100 box, suffocating in furs and orchids.

The next evening Gorky took her to the same show, but they sat in gallery seats. With him, she felt the show spring to life. She observed 'the rhythm and flow of the movement on ice'. He drew on the programme, quick rhythmic sketches. She was sure that if he had been wearing a white shirt, he would have covered it with drawings too. Gorky had loved skating since childhood and was enchanted. That was the night Marny realised she would marry him, 'whether I wanted to or not'.

They had little in common except physical attraction and a love of art. She confessed, 'From the first, I was attracted and repelled. I had rushes of passionate feeling. I wanted to be a "buffer" between this strange lonely man and the indifferent, materialistic world.' One night over dinner with Mischa at Ticino's, Marny picked up Gorky's pen and wrote on a breadstick, 'I would like to be Mrs Gorky.'

On a moonlit night crossing the Brooklyn Bridge, Gorky proposed.

The next day, in a whirl of excitement, he bumped into Mischa. Gorky was coming out of a Russian gift shop, Kafkas, on 8th Street, his hands full

of little packages wrapped in white tissue paper. 'Look, here are my grandmother's jewels!' He unwrapped bracelets and pins. 'I'm getting married!' An Armenian bride would be offered gold jewellery, but he could only afford papier-mâché.

For the next few days he dizzily planned his wedding, setting aside two days for scrubbing and cleaning the studio. He invited friends to a party the evening before the wedding. Prohibition was still in force; Gorky was broke. His closest friends were mobilised. Mischa and Stuart Davis contacted a bootlegging Irish meter-man who found some alcohol. They went down to the East Side to buy fruit and vegetables, 'anything to squeeze into the alcohol'. Mischa arranged them. 'Beautiful colours. Beautiful carrots, cabbages. He had a round table, we piled the stuff.'

His friends were stunned. It was rumoured that the couple had only met ten days ago. The Sandows felt awkward at this odd gathering; Helen was disappointed in the bride. They talked to the Janises, and left early. Gorky was sober at first, then the Prohibition hooch went to his head and he flew about, talking non-stop. Mischa recalled:

> He was raving. How beautiful she is! How fertile he'll be through these vegetables. He made a speech. The girl got loaded in no time. No people like parents there. We drank this bloody alcohol. She started playing around with Stuart, not too obvious. 'Come on, say something.'

Gorky stood up and said: 'I cannot permit my wife to be a bathtub gin-drinker.' The friends took a hint and left.

The next morning at City Hall, the Janises stood up for Gorky, then invited the newlyweds to a champagne breakfast. They thought Marny was engrossed in Gorky and he was very much in love. For their honeymoon, Gorky took Marny to his friend in Philadelphia, Bernard Davis, where they went skating.

Back in Union Square, the story changed. If Gorky expected his new wife to turn into a copy of his capable sisters, he was in for a shock. She was completely undomesticated. He had to do all the cooking on a wood-burning stove. She said:

> It seems the very moment we were married the battle began. Arshile tried to break the barriers, first with tenderness, then with force. But barriers grew in

direct relation to the violence. It was a tragedy for us both. We loved and hated with equal violence.

She remembered Gorky describing himself as 'ferocious as a giant, tender as a little child'.

Gorky had painted his small windowless entrance hall black. When the landlord knocked, he could peep through a crack in the door to see who was there without being spied. He and Marny holed up. He refused to have a telephone. People sent telegrams or stuck notes under the door. When she turned the radio on, he switched it off.

They had little or no money. He gave private lessons, and she thought someone was paying the rent for him. They scraped for food yet 'he could never pass by an art supply store without emptying his pockets and coming home with new tubes of paint and brushes'. Gorky could not understand her desire for material things, any more than she his surrender to the dictates of painting. They had reversed the first phase – 'Love me; love my painting.' She slowly realised that his painting was his primary passion and she fought back.

'He wanted to form and mould me into the woman he wanted for his wife.' Her memory was that they fought and fought and did not leave the studio for six weeks, that she nursed him through flu, then felt an overwhelming sadness in him.

'We never change,' Gorky told her.

She felt homesick for her parents. He hoped that by going home, she would be able to make a decision. When she returned, he told her, 'It will take you ten years before you understand me.'

Then a letter arrived for her with a fake return address. Gorky read that a former boyfriend wanted to know why she had rushed into marriage. Was it to make him madly jealous? He hit the roof, rolled up her clothes while she slept, crammed them into suitcases and dumped them outside the door. He woke her up.

'Now get dressed and get out of here!'

Helen Sandow tried to comfort him. She had found the girl to be shallow. 'He can't have known her well and she couldn't have had much sense to a marry a man she hardly knew.' He explained, 'She reminds me of my mother.'

His friends thought him impossibly naïve. Gaston de Havenon, the

worldly Frenchman, reproached him for idealising women, conducting love affairs with poetry and jewellery, like a *fin-de-siècle* novel, in the New York Depression. To romance a girl, he needed money to buy her dinner. Gorky retorted again that he was a poet. Mischa thought Marny a sorry attempt to replace Sirun, and believed that Gorky never really cared about any woman after her. The practical Saul Schary expostulated, 'Gorky, why the hell do you marry a girl like that for? Why don't you get a nice Armenian girl who'll love you and take care of you? You shouldn't marry these American girls.'[4]

When Gorky asked for a divorce, he discovered that Marny was a minor and the marriage could be annulled. In the *catalogue raisonné* of Gorky's paintings, one entry has the provenance Mr Herman A. Greenberg Collection. He was the lawyer who prepared the papers for Gorky's annulment. Gorky gave him a *Still Life*[5] for carrying out the legal work and he must have rated the painting highly, for he possessed another version of it. Gorky copied only paintings he valued. He had given away an important painting to undo his bungled marriage.

On 24 December 1934 Vartoosh and Moorad arrived in New York on board the German ship *Bremen*. With the help of his friends Mrs Metzger and Bernard Davis, Gorky had managed to secure papers for his sister and brother-in-law to re-enter. It was the end of a dream. Gorky was amazed to see his sister heavily pregnant, radiating a steely triumph.

On Christmas Day 1934 the reunited brother, sister and husband sat in the studio at Union Square. The couple were too embarrassed to face the family in Watertown after their boasting about Armenia. They had never been able to write freely because of censorship, despite the thirty letters they had exchanged. At first the Mooradians had been overjoyed in Yerevan. Their cousin Ado was a big wheel in the Party, aid to Aghassi Khanjian, first secretary of the Central Committee. Although Gorky's father had sent young Ado money for a passage to America, he had refused to leave the Komsomol and his country. He had gone to work in Moscow in 1934. Gorky was delighted to hear about Ado's success; his brother Azad, an engineer, was setting up electric power stations. Vartoosh showed photographs of herself in uniform snuggling up to her handsome strapping young cousin Azad. Moorad's consignment of Ford engines was handed

over to the Cheka but he was not rewarded with an important post in the Party. He and Vartoosh were sent to university for indoctrination in Marxism and Leninism.

Anyone receiving letters from America fell under suspicion. The family had worried about receiving Gorky's letters. One recent immigrant had arranged a code with his family abroad. He would send back a photograph of himself, standing upright if life was good, and seated if it was bad. The photograph finally arrived; he was lying flat on his back.

Gorky too had worried about receiving letters from the USSR for the FBI might suspect him of being a subversive. He was shocked by their accounts of repression, summary arrests and suppression of writers and artists. Vartoosh told him that he would not survive, although Ado pressed Gorky to repatriate. Only idealised paintings of rosy-cheeked workers on tractors, and fatherly portraits of Stalin, were exported. Vartoosh and Moorad just managed to escape before the Iron Curtain, as it would later be called crashed down on them. One month later they would not have been allowed out.

Vartoosh was appalled by Gorky's appearance, very thin and run down, and noticed that he constantly scratched his eyes. 'He had little mites in his eyelashes. I got an ointment from the doctor and cleaned them out.' Indeed there is a self-portrait of Gorky which may date roughly from this period (although it is generally dated a little earlier), where there is a red, unhealthy look to the rims of the eyes.

Moorad and Vartoosh had no money. They had left with debts in Watertown. Moorad had blotted his copybook and could no longer go back to his old job at Hood Rubber. They feared that the FBI had filed them as radicals and subversives. Gorky might be tarred by the same brush. They were poor and crushed. Gorky had the added worry of helping Moorad find a job.

Vartoosh's mysterious pregnancy was not mentioned. Before going to Armenia, she and Moorad had been unable to conceive a child. As her delivery date approached, Gorky pressed her to stay with their sisters in Boston. Akabi was a midwife who could care for her at home. Vartoosh was a woman of unbending haughtiness. She was defensive with her sisters now, and was reluctant to eat humble pie after bragging about Armenia but she had no choice.

On 25 March 1935 she gave birth to a large, healthy boy. To the amazement of the family she did not choose an Armenian or American

name; she called him Karlen. Several generations of children all over the Soviet Union had been given such composite names combining Karl Marx, Lenin and Stalin, but it sounded weird in America and signalled her loyalty to a regime she had abandoned.

Many years later, Gorky's relatives in Yerevan, Azad, handsome and elegant at eighty, and his sister Beatrice, remembered the period in 1934 when Moorad and Vartoosh had stayed with them. Moorad had gone to Riga for their release papers, leaving Vartoosh alone. Her cousin interrupted my interview: 'Why don't you tell her the truth? She's come all this way to find out.' Azad, Gorky's cousin from Khorkom, revealed:

> Vartoosh came to Armenia to get pregnant. Moorad could not give her a child. She met a childhood sweetheart from Van. That's when she became pregnant. I got such a shock when I saw Karlen the first time! So tall and handsome. The living image of that man. I saw him not long ago in Yerevan, still a good-looking man, still tall, a real Vanetzi.[6]

Perhaps Vartoosh confided in Gorky, and perhaps she didn't. In any event, her son would spend a lifetime trying to legitimise Gorky.

24

A Driving Force
1935

At the beginning of 1935 Gorky's poverty was dragging him down a spiral of ill health and despair. When Lloyd Goodrich, a curator at the Whitney Museum, visited his studio to select works for an exhibition called *Abstract Painting in America*, he found Gorky very busy. Goodrich was conscious of Gorky's leadership of the abstract painters. 'He had his own opinions and liked to express them. I always found him very warm and if you liked something, he was delighted that you liked it.'

They chose four paintings: *Composition no. 1*;[1] *Composition no. 2*; *Composition no. 3*;[2] and *Organization*.[3] Gorky's standard titles, also used by other modern painters, did not distinguish the works or make them memorable. Only two have been specifically identified, dated 1927 and 1929. Again, older, safer works were picked. Gorky signed and dated an abstract still life on a table top, and a more curvilinear composition, gathered around the motif of a bird with outstretched wings, tied into interlocking shapes and planes.

At this time, Gorky, Stuart Davis, John Graham, Willem de Kooning, Edgar Levy and Mischa Reznikoff formed a tightly knit group of artists who spearheaded the Abstract Movement, stipulating to the Whitney that they would only appear as a group. However, Davis and Gorky alone were shown on this occasion, which caused some ill feeling. Goodrich argued for Gorky: 'Few painters were doing abstract work – Georgia O'Keeffe, Arthur Dove, Arthur B. Carles. There were no more than ten of them. De Kooning was not known at this time and very influenced. Gorky was far better known.'[4] For Gorky to exhibit at the Whitney with Davis reflected

serious recognition. The art historian Meyer Schapiro emphasised that Davis had enormous respect for Gorky's work. The exhibition, from 12 February to 22 March 1935, maintained the edge of abstract painting against the American Scene. Polemics intensified as the latter gained ground, backed by the Works Progress Administration.

Artists fought against hostile museum officials, even at the Whitney.[5] In the Museum of Modern Art, Alfred Barr operated exclusively in favour of European moderns, ignoring the abstract Americans. Davis, Gorky and Graham were at the head of a large group battering those gates. During the exhibition Goodrich held a symposium, taking 'a rather more detached view of abstract art than the others did'. Gorky, towering above others, spoke convincingly with reference to both classical and modern art. In order to expose Goodrich's intrinsic conservatism he demanded, 'How do you reconcile your view about abstract art with the music of Bach?'

This line of argument was too sophisticated for much of the audience. Goodrich admitted he too was out of his depth; 'At the end Gorky stood up and questioned me. I did not answer very adequately.' Later he was to say, 'He had the ability to see the abstract in art of all periods, to see in Vermeer's work the same principle of abstract design as he did in this own period. He had breadth of understanding.'

Since the Whitney show, other exhibitions were planned, and Gorky rallied artists into a cohesive group but he did not use ideology as a binder, merely the need of unemployed artists for exhibition space. His passionate belief in the primacy of the artist's work inspired others. Max Schnitzler, a neighbour, visited him, feeling undermined and miserable, and received encouragement: 'Max, keep on painting. Keep on painting!' 'He had a very great influence on us,' Schnitzler said. 'We respected him very highly, because he was the driving force in those Depression years. Despite hardships, he had that driving spirit.'[6]

In April 1935 the First American Writers' Congress of Communist Party Writers, in conjunction with the *Partisan Review*, assembled all anti-capitalist writers.[7] Stuart Davis, secretary of the parallel movement, launched the First American Artists' Congress in the Town Hall and the New School of Social Research, with Meyer Schapiro and Rockwell Kent among the speakers. Schapiro attacked racism in 'American Art':

We have many appeals for an 'American Art' in which the concept of

America is very vague, usually defined as a 'genuine American expression' not 'explicitly native art' and sometimes includes a separation of American painters into desirable and undesirable on the basis of Anglo-Saxon names.[8]

Schapiro argued that art should shun nationalism. In years to come, however, the question of American art would become the dominant issue. Schapiro pointed out that Gorky had stayed away from all the activities of the congress.[9] Instead, he returned to Philadelphia for another one-man show of pen and ink drawings at the Boyer Gallery. During the course of the exhibition he lectured on abstract painting.

A photograph taken there became the best-known image of the artist. He sits enveloped in a black coat, with black eyes, black hair, a wing of black shadow on the wall behind him. His face has widened and tapers to a strong chin, with a straight nose and a large moustache. His broad forehead is flicked by straight dark hair. The haunted boy has not disappeared. But the photo bears out his friends' claims: 'He was a very, very, very impressive-looking man with wonderful hands. The largest hands I ever saw. Magnificent. Virile and masculine.'[10] The triangle of his face and head balance the dark mass of his body, with the triangle of his interlocking hands lightly off-centre. He perches on a stool, fingertips touching, 'Very saintly, but not gothic.'[11] Unshaven face, uncombed hair and exposed long wrists without shirt cuffs suggest he was wearing rough clothes underneath. Despite his tough-guy physique, a sense of fragility pervades. He is a man ready for action, mature, but still trailing ghosts of his past.

The exhibition at the Boyer Gallery proved a loss. Dorothy Miller claimed, 'That awful man named Boyer stole a great many drawings from him.'

By July 1935 Gorky's friends Holger Cahill and Balcomb Greene got him to sign up with the Emergency Relief Bureau for the Works Progress Administration/Federal Arts Project.[12] Roosevelt was pushing through further legislation for the New Deal and to create Emergency Work Relief. Five million dollars would be voted to the WPA. The artists must prove that they were paupers to inspectors who came to check. 'You had to show five months' non-payment of rent, show them your larder . . . and then your case was brought up to committees and investigations to make certain you didn't have a hoard under your mattress . . .'[13] Gorky was entitled to $24 per week.

In August 1935 the WPA was formed; Cahill became national director. Gorky breathed a sigh of relief at being placed in the Mural Division where he could complete the nine-month mural project on a salary, however meagre. The Public Works Aid Project was to supply needy artists with a wage and employment in their specialised field. It employed professionals in photography, theatre, film, dance, with specific sections for sculpture, easel painting, murals. They were to be painted all over the country in public buildings, libraries, post offices, court houses and state buildings under the 1 per cent of funds for construction set aside by the government for the artistic enhancement of the building.

Gorky celebrated his pay cheque by making dinner for his friends the Janises and the Cahills. He lavished his efforts on the meal. 'He spent two days preparing,' Dorothy Miller, now married to Holger Cahill, recalled. 'They were marvellous Armenian dinners. He'd do stuffed vine-leaves and shish-kebab. He had a tiny, terrible old stove and he had spits and he would put them under the broiler.'[14]

He talked of many interests outside art, but she never heard him discuss politics. They often discussed the *Partisan Review*, Surrealism and French poetry, which he asked friends to translate.

The large-scale mural needed a firm underpinning and construction. As if in preparation he had been working on *Organization*, a huge canvas which had taken a long time. In the mid 1930s, Gorky entered the most thorough process of abstraction. He needed scaffolding for his organic shapes which materialised as a transformed Mondrian grid. He emphasised the importance of design and form, planning and designing the canvas: 'Only two or three shapes! Don't put in so many shapes.' He had pushed himself through a painstaking analysis, taking apart Picasso's *The Studio* (1927–28). He was finding his own solutions. He traced isolated shapes from his Uccello photostats: a horse's shank, a soldier's foot, a lancer's banner. He showed De Kooning and others how to collage them into a composition. His self-motivation never flagged, as Schnitzler noted: 'I saw him many times standing before his canvas in his studio with a poker face. He didn't want doubt instilled into anybody. He fought it, he burned up his doubts on his canvas in two or three minutes. He believed in his work and he encouraged us.'

Gorky needed greater simplicity and security in his life. He brought a new connotation to the title, *Organization*. In the changes of balance and

veering diagonals which he substituted for the more static vertical and horizontal structure of Mondrian, he expressed his emotions. He cantilevered the balance of diagonals. The fundamental differences between his canvases and Picasso's is a greater interest in the painterly qualities of colour and surface, although he could turn out 'a Picasso' to amuse his friends. Gorky metamorphosed his cryptic symbols – circles with centred eyes and a black three lobed-form in the centre which could be a palette, a heart or a liver. Gorky still referred to himself as 'the Black One'.

Different versions of *Organization* were documented by two photographs taken at different times, charting its progress. In one of the photos, Gorky in the studio has slung an arm over the shorter De Kooning, next to an early version of the work. On the easel is propped up a small painted fragment, the cross-section of an apple. By stretching the top left-hand curve of the apple, the 'black heart' could easily have evolved out of its core.

There were few women artists at the time. Gorky knew Louise Nevelson and he developed a close relationship with her friend Anna Walinska, whom he had known since the Washington Square days. Gorky was very fond of her old-fashioned eastern European ways. He introduced her to his friends: 'Meet Anna Walinska. The only woman I have never kissed!'[15] In October 1935, Walinska organised a group show in her new Guild Art Gallery on 37 West 57th Street, with pride of place for Gorky's handsome *Greek Torso*. The *New York Times* wrote on 13 October 1935: 'Archile Gorky's handsome abstract decoration . . . may be said to dominate the show.'[16]

Walinska was tall with a powdered white face framed by dark hair. Gorky knew her so well that he painted her head from memory. She had been to Paris; she had seen important private art collections as guest in Vienna of Karl Kraus, the editor of the *Circle*, an influential journal. She had met the composers Arnold Schoenberg and Alban Berg, and modern painters. Gorky respected her judgement, for she could identify an old master from a drawing, and she in turn admired Gorky:

He was full of a rich, warm, manly, serious enthusiasm about life and work. There was no question about the importance of art and what he was doing and how he felt about the other artists and the art world. It was easy to feel

alienated at that time, Americana, flag-waving. He would come up and spend time with my Jewish family. He seemed to be a family man.

Walinska's salary at the Federal Art Project paid the rent of the gallery, which she ran together with her partner Margaret Le Franc, also a painter. They would show the best modern and abstract painters in a guild fellowship, without taking commissions from the artists or advertising.

During the same month as her show, the Museum of Modern Art was exhibiting Léger. Gorky told her about his admiration: 'Léger was one of few artists who reconciled the figurative image, the breaking of space and colour and the line – that linear element ties them all together.' On visits to museums, Walinska saw a different Gorky from those who thought him arrogant: 'I loved that beautiful humility. He approached them as masters. His gesture, his eyes, the enthusiasm – to stand in front of a great painting, raise his arms to heaven, as though what else could take its place? He didn't copy Picasso. He really painted Picasso.'

They planned his one-man show, sifting through the drawings over several evenings. They focused the entire exhibition around fourteen drawings and four paintings with titles redolent of De Chirico: *Enigmatic Triptych*; *Nighttime, Enigma and Nostalgia*; *Composition*; *Detail for Mural*. The Pierre Matisse Gallery at this time also had an exhibition, *26 Works by George de Chirico*, which Gorky visited.

In the autumn of 1935, at the Guild Art Gallery, he was visited by his teacher and friend from Boston, Ethel Cooke: 'He looked wonderful. He was wearing a three-piece suit. Very well dressed. I think he had a slight moustache. All the paintings in front of him, all in a row. He asked me to criticise them.'[17] Miss Cooke was bewildered that they all seemed to be 'on the same theme, down the line'. She asked him to explain them. The idea of dealing exhaustively with a theme from its figurative conception to complete abstraction was unusual. It highlighted Gorky's total commitment to a conceptual process, his interest in developing ideas rather than perfecting a single polished work to be marketed and sold. He designed the show around a theme and a concept, which only years later became a fashionable method of exhibition planning. Walinska reflected:

Drawings are the closest to an artist. I think he has greater authority. I rarely see paintings by De Kooning or Pollock in which I think the expression is

inevitable and cannot be changed. With Gorky you do have that feeling. It has been painted and there is no question about it. De Kooning used a line which was Gorky's and those are De Kooning's best.

She referred to the *Black on White* paintings De Kooning would do years later.

On 24 November Gorky gave a lecture, 'Methods, Purposes and Significance of Abstract Art', at the gallery. Gorky in his three-piece suit, handsome and imposing, talking fluently about his ideas and work, made Walinska feel proud. 'He wasn't nervous. He took it very much in his stride.' She said, 'We sold one Gorky to an eccentric art collector, a founder of the Museum of Modern Art – one of the *Nighttime, Enigma, Nostalgia* drawings.' The buyer was Katherine Dreier of the Société Anonyme, a powerful force in modern abstract art, a painter, collector and a champion of Duchamp. Gorky received a good notice in the *New York Post*, 21 December 1935: 'These are not simply studies, but complete large-scale compositions in black and white and skilfully elaborated with a result in the ensemble that is brilliantly effective.'

Gorky included the torso in Venetian red, hinting at the anatomical sources of the seemingly abstract drawings, on which Walinska had seen him 'working with a heavily loaded brush. At one time he was working with the palette knife. He created with a smooth surface, including this torso, the paint with the palette knife and smoothed it out like it was a flat wall.'

'Lift that!' he exclaimed. 'How much do you think it weighs? You see that spot of cadmium red? That spot cost me thirty dollars. That spot.'

Walinska thought, 'He was in love with the *matière*, the quality of the paint. From there to the end where everything is in air and spirit and the paint is a touch.' Artists flocked to see the black and white images looming out of the dark. No New York artist had attempted such an avant-garde show. De Kooning reflected, 'He was the general.' And the sculptor Philip Pavia: 'Gorky was our leader.'

After the show, Gorky was stepping out with a six-foot beauty. When Mischa suggested she was 'the perfect match', he retorted that she had big bunions.

'She's a good-looking girl,' Mischa argued.

'Hell! I don't like bunions.'[18]

Gorky's attitude changed when Mercedes Matter appeared. She was the daughter of Arthur B. Carles, the veteran Cubist painter whom Hofmann had praised along with Gorky. A lot of men ran after Mercedes and she flirted with them. Gorky liked her verve and switched into his Pygmalion role. 'The thing that drew me to him was his total obsession with painting, like my father. That meant more to me than anything,' Hofmann's student later explained.[19]

Gorky, now in his early thirties, had again developed a crush on a girl more than ten years younger. This one, he felt, instinctively understood him. He initiated her into politics, giving her Lenin and Marx to read. She must not be content with mouthing crude slogans. One day she burst into his studio, crying, 'Come on, come on! It's happening! We're going to a sit-down strike!'

Gorky surveyed her calmly and continued dabbing his canvas. She rushed off.

I went to the strike alone. We got beaten over the head and pushed into a police wagon, driven down Park Avenue past the elegant places I used to go. The police of course denied it, even though the front page of the newspaper showed them doing it. In court we gave fake names. Pablo Picasso, Henri Matisse! The judge didn't know the difference.

Every day, Gorky visited her little rooftop studio on 28th Street. He would breeze in singing a hit song of the time, 'Life is just a bowl of cherries'. He was enchanted by her, but she claimed to be in love with another man. He took her to museums and she was keen to talk about art. Mercedes was witty and attractive, educated in art from an early age. She could keep up with Gorky as he quoted Lautréamont and cowboy movies in the same breath. 'He talked about his childhood, almost like chanting poetry, and I didn't know if it was real,' she remembered. 'As we walked, I would look up at the buildings and trees and sky. He looked down at the cracks in the pavement and the road. He would see drawings. He loved lines. Definitely linear.'

He took her to the Frick Collection on East 70th Street, just opened in 1935, in an elegant and beautiful town house. Gorky knew his way around and marched straight past the Boucher Room, Hogarth and Romney, to the North Hall, until he halted before a portrait of a young woman in blue satin

with a cool, enquiring gaze, her hand just below the chin in the pose of Modesty. The width of her skirt was reflected in the mirror behind. 'In front of the Ingres *Comtesse d'Haussonville*, he was gone!' Mercedes remembered. 'He certainly loved that painting. He must have stood for over an hour.'

At that stage Gorky was working purely abstractly and never asked Mercedes to pose. But he announced one day, 'I think you should come to my studio, so I don't have to leave my work all the time.'

She brought her easel and painted near Gorky. Having the woman he loved working at his side was his lifelong dream. His friends thought of them as an item. De Kooning said, 'Mercedes Matter was his girlfriend. She was very much with Gorky. Very good painter too.'[20] Gorky gave advice freely and she sometimes took it. 'Gorky worked from the general to particular and he tried to influence me to work this way.'

She met Vartoosh in the studio; brother and sister performed Armenian dances with Mercedes. Gorky gave her a Russian linen shirt, which she always kept. On more than one occasion Mercedes had accompanied the visiting French artist Fernand Léger on walks around the city dumps and poorer parts of town which he preferred. She and Gorky went too. They took a camera and snapped surreal shop windows and zany shots of one another: dark-haired, slender Mercedes vamping with a hat; Gorky with a cigarette riveted to his mouth in tough pose, like frames from a thirties movie.

His happiness did not last. One day an angry young man in sparkling white sneakers arrived and dragged Mercedes away.

25

Dance of Knives
1935-36

Gorky's mood was volatile in the autumn of 1935. He was to design a mural on aviation and he could think only of flying. A photographer, Wyatt Davis, brother of Stuart Davis, would take photographs of planes for a montage. The athletic Wyatt was a perfect sparring partner for him. In Washington Square, Gorky bet Wyatt he could walk backwards faster than Wyatt could walk forwards, and won his bet. At Wyatt's flat, Mariam, his Armenian wife, made dinner, while she and Gorky chatted. After dinner, Gorky leaped to his feet and picked out two large meat knives. He pushed aside the table, and stood singing and swaying in the middle of the floor. His voice rose. He turned, leapt in the air, swung the knives around his body and slapped his thighs. His black hair fell over his glinting eyes. The knives flashed in the light. Charles Mattox, an artist friend, was horrified. 'It was a wild dance. He was nicking himself. Blood spurted all over the place. He was slipping and dancing in his own blood.'

Gorky, the daredevil, was priming himself for an ambitious project. His *Aviation Mural* was an exciting theme; only seven years had passed since Charles Lindbergh's first flight across the Atlantic. Flying was to the thirties what space travel was to the sixties – adventure at the outer limits of technological possibility. Pilots were like astronauts. Gorky took into account the aerial view and the beauty of forms which made up aeroplane parts. In contrast to the thousands of murals being painted all over America with allegorical themes, American heroes like George Washington and Abraham Lincoln, tracts of landscape, crowds of 'Red Indians' and toiling workers, Gorky decided to have no faces, no figures, no scene painting. He

and Wyatt amassed photos of aeroplanes, wings, propellers, landing gear, fire extinguishers, airport lights – a compendium of forms.

The previous year, the aesthetics of industrial design had been celebrated in a Museum of Modern Art exhibition with Philip Johnson's elegant installation of appliances and machine parts: lights, huge springs, propellers, machines in glossy steel, ceramics and aluminium shown as sculptures of functional beauty. The machine aesthetic was launched in the USA.

In December 1935 Gorky had to complete his sketches. On the WPA/FAP Gorky was paid from December 1935 to July 1937 a total of $2,026.80, a monthly salary of $103.40. His rent for his studio was $50, almost half his pay, leaving him with $53.50 for electricity, food and all other expenses.[1] His friend Saul Schary watched Gorky in the studio and ironically commented:

> The Commies were very much in evidence during the Depression. They went around with an expression: the cat who swallowed the canary! Tomorrow the great white Father was gonna come over from Russia and take over. Stuart Davis was gonna be the Commissar of Art, so and so was gonna be this or that. They were pretty sure of themselves. They started the Artists' Union. To get into the WPA you had to belong to the Artists' Union, which was controlled by them.

Gorky belonged to the Artists' Union and made his large studio available for their meetings and dances, but kept his work independent. Schary pointed out:

> Gorky worked very fast, sure of what he did. He'd do a hundred drawings in the course of a night on one subject. In three days he brought in fifty complete complicated colour sketches. There were a great many malingerers on the WPA – even models got on as artists. When Gorky brought in all these sketches, by God they hauled him up in front of the Artists' Union and raised hell, saying, 'He was ruining the project!' He was showing the others up![2]

Gorky worked on the black and white photos, collaging them into a frieze for the mural. Then he made colour drawings which changed the character of the designs. In the past when students had been stuck he would interrupt them with, 'Come, let's get some inspiration!' Picking up a book of Ingres

or Raphael, he would point to an arm, a horse's shank, parts as complete entities. He exercised his facility in dismemberment on aeroplane parts.

The year 1935 ended on a high note. On 27 December the New York Federal Project Gallery opened with an inaugural show *Murals for Public Buildings*. Gorky's photomontages and gouaches won him a commission from the administrators in the Newark Airport administration building and terminal. The main passenger facility and air-mail terminus of the Post Office, it was equipped with up-to-date aeronautical technology, with thousands of travellers passing through daily.

The regional director dictated that 'photo-murals and mural paintings will be based on the depiction of forms which evolved from aerodynamic limitations'.[3] Next came the imagery: 'early legends and stories of man's aspiration to fly in a romantic period', as subject matter for mural paintings. Gorky was to portray 'the first attempts to build flying machines, through a combination of painted and photo-murals'.[4] Gorky flatly ignored her. He imagined himself airborne. His mural would give the viewer that sensation.

His work fell into two phases. Firstly, the photo-murals provided him with an alphabet of forms. Secondly, after planning the sections, he investigated the engineer's drawing table.

He went with Wyatt to an aeroplane factory, Republic Aviation, Farmingdale, Long Island, where he saw technical drawings for templates and actual-size designs of parts. He studied aerodynamic principles. Rudders and wings in huge mock-ups hung on the workshop walls. Aeroplane parts were wired and connected by systems of cables; wires ran over pulleys to move ailerons and flaps. Gorky had often visualised invisible lines between objects in space. It was a practical application of his imagery, and he delighted in the precision and detail in technical drawings. His mural must convey the physical and mechanical principles of modern aeroplanes. He told Busa, who helped him in the studio, that he 'was very impressed by the beauty of the mock-ups'. He repeated a favourite phrase, 'Anything that's artificial is closer to art. Not the useful object but the useless object.'[5]

Wyatt's photographs of fins, rudders, wings and propellers lay scattered on Gorky's work table. He found elegance in precision engineering and 'made some drawings based actually on lofting drawings'. Fairing, or the addition of a part or structure to the aircraft to smoothe the outline and reduce drag, appealed to Gorky, who argued that Brancusi got a lot of his ideas from these sources. A series of Gorky's drawings from 1935–36

showing rods and wires pulled across the picture space have been attributed
to the influence of Picasso but could be closer to the lofting drawings he was
studying. *Organization*, seen in this light, is a key work, related to the
Newark murals. Busa summed up the method:

> He approached the mural like a natural, a mechanical drawing, like a lofting
> drawing, getting the fuselage and fairing in the lines. Took an aspect of the
> wing and an aspect of the rudder. He used that proportion like Cubists did,
> showing you top elevation, front view and end view. If you see the various
> sections, it's not a realistic plane, but sections which were taken from lofting.

Gorky produced the plane parts as shapes and visual components, but also
to convey dynamic and mechanical principles of fuselage and rigging.
Rather than express forms as static parts, he wanted to show the interaction
of forces that produce lift-off. Although his work was compared to Léger's,
Busa argued, 'The way he approached it was not like Léger. He went about
it like a classical Cubist. He was always taking courses. It was one of the
first principles of Cubism, called "orthographic projection".'

There is no evidence that Gorky had ever flown in a plane, but he
wanted the feeling of being suspended in mid air between the earth and the
clouds, when the horizon itself can tilt and turn, where all frames of
reference of vision become elastic and distorted while huge tracts of land and
cities became mere toys, and speed unlocks the imagination.

His avant-garde design was condemned on all sides. The Mayor of New
York, on opening night, 27 December 1935, could not hide his hostility.
Fiorello La Guardia was a blunt, energetic man with no feeling for modern
art. Busa witnessed the meeting in the Federal Art Project Gallery in New
York, where Gorky presented his plans to the city fathers.[6] Burgoyne Diller,
an abstract artist himself, was keen on Gorky's mural as a showcase project.
The short chunky Mayor looked up at the tall Gorky and remarked, 'Oh,
you look like Stalin!'

Gorky replied with repartee, then explained his murals.

La Guardia exclaimed, 'If this is art, then I'm a horse's ass!' Then he
admitted, 'I am a conservative in art as I am a progressive in my politics.
That's why, perhaps, I cannot understand it.'

Gorky replied, 'Mayor, you know about politics. But I know about art!'[7]

The acceptance of Gorky's mural set the cat among the pigeons. WPA

artists across the country were churning out historic themes and idyllic rural scenes, prescribed by the supervisors who pontificated that art should 'be addressed to the community in general and like the art of all great periods it is objectively understandable'. Only three artists, in New York, dared to paint in a modern style: Stuart Davis, Burgoyne Diller and Arshile Gorky. Gorky was a maverick who kicked at the social realist agenda – 'Art as a weapon for raising the consciousness of the masses' – and displeased the conservatives. In retrospect, Jim Jordan wrote:

> In these large panels he boldly mixed two approaches to picture-making with which he had experimented over the previous years. In the murals, rhythmic, tilting left-right processions of form alternate with centred compositions, where cloud-like shapes float on brightly coloured backgrounds. This combination of geometric and biomorphic, of the sharp-angled with the curved, has broad historical references. Gorky derived the geometric approach from a study of the Cubist tradition; and his biomorphic, curvilinear forms indicate that he had studied Abstract Surrealism.[8]

The year 1936 was to be crucial in the history of artists. Balcomb Greene, who had become a close friend of Gorky, was inspired by Mondrian; as a WPA supervisor, he struggled to employ progressive artists. He did not always agree with Gorky's political stance:

> As a member of the Mural Division of the Federal Arts Project, Gorky joined the Artists Union. He attended Union meetings, served on committees, and spoke with much feeling on many issues. He considered it his mission to instil into the rank and file of the organisation a respect for art and a suspicion of the political adventurer. He would gain the floor on the most inauspicious occasions and declaim about the contours in Ingres, which personally I do not think much attracted him. In his broken explosive English, he seemed to give the impression that Ingres might at any moment lend his support to the cause. I could become furious when he was not on my side. Sometimes, he would seem extremely witty. I wanted Gorky with me, intimately.[9]

Gorky's studio in Union Square was at the hub of the great May Day parades:

In May 1936 the Artists Union had grown strong enough to hold a convention that some 1200 delegates and friends from the East attended. They demanded expansion of existing art projects. They also took a position against 'the forces of reaction, fascism, and war', a stance they underlined by voting to boycott the Olympic Art Exhibition that was to run concurrently with the Olympic Games of 1936 Berlin.[10]

George McNeil was as an abstract painter, a militant who 'would have got himself hit over the head on purpose'.[11] Gorky and he designed and built a float for the Artists' Union with a colossal sculpture for the procession. Artists, filmmakers, writers, actors, dancers, all marched in the May Day parade. Some 40,000 people joined in the demonstration, which lasted for two and a half hours. Bands blared marches. People chanted, 'Give the bankers home relief! We want jobs!' Banners waved. Dignitaries waited on the reviewing stand at the north end of Union Square. The police were out in full force. Dorothy Dehner remembered marching:

> We sang workers' songs. We got through into Union Square and went up to Gorky's roof to watch the rest of the parade. It was three storeys high. Then the WPA dancers came along with castanets and tambourines, dancing into the square. Everybody was singing! I pulled off my scarf and started waving. Suddenly, a policeman.
> 'You can't wave the Russian flag in the United States of America!'
> I had tie-dyed it, half red and pink, merging into red when it moved!

Hearst-owned newspapers called the artists 'hobohemians'. The Dies Committee in the US Congress, later to become the notorious House Un-American Activities Committee, was opposed to the art projects and tried to prevent money being allocated to the programmes. Yet the need was enormous. A former Grand Central student and friend of Gorky's, Nick Mayne, died of hunger in the Village. Gorky felt guilty. He attacked the hard-liners in the Artists' Union for their 'political adventurism'. Rosalind Browne, who had known Gorky since the early days, described his contradictory nature:

> Everybody was very poor at that time, but he had a $50 a month studio, on Union Square, which was an enormous amount of money. He wore good tweed suits, and yet he was part of the activity at the Artists' Union. He was

quite an actor. He had a tremendous sense of humour, very dry. If you were anti-Semitic he was pro-Jewish, if you were pro-Jewish he was anti-Semitic. He loved creating an uproar![12]

It was time to execute the mural, and since its final placement was not decided, Gorky painted canvas panels which could be transferred and stuck to the walls. The next phase was to submit, by autumn, a scale model of the building with his miniature panels in place. He painted through the hottest months in his studio, with its long glass windows catching the sun, while most people deserted New York. He was under pressure to complete at least two panels for *Horizons of New Art* at the Museum of Modern Art. A new romance also kept him at boiling point.

That summer, Gorky fell in love with a painter called Carinne West. He wrote her long, intense letters and poems. He went to visit her in Rochester, upstate New York, and on his return, in a letter dated 11 August 1936, describes the lasting impression she made on him. He divided his letters into three parts, starting with a prose poem:

I love you passionately from the head to the foot of your lovely body and pray the warm sun for our happiness and the success of your work, I love you tenderly, and wait feverishly for the first chance of seeing you again of possessing you fully and fondly.

He divided the love letter with a heading;

INFORMATION
Beloved I am very tired; I have done nothing but rush from one place to another, with my murals, and started a painting 14 × 9 ft this morning have been to Boston with Vartoosh my sister and last week end to the country.[13]

Gorky signed his letter, 'In flames.' His natural language of love was Armenian. In English, he came out with archaic forms, sublimated his love into a semi-religious experience and invested his letters with the power of prayers. He also borrowed liberally from Julien Levy's book, *Surrealism*, just published that year, in which he read texts by Paul Eluard.[14]

West said she reciprocated his love and admitted that 'leaving his presence was agony'. Their long and tumultuous meetings led to 'complete frustration'. His remark about waiting 'to possess her fully' implied that he

had not yet succeeded. Her frustration echoed Sirun's, five years ago. West described their relationship as 'a platonic love of two artists driven by love for work ... obsessed with painting to a fanatical point'.[15]

The dance of knives continued, with Gorky unable to control his excesses, in private life and in art, with each ascent causing him pain.

26

Child of Eden
1935–36

As Gorky worked on his *Aviation Mural* in September 1935, his studio was invaded by Moorad, Vartoosh and her six-month-old baby. His spartan workplace became a nursery and a family home. Gorky was fascinated by the plump baby sleeping in the cot, bouncing on his knee, burbling at him. He could remember Vartoosh as an infant, when he was only a toddler. The smells of baby milk and Armenian cooking, the sound of Vartoosh's Vanetzi lullabies, which she sang with their mother's expressions and gestures, unlocked a floodgate of memories. Brother and sister talked of their own childhood.

Gorky began a very uncharacteristic painting, *Mother and Child*, a nude woman with large breasts leaning over a baby, unlike the abstract works of this time. The pose was characteristic of Vartoosh, hand to her face, gazing at her baby. It was more strongly schematised than his portraits. He gave it to Anna Walinska, who treasured it, believing that she would never have children.[1]

While Karlen slept, Vartoosh sat by the window; her tears flowed. She worried about their poverty, the failure of their trip to Armenia, their lost Utopia. Her son would never meet his natural father in Yerevan. She herself would probably never see him again. She talked obsessively about their dead mother and their losses. Only when she thought of Gorky, she had hopes for the future; she projected and repeated their mother's aspirations and hopes for him.

Living with his family distracted Gorky, but he kept working. He begged his sister to sing and read aloud as he painted. He put on a brave

face, but she saw his grim poverty. One day de Kooning accidentally knocked over a bottle of Karlen's milk in the studio. Gorky had to go out to borrow money to replace it. Debt collectors turned up. Vartoosh opened the door to a man with an IOU for $1,000. Before Gorky could sign, Vartoosh snatched it away.

'I didn't even buy food. You see, I bought paint and canvas to work,' Gorky argued with Rosenthal, an art supplier who had allowed him credits.

Vartoosh started to cry. 'Look, I am here and my brother is supporting me and my little baby. My husband has no work.'[2]

Gorky often held knock-down sales. He put out his paintings and charged $25 a canvas. Sydney Janis came in to buy them for as little as $10. Once, Bernard Davis bought six paintings for $20 to $30 each. Every time he made a sale, Gorky gave a painting as a gift, then dashed off, saying, 'I'll go and buy some paints!'

Vartoosh worried about her brother's health. He ate little, appeared thin and tired. He confided that he suffered from severe constipation. He went to the doctor as often as twice a week. He sometimes tucked a couple of paintings under his arm before leaving: 'I can't pay the doctor, so I'm taking him a picture.' His habitual diet made his condition worse. He went without food, then dropped in for coffee at the cafeteria or automat. Vartoosh cooked him regular meals and invited his friends – De Kooning, Wyatt, Busa. Gorky asked her to sing his favourite song, *Sarn ou Tzor*, 'Mountain and Valley'. She saw his painting change. 'He would get so happy and say, "It's come out really well, just like the colours of our country."'

He loved taking the baby into his bed to cuddle early in the morning, after Vartoosh had bathed and wrapped him in a blanket. As Gorky worked in the studio, Karlen crawled after him like a little pet. He was boisterous and could not be confined. He tossed the pots and pans out of the window. Gorky swept him up in his arms and took him down to Washington Square to see the pigeons. The birds found their way into his paintings. When Karlen toddled his first steps across the studio floor, Gorky was beside himself with joy.

'*Mogouch Jan. Yes ko hokou madagh linem!*', an archaic expression still used, 'My little darling! May I be a sacrifice to your spirit!'

Karlen tried to copy his uncle by painting. One morning Gorky woke up to see *Organization* daubed with black paint. Vartoosh was terrified, but Gorky would not let her punish the boy.

'Oh, Vartoosh, don't upset the child. Mogooch, why did you do that?' He picked up his brushes to repaint his canvas.

Photographs taken in the studio show Gorky's chubby little nephew sitting snugly in his arms, his uncle looking at him, tender and fascinated. In a smart tweed jacket, shirt and tie, with short hair, and a trimmed moustache, Gorky looks like a dashing young blade of the thirties movies. The baby is draped in Gorky's harlequin sweater, cut up.

The baby boy prompted new images: mannikin-type figures, birds, flowers, breasts. A new cycle of paintings evolved out of the *Nighttime* series into abstract still lives with rectangular shapes and forms, and then into a more plastic, flowing idiom. A heart appeared in one of them, grew larger in the next painting, turned itself upside down, while other figures rounded out.

The sudden appearance of a new title for a series of paintings would baffle scholars – *Xhorkom*. For the first time Gorky named a work after an actual place, his own village. The spelling with an 'X', far from concealment, was the Russian spelling with a phonetic rendering of the guttural 'kh' of the Van dialect. An ambitious series was born: *After Xhorkom, Image of Xhorkom.*[3] Later 'kh' was adopted to render the sound: Khorkom became the standard spelling.

The thick, rough surfaces of these paintings are like the dried mud and straw walls in his village. He worked on the dry, grainy textures with his palette knife, he smoothed layers of thick paint, let it form a skin, then gouged into it with the point to make grooves. Soft brown like a bullock's hide, fresh leaf green and warm red, strong earth colours, the crisp white and pale blue of the snowy mountains and lake. His palette became richer and brighter. Gorky was building his village from memory.

One new work, entitled *Painting*, 1936–37, in brilliant blues, reds and white, was selected by the Whitney Museum of Art for the *Annual Exhibition of American Painting.*[4]

As he painted, Vartoosh and Moorad held committee meetings in his studio of the HOK (Hayasdan Oknoutian Komite) Progressive Party.[5] Their hasty return from Armenia had not undermined their faith in the Communist Party, and Gorky heard them discuss rebuilding the country. He never joined meetings. The committee members left Armenian papers and books for him to read. He explained his work and gave them small pictures as gifts, which they chucked in the dustbin on the way home.[6]

Only Badrik Selian, the architect, was sympathetic. In 1935 he edited and published a yearbook, in which he 'used only the sketches by Gorky'.[7]

Gorky felt involved but could not accept their near-delusional idealism. In discussion with Selian, he

> was very curious about Soviet Armenia and the Soviet Union. He found that in literature and composition they had created enormous progress, was disappointed that art and sculpture were so backward. He couldn't understand how such a revolutionary country could be so reactionary in art.

Gorky saw new Armenian books in his studio – literature, architectural studies and photographs of historic buildings and art – which had been published in the 1920s artistic renaissance of Armenia before the clampdown. He discussed these with friends, including Armenian collectors with good libraries. He had a little difficulty in reading Armenian, although he spoke it fluently.

The books prodded his memory. In Armenian illuminated manuscripts, he saw prototypes of Surrealism, birds with human faces and crowns like Max Ernst's bird-woman. The stone *vishaps* (sea monsters in phallic form) of Van were not so far removed from Gaudier-Brezska's simplified statues and Brancusi's monumental, abstract sculpture. Surrealism had been a natural part of life, but he realised that a rich store of primitive or pagan art was also part of his heritage. He did not have to borrow from Africa or the South Pacific like other artists.

Hearing Armenian poetry in his studio, Gorky began another series: *Child of an Idumean Night, Battle at Sunset with the God of the Maize*, and finally, *Garden in Sochi*.[8] They have puzzled critics, yet all had originated in the Armenian mythology of the Van area, which was referred to as the Garden of Eden. The Armenian word *Edem* means 'Eden'; *Edemean* is 'heavenly, paradisiac'.[9] The abstracted figure on a blue background might refer to the birth of Karlen. *Battle at Sunset with the God of the Maize* evokes the Van legend of the Milky Way, called, in Armenian, the Thief Harvester's Path.[10] The god Vahakn fights with the enemy and steals grain for his people, but his sack has a hole. Golden kernels fall on the way, lighting up his path in heaven: the Milky Way.

Gorky completed three versions of *Battle at Sunset*.[11] In the first and most figurative, black outlines suggest figures at battle with lances. The pale gold

of the overall picture and background are in keeping with his title. Uccello's, *Rout of San Romano*, tacked on the wall next to Gorky's easel, may be seen as the inspiration. Several figures with birdlike heads and the same angular configuration as the *Child* also appear in the *Khorkom* series. Double cusps, stylised flowers, closely interlocked curving shapes were echoes of carved crosses, paintings and textiles integrated in Gorky's cultural handwriting. The later versions are small canvases, stylistically midway between the first version and a painting, named later in the 1940s, *Summer in Sochi, Black Sea.*[12]

One night Vartoosh, woken by her baby, found the light on and Gorky painting.

'Vartoosh, I had a new idea. It came to me that I have to change this line. If I leave it till morning I might forget.'

Between the end of December 1935 and the early part of January 1936, Gorky planned the overall design for the ten panels of the mural. In the first half of 1936, he prepared the first set for exhibition. Vartoosh saw him working first on the gouaches, some of which he sent her as a present later. Then he transferred them to great sheets of canvas. She watched the process:

He would line up the paintings of the mural in the window. Sometimes we went outside to see them from far away. Or we looked at them under the light. Or he lined them on the wall and we went to the window far away to see them in the light. They came out so beautiful.

He asked her to light a candle for him in church. '*Ach, Asdvatzt Da vor hachoghem, koutze mi korz enem.* Oh, please God I should succeed, maybe I can find some work!'

27

Elevation of the Object
1936

Gorky executed his largest mural panels in the Works Progress Administra-
tion Headquarters at 110 Kings Street. In a seventh-floor workshop, the
artist stood for hours on a ladder, in spattered overalls, aiming his fine brush
at the edge of a straight line, a pot of paint in his hand. Strong, geometric
shapes rocked and swayed in an open space, on a canvas twice his height.
Muralists were assigned assistants, but Gorky refused to let anyone touch his
work. They mixed paints and prepared brushes, but he painted every inch
himself. The red guard resented Gorky's intellectual demands, especially
since he was respected by older, established artists such as Stuart Davis.[1] At
times Gorky stormed into the administrator's office downstairs which
Charles Mattox, the artist, shared with David Smith, the sculptor, to
complain about lazy amateurs disrupting him. Mattox whisked him up to
the gallery to view the easel paintings in order to calm him down.

He worked on large canvas with oil paint so it could be moved easily.
Discussion raged about whether this was easel or mural painting. His
progress was closely monitored by his friend the architect Kiesler, appointed
to the WPA/FAP Design Studio with William Lescaze, Meyer Schapiro
and Alfred Auerbach to survey locations for murals. Kiesler tackled the left-
wing orthodoxy. He also explained Gorky's decision to paint on canvas
rather than straight onto the wall. 'The brush filled with watery paint is set
right into the wall; that is mural painting. The brush with creamy paint set
on canvas or wood or glass or any material which is hung in front of a wall
is easel painting.'[2] This assured Gorky a plentiful supply of oil paints from
the supply supervisors, who made allowances for painting styles like

impasto. Perhaps it was no coincidence that in easel-painting Gorky was at his heaviest impasto just then. He had invented a new oil-paint technique for murals, described by Kiesler as 'an outflattened equalising cover'.[3]

Gorky's friend Jacob Kainen helped him stretch one of the panels. 'He took off the canvas, laid it on the floor. On the stretcher, provided by the government, we hammered it with nails because we didn't have staples in those days. Elements of the aeroplane abstracted in a good pattern. Very impressive. Good colours.'[4]

Each panel was given a different name: *Mechanics of Flying*, *Aerial Map*, *Study for Aviation*, *Activities on the Field*, *Modern Aviation* and so forth, varying in size from 6 feet 5 inches by 10 feet to upwards of 9 feet by 11 feet. The expanse forced him to open up the space with powerful verticals and diagonals tilting the geometric elements, creating an energetic movement.

Scale models of the airport buildings with gouaches of the murals and the first complete panel were exhibited in the New Horizons Exhibition, 14 September to 12 October 1936 at the Museum of Modern Art, curated by Gorky's friend Dorothy Miller, who now worked at the museum.[5] But the Newark museum, where the pictures were subsequently exhibited, found them indigestible. Under a photograph of Gorky's panel in the *Newark Ledger*, 8 November 1936, ran the headline: 'GOODNESS GRACIOUS! IS AVIATION REALLY COMING TO THIS?'

Among the WPA posters, pottery, New Mexican tapestries, terracottas and pictures of farm life from the West, the reporter singled out the ultramodern Gorky mural with sarcasm:

This little gem is known as 'Aviation Evolution of Forms Under Aerodynamic Limitations'. It's a mural painting (according to Artist Arshile Gorky), which will be hung in the second-floor foyer of the Newark Airport administration building. If you look closely, you can distinguish what appears to be an airship tail at the left, but for the rest he was stumped too.

In November 1936 Gorky was asked to write a report, 'interpreting the relationship of the forms in your mural to their aerodynamic sources' and 'the experimental significance of the abstract work that is being done on the project'.[6]

Gorky kicked off with an image of the house where he was born

while hiding its location. This bizarre introduction to a modern mural project revealed the autobiographical source of his inspiration. It read:

My Murals for the Newark Airport: An interpretation

The walls of the house were made of clay blocks, deprived of all detail, with a roof of rude timber.

It was here, in my childhood, that I witnessed, for the first time, that most poetic image of operations – the elevation of the object. This was a structural substitute for a calendar.

In this culture, the seasons manifested themselves, therefore there was no need, with the exception of the Lenten period, for a formal calendar. The people, with the imagery of their extravagantly tender, almost innocently direct concept of Space and Time conceived of the following:

In the ceiling was a round aperture to permit the emission of smoke. Over it was placed a wooden cross from which was suspended by a string an onion into which seven feathers had been plunged. As each Sunday elapsed, a feather was removed, thus denoting passage of Time.

As I have mentioned above, through these elevated objects, floating feather and onion was revealed to me, for the first time, the marvel of making from the common, the uncommon.

This accidental disorder became the modern miracle. Through the denial of reality, by the removal of the object from its habitual surrounding, a new reality was pronounced.[7]

Throughout the text, a flow of associations linked the themes of his displacement and the death of his society. After dealing with his personal sources, he canvassed for a Cubist conception. Then he took a firm stand:

Mural painting should not become part of the wall, as the moment this occurs the wall is lost and the painting loses its identity.

In these times, it is of sociological importance that everything should stand on its own merit, always keeping its individuality. I much prefer that the mural fall out of the wall than harmonise with it.

He wrote of his desire to create 'a sense of wonder': 'In the panel "Early Aviation" I sought to bring into elemental terms the sensation of the passengers in the first balloon to the wonder of the sky around them and the earth beneath.' Finally, his sense of playful fantasy was expressed: 'In the same spirit the engine becomes in one place like the wings of a dragon, and

in another, the wheels, propeller, and motor take on the demonic speed of a meteor cleaving the atmosphere.'

Gorky's clarity and hard edge were new to his work. He had studied a photograph taken from his studio window of rooftops and tall chimneys, billowing a cloud of smoke across the horizon. Using the shapes in the smoke and clouds, he started a painting with these forms, then used them in the panels named[8] *Mechanics of Flying*, 1936–37,[9] and *Aerial Map*, under the general title *Aviation: Evolution of Forms under Aerodynamic Limitations*, 1935–37.[10] His student Hans Burkhardt recalled, 'He used to talk about that lake and the way he used colours from there – the aquamarine. He loved that Armenian red.'[11]

In his essay, Gorky had entertained the notion of a mural without walls, 'falling off the wall'. In his boyhood by Lake Van, when the evening light fell on the relief friezes on the walls of the Holy Cross, curves and angles, circles and lozenges, elongated the dark lines in pink stone. The long shadows slanted and cut into the figures of princes, animals, a sailboat, angels with crossed wings. To the eye of the amazed child, the mural fell off the wall. Conscious of drawing on his tradition, he dropped clues to his style and iconography. His predecessors had carved angels with wings; Gorky painted aeroplane wings. His message was couched in the imagery of flying – the token of progress in a new rational and spiritual order reflected in the arts: 'These symbols, these forms, I have used in paralyzing disproportions in order to impress upon the spectator the *miraculous new vision of our time* [author's italics].'

He enlarged a rudder, an autogyro, a rounded light fixture protruded like a breast; a pump was phallic-shaped; motifs he had used in his earliest paintings were removed, metamorphosed, changing significance by context from one work to another. Gorky insisted on plasticity. His friend Rosalind Browne had memorised his definition of 'plastic':

You use the symbols on a two-dimensional surface to imply the life pattern that goes on in the universe, to imply the oppositions, the tensions, the actions and counteractions. Simulate the life pattern by the way you make – through illusion – the plane move.[12]

Two years of planning and work would be carelessly painted over when the airport was taken over by the US Air Force in the war. Gorky's

inclusion of the Texaco Star, wrongly dubbed the 'Red Star', caused annoyance and the destruction of the murals. His original inspiration, the tenth-century church on its little island, would be used to stable goats; the gargoyles and carvings would serve as excellent shooting targets for the occupying Turkish soldiers.

In November 1936 Vartoosh moved from Gorky's studio to Chicago, thanks to a job for Moorad arranged by Gorky's friend Bernard Davis in his carpet factory, Samarkand. After living together for more than a year, Gorky suddenly regained his freedom, but felt lonely and missed the toddler chasing after him. He adopted a cat, Bujik ('little one'). On 11 January 1937, five days after Armenian Christmas, he sent a letter to *Eem amena seereli Vartoosh*, 'my most beloved Vartoosh'; he would always repeat these phrases of love thoughout a letter as he started a sentence, *eem seereliners*, 'my loveds', 'my loved ones'. He wrote in Armenian with a fountain pen racing across the page in strong downward strokes. Reversed shapes, decorated loops and capitals transformed the letters into unique configurations, like drawings, which make his script sometimes indecipherable. A flourishing arabesque swept down through two lines on the word 'very'; he wrote, 'Today I completed a very large and excellent painting which I wish you could see – it is very, very good, clean and most authentic.' His largest works at this time were *Composition with Head*, and *Still Life on Table*,[13] both of which he could have considered 'authentic'. He also painted a luminous self-portrait in fresh shades of almond green, pistachio and earthy browns, his familiar colours.

With the mural out of the studio, he needed to work at a more instinctive level, freely improvising in the evolving *Khorkom* series. After the straight lines and right angles of the architectonic mural he found an antidote in curving figures: animals, birds, parts of flowers, hearts, breasts, shields, people in combat, opposing forces in movement. His favourite was *Image in Khorkom in Summer* (later simply *Image in Khorkom*) in warm pink and red; dark earth colours set off the flesh pinks of a female torso with the breasts of a fertility goddess. With bold, energetic swirls and outline, paint is laid on roughly, then left porous to show the colours underneath, piling on layer over layer of paint, memory and emotion. Thin trickles of paint meander on to an image below, for the first time. A centrifugal force in the circular motifs spirals around an eye. The colours evoke Gorky's summers in the

fields, ovals and rounds of pink to red, cantaloupe-yellow and the fresh green of the watermelon rind against a dusty background. The mood is joyful, although the female torso could be seen as an abundant and fertile mother whose baleful eyes might turn him to stone.[14]

In the autumn of 1936, Gorky visited John Ferren's show, next to the Pierre Matisse Gallery. 'Is this something new in Paris?' he enquired about the artist's bands of colour moving chromatically across forms.[15] Ferren had just returned from Paris, where he had seen Robert and Sonia Delaunay's registers of colour on concentric circles. His separation of colour from form in chromatic bands fascinated Gorky, who drank in his reminiscences of meeting Picasso, Miró and Breton. But Kandinsky had impressed Ferren most with his geometric approach to form.[16] 'The advantage of the circle over the apple is that, being a purer form, it permits a more accurate delineation of the creative emotion.'[17] Kandinsky was right; art was the reality behind appearances. In Gorky's studio Ferren was startled. 'He was in the middle of his huge Picasso period. In the thirties to do Picasso was a very way out thing. It was a time of social significance paintings, American barns and social realism.' Gorky longed to be in Paris, and was well informed about life there through his main source, the magazine *Cahiers d'Art*, which Ferren also read. Gorky was shocked when Ferren suggested,

> The way out was not to follow Picasso, necessarily. He was so overwhelming at that time in Paris, that most of the younger painters were much more involved in getting away from Picasso. I don't remember a definite response. I'm sure he meditated afterwards.

Despite being totally immersed in his abstract murals, Gorky nagged at a problem; 'He mentioned vis à vis a drawing that he had been redrawing it for many years, working on it for a long time. We commented that we all have pictures we work on forever.'

In the same year Gorky completed the pencil drawing of Vartoosh and a self-portrait, also in pencil, with the same sensitivity and wistful mood.[18] After completing the mural, he returned to figure drawing. A painter and friend, Conrad Marcarelli, was teaching in the Leonardo da Vinci School, between Lexington and Third Avenue, where Gorky went to draw from models several times a week for about five months. 'He was making black

and white drawings which were complete abstractions out of the figure. To the spectator it looks like he was just doodling. The students looked at him as some kind of freak.'[19] Gorky filled his sketchbooks with drawings of the human figure, in flat sections, which did not necessarily follow anatomy, but created interlinked shapes with a strong flow. Their importance would grow in his later work. At a very abstract, supposedly Cubist period, he returned to drawing from nature. But the figure was both a container of the form and a springboard for new shapes.

Gorky once stopped a group of friends in New York to admire a water hydrant, saying, 'That is more beautiful than any painting ever made.'[20]

His Greek friend Aristodemos Kaldis, an art lecturer and a militant union organiser, called on him in a tight spot: 'Gorky happened to be a very big virtuoso. As senior research worker on the art project, whenever we had trouble with congressmen and senators against modern art, I used to bring them to Gorky's studio on Union Square.' The impressive atmosphere of his tidy workroom, filled with paintings, materials, books and drawings, huge palettes like African shields, a giant easel, left no doubt that a professional was hard at work. Cradling a needle-sharp pencil in his massive hand, his 'surgeon's tool', after a couple of astute glances, he produced a portrait in minutes which amazed the doubters.

'Oh! that guy really knows his stuff!'

Kaldis added, 'Gorky was the protector of the abstract movement. He was always chosen as the draughtsman because he could draw anything, realistically, as well as in abstract style. He drew his mother hundreds of times. He was obsessed with his mother'.[21]

Gorky also drew from landscapes. When his friend Saul Schary finished a house in Connecticut, they took their drawing equipment outdoors to Schary's apple orchard, where, to his surprise,

> Gorky sat right down among the trees. He looked at this landscape and he was then doing a kind of flat colourful Cubism. He sat there, and he sat there, and he started to paint. He went back about eight years to his Cézannesque way of painting and did a pure, beautiful version, as Cézanne would have painted that spot.[22]

Gorky slipped back to an earlier way of painting which Schary loved, as a

more realistic painter. Gorky gave him a drawing and the painting, *Landscape, Gaylordsville.*[23]

Pleased, Gorky wrote to his family on 12 May on notepaper headed the Waldman Park Hotel, Washington DC, that he was to lecture on behalf of the American Federation, and that he was drawing profusely. He decorated the letter for Karlen with a drawing of a dog and a cow lying down, while a comical little car rushed behind letting off a puff of smoke. Gorky cannot have missed the chance to visit the National Gallery of Washington.

June 1937 should have been his moment of triumph, as he finally saw his panels hung in Newark Airport. It was a catastrophe! The canvases were not so much hung as stuck to the walls with the wrong adhesive. Some, over twenty feet in length, began to fall off the walls. 'Visitors to the new Administration Building at Newark Airport were walking around in a daze yesterday trying to decipher a series of startling murals,' wrote a self-styled art critic named Gerard Sullivan on 10 June 1937 in the *Newark Ledger* under the headline 'Mr Gorky's Murals the Airport They Puzzle'. He did his best to ridicule the mural and the artist. A deluge of protest was unleashed. The New York Project had to silence the Newark doubters, trying to jettison the murals. Stuart Davis wrote in farcical vein:

I was the artist member of the committee. We drove over the swamps in a determined mood and shortly met the stubborn and ill-armed locals face to face. There was nothing to it after the first broadside fired by our oratorical Professors, Doctors and Experts. One of the locals quickly joined our side, and the rout was complete. But their unhorsed chairman made a final convulsive effort by whistling for an ace air pilot who charged into the room. 'Tell these Yankees what you think of these so-called modernistic murals,' the chairman gasped. The ace surveyed the huge pieces of canvas. They hung in drapery-like folds on the walls, owing to some slip-up in the secret formula of adhesive which was guaranteed to last forever . . . But the chairman's ace-in-hole blasted his last hope by saying he didn't know nothin' about art but thought they were right pretty. He said he was reminded of the wonderful things he had seen, and began to recite recollections of beautiful cloud formations observed on his numerous flights. He was warming up to give dates, locations and the particular hour of day of these events when the chairman silenced him. An official surrender was signed, and our cavalcade

sped back victorious to the taverns of New York to celebrate. Whatever happened to the murals. I don't know.[24]

No one seemed to know where they should go. Disdain for the artist was leaked in correspondence: 'it is extremely desirable that all murals designed for the Administration Building be placed where they can be removed in case of necessity, *without impairment of the wall* [author's italics].' Not a thought for the impairment of the murals![25] Then a new glue was found; the murals went up again. During the twenty months Gorky was employed for the *Aviation Mural*, he received $2,026.80, averaging a weekly income of $25. The entire mural cost his sponsors a mere 60 cents per square foot; Gorky had covered 1,500 square feet. Ten panels had cost a total of $3,000.[26]

In other hands, the mural became a dangerous weapon; Picasso had completed *Guernica* for the Spanish Pavilion in the *International Exposition* of 1937.[27] Gorky wrote that after the mural he was off the payroll. Broke again, unable to sell paintings, he redoubled his efforts to get a commission for the World's Fair. For the next five years, Gorky believed that the public mural would provide him with work, and in the autumn of 1937 he wrote to Vartoosh,

As for my long delay in replying, the reason is this, I am working a great deal; for more than two months I have been preparing paintings (Worlds Fair). Please God, they be accepted. Nearly $12,000 is available. But my dear, I finished the work three and a half weeks ago and I wait, saying to myself, today, tomorrow, today, tomorrow. That's why I delayed my letter to you, hoping for some good news to write to you – I am always thinking that if they really accept me then we could all be well off, Father, Akabi, Satenig, you and I . . .

Then I have a painting in an exhibition at the Whitney Museum for $2,000 I shall be painting a picture. They haven't put such a high price on my painting if only I could help Father so that he could come down at Christmas – Darling, I miss all of you so very much.

Tomorrow, that is tomorrow night, two or three students will come for lessons and if I get paid I shall send Akabi $15 so she can send it to Father.

This very minute I let out such a bitter sigh – My cat is sitting on the table and getting in my way, he jumped onto the first page and smeared the writing. But it is very pretty and, just like Karlen, snuggles in my arm and for hours sits watching how I paint.[28]

At the bottom of the page he drew the cat, Bujik, sprawled on the table, his wide paws apart, his eyes alert and fierce. Later he abbreviated imagery: intense eyes as circles; a straight nose dividing the triangular face in a straight line; the cat's body in a gradual elongated arc, even his softness appeared in the heavy furred-up paint of *Gray Painting*, later to be shown at the Whitney Museum under the name *Oil Painting*.[29] Into thick paint Gorky had scored dips and hollows, which made it a favourite with his friend the sculptor Isamu Noguchi.

The Whitney *Annual Exhibition of Contemporary American Painting*, in which he showed *Painting*,[30] ran from 10 November to 12 December 1937. Gorky ended a troubled year with an upbeat telegram to his family, on 13 December 1937.

My Dears,
Whitney Museum purchased one of my paintings for $650.
Will write soon.
Love
Gorky.

28

Argula
1938

In February 1938, Gorky painted a Valentine for a new sweetheart. The letters of 'My Val' were cut short with a gouache of stylised birds with open wings, a large heart, framed with his misspelled dedication, 'To Lenore. Arshile/ 38.'

Leonore Gallet was a tall, red-haired musician with striking features and pale skin, the talented daughter of a steel-owning family from Michigan. In her once more Gorky found his ideal woman and favourite model. An exceptional single-line drawing, *Woman with Violin*, depicts Leonore: a clean profile with high forehead, straight nose and bowed lips; shoulder-length curls cascade over the top of a violin scroll, which nestles below her chin and ear. He also sketched her on paper bearing the stamp of the music editor Ricordi. She owned several nudes, most probably of herself since Gorky would not have wanted to embarrass her by keeping them.[1] When his niece Libby came to visit him in New York, she was introduced to Leonore:

'I'll call this girl, and she's gonna take you to see the Cloisters because everyone goes to see the Cloisters in New York.'

Gorky loved walking around the Cloisters, surrounded by Romanesque arches. Construction had just been completed in 1938. He and de Kooning had looked at the tapestries hung there by Rockefeller. Gorky had turned to de Kooning and said, 'Poor people wouldn't spend money on a beautiful building like this. They would spend their money on bananas.'[2]

The enclosed gardens, the columns carved with strange beasts and vines, had reminded him of monasteries at home, which he wanted Libby to experience. Gorky felt protective towards his niece and told her to wipe off

her lipstick and never wear make-up. Then his girlfriend Leonore walked in.

Leonore Gallet was a violinist with the New York Symphony Orchestra. She was so beautiful! Tall, very slender, with reddish gold hair and blue eyes. She was made up quite a bit which struck me as funny. She could have come from the theatre with all her make-up, but she was still a beautiful girl.

Libby stayed with her uncle, but when De Kooning knocked at his door, Gorky hid her in the bedroom. She explained: 'He didn't want anybody to know he was Armenian, they all thought he was a Russian prince. He said he was from royalty.'[3]

On 1 January 1938 Gorky had written congratulating Vartoosh, Moorad and little Karlen on the New Year. 'I felt truly sad not to be with you because I am painting pictures, sketches, for the World's Fair.' He was broke and apologised to Vartoosh for not sending her a Christmas present, nor a cheque to his father, because he had not been paid by the Whitney. Meanwhile he was tussling with new ideas. 'You all know how fastidious I am when I am forever scraping the paint off and painting over the same colour or the same line until my soul is in such great travail that I know not what to do.'[4]

A luscious painting of rich yellow ochre, cardinal red, creamy white and brown, now called *Abstraction*, exudes the energy Gorky describes in his letter.[5] It combines the lushness of the *Khorkom* series with a new evolution of form manifest in *Portrait*, 1936–38, with the kite-like shapes of *Summer in Sochi, Black Sea*.[6] He sold the painting to Ethel Schwabacher for $165, but was still labouring over it. 'I believe I will complete it in a few days.'

While Gorky was working on public murals, his private work was open to such influences as André Masson's automatic drawings, Max Ernst's anthropomorphic landscapes and Miró's simple shapes. They fanned his buried memories and gave him the confidence to use them and to slip into a psychological space in his easel painting. Gorky explored every path of the *Khorkom* theme to uncover dramatic surprises, like a child walking through the village, with its different elevations giving glimpses of the lake, through trees and past mud walls, between the legs of huge bullocks, the smell of dried dung always in his nostrils. In the paintings, triangles were twisted and the sides began to curve, to turn into wings and boomerangs. Straight lines

and angles in torsion interlocked with neighbouring shapes; black boundaries disappeared and colours met but did not merge. Exhaustively he developed themes, in some works relying exclusively on curvilinear shapes, while in others he combined sharp angles and rounded forms. Gorky explained that 'Curved lines brought out emotionality; straight lines gave its structure and its force.'[7]

In 1938 Gorky made a sudden swing to a simple, almost childlike style, introducing fresh symbols and motifs. Gorky's love for Leonore filled him with optimism and confidence in his progress towards 'a purer and deeper art'. His painting *Argula* is a landmark in this adventurous style.

Ar means 'take'; and *gul*, 'flower'. Gorky would later tell his second wife that this was the 'first' word he spoke.[8] *Argula* has a simple and unified iconography. In the centre of a brilliant yellow background hangs a striking green shape called the 'butter churn'. On the left, a figure pushes the huge 'churn' with one arm, the other raised. On the right is another woman with arms outstretched who looks at a circle with curved sections.

In the Van area a butter churn was a cured animal hide blown up like a football into which the milk was poured:

The hairy hide was removed, the skin membrane washed carefully and sweetened, and the legs were tightly tied. Only one opening was left, usually at the neck. It was then hung with strong rope from a wall or the rafters. Madzoun was poured into it, the opening tied, and the churn was shaken gently. When the desired quantity was prepared, the skin was slashed, the butter removed, melted to remove impurities, salted and poured in earthenware jars for storage.[9]

As a young boy, Gorky saw water buffalo being milked. The rich milk was churned and cultured to make a delicious cheese like mozzarella, also made from water-buffalo milk. His elderly aunt Datig, his mother and other women boiled great vats of frothing milk over fires to make thick *madzoun*, yoghurt. A dramatic and mysterious scene for a little boy seeing quantities of white milk poured into an animal skin. He tried to help rock it, like a baby in a cradle. Later, they reached in with their hands and brought out fresh white butter.

A key symbol often painted by Gorky, a spinning circle with a striated centre, often called the 'pinwheel',[10] is the symbol of eternal life, carved on

1. *The Artist and His Mother*, 1926-1935.
Canvas, 60 x 50″. Photograph © Board of Trustees.
NATIONAL GALLERY OF WASHINGTON. Ailsa Mellon Bruce Fund.

2. Detail from a fresco,
Church of the Holy
Cross, Aghtamar.

3. Madonna and Child. Stone
relief from exterior wall, Church
of the Holy Cross, Aghtamar.

4. *Organization*, 1933-36.
Oil on canvas 49¾ x 60". NATIONAL GALLERY OF ART, WASHINGTON DC. Ailsa Mellon Bruce Fu

. One Year the Milkweed, 1944.

)il on Canvas, 37 x 47″. NATIONAL GALLERY OF ART, WASHINGTON. Ailsa Mellon Bruce

ınd.

10. *How My Mother's Embroidered Apron Unfolds in My Life*, 1944.
Oil on Canvas, 40 x 45″. SEATTLE ART MUSEUM. Gift of Mr and Mrs Bagley Wright.

1. *Diary of a Seducer*, 1945.

Oil on Canvas, 50 x 62".

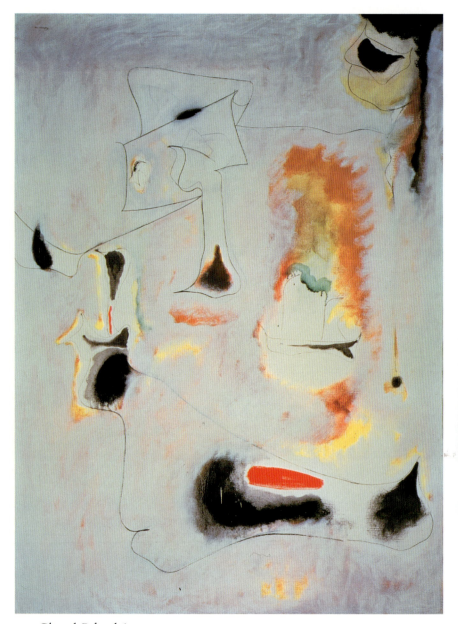

12. *Charred Beloved 1*, 1946.
Oil on Canvas, 58⅝ x 39¼″. MODERN ART MUSEUM OF FORT WORTH, TEXAS.
Collection David Geffen, Los Angeles.

13. Khatchkar, stone cross,
19th century.

14. Nativity Armenian manuscript,
Toros Roslin, 1321. Madenataran
Collection (no. 10675), Paris.
PHOTOGRAPH PATRICK

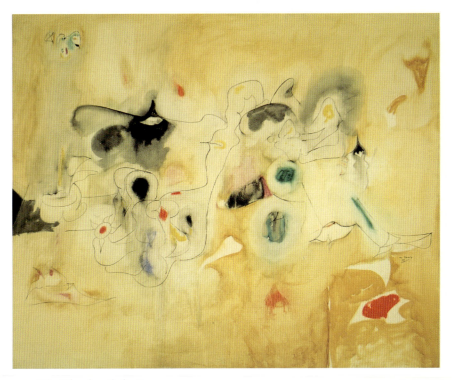

15. *The Plough and the Song,* 1947.
Oil on Canvas, 50¼ x 62¼".
ALLEN MEMORIAL ART MUSEUM, OBERLIN COLLEGE, OBERLIN, OHIO. R. T. Miller, Jr. Fund.

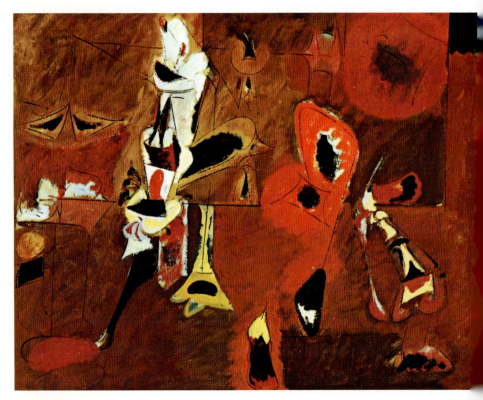

16. *Agony*, 1947.
Oil on Canvas, 40 x 50½".
MUSEUM OF MODERN ART, NEW YORK. A. Conger Goodyear Fund.

every Armenian church, stone cross and monument, almost more ubiquitous than the cross itself. In *Argula* Gorky painted it black with green incisions. In later paintings he reduced it to a black centre with the outer circle dotted, as though whirling. It reappears in many drawings.

The figures in *Argula* may be seen as women in voluminous long costumes, red, green and black, balanced by large geometric headdresses, which, in Van, were wrapped with patterned headscarves. The fluid impasto movement of the paint-laden brush across the canvas allows only the most economic outlines to appear. The picture rocks like the churn on its stand. The paint surface hints at many layers underneath, but the brilliant yellow background is laid on at the very end to carve out the upright figures. Textured edges, thick like grainy sand, contrast with the figures, stroked in smoothly sustained curves.

The childlike innocence of yellow is menaced by the sombre dark green and black figures of powerful women in red. The child could have confused the rocking churn with a cradle; imagined a person inside the distended hide. He had seen his own mother pregnant. In this first painting of the cycle, he has almost filled the green 'churn' with a prostrate figure. It could be the shadowy figure of his mother, the provider of all good things, or a baby. Primary colours and naive forms may have come to Gorky from his study of Miró and Kandinsky, both strongly rooted in their own cultures and folklore. In this painting, the background is held in the same plane as the figures, in an echo of Miró. Gorky often talked of colour with Busa, showing him the brightest paintings by Picasso, Matisse, even a Van Gogh – 'It never feels raw' – to indicate the harmony in his use of bright colours.

Argula is close to other works culled from his memories, with themes from Van: self-sufficient images with an intrinsic narrative.[11] Gorky's first recollections were of the daily life of his people. Later, darker memories would push through to threaten the picture of innocent childhood.

In exhibitions, Gorky concentrated on technical aspects of paintings. Elaine Fried, later De Kooning's wife, remembered:

We went to the Pierre Matisse Gallery to see a Miró show. Gorky was talking about the way Miró laid on the paint, sort of scrubbed it on so it had a transparent quality. Nothing escaped Gorky. He saw everything. He was an incredible craftsman and technician. He could look at everything and go

home and work that way. He thought of art in terms of being able to do everything, an exercise in every direction. He wouldn't limit himself.[12]

In spring Gorky was excited by the news that his painting *Composition*[13] was to travel to Paris, the Musée du Jeu de Paume, loaned by the Whitney from May to July 1938 for *Trois Siècles d'Art aux Etats Unis*. Gorky still had no citizenship papers and no money, but Leonore travelled to Europe where she would see his work in the show. Meanwhile Gorky confided in Helen Sandow. 'He'd come here so he'd have someone to talk to about her. She was beautiful. He saw her, not too often. Her father wasn't too happy. Gorky was so lovesick.' He wrote to his sister that Leonore was in Paris and had written to him that the French papers liked his *Painting* the best of all, that he was the most original painter in America. On the whole the exhibition received derisory and patronising criticism in the French press as immature or slavishly derivative of France. Gorky was thrilled that his work was illustrated in the magazine *Cahiers d'Art*, which often published Picasso's work. He felt he was almost rubbing shoulders with Picasso.

Without Leonore, the enormous studio again felt deserted and cold. Gorky returned to the recurrent theme of his mother with a series of pen-and-ink, and pencil drawings. Like a musician memorising a piece phrase by phrase, he repeated the oval of her face framed by the folded headscarf, the placement of her eyes, nose and lips. He isolated parts of her face and sketched them; he extemporised each feature, to execute it freely. He drew the outline in pencil on a large sheet of Michelet ivory paper. He went over it again and again. He placed the head and right shoulder to the left edge of the paper, shifted off centre, and framed the right side with the same column and window ledge as in the photograph and also the painting.

Over the months, he drew with a technique that he had admired in Seurat, weaving and cross weaving his pencil with the grain of the paper so often that the knobs of the paper stood out in black. By a painstaking process he created a variety of tones and textures, vertical and diagonal strokes, rounded shading and striated lines, cross-hatching on large and small scale. He tacked it up in his studio so often that the corners became pinpricked. Gorky used different pencil weights, and even a little gouache to scumble.[14]

The same smooth finish that he achieved by using several coats of oil paint and a razor was to be recreated on paper. It began to take on the three-

dimensional quality of an alabaster Madonna. The darkest and deepest area he reserved for the black of her eyes in beautifully oval-rimmed eyelids framed by eyebrows which rose in a graceful line from her straight nose. He roughened architectural planes, cross-hatched her pinafore. The cloth acquired weight and texture, but the face was smooth with translucent pale skin. The edge of her shoulders, her chin and scarf were crisply outlined, while other edges blended into one another. All the power of the marvellous drawing was concentrated in the eyes.

It was an old-master drawing executed at a time when no other artist attempted such a technique. 'This is one of our best exhibition pieces,' observed Anselmo Carini of the Chicago Art Institute. 'It touches the viewer in a way, both the almost icon-like impression of the Madonna and the sombre quality of the classical drawing, both solid and spiritual.' When Carini brought the life-size picture out of storage for viewing, I witnessed the study room fall silent and busy scholars drop their pencils and stand up in the commanding presence of Shushan's powerful gaze.

Although the picture sprang from the 1912 photograph, a shift had taken place in Gorky's attitude to his mother. Her expression had lost the hopeless, accusing glance of the photograph and acquired a proud and reserved universality. Gorky drew a woman transfigured. The drawing was signed, and dated to read 1936 or 1938. Gorky's letter to his sister is clearly dated 18 April 1938: the anniversary of her death and the siege of Van, when he wrote,

> Today I painted so intensely that my knees are trembling from standing so long. Painting is an excruciatingly tedious career. Had I only known that, I would not have entered it. Yet the agonies and torments in my mind impel me to recognise that I must have been born to suffer for art. I have drawn a most priceless picture of Mother in charcoal. It required a considerable time and is extremely successful. I will bring it to you when I come.[15]

It was also a shift in his attitude to his background, which he no longer made a secret. 'We all knew he was Armenian. We all knew Gorky wasn't really his name,' Julien Levy's partner, Muriel Draper, said. Busa too agreed: 'People kidded him about it. He said that the Turks massacred a lot of Armenians. His family was touched by that. Sometimes I kidded him for being a Turk. He lashed out like a regular Armenian.' Another friend,

David Margolies, related, 'Definitely, he used to speak about Armenia and the suffering of the Armenian people, the brutality of the Turks to the Armenians in 1915.'[16]

29

The World's Fair
1938

While Gorky was completing the drawing *The Artist's Mother*, chaos reigned in his studio. The landlord gave him notice that he might have to move; the building might be torn down. The WPA was in upheaval, with his weekly salary reduced to five dollars a week. He hung on, hoping for the World's Fair to employ him.

Gorky escaped his lonely studio to haunt the Arax Restaurant at 139 East 27th Street. It had five tables, a few Armenian bachelors reading newspapers, and a young waitress, Arpenik. She sometimes paid for the artists who could not afford 35 cents for a kebab, but never for Gorky, who invariably ordered stuffed peppers, pilaff and *madzoun* (yoghurt). She imitated his accent: "'I am not an Ar⋰r⋰menian, but I can speak Ar⋰r⋰menian. A⋰r⋰r⋰rpenik, sweetheart of the artists." Sometimes he spoke a little broken Armenian.'

Arpenik scrubbed the walls and shamed her boss into buying tablecloths for the dingy place. She thought Gorky 'the kindest person I've ever known, very gentle. He never acted important. His face was *sourp*, a holy face.' With De Kooning and other friends, he talked art and drew all the time. She kept 'a napkin with a drawing of my boss, his hand on his chin, sleeping. I still have it. It's all so brown.' One day he offered her a painting, but she shrieked, 'That crazy thing? I don't want it.'[1]

Among friends, Gorky no longer concealed his origins. He surprised Ruben Nahkian and Ludwig Sandow in the Armenian restaurant, when he said with great excitement, 'This is where I come from', pointing at photographs of Van landscapes in a magazine.

At the beginning of the summer 1938, workmen tore down Gorky's studio and tramped over his polished floor. The landlord forced him to sign a paper disclaiming liability. Gorky stored his paintings. It became impossible to work through the summer and he had no money to visit Vartoosh. One morning Rosalind Browne found him sitting in Washington Square with his head in his hands. They often met at Artists' Union meetings, together with her husband, Byron Browne. A group of friends was going up to Provincetown on Cape Cod for a few days, why not join them?

Gorky travelled on the East River boat with his friend David Margolies. All night they stood on deck, watching people tossing their nickels in the newly invented slot machine. Gorky had nicknamed his friend. 'Malchik, let's watch those guys. You throw a quarter, later I'll come in and maybe we'll win.' They walked off with the jackpot of four dollars, about half a week's wage.

Gorky took Margolies to the Boston Museum of Fine Art to see the newly acquired Gauguin, then peeled off to visit Akabi and Satenig in Watertown.

Provincetown was a small fishing village in miles of sand dunes. Margolies enjoyed himself with a pretty girl. They rented rooms at $7 a week. The pretty girl took up with Gorky, but Margolies only shrugged. Rosalind and Byron Browne arrived with Lee Krasner, future wife of Jackson Pollock, now in the last throes of her affair with Igor Pantuhoff, a Russian portrait painter.[2] Among the tall sand dunes they took off their clothes and swam in the freezing water, then lay on the sand to warm up. Rosalind remembered:

> We had a perfectly marvellous time for a while. Gorky was the great originating force. He picked up one little girl who didn't take her clothes off, but took photographs of all of us which the photographer wouldn't print. I remember him calling her 'a skybaby'. He directed all this. There was no eroticism, nobody touched anybody else. Everyone was with their own. He made remarks which were extremely funny about other people's anatomy.[3]

They wrestled, raced, played leapfrog. Margolies was surprised that Gorky, ten years his senior, could outrun and outswim him. 'His physique was

large, but he was light on his feet. You could see the grace in his body when he moved.'[4]

Gorky drew with a stick in the sand, huge pictures as wide as twenty feet. Racing against the approaching waves and surf, he scored the outlines, which Margolies filled in. People gathered to watch. Just as he finished a huge wave came to wash his drawing away.

He organised a shashlik party, cut and marinated the lamb for twenty-four hours. But on the day, a strong wind blew sand all over the shashlik cooking over the fire. 'He was full of life', Rosalind recalled, 'and used to sing these Armenian songs and tried to get us to come in with the chorus.' Discussion raged. Byron Browne was also on the WPA, Lee Krasner was a belligerent student of Hans Hofmann. By her own admission, if Gorky talked about Picasso, she praised Matisse. He talked to Byron, then Rosalind butted in. Gorky turned on her. 'You're a good painter but you make a lousy artist's wife!' Before the two weeks were over, she and her husband had a fight. He went home with Gorky on the boat, and she with friends.

At the end of September, Gorky was in bad shape: depressed about not being able to get back on the Project. Aliens were first off the Project payroll, and after fourteen years in America, he was still waiting for naturalisation papers. The studio was a mess. He stepped on a rusty nail and infected his toe. He got a stye on his eye, then another. He was run-down and disgusted. 'Dust everywhere and they are doing such terrible and unclean work you would think a dog lives here,' he wrote to Vartoosh. In October 1938, he finally gave her news of the Aviation Building commission for the World's Fair: 'I shall paint pictures on the wall, murals. Yesterday, after dinner, they invited me there, and presented me with a blueprint for the wall plans, and we shall start to prepare sketches with the designer.' As soon as the builders left his studio on 20 October, he intended to start to complete sketches and hoped for $3,000 in payment.

These will be in the Aviation Building and the architect, Mr William Lescaze, is one of the finest architects in America, although he is not actually American . . . he comes from Switzerland. He likes my work very much. He had written to the World's Fair saying that he wanted me to paint, and not anyone else. That will be excellent and I will work hard to finish it.[5]

The World's Fair, to commemorate the 150th anniversary of the Constitution and the inauguration of George Washington, was to present a glossy picture of the history and future of America over the next few years. In the Depression, it would provide work and an optimistic ending to the grim thirties. To accommodate it, 1,216 acres of rat-infested marshland and dumping ground were reclaimed in Flushing Meadows, Queens. Amid bitter controversy over the architecture, Traditional versus Modernist, about 375 structures were constructed, from stalls to major buildings.

New York artists got commissions for murals and sculptures. Gorky's friends in the American Abstract Artists group, Ilya Boltowsky, Louis Schanker, Byron Browne and their chairman, Balcomb Greene, worked in the science and education building. Dali was creating an underwater fantasy with a vast tank in which human mermaids disported themselves with rubber tails.[6] De Kooning designed a mural for the Hall of Pharmacy in figurative style. They shared news, discussed projects. Every morning in the winter of 1939, Gorky got up early to go to work. 'You walked up on a balcony over the entrance on both sides over the entire width of the landing,' Lescaze remembered. 'We asked Gorky to paint a very large mural.'[7] Gorky was in harmony with his employers' ideas, Howe & Lescaze, champions of the International Style.[8] He took a freewheeling approach to the theme of aviation which he had made his own in the Newark mural. The enormous panel was buoyant and enlivened by interconnecting images and clear colours. His conception of space and form had been stretched, and over the next few years, the full imaginative effect would become apparent. He wrote to Vartoosh in March:

> I completed it about a week ago and it is very fine and I am most satisfied with it. Anyway, they loved the sketch so much that I was obliged to paint it on canvas. I used oil paints and as you know oil paints need a long time to dry. I put it up with much difficulty but it was successfully completed. When the World's Fair is finished in two or three years, they plan to take my painting down from the wall and install it in a new airport.
>
> It proved excessively costly . . . the paints and various other supplies . . . so when it was finished, I had only $1,500 left. During these four months, I have not been with the WPA – they sacked me – so accordingly – tomorrow, Monday, I shall enquire if they will take me back or not – My sweet, I have deposited that money in the bank. Of course, from time to time

I withdraw $10 or $15, but I shall keep $1,000 there under my real name, already the bank knows my name, Manoug Adoian.[9]

This was the first instance of Gorky writing out his Armenian name and he himself used Manoug, not Vosdan or Vosdanig, the nickname favoured by his sister.[10] He continued, 'If it happens that the World's Fair has an Armenian Day then do come over, my dear, because I want to visit it that day and you can see my painting. I am now quite well but frankly I had pneumonia in a very mild form.[11]

Gorky had ended up working for $250 per month. He was off the WPA roster from 11 January to 9th June 1939.

A new mural proposal was suggested for the Marine Building by the architect William Muschenheim, Gorky's friend. He had studied in Vienna, worked in Berlin, then joined Frederick Kiesler and William Lescaze to promote modern architecture in America. He often walked over to Union Square from his house in the Village with his children.[12]

Gorky became a regular at their weekend house by the ocean. Muschenheim's father, Frederick Augustus, president of the Hotel Astor in New York, entertained friends on Hampton Bay on Long Island, a hundred miles east of New York. High-roofed bathhouses looked out to the ocean on Shincock Bay. Once, a sea plane hovered, flew behind the bluff, and landed so low they had to flatten themselves. It was the Fascist poet Gabriele D'Annunzio, who strolled out for Sunday lunch, then took the children for a flight. The conductor Arturo Toscanini appeared, together with musicians, artists and other friends. Gorky was a leading light in this cosmopolitan group.

Modern paintings decorating the dining-room included Gorky's lithograph *Kiss*. Lunches stretched into the afternoon. When the Chinese gong rang for dessert the children filed in. Grandpapa puffed on a monogrammed cigar. At last they staggered out to the lawn for siesta. Art Muschenheim remembered 'wild parties, swimming by moonlight', but Gorky also entertained the children. 'He would make things for us. He whittled a bow and arrow out of a piece of wood. He used to carve things and played with us.'

He sketched people or made little abstracts. Lisa Muschenheim's angular

face, deep almond eyes and straight nose were sketched from different angles, set against her husband William's spare profile. In one pencil drawing, a downward curve from her shoulders outlines her undulating back, waist, legs and feet. She wears a long tennis skirt, head and neck are cropped; two inverted V's indicate the back of her dress, while she stretches upward like a plant. Her son explained that she was playing tennis, but Gorky left out the racket, giving the dynamic figure a timeless beauty. The line has the grace of a figure on an Attic vase. Alongside these, he made drawings of highly abstracted body parts sectioned off in curved forms, joints indicated by a little circle, the pelvic area a palette, the buttocks of a man in the shape of a butterfly. He gave them to William Muschenheim.

He organised a shashlik picnic, then outraged the women by separating them into two groups, the 'older' ladies to cut meat, the 'young' ones to prepare the salad. His *Déjeuner sur l'herbe* boasted trailing vines with glossy ivy leaves covering the ground, with a beautiful throne for his hostess. The party was getting merry when some Boy Scouts trudged past. 'Hey!' they yelled. 'That's poison ivy!'

Several members of the party were rushed to hospital. Lisa had to stay for a week.

William Muschenheim and Gorky sat up through the night to mount gouaches for the Marine Building mural on maquette. Nautical subjects were composed in a witty design in blue, white and yellow. They were bitterly disappointed when it was rejected, in favour of a proposal by Lyonel Feininger. The maquette and gouache remained in Muschenheim's possession.

The World's Fair opened on 19 April 1939. The public flocked down a long avenue flanked by buildings in styles ranging from the bizarre to the ultra modern. They headed for General Motors where demonstration cars were ready to give rides through the park. The skyline was dominated by a sharp 610-foot Trylon and a Perisphere 180 feet in diameter, gleaming white and seemingly bobbing above a jet of fountains.[13] At night a light, water and music spectacle was performed. Down the Avenue of Nations, Gorky saw the different national pavilions. The Depression was on its way out to be replaced by a new age of consumerism, but the spectre of war in Europe had not dimmed – Germany had no pavilion.

Gorky's *Man's Conquest of the Air* was housed in what was described as 'the best fair-building' which 'summarized the forms of aircraft and airports'.[14] A striking hemisphere nestled in a structure with a long ramp and walkway. Inside, exposed steel arches supported the aluminium-covered corrugated asbestos sheets forming the lower section wall and roof. Four real aeroplanes hung from structural supports. The colourful murals dominated the prominent wall on two tiers. At eye level with the stair-landing, the viewer came face to face with a frontal view of a plane with its landing gear, propeller and wings. On a larger panel at first-floor level, Gorky floated forms before the background, with clear edges and a childlike element in the imagery of balloons and wings. No colour photographs of the murals appear to have survived, but many viewers remember clear blue, pink and red.

The murals stayed up for a couple of years, but plans to move them to a permanent site failed. After demolition only the preparatory sketches and gouaches remained.

30

Blitzkrieg
1939

In May 1939 Dorothea Tanning, a young artist who later married Max Ernst, was gallery-hopping with friends.

> After closing time we edged into one of our favourite galleries, where there was already a little crowd of nobodies like us sitting on the floor before a large Picasso painting.
>
> We listened as a gaunt, intense, young man, with an enormous Nietzchean moustache, sitting opposite us talked about the picture. It was not his accent, which I couldn't place, that held me, but the controlled passion in his voice, at once gentle and ignited, that illumined the painting with a sustained flash of new light. I believe he talked about intentions and fury and tenderness and the suffering of the Spanish people. He would point out a strategic line, and follow into battle, as it clashed on the far side of the picture with spiky chaos. He did not, during the entire evening, smile. It was as if he could not.
>
> Only afterward I was told that the man's name was Arshile Gorky.[1]

The painting was *Guernica*, on view for the first time in America in the wood-panelled, red-carpeted Valentine Gallery. The stark, grey and black mural went around the world to raise money for the struggle of the Spanish people against fascism. Gorky was a committee member of support.

Tanning recalled, 'How that painting could send him into a spiral of emotion!' No doubt Gorky saw that he too could paint a mural of his people's martyrdom, but it was not until almost a decade later, in *Summation*, 1947, that he would confront the painful theme of the Armenian Genocide.

That spring he was in limbo. Since May he was back on the WPA,

with officials supposedly investigating his 'indigence' and perhaps his political record. His Ukrainian friend Mischa Reznikoff and his girlfriend Genevieve Naylor were there when an FBI agent called. She realised, 'Gorky knew exactly why the idiot was there. He was down on him like a fox.'[2]

With the WPA rumoured to be closing, artists demonstrated against Mayor La Guardia in a march to the City hall. Gorky built 'an abstract tower so large – it was made of painted cardboard, had a wooden skeleton and wires – that six people had to carry it'.[3] Without a mural commission or salary secured, Gorky was on the lookout for a teaching post in an art school.

Guernica was still in New York, when the Museum of Modern Art announced the purchase of Picasso's *Les Demoiselles d'Avignon* for the unprecedented sum of $28,000. Gorky and his friends saw the first exhibition, *Art of Our Time*, in the new Museum of Modern Art in May 1939. But the MOMA was not to make a substantial change in the lives of New York artists. Alfred H. Barr, the museum director, published what they deemed an elitist position, maintaining that social issues had no relevance to abstract art, which developed according to its own inherent rules.[4] In the museum hung splendid works by Kandinsky, Matisse, Rousseau, but no modern American.

A smaller museum also opened in May, for Simon Guggenheim's private collection, kept for years in a suite at the Plaza Hotel. The wealthy industrialist, encouraged by his mistress, the Austrian baroness Hilla Rebay, financed the Museum of Non-Objective Art. Gorky's friend William Muschenheim redesigned a car showroom at 24 East 54th Street; covered walls in pleated grey felt and piped the galleries with Bach. Gorky knew the collection well: Kandinsky, alongside Arp, Chagall, Delaunay, Klee, Moholy-Nagy and Vlaminck. He attended tea-parties given by Baroness Rebay. Short and heavy, she tweaked a fox tippet around her neck, barked at her captive audience in a heavy accent, and preached theosophy. A student of Rudolf Steiner and Madame Blavatsky, she held that Surrealism was 'crazyism', produced by lunacy or criminality, but non-objectivism brought peace and harmony to the world. Her mysticism and attacks on abstract art provoked the art world into controversy.[5] The drive towards abstraction no longer held a challenge for Gorky. Hardliners who institutionalised non-objective art made him uncomfortable. He had already

given the Abstract Artists' Union a hard time when it was founded in
1937. Artists divided into camps: abstract artists worked from natural forms
or objects, pared down and simplified; non-objective artists favoured
geometric shapes composed on the basis of the square, the line and the circle;
while at the extreme Mondrian used only primary colours and straight lines.

Gorky always had at least half a dozen close men friends, even if he felt
betrayed by some of them, like Stuart Davis and John Graham. The latter
had published a book in 1937, *System and Dialectics*, an influential voice in
arguing that modern art synthesised and expressed all the art of the past in a
dialectical movement. He named the important artists of the future, but
Gorky was only mentioned as possessing the 'curse of great taste'.

Instead, Isamu Noguchi, the half-Japanese, half-Irish sculptor, had
become very close to Gorky since Noguchi's return from Mexico in 1936,
where he had completed a mural in Mexico City and enjoyed a passionate
affair with Frieda Kahlo until Diego Rivera threatened to shoot him.
Worldly and well travelled, he had feline charm and savoir-faire.

> We used to go to museums together and Gorky would always be pointing
> out to me the fine points, how beautiful this or that painting was. Not
> necessarily only the more modern and advanced art. Gorky was also concerned
> about the great art of the past. He was a very sweet person. Always sort of
> educating me. I'm sure other people felt the same way. Gorky was very generous
> of his time. And I think that was one of the nicest things about Arshile.
>
> I will say there was no artist who was as voluble or as concerned about the
> craft of painting, analysing art. When I first met him, he was teaching. All
> through the 1930s he taught.[6]

Both men had absentee fathers; Noguchi's was a famous poet. They both
felt alienated in New York and Noguchi's Oriental background gave him
an insight into Gorky's culture and his respect for masters, craft and
technique. He also straddled two cultures and tried to combine abstract
sculpture with Japanese philosophy and art.

As the summer heat set in, Gorky and De Kooning went to stay for a
fortnight with Balcomb Greene, about 70 miles outside the city in New
York State near Fishkill, Duchess County. Greene noticed that 'Gorky

loved to go around without a shirt and with flowers stuck in his hair.' Other artists appeared. 'Socially, his happiest moments were probably in the country,' Greene said. 'Sitting around after dinner outdoors where he cooked his shish-kebab and then we would sing. He really had a very beautiful voice.'[7] Gorky danced around the fire wrapped up in sheets, or turned his jacket inside out to make it into a peasant costume, as de Kooning described.

In August, Gorky went to stay with the Muschenheims. In September he wrote to Vartoosh that Leonore would be visiting Chicago, on her return from Canada. He still loved her and sent a warning. 'Don't say anything about Father to Leonore.' Gorky had allowed Vartoosh to become the visible face of his family. His friends met her, and she could be trusted to keep his secret. Leonore arrived in Chicago to stay in a smart hotel. Gorky had not been able to afford the train fare. Vartoosh instinctively warmed to the red-haired beauty who surprised her by singing Gorky's Armenian songs.

Gorky wrote ardent letters and gave her several pictures, notably a beautiful little oil painting on paper, of flowers, which he inscribed with the words, 'To My Lovely Leonora With Love Arshile, 1939.'[8] He also gave her a coloured gouache of the Marine Building in the World's Fair, and a still life of flowers in a vase. Other drawings in her collection expressed every aspect of his range – portraits of her, seated and dancing figures, and a series of horses. A unique group of about four drawings showed scenes from his own childhood, perhaps of the massacre. Two women burdened by heavy sacks lean down to a small child fleeing from a menacing man with a tall headdress, holding a scythe. A small boy dressed in a robe and holding a stick stands near an alert horse; a seated woman gestures to him.[9] A man with his arm around the shoulders of a woman bends his head to listen and in a frame beside them is a close-up of the same faces, their foreheads touch, while a boy gazes up at the couple. The man's face is exactly like a drawing in Leonore's possession, entitled *Self-Portrait*.[10] A boy is the central figure in each sketch.

The only other woman to whom he had sent autobiographical drawings was Vartoosh. He trusted Leonore and felt her love was strong enough to encompass his family history. His friend Gaston de Havenon observed, 'He wasn't a womaniser. He wanted affection. He wanted a love affair. That's really what he wanted. A romance.'

Leonore wanted more than romance. Although usually Gorky hid his girlfriends, De Kooning met Leonore and puzzled:

> He was really jealous of her. They were like a man and woman. He made it out really good for her. She was a big woman, violinist. He painted her portrait. I think she really liked him, liked to make love with him. He was quick. Gorky was a peculiar guy in front of American girls. He knew how to handle them. He had real passion. But the love is really Hallelujah! I guess in the right time![11]

His jumpy remarks hint that he suspected something was amiss or that Gorky's lovemaking wasn't all Leonore wished. As his painting became fantastical, his love life with Leonore grew more ephemeral. She was the sixth woman he had loved and lost. She stayed in contact with him, acknowledging a powerful bond between them. But like others who had not been able to combat his obsession or his possessive jealousy, she retreated.

In July 1939 Gorky finally received his US citizenship papers. He felt enormous relief at no longer being stateless and was now fully eligible for the WPA, for other grants and fellowships. He wrote to Vartoosh asking why communist magazines still rained through his door. Years later, her son Karlen asked his mother why Gorky had to wait so long for his papers – a full eighteen years of residence in America. Defensively she snapped, 'No reason. It was like that in those days. Don't mention that in your book!'[12]

Hitler attacked Poland on 1 September 1939. Gorky was in Isamu Noguchi's studio on 12th Street when the Blitzkrieg was announced. Their friend Gaston de Havenon recalled the historic evening. Another artist, David Margolies, had arrived to discuss the news. Gorky responded by picking up a pencil. He started a drawing and invited the others to draw on the same sheet. Noguchi remembered, 'He thought Hitler might be an artist, a rather brutal one. During that particular evening, we spent all night, did a lot of drawings together. I have one of them left.'[13]

Gorky had always advocated group drawing. De Havenon watched the drawings change through the evening:

Each one of the painters drew on what Gorky was doing, their own feeling. Pencil, black and white and colour drawing. It was completely abstract. Then they decided to make an anti-war drawing with colour pastels. They expressed their heart out by drawing, each one over the other one. We didn't have a feeling for money then. I don't know if he took it, or Noguchi.[14]

Blitzkrieg, as a word or concept, appealed to Gorky. He went down to the Art Students' League where artists were discussing the events: Raoul Hague, Jackson Pollock, Reuben Nahkian. Philip Pavia reported:

He made a big speech to all of us. He said the Blitzkrieg was wrong, and he didn't like Hitler, but he said the idea of instantaneous war was exciting, and that we should make art instantaneous. That's when Gorky started to give classes at the Grand Central Art School. He called them 'Blitzkrieg Classes'.[15]

Simultaneous or Instant Art was not far from the idea of Action Painting. Gorky chafed at traditional ways of working and wanted a sharp break. Instant painting presupposed a state of readiness, with the artist armed to spring into action.

He challenged the artists to admit they were 'bankrupt'. He argued for combining efforts in group art. Why bother to sign a canvas? Now the WPA was breaking up, they would lose their security blanket and must find a strategy for survival. They must operate a Lightning Strike with simultaneous ferocity on a multitude of targets.

Gorky had seen slogans like 'Let Europe fight her own wars!' America was digging in, refusing to join the war. President Roosevelt declared, 'I have known war and I hate war.' Americans wanted only to profit from the war. Roosevelt pushed the Neutrality Act through Congress in bitter controversy, facilitating the purchase of arms to help the Allies. Russia had signed a non-aggression pact with Germany in August, which threw the American communists into a quandary. Stuart Davis, head of the American Artists' Congress, refused to condemn Russia for attacking Finland. A splinter group led by Gorky's frequent interlocutor Meyer Schapiro, now a Trotskyist, denounced the Stalinist line and deplored the manipulation of artists for propaganda purposes. Gorky's refusal to join the Artists' Congress, even his break with Davis, had been vindicated. Other artists called for open debate on the Finland issue. In April 1940, Davis

resigned from the Artists' Congress, together with thirty artists, half of whom published their criticism in the *New York Times*.

By the end of 1939 a new acceptance of modern art and abstraction seeped through America. The World's Fair and machine-age design in homes made the new streamlined aesthetic acceptable for the urban environment. New York blazoned the new International Style. A change of attitude to Modernism in art was heralded by several important exhibitions: Walter Gropius's exhibition on the Bauhaus, the Museum of Modern Art's vast Picasso exhibition, Miró and Klee, all in the same year. Amadée Ozenfant had opened a new art school in New York. Gorky was friendly with him, had visited his studio and was familiar with his Purist doctrine. Ludwig Mies Van Der Rohe was at the Black Mountain College teaching Bauhaus. But by now politics dominated the lives of artists and writers. In Europe, art was dragged into the theatre of propaganda war.

One evening at a party in De Kooning's loft, artists 'were performing acrobatic stunts', Elaine de Kooning recalled. 'I was doing my stunt which is to put a handkerchief next to my foot, put my hands behind my back and pick it up with my teeth. Gorky was doing his dance, and Bill his Russian *kozowsky*. Suddenly Bill fell on the floor and his leg began to swell up.'[16] Worn out, they drifted into conversation on the lack of respect and support for artists in New York compared to other major cities. Silent gloom descended on the group. Out of that silence Gorky's deep voice was heard booming from under the table:

'Nineteen miserable years have I lived in this America!'

Roars of laughter revived the party. Gorky's expression became a byword for the disaffected.[17]

31

Fantastic Fancies
1940

Two themes preoccupied Gorky during the next few years, his murals and a cycle which he later named *Garden in Sochi*; these were the public and private faces of the artist. He slowly broke loose from the Cubist-inspired Newark panels and the more Miróesque murals of the World's Fair, into fantastic natural imagery. The shift was partly witnessed by Georgio Cavallon, who had been pleading to become his WPA assistant. Gorky had looked him up and down with a sad air and agreed. Cavallon was delighted to associate with 'one of the top painters in the abstract vein'.[1]

From 1939 to 1940, once a week, to satisfy the WPA, he clocked in at Union Square, but Gorky refused to let him even touch a brush. He had to read art books aloud as the artist painted and grumbled, 'You're wearing out the couch.'

Cavallon was awed by the spotless studio with its scrubbed oak floor and by Gorky's fastidious habits. He was working on the unusual project of a stained-glass window. Busa recalled that it was for a prison chapel in Rikers Island Federal Penitentiary. 'With facets of black and extremely primary colours, probably the most primary colour composition he was ever painting. It was the most severe abstraction.'[2] There is no other record of such a project. Gorky slowly opened up to Cavallon and encouraged him to get married:

Gorky had a beautiful girl who was playing the violin and he had problems. He was secretive about women but I sensed that I was in the way. He had problems. Here was this good-looking guy, this girl left him. He was trying

291

to call her, and couldn't get her. He was so depressed, he bought a bottle of whiskey and got drunk. He had quite a good voice and sang. Then he got depressed again. He repeated it the next week. He suffered a lot.

Still he continued to paint night and day. For two years Gorky was frustrated, preparing project after project and having practically all of them rejected.[3] Cavallon spotted a fatalism in him: 'We went to an Armenian restaurant on 30th Street, for about 30 or 50 cents, shish kebab or lamb stew and those vine leaves. Every time he had a Turkish coffee, he turned his cup to see the fortune. Every time, he found it was no good.' Gorky cradled the small cup in his large hand imitating women in Armenian homes, who saw the future in the random patterns of coffee grounds. There was a predatory bird – love was doomed; here a serpent with fangs – jealous enemies would pounce. The cup was perhaps Gorky's substitute for Leonardo da Vinci's advice to artists to look into flames or blotches on a wall to exercise their image-forming skill. Several designs seem to have such an origin: a Christmas card with a bulbous-nosed man blowing at a dandelion; a face for the design for a rug for the Museum of Modern Art.

While Gorky prayed that one of his murals would be accepted, his studio was transformed by two ladies from Philadelphia who brought fresh flowers for a still life. He started several canvases, each one slightly different. Cavallon watched him paint one then put it away and bring out another, day after day. The flowers withered and died; Gorky went on painting for several months 'until he got what he wanted'. He pointed out that Cézanne, in the same predicament, had resorted to artificial flowers. In the end, Gorky earned $50 from a still life,[4] and later gave one to De Havenon for his wedding, the flowers swoop and hover like birds in flight.

Miró's influence on Gorky is traced to 1941 but started as early as the 1930s, when Sirun noted his interest. Since 1930 he had seen Miró's work at the Valentine Gallery and from 1932 at Pierre Matisse, and studied particularly the early works, shown again at the Matisse Gallery in 1940. There are strong affinities between *Flame in Space and Female Nude*, 1932, and Gorky's composition of *Nighttime, Enigma and Nostalgia*. De Kooning accompanied him to a show where Gorky thoroughly analysed *Still Life with Old Shoe*, 1937. The work has been cited most often as the inspiration for *Garden in Sochi*. There are formal similarities in the motifs – a shoe, a column, in the Miró, a gin bottle wrapped in paper – and in the overall

subdivision of the picture plane. But Miró's objects are more realistic, his colours, strident; psychedelic yellow, green, red, blue, in modelled patches fighting through a sombre dark background. A horizon and black clouds create an industrial coldness and artificiality.

As early as 1929, Gorky had painted a boot in two still lifes.[5] These paintings contain two key motifs from Gorky's story about his father's last picnic by the lake: the boot and the egg. Later paintings also feature a frontal perspective of the footwear,[6] remarkably similar to a 1915 photograph of a pointed wooden shoe on an Armenian girl refugee. Perhaps Miró awakened Gorky's earlier fascination with this particular form. 'Art comes out of art,' Gorky was fond of saying.

This footwear has inaccurately been called a 'Turkish slipper' in commentaries.[7] The costume of Armenians under Ottoman rule was restricted in style and even colour:

Until the nineteenth century, in order both to demonstrate Muslim superiority and to foster national rivalries, the Ottoman government enforced distinctions between the different communities. Only Muslims could wear white or green turbans and yellow slippers. Greeks, Armenians and Jews were distinguished respectively by sky blue, dark blue (later red) and yellow hats, and by black, violet and blue slippers.[8]

In one canvas, Gorky has painted the boot the forbidden yellow, and in another, blue and black.

Gorky developed a dreamworld imagery of fantastic forms. Without the imposed agenda of WPA proposals he slipped into a more subjective world where his unconscious rivalled the rich vocabulary of nature. Miro's shallow but oneiric space populated by abbreviated forms, natural, geometric and magical, liberated Gorky. Just as *Portrait of the Artist and His Mother* reincarnates his dead mother, I believe that *Garden in Sochi* is a companion piece about his absent father, the man who walked out of his life. Through a cycle of paintings, starting with *Argula*, the boot object evolves into the womb, the procreating mother, who nurtured him.

Gorky's preoccupation with his father is borne out by a sketch entitled *Self-Portrait*. Any likeness to Gorky is superficial. It strongly resembles the photograph of Setrag which was in Gorky's hands: the angle of the head turned three-quarters to the camera; swooping hairline: long almond eyes

and heavy eyelids; large nose and broad mouth, shaded by a bristly moustache down to the bottom lip; sharp chin; a wide collar. A strange angle below the ear, with the hairline corrected, is explained by the photograph. Behind Setrag's head and ear is the carved post of an intricate wooden chair which Gorky first indicated with a curling line, then removed because it interfered with the face. The sketched head is squarer than Setrag's, the eyebrows straighter, the hair does not recede as the father's does.

Did Gorky superimpose his own features on his father? Or maybe he attempted to show his father at an age when he left Armenia? Gorky drew everyone in his family, and could surely not resist drawing Setrag. If so, it is Gorky's only sketch of his father, and very like the man in the family groups he gave Vartoosh.

Gorky was also involved with the concept of camouflage at this stage; how to disguise an object so that its outline is blurred or concealed; how to make one thing look like something else. He was working in the spirit of Surrealist drawing, as images underwent metamorphosis. Some objects appeared to change identity by symbiosis: the bird woman in Ernst, the furred teacup of Oppenheim, the lion-male in Dali.

In other pictures, identities change through techniques such as photography and frottage; they fuse with another, while retaining a clear individuality, or produce an amalgam where both entities retain their character in equilibrium. In some cases the object seemed to oscillate between two identities. Never seduced by the highly delineated picture, which he disparagingly called 'photographic', Gorky let his hand work quickly until a form emerged. In *Garden in Sochi*, the figures of a woman, a bird, a man with a scythe and other characters may be discerned, but vaguely. An artist friend, Robert Jonas, emphasised, 'They were not abstract ideas. These were related to real experience. They were real to Gorky.'[9]

With excellent references from Holger Cahill, and the artist and poet Max Weber, Gorky had pinned his last hopes on a Guggenheim grant but was rejected. The WPA had dried up, his paintings were not selling, and the students he taught for as little as 50 cents an evening disappeared.[10] Never before had he been so desperate. He considered leaving his studio for a cheaper one. He wrote to Vartoosh on 11 August 1940:

Somehow I'll make my way. I am selling all of my books because I am able to do so, and last month Ethel's husband purchased one picture for $50.

Thanks for $2 from Moorad. Honestly I am so embarrassed when you send me money. The day will come when I shall be able to help you all.[11]

Thanks to an introduction from Isamu Noguchi, a commission arrived in the nick of time, for a mural in a chic nightclub, described as:

The flashiest of the big band clubs . . . Ben Marden's Riviera, at the far end of the George Washington Bridge, in Fort Lee, New Jersey . . . completed in 1937. The Riviera, designed by Louis Allen Abramson, sat atop the Palisades, overlooking the Hudson River and upper Manhattan. Entering past a sinuously curving expanse of dining room, seating over 700 people in a horseshoe pattern focused on a revolving dance floor, as well as a stage large enough to hold a big dance band. Not only did both the dance floor and the bandstand revolve, but the bandstand moved forward and back. The plate-glass windows could be mechanically lowered into pockets and the entire roof of the raised central portion retracted to permit dining and dancing under the stars. Viewed from Manhattan, the Riviera, with its curved facade and illuminated rooftop sign, gave the appearance of the wheelhouse of a great liner, a glamorous cruise-ship temporarily at anchor in the Hudson.[12]

Gorky was briefed by the interior designer, Abramson, to create two curved murals framing the stage. Once more he drew on aerial motifs. Amoeba-like forms freewheel through space, cartwheeling and leaving contrails in weightless flight. The right angles and straight lines of aeroplanes, circles and ellipses of wheels, propellers and balloons of earlier murals were swept up, squeezed, tapered in protozoan shapes. Flatter and more pliant, they no longer suggest actual objects, parts of bodies, but are born out of the act of drawing itself.[13] The forms are curved or ellipsoidal; all sharp angles are banished from a curved space, seemingly elastic.

In the winter of 1941 Gorky travelled each morning to Fort Lee in New Jersey to work on the murals, sometimes taking De Kooning to advise on pigments. Abramson recalled watching him paint into wet plaster on top of scaffolding in the unheated building, but was unsure of the date. At Fort Lee, Gorky had to work straight on to wet plaster, a new technique for him. He had always read up on paints and pigments, different ways of mixing paint, using egg and grinding up colours. As a boy he had made his own

colours, and seen textile dyers using natural dyes. He argued that pure zinc white was more lasting than titanium and other white pigments. He even asked Cavallon to build him a machine to grind colours. Pale lavender and sky blue, tawny umbers and rusty reds make a crepuscular landscape of floating cloud outlines. Soft blues and pinks are anchored by earthy browns in the second panel against a soft buff ground.

A great change had taken place in Gorky's work during the last four years. An airy, floating quality appeared with the lighter mobile forms. Even in the gouaches the background was worked in several shades and incorporated a shadow world parallel to the motifs of the foreground. Gorky was bringing forward his unconscious in subtle ways. He gave an interview marking his new free-associative attitude in the *New York Sun* in August 1941.

I call these murals non-objective art, but if labels are needed this art may be termed surrealistic, although it functions as design and decoration. The murals have a continuity of theme. The theme – visions of the sky and river. The coloring likewise is derived from this and the whole design is contrived to relate the very architecture of the building.

I might add that though *the various forms all had specific meanings to me* [author's italics], it is the spectator's privilege to find his own meaning there. I feel that they will relate to or parallel mine.

Of course the outward aspect of my murals seemingly does not relate to the average man's experience. But this is an illusion! What man has not stopped at twilight and on observing the distorted shape of his elongated shadow conjured up strange and moving and often fantastic fancies from it? Certainly we all dream and in this common denominator of everyone's experience I have been able to find a language for all to understand.[14]

He identified himself in print with 'non-objectivism', aligning himself with Kandinsky but also, for the first time, with Surrealism.[15] These two terms joined up to classify Gorky for ever after as an 'abstract Surrealist' painter, even though his work might not always fit this category in years to come. Later pointing out the Palisades to his friend Jeanne Reynal, 'He said that painting in the future would be like that long, bright cliff – the subject matter "plein air" and the scale limitless.'[16]

PART IV

THE RED
AND
GOLD WORLD
1940–47

32

Seventh Love
1940

One evening in the winter of 1941, Gorky sat stiffly in a row at a loft party. He had gone reluctantly when De Kooning enticed him with an introduction to a beautiful blonde. He couldn't catch Bill's eye for some hint in the right direction. At last the party broke up, and he found himself facing the girl seated next him. She was tall and sinuous with black hair, a pale complexion and a bold stare. Gorky asked, 'Excuse me . . . are you Miss Magwyda?'[1]

'Yes, I am.' She noticed his height, arresting eyes and black, shiny hair. He put on a porkpie hat like her father's.

'Will you have a cup of tea?' That was how Gorky met the seventh and last love of his life.

By the early 1940s many of Gorky's friends were married or otherwise living with women. Locked into a monastic existence, he was the odd man out. Manhattan was full of young girls up from Brooklyn or the Bronx to study art and live a bohemian life. Few broke through the male stranglehold to work as artists. Many shacked up with fledgeling painters and channelled their ambitions into creating celebrities. Gorky had been chased by many such girls who longed to mother him as soon as they saw his 'orphan's eyes' and tall frame. One story had a wealthy girl sitting on his doorstep for days, but he let it be known that he could not love a woman with a nose such as hers. She was back, after plastic surgery. Neither she, nor others who attended the Art Students' League, appealed. By American standards, he

was modest, and the all-night parties in which women ended up naked were not to his taste. Once he walked into a studio warehouse and caught a couple unawares on the floor.

'They did not even stop!' Gorky protested in dismay.

De Kooning's girlfriend, Elaine Fried, was a young art student, petite and pretty, who had come to New York to find a famous artist. She had a sharp turn of phrase which she later put to good use in writing.

> I studied at the school on 34th Street and he [her teacher] said the three greatest painters in America were Arshile Gorky, Bill de Kooning and himself. He was a very intelligent man and coupled Gorky's name with Bill's. Then he introduced me to Bill.
>
> Bill and I sort of started going out and he was teaching me. Bill's studio was just one painting on his canvas or maybe a few others. But Gorky overwhelmed me with the sense of profusion. There were paintings all around. Overwhelming. I thought, I have come as the crow flies to the real artists in America. I didn't know any artists, but I just knew there couldn't be anyone better than these guys.[2]

The brashness of this attitude jarred with Gorky's old-world sensibility. At the same time he was choosy and could be tactless. Elaine realised that Gorky needed someone exceptional.

> The slightest blemish and Gorky would comment on it. Once there was a woman, very attractive, blonde. Gorky was making a play for her, trying to say something nice. 'Oh, what charming little wrinkles you have around your eyes.' I mean, that took care of that. He couldn't understand that Bill and I rolled on the floor.

Elaine had decided to pair off Agnes Magruder and Gorky. 'Oh, what a match! Agnes was very beautiful, very elegant.' Agnes had arrived from Shanghai with 'a wardrobe trunk of satin gowns and foxes' which she had given away for 'jeans and the occasional skirt'. Her innate poise impressed Gorky. 'Gorky seemed to have the real sense of elegance in women. He was very fastidious.' Agnes had overheard Elaine deplore De Kooning's adulation of Gorky, and her hopes that Bill would stop following him around. The right girl might keep Gorky away. It worked. After the

meeting which she remembered as being in January or February, Gorky invited Agnes out for dinner. Agnes, it turned out, was starving.

He took her to the Armenian restaurant on 27th Street and watched her wolf down all the food. He ordered more. Finally he said, 'Let's tek a wok.' They stepped out into a snowfall. Large flakes fell, silencing the city. From 27th Street they walked up to Central Park. The tall trees, the lake, the rocks, which Gorky had studied in his paintings, now looked eerie under soft snow. He was excited like a small boy in the snow with a playmate. Agnes kept pace with his long strides. After criss-crossing the park, she was hungry again. Of their first date, she later remembered mostly the meals he bought her. She was also hungry for adventure. Gorky took her to a Jewish delicatessen on Madison Avenue for a second meal of hot pastrami sandwiches and hot buttered rum.

Agnes Magruder was an unusual girl. Her father was a Captain John Magruder in the US navy. The Magruders produced one son, John, and two daughters, Agnes and Esther. Agnes was born on 1 June 1921 in Boston, Massachusetts. Soon her father was posted around the world and she lived the roving life of a navy daughter, swapping homes and schools, in France, the Netherlands, Switzerland and China. Mrs Magruder had her children brought up by nannies while she pursued her social life. The children saw even less of their father, who was often away on board ship. Having spent most of her childhood abroad, Agnes took Gorky in her stride. 'I was quite used to foreigners after I had been to China. I didn't think everyone had to be a clean-cut American boy.' He was bowled over by her self-assurance. 'Now, entertain me, young man.'

Agnes had 'come out' in a Washington season of parties and balls. Her mother refused to socialise in the 'navy yard', had her groomed in Swiss finishing school to become a diplomat's wife but she fell in love with painting. She had left her family, stationed in Shanghai, with a monthly allowance of $100 a month. She arrived in Iowa City to study painting with Grant Wood. He was not there so she took a bus to New York and enrolled at the Art Students' League. She was nineteen. Gorky was charmed. She looked like a Gorky woman, tall and stylish. She had dyed her brown hair black and wore a fringe, 'to look like Mata Hari'. He invited her to his studio. 'When I'm home, I leave my shoes in the window to air. Just come up.'

Agnes had recently given up the League to volunteer for *China Today*, a

communist magazine edited on 23rd Street, around the corner from De Kooning's studio. In Shanghai, the war between the Communists and the Nationalists had been all the news, and here she was, helping Mao Tse-tung by emptying dustbins, typing letters to Madame Sun Yat-sen, and selling advertising space. Before long, the FBI dragged her off for questioning in the night, during which she lied hopelessly and tied herself up in knots. Gorky told her not to worry and regaled her with stories of his own FBI encounters.

Agnes's father would later cut her off for squandering his money on commies. She lived in a pest-ridden flat, and one day she asked Gorky, 'What are these spots on my waist?'

'Bed bugs! We must get you out.'

'He moved me out on St Patrick's Day.'

Gorky helped her move to a studio in 16th Street. She became a visitor to Union Square.

The studio was light inside and such space, spareness and beauty. Lovely silvery grey scrubbed floor, parquet, suggesting a grander past, and a pressed tin ceiling. No particle was allowed to drop on that floor. The window sill of this vast studio window reflected a rather pink light from the brick building outside. From the outside it looked like a two-storey building. Under the sill of this skylight was a long row of jars and pots of various kinds, Spanish ones, and any pot that took his fancy, from 4th Avenue. They were allowed to get as dusty as possible because they became more charming. Otherwise, no cobwebs. Everything very sparse. A daybed covered with very prickly dark cloth, that had three pillows of the same material. Then there was a round black table on a tripod. An old model stand near the skylight. Then a great big easel. That was the furniture. Three chairs. It was thirty foot square and had a single naked light bulb.

Soon Agnes moved in. Gorky impressed upon his friends that he was living with 'an admiral's daughter from an old American family'.[3] His impoverished artist friends assumed the beautiful deb on his arm must be loaded. She earned a little money on top of her allowance and in any case thought poverty a huge adventure. 'Since she had come to New York determined to be 200 per cent bohemian,' said a friend of hers, 'what could be more shocking than to take up with a man twice her age, an artist and a foreigner at that?'[4]

Gorky took her to meet the Schwabachers, the Muschenheims, the

Sandows. All of them were enchanted with her *savoir-faire*, her European 'finish'. She talked in what was described as 'an expensive voice'. Ethel Schwabacher said, 'Agnes had bold, large blue eyes and jet-black hair. There was a straightness about her, a something mysteriously alerted, springy, very beautiful.'[5]

Gorky also invited her up to the Palisades for dinner at the Riviera Nightclub, with Isamu Noguchi. It was glamorous, noisy and so dark, she remembered, that she couldn't see Gorky's murals. He didn't mind. Next he took her to see the World's Fair mural which equally failed to register in her mind apart from being 'very abstract'.

Agnes found Gorky knowledgeable and brilliant. But he carried the scars of the Depression and his failure with Leonore. Soon he made Agnes the miracle of his life: 'He loved everything I did. If I fixed a flower or did anything, he made a great fuss of me. When I offered to cook breakfast, he seemed overwhelmed. As though no one had done anything for him since his sister left.'

Gorky's glamour as an artist was irresistible, and he had an emotional range she said she would never find in any other man. She knew nothing of his past. 'He kept me in raptures with his stories.' His other girlfriends were soon forgotten. When he was invited to an ice-skating show in Madison Square by Leonore, Agnes ridiculed the idea, perhaps to oust a rival. That was the end of Leonore. Agnes felt that 'he was exactly the sort of man I was looking for. When I met him, it seemed that we were on a mission or a crusade. Gorky had a truth and I must help him get it out, to express that truth.'

In Agnes, Gorky found an unwritten page. She aroused his protective-ness, he saw her as someone he could nurture like his little sister. He turned her into an Armenian with his favourite nickname, and transformed her into a 'Gorky'. She earned it for herself when he had been tapping a nail gently until she swiped away the hammer and gave the nail an almighty whack. He laughed and called her Mogooch, which she took to mean 'Mighty Mouse'. 'Mogooch' was his brother-in-law's nickname (Magruder sounded close to Mgrditch), his nephew's and his cat's. She had hated being nicknamed 'Aggie' by her own family, so was pleased with her new exotic name. She absorbed everything, soaked up his thoughts and reflections. He was delighted that she could read French, and she translated *Cahiers d'Art* for him, seated on the prickly couch for hours, while he painted. 'He just

had my whole attention. He painted all the time, the way someone doodles. Up at his easel the minute he wasn't eating or lying down or sleeping. He listened to the radio as he painted, roared with laughter at soap operas.'

Gorky was overjoyed to have a woman in the studio again. They hardly cooked because she had been used to servants and he knew only a few dishes. After a simple meal, he jumped up to the row of large bowls on the long table under his studio window, into which he had squeezed tubes of paint. Once they formed a skin, he stabbed his brush, releasing the delicious smell of oil paint. She watched his delight as he painted, reworking old canvases in rotation. Meanwhile, he kept her 'in stitches'. He loved to laugh and told impossible jokes with delight. 'He had a very unusual way of seeing people, observant, summing up a person with two or three words. His distortions of the English language gave it a vividness.' They played like children. 'We used to have marvellous wrestling matches with hopeless giggles on either side. Like puppy dogs. He loved that.' Gorky had never understood how anyone could resist painting and had happily given lessons even to beginners. He placed a fresh canvas on the easel for Agnes, the art student. 'Now, you make a painting.' He longed to paint alongside her, as he had done with Mercedes, but Agnes was paralysed. He went out to give her space. On his return, only a few nervous little lines had appeared in a corner of the canvas. 'I didn't want to be encouraged. I'm very stubborn. I loved watching him paint, to see those lovely colours going up. And I never painted myself again.'

She leafed through art books which he studied for hours, catalogues of exhibitions, covered in his thumb marks. Agnes also remembered 'his cookbook', a volume on painting materials by Max Doerner. Gorky consulted it, 'like somebody mad about reading recipes. How Titian created a Titian and all the techniques he mastered.' He drew or commented in the margins. A book on Islamic miniatures, with black and white reproduc‐ tions, was inscribed with a long pencil scrawl across the inside cover, 'The Divil take you!' with an arrow pointing to the price, $2.50. He haggled down reproductions to a few cents, pinned them up, turned them upside down or sideways. A large photocopy of Ingres's self‐portrait stayed pinned to his wall upside down. He swept up Agnes with his passion for all the things which he loved.

Once he came home beaming because he'd bargained down a Raphael book to a mere fifty cents. No sooner had he settled down to study it then he

burst out laughing. 'He had a frightfully funny laugh, not ha ha ho ho . . . it was an unlikely drawn-in hee hee! Didn't believe in showing his teeth. He always said it was very American to laugh with an open mouth.' Agnes went to see. The book had only three pages of reproductions, repeated again and again – a publisher's dummy.

Gorky confided in Vartoosh about his new sweetheart. Like a prospective Armenian bridegroom, he reassures her that he has sent them her photo and has taught her a few words of Armenian. A finely drawn woman's head with pensive expression illuminates the first page. Gorky's writing is bold and confident, the capitals and strokes wrap around each other like lovebirds.[6]

Meanwhile Agnes's father had arrived on the East Coast. She went to visit her family. Gorky felt lost, then very upset without her. He wrote her a long letter.

> Yesterday . . . I went to the zoo. The beasts had a curious effect on me, which I haven't hitherto experienced: I have always admired them, but now I hate them, the dreadful savagery of these wild animals who hurl themselves on their food is too horribly like the ways of humans. What moved me most was a group of four chimpanzees. They were like primitive man, they walked helping themselves with their hands, and looked like old men, their backs all bent, they discussed things in groups, shared food without dispute but with much wisdom – the strongest giving bread and carrots for the oranges and bananas belonging to the others. It's most depressing thus to see our own origin – depressing because we sprang from this, but that we may easily slip back to it. Our knowledge is so great but so empty! How ephemeral! So small a thing, and we lose all. We no longer know chemistry as did the men of the Italian Renaissance, and it will be a long while before we discover their secrets. Art comes instinctively to us, but it is uncertain.
>
> We are part of the world creation, and we ourselves create nothing. Our knowledge allows us to make use of all the forces already in existence, our art to interpret emotions already felt. One big war, an epidemic, and we collapse into ignorance and darkness, fit sons of chimpanzees.[7]

Agnes was convinced that 'nobody else had such interesting thoughts as Gorky'. She did not know that he was writing in pictorial terms about his experience at the hands of the Turks in Armenia.

if the blind masses of humanity, which always persecute their pioneer spirits, had the desire, or rather the power, then would our tall and erect stature be bent, and we should be covered with hideous fur, the grass would grow over our finest works, and we should return to bestiality.

Swept up in emotional and erotic turmoil, he pinned all his hopes on her.

I am so blessed in being able to love you, blessed be the day when the great sun guided me to you. Without you, love, I should have been flung into an outer darkness, where bones rot, and where man is subject to the same law as beasts – final destruction, the humiliation of extinction. Dear, dear love, I press you to me with all my force, and only your help enables me to work. I thank you, dear fair lovely star, in having created our hearts and, by the union of our passionate bodies, better liberate our soul, making of us a single creature – the absolute human which you have endowed with so many gifts.

Goodnight, dear heart, sweet – sister, mother. Think that we are together in the same bed, and by our perfect union, making prayer to God.

Gorky's religious background surfaced again. He was determined never to lose sight of Agnes, his 'lovely star'.[8]

33

Out West
1941

In the spring of 1941 Gorky's painting *Argula* hung in the place of honour at a *Recent Acquisitions* exhibition in the Museum of Modern Art. From March to May it remained on show, enthusiastically praised. Gorky had smashed into the bastion of European art with an oil painting for the first time. He had previously shown sketches in the Museum at the WPA Murals exhibitions, but this was his first permanent hanging. *Argula* was donated by his great friend and patron from Philadelphia, Bernard Davis, perhaps the closest person Gorky ever had to a father figure.

That May Day, Gorky watched Agnes march into Union Square under the red banner of the Chinese communists. From the pavement, he waved indulgently, as he had done with Mercedes. 'He was very enthusiastic about my politics,' Agnes claimed, 'but not consistent from their point of view, so he wouldn't have been very useful.' He was useful to her in laying out the magazine and producing a cover which was too smart for the editor.

One day Agnes demanded to see the whole of Gorky's face. When he refused to shave, she danced about the studio, crying, 'Oh, you nasty t'ing. Oh, you nasty t'ing,' mimicking his pronunciation.

His Armenian men friends were horrified. A man's moustache represents his manhood, they believed, and a woman who cuts it off emasculates him. Gorky looked vulnerable with his small pointed teeth. When he returned from the uptown galleries, he puzzled, 'It's absolutely extraordinary! Everybody came out and said: "Why, Gorky, is that you?" And then they smiled at me! Do you think I used to frighten them?' He did not grow it back until several months later.

One night at dinner with Isamu Noguchi's friend Margaret La Farge Osborne (nicknamed Peggy), Gorky met a mosaicist, called Jeanne Reynal, a slim blonde woman in a smart Paris suit. She showed great interest in his work. The next weekend, Noguchi drove them all to the country. Reynal thought Gorky 'very handsome' and 'magnificent'. Agnes struck her as 'a very tempestuous and attractive young woman with half the world in love with her. Wild and witty.' Gorky appeared 'not trounced – it wasn't his idea of female behaviour, but he was enchanted. It was the masculine quality he had. But she was not a tamed colt.' They went to a lake and swam. 'Gorky was singing and Agnes had learned some of the songs.'¹ It was the beginning of a lifelong friendship.

Agnes and Reynal were kindred spirits. Jeanne had been living in Paris for the last ten years as one of the three mistresses of the Russian mosaicist Boris von Anrep. She had learned mosaic-making by working with him in London, at the Bank of England and the Russian Church in Bayswater. She had returned to the USA in 1938 to receive her inheritance. Now she was based in California, and offered to arrange a one-man show for him in the Museum of Modern Art in San Francisco. Gorky could live and work on her boyfriend's farm nearby. Reynal grasped the originality of Gorky's art and her decision to buy a painting at ten times the price of his other collectors made Gorky dash a letter off to his sister.

Vartoosh dear, sometime during the next three weeks I am going to San Francisco by auto with several friends. A very dear and pleasant friend, who is an artist, visited here a few days ago and liked my paintings so much that she purchased one for which she immediately paid $500. And she invited all of us to go and paint there this summer. Frankly, it would be quite pleasant as it has been 16 years since I have been out of New York.

As you know, my acquaintances here will pay no more than $25 or $50 for my paintings so that when I sell a painting I am unable to paint another one with this money because supplies are so expensive. Two weeks ago I approached Mrs Metzger, who for 14 years has been waiting to buy a painting, and when I explained to her my pronounced need for money, she replied, 'We are all in a similar situation.'

My friends believe that a change of scene is most necessary for all artists. Therefore, I want to hear from you about this, so write to me immediately. Agnes will also come since her father will be there for naval matters.²

Gorky still needed his Vartoosh's blessing for his plans. He had to raise money to drive down with Isamu Noguchi. He went to see Dorothy Miller at the Museum of Modern Art. 'Can you think of anybody who would buy a painting from me?' She bought one herself, with two instalments of $75.

Gorky's paintings were dispatched to the museum; they packed Noguchi's sculpting tools, and the three of them piled into his Ford station wagon. As soon as they left New York, Gorky began to fret and display the anxieties of a refugee cut off from his patch. He missed his studio and his paints. He was not impressed by the landscape. It was never dramatic or grand enough. He described the mountains around Lake Van, the iridescent effects of light on the snowy peaks, the beauty of his childhood landscape. In roadside diners he glared at the canned soup, then at the pretty waitress.

'What is this you have made for me in this pot?' And afterwards, 'How come these girls know how to paint their faces so well, but they can't make a soup?' His sensitive stomach could not tolerate the junk food. 'They fry everything but the ice-cream!'

In the car tensions rose. Noguchi commented, 'He was always seeing some peasant woman up there in the sky, in the clouds. We had terrible arguments about it.' Noguchi refused to play along: 'Oh Gorky, why don't you just see a cloud as a condensation of water?'

Later, he grasped that Gorky's childhood was the prism through which he perceived his surroundings, giving them meaning and atmosphere. As a Japanese conversant with Shinto, he understood Gorky's feeling that spirits inhabited nature. He said:

> When he later did those nature drawings and paintings, he was always seeing in them other things. Nature didn't look the same to him as it did to somebody else . . . not just botany and horticulture. There were all kinds of mysterious things going on which, in his beautiful way, was expressed in his art. Gorky was always sort of celebrating and weaving a lace-work of imagery into whatever he saw. And that, I think, is where his most characteristic development came from.[3]

Gorky felt insecure, his money was fast disappearing. The trip was a fiasco! In the middle of the long bridge over the Mississippi, he ordered Noguchi to stop and started to walk back across the bridge back to New York! Agnes

hurried after him and persuaded him to return to the car.

Gorky cheered up in Santa Fe at the Native American reservations. The adobe huts, brightly coloured textiles, rugs and pottery reminded him of his own dusty village. However, when they reached the Grand Canyon, both he and Noguchi turned their backs on it, preferring to look at the smaller canyons.

Noguchi parted from them in Los Angeles. Then they went on to San Francisco. Reynal had switched boyfriends so the farm was no longer available. He wrote his sister a miserable letter, worrying about his expenses and the cold weather.

My dears, in all my life I had never before made such an error. It appears that my friends wanted me along for the purpose of reducing their travelling costs. They brought me out here and I don't know what to do. I am going to think things out for several weeks and then return to New York. What awaits there I cannot know, but fortunately I have not rented my studio.

I have not slept a single day or night, and the only worthwhile things here are the hills and mountains.[4]

Agnes had her own dream. She asked the publisher of the *San Francisco Chronicle*, who knew her family, if he would send her to China as a war correspondent. He declined. Then she found out that she was pregnant.

Gorky was overjoyed. They would marry and look after the baby. A chance to have a family of their own. But Agnes was not pleased; 'I didn't want to get married at the end of a shotgun like some Victorian servant girl. It has to be a totally free choice.'[5] He pleaded with her; they argued and shouted. Manuel Tolegian, the Armenian artist, happened to be living in their building. He had shared a studio in New York with Jackson Pollock, and had introduced Gorky to William Saroyan. He related with embarrassment:

I was visiting San Francisco, staying in the apartment of a magazine editor. Right next to it, I heard all this commotion. Things tumbled. I thought there was a party going on. I ignored it, then, again, at 3.30 in the morning. Well, they were having a big fight. I settled the whole thing and I asked him to come up to my room with my wife, which he did with this girl friend. I don't think he cared for that woman very much. We sat together until eight that morning. Then we both went out somewhere and had some nice food.

We got reacquainted. He was happy to see me again and we remembered old days.[6]

Abortion was illegal in California. Jeanne Reynal was no stranger to abortions. Agnes went down to the waterfront with an address, not knowing what to expect.

> They slapped me all the time, then said Miss Bagruder, stop making so much noise. Then they stood you up and shook you hard and said walk downstairs. They didn't put you out, quite, because they were afraid of being raided. You were to pretend it was your tonsils. I walked downstairs and there he was waiting at the bottom of the stairs.

Gorky was appalled to see her shaken and pale. But she had carried out her decision. 'I had it out, as tough as that was. I was rather upset afterwards. He always wanted to have a child and I'm very sorry I didn't just have it, and wasn't so stubborn about myself. In a funny way, I wasn't in love with him, I just loved him.'

Unexpectedly his friend John Ferren turned up after a hiking trip in the Sierras with the poet Kenneth Rexroth. He had heard that Gorky was in town, and tracked him down to Telegraph Hill: 'Gorky was there alone. He seemed very depressed. It was a very unsatisfactory meeting. He seemed very disturbed, upset about something.'[7]

Jeanne Reynal breezed in every morning to see them, and to her surprise 'He didn't paint for three months. He didn't want to. He made a gouache for me — a design for a mosaic.'[8] She tried to get him to focus on his exhibition. He wrote to his sister:

> Since my last letter, which was so discouraging, everything appears to have improved. I have met many people who in turn have introduced me to lots of others. Agnes, too, is here, and her mother and father are expected shortly. They have many acquaintances whose influence, I feel, will make matters better. Frankly, she is working diligently for the success of my exhibition. Truthfully, Vartoosh dear, Agnes often asks about all of you and wants me to give you her love and greetings. She always says it would be nice if we stayed in Chicago for two weeks upon our return.
>
> Vartoosh dear, by the way what do you think about this war and how do things look in the Soviet Union? I ask both of you to give me your views.

Oh, I forgot to say that we rented the most beautiful house, surrounded by trees on three sides, while the ocean is on the fourth.

The relationship between Gorky and Agnes shifted as both of them concentrated on his exhibition. Jeanne had donated Gorky's work to the museum, made arrangements, contacted her friends and was helping to create a social life for them. Gorky did not hit it off with the Californian artists and their relaxed attitudes. He asked, 'How can you just stop thinking about work because it's Saturday?' But he met a few people with whom he struck up friendships. The Russian architect Serge Chermayeff and his wife, émigrés from London, were lively and interesting. Fernand Léger was teaching at Mills College, and became very friendly with Gorky. Léger had the head and torso of a construction worker, *costeau* (sturdy) in everything he did – it was his favourite praise for art. He suggested they make *pot au feu* and instructed Agnes to buy a hunk of beef and some vegetables. He arrived for supper with Marshal Pétain's niece, to find the beef raw, the potatoes unpeeled, leeks, onions and carrots piled on the table. 'What shall I do?' he teased. 'Shall I go to the butcher?'

They had to eat an omelette instead. Léger spoke some English. He and Gorky often discussed Surrealism. Léger remarked, 'In my day, the painters used to put the poets in their pockets. Now the Surrealist poets are trying to put the painters in their pockets.'

One day Gorky had an unexpected call. Agnes opened the door to find a pretty woman who said her name was Marny. It was Gorky's first wife. She had continued to write to him in New York but he had chucked her unopened letters into the dustbin. Agnes was intrigued, but Gorky did not want to see her again.

The exhibition at the San Francisco Museum of Art was open from 9 to 24 August 1941. Gorky had made a cautious choice of works from the early 1920s and 1930s.[9] Family portraits, the magnificent drawing of his mother, some still lifes from 1929, several important paintings from his Cubist period, later curvilinear canvases of the powerful *Khorkom* series. The broad sweep of bold works included both the constructive and lyrical. The exhibition received some critical attention and favourable notices in the

press. Many critics tried to display their knowledge of modern art by spotting Picasso, Léger and Miro in the paintings, instead of looking at them with a fresh eye. Gorky read the papers, spitting out, 'Bah!'

Reynal was furious at their ignorance. 'THEY ARE INCAPABLE OF MAKING THE EMOTIONAL RESPONSE that his painting requires.'[10] The American obsession with originality was vulgar and superficial; the critics were ignorant. Gorky told his favourite story on originality: a contemporary critic had challenged Ingres for daring to sign his name to 'those Raphaels'. Gorky was fond of saying, 'Just wait forty years.'

One gentleman confessed to Agnes that he could not endure being in the same room as Gorky's paintings because he found them too painful. She repeated this to Gorky, who nodded. 'Quite right! He must be a very sensitive man.'

Gorky then tried his hand at sculpting again, and chipped away in a sculptor's yard with Agnes as his model. Two weeks later when he had chipped almost all of it away, he was crestfallen.

'There's not much room left for you.'

After the show Jeanne Reynal and Urban Neininger, her current boyfriend, suggested a camping trip. But Gorky and Agnes had to get married, she insisted, otherwise she could be arrested under the Mann Act which prohibited transporting a woman across a state line for 'immoral purposes'. At first Agnes 'didn't have any intention to marry him. I didn't have marriage on my mind.' After the abortion, however, she was slowly coming to the realisation that she could not live without Gorky. When he spoke to Dorothy Miller and Holger Cahill who had arrived in San Francisco, Gorky told them, 'Oh, Dorothy, I'm so happy! I'm going to be married!'

'Why, Gorky, I can't believe it! Who is she?'

He gave his standard answer. 'Her name is Magruder, but I call her Mogooch.'

Dorothy pronounced Agnes 'absolutely the most beautiful creature I've ever looked at. I guess she was twenty-one. We wandered all around the city, around Fisherman's Wharf. Gorky was indeed so happy, and she was too. She had written a magnificent letter to her parents who opposed the marriage, telling why she was going to marry Gorky, and Gorky was so proud of her, and in love with her.'[11]

Gorky was driven into a dusty ghost town in Nevada on 15 September 1941. It looked like the backdrop of the Wild West movies that had inspired his first alias, Archie Gunn. On the way, the campers had stopped off at the five and ten cent store for some brass curtain rings. An 'old codger' in the courtroom of Virginia City drawled the words which transformed Gorky and Agnes into man and wife. In a deserted old bar with dusty sepia photographs of the Astors and the Gold Rush, Jeanne ordered champagne.

Gorky had chosen a second wedding away from his family and friends among people who knew nothing about his background. It could not have been more different from the Armenian weddings in his family. Nonetheless, he dashed off a postcard to Vartoosh: 'Just now we got married and the two of us are sending our love. Mogooch and Gorky.'[12]

The camping trip became their honeymoon, with Jeanne and Urban. Up in the high sierras, they built fires, cooked beans, baked bread in hot ashes. Their kit did not stretch to tents, so the couples bedded down in sleeping bags under a sky studded with stars. Gorky was worried about 'creepy crawlies and snakes', proving that he had become a city boy. Agnes kept a wary eye out 'for bears'. Their worst moment was the deafening rattle and hoot of a huge train which seemed to hurtle straight at them. They leaped up and scrambled away, tripping in the double sleeping bag. The train pulled away, the hoot echoing through the mountains.

Towards the end of September, Gorky and Agnes travelled by Greyhound bus to Chicago and arrived, hot and dusty, at the Mooradians' flat on Northside by the lake. Agnes was so exhausted it seemed to her that she slept for two whole days. Gorky slipped out in the morning to sit with his sister in the kitchen, while she cooked breakfast. The small flat was colourful with Oriental carpets and Gorky's pictures. He was pleased to see the Mooradians living comfortably, after his efforts to help them out of Armenia and back on their feet. If Vartoosh sent him money, it was not merely out of gratitude. She said:

When he was single, I was always thinking about him, every meal-time. Is he now walking the streets hungry? But when he married, the burden of my thoughts lightened. At least he had someone to think about him. I was very happy and felt joyful that he married Agnes and they were so much in love.[13]

Agnes had seen portraits of Vartoosh, and recognised the slim woman with straight, jet-black hair and intense dark eyes. She dressed simply and spoke sparse, broken English bumping against 'th' sounds. The handsome and genial Moorad was no match for her steely temperament. Moorad was fluent in English, having served in the US army. Compared to Gorky, Agnes thought him more urbane and assimilated. Vartoosh laughed and cried in the same breath. Children came first and nothing was too much trouble for family and friends. But Agnes sensed that Gorky was on edge. 'I was never allowed in a room alone with Vartoosh.' Gorky feared that his sister might slip up and talk about their father, whom Agnes supposed to be dead.

Gorky had written to his sister that Agnes was 'very beautiful and cultured with a fine mind'; that she had been educated in four countries, was well travelled, had been reading Lenin, Marx, Engels and Stalin, and was learning some Armenian and Russian.[14] Vartoosh was bewildered that a girl from a good family would just go off with a strange man and marry him without her parents and family. But she planned to celebrate her brother's marriage with a dinner party with Armenian and American friends.[15]

Kohar and Alexander Avakian wanted Gorky's advice on paintings by the Albright brothers, well known at that time. Gorky told them, 'One of the brothers is very good in his own way, the other, only if people don't know art. If you get a picture you don't like after a couple of weeks, don't keep it. Somebody, some day, will paint the pictures you like.'

Toasts were made to the young couple. Vartoosh's wrapped vine leaves and Vanetzi dishes were passed around. She sang, 'D'ele Yaman', at Gorky's request, then he responded with a song. Another guest, Mrs Kelekian, declined his invitation to sing: 'I don't sing in small rooms, only in a concert hall.'

The devil got into Gorky. 'Once some very prominent people asked Chaliapin to a banquet and invited him to sing. He said. "I won't sing. My performance is worth two thousand dollars at the opera." The host called the butler. "Give Mr Chaliapin two thousand dollars." Then in a loud voice, "Now give Mr Chaliapin his hat!"'[16]

The company was stunned. Her husband, Dr Kelekian, said:

He didn't talk much. He looked very gloomy. When I came home, I tried to find out what the word *gorky* means, it means bitter one. He looked exactly

that. Sad and silent and bitter. Physically, he was worn out. He struck me as a good genuine artist. He was reserved, withdrawn, inside himself. He looked aloof in that circle.

Gorky did his best to hide his poverty from Vartoosh but she regretted her actions: 'If only I had given that money to him instead of spending it on the party. It hurts me to think he needed it far more. They had to hurry back. They didn't want to lose the studio. I just didn't understand how much he needed it.'

Four nights later, Gorky kissed his sister and brother-in-law goodbye and hugged the six-year-old Karlen. Vartoosh pressed food on them for the journey, clung to her brother and asked them to come back and settle in Chicago. The fare back to New York was $30. They tried to sleep on the bus but when Gorky dozed off, he shrieked with terror in the night. His journey west had been a disappointment, but he was returning married to the woman he loved.

34

Blithe Spirit
1941–42

Gorky was happy to be back in his studio after three months away. He looked at the canvases he had left behind with a fresh eye, particularly as a letter waited for him from the Whitney Museum, asking for his entry to *Paintings by Artists under Forty.* He chose a large painting in strong apricots and oranges to rework; meanwhile, listening to the news about a conference of world leaders in Sochi, he came up with the title – *Garden in Sochi.*

The work was like a wartime version of the innocent and light-hearted *Argula*, incorporating the 'boot/churn' motif, and biomorphic shapes. In one night he repainted it green, revealing his preoccupation with camouflage and war. Cutting through its sobriety darted brilliant rainbow forms of clear yellow, red and blue. Rough brushwork over old paint suggested the permanence of wood or stone.

By contrast, Gorky swept the dazzling brightness of a California desert over an older canvas, later to be called *Mojave.*[1] He had allowed the darker earthy ground to show through the brush marks of a dazzling primrose yellow. The quirky humour of rounded forms hovering around the central boot form as if by magnetic attraction; all were abstract objects – white double cusps, half moons, a sun-moon. His impulsive hand swooped over red, green and black shapes, and carved out poignant little crescents speckled with older layers of colour. By reworking the edges crisply in orangey red and white, this final coat of colour pulls background and foreground onto the same plane. He radically changed the entire balance of the canvas by overpainting, as well as redefining its basic elements. *Mojave* is a good example of this method which he was soon to abandon. There is a

poignancy in his care for the earlier under-painting, the history of the picture, as the top yellow zigzag brushstrokes resonate against traces of the earthy base.

During the Whitney exhibition, Gorky also visited the Museum of Modern Art for the retrospective of Joan Miró and Salvador Dali, protesting that the exhibition was too massive to take in. It also marked the end of his interest in Miró, who by the 1940s was painting with a hard edge, black circuitous lines and podlike forms. Gorky spent his time scrutinising technical details.

A month after their secret wedding, the Gorkys visited Agnes's parents in Philadelphia. Gorky was greeted politely by the tall naval officer with cool hazel eyes and a Southern drawl who seemed to share a special bond with his daughter. His pretty, Northern wife chatted about world events. On war and politics, they were diametrically opposed. Since Agnes had become a diehard communist, they assumed Gorky must be a 'Red Russkie'. At dinner Gorky switched to a more personal note and waxed lyrical about his childhood, the lake, mountains, birds' nests. Agnes glowed with pride at her 'poetic' husband, while her father looked baffled.

As they said goodnight, the Captain took her aside and whispered, 'Don't forget, dear girl. The key is always in the lock for you!'

Gorky entrusted to Agnes the task of writing regularly to their families. She composed gracious letters, and assured Vartoosh that Gorky was well cared for and was enjoying the cheeses she had sent with her husband Moorad. Gorky was ill with flu but enjoyed staying in bed with his books and pictures while her teenage sister danced in her block shoes for him. She always signed off as 'Agnes'.[2] To Vartoosh she exaggerated the esteem in which her family held him although she admitted, 'My father thought I had wasted an expensive education by marrying Gorky.'[3] Her mother tactfully hid her disapproval. She tried to be a perfect wife. 'I was making him a life he'd never had. I knew that from the moment I moved in.' However, their attitudes to marriage clashed:

> I told him that I felt it was quite impossible to be faithful. How one person couldn't be all things to everybody from birth to death. Surely there were all sorts of facets to everybody's personality.

When I first went to live with him, I couldn't understand what I'd done. It was all right then because I had a bolt hole. I could go and see my parents or my grandfather on Cape Cod. I could do things, couldn't I? But once I was married, well, he didn't want me to go out any more, working nights or days.

Gorky's model of marriage came from an older culture. The home, family and kinship ties were the only security for Armenians and for their ethnic survival. Gorky's sisters and their husbands, and his Armenian friends' families, reinforced the pattern. American values seemed alien, and did not make any impact on the first waves of immigrant families.[4] Agnes was used to moving every two or three years and leading an active social life. In her experience of family life, wives were alone for long periods, went to parties and dances without their husbands. Children were sequestered with nannies. Agnes spent more time as a child with the servants in the kitchen and garage than with the adults of her family, whose life seemed unreal. Now she felt the urge to get down to basics. 'I wanted to scrub floors' and 'raise children without nannies'.[5] Gorky and Agnes could not gauge the vast social divide between them. They saw themselves as forging their own life, in the early stages of high romance.

Agnes grew into her new personality as Mogooch. She 'combed the newspapers and employment offices' for work but had no high school diploma. During their trip to California Gorky had not sold work and now pinned his hopes on receiving a commission for another mural.

On Sunday 7 December 1941 came the devastating news of the attack on Pearl Harbor. The USA declared war the next day.

For the first time, Gorky spent Christmas in New York and did not go to his relatives in Watertown. He brought home a little fir tree, set it in the middle of the large studio and decorated it with lights. 'It looked comical and sweet' to Agnes. At the end of the year, Gorky wrote to Chicago:

As you know I was going to do a relatively large mural painting for the architect here, and he liked it very much. But the architect wrote me that due to the war situation, Mr Marden wants to wait several months to see what conditions here will be. Frankly, I worked an exceedingly long time on those pictures, that is the sketches, but what can one do? Actually, I toiled on them for two months and now a few words turn everything topsy-turvy.

Vartoosh dear, Agnes asks me to give you the very best gift, a hug to all of you. During these holidays we felt as though we two were with all of you.

... we truly regret that the repercussions of the war have created such a serious situation. We artists have organized so that if we are drafted we will serve as artists and not as soldiers.[6]

The cosy utopianism and quaint formalism favoured by the WPA and the American Scene were suddenly irrelevant. The Nazi onslaught on France, the UK and the USSR alerted Americans to virulent new powers of destruction. Many French avant-garde artists fled to New York rather than remain under Nazi occupation. A new group of art promoters saw the chance of pushing American art to the forefront and making New York the artistic capital of the world. During 1940–41, the US government had launched 'Buy American Art Week'. Support for American art was being pushed as a patriotic duty to create unity, and *Life* magazine publicised these government-sponsored shows.

> Our country today is turning toward the arts as at no other time in the history of the Republic. A great tide of popular interest in American art has been rising during the past few years. There are strong currents toward an art of native character and native meaning which shall express with clarity and power the interests, the ideals, and the experience of the American people.[7]

A private market was launched by gallery owners, writers and publicists, but also by covert government agents. Unknowingly artists were being manipulated in the first step of an aggressive drive towards cultural domination. With Europe fighting for survival, the USA saw its chance to make the next half of the century the 'American Century'. Jazz, film and literature were in place together with architecture and industry, but where was the art with its 'native character and native meaning'? A strategic letter in the *New York Times* goaded artists:

> Now is the time to experiment. You've complained for years about the Frenchmen's stealing the American market – well, things are on the up and up. Galleries need fresh talent, new ideas. Money can be heard crinkling throughout the land. And all you have to do, boys and girls, is get a new approach, do some delving for a change – God knows you've had time to rest.[8]

The letter was described by the *New York Times* as a 'bombshell'. It was a

declaration of war on Paris, the arbiter of taste, now under the Nazi boot. Many American artists protested that new art existed, but was not being exhibited. In response some of them formed the Bombshell Group, while other independents including Gorky, Stuart Davis, Milton Avery, Carl Holty, John Graham, Jan Matulka, Mark Rothko and Adolph Gottlieb, exhibited in Macy's department store in January 1942.

Gorky's thoughts on 'serving as artists not as soldiers' had turned to organising a camouflage course. An official *camoufleur* would not be sent on active service. He had brainstorming sessions with his scientist friends Warren McCulloch and Alexander Sandow and the artist Ad Reinhardt. Ethel Schwabacher, one of his students, recalled, 'For this course he prepared with his usual eagerness, voraciously consuming all the literature on the subject, a literature which covered data on protective coloring in zoology, optical illusions in the physics of light, and visual reactions to movement in Gestalt psychology.'[9]

Gorky's imagination broke the bounds with an ambitious project he described to an Armenian acquaintance, Oksen Sarian; he wanted the *New York Times* and other papers to publish his plan for camouflaging the whole city in case of war.[10]

Art on such a scale was revolutionary. Gorky's excitement in discussion was infectious. An artist friend, Robert Jonas, transcribed blasts of phrases and ideas which they shaped into a pamphlet on camouflage to announce a class by Gorky at the recently reopened Grand Central School of Art:

An epidemic of destruction sweeps the world today. The mind of civilised man is set to stop it. What the enemy would destroy, however, he must first see. To confuse and paralyse this vision is the role of camouflage. Here the artist and more particularly the modern artist can fulfil a vital function for, opposed to this vision of destruction, is the vision of creation. Historically, it has been the artist's role to make manifest the beautiful inherent in all the objects of nature and man.

He compared the investigative role of the artist with that of the scientist:

In the study of the object, as a thing seen, he has acquired a profound understanding and sensibility concerning its visual aspects. The philosophy as well as the physical and psychological laws governing their relationships constitute the primary source material for the study of camouflage. The

mastery of this visual intelligence has been the particular domain of the modern artist. Intent on the greatest exploration of the visible world it was the cubist painters who created the new magic of space and color that everywhere confronts our eyes in new architecture and design.

His remarkable idea that objects are revealed by art was given its best expression here:

Since then the various branches of modern art through exhaustive experiment and research have created a vast laboratory whose discoveries unveiled for all the secrets of form, line and color. For it is these elements that make an object visible and which are for the artist the vocabulary of his language.

This course is dedicated to that artist, contemporary in his understanding of forces in the modern world, who would use this knowledge that will deepen and enrich his understanding of art as well as make him an important contributor to civilian and military defence.[11]

It was nothing less than Gorky's manifesto. He set out his own agenda for the next few years. Like a scientist, he would unveil 'the secrets of form, line and color'. There was no mention of aesthetics. Knowledge itself could be put to any purpose, even war.

Among the students was Betty Parsons, who would later open a gallery. She attended a class of twenty to thirty people who met twice a week for three to six months. 'I saw him in his studio and then in mine when he came to my studio to teach drawing. He was very big physically, very big within himself. He had the big point of view. No patience with the mediocre or the compromising. He was an uncompromising artist.'

Agnes wrote to Vartoosh on 4 January 1942 explaining their difficulties at the prospect of Gorky being drafted. They believed that because of his age and his wife who was dependent on him, he might not be called up.

Gorky had written to Akabi and Satenig telling them he was married, and was hurt that they had not replied. Libby was the first to meet Agnes. She dropped in with a friend whom she had warned about her eccentric uncle.

Agnes's first words were, 'How old are you?'

'I'm twenty-four.'

'Oh! You're much older than I am,' replied Agnes, who was twenty-one. Libby warmed to her. Over coffee Gorky questioned her about her government job in Washington, warning, 'I don't want you to talk anything but Armenian.'

'But the others don't understand. *Amot é.* It's rude.'

'I want to hear your Armenian.'

Gorky longed to hear her news but Agnes must not know about his family, especially his father. Impressed by his wife's imposing and affluent family, he felt increasingly ashamed of his own. His 78-year-old father had fallen on hard times after leaving the Norwood farm, and now worked in Milford as a farm hand; 'nothing but a slave', his grandson Charles remarked.[12] Gorky's sisters had also suffered in the Depression, struggling to support their husbands and families. Akabi was now a midwife; Satenig stitched shoes. Her husband was grateful when he found work, collecting garbage. Gorky could scarcely share this news with Captain Magruder.

Yet Agnes was fascinated by everything he told her about his origins. 'I didn't have the historical background and he didn't give it. I didn't even know where Van was.'[13] Her spirit was unbroken and could not mirror his pain. Grateful for this, he was able to leave his ghosts behind him in her new world. Gradually he drifted away from his family.

35

The Waterfall
1942

In 1942 Gorky met a young man who would become fatally embroiled both in his professional and personal life. Gorky had continued visiting Julien Levy's gallery regularly, where he was introduced to a short young Chilean, Roberto Matta Echaurren, born in 1911. While working in Le Corbusier's atelier in Paris, Matta had sought out the Surrealists through Dali and gained an introduction to André Breton, then directing the Gradiva Gallery of Surrealist art. In 1937, he began drawing and painting, in the company of a wealthy young Englishman, Henry Onslow Ford. He soon entered the Surrealist circle where his quick-witted intelligence endeared him to Breton. He became involved in publishing in *Minotaure*, the Surrealist review, and illustrating *Les Chants du Maldoror*, Lautréamont's key Surrealist text. In 1939 he had arrived in America as a torch-bearer for Breton. Extremely ambitious, he played his role to the hilt to attract painters and create a movement of his own, as leader of the new doctrine.

His meeting with Gorky became a key event described by many artists whose imagination it captured. Gorky and Matta were opposites in everything: Gorky, tall and rugged, Matta, short and fine. Gorky's speech was slow and reflective; Matta's quick and barbed. Levy recalled that they talked in his office for several hours when the famous exchange took place. Gorky protested, 'You paint too thin!'

To which Matta retorted, 'And you paint too thick!'

Gorky's candour and innocence were no match for the sophisticated and perverse quirks of Matta's more calculating temperament. Yet they were

matched in enthusiasm, playfulness and avid curiosity. Soon they were exchanging drawings for study.

A group of artists began meeting regularly, under Matta's leadership, to explore automatic drawing. He tried to recruit Gorky, together with de Kooning and Motherwell, who had only just started painting in 1941. For years Gorky had practised automatic drawing, not as a game, but to extend his territory into the unconscious. Matta initiated occult surrealist games, synchronicity and inspired accident, using automatism as a tool to impose himself as a magus upon the group. Gorky refused to join and De Kooning followed suit by staying away. Matta was still attracted by Gorky but often lost patience with him.

'Why keep painting on the same canvas? Leave it and do another one. Let them fly out of your hands,' he urged Gorky. He suggested mixing turpentine with his paint to do faster and freer work. The more improvisation he permitted, Matta argued, the stronger his drawing and painting would become. Gorky found it hard to shake off his self-imposed rigour although confirmation that his new works were appreciated was increasing.

Garden in Sochi had caused a stir when Lloyd Goodrich displayed it in the annual show at the Whitney, in the place of honour. He advised Alfred Barr, the director of the Museum of Modern Art, that it was the best painting of the year. Despite Dorothy Miller's enthusiasm for Gorky, Barr continued to see him as an impostor. Agnes recalled, 'Barr heard about the painting and came rushing down to see it.' He was clearly impressed, but proposed a part exchange. In return for *Image in Xhorkom*, 1936, which the Schwabachers had given to the Museum, he would take the newer painting and pay an additional sum, as though he were trading in an old machine for a new model. Gorky could not avoid this humiliation without the clout of a good dealer, to push an outright sale. He had to represent himself, and Barr counted on the vulnerability of the artist tantalised by the exhibition of new work in the Metropolitan Museum of Modern Art. Agnes noticed that Gorky was unusually tongue-tied and agreed to the return of *Image in Khorkom*. The Museum would then only have to pay a further $300 for *Garden in Sochi*. After Gorky's death, when Barr came to buy a painting

from Julien Levy, he grumbled at having to pay thousands of dollars, when he could have had it for a few hundred while Gorky was alive.

In June 1942 Dorothy Miller asked for a text to accompany the painting. Gorky dictated to Agnes a personal extemporisation. Although he had spoken and integrated aspects of Surrealism since the late twenties, this text was later cited erroneously as evidence of Gorky's precipitous conversion to Surrealism. He opened in a positive mood.

> I like the heat, the tenderness, the edible, the lusciousness, the song of a single person, the bathtub full of water to bathe myself beneath the water. I like Uccello, Grunewald, Ingres, the drawings and sketches for paintings of Seurat, and that man Pablo Picasso.
>
> I measure all things by weight.

Then Gorky made a sudden foray into the garden of his memories.

> About 194 feet away from our house on the road to the spring, my father had a little garden with a few apple trees which had retired from giving fruit. There was a ground constantly giving shade where grew incalculable amounts of wild carrots, and porcupines had made their nests. There was a blue rock half buried in the black earth with a few patches here and there like fallen clouds. But where came all the shadows in constant battle like the lancers of Paolo Uccello's paintings? This garden was identified as the Garden of Wish Fulfilment and often I have seen my mother and other village women opening their bosoms and taking their soft and dependent breasts in their hands to rub them on the rock. Above all this stood an enormous tree all bleached by the sun, the rain, the cold, and deprived of leaves. This was the Holy Tree. I myself don't know why this tree is holy but I had witnessed many people, whoever did pass by, that would tear voluntarily a strip of their clothes and attach this to the tree. Thus through many years of the same act, like a veritable parade of banners under the pressure of wind all these personal inscriptions of signatures, very softly to my innocent ear used to give echo to the sh⁄sh⁄h⁄sh⁄h of silver leaves of the poplars.[1]

The ancient cult of the earth had not been extinguished in the Van area. There were other rituals, where men had dug holes in the ploughed field and copulated with Mother Earth, in order to replenish the soil. The émigré

identified his art with the earth of his homeland, which in turn represented the body of his mother.

This text was instantly treated as an inventory by avid interpreters of his paintings: spot the tree, the rock, the women, the breasts. Any shape became a Rorschach test. Gorky loathed 'interpreting by numbers'. He once met Meyer Schapiro, whom he respected highly, at an exhibition of the Cuban Surrealist Wilfredo Lam. Gorky murmured the word 'pregnant'. Meyer leapt in with, 'I see what you mean. Here is a protuberance.'

Gorky came home irate. 'Bookkeepers! Bookkeepers, all of them!'

In June they visited the Magruders in Washington, DC. Gorky helped his mother-in-law with some decorating. The highlight of his trip was a visit to see Ingres's *Odalisque with Slave* in the Walters Art Gallery.

Gorky was happy that the Metropolitan Museum 'bought a very large painting from me two weeks ago, and they are going to spend $350 in order to make a coloured print so that it will be published in a book'.[2] His carpet design *Bull in the Sun* had been executed. He told Dorothy Miller, 'The design is the skin of a water buffalo stretched in the sunny wheatfield. If it looks like something else then it is even better!'[3]

The war had made European art supplies unobtainable. Gorky tried to stock up on his favourite French and English brands, Lefranc and Windsor & Newton. He bought Russian linen for his canvases, but disliked its cheap absorbency. He applied for a job at Brookline College, Massachusetts. Agnes wrote to Vartoosh that he had received glowing references from the most influential museum directors and critics.[4] But still no job.

They walked in the morning; then he painted while she read to him. They went to the cinema to see Papa Stalin, returning home starry-eyed. Even after the Mooradians' experiences in the USSR, Stalin was unblemished in their eyes. They caught the 86th Street Express uptown for dinner at the Schwabachers. Agnes recalled, 'We just hoped they would pass the steak twice. They were awfully sweet. "Oh, is that steak?" we would say. Sometimes there wasn't enough to go around twice.'[5]

They visited the Metzgers, and Willi Muschenheim's, where Gorky's *Sunset in Central Park*[6] hung in the dining-room, and to the Sandows, who believed in this marriage. Most artists could not survive without their wives. Dorothy Dehner, the artist married to the sculptor David Smith, believed,

The women were very stable, worked terribly hard, looked after the men.

Rothko's wife supported him, Esther Gottlieb and Sally Avery were much
honoured. I supported David with private income and made Christmas
cards. Graham had five wives and innumerable mistresses in between,
without having a troubled conscience. He always found perfect ladies who
looked after him and paid. Never had any whores.[7]

Mrs Chaim Gross added, 'Mrs Raphael Soyer taught until she was ninety.
Raphael was never on the WPA.'[8] Despite this, women were badly treated,
and wife-beating was common, especially after frequent bouts of heavy
drinking. David Smith became violent and Dehner observed, 'They never
could take off their masks before a woman.' The paradox of women
idealised as models ended in their abuse. But Gorky's sensitivity to women
made its impact on Agnes, who said later, 'He was everything – mother,
sister, aunt. He showed me his love in every way.'[9]

He enjoyed drawing and painting her, but never in the nude, as he had
Sirun and others. The sketches show him discovering different aspects of her
character. In a softly shaded drawing, a pensive girl looks down, her hand
to a petulant top lip, long hair about her face. By contrast in a crisp
execution with fine pencil point, a powerful young woman's pouting lips
combine with a determined chin, a long straight nose, and eyebrows
winging over staring eyes. Gorky revealed intelligence and sensuality, as well
as courage and defiance. His favourite metaphor for a woman had always
been the thoroughbred.

Her features are echoed in *Portrait of a Man with a Pipe*, 1943. It shows a
balding middle-aged man, head on a cushion, pipe in hand; Agnes
identified him as her father. Fingers curl around the pipe; eyes glare, half-
hidden by the top eyelid, revealing the white of the eye in a lizard stare
echoed by a stubborn protruding bottom lip. Gorky has caught an iron will
and a strong temperament. Gorky's hand revealed truths which his feelings
kept from him.

In 1942, he finished the series with a magnificent pen and ink profile of
his archetypal woman, resolute nose and brow in upward angle, as though
he had resolved the contradictions by idealising Mogouch, his wife and
muse.

In summer Saul Schary, his old friend, noticed that Gorky seemed fearful of
being drafted and looked 'dreadfully upset and tired'.[10] Schary was gruff and

unpretentious; his wife, Hope, worked in the garment industry. He, Gorky and Agnes left for his Connecticut house, leaving Schary's wife, Hope, to follow. Schary said:

> I took him down to a ruined mill on the Housatonic River. An old silica mill ... these huge grindstones lying about on the edge of the river. They used to grind up those huge rocks. The Connecticut Light and Power Company had gotten control of all the water power and anybody who had a mill couldn't use the water power, so these mills were abandoned. Over the years it fell into ruin until it was a really handsome and romantic ruin. Just below where they took the power was a waterfall. I used to love to go down there and paint.

Gorky came alive as soon as he approached the river and felt the force and freshness of the water hitting the huge rocks. Invigorated, he stood on the rock in midstream. Schary waited for him to settle down. But Gorky was exhilarated by the thunder of the crashing waters and the flying spray.

> He stood on a rock and he wouldn't come out of that water. He loved it so. It reminded him of a spot back home. He just stood on the rock and let the water flow past him.

Gorky drew energy from the torrent. He saw abstract patterns around him, diagrams of natural forces. Gorky drew the waterfall which undoubtedly reminded him of such scenery in Armenia. Schary, a traditional painter, was delighted:

> Until very recently, I had the first drawing of this spot, which led to this series of water mill pictures. A drawing of Gorky's, more realistic than this *Waterfall*, shows very clearly how this evolved out of the water falling over the rocks and splashing up and making these strange kinds of forms. Hirshhorn, who has a fabulous collection of modern art, bought that drawing.

Gorky stayed two weeks and completed more drawings. As well as realistic ones, some were like diagrams of forces or Leonardo's drawings of waves, wings and physical phenomena. Agnes and Gorky were hoping to have a baby. The pregnancy test had proved positive. Gorky looked forward to becoming a father.

Without telling Schary about the pregnancy, he asked casually, 'What you t'ink, Schary, I have a baby?'

Schary sensibly argued that Gorky could not afford a child. How could he work with a wife and baby in the studio? Gorky was incensed. Schary heard that he went about New York muttering, 'Watch you t'ink about this fellow Schary? He says I can't have baby!'

Schary was upset over the misunderstanding, but he also blamed Agnes for being pushy and contemptuous of his wife Hope, who worked in the dress business. The friendship cooled for a time, until Schary came to play a critical part in Gorky's last year.

36

White Angels, Black Angels
1942–43

Gorky became more closely identified – in other people's minds – with Surrealism after his text on *Garden in Sochi*.[1] He focused increasingly on personal and autobiographical sources as his primary material, while using the technique of camouflage to break down boundaries between contiguous figures and areas in his work. He developed two cycles of paintings, *Garden in Sochi* and *Waterfall*, which became a watershed in his style.[2]

The first of three oil paintings of *Waterfall* was mainly in white, and is linked to the more figurative *Garden in Sochi*.[3] The latter, with its flowing black lines, draft out the main figures with a few variations in attenuated delicate leaf-like forms, contrasting with the solid green heavier facture of the 1941 version (purchased by Schwabacher). However, the subsequent versions of *Waterfall* established a new departure in fluidity of image and line.

Many writers attribute this change to Matta. They discussed contrasting approaches. Matta was concerned with developing his Surrealist sensibility to take possession of him and push him to the outer reaches of insanity. 'He had a passport from Le Corbusier, a passport from Breton, and came straight from Europe,' said Agnes. Matta, live wire, brilliant talker and charming publicist for his ideas; 'With Onslow Ford they talked about "morphologie/ psychotique" – they took plants and turned them into something else,' his wife reported.[4] Gorky was intrigued. Matta's lack of training gave him an untroubled insouciance, whereas Gorky relied on discipline and highly developed control. Matta brought other artists to visit Union Square. William Baziotes, a Greek painter, had begun working

with automatic drawing and painting, had exhibited with the Surrealists in New York and was interested in Gorky.

Surrealist Paris infiltrated New York with an influx of artists, poets and collectors escaping Nazism in Europe. The heiress and art collector Peggy Guggenheim brought with her Max Ernst. André Breton followed with André Masson and other Surrealist painters; some came to save their Jewish wives. On his arrival, Breton started organising a publication and exhibitions. With a first astounding exhibition, *The First Papers of Surrealism*, on 14 October 1942, the Surrealists challenged the New York art scene. Gorky entered the vast private Whitelaw Reid Mansion on Madison Avenue, which had been turned into a dreamscape. The flair and flamboyance of Parisian Surrealist events was enhanced by Marcel Duchamp with American money to create a mysterious spectacle. On opening night Gorky peered at paintings through a cobweb of white string criss-crossing the lofty rooms from floor to ceiling, while children tricycled across floors scattered with autumn leaves. Picasso, Arp, Miró, Ernst, and Dali were shown along with Kay Sage, Kurt Seligman, Leonora Carrington, Esteban Frances and Matta, and a new generation of Americans, Joseph Cornell, David Hare, Baziotes, Hedda Stern – but no Gorky.

Frederick Kiesler, a host to visiting European artists, spoke to Gorky of his designs for Peggy Guggenheim's museum-gallery in which she would blazon the European avant-garde with her large collection. Armed with a dynastic surname and a fortune with which to realise her wildest dreams, she had also convinced Max Ernst to marry her. She had been collecting for years, advised by the English critic Herbert Read. Her European advisers were Breton, Ernst, Duchamp and the Americans, Alfred Barr, James Sweeney, James Thrall Soby and Howard Putzel.

On 20 October, *Art of This Century* opened with Guggenheim's paintings of European Surrealists and some Americans; a catalogue edited by Breton included entries by Futurists, Constructivists, Purists, Surrealists – every important modern movement, with texts by their respective founders. The curving space and concave walls invited the spectator to explore the interior as sculpture.[5] Paintings pivoted from the wall, or hung from the ceiling. Curvilinear stools also acted as plinths. New Yorkers had never seen such a gallery. Ernst, Dali, Duchamp, Kandinsky, Klee, Breton, Tanguy and Masson were hung. Duchamp's *Boite en Valise* had to be spied through

a peephole on a rotating wheel; Klee's paintings moved on a conveyor belt; Breton's *Portrait of the Actor A. B.* was in a shadow-box.

Although Gorky was a close friend of Kiesler, he was not included with the American artists. His wife remarked later that they were snubbed at openings; Gorky was not a fashionable figure and people talked to her as though she were 'married to some old organ grinder'.[6] Matta hesitated to introduce him to Breton. Gallery owners in New York did not consider his work promising despite the hanging of *Garden in Sochi* at the Museum of Modern Art. Dorothy Miller, however, had faith in him:

> Gorky was desperately trying to find a dealer. He'd been dreadfully neglected by everybody. I had sold some paintings for him and we made a determined effort, he and I and my husband, to get him a dealer. He went to Paul Rosenberg, a refugee dealer, who we really thought was going to take him. He had a few Americans at that time.[7]

Only Paul Rosenberg's large gallery on 57th Street competed with the Pierre Matisse. He showed Picasso and Braque. Agnes recalled that Gorky took him some of his new paintings including *Waterfall*. Rosenberg was baffled, yet he had always been impressed by Gorky's impact in explaining art to visitors in the gallery and asked him to come in regularly. Rosenberg would then captain his work but would embellish his complicated biography. He suggested, 'It would be helpful to your career if you are a little bit Jewish.' But Gorky was already tired of juggling the complications brought about by his own assumed identity.

Then Miller suggested a favourite gallery of Gorky's, where he had lectured on *Guernica*:

> Kurt Valentine was a German refugee and started the gallery in 1937. Around the forties Valentine liked Gorky so much, personally, that he very much wanted to take him. While he was deeply considering it, Gorky gave a dinner for us and Kurt, eight people. Kurt was a wonderful person and dealer; he never really had an abstract artist in his place and he just didn't understand abstract art or like it or respond to it.

Despite being married to an American and mixing almost exclusively in artistic circles, Gorky, still in contact with Armenian friends, heard about

the fortunes of Armenia in the war.[8] He was asked to donate a painting for an auction to support the Armenian Tank Division.[9] Huge numbers of his countrymen were in the Soviet army, especially in Stalingrad during the four-month siege and defence. In Armenia food and fuel were scarce; industry was diverted to the war effort. When the organiser, Haroutune Hazarian, a collector and acquaintance, called to collect the painting, Gorky gave him a second one: *The Head*[10] and a larger work, *Summertime in Sochi, Black Sea.*[11]

It was Gorky's first hanging in a show among Armenian *objets d'art*. He attended the opening of the Art Exhibition for the Benefit of Armenian War Relief with his friend Selian, in the Art Students' League on 19 October 1942. His reaction amazed Hazarian:

> I had pencil drawings of Vanno Khojabedian of Armenia, a collection of 25 drawings, an entire wall. Gorky didn't care about anything else – Bibles, manuscripts and miniatures from 14th, 15th Century. He fell in love with those drawings. I'll never forget his words.
> '*Khonarhoutioun genem ays artistin archev*. I kneel down before this artist.'[12]

The small drawings had been made by a young porter who had worked on the streets of Tiflis, in animal markets, taverns, on the trail of fleeing refugees. Khojabedian had died young in 1924, his work neglected for years afterwards.

Gorky's Cubist *The Head*, with one eye and huge eyelashes, and *Summertime in Sochi* provoked hot arguments among the Armenians. Gorky was relaxed. 'This picture shows the sea coast of Sochi, and there, standing, are my mother and I.'[13] He encouraged them to free-associate. The abstract from the *Khorkom* series, 1936, suggested the sea with triangles and kite, while a heart and birds hinted at childhood.[14] His mother had already died before Gorky went to Sochi. No one could make her out in the picture, but she had always been in Gorky's mind as he left Armenia and through the sea voyage. In his emotional landscape Sochi could be read as Khorkom, the Black Sea as Lake Van.[15]

Later Gorky heard that Hazarian had bought his pictures for five dollars apiece. He was furious for he had sold comparable works for over $500. 'If the Armenian ladies asked me to give five dollars, I would be

happier!' Gorky told Selian. He rang the wealthy collector and offered the same sum to get his paintings back but Hazarian refused. Selian commented, 'He knew they would be valuable one day.'[16]

During the year, Gorky found himself in the same predicament as many other artists who felt marginalised. Agnes wrote to Vartoosh that Gorky had many buyers but they were hesitant to spend money on art because of new taxes they would have to pay now America had joined the war. Gorky was hoping not to be drafted and was looking for a teaching job. The attempt to include artists in the war programme had not succeeded, she complained.[17]

When Gorky finally went up for the draft, armed with his credentials as an official *camoufleur*, he was extremely nervous. The prospect of fighting after his war-scarred childhood and the ordeal of a medical examination, with its echoes of Ellis Island, threw him in a panic. Early the next morning, he banged at Busa's door.[18]

'Yesterday I went to the draft and I got a 4F. Is that good?'

'Yes. That's very good. That means you can get out of the army,' a sleepy Busa reassured him.

But Gorky was not satisfied. 'Maybe that's not so good. Maybe there's something wrong with me – an ulcer. The doctors may know something I don't.'

He had dressed, in the middle of winter, in a light shirt, a tie for a belt, and tennis shoes. He told Busa that he could not take his eyes off the doctor, who looked like a Picasso – no, more like a Soutine! His face drooped, he was cross-eyed, one eye went this way, the other that way. At the end of the test, the doctor asked what he thought of the pictures on his wall.

'I don't like them!'

'What's your problem?'

'I don't have a problem.'

It was a Gorky farce. Busa heard him out.

He spent the whole morning talking about how maybe the doctors knew something he didn't know. He was afraid he had an ulcer. He went through physical aspects and Freudian aspects. He was very involved with Freud and read a lot of it. He never needed analysis. By that time I was exhausted. He'd ruined my day.

Then Gorky sprang to his feet. 'Enough of this. I've got to go to my studio to paint!'

The authorities' contempt for art was highlighted by an incident much talked about among artists. A lorry had driven up near Canal Street with a load of canvas. Chaim Gross, the sculptor, happened to see it and discovered that the lorry was piled with unstretched paintings. The driver had bought them in bulk from the WPA to sell to plumbers for wrapping pipes, since canvas was scarce in the war. Gross paid a few dollars for a pile of unstretched canvases, including two Gorky abstracts.[19] This appears to be the only evidence of Gorky's easel painting in the WPA. Hundreds of paintings were literally scrapped when the WPA ended, without giving the artists a chance to save their work.

The latest news of the war sobered artists who read of European artists persecuted, incarcerated, driven into hiding and exile; a few still remained in Europe. Picasso refused to budge, taking a stand with his anti-establishment work, in spite of the Vichy government.

In America artists were recruited as propagandists. At the end of 1942 a vast exhibition called *Artists for Victory* was staged at the Metropolitan Museum, but was generally denounced as 'canned art', for most of the paintings dated from before the war. Military exhibitions were held at the Museum of Modern Art to whip up patriotism with blown-up photographs and heroic images of Americans helping to fight the war. *Road to Victory*, a stylish and bold exhibition, was designed by Herbert Bayer, who had been part of Hitler's team of architects. He was now living in America and was to marry Julien Levy's ex-wife Joella Haweis in 1944.

Artists who had argued with Gorky about the need to raise the consciousness of the masses now believed the political game had been played out. Members were disillusioned with the Stalinism in the American Artists' Congress and left to create the American Artists' Federation of Painters and Sculptors. Jockeying for position in institutions and securing the top posts was a way of getting one's name heard. 'It didn't matter as long as you could stick your name on a letterhead,' commented Peter Busa. Political content was stripped from art. Flag-waving Americana, still part of the art world, was now dressed up as 'internationalism'. Gorky remained independent, reluctant as ever to join a group.

In the autumn of 1942, the Museum of Modern Art asked Gorky for a portrait to hang in their forthcoming exhibition *20th Century American*

Portraits. He selected the vibrant apricot and russet *My Sister, Akho.*[20] He had used a photograph to paint it in two different versions. He signed it and dated it, 1917, which later led to quarrels among scholars. His reason, as usual, was highly practical. 'He said he painted it in 1917 because he didn't want it hung next to the boys in the back room,' Agnes explained. Instead it hung next to a Matisse. 'He stood in front of that painting all the time. "Look how beautiful! Look how lovely it is!" And it was out of this world.'[21]

As Agnes's pregnancy became more visible, she lost her job. The baby was due in April. She sat for a portrait in Raphael Soyer's studio on 90th Street. Gorky also drew her, wearing a cloak and a hat he had bought her. Soyer thought the couple 'very happy and full of friendship. He wore a brown coat and a red scarf. His wife was very bohemian-looking at that time with a cape. She actually became so much like Gorky himself for a while in behaviour, in appearance.'[22] Much of the talk was about war. Agnes wrote to Vartoosh about the wonderful Red Army. Everything else seemed to pale in significance. When Soyer completed her portrait, 'she was dying to get that picture which I was going to give to her'.

But Gorky discouraged him: 'You'd better not give us that painting because who knows maybe some day I'll need a canvas and I'll take that one and I'll destroy it.' Gorky's oil painting *Portrait of the Artist's Wife* is a realistic portrayal in which she is seated, facing out with a sharp look, not at all the contented 'cow' she described herself in letters.[23]

Soyer served dinner after the sessions. Gorky listened to his friend talk about communism, but remarked to Agnes that he was a strange kind of communist who talked about their maid as though she belonged to another species of human being. David Burliuk sometimes joined them. He had completed some sketches of Gorky in 1941; one in charcoal, chalk and pencil captures Gorky in profile with the characteristic high forehead under a swoop of raven hair, muscular neck and strong chin. There were other Russian émigrés: Gorky's neighbour, and the architect Serge Chermayeff.

While helping Gorky in the studio, Peter Busa sensed a disharmony in the couple.

When he first married her she was the right type. He imposed an attitude on her which was his own. He wanted a mother. His whole psyche, he was

transferring his whole affection for his mother onto his wife. He used to have Agnes scrub the floor. She was a socialite!²⁴

For Christmas 1942 Gorky bought a new record of the eighteenth-century Armenian troubadour, Sayat Nova, to which he listened as he painted a new version of *Waterfall*.²⁵ The independent line of flickering black brush, from the 1943 *Garden in Sochi*, reappeared with yellow and red infilling against a scumbled white background. He conjured rocks, cataracts of water, rills and whirlpools in a powerful rush of colliding forces. He blurred and invaded forms in juxtaposed colours in patterning derived from his recent expertise with camouflage techniques. He allowed the runny colours to tint and blot the linen. Despite his rejection by galleries, he wrote confidently to Vartoosh on 17 February 1943, 'I am drawing and painting very beautiful and valuable pictures . . .'

That month, Fernand Léger arrived in New York. Gorky gave a dinner to which he also invited the Burliuks. The artist was late, and Mary Burliuk had time to notice that Gorky's austere studio had been turned into a comfortable sitting room furnished with a huge red chair and cushions from his mother-in-law, with a carpet on the wooden floor. Floor lamps replaced the glaring overhead light bulb. When Léger arrived, Gorky appeared 'thin, nervous, with his soft voice and enchanting laughter – looked overwhelmed with emotion'. They had not seen each other since San Francisco. Gorky was pleased to receive the artist on home ground and surrounded by his own work.²⁶ Léger instructed Agnes how to prepare steaks, French-style. After the meal he sat on the sofa and spoke to Gorky in French.

'Now if you are not in the mood to show me your paintings – don't do it. One's heart belongs to his art and not always can one open his heart. But I would like for Agnes to tell me everything about Arshile's childhood. I want to know what made him feel that he must paint.'

Gorky replied in English with Agnes translating:

I remember myself when I was five years old. The year I first began to speak. Mother and I are going to church. We are there. For a while she left me standing before a painting. It was a painting of infernal regions. There were angels on the painting. White angels and black angels. All the black angels were going to Hades. I looked at myself. I am black, too, it means that there

is no Heaven for me. A child's heart could not accept it. And I decided there and then to prove to the world that a black angel can be good, too, must be good and wants to give his inner goodness to the whole world, black and white world.

37

Skybaby
1943

Pale washes of blue, lavender and ochre float on large areas of unpainted canvas. Runnels of paint drip down, rough patches honeycomb across colours, anchored by sharp black lines containing the flux. In contrast to earlier works when Gorky had overpainted layers of existing colours, now with a startling delicacy he made a transparent painting, more ethereal than *Waterfall*, which he named *Pirate*. The rounded form in the centre has often been interpreted as a dog, seated on its haunches, supposed to have given its name to the painting.[1] The shift in Gorky's painting during 1942–43 coincided with pregnancy and birth.

Matta and his wife Ann Alpert were also expecting a child. Ann had been nicknamed Pajarito, 'little bird'. She looked fragile and candid, remaining girlishly vulnerable even in later life. From the Chicago Art Institute, she had gone to study art and textile design in Paris, where she had married Matta. In New York she started a dress shop with Suzy Hare, the wife of the artist David Hare, making Surrealist clothes for a handful of friends.

Over dinner at a 3rd Avenue restaurant, the young women compared bellies and giggled, betting that Agnes would have a boy and Ann a girl. Gorky looked forward to his baby. Matta dreaded his, feeling outraged by the pregnancy and threatening to leave his wife. She needed to have children, she said, because the people around her were 'playing on the borderline of madness. Surrealism was in this used madness.' The couples visited often; Isamu Noguchi sometimes joined them. Ann thought of Gorky as a loner, 'He was not part of the abstract expressionists. Everything

was big about Gorky. Very handsome. Generous. He was a good person. He would take up this instrument and strum it. Could go from happy to morose in two seconds flat. She was down-to-earth. Tough.'²

Matta rushed about trying to make himself a pivot of action, broadcasting his views, influencing critics, trying for a better gallery. Agnes was impressed by his ability to entice. 'He was so interesting and funny and very nice. He could talk up his work and wrap those art critics like James Thrall Soby around his little finger. Gorky seemed so tongue-tied.'³

Gorky appeared untouched by the political and financial hotbed of the art market. He and Matta developed a warm relationship, meeting at exhibitions, discussing work. Gorky was known to everyone, but seemed almost tainted by his early involvement with Cubism and abstraction. His achievement in having understood and assimilated the major currents a decade earlier than most had the reverse effect of making him appear passé. He was only forty. In spite of their close friendship, Matta had still not introduced Gorky to André Breton, who was actively looking for American artists to include in the Surrealist review *VVV*. It seemed like a deliberate omission.

Positions polarised among artists who had joined different groups. Gorky's friends sat at the Waldorf Cafeteria, rubbing shoulders with a group of dockers. Fights often broke out between the dockers and the artists. The sculptor Philip Pavia explained, 'We'd all sit around a big table – eight or nine of us – we'd have big discussions and big fights. We'd fight about the Surrealists and French culture. Bill de Kooning talked about his Picasso, and Gorky talked about his Picasso.'⁴

The strong anti-German and anti-Japanese prejudice also produced tensions. Pavia said, 'Jackson Pollock began bragging about being a real Irish immigrant, and I told him my father came here from Italy in 1879, and Franz Kline kept saying that he was half English and half American, which was true. Nobody knew what to say, really. Nobody could put his finger on the kind of mixture everybody was.'

Pollock's German ancestors conveniently disappeared; Willem de Kooning had become Bill; Byron Browne was originally John. Artists were packaging themselves for a new age. Peggy Guggenheim exhibited and sold mainly French and European work, but with her marriage to Max Ernst collapsing and her relationship with Breton under strain, she turned increasingly to American artists.

Gorky was to be included in the Museum of Modern Art exhibition *Painting and Sculpture by Young American Artists*, 17 June to 25 July 1943, with *Garden in Sochi*. It was a difficult year for Alfred Barr, who was demoted from his post as director of the Metropolitan Museum to advisory director. In imitation of the Surrealists in Paris, he had shown the work of a slipper manufacturer as naive American art, displeasing his trustees.

Gorky could not resist the impulse to touch base with his Armenian family in Watertown before the birth of the baby.[5] He was put off by the Magruders' talk of nannies. Tommy, Akabi's son, remembered, 'He wanted Mother to take care of the baby.' Gorky was delighted to meet up with Yenovk, who was having problems modelling a Van plough without an accurate idea of its shape. Gorky sketched the parts while Yenovk cut them out. When they assembled it, Yenovk tried to nail them together. Gorky objected. Didn't he remember that in Van they were dovetailed with wooden dowels? As they pushed the little plough through the earth, it broke up. They were heartbroken. Early next morning, before catching the train to New York, Gorky finished another one and took it home. The plough became the theme of one of his most important paintings.

By March 1943, Burliuk, 'Father of Russian Futurism', was painting *faux naif* flowery carts which he sold thanks to the support of the *Daily Worker*. He introduced Gorky to one of his collectors, Joseph Hirshhorn, who viewed many paintings in the studio. Burliuk was a good salesman but the collector was interested in traditional older works, 'nothing abstract'. Agnes related, 'He bought 30 Gorkys for about $300 or so. Small ones. A bargain basement.'

He had never bothered to sign paintings in the past, but now Gorky also added dates, some as early as the 1920s. He and Burliuk celebrated the sale with rock and rye, a sickly strong drink, then Gorky gave his friend a painting in thanks. Half an hour later, the short square Burliuk, all crumpled and whiskery was back, waving the canvas. 'But you forgot to sign it. It's worthless!'[6]

One evening while Gorky was at the movies with his mother-in-law and pregnant wife, her waters broke. They rushed her to New York Hospital. She was in a public ward and could not be accompanied by a member of her family. 'Eight hours in a soundproof room without anybody,' she said. 'I made as much noise as I could because it seemed to me that it might come

at any minute and there wouldn't be anybody there. What was I supposed
to do? Bite the umbilical cord?'

A healthy daughter was born at 8.30 a.m. on 5 April 1943. Immediately
she was consigned to the nursery. Agnes lay in bed wondering whether 'it
had all its fingers and toes'. She longed to undress her baby and take a good
look but dared not under the watchful eyes of the nurses. Gorky sent notes
and flowers to cheer her up. He was forced to wait two days for the official
visiting day. Even then, he could only peer at his new baby through a glass
wall; he was not allowed to hold her. Gorky was distraught and ecstatic.
His daughter weighed eight pounds, had long fingers, dark eyes and was
'bald as a billiard ball'. As soon as Agnes had fed her, the infant was
whisked away again.

Gorky returned home to spring clean the studio for their return. He
stripped down a table and for several days tried to build a cradle, which he
then threw out. He scrubbed floors in a frenzy of nest-building. He hung
'welcome home' signs and put out flowers. By the time Agnes came home
with the baby, he could only slump in a chair, overwrought and exhausted.

Gorky was overjoyed with his daughter, his 'skybaby'. He treated her as
the greatest miracle of his life. Never before had Agnes seen a man behave so
tenderly with an infant. Although she had secretly hoped for a son, Gorky
did not mind. He tried some Armenian names on Agnes, who loved the
name Maro. She was a heroine of Gorky's childhood, a powerful woman
who 'rode like a man through the valleys on a white horse'. Maro or
Mariam Vardanian had been a founder member of a revolutionary party
who drafted plans for a unified socialist Armenia.

Jane Gunther, an old friend of Gorky's, visited them and thought Gorky
'looked like a child himself, as he watched the baby, entranced'.[7] Mrs
Magruder engaged and paid for an English nurse, all starch and aprons,
who arrived straight from General Pershing's residence. Miss Wilkes
intimidated everyone and must have found Union Square a very bohemian
household, after the Park Avenue apartments with solariums and trays of
food served by the butler. Gorky disarmed her, plied her with drink, and
they bonded in tipsy rapport. Miss Wilkes decreed that a doctor should see
the baby for a postnatal check-up and summoned the most famous one in
New York. Dr Bartlett, of the *Bartlett Baby Book*, had penned the motto
'Cow's milk is meant for calves, and mother's milk is meant for babies.'

He had been Dr Spock's teacher. When Agnes discovered this, she called to cancel the appointment because it might be too expensive.

'We won't worry about that!' said the secretary.

The next morning, at 8.30 prompt, Dr Bartlett, with boyish face and bright-blue eyes, swept into the studio, surveyed the paintings on the walls and pronounced, 'Picasso! Pissarro!' He then gave a very deep bow to Gorky. 'And where's our baby?' He blew a huge cloud of cigar smoke in her face. 'Excellent healthy lungs.' Agnes recalled that he picked up her legs and flipped her over like a chicken. Then he examined her. 'Absolutely splendid! In a week's time report on her weight and bring her up to see me.' With another deep bow he strode out.

Gorky thought him marvellous, the best kind of American. Agnes too was bowled over. 'He was adorable. Awfully nice looking.' He nicknamed her 'Glamorous Gawk' and whenever she went to his office he brought out a bottle of champagne. 'He never ever sent a bill at any time,' Agnes said.

Gorky's life was turned upside down. He could not paint or teach with an infant crying, needing to be fed and changed. While the baby slept, Agnes enthusiastically used their new telephone to describe the baby who appeared calm, solemn and wise. She wrote to Vartoosh that Gorky sang and danced with little Maro in his huge hand. The baby was familiar with her father, appearing to smile and wave her arms in response.[8]

The little family folded itself around the baby. Gorky's friends, who had known him as a wild bohemian, were moved by his tenderness. Unlike other fathers, he did not mind being seen wheeling a pram around Union Square. It was their moment for making a life for themselves and Gorky had lost interest in going out to the Art Students' League or sitting in cafeterias talking all night. He had announced to Vartoosh in February:

Agnes's father and mother have a large farm approximately 110 acres which they bought last year. This summer we are supposed to go there, though things are still uncertain, and if the opportunity arises I shall be able to work there better, directly from nature.[9]

As soon as Agnes recovered, she suggested, 'Why not stick a couple of mattresses on the floor and camp in the farmhouse for a while?' It was June. They could live off the land and Gorky would be free to paint. They let the

studio to Jeanne Reynal, who had returned to New York. Agnes asked her mother if the house was free.

'Oh yes. What a good idea!' said Mrs Magruder. 'I'll come too!'

In late May 1943, Gorky, Agnes and Maro were driven by Jeanne Reynal and her partner Urban Neininger to Virginia, south of Washington, DC. Rich horse and farm land surrounded the Magruders' property, Crooked Run Farm, but it was still full of builders. Mrs Magruder rented a house nearby for a month and every day Gorky and Agnes walked up the hill and across Crooked Run Creek to the farmhouse to supervise the finishing touches. Gorky was transported by the open sky, mature trees and lush fields. Agnes told Vartoosh how much they loved farming life down there, getting used to pushing cows aside as they walked through pastures.[10]

Gorky was handy, putting to use the carpentry skills he had learned in the orphanage to fix everything his mother-in-law asked of him. He took over a disused barn, cleared it and set up a studio workshop where he sawed a table out of a door on which to draw. They moved into the bare house, all set for a simple life. The water from the taps was brown with mud from the pump house after heavy rains, but Maro seemed none the worse for it.

Gorky's family unit was complete, like that brief period of his early life when his mother and father had been together in Khorkom before the split. He laboured on the house and on the land, like his father. He threw off his city clothes and strode round and about the property, getting a feel of the countryside and farms. From the house, the road dipped sharply, surrounded by oak and maple forests, fields with plump haystacks and cows grazing in lush meadows. He was the only foreigner for miles around. The locals gawped at this dark giant loping through their fields. At the chandler's shop where Gorky walked to collect mail (care of Post Office Lincoln, VA), A. M. Janney remembered him clearly:

He'd just come here in his overall with a high bib. That's all. No shirt and always barefoot with a long staff. Didn't look like the rest of the or'nary folk going up and down the road with pants and a shirt on. He looked like a European peasant, a rough farm boy. I was born in 1908. He looked ten years older than me. He'd been all over the world; I'd never been out of Lincoln. I

tried to get to talk to him once in a while, but he was hard to unnerstand. Never worried about learnin', stand around and talk, best he could. I guess he was different from other people. He was quaar![11]

For Gorky it was a flashback to his boyhood, when he had walked to school barefoot feeling the earth under his feet, run along the lake, balanced on the ploughshare as the oxen tugged, gripped tree branches and felt the wind rustle the leaves. As he watched his baby, lying on her back in the Kiddie Koop, gurgling at the leaves and birds, staring at clouds, he lay flat in the grass next to her, looking at leaves, pods, insects in the undergrowth. He changed his viewpoint for hers.

Agnes took to their new life with a passion. She wanted to start a vegetable garden, so they dug a patch. They put the baby to bed and took long walks, explored the countryside, picked up grasses, flowers, bones. They swam and caught fish with their hands in the creek. He carved a comb and made things to amuse her. He dandled his daughter, singing to her. Gorky felt he was living out his dream of country life with the woman he adored and their baby. The war which was raging in Europe seemed far away: the destruction of Warsaw, the fighting in Russia and other events. For weeks they had no newspaper and no working radio so they hardly knew what was going on, Agnes wrote, but surmised that the Allies seemed to be winning and praised the courage of the Russian army.[12]

They met neighbours, and particularly liked Bob and Mary Taylor, Quaker dairy farmers, with a son aged one. The Taylors' second baby was born with the Gorkys still in Virginia in October 1943, which tightened their bond. Bob Taylor remarked:

His behaviour wasn't particularly odd, but people said so. Always on the byways up and down, in short pants and huge bare feet, he was dreaming or finding things to paint. I don't ever remember seeing him with an easel and brush. Never. He looked as though he didn't have anything at all on his mind. We liked him very much. He was such a nice man, interesting, funny, told jokes.

Gorky enjoyed talking with real farmers, but was puzzled by the buttoned-down Southern Baptists and Quakers. He would exclaim in disbelief: 'In my country everybody sings!' The Taylors laughed at his quaint notion of

farm workers singing in the fields. Gorky often talked of art. Agnes felt that her opinions 'weren't apparent at that point', but the Taylors recalled:

Agnes was an enthusiastic communist at this time. She quoted her father saying, 'The FBI have a file this big on my daughter.' She was making some derogatory remarks about the sappy questions the FBI asked to try to flush out Communists when Gorky said, 'But they're not all foolish, Mogooch!'[13]

Mary Taylor had taken a course in history of art which made her all the more conscious of her shortcomings. Together they visited the Mellon Gallery. Gorky shocked Mary by pronouncing some of the Rembrandts not genuine. He was later proved right.

Gorky dutifully accompanied his mother-in-law to pick up cheap furniture. She liked dark, polished pieces. Gorky, on the other hand, wanted to strip and expose the natural grain of the wood. It summed up the contrast in their attitudes to life. Agnes's sister Esther remembered that her mother insisted on eating breakfast in bed on a tray, but without a maid she had to prepare it herself and carry it up. Not so easy in a kimono, she slipped and the cream went flying. She was not cut out for the country life. One farmer was outraged when she invited him for a drink. Esther explained, 'He'd never heard of having a drink with women!'

Gorky visited some farmers who mostly raised cows and corn. He made many drawings, sometimes quirky, showing parts of a cow, the rear and haunches, udders and hooves. One local eccentric had devised an effective apparatus to swat flies off his cows. Gorky loved absurd contraptions; later in New York he suggested to Peggy Guggenheim that she give an exhibition of 'useless objects'.[14]

Gorky took time to settle down artistically. After pacing out his surroundings, he started finding Gorkys in nature. The sketches and pictures of that summer teem with rich curving forms and delicate organisms transposed upon expansive landscapes. He went out to work at six each morning. Visiting a spot he had found on his exploratory rambles, he would sit and make drawing after drawing. He picked a distant copse of trees on the horizon, a hayrick, the play of light and clouds. An important aspect of his drawing was to convey the emotion at seeing a bone, a pod, an

insect, with the action of pencil or crayon. He once told Ethel Schwabacher not to worry about her painting. The emotion of the object would carry her through. 'Find something you love and concentrate on it.' Gorky drew straight from a group of trees, the shapes of hills, telephone poles, never placing humans in his landscapes. However in nature he visualised fabulous animals, threatening faces, the world as though it could breathe, expand, in ebb and flow.

At first Gorky made only drawings outdoors, carrying very little equipment. After his rambles he worked nearer the property, discovering vantage points, one by one. He explored extremes of density in forms and sparseness in composition. His drawings were different from anything he had done before. They showed groups of forms clustered in cell-like aggregates, seemingly in perpetual motion. Some of the very dense configurations recall parts of Gorky's earliest drawings, particularly the back of a male nude with the muscles and hollows shaded in varying tones. Leaves, pods, swelling forms interweave and link. By contrast other drawings hold the different motifs in suspended animation in a space without horizon. They share the airy suspension of the Riviera nightclub mural. New biological shapes are born in curving, pushing, tapering entities, coupling in a fertile landscape.

As the summer wore on, Gorky grew stronger and healthier as he had not felt since childhood. Those feelings were expressed in the brilliant colours of the Van landscape, the blues, purples, oranges of the sun on the lake and mountains, the deep reds, yellows, greens of textiles and carpets which decorated the houses. Flashes of Armenian women wearing their embroidered scarves and aprons, and Kurdish women in vibrant colours, can be seen in the drawings of Virginia, sometimes inappropriately named as landscapes or pastorales. The colours come from another time and place.

He also began using crayons in a totally new fashion. He drew bold outlines with pen and ink, then used colours to create different forms, out of synch with the black outlines, often leaving much of the background bare, in parallel with his recent innovations in painting. Flamelike patches start with an inner coil of intense colour, moving outward to a more transparent elliptical whirl, spinning upwards like his feelings of optimism. He used a mixed range of media; many works were done in pencil and crayon, pen and ink with pastel, crayon and wax. He varied the ways of applying

crayon marks for texture and grain. He was delighted when the wax crayons melted in the sun, a luscious medium forming a veneer.

In some drawings, close and highly differentiated massed figures move rhythmically across the plane, echoing old masters, particularly Bosch and Breughel. Every time Gorky dined at the Taylors', he saw 'four Breughel prints of the *Seasons* on the dining-room wall'; he told Mary that 'he had copied the *Harvest* in the Metropolitan. In fact he had copied almost every painting there.' His discipline in masterworks underpinned the apparently spontaneous drawings with coherence and balance. Agnes realised that he had memorised an entire catalogue and could summon up at will a Corot, a Poussin, a Vermeer. She perceptively remarked, 'That was his landscape!'

He worked all day outside, not caring about the changing light. His imagination had been set free as he focused on his surroundings. He told Agnes that he 'saw the trees as battles and horses in Uccello, and he saw knights in armour and everything alive, their arrangement against the sky or against the hillside. He saw everything in tensions and relations of shapes to each other.' She saw that he was startled by what emerged on paper.

He was almost shy about showing it me. He really didn't know that I wouldn't think he'd lost his mind or something. Once he felt he was on firm ground, he didn't look back. It was never a question any more. Just like a fisherman bringing home a netful of golden fish, two, three, four. Sometimes he did four in a day.

Gorky asked her over and over and again if the drawings really had something new. She gave him the confidence to carry on and did not question him about content.

In his childhood, stories and fables all centred on trees and rocks, animals and birds. Nature had always been the richest source of his fantasies. In Khorkom, natural forms became the first constituents of his vocabulary. The vigour in his first batch of Virginia landscapes was like an infant's discovery, before concept and language intervened. Gorky was in the state identified by the Surrealists and Breton as *dépaysement*, being displaced from one's country. Abrupt dislocation from his homeland had produced a psychological detachment or estrangement. Breton consciously cultivated it as a technique for experiencing sensations as new and strange, 'encountering the marvellous'. Spontaneity in the artist or poet also led to a desire for, and

acceptance of, chance and randomness. Deprivation of food, lack of sleep, the border between sleep and awakening, could stimulate this state. André Breton and Philippe Soupault had criss⁄crossed Paris through entire nights, then returned to write until dawn without sleep, producing *Les Champs Magnétiques*. Soupault once described how, between sleep and wakefulness, a word or a segment of a phrase lost its meaning and grew into an object, a thing present in the space.[15] Picasso, Miró and the Surrealists tried to achieve it by drugs; Pollock, De Kooning and others by alcohol.

The more spontaneous his drawings became, the more Gorky disregarded the *plein air* landscape painting he had done in Watertown, Staten Island, and Central Park. The Virginia drawings were his first step towards integrating spontaneous drawings into composed paintings – he fused classical rigour and discipline with free psychological content.

Gorky was painting his interior Armenia, but it was a secret. Living with his new family on the land, he had re⁄established roots and re⁄entered his own psychological space. He would make three trips to Virginia. The first, in 1943, had given him an entry to the promised land; the second, in 1944, would allow him time to discover and enjoy it fully; and the third, in 1946, would be eclipsed by his demons.

38

Papa Breton
1943–44

Back in New York, tanned and healthy after his summer in the country, Gorky went to see Dorothy Miller at the Museum of Modern Art. He was both elated and terrified, but she was an old friend he could trust. 'He came back with this huge portfolio full of those wonderful pencil drawings – crayons with pencil in them. I was crazy about them.'

The drawings fell into three groups: the first, vibrant, densely figured black and white drawings with complex and contiguous natural forms; the second, similar drawings with highly coloured shading filled in and with solid coloured background; the third, bold single line drawings without any shading with pure colours in transparent cartouches and spinning ovals, polarised between pencil line, colour and background. Miller assured him that they were a breakthrough.

'You must have one, Dorothy,' was his reaction.

'No, I'm sorry,' she replied. 'I buy what I can, but I can never accept a gift from an artist. It's a principle we have in the museum – unfortunately. But I'll take three of them for an exhibition which we're going to take out on the road.' She gave him the first accolade, but it was a loan and not a sale.[1]

Gorky still had no gallery, but other friends also bought drawings and the Whitney asked him for a work to exhibit in their Annual Collection, November 1943 to December 1944, for which he sent *Shenandoah Landscape*, 1943, a pencil and crayon drawing.

Gorky's good health lasted through the winter. He began painting from his drawings in an optimistic frame of mind. Throughout the autumn and

351

winter, he studied and selected certain drawings, then squared some off for painting. The Virginia drawings prefigured a series of important steps over the next two years.

※

At the end of 1943, Jeanne Reynal asked Isamu Noguchi to introduce her to André Breton by inviting him and the Gorkys to dinner at the Lafayette Hotel. She was keyed up for the meeting, later describing Breton as, 'one of the most *sensuel* people I have ever met. Any woman is bound to be affected by him.'[2] Agnes and Jeanne translated for Gorky and Breton. Although Breton understood, he considered his English less than perfect and refused to speak it. Gorky who had seen Breton's writings in journals thought his refined manners and sad courtly air epitomised the true poet. The two men felt an instant rapport.[3]

Breton was in fact depressed at the time for personal and professional reasons. His wife Jacqueline Lamba, to whom he had written countless poems and texts in the past, had left him for the sculptor David Hare. The young American had been a prime organiser in getting the artists out of occupied France with the help of his wife Suzy. He had become editor of *VVV*, and ended up with Breton's flamboyant wife, ex-mermaid dancer and artist. Breton was disappointed at still not finding new talent in New York. He was therefore eager to see the canvases of this highly original man who spoke eloquently of his roots and of painting.

Walking into Gorky's studio, Breton saw the powerful and fresh masterpieces inspired by his return to nature that year — *The Liver is the Cock's Comb*, *Water of the Flowery Mill* and many others, not yet named. He realised that Gorky was working on a different plane from other American artists, fusing his fantasy and his personal history. Richly ambiguous imagery, a revolutionary spatial structure, brilliant colours handled with a fresh touch, Gorky's command, dazzled the French poet. In the last two years in New York, Breton had constantly looked for ways of expanding Surrealism into a world movement without success. The meeting with Breton was not only a turning point for Gorky; it was also a revelation to Breton. He was rapturous about Gorky's paintings and immediately asked for some to be photographed for *VVV*. Breton spoke to his circle of what he had seen. Ann Matta observed:

Breton felt very close to Gorky. He visited him a lot, appreciated him and helped him find his way. Breton had a wonderful way of inventing artists. He saw things in their work and he made suggestions to the artists that became a reality for them.[4]

By the time they met, Gorky was on track with his newest works. Breton could give him confirmation and support, but it was too late to 'invent' him; Gorky had already done that rooted in his own myth, as Breton recognised. He was fortunate in seeing the work at a mature stage, when Gorky had integrated his major influences. The painting which came to be called *The Liver is the Cock's Comb* is one of the largest Gorky ever realised, 73 by 98 inches.[5] Breton simply thought it was 'the most important picture done in America at that time'.[6] It is set on a frontal plane, almost in a theatrical setting, like the raised altars in Armenian churches. Animated figures, ellipses of scumbled colour, intricate black lined creatures embrace, dance, fly away. An entire universe of symbiotic organisms emit haloes of blue, black, red, yellow. Creatures with cockscombs as crowns and feathered parts hover, interlock, couple, proliferate. Gorky applied transparent washes, drawing in and with colour. His abstract hymn to creation would be read and reread for erotic content, always permitting a new interpretation.

When Sydney Janis asked for a painting for a large travelling show to start in February 1944, Gorky offered this work. Janis asked if he should call it 'Improvisation'. By no means. Gorky would supply a title and an artist's statement. Instead of an explanatory account, Gorky let rip with a surreal flight of poetic images:

> The song of the cardinal,
> liver,
> mirrors that have not caught reflection,
> the aggressively heraldic branches,
> the saliva of the hungry man
> whose face is painted with white chalk.

His title contains a visual pun. In his poem, he has hidden a catalogue of themes from his Van ancestry. 'My liver' is an Armenian term of endearment. The cockscomb, or crown, denotes masculine pride. Gorky painted pictures making lines, shapes and colours alliterate and rhyme, tearing forms out of their background. The cockerel was a symbol of

manhood, in some villages beheaded with a single stroke of the knife by the bridegroom to prove he was not 'lily-livered'. It has been suggested that in his text Gorky cribbed surrealist poetry from *View*, as he had done from Eluard or the letters of Gaudier Brzeska. His symbolism and poetic leaps also have an earlier source in the incantatory songs of Van. The song of cardinal red was a song for a bridegroom, called 'king', on his wedding day, transcribed in Van in 1910, when Gorky was a boy:

> Our King was brave
> His cross and chest brave and true,
> His sun was red, Armenian red
> His wreath was red, pomegranate green . . .
> His belt was red, his hat was red,
> His golden chain, his sun was red
> Red Armenian red . . .[7]

He had heard these words sung and recited at weddings. He might have learned fragments, just as he had memorised large chunks of the Bible. The mirror without a reflection might be a ghost, or Gorky after losing his old self, Manoug Adoian. Among his papers he left a note in Armenian, 'Manoug to become Gorky.' The white chalk face of the hungry man was always at the back of his mind, the sight of starving people in Yerevan. In moments of intense joy, the survivor remembered those who did not escape. The easy exuberance of the work gave no indication of its painful process of gestation.

Sydney Janis's show, *Abstract and Surrealist Art in America*, assembled an important selection of Surrealist and abstract painters from Europe and the USA. The catalogue's introductory essay owed much to Gorky. Dorothy Dehner remembered that when Janis had first thought of the exhibition, he held a meeting in Gorky's studio to discuss it and gather material and ideas for his text. Gorky talked about art to Janis, advising him on paintings for his collection, whose cornerstone, *The Liver is the Cock's Comb*, was a key work. Janis's introduction, 'Sources in Twentieth-Century European Painting', argued for an orchestrated movement in art; 'the whole purpose of painting has been re-examined with scientific precision reaching in several directions and carrying over from one painter to another, from one movement to another.'

Gorky did not sell this work which had earned so much admiration. Instead he gave it as a present to Jean Hebbeln, a friend who had generously given them money without being asked for it. In April Jeanne Reynal wrote, 'I am absolutely wild about the painting of the mask in the sky . . . I do understand why Gorky feels the need to work so much on a painting. Something very different emerges. The struggle, as he says. That is the most beautiful painting I saw in New York. If ever Jean could be persuaded to part with it, I would love to have it.'[8]

Gorky was featured with Milton Avery, Morris Graves, Roberto Matta and Jackson Pollock for a double-page spread in *Harper's Bazaar*, 'Five American painters'. He had shown the art critic James Johnson Sweeney his drawings and paintings without explaining them to allow him to reach his own conclusion. However, he mentioned drawing close-up from nature in Virginia. This gave Sweeney his copy which ran: 'Arshile Gorky's latest work shows his realisation of the value of literally returning to the earth. Last summer Gorky decided to "look into the grass" as he put it. The product was a series of monumentally drawn details of what one might see in the heavy August grass.'[9] Sweeney had needed more help, but he did not get it from Gorky. Neither Gorky nor Agnes thought of exploiting the publication to secure a gallery for Gorky. Lee Krasner Pollock, on the other hand, used the feature to negotiate a deal with Peggy Guggenheim for her husband. After so much acclaim to build on, the Gorkys were planning to leave New York. One day soon after Maro's birth he confided in Dorothy Miller, 'I just can't work any more with a wife and a baby in the studio. I can't work at all!'[10]

He needed a home for his family, but could not afford it. Gorky decided to sublet the studio and go to Virginia in early spring. He would take the giant easel, 'his Golgotha', for painting large canvases. They had an idea they might stay on in the country, grow their own food, live off the land all the year round. André Breton, Jacqueline Lamba and other friends suggested that they visit France. Italy had surrendered, France would surely be liberated any moment and the war would be over.

They had a farewell dinner with Breton. Agnes enthused about him to Reynal in an emotional nine-page letter.[11] Gorky now referred to the French poet as 'Papa Breton', served him the best steak he could afford, and French cheese which they forgot to eat. The studio glowed with the jewel colours of *The Liver is the Cock's Comb*. Breton's enthusiasm for the work made him

speak of it with eloquence and passion, pointing out parallels with Lautrec in form and colour. Gorky was astonished by his observation and his praise. They talked together quietly, then Breton looked carefully through Gorky's drawings to select some for colour reproduction in the *VVV*, which had lately sold out.

A colour plate was too expensive; silk screen had to be used instead, but it could not reproduce Gorky's fine and differentiated colours. Duchamp was trying to find another method. Meanwhile Gorky had entrusted his portfolio of drawings to his friend Peggy Osborne, who was renting the studio.

Gorky realised that Breton's frame of reference was more universal and his perception sharper than that of American critics who had discussed his work. He was moved by Breton's appreciation, and the writer was clearly touched by the poetic spirit which welled up in Gorky. They were not embarrassed to show their deep emotions for one another that night, and spontaneously jumped up to grasp hold of one another's hands. Agnes observed every detail for Jeanne since she had to translate their nostalgia for the countryside and what each loved most, their regret at the impossibility of true happiness.

Breton had found a rare spirit in Gorky. In an effort to communicate, the Frenchman managed some English, which sounded coarse and pedestrian. Nothing escaped his eye. He pointed at the wooden hobby-horses Gorky had carved for Maro, and found in them the same life-giving spontaneity as in the large painting.[12] Gorky had also struggled with stone over the years without satisfying himself, although Dorothy Miller had seen a stone figure, spare and beautiful, 'before Giacometti did those very thin figures, Gorky's looked like that,' she noted.

Agnes even described the poet's leave-taking, walking backwards down the corridor as if on stage, his hand held up in emotional farewell, willing them to hold on to this image of his departure.

Gorky took courage from his enlightened friendship. Agnes detected Breton's self-consciousness, but his enthusiasm was sincere. As an astute critic and publicist, Breton knew that it was only a matter of time before Gorky would be acclaimed by a large public and he would exercise his role as John the Baptist to a new genius. Their relationship would deepen and later Breton would be described as a father-figure to Gorky, although he was only five years older. With Gorky, he showed respect and deference,

recognising him as an equal. Although it was apparent only to a few, Breton needed Gorky as much as Gorky needed him.

39

The Glorious Summer
1944

Gorky returned to the Virginia countryside as though returning home. He
and Agnes dreamed of living there all year and started looking for a house of
their own. Gorky went back to the land with enthusiasm, digging, hoeing,
watering for a summer crop, even though his mother-in-law had a gardener.
He planted his colossal easel in the barn, among the farmer's compendium
of forms – walls decorated with horse bones he had found and hung on a
fence to dry, strange rusty farm implements, bits of machinery, piles of hay –
while pigeons sat in the rafters cooing and making a wall of droppings
beneath. His surroundings were rich with organic growth and decay. The
life cycle marched on, his drawing and painting becoming a part of it. Far
away from the galleries and art scene of New York, the chatter and one-
upmanship of artists and dealers, Gorky immersed himself in his private
world. From Soda Springs, California, Jeanne wrote of Gorky, 'I "feel"
what he means when he says a painting is mechanical . . . that is what
Arshile has in his drawn line, the absolute heat of really felt effort.'[1]

Gorky, Agnes and Maro roamed around and went skinny-dipping in the
creek, they caught fish with bare hands. She basked in his love. 'It was
incredible the way he was with me, making any little thing for me, carving
combs out of wood. Any little pebble I picked up he loved, anything I did
was wonderful.' They enjoyed beautiful summer days, and nights. Agnes
dropped hints to Jeanne of having a wonderful time in a field at night,
letting her know, perhaps, that they were trying for another baby. They
made a hideaway in the milk house which was a small wooden
outbuilding. They dragged in a rough bed and table, which was all they

wanted. They were surrounded by green fields which rolled up to the house and almost blocked the horizon. They hung a mobile of metal circles on wire which chimed in the wind. Through the other window clusters of trees and blackberry bushes could be seen, cows pushed their noses onto the table where she wrote, rabbits bounced in, while overhead bees constructed a hive.[2]

Agnes was on a self-imposed crash course in Breton, reading *Nadja* and *Les Vases Communicantes*. Gorky could not be bothered to stop and read him, as she wrote to Reynal, perhaps because he had already sorted out the matter in his head or was too involved in his work and only willing to hear a few tasty morsels.[3] But Reynal never tired of discussing him. 'Do you not remember as we got up from the table the night I dined with you when He was there, he said rather sadly, "La femme change mais c'est toujours le même amour"?[4] She sent his books for Agnes to read. Gorky charged her for being besotted with Breton and she admitted it was true.[5] Between Gorky and Breton, Agnes had been the conduit, interpreting every thought and word. She was flushed when Breton had praised her for translating him with sensitivity, perhaps not insensitive to her charm. The two friends were like teenagers with a crush on Breton. Agnes imitated automatic writing and abandoned punctuation and syntax. She spared Jeanne no detail of her life as an artist's wife, from Gorky's snoring to his preparatory rituals of canvas stretching and stick gathering to beat back snakes before setting off to sketch. She dropped hints about wanting to write but complained of her unschooled mind. Gorky continued to make fun of her for losing her head over the Surrealists.[6]

Maro was a year old and could sit on Gorky's shoulders during their long rambles. 'I don't know if it is Armenian, but for Gorky, this baby was like a magic potion,' Agnes said. Gorky played with her, picked her up whenever he felt like it or when she cried. He dismissed the current doctrine for child-rearing that infants were not to be held or touched too often, should be left to cry, and fed only by the clock. Agnes complained that Gorky spoiled her. He insisted that she grow up naturally, just as he and his sisters had done in the countryside. The toddler went about naked, crawling freely around the lawn and bushes. She clutched the tree trunks, pulled out thorns from her bottom and stared at the birds. Gorky built a little cart with wheels to push her around. One day she had asked for flowers in a field so he picked her a bunch. But she cried because he wouldn't pick all of them.

Gorky translated an Armenian expression to Agnes, 'She has holes in her eyes.'

Gorky discovered favourite spots to which he returned. One was a little island in the river, where he stood and drew for hours, never noticing the people walking by or hooting and hollering to move the cows milling around in the fields. Gorky was transported. Once Agnes asked a farmer if he had seen Gorky working.

'He was lookin' up, lookin' down. If you call that workin', he's workin'.'

Crooked Run would soon fill up. Mrs Magruder now had a housekeeper and cook brought over from St Croix to work for her. Esther, her other daughter, had married a violinist and was expecting his child. Her husband was in the air force on bombing raids and she worried for his safety. She stayed to have her baby in Washington, DC, praying that her husband would come back in time. Gorky liked Esther, although she was a little awed by him. He teased her about ballet dancing, telling her that her favourite music, Stravinsky, was 'all blue and pink'. Before marriage, when she developed a crush on a French poet, Pierre Emmanuel, Gorky had given her a postcard and told her to put it in a huge frame over her bed until she found his double. Younger and more timid than Agnes, she saw him as an eccentric.

He never wore shoes, neither did she, and they stripped naked at the drop of a hat. He loved gardening. He had a vegetable garden. The cows got into it, very early one morning. I heard the cows eating. I was out there, Gorky and Aggie were stark naked, trying to chase them out.[7]

Esther was sick with worry about her husband and in the late stages of pregnancy she found the household explosive. Mrs Magruder liked to hold forth on politics, but the young generation made no concessions. Esther said:

Politics was a romance for Gorky. He dreamed there was an ideal world out there. Someday everybody would love everybody else. He would paint and everything would be perfect.

Gorky would talk politics and defined what Stalin was, and my mother went through the roof. No one avoided conflict. Almost every evening they had fights about politics. I couldn't stand all those fights.

One day, it was rumoured that the farmer's bull was to be mated. Much

to Mrs Magruder's horror, Gorky and Agnes 'fussed like children about being taken over to see this event'.

They had barbecues on Crooked Run with local people attending, the Taylors, Jannings, the postmaster. Gorky was in festive mood and of course cooked shashlik; there was drinking and swapping stories, even a little dancing. Esther overheard a little exchange which would have gone unremarked in Greenwich Village:

> Gorky told A. M. Jannings that Christ had been back to the world and he knew it for a fact because he had left a pubic hair in the whorehouse which was identifiable. I remember thinking, This isn't going to go down very well. A. M. Jannings was just laid out. He was a Southern Baptist and went to church every Sunday and he was in total shock.

One day Mrs Magruder showed Gorky her ancient ice-cream maker. He wrapped it in ice and salt and churned away at the cream for an hour. It was dark by the time he finished. They sat on the porch, poured chocolate sauce over the cold stuff and ate the lot. In the night they were all sick. The next morning they discovered that they had eaten pounds of pure butter.

Gorky not only loved to dig and weed in his vegetable garden, but also to draw in it for hours. He then moved on to a field, sketched for a few days, then returned to an old spot. He staked out the sheds, the barn, the pump house, which he particularly liked because it had a snake and a frog in it. There was a particular plant – milkweed – which he found very beautiful. It was fragile, opened up with silky shoots that floated on the air ending in a little dot. They thought it so lovely Agnes mailed a box of it to Jeanne.

Gorky was fully absorbed with his work but Esther saw a different side of him from Agnes:

> The people around there thought Gorky was the weirdest thing they had ever seen, lying down in the field, flat, and looking up. Their idea was, if he's a painter, he sits up. Maybe he did sketches. I don't know, I never went up to him. He was concentrating.

Agnes described how in a white heat he attacked two paintings, furiously fighting and struggling to get them under his control, then abandoned them to go back to the fields and draw, day after day. Once Gorky was on the

hill when the farmer mowed the fields below for cow pasture. As the tractor churned up his beloved purple thistles, ragweed and milkweed Gorky was distressed. Suddenly his landscape became tame and tidy. Agnes would often repeat his lament, 'They are cutting down the Raphaels.'[8]

His lust in attacking paper and canvas excited her. She described it in heroic terms, as though experiencing the passion through him. Perhaps this was the most erotic aspect of her relationship with Gorky. He was complete and self-fulfilled, looking to no one outside himself, or so she believed, and she admired that power and independence.[9]

In August, Agnes took a seasonal job with their neighbour, John Ward. Tassels had to be pulled out of the female hybrid corn to pollinate the males. She had to stretch up, grab hold of the tassel and rip it out, the same movement over and over under the hot sun. Everyone worked for just above minimum wage for the last fortnight of the summer. Mary Taylor called it, 'Part time work you might do as a lark.'[10]

It might have been, if Agnes had not been in the early stages of pregnancy, which she announced to Jeanne in an undated letter, admitting that she felt ill after working ten hours a day, but pleased to earn $30 a week which was more than she got as a clerk.

She also wrote that there was no reply to her letter from Breton, which made her feel insignificant. Breton had retreated with his new love, Elisa Caro, to a remote northern French-Canadian village for three months to write *Arcana*. Meanwhile the Gorkys received news from his wife Jacqueline in Mexico, that she was hoping for a reconciliation with Breton. Agnes confessed to Jeanne that she dreaded becoming isolated from the hub of activity. She envied people like Gorky and Jeanne whose work was their chief focus while she still toyed with the idea of writing. Her vivid letters suggest that she had some talent but she could not settle down.[11] They were in their fifth month in the country and she was getting bored. Jeanne was quick to bolster her confidence with the outrageous statement: 'You must not kick yourself about. It's not really more important to be a painter than to be the wife of a painter.'[12]

In June, they heard about D-Day and the advance of the Allied troops through occupied France, until all of France was liberated by the end of September. Surely it was only a matter of time until Germany would be defeated. By 25 August 1944, Americans and General de Gaulle's Free French and Resistance forces entered Paris as the Germans retreated across

the Seine. The mood of optimism pervaded Gorky's work. His immersion in new drawing prepared the ground for the larger canvases he was about to paint. He generally worked on drawings in groups, to evolve a sequence of them. Then he selected some parts to collage into others. A finished drawing was different from outdoor sketches, made up of subjects from other drawings, then incorporated into a unified composition.

During his second summer in Virginia his painting was becoming more ethereal and transparent. He loosened the boundaries between colours to such an extent that they began to merge in a continuous transition from one colour to the next, to overlap and drip over the unsized canvas which he had first bleached against the barn wall in the sun. Gorky now linked the paths and points of energy between figures in a smoother, simpler action. He achieved a stage of editing as he drew, selecting, exposing only the essentials. Colour did not have to be confined within black shapes but could be allowed to take its own shape as it fell or spilled or moved on the surface with its microstructure. As Reynal recalled, 'Arshile talked so much of last year, the dark line yet in paint overlaying describing another dimension another thought.'[13] The final stage was always to square off a drawing, sometimes copying it first to save as a drawing, then to block it out in oils on canvas. But lately he let the paint and colours take over and sweep over the whole length and breadth of the canvas.

That summer Gorky went deeper than prising images and symbols from a psychological text. Just as a carpet weaver with an intricate design plays with variations, he manipulated the materials, giving them his characteristic imprint and allowing his spontaneity free rein during the entire process.

Towards the beginning of autumn, Gorky was in the garden one day when he heard a scream from the bedroom and dashed upstairs. Agnes was lying in the bed in a pool of blood. Above her stood their aged Quaker gardener accompanied by a little black boy still holding his rake. Gorky rushed in looking distraught, carrying Maro. Agnes dived into a cupboard, not wanting to scare the child. When the doctor arrived he told her tall stories about labours and abortions in the area, making her ache with laughter, or so she bravely told Jeanne.[14]

Gorky was heartbroken over the miscarriage, while the downcast Agnes blamed an unlucky summer. Rain and wind prevented Gorky from

working outside, although this was his favourite season. He had sharpened his concentration over the summer months, done all his groundwork on paper and the transfer to painting made him feel elated. He had completed hundreds of drawings, at least twenty paintings and was still working on another ten. Still he believed that he should take even more drawings and canvases if he was to exhibit later on in New York, for he would not have the studio space nor uninterrupted spans to work at the same pace.[15]

Agnes's problems were not over. In October she went into hospital for a few days, Mrs Magruder took Maro to Washington, and Gorky was left to paint and mind the vegetable garden. In the evenings, when he could no longer work, he walked over to the Taylors for supper, passing by his favourite tree which he called 'the sea horse'. They warmed to him even more. Once he went upstairs to the children's room and they heard a gasp. He was transfixed by the walls, which were all covered in doodles. The children had drawn wherever they liked over the unpainted white plaster walls and even the light fixture.

'Ah!' said Gorky, staring. 'But this is what I try to do.'

Gorky planned to return to New York as the winter weather set in, unable to work outdoors any more. Peggy Osborne, his tenant in the studio, would move into her new house on East 62nd Street. By the middle of October they were all down with colds, and Gorky begged to have his bones removed, they hurt so much.

Agnes spied Gorky from her window, out in the fields making the most of his last days. Her unreserved letters during this period were the most impassioned she would ever write, expressing admiration for his courage in overcoming difficulties which would have crushed the strongest of men, yet preserving himself intact. She pictured him to Jeanne stuck on a hillside opposite, motionless, propping up his drawing for seven hours at a time. He was all alone, confronting the brilliant colours of the autumn trees and fields, pitting himself in a battle against them.

Gorky was hypnotised by the deepening light as summer ebbed and the colours intensified. Each tree was a different shade, glowing with yellow, brown and gold, the stubble on the fields a dusty ochre. Gorky's was a rich harvest that year, many works, now considered his best and most lyrical.

Three groups of paintings emerged. The first combined the black line drawing with colour patches developed in *The Liver is the Cock's Comb*.

These included *The Sun, the Dervish in the Tree,* with airy blues and fresh yellow and green washes balanced by thin black line leaping into a dotted somersault. In *Love of the New Gun* and *To Project, To Conjure,* fine, dart-like black lines, often dotted or spiked, impale the fleeting clouds of colour, hinting at underlying life in nestling curves and mossy surfaces. *Good Afternoon Mrs Lincoln* is highly controlled by the draughtsmanship, modelled in greys with whispers of colour.

A second group magnified the fall of paint on canvas, letting it cascade and invade the neighbouring natural shapes and motifs. As if in a frenzy of certainty, Gorky whipped up the honeycombs and highly nuanced colour skeins of *How My Mother's Embroidered Apron Unfolds in My Life* and the deeper, more dramatic *One Year the Milkweed.* He had reached a pitch of speed and an unerring instinct across a broad range in works of variation and contrast. The colours washed into one another; black lines were painted so thin, they dribbled and softened into grey. The basic outline was like a phantom which blurred. All forms shifted boundaries, and intermingled in flux.

A third group mirrored the pencil drawings on paper, with their network of almost linked lines and shapes. *They Will Take My Island* and *Painting,* 1944, are the purest examples of this group of paintings *drawn* with a black brush, varying its intensity and texture on almost bare canvas. The line modulates from a knife point to velvet. Sparse areas of colour hold parts of the picture in balance. A dark green ellipse against a flickering red flame and a golden whirlwind conjure *vishaps* and *djinns,* the spirits and dust storms of childhood fables. Where the black circuitry is set in motion, the canvas seems to crackle with the energy of the charges left by Gorky's brush. The empty spaces in between quicken with an electric charge, empty canvas comes alive with the excitement of a strange new organic geometry. Outlines do not always yield solid objects – sometimes they function as energy patterns defining a field. The movement of the parts is not fixed, they can be imagined shifting, caught in perpetual motion. Later he said of these works, 'Any time I was ready to make a line somewhere, I put it somewhere else. And it was always better.'[16] His line simplifies out of sheer necessity, like a stone carver chiselling loops into a stone cross, where no wavering can be permitted, and the finished work must balance right across the surface.

All three types of paintings have something in common with Gorky's childhood tales: a breakdown of boundaries between the earth and the sky,

between real creatures and mythic monsters. Nothing conveys this more than a myth from Van.

> On the south side of Mount Varak there are many *vishaps* who sometimes appear to the shepherds who run to the nearest trees, for when the *vishap* passes, he makes such a rustling that it loosens the stones from the movement of its tail and like a huge cloud dust rises up to heaven. Whatever animal it sees, man, animal, snake, all of them it swallows whole and then strikes its belly onto large rocks and stones so that it can digest what it has eaten.
>
> In Lake Van there are enormous *vishaps* of terrifying size. One lives to a thousand, the angels of heaven drag it out, fly with it to the sun. It burns from the heat and turns into ash, falling onto the earth as a thick fog such that people cannot see each other even within a few feet.

Gorky's father had loved telling stories. For the artist, these legends symbolised natural forces in collision. Just as they were packing to leave he started one final mammoth canvas. Agnes wrote in an undated letter to Reynal that he was going at it with such heat she could only divine how fired up he felt inside. She spoke eloquently of large tracts of bare canvas and his aphoristic line which changed and twisted the planes with a new clarity. She even drew a little whirlwind to show how he touched the canvas with isolated colour. She feared that critics would attack him for not being painterly and challenging the conventions of art.

Many did say exactly that, and continued to do so. Gorky was criticised for drawing on canvas instead of painting, and for painting on paper instead of drawing, as though these activities must be rigidly separated and never combined. The large canvas she described is most likely *Painting*, 1944.[17] He also drew indoors at night and she explained that he found his drawings from nature more faithful, yet when he sifted through his sketchbook by the fireside, making a new composition out of several sketches, he felt the result was more artful and less spontaneous.

Space was not empty for Gorky, and never neutral. It was inhabited by his past. Shapes expressed emotion for him. Walking around an exhibition of his work, Mogooch said, looking at the Virginia landscapes:

> Nothing went into Gorky that didn't stay there. Space between trees were as important as trees themselves. He would see this tug of war. He read all sorts of human emotions into the landscape. Fear and arrogance, aggression and

menace. His landscapes don't have the calm quality of an English landscape of trees. It was animated.

Gorky's most faithful collector was Jeanne Reynal and Agnes wrote to her of his latest discoveries. She responded warmly.

> Tell him he is very wonderful indeed. To work under those circumstances is so terrific, that I feel tears in my eyes. He is really the most moving painter that I know. The great poet. I am dying to see the new work. What he does always makes me feel better. 'My Painting' here gives me continuous joy. No, he must be in New York. You must have a decent studio for him; damn the money. It is very necessary to have contact with people from time to time, not 'popular acclaim' but the genuine warm understanding and excitement that is created in people who are sufficiently developed to know what Arshile has done, is doing.[18]

After her sister Esther's agonised wait, her shell-shocked husband appeared just one day before she gave birth to a baby girl. The young couple had to go straight to a rehabilitation centre in Atlantic City. The Gorkys heard that another friend, Jean Hebbeln's husband, who would play an important part in their lives, had been given a dishonourable discharge. Reynal supplied more books and magazines. She discussed Breton's ideal of 'transparency' in a relationship and Agnes assured her that Gorky would have no interest in making those kinds of observations about himself. He scared her because he refused to observe himself and preferred to function on instinct in a purely unselfconscious way. Yet she idolised her mature husband because he had no need of having his ego propped up as did younger couples. Strangely she pinpointed many of the issues which would later unbalance their marriage.

Before leaving Virginia, Gorky wished to thank the Taylors for their hospitality during the time Agnes had been in hospital. He invited them to his studio for the first and last time. They were unprepared for the sight that greeted them in the barn, filled with rusting implements and bones and droppings, and the great stack of canvases. Bob Taylor said:

> There were some very spectacular pictures. It was overwhelming to look at all these paintings which were totally foreign to anything we had studied. He

couldn't think what to say. We couldn't think what to say. He couldn't figure it out himself!¹⁹

Gorky gave his friends and family drawings and paintings, to be kept even if they didn't like them. It was his gift of a future nest egg. In most cases they were later sold to buy a house or send a child to college. He wanted to do the same for Mary and Bob Taylor. Their two-year-old son Henry toddled around and stepped on a canvas. Gorky whisked him up into his arms and hugged him. Realising that his tongue-tied Quaker friends could not conjure up a response he led them over to some drawings.

'Let me explain to you, let me show you where I was standing when I did that drawing.'

He pointed out of the open doorway of the studio barn at a peach tree and the fields beyond. (Mary later showed me the peach tree and horizon on the picture.) 'This is almost realistic, a hay or straw rick, and lines like this appear in fields when they've been mowed, and this represents water, of which there was none in the field. This is trees, this is the peach tree branch. This is a landscape just because you have a horizon here. It looks as if there's sky.' Gorky had said simply as he gave it to them, 'You might understand this better.'

Mary joked, 'We will save this and make a fortune.' In fact they treasured it and learned to love it, unlike Gorky's artist friends who were quick to sell theirs.

While Agnes packed the house, Gorky flung himself into the last frenzy of painting, using his drawings as a springboard to dive freely into the realm of painting. During the last year he had tried to translate his drawings precisely into paintings, and laboured over the process in the face of opposition and doubt by his friends. He now loosed his painting technique and produced twelve works. In November Gorky sadly folded up the giant easel, sorted his brushes and paint, and packed up his canvases and drawings. He was on a roll and afraid to lose the momentum.

40

In a Biddy Whirlpool
1944

In November 1944 Gorky returned after his longest absence from New York. He had been away almost eight months. Breton was back from Canada and eager to see him. Excited by Gorky's new canvases from Virginia, he was certain that these thirty paintings emerged from a revolutionary change in outlook and method. He promised, at once, to find a gallery for Gorky. One work was to be photographed for his new book, *Eternal Youth*. He discussed Gorky with Duchamp and Ernst. It was a confirmation of the vast talent recognised the previous year. The many canvases, including *How My Mother's Apron Unfolds in My Life*, *They Will take My Island* and *One Year the Milkweed*, were sure to cause a sensation. The writer Lionel Abel, who helped with the magazine *View*, recalled his conclusion: 'He's the only painter in America. I don't care for any of the others.' Abel maintained, 'He told me that many times. He was careful not to overpraise Matta. He didn't judge him to be that important – was rather chary. He dismissed Motherwell. De Kooning was not known then. Breton was captivated by Gorky.'[1]

Suddenly, everyone wanted to see Gorky's new work and visit his studio.

Before leaving France, Breton had looked for a new direction for Surrealism. In the beginning, Surrealism had been based on Freudianism and Greek mythology, replaced by the Hegelian dialectic and communism. Breton had then developed his notion of *Les Grands Transparences*, based on the philosophy of the German Romantic poet Novalis and the American psychologist William James. In New York he was close to the anthropologist Claude Lévi-Strauss, who was then in the process of

developing his structural anthropology based on the Native American myths, in a non-narrative analysis. Breton now believed that the artist needed to be in touch with a myth, a collective myth.

After Gorky's isolation in the country, he plunged into a pressure cooker of shifting alliances and feuds, Breton's way of life. There was a new softness in him after his summer with his new lover Elisa, whom Agnes found girlish and lightweight as opposed to the more headstrong Jacqueline. Breton, who hated music and had banished it from his circle, was learning to accept it since Elisa was a pianist. Agnes, still not a very good cook, tried hard to entertain them to dinner. Extravagantly she threw in a mound of butter into a pot of rice to make an Armenian dish but it refused to cook and Gorky was mortified that his illustrious friend had to eat bread with his shashlik instead.[2]

She was pleased that Breton dedicated eight lines to their one-year-old daughter in his book. Agnes was perfectly in command of their new-found popularity. She now ran off very detailed letters to her confidante, Jeanne Reynal. David Hare and others had warned them of Breton and his mania for control but since Gorky did not know French they were not embroiled; Breton was probably niggled by the Gorkys' friendship with David and Jacqueline, but had nonetheless suggested to Pierre Matisse that he take on Gorky and she confessed that they were nervously waiting for his reply.[3]

Several Surrealist painters exhibited at the Pierre Matisse, one of the most important and beautiful galleries in New York, mainly for European art. In March that year, Matta had left Julien Levy for it; Wilfredo Lam, the Haitian Surrealist artist, was also taken, and – even more interesting for Gorky – a Miró exhibition, *Constellations*, was planned for January. Gorky prayed to be accepted by Matisse. He trusted Breton to launch him. As a dealer and gallery director in Paris, Breton did not underestimate the importance of proper representation and publicity.

Breton wanted to win Gorky over to more evocative titles like the first line of a poem in order to recreate the background out of which his paintings had emerged. Hearing Gorky speak of his own culture and weave imagery from his folk tales, Breton suggested that the abstract paintings be given contrastingly concrete titles. Agnes wrote in some confusion about the difficulties Breton would have in finding out about Gorky's origins. She wrote in vague terms that any knowledge of the subject was lost and there was no literature, as though he came from an extinct tribe whose name she

did not know.[4] As she later admitted in interview, her bewilderment indicated how removed she was from his roots at that time and ill-equipped to help, although she was intent on being useful. 'We had talked at length about Gorky's childhood, the killings, the genocide, his mother's death – Breton was referring to it.'[5] Thus she confirmed that Breton had known at that time that Gorky was Armenian.

The word about Gorky's latest work continued to spread and newcomers appeared at the studio. One of the first was Peggy Guggenheim, whose advisers Sweeney, Barr and Soby had not, so far, recommended Gorky, although her friend Howard Putzel had purchased a Gorky. It was David Hare who brought her to Gorky. She had admired *The Liver is the Cock's Comb* in Janis's show and 'she was desperate to buy it but felt it was too large', Agnes said. In the studio, Guggenheim was struck by a powerful new work with strong lines tracking over the large canvas suggesting forms and paths which were left unfinished, lit up by intense and transparent panes of colour. She made the choice alone and it left the studio without a title, as *Painting* 1944, before the picture-naming session with Breton. She then hung it in pride of place for everyone to see.

Gorky was delighted to meet old friends after his long absence, in particular Isamu Noguchi, who was impressed:

Those things had human interest, a very beautiful fluid quality. When he went through somebody's art, he was very respectful of it, he did not make it into his own so much. When he went directly to nature he had his own quality, that is why it was so important for him to go through nature.

He said to me once, that he had discovered nature when he went out to Virginia, where he really found himself.[6]

Noguchi had thought of Gorky and himself as complete New Yorkers. 'He would go into ecstasies about an oil splotch in the sidewalk. It excited him. For him to discover nature in Virginia was a complete shock and a revelation.' Noguchi had made the first introduction between Breton and Gorky, but now had misgivings for he had seen Breton manipulate, divide and rule, falling out even with his intimate friends. Most people thought Gorky fortunate to have Breton as his champion. Noguchi reversed this view. 'I would say that Breton himself changed his category of Surrealism to include Arshile. If Breton said he was a Surrealist, he was a Surrealist.'

Noguchi doubted that his friend had suddenly become a Surrealist but he pinpointed features he had found to be unique in Gorky: 'He always romanticised his childhood. His images were always sort of tinged with the Middle Eastern viewpoints – a kind of animistic interpretation of atmosphere. He had a mystical streak in him.'

Matta too was quick to admire the new work and buy a drawing. He had left Ann after she gave birth to twins, and was now with an heiress, Patricia Kane. He had cemented his differences with Breton and, in the sudden flush of rapprochement, Breton had written a poem to him. Now they were collaborating on Matta's illustrations for *Arcane 17*, while Matta pushed further in the direction of the occult to the dismay of André Masson and others.

After the isolation of Virginia, Agnes was flushed to be part of a new group and quickly picked up their subculture. Jeanne Reynal had requested one of Matta's erotic drawings and Agnes wrote asking whether she wanted it with phalluses.[7]

Gorky was anxious to continue work on his last paintings but was trapped in a studio brimming with family life. The sculptor David Hare offered to lend them his house and his car in Connecticut, while he and Jacqueline took a long trip to Mexico. Hare looked transparent, all profile and no face, like a nervous kid brother next to Jacqueline, who flaunted her mane of wavy bronze hair and dancer's body in provocative Surrealist clothes.

Gorky looked forward to working in David Hare's studio, living in the country with Agnes and Maro. They had been given a dog, a present from Jean Hebbeln, which Gorky named Zango after his childhood pet. Agnes confided to Jeanne of the tyranny over the Surrealists' lives, ruthlessly propelling them in and out of favour. As Ann Matta remarked, 'It was like living in a biddy whirlpool.'[8] Gorky was astonished to be so suddenly the centre of attention, praised extravagantly by people who had ignored him just a short while ago. Baffled, he asked if his work had really altered so drastically.[9]

Even Jackson Pollock, who had never figured on Gorky's horizon except as a student at the Art Students' League, wanted to visit. He himself had lately been painting under the influence of Picasso, but Gorky thought his wife, Lee Krasner, the more interesting painter of the two. Busa took him to the studio.[10] 'Gorky was very nice. Had a liqueur he liked there. Put a little

water, gets a little pearly. So Jackson took that. He started taking out his canvases to show us.' Jackson leered at Agnes, then drawled, 'Why don't you put a little shit in your work?'

Busa was embarrassed. 'Keep your fuckin' mouth shut. That's not the way to talk among friends.' Busa was not surprised when Pollock threw a tantrum.

He was very envious of Gorky. Krasner's early paintings were copies of Gorky. He knew that Gorky was highly respected, but Jackson always had to be a star. Lee was a charter member of the American Abstract Artists. She would sometimes try to show him something on canvas. How did Pollock ever get interested in Picasso? Through Lee and Gorky. Gorky was the greatest advocate for Picasso.

Pollock would not start to do his all-over drip paintings until three years later, in 1947. He had had a fallow, drunken summer, and seeing Gorky's work made him jealous. Pollock's bar-room swearing and lewdness towards his wife angered Gorky. Agnes wrote off this unexpected visit as a sign that Gorky was now someone whose measure other artists had to take, although she pointedly remarked that he had not yet arrived in the eyes of the world.[11]

Still Gorky was without a gallery. His friend Gaston de Havenon said, 'Gorky knew he was a good painter, that he was doing something new, but he never made a big fuss about it because people didn't accept him yet.'

Gorky catapulted into a worldly group which was as money-oriented as a circle of bankers. When he had been poor in the past, he had switched to coffee and doughnuts. Now Agnes and Maro were dependent on him. Agnes had been unable to get a proper job, and now they had the responsibility of a child. He could have sensed that she was disappointed, having their hopes raised to a pitch of excitement then abruptly dashed.

After making overtures to several galleries without results, Breton finally brought Julien Levy to Gorky's studio. Like everyone, he had seen *The Liver is the Cock's Comb* and had known Gorky's work for fourteen years or more. Recently many of his artists had stampeded to the grander Pierre Matisse, and his business had suffered. He was confused by the sudden emergence of Jackson Pollock and the Abstract Expressionists. Both

Duchamp and Breton urged him to give Gorky a show. Muriel Draper, Julien's striking girlfriend, raven-haired and blue-eyed, remembered their visit.[12] 'It was startling. He was beginning a very abstract personal style that was new. A synthesis. It was very different and mysterious.' Levy was used to Gorky's Picassoesque works and was bewildered by the new ones. Embarrassed by his confused silence, Muriel blurted out 'inane conversation about Gorky's beautiful brushes'.

The galleries Rosenberg, Matisse and Valentine had still not made Gorky any serious offers. Gorky had been a regular visitor at Julien's gallery. Years ago, when Joella was married to Julien, she and Gorky had gone for long walks through Central Park, and had visited their flat where he saw Duchamp's *The Bride Stripped Bare by Her Bachelors, Even* for the first time. Julien had noticed how carefully Gorky studied the work. Now Duchamp, his most respected adviser in the gallery, had become familiar with Gorky's recent work, choosing drawings for the Surrealist publications. He praised it to Julien. Max Ernst added weight to Breton's recommendation. Peggy Guggenheim had bought one of the largest paintings, and others were talking.[13]

In the autumn, Gorky at last reached an agreement with Julien Levy on $175 advance a month, in exchange for a number of paintings and drawings to be delivered later in the year.[14] After selling work to cover his outgoings, Julien would take one-third commission on every work sold. Gorky was relieved that his family's basic needs could be met, even if not lavishly. He had scarcely begun to make an impact in New York after his return from a seven-month absence, when he had to leave again. He found himself in a financial bind with his workplace as his only asset. They would move to the country and sublet to Esther and her baby and John Magruder's new wife, Vivi, while both husbands were away fighting in the war. Vivi was an art student at the Ozenfant school.

Gorky attended Vivi's wedding reception and behaved outrageously, to her great delight. Amidst the New York dowagers with asymmetrical cocktail hats and orchid corsages, Gorky positioned himself, cigarette dangling from his lip, white handkerchief in one hand, let rip a few torn and lilting phrases of Armenian song, and stomped out a folk dance. Wan smiles greeted this quaint behaviour. A photograph was snapped so writers could lampoon him later for pretending to be a peasant dancer. A few steps,

a few songs, were the stirrings of ghostly aftershocks from a culture which had collapsed. As he trod the parquet floor of the elegant uptown apartment, the assimilated Armenian chalked out the circle that separated him from his surrounding society.

41

Good Hope Road
1945

On a snowy night, Agnes and Gorky arrived on Good Hope Road, Connecticut, to move into David Hare's house. A dazzling morning greeted them when they woke early to a rosy dawn.[1] From the top of the hill they saw the countryside and roads deep in snow. Gorky nailed two pieces of wood to the laundry basket as a sled for Maro. They set out across powdery snow fields for the Roxbury General Store. Every twig and leaf encrusted in hoar frost glistened against a brilliant blue sky.

The small town was a fair distance over the crest of a hill. Three hours later, they returned, dragging their child and provisions. The snow had thawed and made them wish they had gone by car, but they enjoyed the adventure. Agnes gave a vivid picture of the new dog leaping in the snow while Gorky, wrapped up in several coats and hats, took them off one by one to cover Maro freezing amongst the fruit and vegetables on the makeshift sled.[2]

Gorky was used to living sparsely, and shifted the macabre clutter of Surrealist bric-a-brac into the attic. However, they could not eliminate an all-pervasive genteel ambience.[3] He was grateful to retreat to a separate studio.

He started the new year, 1945, on an optimistic note, with a visit from Breton and Elisa. Breton was writing the catalogue essay on Gorky's first show at the Julien Levy Gallery, and asked for titles. Gorky's old stand-bys, *Painting* and *Organization*, had been reused so often that they only caused

confusion. Breton wanted titles with a unique imprint of their own. All he asked of Gorky was that he look at each picture and extemporise on his thoughts and feelings.

Breton was too late to have a shaping influence on Gorky's art, but he freed Gorky of the snickering by some American artists familiar with the stories of his childhood, his songs and dance. Breton took them seriously and noted them down. Encouraged, as they moved from one canvas to the next, Gorky let images, associations and memories of his past spill out:

> I tell stories to myself, often, while I paint, often nothing to do with the painting. Have you ever listened to a child telling that this is a house and this is a man and this is the cow in the sunlight . . . while his crayon wanders in an apparently meaningless scrawl all over the paper? My stories are often from my childhood. My mother told me many stories while I pressed my face in her long apron with my eyes closed. She had a long white apron like the one in her portrait and another embroidered one. Her stories and the embroidery on her apron got confused in my mind with my eyes closed. All my life her stories and her embroidery keep unravelling pictures in my memory as if I sit before a blank white canvas.[4]

Breton jotted in his notebook: *How My Mother's Apron Unfolds in My Life.* He understood English but Agnes was on hand to translate when necessary. He prompted, not for explanation, but evocation and association. Gorky was to sing the song of each painting. As if staring into his coffee dregs, Gorky looked deeper into his marks and figures; 'one image leads to another, one wisdom leads to another when you look into it, like peeling an artichoke . . . the leaves lying in the plate like feathers . . . and of course the silhouette of an artichoke leaf is quite simply that of an owl . . .'[5] The first time Breton had come to dinner, Agnes had searched for the most beautiful vegetables, choosing artichokes for a poet. Plucking leaves, they had talked about their shape and joked about analogies. Breton jotted down: *The Leaf of an Artichoke is the Owl.* Gorky responded fluently while Breton neatly harpooned the fleeting word play and paradoxical pictures in which Gorky spoke. In his work, repeated forms nested inside each other. Gorky mused, 'Down the road, by the stream, that Old Mill, it used to grind corn, now it is covered with vines, birds, flowers. Flour Mill – Flowery Mill. That's funny! I like that idea.'[6]

Some titles hit targets visible only to Gorky, such as *They Will Take My Island*. Lobes and spikes against the bold curves, tilted straight lines upon a washed canvas, evoked the texture of weathered stone and deep shadows in the incised figures of Aghtamar church. The future tense used in the title cast a backward look at the boy Manoug standing by the lakeside. His home, his mother, their land, snatched away, could only be reached by crossing the water to the island in the dream world of the exile.

The effort of turning his images back into words had a parallel for Gorky. Letters of Armenian script, in the illuminated manuscripts, had been turned back into nature: *nzhaghgakir*, flower-letter, *trchnakir*, bird-letter, *kazanakir*, animal-letter. The hidden narrative of Gorky's paintings, even his use of colours and loosely linked composition, was closer to these illuminations than anyone might guess, especially in the group *The Liver*, the *Flowery Mill* and *The Sun*. Breton sensed that Gorky's paintings were a screen hiding an unknown story and a hidden culture which he must capture in his writing.

The show, to be held in the first week of February, was postponed until the beginning of March, for framing and catalogue translation and printing. Agnes commented that it was worth taking time over this, meanwhile she would look better with some teeth extracted. She now looked more sophisticated with her long hair swept off her brow with combs. At openings and parties, she was surrounded by admiring men. The Surrealist women, artists and muses, like Jacqueline, got themselves up in provocatively fantastic or eccentric clothes and hair, making themselves into works of art. Not Agnes, who preferred simple clothes in classic materials.

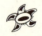

The winter was cold and pitiless in Connecticut. Gorky spent hours each day shovelling snow. Agnes announced that she was expecting a baby in August.[7] Gorky was engrossed and excited, getting ready for his show. He would go into town to talk things over with Julien. Jerrold Bayer, Julien's elder son, had vivid memories:

His black hair, long, shirt always buttoned down. He talked to a child as if the child was a real human being. A child was obscene and not heard, shunted off to nursery with nannies. I was favourably impressed with Gorky,

as with Duchamp, soft-spoken and gentle, very thin. He and Duchamp sat outside the gallery and talked.[8]

The youngster preferred him to less approachable luminaries:

I was scared of Max Ernst. He looked ferocious, scary blue eyes, beak of a nose. Dali and Gala! She was very dumpy and drab, severe and extremely bourgeois. Dali was a showman. Had that bloody moustache and talked a lot, very affected. I remember Julien talking about them before they had thrown bricks in a department store, smashed windows. Nobody knew who the hell he was so he did it as a publicity stunt.

Gorky could meet any of the Surrealist artists at the gallery. They were intrigued by him too. With every day that passed, he became more jittery. His first solo exhibition in New York was about to open; he could no longer concentrate on painting. By coincidence, Matta was showing that same month in the Pierre Matisse Gallery and including among his works *Le Poète*, a portrait of Breton. Everyone in New York compared Matta and Gorky. Of the two, Pierre Matisse had preferred the showier Matta, more worldly, loquacious, chic, married to a wealthier woman, Patricia, who later married Pierre himself. Lionel Abel thought that Matta 'could not put up with not being successful and he regarded Gorky with a certain derision for struggling and not quite getting there'.[9] Comparing them, Meyer Schapiro judged that Gorky loved the act of painting, with a patience and sensuality which Matta could never achieve.[10] Friendship between them was laced with rivalry.

Gorky's paintings were hung in Levy's gallery. Breton's text lent its name to the exhibition, *The Eye-Spring: Arshile Gorky*. A temporary assistant, Ruth Francken, then a young artist, was astonished by the man introduced as Arshile Gorky: 'He seemed to have difficulty putting words together. Clumsy like a child.'[11]

A nervous Gorky came into town with his lovely wife on 6 March 1945. His eyes flashed, his silky black hair shone, he stood tall and broad-chested in an elegant tweed suit. His Armenian looks contrasted with Agnes's light skin. Tall and handsome, they made a spectacular couple. A few friends and critics were sipping cocktails, courtesy of the loyal Bernard Davis. The small gallery exploded with the colour and profusion of Gorky's enigmatic

paintings. The centrepiece, *Water of the Flowery Mill*,[12] was like a firework display, the largest and most brilliant. Examples of the most exuberant masterpieces he would ever produce were massed together along with drawings of equal importance from 1943–44.[13]

Breton had advised Julien to choose the two most important paintings and put them in expensive frames, leaving the rest in simple frames or on easels. Instead they were all framed with salmon-pink narrow wooden strips. Breton was furious with Levy. Gorky and Agnes worried about their quarrel. They arrived late so Gorky had missed the critics. Levy did not spare his nerves. The critics, he said, had been more reserved and stingier than he had ever known. Unable to maestro them into a sympathetic mood, he sensed a stubborn antagonism.[14] This was too much for Gorky, who for two decades had waited and prayed for a night such as this. He hit the martinis and downed several with Agnes, who wrote excitedly about all the details and Gorky's crazy devil-may-care look.[15]

The French painter Jean Hélion, Breton, Matta, family and friends showed up. Some reassured Gorky the show was very beautiful. Serge Chermayeff dismissed Breton's foreword and titles as fanciful. Agnes's mother, not realising who Julien Levy was, interrupted his conversation with Gorky to protest that the wrong works had been chosen.[16]

Gorky was seen to dive again for the martini jug. Pierre Matisse turned up and, perhaps realising his mistake in refusing Gorky a show, invited them to dinner the next night. However, it seemed after all that it was a successful show from the point of view of the people who were important to Gorky and Levy had sold some drawings.[17]

If Gorky retired in confusion that night, the critics were even more baffled. Gorky was anticipating by some years the all-over field painting of Jackson Pollock, the colour fields of Mark Rothko and the calligraphy of Adolph Gottlieb. Aspects that were integrated in a single Gorky canvas would later be singled out and separated as sufficient for a complete work. Breton's foreword for this historic show was beautiful and incisive, remaining the most frequently quoted commentary on Gorky to the present day. Familiar with the aphorisms of primitive art, Breton unpacked the poetry of Gorky's terse forms, and saw through the sumptuous smoke screens of colour. He opened with a dynamic image, 'The eye-spring . . . Arshile Gorky – for me the first painter to whom the secret had been completely revealed!' He discussed freedom from 'mental prison' 'in a free unlimited

play of *analogies*'. He praised one of his favourite paintings: 'one can admire today a canvas signed by Gorky, *The Liver is the Cock's Comb*, which should be considered the great open door to the analogy world.' After warning against literal interpretations of the paintings as still life, landscape or figure, he challenged his audience to 'dare to face the hybrid forms in which all human emotion is precipitated . . . for the first time nature is treated here like a cryptogram on which the sensitive early imprints of the artist come to affix their grid, in the discovery of the very rhythm of life.' He declared that it was no imitation of surrealism but 'an entirely new art'. In one stroke, he characterised both the man and his painting:

Here is the culmination of a most noble evolution, a most patient and rugged development which has been Gorky's for the past twenty years; the proof that only an absolute purity of means in the service of unalterable freshness of impressions and of a gift of unlimited emotions, can empower a leap beyond the ordinary and the familiar to indicate, with an impeccable arrow of light, the real feeling of freedom.

Consternation among critics was led by Clement Greenberg, an enemy of Surrealism and a champion of Pollock.[18] A former art student of Hans Hofmann, he had once stood pontificating outside the school when Gorky challenged him to chalk a drawing on the pavement to prove his point. He had retired in confusion. He had stopped paintings and later became a Trotskyite literary critic, and was now intent on ousting the School of Paris and praising American art. Gorky's support by Breton was a red rag to Greenberg, snubbed at not being considered important enough to meet the French poet. Other critics vied with each other to pillory Gorky for introducing what would become the main axese of Action Painting in the years to come. *Art Digest* reported:

Arshile Gorky . . . is painting incoherent 'accident' pictures (and don't try to deny this because a good percentage of the areas of his new paintings are running drips of turpentine), which it is said he paints in direct contact with nature . . .
 Of what value is it to the artist or to ourselves, the untutored in sublimities, that Breton calls Gorky 'The Eye-Spring' and states that Gorky 'is for me the first painter to whom the secret had been completely revealed!' What's the secret? He doesn't say. Snobbery in the arts has surely reached its height.[19]

The reviews dismayed Gorky, who was not the man to take delight in a *succéss de scandale* as Duchamp might have done, Agnes wrote, but needed some serious appreciation after years of being misunderstood.[20] His American fellow artists, and even Julien Levy, latched on to Gorky's alignment with Surrealism. Levy later wrote somewhat misguidedly, 'He began, by some liberating accident, to regard painting as a deliberate confusion rather than an analytic dissection. There was an emotional orgy in this liberation.' Gorky, who was known above all for his clarity in drawing, had supposedly 'found his fantasy legitimised, discovered that his hidden emotional confusions were not only shameful but were the mainsprings for his personal statement'.[21]

Gorky's show coincided with widespread optimism for the end of the war. The Allied armies were on the Rhine and victory over Germany was only eight weeks away. The Gorkys stayed in town and revisited the gallery. When Sweeney, Soby and Barr had to climb up four floors because the elevator was out of order, Gorky decided to leave the situation in Levy's hands and escaped. Although Sweeney had decided to buy two canvases, Soby one and Barr two drawings, they left without a firm decision.[22]

In the meantime, Gorky paraded his elfin daughter, showing her Egyptian mummies in the Metropolitan. The couple dined with Breton, who gave them his preface in the original French. Then he took them to a party given by Bernard and Becky Reis, collectors, backers of *VVV*, and hosts to the French artists. This was their entrée into the inner sanctum of the Surrealists, and Agnes could hardly contain her excitement. In a letter to Jeanne Reynal, she recounted how Gorky chatted about his daughter, oblivious to a clash between Breton and Seligman. Meanwhile the rest of the circle had watched them confront each other, almost coming to blows while Gorky prattled on about his daughter's babbling.

Next, it was dinner *chez* Pierre Matisse, decorated with more modern paintings than the Levys' apartment and its gloomy canvases. Knowing how important this was to Jeanne, Agnes gave a lively account of the same group at dinner with Breton and Hélion present in a more restrained atmosphere. Matisse was very considerate to Gorky, having let Jacqueline Breton know how much he had admired the new show but regretted having too many artists to manage just then.[23]

It was a strange world for Gorky, who missed a lot of the conversation flying around in French. At one Surrealist dinner, the game of Truth and

Consequences was played. A question was asked, usually a probing, erotic one, and the victim was to answer truthfully. At the slightest hesitation or suspicion of an evasion, Breton shouted, 'Gage!' and imposed a punishment on the sinner.

'Kiss a stranger, or someone of the same sex on the mouth.'

'Make love to a chair.'

Some players found this deeply disturbing and broke down in tears, which made them even more suspect. Breton had presided over these games for years, and had also chaired notorious trials of his friends, who were accused of transgressing the Surrealist code. He acted as self-nominated judge of the entire movement. The game of Truth was a ritual stripping down, 'an ordeal to the symbolic death'. Lévi-Strauss, who sometimes played with them in New York, called it 'an initiation rite'.

Gorky stood aloof, on the fringe of the circle of players seated around the table. Agnes was asked. 'Which part of a person of the same sex would you find erotically the most exciting?'

She blushed and stammered. Perhaps they suspected her friendship with Jeanne Reynal or their friend in Connecticut, Jean Hebbeln, since her name wasn't linked to a lover. A thundercloud passed across Gorky's face. Breton drew himself up and pronounced, '*Passons!*' He rightly gauged Gorky's temper. That night a group photograph was taken, showing Agnes sitting between Ernst and Breton, across from Duchamp. Matta sprawls in front with a self-satisfied grin, surrounded by Surrealist wives. Gorky skulks in the farthest corner, hair flicked forwards over his scowl.

Gorky would not display his emotions to make sport for others. He could not play the Surrealist games which required a dose of detachment and voyeurism. After two years spent observing this group, he would see feelings betrayed, loyalties broken, friendships made and unmade. He had reassured Susie Hare, the deposed wife of David, 'Don't worry, Susie, the last one is the best one,' but Agnes had found this 'killingly funny'. Marriages were crushed and re-enacted as a joke.[24] His wife attributed his modesty to the difference between East and West. Breton had the measure of Gorky's imperious nature, a man cast as a whole. He was in awe of Gorky, as he was of that other towering figure, Marcel Duchamp. They belonged to another realm, self-sufficient, impervious to prurience.

At another party, in Pierre Matisse's flat, Gorky met the celebrated French architect Le Corbusier. He was in New York with plans for the

United Nations headquarters. Gorky was friendly with his brother, the Purist artist Ozenfant. Le Corbusier was a womaniser who covered architects' plans with doodles of women's protruding buttocks. The balding architect turned to the attractive young Agnes, stared through his owl glasses and asked where she was born. When she replied, 'Boston', he protested.

'Ah, you must never say that. Rather say you are from the Tierra del Fuego! Land of Fire!'

Agnes laughed. He turned to Breton. Gorky was watching. Breton caught Corbu's one good eye and sharply slid a hand across his own neck, with a glance at Gorky. Agnes saw the gesture. She thought it a sign of Gorky's 'unreasonable jealousy', which would slowly become a serious problem over the next few years.

42

Rollercoaster Living
1945

In April 1945 Gorky was absorbed in a series of line drawings for Breton's book of poetry, *Young Cherry Trees Secured Against Hares*, to be published by Charles Henri Ford at *View*. Agnes explained that there were no new poems for the most part, but they would be published in French and English with Gorky's illustrations. Twenty de luxe editions would have four coloured drawings, while the others would only include two black and white drawings. The cover design was by Duchamp.

Breton and Elisa came to stay for a long weekend. Breton looked at the drawings and asked Gorky to participate in a new Surrealist paper, since *VVV* had folded. Breton suggested that, together with Matta and Tanguy, Gorky do a couple of drawings as part of a concerted effort to produce such papers from different countries.[1]

Gorky had become Breton's second main collaborator in America, together with Matta. Through him, Gorky became friendly with the French artist Yves Tanguy, who lived in the neighbourhood with his wealthy American wife, Kay Sage. A photo shows them all sitting in Tanguy's garden. Kay Sage landscaped her garden to look like his paintings, and modelled the house to please him. Theirs had been a marriage in which Tanguy more or less acquiesced in order to secure an American visa and his passage in the war. She was a large, imposing woman with imperious ways, divorced from an Italian prince. She had helped Breton and many others to New York. She loved Tanguy jealously, and all but imprisoned him. They occupied separate wings of their house, each had a studio, and the two halves were joined by a large pool table on which they dropped notes to one

another. Kay would not let him have a car so Tanguy had to jump on the
milk van to escape. Both alcoholics, they waited until six in the evening for
the first daquiris. He was comic and often bellicose. After a game of pool,
according to Levy, he insisted on banging heads with his opponent. 'He'd
knock people out that way, and he'd just blink a little bit and never even
have a bruise.'[2]

Gorky met other artists and writers who settled in Connecticut, but they
had no real roots, drank heavily (unlike Gorky, who drank occasionally)
and were a disparate group. The children suffered from fractured families.[3]

Gorky did not associate frequently with this crowd, Agnes recalled, but
saw individuals from time to time. Breton brought his daughter Aube to
stay with the Massons, while Jacqueline was travelling with David Hare.
Children returned from school to be told that their parents weren't talking
with friends or had ganged up against one another. It was a disturbing,
unpredictable world, sometimes violent. Guns were kept, and it was
rumoured that the Tanguys took pot shots at each other.

Gorky settled back to work after his show like a monk, but he
complained that he could not get inspired by the country around Roxbury,
'suburban, not enough huge trees or rocks'. The prospect of having another
child, perhaps a boy, thrilled him. He and Agnes went for long rambles in
the forest to find new subjects.

At first the novelty of being among noted artists pleased him. But Gorky
was a fish out of water and would feel more displaced and alienated in
this French-speaking set. For years his studio had been the fixed point of
his existence. Since marriage he had been to San Francisco, and twice to
Virginia. Now he must find his touchstone in Connecticut. For a refugee, it
was hard to adjust to so many moves. His only anchor was his nuclear
family, for he had lost touch with his extended family in Watertown, his
sister in Chicago, his friends in New York. With her dizzy enthusiasm and
good intentions Agnes set a fast pace. Unlike her, Gorky had to wait, to
locate himself emotionally in a new place, so that he could work again. He
had loved his studio in Union Square. It was his island. He made a sacrifice
in giving up the light-filled room where he had worked and lived. He could
no longer go out for a coffee with a friend, see a show, talk paintings with
other artists. His sole companion was now Agnes. An unaccustomed note
of irony crept into her letters as she wrote to Jeanne Reynal with less
enthusiasm about him. She described Gorky's delight with his new studio,

yellow sofa and his new-found freedom. Whereas she had once been delighted to read and translate for him, now she called it wishful thinking on his part, explaining that she would nod off in the middle of reading his favourite book on David from French.[4]

She concentrated on 'making a life for him'. Imperceptibly, his entire mode of existence was changing: a house in the country, children, dogs. 'One fine day I took him to Abercrombie and Fitch and bought him a tweed jacket and pair of flannels. That was when I gentrified him.'[5] Jean Hebbeln had offered to buy Agnes a leopard coat in winter which she refused, telling her that the money would be far more useful. Before they moved to the country, 'he was taken by Jean Hebbeln to buy 1 jacket, 1 pr. trousers, 1 waterproof warm jacket; *he* chose them.' Gorky was responsive to everything Agnes arranged for him and they appeared to be in perfect harmony.

Breton came to see them and was delighted with Gorky's simple, pliant drawings, which looked as if they had sprouted on a vine. Nothing so clean had ever appeared in the Surrealist publications. Duchamp's cover was a satirical photo collage of Breton's face inserted into the Statue of Liberty. Agnes now talked of 'André'; Elisa was often nicknamed 'Greta Garbo', for her crisp features and auburn bob, a natural foil for the more posed self-reflective Breton. Agnes admitted that it was her fears and not his behaviour which made her feel in awe of him, while Gorky was pleased simply to have him there.[6]

They went together on walks, enjoying the countryside. Elisa snapped the shutter on Breton and Gorky together, then with Maro riding on Gorky's shoulders.[7] Gorky planted his feet apart on the grass, looking like a farm hand in checked wool shirt and rough, baggy trousers. His shaggy head and moustache protrude from under his child's legs. He is leaning on a wooden staff whittled out of a branch, a worn wicker bag slung over his arm. By contrast, Breton poses, a pitchfork held like a theatre prop, gold watch chain draped from his corduroy-velvet jacket collar, very much the dandy with his head cocked, hand in pocket, looking incongruous among the grass and trees. With Gorky's thin, craggy looks and big moustache and Breton's fleshy matron face and wolverine mouth, the snap resembles a chance meeting of Maxim Gorky with Oscar Wilde on an American prairie.

Breton was then considering his eventual return to France. He urged Gorky to come over and they made plans on how he could live and work in

Paris for a while. Breton promised to show Gorky's work. Agnes was thrilled by the promise but complained that Gorky was quite unmoved by Breton's talk of revolution and simply went on working as usual.[8]

Spring was cold and weighed Gorky's spirit down. He worked himself up into a lather over forty drawings for the de luxe edition. From the house Agnes would hear him swearing across the field. After consuming stacks of the most expensive paper he was exhausted but content. He was gratified by Breton's delight as he savoured each one for its individuality and delicacy.[9]

Gorky's drawings for *The Cherry Trees* had developed with organic forms which were refined and compelling. His space could be entered and traversed freely without overt interpretation. His line sculpted and shaped the space itself like the narrative of an illuminated Bible where the scenes meander or crowd with detail. Gorky also embraced the text in his diagonal composition, with an upward spiral to balance a single figure. The seemingly loosely improvised, open forms of the line drawings stood out elegantly from Breton's printed word. Agnes feared that all this pandering to the wealthy book collectors with special editions exploited Gorky, and she privately criticised the Surrealists to Jeanne.[10] The artist was not offered any royalty for his work except promises of exhibition in France. Nonetheless Gorky wanted to give Breton a present. He asked Agnes to take him a recent painting from 1944 together with his original drawings for *The Cherry Trees*. The latter would never be returned. Agnes delivered the art to him in New York, where they had lunch. Then she felt a pang as he rushed across the street to his *Voice of America* radio programme. Despite the regal bearing of his leonine head and his dignity, he showed his age and his disappointment, she thought, very like Balzac.[11]

Agnes was fascinated by the poet as a figure of authority, an 'artiste assassiné'. She projected onto Breton a situation soon to apply to her own husband. She saw in him a purity which was abused by prejudice and lack of understanding. People's idle curiosity in pointing out his faults seemed a form of cruelty while he deserved magnanimity and tolerance.[12] By identifying with him, she would soon also become beset by similar personal problems. Gorky kept himself away from private liaisons. In Breton, he respected the critic and poet, his old-world courtesies reminiscent of the Armenian and Russian intellectuals of Gorky's childhood. Breton's

association with Picasso, Miró and De Chirico brought Gorky in a direct line with those masters. Although Breton was dictatorial with his collaborators, he was always deferential to Gorky.

Jacqueline and David Hare sometimes spent weekends with them. David was very fond of Gorky because besides sculpting he had contributed to *VVV*.

> Gorky liked meeting European artists like Max Ernst. It was a big stimulus to him to run into people he knew only by reputation, who liked his work. He was working along by himself, then suddenly came across people who thought he was pretty good.[13]

Agnes repeatedly discussed Jacqueline's break-up with Breton in her letters to Jeanne, even expressing the wish that the same fate should not befall her marriage with Gorky.[14] Jacqueline and her daughter Aube came to celebrate Maro's birthday in April. Gorky helped to decorate a home-made iced cake with apple blossoms, rosebuds and candles. They thought about boys' names for their baby due in August.

With *Cherry Trees* finished, Gorky returned to his Virginia sketches for transfer on to large canvas. But he missed the heat of Virginia, the open rolling countryside. His own exuberance was absent and it was with much difficulty that he painted *The Unattainable* and *Landscape Table*.

The relative comfort and peace of mind Gorky enjoyed with his regular pay cheques from Levy was not to last. His sister-in-law Esther, who was in New York, remembered an SOS call. 'I went to help Aggie keep the baby.' She helped Gorky prepare food and carry trays upstairs. Maro, aged two, was delighted with Esther's eight-month baby Sandra.[15] Meanwhile, movers had come to strip the house of furniture belonging to David Hare's mother-in-law, while a bemused Gorky in the middle of cooking almost had a jar of oatmeal swiped from his hand.

Gorky's attitude to family life was helpful. He cooked, and was fanatical about cleaning and washing-up. He loved having meals with his family, playing with his daughter. Agnes complained that he over-indulged Maro outrageously then left for his studio so she had to discipline the child, even having to hit her.[16] Gorky enjoyed children, perhaps being a little childlike himself. He explained how important attention was for a child, telling his mother-in-law that she had not paid attention to Agnes when she was little. Wanting to be both modern and tolerant, Agnes was in conflict since she had been raised by nannies.

I thought they had to be treated gently. I didn't understand that it didn't hurt them one bit for Gorky to be a lion. That a child just knows. He was wonderful with Maro, always singing songs and dancing with her. She lit up when he was there.[17]

Gorky was missing out on some of the Surrealist *événements* in New York. Breton's *Arcane 17*, the *Book of Hours of Elisa*, got a special window in Brentano's bookshop, styled by Duchamp with a headless mannequin and a breast. Matta's poster showed an embracing couple, with science-fiction genitalia where their faces should be, strained in painful copulation. The window caused offence and was transferred to Gotham Book Mart on West 47th Street. Breton's *Le Surréalisme et la Peinture*, first published in 1928, came out in English, with revised essays and including 'The Eye-Spring', renamed 'Arshile Gorky'.[18] In four years, Breton had discovered only one American painter and he was an Armenian immigrant. Many American artists and critics were furious.

As June brought warmer weather, Gorky still could not recapture his Virginia summer. He was working aggressively all day, then returned to his studio to repaint everything he had done through the night. Agnes was infuriated by what she considered his crazy obsessiveness, expressing her frustration in an outburst to Jeanne.[19] Not an artist herself, she failed to appreciate the trials and errors, repetitions and reworking of the creative process which Gorky had developed over the years. Jeanne had quoted Seurat to help the impatient young woman understand: 'with all his theories, he said, it was will power that created the picture finally'.[20]

The canvases became darker and more premeditated compared to the expansive lyricism of that heady moment the previous autumn. Gorky felt ill and drained. He also worried about where they would next live. Help came from unexpected quarters; their friend Jean Hebbeln offered them a home. Her architect husband had just bought several acres of fields and woodland only fifteen miles away by a stream. He planned to renovate the old farm and outbuildings which included a stone-crushing plant and offered to rent the conversion to Gorky's family.[21] Their new home would come to be called the Glass House. Gorky looked forward to the more rugged hilly landscape with fir trees and even a waterfall. In summer, as soon as it became warm enough he would go out to draw in the fields and surrounding countryside.

Gorky had already met some of his neighbours in Sherman. Malcom Cowley, writer for the *New Republic*, had written in Paris about Dadaist and Surrealist poets, Ezra Pound, Ernest Hemingway, Hart Crane, Gertrude Stein. He lived with his second wife, Muriel, a fashion editor, and their son Robert. Gorky had met them at the Sandy Calder's house soon after their baby was born. Mrs Cowley had been touched by the way he held the tiny baby in his big hands and crooned Armenian songs to her, so unlike an American man, while Agnes declared she wanted six babies. Mrs Cowley recalled knowing that Gorky was Armenian at the time, because he was very excited about the return of some 'territories to Armenia which he said were historically theirs'.[22]

When Gorky was still in Yerevan, Lenin had given up the Soviet Armenians' claims on the Armenian territories seized by Turkey as a result of the genocide. However, Stalin reversed this policy and soon after the Yalta Conference, in February 1945, the Soviet government launched a campaign to encourage Armenian settlement in the Armenian republic and to recover territories in Western Armenia under Turkish rule. That summer Gorky talked to the Cowleys as he followed the news.[23]

43

My Little Pine Tree
1945

As Gorky waited to take his wife to give birth, news broke that the atomic bomb had been dropped over Hiroshima. At 8.15 a.m. on 6 August 1945, the searing flash about 2,000 feet above ground had left 80,000 people dead and 100,000 wounded or suffering from deadly radiation. Almost seven square miles of the city was turned to rubble. Fires broke out and flared up in high winds. Half an hour later a fine black rain fell on the ruins from a cloudless sky. The war had ended in Europe but the USA was still fighting Japan.

Two days later, Agnes gave birth to a healthy baby daughter in Columbia University Hospital, and wrote to her friends. Gorky's niece Florence recalled a note. 'She called the baby "a skirt"! That was very sweet.'[1] Agnes was surprised by an extremely large baby with coal-black hair, long hands and feet.[2] The infant's birth was overshadowed by the cataclysm.

But President Truman had not finished with Japan. Another bomb was dropped on 9 August over Nagasaki. A quarter of a million people died as a result of the two explosions. In between nursing their newborn babies the women passed around the newspaper with articles about the atom bomb. Agnes looked at the horrific pictures and told Jeanne Reynal how shocking and surreal her life felt at that moment.

Every day the infant looked more like Gorky, very hairy with dark hair swirling above defined eyebrows. Gorky named her Yalda and liked to call her his little pine tree.[3] Only he knew where the name came from. In Yerevan, his cousin, Azad Adoian, explained, 'Vartoosh, we called

Yaldouz back home.' Yaldouz or Yalda figured in the songs and poetry of
the Van area. It meant 'diamond', 'golden', 'shining'. News broadcasts in
February 1945, reporting the Conference of Yalta, with Churchill,
Roosevelt and Stalin, had reminded Gorky of the name.

A month later the family moved back to Sherman. A photograph taken
on 10 September 1945 shows Gorky as a farm labourer artist. His cigarette
droops from his bottom lip, he wears his knitted fisherman's cap and
crumpled, baggy overalls. He holds his two-year-old barefoot daughter
casually on one arm; the other arm is draped on the side of a small lorry
loaded with their belongings and a giant easel. They were ready for the
move to the Hebbelns' house, where they soon found that Henry and his
wife fought daily, and drowned their problems with alcohol. Gorky painted
in a barn.

He escaped on long walks with Maro on his shoulders, into the lakeside
and hilly country. He looked for places to paint as he had done in Virginia.
There was a stream on the property and farther away a waterfall and lake.
The straggly town of Sherman itself did not amount to more than a church,
a couple of shops and a gas station.

Breton and Elisa had returned from a trip to Reno, where Jeanne Reynal
guided them through a fast-lane American divorce and marriage, then took
them on a trip to Lake Tahoe and to the Native American villages of the
Hopi and Zuni tribes. Breton was on the lookout for masks and dolls to sell
on his return to France. They met together with the Gorkys, and Jacqueline
who had married David; they talked of their trip and especially of seeing the
snake dance. Agnes observed sharply that Elisa appeared to be pushing
herself to be like Breton. She herself was no longer content to fuse with
Gorky and confessed to Jeanne that she could not venture an opinion on art
because she was so used to Gorky's perspective. Her comments were
couched in a jumpy tone as she protested that Gorky found her thinking too
cool and rational.[4] This was the second time she referred to feeling swamped
by him. They had been living together for three years and the miracle of
discovering one another had settled into predictability. She had swapped her
dreams of art and journalism to become a homemaker. Practical problems,
lack of money and food, which had been a joke earlier, seemed more serious
now they had two young children. Jeanne had always supported her and
woven the myth of the artist's wife about her.

It is not so much that one is blind but that one is unfeeling cold so cold to have that wonderful love that Arshile has in everything is rare indeed. I never tire of looking at my painting here or in the city he is a great great and noble soul and a beautiful poet.[5]

Agnes wrote out her credo like a Surrealist Alma Mahler emphasising that the most important thing was her husband's art and nothing should interrupt his working at any price. Then her doubt crept in. Was art something more than life and were they in danger of short-changing their lives in the name of art?[6] It was hard for her to feel the same commitment as Gorky since she lacked passionate involvement in a profession of her own. Hair-line cracks were beginning to appear in their union despite her determination.

But Gorky had also lost his freedom and peace of mind. Although he loved them, Agnes felt they were trapped by lack of money, by Gorky's discomfort and her own physical frustration at which she hinted in code to her friend. Their alcoholic hosts got drunk and abused each other, with Jean trying to ignore her husband's homosexuality. Gorky had to put a brave face on it, in the hope of having a house of his own soon. Agnes worked hard at trying to make a home, even cooking, housekeeping and driving for Jean, who became incoherent. Although Jean was generous, she was possessive and wanted to control them. Gorky had no car so they could not escape, she told Reynal.[7] They considered throwing the whole thing up to live in a cold-water flat in New York. Before leaving Roxbury, Gorky had been working on a large canvas for many months. He felt he was about to resolve it when he had to move to Sherman. Julien was very pleased with the new paintings he brought to New York and did not press him further.

His sister Akabi had moved to California in 1944; Agnes regretted in a letter that they had never met.[8] In three years Gorky had not introduced his wife and daughter to his family. His father and Satenig were not far, but he stayed away. This added a strain, as he tried to hide them from the Magruders. As Gorky's daughters grew up and his circle of friends changed, his ties with Vartoosh weakened. The stream of letters he and Agnes had kept up in the first years trickled down to three during 1945. The replies always came in Armenian, so he could translate selectively to Agnes. She replied on Gorky's behalf, while he read over her shoulder,

informing her of their plans to go to France as soon as they had some money. She felt sure that Gorky would be taken up by a more appreciative public in Paris; meanwhile, he was working to produce new work in the country. She criticised the US for becoming increasingly right/wing and looked forward to France.[9]

In November, Gorky lassoed a few lines to Jeanne in his large bold hand, with great strokes barring the 't's' and decorated capitals, large initials and arabesques, flowing with rhythm. He affectionately praised her mosaic and invited her to stay with them. He thanked her for offering to buy them a second/hand car. Meanwhile she had received one of his best paintings from 1944, *They Will Take My Island*.[10] Agnes added on the next line that Gorky had rushed off because he was so unused to writing letters after their daughter's birth and the task made him feel awkward. She apologised for his misspelling of 'Urban'. She slipped into a motherly tone about her *enfant sauvage*.

With the Hebbelns staying in their Union Square studio during the week Agnes was able to tell Jeanne of their visits to the Tanguys where they also saw Breton. Gorky and Tanguy were depicted as good friends and highly comical together, while Breton was carrying on about some delayed money. Jeanne often begged her for 'gossip' and Agnes delivered the latest on Noguchi, who had completed a vast sculpture and seemed more relaxed. Noguchi had taken trips to San Francisco to Jeanne Reynal's place, which he had used as his headquarters to organise a committee for the Japanese Americans. Anti/Japanese feeling was very strong and Noguchi had felt devastated by the bombing of Hiroshima and Nagasaki. The war had sharpened his dilemma since his father, a famous poet, publicly supported the emperor. Gorky had not seen him for more than a year. Noguchi felt estranged:

whereas I used to see him a great deal, and even somewhat after he married Agnes, but less and less. When he became successful and had a show at Julien Levy's I almost stopped seeing him altogether. It may have been my fault but he became one of the boys. In fact I introduced him to Breton and Jeanne Reynal. So I knew those people but they took him over like a pet darling.[11]

Agnes also jibed at their friend Matta for showing off and for his shrewd

purchases of paintings through intermediaries like Duchamp. This was annoying everyone, she told Jeanne in a sharp, critical tone, and furthermore that he exerted control over Breton and she saw how he did it. She described Matta as a diminutive and odd character whom she loathed and hoped to see undone for despising Breton.[12] She jotted down her own thoughts which had nothing to do with Gorky. Perhaps she was finding her husband's ascent too slow and Matta's irritatingly easy but her sentiments struck an odd note in view of her later involvement with him.

Breton introduced Gorky to other artists who had made a colony in Connecticut, living cheaply and working in spacious studios. Gorky had only known them by name, studying their work in the late 1920s. He made a deep impression on André Masson. Masson had accompanied Breton to America on the same ship from Martinique in 1941, and settled in Preston with his wife and sons, near the sculptor Alexander Calder. Diego Masson described his father:

> My father could talk for hours with people. He was a very nice man, always welcoming, very friendly. He liked younger people and younger artists. He was a very heavy drinker and heavy smoker and heavy eater, and a very heavy talker. He worked every day from ten in the morning until sunset. Then he stopped, because he hated electricity.[13]

Gorky was fascinated that Masson had done his automatic drawings and paintings long before the Surrealists, in order 'to free the mind completely, to get at the unconscious', inspired by Zen Buddhism and Chinese philosophy. Breton had bought a Masson from Daniel-Henri Kahnweiler, Picasso's dealer, and made him a linchpin of the Surrealist movement. But Masson was a rugged individualist; his friends were poets, Soupault, Eluard, Peret, Aragon, Artaud, and later Georges Bataille, the prophet of destruction. Diego clarified, 'My father couldn't stand the dogmatic side of Breton. Those strict rules, you couldn't listen to music. My father and Miró were crazy about music.'

In the 1930s, André Masson had gone to Spain to work with the Federation of Anarchists in Barcelona, making drawings and posters, and had left only when the Germans occupied France. In Marseille, unable to work, he drank from morning till night, and spoke vociferously against Vichy. His family packed him off on the last ship to Martinique. On

Gorky's visits, though without a common language, they struck up a rapport:

My father liked him and spoke very often about him. He liked his work but also he liked the man very much. Even after we left and went to France, my father always spoke about Gorky until the end of his life, when he was ninety.

Masson avoided the clique in New York and realised that Gorky was not cut out for the fray. Gorky made a vivid impression on young Diego:

He was from another world. Such a fantastic physique, very tall – extremely tall! He looked very healthy and broad. There was a kind of warmth about him. There were brilliant guys around, but in Gorky was a sadness. You were very moved with him. Not that he said anything dramatic, just a mixture of tenderness, sweetness and sadness. Maybe because he didn't speak French, he seemed a little shyer. With people like Gorky, you don't have to speak to understand. The eye exchange is very important. He seemed very gentle, unlike the others. Gorky was the nicest to me as a kid. I liked him most, out of all those people.

Gorky saw little of the French émigrés: 'They'd sit around and get drunk. Usually we were sent to bed because the drunkenness got too heavy. My father could drink between twenty and twenty-five cans of beer.'

Masson resisted Breton's tyranny and had helped to raise money in New York for the Free French. Breton hated Stalin and de Gaulle, making it a condition of his contract as French announcer on the *Voice of America* that he would never have to pronounce their names. He and Masson split, not even meeting later in France. Ironically, Masson and Aragon concluded one day, 'Well, after all, Breton was our Stalin.' Gorky did not see this side of Breton, and trusted him utterly. Disenchantment would come soon, apparent even to young Diego:

Those were frictions you have between the French. A guy like Gorky coming in, all those things didn't exist. He was just an artist. Somebody pure – totally pure. A man outside of the clans, all the jealousies in those milieux.
 Breton was always 'hautain', always posing. Breton dictated surrealism, 'not the right surrealist', 'not this one, not that one'. He and Father had a

love-hate thing. I can't see him with Gorky. But Breton had a brilliant eye for art and he had been *conseiller* [consultant] to a man in the fashion business, Doucet. All during the '20s and '30s, he had made money from dealing privately.

In New York, Breton and Claude Lévi-Strauss often visited Julius Carlebach, a dealer in Oceanic and American Indian art on 3rd Avenue. At the Museum of Man, Breton bought many duplicates of ethnographic artefacts, including Native American art, to sell them to clients in France. On his last trip to the reservations he had also bought extensively. Many of the French who knew Breton from Paris thought of him as a dealer, while the Americans always called him a poet. However, he tried to tighten the reins on his small team.

For the moment he was Gorky's hero, but the artist kept a canny distance. He sent Julien Levy new work, and Levy was quick to call Gorky to tell him that he was in love with the new paintings and constantly hanging them up to see them better. Gorky was to go into New York to discuss extending his contract for the next year. Another exhibition was discussed. At the Museum of Modern Art, Dorothy Miller was planning a large show of American artists and she wanted to include Gorky's paintings.[14]

Just as the prospect for his work improved, Gorky's health worsened. He experienced pains in the lower half of his body, chronic constipation and when he went to the toilet he bled heavily. He was terrified by the sight of his blood, Agnes wrote to Jeanne Reynal, who suggested that he sit in a bowl of warm water for relief. They consulted doctors in Columbia, who found nothing very wrong except a mild case of 'haemorrhoids'.[15] Gorky demanded why his pains were getting worse, and if nothing was wrong, why the haemorrhage? An exasperated Agnes rang the doctor in Columbia, who retorted, 'Your husband is a hypochondriac. Tell him to stop worrying about himself.'[16] She begged them to do something. Perhaps they should operate. He had been ill for six months; now this heavy loss of blood. Visits to the doctor were expensive. She was at a loss. Later Gorky confessed to a friend that the pain in his stomach had become unbearable. He bravely struggled to paint for as long as he could stand with dreadful foreboding.

44

Burning Easel
1945

Gorky returned to New York for the opening of the Whitney *Annual Exhibition of Contemporary American Painting* in November 1945, unaware that he had become a celebrity among certain groups. Younger painters regarded him as a cult figure and talked of him as 'a Surrealist character', 'a fantastic personality', 'a man with an extraordinary notion of himself, a real artist', 'a natural aristocrat', 'the tallest one of them all'. After his last show, what would he do next? His new painting had a French title, *Le Journal d'un Seducteur*. In the old Whitney building, Paul Resika, one of those young students, indicated the place and said, 'Here, between these two windows, I saw the greatest painting, in the place of honour. It was called *Diary of a Seducer*. A great painting for us. We all knew Gorky from the Whitney shows.' Resika gave a perspective of the younger generation's reaction: 'Gorky was the figure. He had combined Picasso and Miró. He was just exactly what we wanted to be and to do. I saw him in a beautiful tweed sports jacket coming out of Peggy Guggenheim's gallery. We were excited about him.'[1]

Le Journal d'un Seducteur was named by Max Ernst, who had become enchanted by the nocturnal ambience of the large painting, as though soot and smoke had stained the stone walls in a candlelit church or cave.[2] Composed in a cross form, a curving space enveloped velvety figures. Gorky's story about black angels and white angels, his compulsion to 'prove to the world that a black angel can be good' was invoked. *The Diary of a Seducer* was Gorky's *Guernica*. He turned to the severity of *grisaille*, like Goya at the end of his life. The ash, soot and blackness of the *Diary* appear to

mask a painting of a brighter world, like the soft black rain of fallout which poured out of the cloudless sky on Hiroshima. The work suggested large forms through billows of charcoal, silver, ebony, pearl, tied with taut black line. Subdued ochre and earth tones rhythmically light up areas of surface, like candles in the gloom. The only vivid colours are smudges of red and ochre.

Although it is an abstract work figures have been discerned. A torso tapered off in a cruel barb, in the top left a tall bearded male hovers, head bowed as if in prayer, like an Apostle.[3] Below is a bright patch, one of only three pools of red. The centre is the lightest area, like a cupola with open lantern windows, and directly below hang two long, pointed shapes, like the silver oil censers suspended across the open central space of the Armenian churches.

Applying different techniques, Gorky had rubbed on paint, washed small areas, thinned out the dark grey, roughened edges to enliven the surface. In a reverse of Ernst's *frottage* method, he scraped off the blacks and greys to reveal lighter parts of hidden pictures, like frescoes on a stone wall blackened with shading and texture.

The central core is a white heart or a kidney with a deep red centre blackened and ringed with radial lines of tension. The whole 'organ' is shadowed in dramatic red and encased in glossy black. Gorky's presentiment of fearful physical changes occurring inside him was represented by these dismembered parts of his body. Soon doctors would be peering at black X-ray pictures of him. As his health deteriorated during the last year, full, rounded objects shrank to thinner ellipses. Even his beloved symbol of eternity was turned on its side, as though all energy had drained out of it. He tortured the landscape with spikes, jagged ends, barbs and hooks of pain. Yet, in spite of a subdued palette, this was not a gloomy picture, for light emanated through its soft darkness.

Diary drew many critics to the Whitney, among them an acquaintance, Harold Rosenberg who was now also a critic. Year later he would pronounce it 'Gorky's masterpiece . . . Its soft, organic shapes, linear fluency, and concave "sheltered" space mirror the emotional states and reflective interests dominating Gorky's personality.'[4] Gorky stood with him explaining the title when the bell rang for closing time, and a heavy, balding man joined them. They drifted out to the Cedar Tavern, nearby at 24 University Place, a favourite greasy hangout with Chinese decor. The stranger lectured Gorky about his painting, until Gorky burst out, 'Who the hell is this guy?'

'Oh, don't you know him? This is Clement Greenberg.'

Gorky leaped to his feet. 'I'm going to kill him! The son of a bitch! That bastard, he said I was impotent! And here I am a father of two children!'

The critic insolently replied, 'I didn't mean *you* were impotent. I meant you were impotent as a painter!'

Gorky grabbed the sugar bowl. 'That's even worse!'

Greenberg's review of his last show had incensed him. He had gone around New York to punch him but didn't know what he looked like and almost beat up the wrong person.[5] The offending comment in *Nation* read:

> Gorky remained so long a promising painter, the suspicion arose that he lacked independence and masculinity of character . . . Last year his painting took a radically new turn that seems to bear this suspicion out . . . perhaps Gorky was meant to be charming all along; perhaps this is his true self and true level; perhaps he should have pastured his imagination in the surrealist meadow long before this; perhaps his 'corruption' was inevitable.[6]

Much art criticism at this time extolled the macho American male. Pollock had been deified as 'unpredictable', 'undisciplined', 'explosive', by Sweeney the previous year. The wild and virile Abstract Expressionism, according to Sweeney, 'spills itself out in a mineral prodigality'.[7] The message about the new American superhero and his overabundance was to travel all over the world. A concerted strategy and publicity machinery had been planned to launch the 'Wild Bunch', with colluding critics, but Gorky's seat on the bandwagon was precarious. By the end of the year Pollock would oblige by fixing once and for all the image suggested by his backers, spilling and dripping all over the canvas, freed from the bourgeois hang-ups of a 'decadent' control.[8]

Lee Krasner tried to argue that Pollock could never have been influenced by Gorky 'because those days you couldn't see Gorky very easily. Where would you have seen the work? We had no galleries where work was exposed. It was a closed little world, unless you went to see his studio.[9] Gorky had been exhibited annually at the Whitney and had appeared in other exhibitions. For dropping her career to promote Pollock, she wanted star billing, as his muse and manager. However, Pollock had often listened to Gorky, who had ignored him according to the sculptor, Philip Pavia:

One day, in the lunchroom [of the Artists' Club], Gorky was telling Jackson Pollock all the mistakes that the drawing teacher at ASL [Art Students' League] was making – that his drawing teacher was stupid and didn't know Picasso. But Jackson kept telling him that all he knows about drawing he learned from this teacher, I think Bridgeman . . . Gorky was like our guiding star, even though, after he left the lunchroom, we would all talk against him – what a terrible person he was, and how arrogant.[10]

While he was in New York for the Whitney opening Gorky met friends and renewed his contract with Levy. They planned an exhibition early in the year. Gorky, the Village bohemian with holes in his elbows, was no more. He was glimpsed elegantly dressed in the Lafayette. At the Cedar Café, artists went out to talk to him on the pavement because his chic Old English Sheepdog was not allowed in. Jeanne Reynal remembered him going to fashionable parties which he could not enjoy.[11] Once the centre of attention dominating any gathering, Gorky was now silent, unable to understand French.

At the end of the year, Breton left New York to visit Haiti and Martinique. With relief, Gorky at last moved into the studio⁄barn on the Hebbelns property, renovated, but without heating. As late as November, Gorky painted in the unheated barn. Winter was harsh with icy winds and deep snow. Just before Christmas, he was short of funds. After much pleading, Julien Levy advanced $100 for art materials, pressing meanwhile for new paintings before the New Year. They installed 'a $20 pot⁄bellied wood stove' for him.

David and Jacqueline visited on Christmas Eve bringing Father Christmas for Maro – little Aube dressed up.[12] On Boxing Day Agnes flew with the babies to Washington for a holiday with her parents. Gorky stayed, mindful of Julien's demands for more work.[13] Gorky hated being away from his wife and children. He took refuge in the barn, stoked his new stove, read his favourite books and plunged himself into painting. As he worked he sang and talked to himself.

On 16 January 1946, three weeks after the family had left, Gorky was engrossed in work, his cigarette dangling from his mouth, sending up a spiral of smoke. Suddenly he heard a fierce crackling, a roar. He looked up to see that the chimney had caught fire. Flames were licking at the wooden roof. He rushed to the house to fetch a bucket of water. He raised the alarm

and Jean Hebbeln called the fire department. When he returned, the whole
barn was blazing. He rushed in and threw water over the stove, but flames
and smoke filled the place, choking him. In panic, he grabbed a few
canvases, ran for more water and phoned his neighbour. Malcom Cowley
arrived with his young son Rob and Peter Blume the artist. Gorky dashed
into the barn and slammed the door behind him. They hauled him out,
then stood helplessly watching the flames engulf the building. The Sherman
Fire Brigade of part-time volunteers took their time to arrive with a fire
engine which they did not know how to operate. The barn was roaring.
Peter Blume helped Gorky shift the few unpainted canvases he had rescued.
Cowley's boy was mesmerised.

'Gorky was on the ground weeping and banging his head, bang, bang,
bang. His dog was beside him, barking and whimpering.'

'All my work is in there! My life's work is burning!' he shouted. But he
had not been able to save the painted canvases. Gorky wept like a child, his
face on the ground. Cowley was awestruck.

'I realised Gorky had another dimension to him – he was tragic.'

Gorky could hear his paintings, art books, drawings, photographs and
canvases go up in a gigantic funeral pyre. Oil paint and turpentine, paper
and canvas, fed the flames. Tubes of paint exploded like gunfire. He kept
his face on the ground, unable to look.

Still seated there, he looked at the few odd things he had saved: a
screwdriver, a hammer, a box of powdered drawing charcoal. He also held
something precious, snatched from the flames: the photograph of himself
and his mother, taken in Van.

When he spoke to his wife after the fire, her spirits sank at his voice; so
empty it seemed to her. But she was not there to comfort him. He wrote to
Vartoosh, 'I was unable to retrieve a single painting or drawing. Everything,
even my books turned to dust. I'd rather not write about it.'[14]

The next day he went to New York. Agnes flew up to meet him, fearing
the worst. But as he strode into the studio that morning, he seemed
miraculously recovered. She wrote that he was astonishing and continued to
be so.[15] Gorky had finished grieving alone. He told her simply, 'It is all
inside me, the painting on the easel, the one I was working on during the
fire is still burning, inside my mind. All I want is to get to work
immediately.' She was uplifted by the change in him. 'Gorky is a most
awesome phoenix.'[16]

But as the day passed and he reckoned up his losses, he realised just how much he had lost: three years' worth of drawings, twenty new paintings, most of the canvases done in Roxbury, portraits of Agnes – except those he had stored at Levy's and in Union Square. He had also just bought a quantity of art supplies to use in new work for his show. His favourite equipment had burned, especially the giant easel, his 'Golgotha', which he had used since the early days to crank up large paintings, his shieldlike palettes, the brushes he had carefully prepared, his special books.

Friends rallied. The first was his student Bayard, Peggy Osborne's son, who scoured New York for an easel. Others offered help and money. A friend gave him $500, Ethel Schwabacher another $300 for paint and materials. Hearing of his plight, her friend Mrs Hochschild offered a space for him to work in a penthouse ballroom on the seventeenth floor on Park Avenue. Levy postponed the February exhibition to April, giving Gorky just two months to reproduce the lost paintings. The Gorkys decided not to return to Sherman, since sharing a home had been disastrous, four months of emotionally draining misery.[17] They left to fetch their daughters from Washington, where they had been left with their grandmother.

Seeing his babies again after a month's absence was the best cure for Gorky. Agnes described how seeing the baby Yalda was a miracle for her husband with her jolly nature and funny little eyebrows in a mobile face always breaking into chuckles. Maro lit up as soon as she saw her father although Agnes feared that she was a very complicated child. The girls gave Gorky a stake in the future and kept his terrors at bay. He wrote one of his now rare letters to Vartoosh, and attached as much importance to their colds as he did to the fire. 'I will paint again,' he wrote.

He told his wife that now the paintings had disappeared he discovered a new sense of freedom like a young man without a past. Isamu Noguchi thought, 'That was also Gorky, that no matter what blow came along, he turned it around to make it beneficial. Clean the slate. Start afresh. He had a tremendously powerful personality.'[18] Jeanne Reynal wrote, 'It's not given to everyone to die in life and spring braver more sure than ever.'[19]

No sooner was the *Diary of a Seducer* taken down from the Whitney Annual Exhibition, than Gorky was showing a coloured drawing, *Anatomical Blackboard*, in the next show opening on 5 February, *Annual Exhibition of*

American Sculpture, Watercolors, Drawings. Dating from 1943 and done in Virginia, the pencil and wax crayon was a magnificent landscape of organic groupings and rhythmic structure, rich with Gorky's symbolism, even a hint at the *Garden in Sochi* butter churn in a mirrored image.

Every morning Gorky now left Union Square with a little black lunch pail, heading uptown all the way to 101st Street and 5th Avenue to his borrowed studio. Roof gardens surrounded the penthouse ballroom with a panorama of Central Park. He set up his new easel in the natural light and, from memory, began to recreate the last painting he had been working on before it had been incinerated.

Charred Beloved emerges from a snow-white feather shroud with the natural sinuousness of a living organism. Layers of ochre and warm sienna push through a scumbled surface with ragged edges like angels' wings suspended in the same plane. The base of the picture is anchored by a large androgynous figure, recumbent, outlined in black. A pool of blood lies at its centre, surrounded by black. The poignant motif vibrates with associations. The Virgin after Nativity is always painted in the Armenian medieval Bibles with her head to the left and her legs stretched out to the right as she holds her baby.

Gorky's pale, warm and melancholy tones, the transparency of paint and the economy of figurative elements, rich in effect, distil his lost paintings. They speak of a more deeply buried tragedy with delicacy, tenderness and grace. He combines controlled elements with free spontaneity in a lament which remains hopeful and lightly foretells disaster like an augury read in smoke.

Gorky made two versions, *Charred Beloved I* and *II*. The second is the darker of the two; without the downy optimism of the pale canvas it pushes to a stronger resolution. The lower figure loses its generous fullness and the telltale indentation of the buttocks; it metamorphoses into a thinner male contortion in a reminder of Gorky's physical discomfort. He was suffering great pain and haemorrhaging. Paradoxically there followed another tranquil series, *Nude*, based on drawings by the same title.

At the beginning of February, Gorky received an anonymously delivered letter from his favourite cousin, Ado Adoian, who had disappeared for ten years. From 1937 to 1939 he had been in prison in Armenia, where he

endured 'only dreadful beatings', according to his brother, then he was banished to the Gulag in Karakanta, Kolkoz.[20] Gorky had enough schoolboy Russian to understand from the guarded letter that Ado was well and pleased to hear that he had become a successful painter in New York. Gorky warned Vartoosh to reply very briefly and to avoid any serious topics.

In his peaceful tower, across from the Metropolitan Museum of Art, Gorky had time to reflect on their parallel lives. His difficulties paled next to those of Ado, promoted in the Party, then slung into hard-labour prison camps. In America, Gorky had grasped every opportunity to make the most of his life, to pursue his own métier, to guide his own development. Ado had refused to come to America with Setrag's money. In 1935 he had even urged Gorky to return to Armenia, quoting the French revolutionary Danton, 'Dare and dare again'.[21] His cousin's talents had been wasted, like those of thousands of other Armenian artists and leaders. Gorky would never have survived. Despite his ill health he was free and he worked fast to repair the irretrievable losses caused by the fire.

45

Rearranged Body
1946

For a fortnight in February, Gorky climbed up to the empty ballroom every day to paint, throwing himself into a fever of activity.[1] The incinerated paintings and drawings haunted him like lost friends. But he felt his own strength ebb away with them. He could no longer endure his intense pain and was suffering ever more heavy bleeding.[2] He remembered a doctor recommended by the Sandows, who had saved his fingers from amputation by diagnosing lead poisoning from pencils. Gorky went to consult Dr Harry Weiss. He was immediately referred to hospital for a biopsy and tests.

There were conflicting memories about these days. His friend Gaston de Havenon remembered a dinner, though Agnes denied that there had been any time for such an event. De Havenon recalled that Isamu Noguchi came with his sister-in-law, and Madame de Saint Exupéry, wife of the great pilot and writer.

Gorky took him aside. 'You know, tomorrow I am going to Mount Sinai Hospital. I have those haemorrhoids. They are bothering me.' Gaston was shocked. That night, Gorky drank more than usual. Then the artist showed his friend 'those wonderful pastels and drawings from Virginia'.[3]

Agnes, however, reported that when Gorky went to be examined by Dr Weiss, he rang to tell her that Gorky was going straight to the hospital for tests and she should come directly there bringing his pyjamas and toothbrush: 'NO WARNING at all.'[4] In any case, early in March, Gorky entered hospital. His biopsy had confirmed Dr Weiss's worst fears. He would have to undergo an operation: a complete colostomy for a tumour. Agnes said, 'He was absolutely numb.'[5] He had no time to react. The

operation was to be performed immediately, to prevent the cancer spreading. Gorky was not told he had cancer, but he could have guessed.

He confronted a serious risk, for it was a relatively new operation in the mid-1940s and he was not in good shape for major surgery after six months of bleeding and severe pain. He suddenly had to face the possibility of dying. And even if the operation was successful, his body would never be normal again. He was bewildered.

On 6 March, the operation was carried out. Agnes informed Jeanne immediately that he had been operated on by an excellent specialist under the observation of two doctor friends who reassured her that it was a highly successful operation. She managed to describe clearly what this surgery had involved. Gorky had an incision in his stomach, his bowels were scrutinised for carcinoma, his rectum had to be removed and an opening was made in the side of his abdomen. Agnes was told that if he survived five years without the carcinoma reappearing he could look forward to a regular life. The doctors told Gorky that they had simply removed a tumour. Agnes was jolted by the operation and the fear of almost losing him, telling her friend how much she loved him and wished she could take this illness upon herself.[6] Jeanne wrote back, 'Dear beautiful Arshile, how much is asked of you? It is almost too much for your friends to bear. Only you seem to give the necessary courage. I love so much to hear from Mogouche that all you want is to get well and strong again to paint.'[7]

Gorky lay in a public ward. Tubes came out of his body, to drain away fluids and waste products. He was told that his abdomen had been cut open to bring up the end of his colon to form a stoma (mouth or opening) to one side, below his navel. Noguchi came to see him. With his Oriental sensibility, he felt his friend was in agony. Gorky's face was haggard. Although he was drugged with painkillers, he suffered acutely. He put on a brave face for his wife, but he could not hide the truth from his friend: he would be incontinent, and there was also a threat of impotence. Vital nerves governing erection and ejaculation might have been severed in surgery. He and Noguchi had both been exceptionally beautiful young men: Noguchi with his grace and arresting Eurasian features; Gorky with his magnetic dark eyes and height. Noguchi felt Gorky's humiliation: his body was maimed, his sense of manhood destroyed. He warned de Havenon to stay away until he came home, and, above all, not to mention cancer.[8]

After the suddenness of the operation Gorky had to come to the realisation that he would never be normal or healthy again. He couldn't sleep at night, waiting for the next lot of drugs. When Ethel Schwabacher visited him,

> he spoke to the men on either side of him in the public ward; he was evidently touched by their patience in bearing pain. In front of him on the rolling bed-table was a Calder mobile lightly trembling as footsteps passed by. There were flowers too.[9]

Agnes told Reynal that he had lost 20 pounds. Trying to reassure her friend in her first letter after her husband's life-endangering operation, she wrote that she was fixing the little store-room in Union Square as a bedroom for them, with his easel. In the same letter she also announced the astonishing news that his exhibition at Julien Levy's would be held as planned with half a dozen canvases and some works on paper.[10]

Gorky acquiesced to everything and, as she said, 'Julien was boss.'[11] To divert him she told him of meeting friends who wished him well, exhibitions, openings. He remained in hospital for three weeks, staring at the ceiling, wondering whether he would live. Sometimes his hand moved to a pencil and pad. He would sketch the rough beginnings of a series of fearsome drawings which would come to be called *Agony*.

Before leaving hospital, he had to look at his stoma, which was a wet, raw hole, like the inside of a puckered mouth. He was offered a large, heavy bag of black rubber like a hot-water bottle. It had to be strapped or stuck on with adhesive. Gorky was revolted. He decided he would wrap clean bandages around his waist and irrigate himself instead. The hospital had a brisk, frank attitude which made him cringe. To encourage him they gave him a list of famous people who managed active lives with a colostomy bag.

Gorky returned to Union Square a changed man. The robust landscape of his body was destroyed, and with it the powerful patterns of his mind. He now carried an open wound. His physical functions were out of his control. His digestion was unpredictable, his bowels erratic and noisy. Gas escaped involuntarily. He thought he stank. The weight of his body bore down on just a few sharp stitches and a painful wound. Unable to sit, he could only lie, recline or stand. However, Gorky had great confidence in his doctor. Agnes was brave, resourceful and not a bit squeamish. She was more

fearful of how he would react. She said forty-five years later, 'He was very puritanical. I don't know if all Armenians are like that. He thought it was just terrible. Had a horror of caca. He wasn't able to take it lightly.' His refusal to wear the sack, like 'any normal person', was disturbing because Dr Weiss explained that it would be harder on him. 'He insisted on a clean bandage attached with adhesive tape. When he removed it, once or twice a day, he had raw skin from the sticking plaster.'[12]

Gaston de Havenon visited him in Union Square. Gorky said, 'You know the truth? It is all right. I can live. Maybe it's even better what they did to me. Now I feel more comfortable. I didn't say anything, even to you, how much I suffered, what terrible pains, until I was going to hospital.' But Gorky could not hide his dread of the disease which had invaded him and at the threat to his virility. He knew Gaston was thinking of it too.[13]

The most urgent problem was money. Loyal friends stepped in. Ethel Schwabacher's husband Wolf succeeded in securing a grant for Gorky. Serge Chermayeff wrote asking friends to chip in. Reynal sold some securities to send cash. When Vartoosh sent a cheque, Agnes asked her to keep it, reporting that her brother had returned home, looked incredibly good despite his weight loss and was astonishing the doctors with his miraculous recovery. He could not yet eat solids but would begin soon. Most of all she praised his courage and determination to go on painting as soon as he was up.[14]

The surgeon had not charged Gorky, and they felt rich for the first time in their lives, thanks to their affluent friends who had been generous.

Gorky took baby Yalda onto his bed. He adored playing with her and Maro joined in.[15] Their vitality buoyed him up and gave him his life-line.

Agnes, now twenty-five, had the care of two babies, and a gravely sick husband. She had to deal with the shock of the operation on Gorky, her own grief and the effect on their relationship. No counselling was offered. Agnes and Gorky had never been able to discuss their sexual problems in the past, and soon they would have to face a minefield of complications. His shame and embarrassment would have the effect of isolating him from people.

At first, however, old friends came to cheer him up. Frederick Kiesler passed on choice bits of gossip and described Peggy Guggenheim's new nose. Gorky begged him not to make him laugh because it hurt.

Gorky's second one-man show opened at the Julien Levy Gallery on 16 April 1946, just six weeks after his operation. He attended the show, but his face looked cadaverous, with heavy lines of tension; in his eyes was the wounded frightened look of invalids. His large 'saint's hands' hung limp and bony, suddenly disproportionate to the rest of his body.

The pictures included his most mature recent works, in which he had assimilated the birth of his second daughter, the end of the war, the fire.[16] In the minds of their friends and, indeed, over the whole show, hung the double tragedy which had shattered Gorky's work and life in the last two months. If the fire had not destroyed his paintings, if Gorky had been fit enough to continue painting, what other works might have been exhibited? Gorky's faithful friend from Philadelphia, Bernard Davis, was at his side, fatherly and generous. He gave a sumptuous dinner for Gorky and all his friends after the show. Agnes told Vartoosh how her brother sat like a potentate with women on every side and it was hard to believe how dire his condition had been just a few weeks earlier.[17]

There were two groups of paintings, the more line-based group of map-like diagrams of forces in a field of movement.[18] A tightly sprung black outline had replaced the colliding waves of colour in *How My Mother's Embroidered Apron Unfolds* and *One Year the Milkweed*. A second group, developed from the luscious, coloured organisms to a tougher, more sinewy treatment. Gorky exposed conflicts and clashes in his opposing worlds. *Landscape Table*, *Portrait of Y. D.* and *Hugging* were painted in 1945. They had strong tinted washes and an expressive brushing of background colour. He drew with paint, making a silhouette out of the falling colour edge. At the end of 1945, he progressed to the austerity of almost banishing colour in *Diary of a Seducer*.

After those, he was on a tightrope. The sharp black lines of *Delicate Game* are so finely tensed that they could only bear the most restrained colour. In the centre is a curved outline suggesting a female bent over, like the profile of the Virgin nursing her baby. A single yellow line, the only coloured stroke, swoops around her crouching body, over her head and back, like a halo. The simple shell-like outline would recur in other pictures as an ideogram for the Madonna or Mother.

Many paintings were sold, although Agnes complained to Vartoosh of bad critical response.[19] Most critics were bewildered by the direction Gorky had taken. He had ripped away their handrails, leaving his influences far

411

behind him: Léger, Miró, Kandinsky. But at last, 'Greenberg ate his hat,' Agnes reported. He wrote guardedly in the *Nation* that:

> Gorky has finally succeeded in discovering himself for what he is – not an artist of epochal stature, no epic poet, nor a lyrical, personal painter with an elegant, felicitous, and genuine delivery. What he lacks in invention and boldness he makes up for by a true sophistication that transcends the merely charming and exploits to the maximum the painterly instinct, the ability to think and feel paint that is Gorky's greatest asset. He has now produced four or five paintings in which the influences are completely digested and which add something no one else could have said to that which Picasso and Miró have already said.[20]

Greenberg noted 'the phenomenal sensitivity and sensuousness of Gorky's calligraphy'; but was, like all American critics, unfamiliar with the Armenian sources of his art. Attempts to characterise him fell back on caricature: 'the Slavic passionate type', 'a Byzantine melancholy'. Gorky had obscured his history from himself and others, and now when he returned to it he was parodied.

46

Life on a Leash
1946

Through the spring and early summer of 1946, Gorky remained in New York. He was still very weak from his operation. His insomnia gave him little respite from the nightmare of his waking life as he struggled to adjust to living with his colostomy. Slowly he developed a routine of hygiene. He took a long bath every day, and gave himself an enema until the water was absolutely clear. 'When he came out of the bathroom,' Agnes said, 'he was as white as a wall, and could hardly stand. If you understand the man, you would realise that he couldn't have gone around with a sack of shit on his stomach under any circumstances.'[1] She was perplexed by Gorky's fastidiousness: 'He was absolutely a nut about cleanliness. Hands, bottom, everything had to be washed all the time.' Soon he became obsessed with the cleaning routine until the whole day revolved around it. He loathed the very smell of himself and became a prisoner. Agnes said, 'He could never go anywhere far from the bathroom, for fear some little squit leaked out.' Gorky felt ill and trapped; but Agnes was healthy and trapped.

Maro went to 'the little nursery school for three hours to give her some companions and to give Gorky some peace', Agnes said later, but confiding to Jeanne her fears that the child might be affected by the uninhibited shouting and yelling that she sometimes could not control.[2] His younger daughter had been renamed after Gorky had been told in a local bar that 'yalda' meant 'idiot' in Yiddish. Agnes chose the name 'Natasha'. Gorky sketched and longed to paint again. The ballroom was no longer available. When they discovered that Agnes's parents were to go on holiday to Canada, and Crooked Run would be vacant, they dreamed of having the

place to themselves alone, but could he undertake the long journey to Virginia? Gorky felt that he could no longer survive without immersing himself in drawing and painting.[3] He would convalesce in the countryside, return to the place of his inspiration.

His friends had made sure he did not become isolated after his operation. Wilfredo Lam had a vivid memory of Gorky coming to welcome him:

> I saw Gorky for the first time at New York Airport when I arrived from Havana in 1946. He was there with his wife and with Jeanne Reynal, who was dressed like an American Indian. We were invited to Nicolas Calas where we talked all night.[4]

Lam had been in Marseille with Breton and the other artists before they had sailed for America in 1941. Gorky saw his work several times in New York. It sprang from a Cuban folk tradition: pointed, angular figures recalled primitive woodcarvings, sculpted figures, the *femme cheval*, winged creatures and 'horned creatures that synthesise the Christian cherub and the Santeria'.[5] He painted in warm earth tones with an inborn authenticity that set him apart from the sensational treatment of primitive art by certain American painters who discovered it in the late 1940s. Lam told of a growing friendship: 'The next day we went with Frederick Kiesler to Gorky's studio in Union Square. There he showed us his pictures and we spent a very beautiful evening. Gorky was a person of great warmth.' Kiesler knew Gorky's condition to be precarious. He tried to foster a friendship with the gentle and talented Cuban Surrealist, who wrote:

> The next day Gorky and I went to the *Vogue Magazine* photo studio accompanied by Rosamond Raily [Bernier]. Irving Penn photographed us all afternoon. He enlarged one very beautiful photo where Gorky and I are seated around an old Paris bar table.[6]

In this first portrait after his operation Gorky, in a tweed jacket and wool tie, turns to Lam, who confronts the camera, deflecting it for Gorky. They relax, like two friends at a pavement café, yet Gorky's long fingers are tightly intertwined, resting on his small sketch pad. Deep lines have cut into his cheeks and around his mouth. In photographs after his colostomy, Gorky avoids looking directly at the camera. Agnes wrote to Jeanne how much she

warmed to Lam, who was innocent and unspoiled and reminded her of some juicy fruit. Gorky also felt close to him and remarked to his wife that Lam reminded him of himself before he had become embittered in America. He was a welcome relief, she said, from the Surrealists.[7] He was going to Paris for six months to participate in the new Surrealist exhibition, the following year.

Gorky wanted a photograph of his family 'so he could keep them with him while he was alone in the studio'. Kiesler accompanied them to the photographer Gjon Mili, who had a studio below Levy's gallery. They had been friends since the 1930s, at Romany Marie's in Grove Street, where Gorky often 'sang Georgian songs'. An Albanian Greek, Mili was sympathetic to Gorky because his people had also suffered under Muslim rule.

'Gorky was a good man, a genuine man who had a sadness about him,' Mili said. 'He was very congenial, if he liked you – really liked you. He was quite a proud man.'[8]

Mili posed the little girls on a huge leather pouffe in the middle of the studio floor. They wore summer frocks, with drawn thread-work and Van patterns, embroidered by Vartoosh. A brimmed hat balanced over Maro's peach face, her lips pouted and she stared fiercely with dark Armenian eyes, while the toddler, Natasha, flung out her hands in mid air.

Mili composed elegant studies of Gorky in a herringbone tweed jacket, flannel trousers and knotted woollen tie, his feet in woven sandals. Dark shadows under his eyes reveal strain as he looks away, but a cigarette points to the camera. His secret fear that cancer might be spreading had sent him back to Dr Weiss complaining of the pains he had had before the operation. Agnes was terrified but the doctor had cleared him of reappearance of cancer and she believed he had become overtired from working and staying upright too long.[9]

In July 1946 they piled into the Magruders' somewhat ancient jeep which would not exceed 45 m.p.h. They furnished the back with a mattress for the babies and a blow-up cushion which Kiesler had thoughtfully given Gorky. Agnes rushed through the Holland Tunnel, no mishaps ruffled her poise as she made it to the Pulaski Highway. It was painful and exhausting for Gorky, who collapsed on their arrival and had to rest. They luxuriated in the sun and slept outdoors to recover. She described how they stayed to

watch the sunrise and sunset in the fields with birds swooping overhead, Gorky slowly surrendering himself and his senses to the healing power of nature.[10]

Soon he was picking up his pad, looking refreshed, content to be drawing and doodling on paper with his colours and pencils, not caring where he started. Agnes commented perceptively that he always started this way no matter where he was.[11] He was happy to be in his favourite valley, alone with his family. Natasha was nearly one, 'a ball of fire'; Maro at two and a half, Gorky thought, 'an angel. I believe she looks a lot like Mother.'[12] He enjoyed lying down in the grass, on eye level with his children, inspecting the insects, leaves and flowers. He drew continuously. Agnes counted almost two dozen small drawings which she calculated were more than he had done in an entire year in Connecticut and wondered why he felt so enchanted and absorbed by this place.[13] She too settled with relief into country life, gardening, reading, writing letters to Jeanne. They discussed whether there was such a thing as woman's art. Agnes wrote that she did not believe there was because art had to be equally masculine and feminine. Thinking of her husband as an anti-feminist, she was surprised by his reaction when he glanced at this over her shoulder. Gorky told her she was mistaken, that there had to be feminine art but it had not yet happened because women had been too busy imitating men.[14]

Their plans for going to Paris, which had been brusquely cut short by Gorky's illness, were revived. News had trickled from the Tanguys of Breton holding court to dozens of people at a time in the Deux Magots and only receiving people by appointment. Agnes repeated Tanguy's malicious little comment that Matta had left Paris brusquely because no one had made a fuss of him. She was pleased about Breton, and confessed she had not yet written to him.[15] Gorky could not have felt confident enough to undertake a long sea voyage only five months after his surgery. He longed to stay in one place, to regain strength. She hoped he might exhibit in Paris and was delighted that he was burning with excitement over his new drawings. After only a few weeks she noted that he had already produced a vast number and some of them were exceptional.[16]

Another disaster had struck. While Gorky was away in winter, the old barn where he had painted had also burned down. He comforted Agnes that he would go on drawing because he had not yet found what he wanted to paint. In August, just a few days after Natasha's first birthday, Gorky

wrote his sister a rare two-page letter in Armenian; the heart of a large spiky flower of thorns containing the words *Eem amena seereli Vartoosh* (my most beloved), sketches of treelike forms, an archery bow and other floating shapes like a Calder mobile decorated it. Gorky was delighted that she had received another clandestine unstamped letter from Ado, out of prison and to be reinstated. 'I hope that his innocence will be proved,' he wrote and offered to send him clothes and school supplies for his son.[17] He told Vartoosh how he missed them, as ever repeating the endearing phrase, *eem seereliners* (my loveds).

As Gorky sat on his camp stool in the fields, drawing landscape after landscape, terrifying images came up. In previous years, he had been attracted to billowing clumps of trees, burgeoning leaves and swelling pods; now he drew barbed and dried thistles, spiky lanceolate leaves, preying insects crawling through the undergrowth. Nature became cruel and predatory, as he struggled to come to terms with his harsher reality. He was fighting for his emotional as well as his physical health.

New spectres appeared, such as an artificially constructed body, with elongated, jointed limbs, and sharpened claws which hooked back into themselves. He drew human-machines, insect-flowers, denuded of features and detail, as if to obliterate all personal references. The constructs began to fill his pages, as he sat in the peaceful valleys of Virginia. He paraphrased and pared down portraits and figures into streamlined entities, like Duchamp's *Bride*.

His free, organic sketches were both diary and notebook. He drew what he saw around him but intense feelings transformed them into fantasms. The ghosts of Gorky's black and white drawings had first appeared after his operation: bandaged bodies like mummies with strange protrusions, prostrate in a field; skeletal creatures with gremlin and insect heads with proboscis; composite monsters of oddly proportioned bodies with flattened heads; tall figures in flowing garments with dark angels' wings and cylindrical heads, like women's silhouettes in Van costume.

They enact elaborate scenes. One is half-suspended above an operating table, with an elaborate fountain balancing on its pelvic area, lying with its innards dragged out. Prostrate figures, knees together, lie on a narrow examining table or in a coffin. They are drawn from many perspectives, often in one sketch. Many have a large pelvic area which has opened out

with a pointed tongue for the genitals. These creatures incessantly metamorphose into new spectres with longer limbs, spiky phalluses, barbed crowns, occupied in a ferment of activity which evoke Bosch's semihuman and fantastical monsters in *The Garden of Earthly Delights*.

Agnes encouraged Vartoosh to be optimistic about her brother, reassuring her that she heard him sing as he worked like in the old days. But to Jeanne, she admitted that he was sometimes cast down by dreadful sadness which threw them both off balance. It was due to his illness, she believed, and the difficulty of cleaning himself every other day which was tiring and left him dispirited. She could not always find the energy to pull him out of his despondency by herself and felt they both needed others to cheer them.[18] It was the first intimation that she could no longer cope with Gorky on her own.

When the Tanguys called to say they had found a farmhouse with 130 acres of land, and invited Agnes and Gorky to look it over, they went to see it. Gorky shrewdly estimated the farm far below the agent's price of $22,000, and way beyond their wildest dreams. She raged against her father who had refused to help or even provide guarantees to enable them to borrow the money. She hoped that Levy would sell some drawings and she grabbed fifty to post to Julien before Gorky could change his mind. He dithered and protested for two days then asked her to tell Julien that they were not as good as the drawings he had made only that day.[19] Gorky often used the word 'discovery' in connection with his drawing rather than aesthetic judgements. It was the process of exploration which kept him on the chase rather than the desire to make perfect drawings.

One day Gorky received a package with two originals of the limited edition of *Young Cherry Trees Secured Against Hares*, which he was asked to sign for sale at $150. Agnes noted how marvellous his drawings looked, but Breton had not offered him one copy for his trouble in making and donating the drawings. This prompted her to write to him about their visit to France. Jeanne had offered them a $1,500 loan to pay for the journey.[20]

Her parents returned after six weeks to impose a more conventional routine, devoting hours to their obsession with making a lawn, yanking the offending thistle and milkweed. A garage was to be finished and Gorky would be able to work above it. His father-in-law, now promoted to Commodore, sat under a tree polishing his gun, while a convict climbed in the trees above his head, pruning them. The Commodore was resigned to

his daughters' disastrous marriages: 'So you married a Kike and I suppose yours is an Armenian!'

Gorky had other problems to think about. The horrific casualties of the war had caused a profound pessimism after Hiroshima. The Utopian changes towards a new egalitarian society in Russia had not materialised. Their hopes for a new united world, led by the League of Nations, were dashed. The boundary lines were drawn up for the Cold War. At Yalta the world had been divided by the Big Three, who carved out their spheres of influence as superpowers. Gorky had corrected Breton as he admired one of his paintings. 'No, the black spot is not Hitler's moustache. But imagine all those generals sitting before a map and carving the landscape as if it were food.' He called it *Landscape Table*.[21]

The Nuremberg Trials had started in November 1945, exposing all the horrific facts of the Jewish holocaust. For Gorky, the photos were a terrible reminder of the Armenian genocide in 1915. His nightmares returned; his wife was disturbed that he could not stay in bed at night. Many survivors suffered breakdowns at this time, reliving the genocide experiences. Turkey had wiped out an entire civilian population in Western Armenia and had still not been brought to justice. Gorky's deep sense of betrayal at this cover-up and injustice (he used the word 'bitter') deepened with his own illness and depression. Hitler, when planning the holocaust, had referred to them with the words: 'Who remembers the Armenians now?' And in the Second World War, more than half a million Armenians had fought and died for the Soviet Union.

In his drawings, which he now executed at a feverish rate, he was documenting his own journey, the rekindling of his genocide memories detonated by his own suffering and the recent events now often in the news.

A large number of drawings have been called *Fireplace in Virginia*. As the autumn drew on, the countryside lit up with golden corn and fiery red leaves against a blue sky, and evenings became colder. In the quiet of the evening, he heard a neighbour's son, who lived over the brow of the hill, singing as he came home at night. In the cool evenings they sat by a fire and Gorky refined the sketches he had made outdoors, or drew freely from memory. Agnes commented that the catch-all title *Fireplace in Virginia* encouraged writers to identify an actual fireplace, chairs, tables, a cradle for wood, any object which they could name.[22]

Gorky had made a recovery finding the inner resources to create again.

He wrote his last letter to Vartoosh telling her how pleased he was with the quantity and quality of the drawings.[23] In a studio he could have completed many paintings that year but the intimacy of drawing still enticed and reinvigorated him. He had squared off the large drawing for the painting *The Plough and the Song*. Another group from Virginia is more linear and abstract, with coloured crayons or washes. Fluidity and transparency in his paintings, from 1944 onwards, signalled a new approach. On these 'landscapes' he superimposed creatures which embodied his terrors and agonies.

Gorky still remained a local figure of curiosity. One farmer looked at his drawing, then at the view and back at Gorky's picture again, baffled by the lack of any resemblance. The pen flew across paper. He turned to console Gorky. 'Well, never mind. You jes' keep on tryin'!'

47

Catastrophe Style
1946–47

Returning to New York in November, Gorky was desperate for a studio where he could begin to work over the 292 drawings he had brought back from Virginia.[1] They were more than sketches, blueprints for his paintings over the next year. Not only was he brimful with ideas, but he was also physically stronger and more optimistic. At least two of his canvases show a return to his elated mood of 1945. He had achieved catharsis by drawing out the pain and phantoms in hundreds of drawings and could return to a lighter happier frame of mind. He rented a studio across 16th Street but it did not feel right.

Miró was in New York and came to Gorky for dinner, with the Spanish architect José Luis Sert; also present were the Schwabachers, Margaret Osborne, Jeanne Reynal and the classical Spanish guitarist Carlos Montoya, who had been their neighbour in Crooked Run. Gorky had expected Miró to be a man of the earth, naive, childlike, but the Catalan seemed very *mondain*. When Gorky talked of going to Paris, Miró urged him to be there in the 'season'. He relaxed after dinner, when Gorky brought out a flask of wine, rested it on the back of his arm and poured wine into his mouth, peasant-style. The Americans tried, but spilled the wine. Ethel Schwabacher described how Miró 'gaily took the flask, sat straight, his legs firmly planted wide apart, then with a gesture of bravado and virtuosity, accomplished the feat. Waves of applause greeted him.' He had learned it as a child in Catalonia. Gorky was asked to sing. He complied with 'wailing trills and arpeggios'. Miró replied with Catalan songs, 'close in spirit, high-keyed, ringing intensely melancholic'.[2] Stirred by his singing, Gorky

managed to dance a few steps. Montoya played the Spanish guitar while the short stocky Miró, Sert and the towering Gorky danced, each in his own fashion.

Gorky was no longer fired up by the recent work of Miró or Picasso. He felt that by the forties Picasso was digging into his own past, copying himself. Once when David Hare brought a Picasso and left it with him for an evening, he examined the canvas and even took it out of its frame, turning it upside down and sideways, scrutinising the paint surface. He remarked to Agnes that the Picasso had a 'vertical' feeling compared to his own canvases.

Gorky attended the opening of *Fourteen Americans at the Museum of Modern Art*. This was the first public showing of *The Artist and His Mother*, which made a deep impression on many abstract painters at the time, and with the substantial exhibition of his work, signalled that he was now considered one of the top painters in America.[3] Meanwhile on the roof terrace Matta flirted and made passes at Agnes, who laughed him off.

In the following days Gorky confided to Ethel Schwabacher that the reviews disappointed him and he thought 'full recognition might well come only after his death as it had with so many of the great artists who had been ahead of their time. Eventually, he felt, the public would accept these very paintings.'[4] His dreams of buying a house in Connecticut were shelved. A second studio in Union Square was too expensive and nothing else was affordable. They would have to return to Sherman.

The Whitney's *Annual Exhibition of Contemporary American Painting* opened on 10 December 1946 and, as always, included Gorky. After the enigmatic symphony of *Diary of a Seducer*, Gorky and Levy chose the stark solo elegy, *Nude*.[5] It belongs to the same period and theme as *Charred Beloved*, linked to the drawings of the *Cherry Trees* series. Its concentration on a few motifs was a powerful balance of control and improvisation. Gorky had said, 'I like the song of a single person.'[6] The subject at the top was variously interpreted as a stooping figure or the female and male genitals joined together. The Freudian construction has since gained, with Gorky's paintings seen as an orgy of sexual imagery. When Levy triumphantly told Gorky that one of his paintings had been turned down by a Women's League for offensive imagery, Gorky was dumbfounded. But a contributor to *VVV*, Lionel Abel, once saw a drawing in Levy's back room of

'breasts, testicles, genitals, and it was really beautiful'.[7] Turning to Matta he exclaimed, 'Why, that's the best pornographic drawing you ever made!' 'It's not mine,' Matta replied. 'That's Gorky's!'

Gorky had tried to out-Matta Matta. However, he did not confuse such pictures with his real work. For Gorky, Eros had to mean Life. In *Nude*, the paired images embody the split duality which haunted him. His concerns with the mortality of his work and his body laid this conflict out in the open. *Nude* goes below the gorgeous painted skin of *Charred Beloved*. As he faced survival, only Eros challenged his awareness of Thanatos (Death).

Levy planned an exhibition of the recent Virginia drawings, recognising them as the most complex and ambitious in scale. He hoped they would be easier to sell than the more expensive paintings. He had not collected any insurance money for the fire. Gorky was reluctant to raise the matter with him until he had completed some new paintings. Agnes wrote impatiently that Gorky would some day have to start asking for the same money as even unskilled workers were now earning, but they would have to be patient for the moment.[8]

Gorky saw more of Levy that winter in New York. Levy came to appreciate and understand his work through frequent conversation and excused his earlier neglect with the claim that he had waited for Gorky to be 'with Gorky'. The slick phrase stuck and is still repeated.

A shift had taken place in the Surrealist group after the repatriation of some of its members to France. Max Ernst did not enjoy success in New York after he split with Peggy Guggenheim. While Matta went from strength to strength, and Matta's wife Patricia financed his review *Instead*, Ernst had been forced to return to Levy but was dropped by the gallery. 'Matta lent Max one hundred and fifty dollars. This enabled him to load his unsaleable masterpieces in the trailer of his old Ford and embark with Dorothea on the two-thousand-eighty-mile trip to Arizona.'[9]

Gorky remained in the fold, presumed a better commercial proposition. In 1946 he tackled a major theme, *The Plough and the Song* – he had lost two paintings from this series in the fire in 1946. He must have left some sketches with Levy in New York, since a squared-off drawing was used to complete three new paintings in the series. Of all Gorky's titles, *The Plough and the Song* is the most expressive of his ethos. It combines two family symbols.

Koutan, the plough, was his birthright, from his father, who had owned and worked their land until they were dispossessed. His mother's bequest was *yerk*, the song, which she taught him to love: the religious chant and folk song, classical and modern Armenian, the beauty of her language in word and fleeting song. His title is a direct translation; Gorky often sang *Koutani Yerk*, 'The Song of the Plough'. It starts with a strong alliterative yodel to the bullocks, 'Ho⁄ro⁄vel ho⁄o⁄o', and goes on to praise the beauty of the six strong oxen pulling the heavy wooden plough. With the muscular melodic line Gorky loved, long phrases call into the open fields with ornaments and jumps of interval; it leaps from guttural *kh*, *rr*, a raw yell to the animal and to the earth. Such work songs were used to control the animals during the different stages of ploughing and are still sung by Kurdish peasants who plough that soil now.

Gorky uses the same process of consonance in form and shape in the heat of drawing, like a fine singer or dancer improvising. Shapes come from other drawings, from a phrase or line he has memorised, the outline of a crossbow, a scattering of cruel barbs, part⁄human creatures, cantilevered, uncertain. With these, he expands his line, or accentuates a space, moves forward combining and clustering other objects to form the phrases in *The Plough and the Song*.

In a wide open, shallow space, divided into three bands, with top and bottom free like sky and earth, a procession moves across the middle band of working figures in activity. A cornucopia, closed at the top with an elaborate headdress and pointed breast, resembles the prong of the plough which Gorky had modelled. It flows downward. From its opening, life issues in the shape of a flower, a smaller figure like a miniature of the main subject giving life to itself. The white figure links up with the butter churn from other paintings. In *The Plough*, the tall figure with pinched waist may be a fertility goddess, Anahit, whose springtime feast was absorbed by Christianity with the Feast of Vartavar, the day of roses. The theme of fertility and new birth was at the core of pre⁄Christian and religious rituals of the Van area.

The bone form also refers to the myth of creation and the rib of Adam which begot Eve. On the extreme left, a tall jointed column balances the main feminine subject. Gorky would develop it further in *Betrothal*, also painted in 1947. 'The tall construction at the far left resembles nothing so much as it does a construction of bones,'[10] wrote the art historian William

Seitz. The surface of the canvas is worked over and furrowed like rich earth with vigorous, scumbled brushmarks disturbing the top layer to reveal red soil underneath. The surface becomes a metaphor for the lost earth of Western Armenia which returned to nomadic infertility after the Armenian farmers, like Gorky's father, were driven out.

Gorky painted two more versions of *The Plough*, one now at the Art Institute of Chicago, another at Oberlin College, Ohio. The latter is a freer wash of golden ochre with forms outlined in fine black line, the colours scrubbed into the figures, as in *Good Afternoon, Mrs Lincoln* (which also has in the upper right a figure suggesting a pregnant woman in peasant scarf).

In February 1947 Gorky attended the opening of his show, *Arshile Gorky: Colored Drawings*, at Julien Levy's. *Art Digest* reported:

> Aside from Mr Breton's hybrids, we easily recognised the more intimate parts of flower ... buds, leaves, tendrils and the productive end of a cow.
>
> This is all done in pencil in a rather loose manner and occasionally touched up with a spot or two of bright watercolor. It is a highly personal, acutely concentrated kind of doodling and quite intriguing. One feels, rather than 'sees', what he is getting at.[11]

In the same month, his oil painting *Nude* was in a group show called *Blood Flames* at the Hugo Gallery.

Gorky did not work well that winter and bickered with his wife who was feeling discouraged. They were cooped up in the studio, which was too small for them now. Encouraged by her great-aunt Marion, Agnes went for counselling to a Jungian analyst, Dr Harding, for four months; she kept a journal at her analyst's behest to record her dreams and free-associations. The Jungians considered her too young for a full analysis.[12] Still in her twenties, she found it hard to adjust to Gorky's collapsed confidence. 'He really was terribly depressed, tight-mouthed and tragic. I was too young.' She felt that after struggling to create a home, produce two children and support her husband, they still had not come through their difficulties. With hindsight she reflected, 'We were terribly poor. He was jealous of me. The children got on his nerves. There has to be a cherry occasionally. You can't

have a life with no cherries.' Ann Matta visited them with the twin boys and was appalled by the change in Gorky. 'It was dismal. He was hard on her. Picking at her.'[13]

Gorky was haunted by the fear of death. He randomly popped a question in company, 'What do you know about cancer?' He also wondered whether men thought him impotent. He disliked the studio he was renting. Agnes watched him work beyond his strength. 'He painted for as long as he could stand up.' She determined to arrange for him to work alone in Union Square. From June until September she would take the children to stay with Aunt Marion in Castine, Maine. 'I thought it was having them around made him nervous.' He would be 'free to paint without the irritation of the children'. She would write every day, and even prepared a pile of stamped, addressed envelopes so he could quickly post his letters. Gorky agreed, relieved to know that his family would benefit from a change of scene.

Just before they left, his old friend Yenovk came to visit. He had gone to California, married unhappily, divorced and returned. He had just heard of Gorky's operation, but he was unprepared for the sight of his boyhood friend almost stooping, his face lined, pale, and with a wounded expression. Blond blue-eyed Yenovk too had lost his youthful, naive dash. Gorky's embarrassment put Yenovk on edge. 'What an aristocrat you have become to me. "Pardon me, pardon," every time you stand or move.'[14]

'*Derderos* boy, priest's son,' said Gorky. 'They cut me up!'

With Yenovk, Gorky suddenly found the Armenian words to tell his story. Yenovk told his interviewer in a broken voice, 'I wept.' He saw the tears in Gorky's eyes.

'Don't you dare cry!' Yenovk was shocked by Gorky's strength as he shook him, over and over again, lifting him on the stool. 'Don't you dare cry!' It was like the time in their childhood when Gorky had almost drowned him in the lake.

'All right, Manoug, forget about it. Why didn't you tell me? Why didn't you write to me?'

'Eh, was it worth the telling? Was it a wedding that I should send you an invitation?'

Then Gorky went to the bathroom and Yenovk reflected, 'Manoug suffered a lot when he went to the toilet to get cleaned, it took at least half an

hour, he came back and lay like a corpse, on a couch there, and rested. We had a glass of wine. Agnes was taking her children somewhere.'

The calm and sweet-tempered Yenovk had seen Gorky through his crisis with Sirun.

'Stay the night,' Gorky pleaded. 'Agnes won't be here.' She was about to leave for Maine with the children.

'No, I have an appointment,' he lied.

Next day Gorky took him to the Armenian restaurant on Lexington. 'Manoug, you aren't supposed to eat fatty food.'

'Whatever's going to happen, let it happen! Today I'm with you. Whatever you eat I'll have the same.'

Yenovk protested, 'I'll have the same as you.'

'No, you talk too much. I'm going to eat – on condition that I pay!'

At the studio, Gorky stretched out on the carpet, with Yenovk in a chair. 'Why don't you stretch out? What's the matter? The other day you called me an aristocrat. You've become an aristocrat, sitting on high.'

'No, I can't lie down.' He pleaded an old war wound.

Gorky insisted and they lay as they had on the grass talking and daydreaming years ago, 'from the hills and valleys' as Yenovk put it. In California, Yenovk had visited Gorky's uncle Aharon, Shushan's brother, asking permission to sing the ballad of the family monastery, St Nishan. Aharon feared the curse, after his brother's murder and the burning of the church. Gorky's illness bothered Yenovk.

'Why did it happen? How did this happen?'

First, Gorky ignored him, then he said, 'Yenovk, if you had listened to me then, if you'd lived with me, I wouldn't have ended up like this.'

'Manoug, you are an uncontrollable, ungovernable rebel! What could I have done with you?'

'No, I wouldn't have turned out like this.'

Yenovk murmured, 'I would have ended up like you, too.'

They fell into a long silence. After a while Gorky said, 'Now, I have a studio, we can paint together.'

Yenovk objected that he had no supplies. Gorky opened a cupboard full of paints. 'Which ones do you use?'

Seeing Yenovk alone, Gorky understood that he had destroyed something in himself, which only his friend could retrieve. Yenovk noticed:

After the operation he appreciated Armenians, when he got in touch with nature. Once he realised that this thing God created, nature, what we had and what we lost, the scenery and everything. He was always talking about Ardos, Aghtamar, Vanalidg, and Hayotz Dzor, Shamiram, sailing boats. Every time he was with me, he made me to talk about old country.

Yenovk saw his new paintings and puzzled. *The Plough and the Song* was also about their friendship. The plough they had built together was Gorky's poetic symbol. Yenovk was one of the few who understood his state of mind and Gorky's regret. 'What we had in our country, we didn't value, we didn't appreciate. Now I know my way. I found my way to realise what beauty is in nature. And we didn't see it.' Gorky explained that when he started drawing wild flowers in Virginia, he was pleased and had a lot of faith in what he was doing. Yenovk remembered his last words. 'Now I know where I stand.'

48

City Pastoral
1947

Gorky was in New York from June to September 1947, living as a bachelor in his old studio for the first time in his six years of marriage. His days of painting till he was exhausted, then dashing down for coffee and doughnuts, were over. He had to manage on his own: eating, washing, dressing, and overcoming troughs of despair.

Vartoosh had received a letter from Agnes telling her that Gorky wanted to stay in New York so he could paint for his new show while she and the children were going to stay by the ocean. She looked forward to the break which would give her the opportunity to relax, bathe and walk, while the children would enjoy the beach. She regretted having to be away from Gorky for the first time but assured her sister-in-law that it would be a breather, benefiting both of them. Vartoosh should not concern herself unduly as the doctor was keeping an eye on Gorky, who was recovering. In the same letter Gorky dictated through Agnes his comments on a set of drawings by his nephew Karlen. He encouraged the little boy, telling him that he would succeed as a painter if he persevered. His uncle told him that he should not bother with shading and instead work on evolving his line making it clear and lovely. He stressed that this should be his most important aim and sent him a line drawing of his own as an example.[1] When writing and talking in Armenian to Vartoosh he always used the words *makour yev shad harazad*, 'pure and very authentic', about his drawing – also his ideal for living.[2] Vartoosh replied to Gorky and hinted that she would come up and care for him. She warmly expressed her concern for him, that she longed to have a moment with him for a special reason:

'Lately I bought Aram Khatchaturian's Concertos and the Kayané Ballet record which is marvellous. If only one day we could be together to listen to them side by side.'[3]

Gorky's letters to Agnes in July were romantic. 'How wonderful your sweet letter is my darling Mougooch. I read it every night before going to sleep it lives me dreamy all of the nights & all of the day with the thought of you – wishing we were together holding hands walking in the wood or in the city with our little darling Maro & Natasha.'[4] And 'It is night now my darling I think you are in my arms & I kiss you – and you sweet body.'[5] Gorky would never be so close to Agnes as when he was writing. He could idealise his physical emotion without being humiliated by his handicap.

In Paris, Breton was preparing the first great Surrealist show since the end of the war. In the Galérie Maeght, Kiesler designed a space suffused with the spirit of magic, tribalism and oneirism. Duchamp stayed in New York, colouring by hand 999 foam-rubber false breasts for the cover of the catalogue *Le Surréalisme en 1947*, which would read, 'Prière de Toucher, Please Touch, de luxe edition'. Gorky wrote, 'Yesterday had to take a drawing at Marcel's studio to be send to Paris André ask for it to be sold for Peret (Hommage to Peret) We had lunch together I had a lone two hours with him.'[6] Duchamp was fond of Gorky and, unlike other French artists, he spoke excellent English. He filled Gorky in on how Kiesler was taking over the show but Breton had regained control over it. Gorky had sent *How My Mother's Embroidered Apron Unfolds in My Life*.

Jeanne Reynal had promised to keep an eye on Gorky. Her door was always open; she gave parties for artists and friends who stayed in her Greenwich Village apartment, hung with paintings by Gorky, Matta and Pollock, along with a large collection of Hopi Indian dolls and primitive artefacts. She wrote to Agnes:

> he is working very well and its a pleasure to see him like that, the drawings are beautiful and I think he is finding great satisfaction in their magnitude. he does not show them to anyone . . . A painting too he showed one before your departure which is even in the present state extraordinary. Last night the Calas came here and Arshile and then we just . . . talked. Dear A was out to do everyone down on all scores politics Saint Freud everything it was quite fun I thought.

Jeanne was blunt about Gorky's illness: 'we shall see them [Julien and Muriel Levy] but alas A [Arshile] will not be there for it is his night with his guts'.[7]

Peggy Osborne, who had lived in Gorky's studio, understood his dilemma: 'The cancer was a terrible blow and I expect it made relations with his wife impossible.' She characterised the artists around Gorky as 'brilliant and gifted', but reflected, 'They were much more worldly. These people were cruel . . . I won't say they thought it was a joke, but they thought it was a situation. Perhaps a rather interesting one.' Gorky was etched in her mind:

> He was a solitary and single human being. He was never meant to belong to a crowd. He needed the crowd for his own confirmation. He was a noble human being with noble ideas about life, old fashioned. He tried very hard to fit himself into a thing where he didn't belong. It was a very intellectual crowd. It's a queer thing to say about him, he was a very innocent man.[8]

Agnes herself had often written to Jeanne about her fears that this somewhat ruthless group could shine the spotlight on someone then suddenly ostracise him.

Gorky felt lonely without his family, but could not fall back on his old friends. Some of them had dropped out of his circuit or felt that they had been dropped: John Graham, Stuart Davis, Mischa Reznikoff, Raphael Soyer, Peter Busa, Saul Schary, even Isamu Noguchi. Elaine slowly eroded their tie to make De Kooning less dependent on him over the last few years. Gorky missed his companionship and De Kooning lost an irreplaceable stabilising influence. Gorky had been his guru not only in art but also in life, always putting art first, challenging De Kooning by his exacting standards. Gorky's integrity had been the greatest inspiration, and without him, De Kooning began drinking heavily.

The 'large painting' which Reynal mentioned having seen in his studio was probably *The Calendars*. Later it burned in the fire at the Rockefeller Government House in Albany, New York, in 1961, like many other Gorky paintings which would share the same fate. Like *Agony*, *The Orators*, *Summation* and *Dark Green Painting*, this canvas was assembled like a great opera with a backdrop, props, characters, each element playing a key part in

Gorky's inner scenario. The paintings would chart a process of disintegra⁄ tion and dismemberment, followed by transcendence.

As summer wore on, Gorky fell into a more cerebral, reflective mood, editing material, using drawings as a basis for composing paintings. In hospital, he had sketched himself as an effigy in a series of impassioned drawings, some so violent that his ink nib had scored through the paper and left filaments and blotches in its wake. With a flick of practised movement, he set washes of ink whirling on paper. This series of small drawings, among the best and most powerful of Gorky's work, is both savage and tragic. He drew his body, racked by pain, in every conceivable way as part⁄ automaton, part⁄human. He lies down, tightly swaddled in shrouds. The action of his impetuous pen leaves energetic lines which dart across the small page.

The personage in *The Calendars* portrays the self without flesh, all bone and sinew, a construct but also a person, like the Indian Kachina dolls of wood and feathers at Jeanne Reynal's house. Gorky felt himself to be a skeletal figure who could no longer take part in the pleasures of the flesh. His year was no longer measured out by seasons but by visits to the doctor, and each day he had to measure the length of his work periods against rest periods and time for bodily functions. The dominant figure is a symbol of his diseased self, opened out like a frog on a dissecting table, or a flattened skeleton. Like a jointed wooden artist's mannikin, the body lies down, sits at an angle or stands erect. In *The Calendars*, it is still on the operating table.

A seated female is squat and headless, with the cleft of Venus's mound accentuated. She appears in numerous drawings, and some are dedicated 'To My Mougouch' with variants of spelling; other sketches are inscribed 'To my Maro'. This female also appears in the *Plough and the Song*, and *Orator*. The dog, another favourite subject, is stylised in flattened planes with long drooping ears covering his face – Gorky's id, the unconscious animal self.

His absorption in art produced a resurgence of creative power. He worked simultaneously on canvases of distinct and contrasting approaches. For instance, *Plumed Landscape* is a bold and deliberately simple painting. Gorky blew up a large image from a detail and made it more ephemeral and ambiguous. *Pastoral* and *Terracotta* are sketched in with broad brush, then left to drip. Their apparent ease was the product of a long process of

4. 'Soulmates from Van', Gorky and his Armenian sweetheart Sirun
Mussikian in Watertown, 1930.

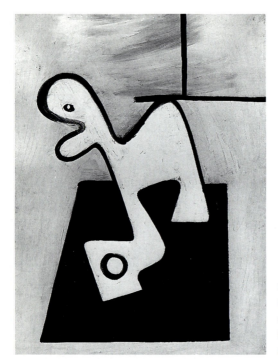

15. *Form in Space*, 1936.
Oil on hardboard.
COURTESY OF THE ART
INSTITUTE OF CHICAGO,
Gift of Apollo Plastics Corporation.

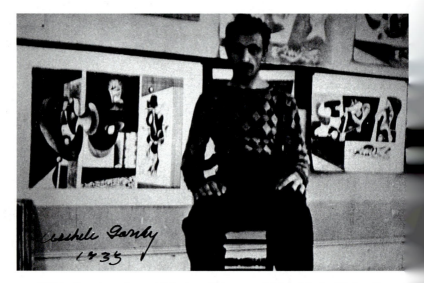

16. With drawings from *Nighttime, Enigma, and Nostalgia* in Union Square studio taken by his friend Alexander Sandow.

17. Gorky with beard,
'I want to paint myself
like Jesus Christ', 1930s.

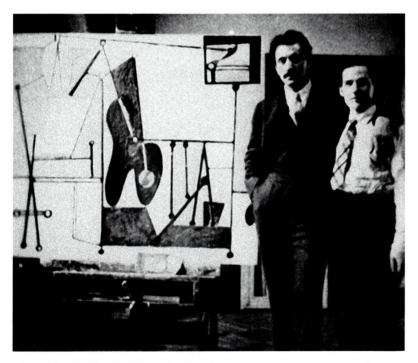

18. With his friend Willem de Kooning next to an early version of
Organization, 1935.

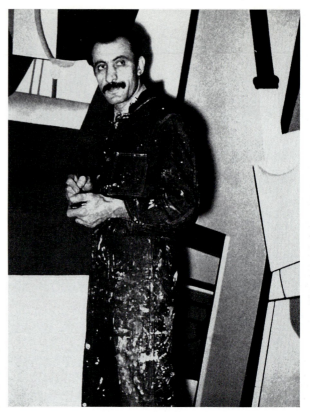

19. 'Gorky refused to let
anyone touch his work';
Aviation Mural for
Newark Airport, 1936.

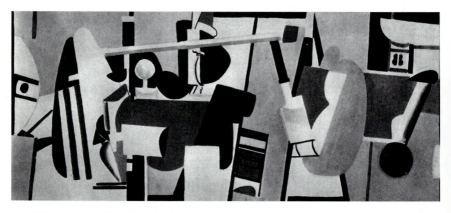

20. Mural study for Newark Airport, New Jersey, 1935/36.
Gouache on paper, 13⅝ x 29⅞", MUSEUM OF MODERN ART, NEW YORK;
Extended loan from US WPA Art Program.

21. 'I call her Mogouch',
Agnes Magruder photographed
by Gorky around 1941.

22. 'Skatch after skatch', Union Square mid-30s.

23. A few months after his operation, with Cuban artist Wilfredo Lam.
PHOTOGRAPHED FOR *VOGUE* BY IRVING PENN.

24. Dinner for Breton; *left to right standing* Bernard Reis, Irene Francis, Esteban Francis, Nicolas Calas. Sitting Max Ernst, Agnes Gorky, André Breton, Becky Reis, Elisa Breton, Patricia Matta, Frederick Kiesler, Nina Lebel, Matta, Marcel Duchamp, 1945.

25. 'A chance meeting of Maxim Gorky with Oscar Wilde on an American prairie'. Gorky with daughter Maro and André Breton in Sherman, Connecticut, 1945.

26. Last photograph of Gorky wearing a halter, with his dog, Sherman (*far right*),
Connecticut, July 1948. COURTESY OF ESKIL LAM.

development. Lyrical and transparent, they prompted Reynal to write to Agnes, 'I have seen some paintings, like butterflies, or the wings of butterflies.'

That year Gorky developed another group with *The Beginning* and *Making the Calendar*. Glancing thin black line and restricted spots of colour were floated as if onto the texture of stone. His porous canvases, washed, dried and bleached in the sun absorbed pigment from the runny wash of paint. He stained the cloth and watched for accident, chance variations and imperfections. As a child he had seen dyers in Van dipping skeins of wool into vats of colour. The artisan's control over his raw material had stayed with him.

Gorky's new-found lightness had a dark undertow in his secret narrative. The real impact of his mother's Bible teaching had not always been comforting. Gorky had told Agnes that the terrors of Hell she described sent the children diving under the bedclothes. *The Betrothal*, *The Orators* and *Agony* illuminate major life events and can be assembled in a sequence and a chronology, like an illuminated book or a series of frescoes. Gorky's three paintings might be hung in a tryptich. Gorky owned and had studied a set of reproductions of Grünewald's *Isenheim Altarpiece*, integrating into his abstract paintings the configuration of Christ's body on the Cross, his pierced wounds and drooping head. His clarity about such influences was evident in his remark, 'One artist could beat his hands on the table, and years, even centuries later, another could feel the rhythm.'[9]

The Orators has been linked to his father's funeral, although his father was still alive when it was painted, in 1947.[10] A prostrate figure with a large pink face can be interpreted as a part-black male body, with a bright-yellow middle and blue legs. The floor is strewn with bones or organs. Perhaps he had heard of his father's declining health and felt guilty for not helping him through his poverty-stricken old age. At his feet is a blue vertical, a candle – 'A candle gutters out like a life,' he had told Levy. The reclining figure may be seen as Gorky lying on the operating table, with the surgeon and anaesthetist leaning on either side of him. To the right, an immense, ghost-white phallus rises, like a phantom of the ancient stone monuments in the Van region. The erotic image waiting at his side might be seen as a symbol of his endangered virility. By rejecting his father Gorky had also failed to receive from him the masculine archetype or principle. Although Gorky's ambiguity was unrestricted, his most 'figurative' works have multiple

connotations. Matta remembered Gorky saying that 'he wanted to get some kind of human reference in his work'.[11]

Two of his most powerful works set out his alienation and transfigura-tion: *Agony* and *The Betrothal*. A large number of black and white sketches, named after these paintings, introduce a compelling racked figure. In the painting *Agony*, the dominant figure is also composed of disparate parts – shield, palette, wings, feathers, shanks – arranged roughly in a human form, the 'rearranged body'. *Agony* is entirely conceived in reds and black, from carmine and cadmium to the colour of congealed blood. No other work unpacks the horror of Gorky's nightmare as powerfully as this profound masterpiece. The bony figure leans back in the posture of Christ on the Cross. A thin black vertical crossing the horizontal faintly recalls the arms of the Cross, hanging in solitary beauty; evocative shapes enmesh the spaces between. To the right and lower down is a complementary but compact figure, more prostrated than the first. In the foreground, a perilously balanced lectern supports an extended rectangle on a heavy fulcrum, like a weighted pop-up toy. The motif always appeared in illuminated portraits of the Apostles. In other paintings, Gorky had painted it upright and erect, or pliant as a stalk. The Word, the book on the lectern, is upside down, like Gorky's interior and exterior world.

His titles, *The Beginning* and *Days, etc.*, make clear reference to the Old Testament Creation. He had once learned the Books of Daniel and Ezekiel by heart – dreams, visions and fire – chanted them in the church of Khorkom. The rebel grandson of a priest reverted to religious scaffolding in a spiritual crisis. His struggle with his demons is marked not only by the insistent reds and rich browns, but by a terse and jagged line, sharp angles and tapering triangles. The central Christ/Gorky effigy is composed of kidney or palette shapes, stacked on top of one another with clean lines which draw attention to the pale central figure drained of blood, except for a red tongue springing from the pelvic area. Each figure occupies its own separate space, in perilous balance, and no solid contact with terra firma. Gorky painted himself in agony, like a Crucifixion on a ground of blood.

The Betrothal has a pale translucent ground of buff and twilight lavender. Tall figures rise on thin black stems with the leaden grace of Art Nouveau flowers. Once again, there are two main figures, a male and a female. The barbs around the pod/head of the Betrothed evoke the Grünewald

Crucifixion, Christ's head fallen to one side, crowned with cruel thorns. Will the head lift and flower, or wither on its broken neck? All volume and mass have drained out and reduced the figures to mere lines. Duchamp's *Bride* is evoked. In Armenian the word for betrothal is *nishandook*, 'exchange of signs' (for the rings). Gorky may have looked back to the brass ring wedding as he registered the stages of disintegration of his marriage in each successive canvas. The blanched poignancy of this canvas is chilling compared with the blood-red *Agony*. The fight has gone out of it.

In August Gorky briefly visited his wife and children in Castine, Maine. Unable to swim, he sat by the ocean, playing and sketching with the girls. After his passionate letters, the longed-for meeting was an anticlimax. Gorky could not switch into a holiday mood. Agnes and the girls appeared a self-sufficient trio, making him feel estranged. His awkwardness made him hostile to her new friends and upset her. Since his illness, he needed even greater assurance of her love and she tried her best. By September, Gorky was again telling Agnes that he longed to hug his children and, 'I want so much to see you and to talk to you, yes, I kiss you my love, kiss you passionately!' Being without her was 'agony'. But then he received news that she had been invited to stay on an uncle's country property in Boston, and he should join them. He had counted the days to their return and, as when she was in hospital giving birth, he had scrubbed the studio, putting flowers out and messages of love. He wrote back. 'I can't come to Boston. Because I am working you know and have so many, many, things to do here . . . I am painting and have so much cleaning to do.'[12]

He forced himself into overdrive to complete his last canvases, for once his family arrived, he would lose the pitch of concentration. He had overtaxed himself and was exhausted. Reviewing his progress that summer, he evaluated it with a telling phrase at the end of a letter:

'I am beginning to see the promised land.'[13]

Aunt Marion advised Agnes not to delay, but she stopped in Boston, where her uncle 'had a terribly nice house and lots of lovely land around it. A tiny bit of liberty and it was fatal. I couldn't see why I couldn't stay two more days before going back to my treadmill.'[14] Gorky, who had been reading

about women's rights, confided to Aunt Marion that he was furious with Agnes for breaking her promise; what she needed was a spanking. Aunt Marion pointed out that in North America husbands did not hit their wives.

When Agnes saw the large number of canvases he had completed, she was convinced that she had done the right thing by going away. 'That summer he was as happy as could be. He painted like a sand-boy. A lot of wonderful work. A lot! I should have gone away earlier but he couldn't, he wouldn't let me go.'

Gorky had looked for another studio in New York, but rents were high. Agnes blamed their difficulties on the move. 'Leaving New York was bad. It was very good for him to be in that studio alone. If we could have lived somewhere outside in the country, he could have lived in New York in the studio. His roots were there.' They decided to try living in the Glass House in Sherman Connecticut once again.

PART V
THE SONG
OF A
SINGLE PERSON
1947–48

PREVIOUS PAGE Untitled, c. 1946 Detail of drawing.

49

Full-Blooded
1947-48

On 6 December 1947, the Whitney Museum of American Art opened its *Annual Exhibition of American Painting and Sculpture* with Gorky's new work *The Calendars*.[1] The critics were impressed and hailed it as a most significant work; even the formerly antagonistic Clement Greenberg repeated his stock phrase that it was 'the best painting in the exhibition and one of the best paintings ever done by an American'.[2] Lloyd Goodrich, the museum director, who enjoyed a good relationship with Gorky, and regularly exhibited his work, commented:

He evolved his advanced style early on. He planned his pictures very well. There were several versions of the picture – two versions of *Betrothal*, ours was the second. He was a conscious artist, different from the later, younger practitioners, many painted like automatic writing, letting instincts take over, producing instinctual art. Gorky was more a planner and designer. I see in Pollock, in de Kooning, Gottlieb and Tomlin, not an influence but an awareness of Gorky's work.

Goodrich did not misrepresent Gorky as a Surrealist.

Gorky's main characteristic is a remarkable command of the medium itself, a sensuous command. He evidently enjoyed painting, with a deep pleasurable quality in everything he touched. The colour is arresting and beautiful. The pigment is used in a sensuous way, all through the picture. There's nothing thin-blooded about Gorky – he was full-blooded always. He was magnificent in colour. As a linear artist, a draughtsman, he is one of the finest we have

ever had in this country. It shows in his paintings. They are drawn with a brush. They're spontaneous, planned in design, but with freedom and spontaneity in execution.[3]

The exhibition ran into the New Year 1948. The Gorkys planned Christmas in the Glass House with great-aunt Marion. Agnes now drove a 1940 Pontiac station wagon, financed by Jeanne Reynal. Agnes wrote to Vartoosh of Gorky's contentment with their house. The city was too stressful for him but in Connecticut he felt rested and tranquil.

Before Christmas Day, Gorky went into the woods with his axe to chop down a tree. Vartoosh made a long-distance telephone call, but could only speak to Agnes. Gorky did not return her call. For the rest of her life, she never forgave herself for not having rung back.

The girls were two and five. Maro looked down from the balcony over the living-room at the tree covered with silver streamers. 'Who hung worms all over the Christmas tree?'

It was one of Gorky's favourite stories. He loved to talk of his girls. Muriel Levy remembered when he found Maro sitting on a stool beside Natasha's crib, watching the baby sleep.

'What are you doing, Maro?'

'Oh, baby-sitting, I guess.'

'He just adored those children. To see him with them was a delight,' Muriel said.[4]

He wanted them to grow up as naturally as possible. When Karlen was about Natasha's age, Gorky had written to Vartoosh not to push him: 'Mothers always want their children to become brilliant and well behaved to impress others.' He thought it best to 'give them culture . . . but avoid trying to accelerate his growth'. Above all, 'when he is a child, allow him to be a child because you must realize that youthful days are but dreams and harmless. When he reaches maturity, a man . . . speaks intelligent words . . . at that time let him make himself evident.'[5]

Muriel and Julien moved into a farmhouse across the river, in Bridgewater, which Gorky and Agnes had found for them. Suddenly his friends talked of him as an Armenian, as though he had dumped his mask. Jerrold Bayer, Levy's teenage son, puzzled over his father's friend.

I was impressed that he was Armenian. How did he leave? How did he get

here? I looked at a book of First World War, then pictures of Ataturk. I was aware of the Turkish massacres. My father told me that Gorky had passed himself off and taken the name. Julien told me his mother was very close. I saw the painting. The eyes and hands stayed with me.[6]

Gorky had come to occupy an important role in the gallery and in his father's esteem. 'Julien was protective of him. I think he really loved Gorky.'[7] The relationship was complicated by Levy's inability to sell much of Gorky's work, so the $175 per month could not be supplemented. 'Julien was not good at business,' both Jerrold and Jonathan confirmed. Neither Gorky nor Agnes had thought of cataloguing or numbering his drawings and paintings. The formal agreement stated that Levy would receive twelve paintings and thirty drawings a year. Gorky simply handed over stacks of untitled drawings to be sold by Levy. Agnes later wrote that Levy held most of Gorky's output excepting some works on paper, that he did not inform them of sales and they had no way of finding out since the pictures had not been catalogued. Agnes asked Wolf Schwabacher to intervene as their lawyer, before Gorky renewed the old contract. Levy was offering a further $300 per annum, with the proviso that he would receive more work against the sum. Meanwhile Gorky asked for funds specifically to cover his paints and other material outlay. Agnes concluded that they were satisfied with the extra cash and decided to accept.[8]

Gorky was approached by two French galleries; one in particular would co-operate with Levy, and the other independently with Gorky. But when Levy visited, they were too timid to tackle him and Gorky's work stayed in Levy's hands.

They invited the Schwabachers for a weekend. Agnes painted a magic snowy landscape but warned that the food was simple and bedtime as early as 8.30 or 9 o'clock. The converted house was being photographed by *Life* magazine, she wrote, although there would be no publicity for Gorky's work, even if the photos conjured up a more modish life than they actually enjoyed.[9]

The photos in *Life* told a different story. The remodelled house, surrounded by mounds of snow, looks romantic and peaceful, yet the interiors have a chill about them. Gorky, in checked wool shirt and Indian waistcoat, perches low, his back to the camera, looking out over the snowy landscape. His melancholy is almost tangible. The family group is

heartbreaking. Gorky sits at the head of a small table, stooped over his plate, his little daughters on either side. Agnes is playing Mother, and serving food with a wan smile. There is no eye contact between them. His head is lowered and his eyes fixed before him. In every photograph, he sits looking away. His hunched shoulders and sad face are even more forlorn than in the photographs taken just after his operation.

The life-style feature is concerned with the renovated barn:

> The house shown here is an outstanding example of how an old-fashioned dwelling can be transformed into a striking modern home . . . The sun-filled result is a blend of traditional and modern architecture that comfortably houses tenant Arshile Gorky, an artist, and his family in its eight rooms.[10]

His paintings are nowhere to be seen.

They lived quietly in the Glass House. Agnes herself had few recollections of socialising. Wilfredo Lam visited whenever he was in New York, and noted that it was in Gorky's house he first met Alexander Calder and Robert Motherwell. The Cowleys and Blumes dropped in, but they were older than Agnes. Rob Cowley went there as a teenager to shashlik parties with music and dancing. He thought Agnes impulsively generous for giving him some jazz records at her party. Agnes chafed at the bit. 'He was always very jealous. I was never allowed to talk to anybody, if he saw them looking at me. He was jealous of David Hare. Even Pollock.'

By 1948 Levy, a pioneer of the Surrealists, no longer possessed the financial backing to keep his edge. More efficiently run galleries with bigger premises had opened: Sydney Janis, Sam Kootz. After years of art publicity and experience, they encouraged the public to buy modern American art, especially Abstract Expressionism. Peggy Guggenheim left New York in 1947 after publishing her memoirs, which almost put Max Ernst in prison as an enemy alien. Her gallery was taken over by Betty Parsons, an ex-student of Gorky's.

Soon after Levy moved to Bridgewater, his heavy drinking was noticed by the locals. Jerrold (Levy) Bayer said of his father:

> Julien was cruel. Made overly sarcastic statements. He was complicated, neurotic and prone to depression. Once we were having supper with Berenice Abbot. They fell out over sharing photographs they'd bought

in Paris. A bottle of mead exploded all over Berenice. Julien was terribly apologetic. He went after Muriel. Took hold of her wine glass. Smashed it on the table![11]

When Levy later wrote *Memoir of an Art Gallery* to highlight his career, he exposed his fascination with sleaze and sensationalism. Muriel, his second wife, remembered starting every morning in a haze of alcohol. She could not break free, even with the help of a psychiatrist. Levy often saw Dr Kinsey, who was documenting the sexual behaviour of Americans. They sat up all night poring over a vast collection of French pornographic drawings and photographs of genitalia. In the repressed postwar atmosphere, sex was not openly discussed. The book caused a stir in America with its frank picture of sexual habits in 1948.

Levy's uneven personality and alcoholism could not have had a reassuring influence on Gorky, who needed stability. In Connecticut, everyone seemed to be at each other's throats. His son Jerrold said, 'If you take that whole bunch, I don't know that this was a human society, with the amount of drinking, of weirdness going on.' Kay Sage was 'a tiger' but also a friend. Reynal reported her saying, 'Gorky is a sweet man but such a bad painter!' Alexander Calder did not feel close to Gorky either.

I always thought he was Russian. We were very good friends with Mogooch. They were having a hard time, they came over to Roxbury. He gave me a drawing he said Miró would like very much. He was very pleasant but tended to be plaintive or sad. Perhaps he suffered from lack of confidence.[12]

His daughter Sandra Calder remembered disturbing parties with heavy drinking. Her parents lived to dance: jazz, sambas, musettes. Gorky seemed a dark person, uncomfortable in this disjointed community, conscious of being an outsider.[13] Agnes too felt they were 'not part of this scene'.[14] However, on the occasions when Gorky may have wanted to see people, this was his wider circle and he had no other close friends nearby.

In February, Gorky's one-man show of paintings opened at the Julien Levy Gallery. This exhibition was critical for his future. As many artists were poised to leap in a new direction with greater abstraction and all-over

field painting, the New York art scene had not yet crystallised. Fellow artists' eyes were on Gorky, who had always run ahead of the pack.

Many works were large, around 50 by 60 inches, *The Orators* 60 by 72 inches. There was a compelling array of mature works from the previous year.[15] Ethel Schwabacher was excited by the paintings and noticed people's reactions. 'Levy, quick, dark, subtle, willingly interpreted Gorky to those who came to the opening. He had taken on the ungrateful task of providing a "Baedeker to a continent".'[16] Many people milled around; their words drifted: 'Too like Miró . . . obscure . . . extreme.'

Gorky's latest works no longer seduced with billowing colour and dancing forms. Their distilled volume, condensed symbols and whiplash lines spoke of a man's steady struggle. With sober maturity, the titles named the stations of a life's journey: *The Beginning, The Betrothal, Agony, Year after Year, The Limit*: 'I have been so lonely, so exasperated, and how to paint such empty space, so empty it's the limit!' Levy reported him saying.[17]

The day after the opening, Gorky and Agnes went to lunch at the Schwabachers. Noticing Gorky crestfallen and 'very dispirited', Ethel expressed her appreciation of his work. Agnes wrote to thank her soon after returning to Sherman, for raising Gorky's confidence with her praise and her understanding comments. He had been so shattered by the general incomprehension and absence of reviews that he bolted back to the country to find refuge in working again.[18]

The critic for *Art News* noted 'a linear, automatic style, and still keeping an eye on the experiments of Matta, Gorky has added brilliant colours and complex textures to his calligraphic patterns' and completely missed the point; 'Gorky's little masks, books, dogs and figures are spotted among the hot reds and yellows to give a gay, decorative effect which is sometimes marred by sloppy technique.'[19]

Clement Greenberg had finally come around to writing a seemingly rave review, thought it failed to appreciate the seriousness of the work:

What is new about these paintings is the unproblematic voluptuousness with which they celebrate and display the processes of painting for their own sake. With this sensuous richness, which is a refined product of assimilated French tradition and his own personality as an artist, with all its strengths and weaknesses, Gorky at last arrives at himself and takes his place – awaiting him now for almost twenty years – among the very few contemporary

American painters whose work is of more than national importance. Gorky has been for a long time one of the best brush-handlers alive, but he was unable until recently to find enough for his brush to say. Now he seems to have that in celebrating the elements of the art he practices and in proclaiming his mastery over them.[20]

Years later Greenberg printed an apology – too late for Gorky. It seems unthinkable that he called Gorky of all people 'a complete hedonist, deeper in his hedonism than almost any French painter'. But he ended:

Arshile Gorky, in my opinion, has still to paint his greatest pictures. Meanwhile he is already the equal of any painter of his own generation anywhere.

Gorky had elicited five columns in the *Nation*. He had been compared with Matta and found to possess 'painterly qualities such as Matta himself appears incapable of'.[21] In reply, Gorky generously offered Greenberg a drawing. Familiarity with his work might be the best education. Greenberg said, 'I chose rather a good one,' and soon 'sold it for a high price'.

Gorky was too subtle for an America longing for the rhetoric of heavy paint and symmetry. An American historian of Surrealism wrote:

The Americans who adhered openly to surrealism were subject to severe ostracism from those spokesmen for American cultural nationalism. Arshile Gorky especially suffered from this snobbish ostracism: many critics and friends brutally turned against him after his association with Breton.[22]

Sydney Janis, who would later represent his work, gauged the situation: 'He was the best, not the second best. But he was admired by other artists, even before he found himself, grudgingly. They felt a little resentful because of his dominating personality but nevertheless they held him in great esteem.'[23] Barnett Newman considered that Gorky 'had a more public position', and 'there was no question that art was his life. When you were with him you always felt that he was the artist with the capital A.' Newman had known Gorky since the 1930s, had seen him stride into an opening, declare, 'What beautiful walls!' and march out. He commented, 'When he walked into a room, you always knew that he was there. He'd sometimes get dressed up beautifully, the most marvellous clothes, but the stockings

[long socks] always had holes in them.' They met again when Gorky went to a party given by Matta and Patricia, soon after the publication of the *Life* article. Gorky demanded to know who he was. Newman countered, 'Well, you know who I am. I'm Barney Newman. Who are you?' Then he added, 'I was glad to see you as the first American artist to be featured in *Life* magazine.'

Gorky replied, 'Yes, but didn't I look sad? Didn't I look unhappy?'

'Just quiet,' Newman reassured him.

'Oh, to hell with all that!' Gorky snapped. 'The important thing is life! What interests me is my two daughters and not all this nonsense about the art world.'[24]

50

The Crumbling Earth
1948

Gorky's father had died on 27 December 1947, but Gorky kept it a secret from his wife since she had believed him dead long ago. His nephew stated, 'They sent telegrams to the families, to Gorky, California, Chicago and Watertown, to get the relatives to pay their share for the funeral.'[1] His lost father had been Gorky's most deeply buried secret. Despite Setrag's genuine efforts to help his family, his son had felt abandoned. Setrag's death left him with a morass of regrets and unfulfilled longing. 'My father's death, and everybody making big orations while a candle gutters out, a life. I didn't love my father very much,' he had said to Julien Levy in connection with his painting *The Orators*, 'but I know about Armenian funerals.' This was the first time Gorky publicly pointed to his origins as 'Armenian' while sticking to his official Georgian biography. Gorky recalled how the corpse was laid out in Armenia, covered with a cloth, his face exposed. On either side, mourners had lamented, retelling the deceased's life story.

That spring Gorky was depressed and unable to settle down to work. He had depleted his resources during the last six months of the previous year and needed a rest. The winter season had never been his best time for working. There was little stimulation around to help him replenish his resources. His inability to launch on a new phase of work made him feel dissatisfied and irritable. His wife believed that he no longer bothered to talk about his work or listen to others evaluating it, least of all herself.[2] She took this as a sign of his growth and maturity but it also could have been a symptom of his isolation. Stuck in the country, he no longer had an active dialogue with artists on a daily basis. Gorky's dramatic way of talking,

which had delighted her, now became melodramatic. His illness featured as the main topic. Maro mimicked him, 'Oh, stop it, stop it, my head is going around! Oh stop it, stop it, my stomach is all upside down!'

'Since Gorky's operation in 1946, there had been increasingly serious personal conflicts which threatened Gorky's happiness and even his sanity,' concluded Ethel Schwabacher.[3] Life in the Glass House was tense and explosive. 'I needed a little encouragement,' Agnes said later. Her friends in New York sympathised when she argued. 'I wasn't changing myself to be rebelling against Gorky – but to get him to treat me much more like a person, less a child. I didn't think I was sacrificing anything. I did feel I was growing into a woman. He denied my existence as a woman.'[4]

Muriel Levy saw more of Gorky that winter in Connecticut. She was adamant that 'he didn't seem ill', had come to terms with his physical problems, and appeared in society without much anxiety. Muriel had never considered Gorky a handsome man and 'could not understand how someone as desirable as Agnes could find him attractive', until one day Gorky and Agnes were sleeping in the 57th Street apartment overnight. She had to pass them to get to the only bathroom, and spied Gorky 'nude down to his waist, asleep' and exclaimed, 'Oh God, that was a beautiful male body!' She enjoyed his visits. 'He was so funny. And such a joker. He told wonderful stories, and lots of them had an Armenian kind of folk feel. I only saw the gentle, affectionate, serious side of Gorky. But obviously that was not all there was!'

During the 1948 winter, she witnessed a marked change:

> I began to see Mogooch, and their relationships, their lives, were deteriorating. Mogouch was taking the children to Virginia, to her parents' place, and Gorky was suffering. He'd get somebody to drop him over. It was quite a drive between Sherman and Bridgewater, Connecticut, across the river. He would get a lift sometimes, just to talk.[5]

He did not complain and mostly talked about his situation in general terms. As they walked in the countryside around the farmhouse, he talked of painting, which she had taken up. He gave her an exquisite 'bone painting' (as she called it) on a dark background. She liked him, but her heart also went out to the young wife. 'I'm sure that Gorky was punishing her for his illness. They had a miserable time. It was too bad because of the children.'

Agnes was in contact with her mother by letter, although she had hoped for more financial support from her parents in their times of difficulty. Any help had always come from their friends. Gorky considered his mother-in-law, Essie, spoiled. 'Women weren't supposed to think of themselves at all, only their children or husbands. She was American,' said Agnes, torn between them. In March, her beloved great-aunt died.

To the Schwabachers, she sketched an idealised picture of country life – great beauty with the children scrambling happily in water and earth, while she rushed about the place raking and sweeping up. Gorky meanwhile painted, rubbed and repainted indoors, then flew out to embrace the nearest person before returning to his work.[6] Ethel would later take issue with this glowing misrepresentation of Gorky's life which prevented her from offering help.

Spring brought a little spurt of energy and hope. He had completed the critical two years' convalescence, and cancer had not recurred. Ethel Schwabacher was close to Gorky and also on good terms with Dr Weiss. She made a point of writing that Gorky had not become impotent as a result of the operation. Dr Weiss suggested to Agnes that they establish their intimacy again but she said that she did not know how. Gorky was too inhibited; in any case, she had never enjoyed an erotic relationship with Gorky. 'I loved him but not physically.' He had complained that she was 'cold', that 'if he so much as touched an Armenian woman, she would go into ecstasies.' Although they read the Kinsey report with great interest and giggles, they were both hemmed in by their own inhibitions. They had not been able to break down their barriers during the seven years they had been together and now it was too late.

His mounting jealousy and lack of trust were poisoning their lives. Gorky felt betrayed by Jeanne Reynal who had recently started buying the work of Jackson Pollock and other painters. He took this as an act of disloyalty and could not help feeling abandoned by her, but Agnes continued to visit Reynal who was her closest friend. The nature of Gorky's illness made them a prey to gossip, he suspected particularly about his supposed impotence. In New York Muriel Levy heard 'confidences' exchanged about Agnes, which she considered 'filthy talk' not worth repeating. She surmised from Agnes's 'behaviour and little insignificant things she said that I felt that her analyst was encouraging her to go out and sleep with other men'. By then, Agnes pointed out, she had stopped seeing her analyst and she was too

overburdened with children and a sick husband to have affairs. The point was that even if they had no foundation, the rumours were rife and drove Gorky to become more defensive and suspicious.

Ethel Schwabacher realised that the idyllic country life described by Agnes was proving disastrous. On a visit in March she admired their home, with its 'spacious room all glass at one end' and 'a mobile by Calder, a mosaic by Jeanne Reynal, a painting Gorky had purchased from my 1947 exhibition, and a drawing by Matta. Tall art books, a large couch and a fireplace, in which pine logs for fire soon burning completed the setting.' However, the next morning when Gorky took her into his small studio, she noted, 'an old stove in the corner heated it and also dried the children's clothes'. Gorky let her know how lonely he was by inviting her to work with him. She refused, still not confident enough to paint alongside her teacher. Instead they took a walk in the snow with Natasha, Gorky remarking, 'She is a healthy girl. Look how solidly she plants her feet on the path.' Then he pointed to a curve of pine trees in the hollow of a slope, 'this green that found its way into the painting, and the red-brown of the fallen pine-needles'. Ethel felt a chill: 'the whiteness invaded him with a sense of emptiness and finality'. She identified the effects of his illness beyond the physical. 'As poet, he converted the experience of the operation into a quasi-mystical voyage into the unknown – a search for a phoenix-like rebirth.'[7]

When Peggy Osborne visited them, she was bowled over by Gorky's new-found sophistication as he mixed cocktails in place of 'some perfectly innocent drink, sickly sweet and strong', they had drunk in the past.[8] Next day Gorky confided in Peggy: 'I don't like the atmosphere and some of the jokes and the things they're doing with my wife. I'm very old-fashioned.' She heard him out. 'Gorky felt that the situation was too much for him. Too many blows had come very fast.' However, she sympathised with both of them:

He got out of Union Square into another world which he wasn't equipped to handle. They [the Surrealist artists] took sides. They felt that she was the important thing . . . A lot of people made a joke out of it, that Gorky acted like an old-fashioned hero in a melodrama. They were very sophisticated worldly people who were extremely modern. They felt it was very hard for Mogooch, which it was, but I don't think it was as hard for Mogooch as

for Gorky. They both suffered and tried to hang onto something. He suffered the most because his pride got hurt.'[9]

Agnes said: 'He was jealous of anybody, if he saw them looking at me.' Gorky's attitudes were proving very different from other Americans', as she later pointed out. 'Gorky didn't live the sort of life that Elaine and De Kooning did. He didn't mingle with them.' The men's friendship had cooled after Gorky's marriage because 'Bill was a westerner, a Dutchman' and 'considered Gorky like someone from another planet'. He and Elaine lived 'a perfectly normal, New York, Bohemian, easygoing life'. He wasn't 'trying to make Elaine into a cow girl or peasant. They were much more sociable. Elaine was enormously promiscuous. So was Bill. They got on with their lives.'

Their dreams of going to France had also dissipated. No invitation had come from Breton, who was facing poverty, opposition and political ostracism in Paris.

A photograph shows Agnes at a party she had gone to with Gorky at Jeanne Reynal's house chatting animatedly with David Hare, an outré necklace around her neck, long dark hair falling down her shoulders. She looks radiant, a young woman in full bloom: 'I felt why should I have to be bowed down?' Jeanne pointed out her red dress to Muriel: 'Look, Mogooch is in her Madame Bovary dress.' She said, 'Occasionally I bubbled, laughing and flirting with Hare. He said, "I didn't know you could be like this."' Wilfredo Lam's wife, Helena, reflected, 'She was very tall and very beautiful, thin but resilient. You knew she would survive anything.'[10]

Gorky felt he was being made a laughing stock and tried to curb her. His friend Helen Sandow said, 'The last thing Gorky could have put up with was infidelity. Betrayal. Why, he couldn't stand the thought of it with another man's wife.' Agnes stuck to her views or social conditioning. Even before marriage she had made it clear to him that her body was her own. She was to remain true to herself throughout her life. The encouragement and playfulness she had come to expect from him had turned into self-absorption, jealousy and brooding. The flow of communication between them had dried up. Agnes remembered that he had taken interest in her analysis but, 'He didn't relate it to his being connected to me. He was interested in Jung. The interpretation he was interested in was whether he

was bringing up his unconscious in terms of his painting. The image of himself was in his own painting.'

During the long months of separation, Gorky had dug deep into his subconscious; the way back up was difficult. After his father's death, his mother was gaining a stronger hold over him. Agnes said forty years later with hindsight, 'If only I had been a little older. If I had understood how desperately he needed help.'

When Gorky stopped laughing with her she needed someone else to share her laughter. One of the people who made Agnes laugh now was Matta, still married to Patricia, pretty, vivacious and able to finance him and his magazine. Muriel Levy was surprised by Matta's success with women. 'I could understand Gorky's appeal, but Matta? I never saw it at all, at all, at all. He was bright and glib. He loved talking. Facile, I mean. Apparently very amusing and very attractive to women.' Agnes's mother told her he looked like a waiter. He was short, with shiny black hair, a boyish face, bright, wicked eyes and an excitable nature. 'Anything that involved Matta at that point in his life was very suspect of sensationalism, private sensationalism . . .' recalled Muriel, who was not a prude; 'Matta liked hard liquor and when he was married to the second one he liked martinis.'

But Matta showed another face to Gorky. He visited to discuss art and talk about his plans. With Breton no longer in New York, he was not overshadowed. But lately he was being unfavourably compared to Gorky. Since 1940, Gorky's work had developed and expanded beyond the confines of the New York scene. After 1945 he went beyond Abstract Expressionism and Surrealism. 'Gorky looked on Matta as a young whippersnapper who had taken up painting rather late,' Agnes said. 'Matta thought immensely highly of him.'

Whereas in the early 1940s people confused drawings by Matta and Gorky, by the mid- and late 1940s Gorky was able to generalise and universalise, while Matta became more particular, both in style and content. He cannot have failed to notice that Gorky had outstripped him, even with the techniques he himself had suggested, by investing them with a deeper seriousness and wider scope. Despite Matta's greater commercial and social success, he may have sensed that he lacked something of Gorky's depth. But he was far more ambitious for worldly success. He was also aware that his

friend's wife was unhappy. 'He always fancied me,' Agnes said. 'Oh yes. He made it clear in a very nice way. He didn't try to seduce me.' Muriel pointed out that no matter whether there was any substance to the rumours there was enough talk to upset Gorky. 'It was very public. Mogooch was very belligerent about her rights.'

Mrs Magruder arrived to spend Agnes's birthday with them on 1 June, alarmed by their unhappiness. She tried to reason with Gorky. 'You know you do keep her on a very tight rein for an American girl. She's used to having a certain freedom that I have.'

Mrs Magruder tried to give the couple a break by taking the children away.[11] This terrified Gorky, who told Muriel Levy that his 'home was being broken up'. His life seemed to fragment after that. 'I can hardly believe it when I think how it began,' Agnes said in retrospect. 'It was very difficult. It gradually became a terrible nightmare. He knew he had cancer.'

While they were on their own that week in June, Matta visited Gorky in Sherman. He talked enthusiastically about his magazine and animated Gorky. 'We both enjoyed him,' Agnes commented. Next Julien visited, drank heavily and talked crudely about women: 'how a woman had to be like a stable that you backed your cart into after the big outside world. It seemed such a dim vision of womanhood that I backed my cart upstairs and bawled in my pillow,' she said. Next morning, on 17 June, she told Gorky she was leaving and would be back in two days. She did not come back that night, or the next day. She was gone all weekend.

When she returned home, Gorky did not question her straight away. Perhaps he was afraid to hear the truth. To Agnes's surprise, her weekend was no secret: 'Julien knew. I don't know how, but he knew.'[12]

Naively, she did not realise that her lover might boast of his success.[13] He was an irrepressible gossip, and had never believed in sexual secrets. It was she who had telephoned him, he would later point out to his men friends. Muriel knew about it too, and was upset for Gorky: 'What with Matta's pornographic drawings and his showing off, it was awful.' The situation could not be contained. As a fully fledged Surrealist, Matta was contemptuous of bourgeois marriage. Following one's impulse was exercising the right to freedom – transparent living had been their ideal.

Agnes shocked Muriel with a remark: 'I don't believe in personal happiness.'

Gorky had been told that his wife and close friend were having an affair. After that weekend, he had to face his wife whom he now suspected of infidelity. With the children away at their grandmother's there was no one to distract them. He feared the break-up of his family and had no resources to cope with it, nor the resilience to deal with the blow to his confidence.

51

Darling Gorky
1948

One day in June 1948, when Gorky got up, he did not hear voices. Only the dog, Zango, was at his side. The children's beds were empty. Their clothes and toys were strewn about. He went back into the bedroom at the corner of the house, overlooking fields and trees. Beside the bed was a table with books.

There was the large exercise book he had seen before – the diary Agnes still kept at her analyst's bidding. It must contain a clue. He opened it, and phrases leaped up at him: her dreams, wishes, their failing communication, the rupture between them.

He could not bear life without his family. For the last two years he had struggled against illness and the grotesque changes to his body. Now he was just beginning to come out of that nightmare. He had felt his creative power return and had given proof of it in his work that summer. Perhaps for their relationship it had come too late. He was disconsolate.

Julien Levy arrived to pick him up. At the Levys' house, they walked around the 'green New England pasture, punctuated with meager stones and dark little hemlocks'. Levy sensed that Gorky could relax among the animals and hay. They looked through the cow barns and sniffed their composted warmth, the smell of his childhood. Gorky took a deep breath and Julien recalled him saying once, 'This is something you must always have nearby to smell, if you live in the country, this and a fireplace.'

Then Gorky said, 'I hope you are happy, Julien. I am not. Mogooch is leaving me.'[1] Gorky told his friend that he had read his wife's diary and asked him not to mention it to her.

They drove to Ridgeway for lunch with Allan Roos, a Columbia University Freudian analyst. He and Muriel stood in the window, watching Gorky lope up the driveway through the rain, his knitted sailor hat pulled down to his eyes, his arms hanging down at his sides provoking the remark from Roos that he walked like a schizoid.[2]

Nothing relieved Gorky's deep gloom during lunch. He was surrounded by distinguished psychoanalysts, including Sandor Ferenci, talking about 'the role of the unconscious in artistic creation', but Gorky did not join in. Allan commented to Julien that his friend was depressed. Julien replied that Gorky's wife had been in Jungian analysis, but 'the very idea throws him into a rage'.

Allan had just given Levy a boxer puppy which they took away as they drove back to the Levys'. They picked up a steak for dinner, hoping Gorky would stay the night, but he was 'very fidgety' and asked to be taken home in case his wife called from Virginia. The summer storm coming off the hills got worse. The electricity went off, cutting the telephone lines. Gorky became 'frantic' and insisted that 'even if the electricity and telephone were off there too, he had grills and pots to cook over a fire in his enormous fireplace'. In the early evening, Julien, Gorky, and Muriel, clutching the puppy, piled into Julien's old station wagon to take Gorky home. Muriel was nervous because of the rain and Julien's erratic driving. He always charged down the middle of the road, and his passengers shouted to warn him of an oncoming car or traffic light.

> Julien was drunk. He had a bottle of wine in the car to take to Gorky's for dinner. It was 5.30 p.m. I was in the back seat with the new puppy. Gorky was in front next to Julien, who was talking and driving. Oh God, Julien was the world's worst driver and he'd had a lot to drink that day.

Muriel's voice broke as she recalled that day forty-five years before. She paused, struggled with tears, then huddled over in her chair as though protecting the puppy in her lap.

> It was now pelting with rain. We couldn't see a thing. We went around this curve on a steep hill and there was a stake on the right-hand side. Chicken Hill. It was notorious. Downhill curve. Treacherous at best. Julien hit the

stake. The car turned over on Gorky's side. Turned upside down, once or twice. The car was smashed up. Julien's dog was yelping.

People rushed out of their houses to drag the victims out of the upper door. A state trooper took a report of the accident. They were driven to the hospital and all three were X-rayed. Julien's collarbone was broken and they bandaged him. All he cared about was the puppy. Muriel had mild concussion. Gorky refused to wait for his X-rays to be read and insisted on leaving. Someone agreed to drive him home. Julien yelled, 'If Mogooch phones, tell her you need her!'

'Gorky wouldn't allow them to do anything to him,' Muriel confirmed. He insisted on going home for his phone call. That night, 26 June 1948, Gorky remained at home, but he did not get through to his wife, perhaps because the lines had been cut by the storm.

In his book, Julien Levy gives an account of the accident which is vague and tries to be poetic. He feels Gorky as 'a black presence who seemed to be exuding darkness over all of us like a tangible substance', which might have been the effect of too much alcohol. 'I myself was not driving as fast as the rain,' he claims. 'I slowly, gently, and with great caution pressed the brakes. But it was too late.' Looking at it, Muriel snapped, 'That book is full of lies!'

The very next morning, Muriel was startled to see Gorky breeze in through the back door. With a wry expression in his dark eyes, he said, 'We-ll, Muri-el ... We could all be angels now!'

Kay Sage had driven him over. No one realised that he was in pain. They drank brandy – a toast to angels! The car was out of commission. Julien fussed over his puppy. Over lunch, Gorky was unusually silent. He called the farm in Virginia, but didn't get through. Then the telephone rang. It was not his wife, but the New Milford Hospital for Mr Arshile Gorky. On re-examination of his X-rays, they had found that he had fractured bones and must come into hospital immediately. Kay Sage insisted on driving the reluctant Gorky.

As soon as he walked into the hospital, a doctor ordered him to lie down. He had a broken clavicle and fractured vertebrae. Gorky was strapped on a narrow iron bed and attached to a huge apparatus. Pulleys and weights bore down on him. He protested and tried to get up, but the doctors forced him to lie down and stay quiet. He was held to the bed while

they fitted a leather chin strap around his neck, then tied it to a winch, so that he could not move his head from side to side. They pushed his body towards the top of the bed so that his head hung in mid air, with a heavy weight to pull it away from his shoulders. Totally immobilised and stretched out, he felt trapped, and shouted to be released. He was given a painkiller and told he must stay quiet. Julien was aghast. 'It did indeed seem a torture. And he only submitted to it almost by force.'

Kay Sage went to telephone Agnes and tell her that Gorky needed her.[3] She flew back from Washington to New York. It was Matta who drove her to the hospital.

> I came rushing up. Matta did drive me to the hospital. How would I have got up there otherwise from the airport? Matta picked me up and drove me to New Milford, and waited there, stayed in a café for four hours, poor thing. Took me back home and left me there.[4]

Gorky was in shock and terrified of being shackled. He could find no position that did not cause him pain. He begged to be taken out of traction, weeping like a child. He was on morphine, which may have relieved the pain but it made him delirious. As he looked up at the white ceiling, Gorky's active imagination produced ever more terrifying images. He had drawn and painted the spectres of his fears in the past, but these were beyond his control. Friends who visited him were horrified. Peter Blume described him:

> Lying on his back, with weights hanging down from all sides so as to stretch his neck and keep his vertebrae separated for proper healing. He looked like Christ in crucifixion. That head of his pulled way back in traction. And he had sort of put his arms out. And he was very touched when we came to see him. He was feeling so badly. But I've never seen anything that reminded me more of a crucifixion. I have never known anybody just like Gorky.[5]

He yelled at the interns to free him from the 'rack of torture'. He told them he was 'a famous genius' and 'throngs' would come when they heard about his torture.[6]

Agnes 'got him off the morphine'. She sat with him and read aloud, as she had when they first met. He was obsessed by the fear that she would leave him again. She said that he would not let the nurses deal with his

stoma because he was so used to doing it himself. The nurses tried to make him lie quietly and relax. He replied, 'How could I possibly be relaxed when I've spent my whole life peeling my outer skin off me so that I would feel every passing breeze?'

Peggy Osborne, who was suffering from a back injury herself, took a painful drive from New York to bring him some painkillers. She was unprepared for the sight. 'It was dreadful to see him like that. He was harnessed and immobile. He was miserable, miserable. In a lot of pain. Terribly distressing thing to see. I've never forgotten. I came away thinking, Gorky was crucified.'[7]

The first thing Agnes did on her return home was to drive to the scene of the accident to investigate the terrain for herself. She wrote a detailed report in a letter to Ethel Schwabacher on 29 June, three days after the crash. First she reassured her that Gorky was improving, although he was in horrific pain and distress at being trapped in the harnesses. She insisted that he had been extremely well when the accident took place. She then went on to describe the scene of the accident. She exclaimed about his torments, the 24 pound weights which dragged his head back while his face had to be wrapped in thick layers of cloth and bandage in the heat all through the night. The apparitions which had haunted him had abated and he was beginning to move his right arm which consoled him, for he feared that his drawing hand had been paralysed. He seemed to be more at ease when she sat by him while there was nothing she could do to help but hope for his recovery.

In this letter breaking the news of the accident, she also wrote that she was trying to sell the house she had inherited from Marion Hosmer in Maine, for a down payment on the Glass House. Her aunt had left her $75,000 in trust, but the executors refused to allow her to touch the capital. She now wanted to use the accident insurance money to build a detached studio to cheer Gorky up during the next three months while he would have to keep wearing a neck brace.

Like all traction patients, he was desperate to escape and didn't want to stay in hospital until his neck had healed. He succeeded in getting himself released early whereupon he was fitted with a huge neck brace to support his head when standing. The collar was made of iron and leather. It was

heavily padded with wadding, and lined with lint. That July was very hot, and sweat poured down his neck inside the collar. The cloth chafed his sore skin, which rubbed and blistered. Overheated and uncomfortable, he took it off, but his weakened and atrophied muscles could not support the weight of his head.

Their home was not ideal for summer weather. The sun blazed through the great glass wall in the open-plan living room. Their bedroom under the rafters was hot and they moved downstairs to the first-floor bedroom. Gorky had severe headaches and pain in the neck and shoulders which prevented him sleeping. The immobility of his right arm made him fearful that he might not be able to draw and paint again.

His dislocated body felt and even looked like the semi-mechanical apparitions he had drawn repeatedly in Virginia, especially the central figure of his great painting *Agony*. Each body part was jointed but barely standing upright, strained in tension. The head appeared detachable. Gorky had peopled his pictures with the strange phantasms of his imagination and they returned to torment and haunt his life. He had no more strength to fight back. In his mid-forties, he was already trapped in a broken, wasting body.

Agnes spent a week alone with him. She was upset when he said, 'At first I missed you and the children so much, then I thought I would get used to your not being here any more.' She brought back the girls, and he brightened up at seeing them. Friends visited him, trying to conceal how appalled they were at seeing him imprisoned in the clumsy halter which encased his neck and chin, reaching down over his shoulders to the top of his chest. But Julien Levy remarked, 'He seemed happy, surrounded by his children, cared for by his wife, and preparing canvases to paint again. He looked like some barbaric warrior in the strange armour of his leather and steel neck brace, and he showed me a model of an arbalest (bow) he was carving.'

Levy could not hide his disapproval of Agnes for leaving Gorky. Levy had lost his mother when she had died in a car crash, in the midst of a love affair which had split the family. He could not forgive that betrayal, and saw a parallel in Gorky's situation. Agnes in turn blamed him for the accident. She busied herself with raising a mortgage to buy the Glass House and Levy encouraged her to make an insurance claim for the accident and for Gorky's loss of earnings.

Gorky continued to receive people. His first friend in Rhode Island,

Mischa Reznikoff, had been in Brazil for a couple of years. On his return, he and Gorky had resumed their friendship. Gorky had offered his wife Genevieve the land around the house for a fashion shoot. She brought models from *Harper's Bazaar*, and observed, 'He seemed very happy that day. His two girls were there. He was baby-sitting. Although I don't know how long he could tolerate them.'[8]

Gorky said, 'You know Genevieve, it's a wonderful thing to be able to have a studio where I don't have to worry that I have to pay the rent. I can put my things here and be sure that they will be here for ever.'

Jeanne Reynal recalled that Gorky came to her house in New York after a visit to Dr Weiss to check his colostomy and seemed so distressed that she rang Wilfredo and Helena Lam for company to drive Gorky up to Sherman.[9] From the window in Pierre Matisse's flat on 72nd Street, where they were staying, Helena looked down:

> Gorky stood by the car with his arm completely stiff. It hung down, he couldn't move it. With the other he held a doll of wool – maybe from Armenia – kind of primitive doll. Jeanne and Urban were in the car but he was standing outside waiting for us. He had a big frame, but he was thin.[10]

Gorky and Lam talked about painting on the way to Connecticut. He seemed 'warm and kind, but very subdued and depressed. No, both angry and depressed.' Just before reaching home, Gorky asked Jeanne to stop the car at a little store in Sherman to buy some sweets and chocolate to treat his children. Helena also got out to stretch her legs and buy chocolates. When Gorky offered to pay for them, she objected. He fixed her with a look. 'Helena, nothing matters any more.'

She experienced 'a terrible feeling when he said that'.

They continued to Sherman where they were greeted by 'his wife, wearing a long white skirt and blouse. Long hair. He was very much in love with her. There was no question.' They drank tea and whiskey. Helena had noticed in the past that Agnes had behaved with Gorky in 'a matter-of-fact, but kindly and lovable way'. Then, she said, Agnes 'put on a Yiddish song, a record, or maybe she just sang it. It was a hit at the time.

> Bei mir bist du shayn,
> Bei mir hast du chain,

Bei mir bist du der beste
In der Welt.[11]

"You are handsome, you are precious, for me you are the best in the world." And she started dancing all by herself.' Gorky in his neck brace, his face haggard after a long car journey, sat with Jeanne, Urban and Wilfredo around a table. Agnes, a luminous figure in white, was momentarily distracting herself with a song. Helena sympathised, 'She was in another world ... She wanted to go on being happy.' Gorky lost his temper. On the drive back Helena remarked to Jeanne, 'It must be difficult for that young girl because she wants to have fun and her husband won't let her.' Helena pondered, 'She felt abused. Whatever she had to do went beyond her capacity for suffering. She needed an outlet.'

Again, Gorky was completely dependent; like a child he feared being abandoned. Racked by terrible pain and the fear of not regaining movement in his hand, he was unable to cope. The only thing that calmed him was drawing, and he tried drawing with his left hand. One day he was driven over to the Levys and went for a walk with Muriel in the hills. She had heard from Agnes that Gorky had hung ropes in various outhouses. 'I would never kill myself because I love my little girls too much,' Gorky reassured her.

As a friend, she felt inadequate to deal with the crisis because she 'was so disturbed inside but suspected that Gorky needed help'. She painted the picture of a circle of friends none of whom was coherent enough to help him. In New York she asked her own analyst about Gorky. He suggested calling Allan Roos, who already knew him. At first Roos refused to intervene unless Gorky asked him, but Muriel finally extracted his promise to talk to Gorky the coming weekend.

One night when the children were in bed Gorky had a little too much to drink and because of his delicate stomach became drunk very quickly. Agnes said that he 'smashed up Matta's picture'; presumably with his left hand since the right was injured.[12] When she tried to stop him from destroying other gifts, he pushed her roughly away on the tiny landing, and she tripped and stumbled on the stairs, hurting herself.

The children woke up in the commotion and she went outside, hoping

that Gorky would calm down and comfort them. She saw him through the window come downstairs with the girls, go to the telephone and make a call. Agnes returned, and they took the children up together.

'Darling, you know I'm an artist and artists sometimes act crazy,' he said to his elder daughter. 'You understand that, don't you?'

The five-year-old replied, 'No!'

They settled the children and tucked them up to sleep.

Gorky and Agnes went downstairs again, took off his collar and stretched out on cushions on the floor in the moonlight where they often lay in the cool of the evening. Gorky still suffered excruciating headaches from his neck injuries and permanent insomnia; he had not yet recovered from the trauma of shock. It was less than three weeks since the accident. They talked calmly and quietly in the lull after the outburst. In the intimacy of that moment Agnes 'told him about everything after all those years of bottling up'. She felt very close to him as though all the old barriers had come down between them and he seemed to understand her in a new way. Then he asked his wife the question that had stuck in his throat for a month, that he had agonised over as he lay in hospital.

Had she gone away with Matta that weekend in June? He had given her a month to plan her reply. She told him without hesitaton that she had gone up the Hudson with Matta. Until that moment, even if he had heard rumours, there had still been a faint hope that they were wrong. It was probably the most ill-timed conversation of their life. She told Gorky she still loved him and was not planning to leave. But he had thought of Matta as his friend, a fellow artist who visited their house freely, a younger brother. Angry that Matta had betrayed him with his wife, Gorky said he would give her freedom.

They argued and talked lying on the floor side by side. Gorky swung between seeming to understand her and sudden 'lurches' of bewilderment and rage. It was not the best way for him to convalesce. She was 'anxious to bring him around'. He managed to control himself and appear composed. They went on talking all night long. At last she believed that he was reassured and in the early hours of the morning they drifted off to sleep.

52

Agony

Gorky went to New York the next morning with Agnes and the children. They both had appointments to keep with doctors. They were at peace, she thought, and had established 'a glimmer of hope'. They kissed goodbye, agreeing to meet at Jeanne Reynal's. She dropped him off for his colostomy check-up with Dr Weiss while she went to have a mole removed. After lunch they would all drive home together. She did not know that Gorky had secretly arranged to meet Matta in the park; he did not know that she had written her lover a letter to warn him not to see her husband.

As Gorky walked in the park, he carried an Irish shillelagh stick.[1] When he saw Matta, he chased him, brandishing his stick and threatening to kill him. In his healthy days he could have done it with his bare hands. He charged Matta with disturbing his family and breaking up his home.[2] But the home was sacred only to Gorky. Matta himelf considered fatherhood 'an insult to his testicles', and had abandoned Pajarito after she had had their children.[3]

Gorky was angry, but also sickened. Matta managed to defuse Gorky's fury with his quick tongue: captured Gorky's attention, made contact, distracted him. They ended up sitting on a bench talking about Stalin, which Matta later turned into a joke. Then Gorky said he was going to make him a gift. Matta became suspicious, but they parted without further incident.

Agnes was afraid her warning letter to Matta would arrive too late so she telephoned, telling him of Gorky's anger the previous night. She was astonished to hear that they had already met and Gorky had threatened to

kill him. Agnes should go to see Dr Weiss straight away, Matta insisted. Agnes explained:

> Dr Weiss had just seen Gorky. He listened to my confession that I had spent two days with Matta. He said that I could not expect Gorky in his condition of mind & body to forgive me or understand me and that for the children's sake I could not risk going back alone with them & G. to the house in Conn. He would tell my parents. He called the airline & booked my tickets. He called Jeanne to send the girls in a taxi to join me to go to the airport. He told Jeanne he would send her strong pills to calm Gorky. That she must keep him there if she could until he could get help of some kind. I said if I leave him now with the children Gorky will kill himself. He asked me if I wanted to have him put in a straightjacket? I was horrified. I went to take the children away from his anger with me.[4]

Gorky returned to Jeanne Reynal's. Agnes was not there. His little girls sat in the kitchen having lunch.[5] The taxi ordered by Weiss arrived to take them to the airport. It was the last time Gorky would see his daughters.

The question remains until today as to whether this doctor overstepped his brief. Weiss's attitude is understandable from what Agnes wrote to Ethel Schwabacher two years later, that when she had explained to the doctor Gorky's rage over her adultery, he concluded that they did not love one another. She protested to Ethel that, although their physical relations throughout most of the marriage had been so arid she could no longer feel attraction for Gorky, nonetheless there remained a deep attachment.[6] Some friends, Helen Sandow in particular, felt that Dr Weiss, being a physician not a psychiatrist, should not have interfered in their lives.[7]

Gorky called several friends, among them Peggy Osborne. He told her that Agnes had left him and asked her to come to Connecticut. Gorky was incapacitated by his collar and semi-paralysed right hand, which made it difficult for him to feed and look after himself. Above all he needed a friend for moral support and knew he could not cope alone. But Peggy was still suffering from back pains. He then talked to Mrs Metzger, also a friend of Dr Weiss. She invited him to come and stay with her while Weiss found him a psychiatrist, but Gorky was intent on going home. He reassured her he would return to New York another day.[8]

Next he tried Ethel Schwabacher. 'Ethel, I am very sad. My home is broken up.'

She was 'taken completely by surprise'. She was the last to hear of their break-up and 'had no idea how serious it was'. Agnes had given no intimation of any difficulties or marital problems.[9]

Jeanne Reynal tried to care for him, gave him a sedative, and persuaded him to lie down. On no account, Dr Weiss had warned, should he be given more than one of those six pills, or have them in his possession. She had convinced herself that Gorky was 'schizoid'.[10] She said to a friend, 'Oh Gorky knew he was mad.'[11] She believed that Agnes had been abused and was right to leave. It was not surprising that Gorky could find no rest in her house. In his eyes she had betrayed him, encouraged his wife's adultery, colluded to take his family away, and he could no longer trust her. No sedative could knock him out. He got up to wander on his own through the city.

The account of Gorky's last two days are confused, 'various and appalling'.[12] However, late at night, he wandered from the Village and found himself at 7th Avenue East, near the old Hotel Brevoort, where Gaston de Havenon lived. Gorky rang his bell. He went on ringing, certain that his friend would wake up, even at this hour. But there was no answer. He walked all the way back down to the Village, to McDougall Alley where Noguchi lived. They had often sat up all night, talking and sketching. He had not seen his friend for over a year, maybe longer. He stood before the door which opened on Noguchi's little courtyard, ringing the bell, calling his name from the street. 'Isaamu. Issaammu! Isaamuu!'

Noguchi later told de Havenon, 'I heard someone calling. I thought I was dreaming but then I realised it was a real voice. Isaamu, just like our friend.'

He got out of bed and went down the stairs to his courtyard. It was still dark, but he made out a grotesque silhouette on his doorstep. It was Gorky, with a collar around his neck, and in each hand he held a little cloth doll. 'Old, dirty rag dolls,' Noguchi said. 'And tears were streaming down his face.'

Gorky held out the little dolls to him and said, 'This is all I have. This is all I have left!'

Noguchi was stunned. He took his friend up to the studio. In familiar surroundings, Gorky looked at Noguchi who had been close to him for years and had sat with him through his black moods in the past. Noguch

was alarmed by his uncomprehending, fearful look. Gorky unburdened himself. His old friends had turned away from him. He had made a little gift, a paper bird for Gaston, but he wouldn't open the door. People who had pretended to be his friends were not his friends; they made fun of him; he had been betrayed; he felt he had been emasculated morally. Noguchi concluded:

> The society people had taken him up, used him and then abandoned him. He believed people were laughing at him because of his operation and his injury, that they had no further use for him, and did not look after him properly when he was ill . . . they were only interested in him as a successful hero and not as a tragic hero.[13]

They talked for a long time. Gorky asked Noguchi to drive him up to Sherman, but Noguchi told Gorky to wait until morning. He said, 'I was frightened to take him alone, frankly, because he was so upset.'

In the morning Gorky again asked Noguchi to take him home, but first he wanted to call on his doctor. Noguchi waited in his car. When Gorky returned from Dr Weiss, he said to Noguchi, 'They want to do a lobotomy on me!'[14]

In 1948, lobotomy was regarded as 'a miracle operation' on highly disturbed patients to cause radical changes in the personality. It has since been discontinued and replaced by other treatments. Noguchi could not understand why, if Weiss had thought Gorky disturbed enough to need a lobotomy, had he not referred him to a psychiatric specialist earlier. Gorky was panic-stricken. He had been convinced that he was within a hair's breadth of being committed to an asylum. Noguchi took a grave view of this. 'If someone keeps telling you that you are mad, you end up believing it.'[15]

He understood Gorky's anguish, but could not cope with it on his own. Not wanting to drive two hours to Connecticut alone with Gorky, he picked up Wilfredo Lam to accompany them. Noguchi said:

> The three of us drove up to the country. He got out. Then it was afternoon, latish when we got out there. He was almost . . . he was happy to be back there, so to speak. He was walking along in this orchard. I felt relief too somehow when we got out.

Wilfredo Lam wrote:

> Gorky had had his car accident and I found it strange that he wanted to be
> alone in New Milford. When we arrived I took several photos of Gorky
> seated on the lawn outside his studio with his strange plaster neck brace to
> prevent him from moving his head.

Years later, among Lam's possessions, a snapshot was found of Gorky
sitting in the shade of a tree. The sun casts dappled shade over him in the
photo as he leans on a rough wooden post. His chin rests on a pad on the
iron halter which encases his neck. He looks exhausted, and his eyes are
closed. He supports his right arm on one knee and props his head against
his large hand. Shirtless, his strong chest and powerful build contrast with
his weak arm. He wears trousers with braces, and cheap, unlaced shoes. It is
the picture of a powerful man, shattered.

The three men walked around the fields near the house. At home, in the
company of Lam and Noguchi, Gorky looked less tense. Noguchi
suggested, 'Why don't you give Mogooch a call?'

Gorky's despondency returned. 'She's mad about Matta!'

Noguchi persisted, for he too had lost a woman because of Matta. But
Gorky said, 'She's in love with him. It's no good.'

Out of habit, the three artists went into the studio to look at canvases,
where Noguchi noticed 'stacks of unfinished paintings'. Gorky had often
worked while his friend sat in his studio, keeping him company. Gorky,
Noguchi and Lam had a common interest in biological forms, cell-like
structures and the streamlined shapes of bones, which had also become the
basis of Noguchi's latest work. All three exiled artists had integrated their
roots into their work, eliciting Noguchi's comment:

> when he later did those nature drawings and paintings, he was always seeing
> in them other things. That is to say, nature did not look the same to him as it
> did to somebody else. I mean it's not just botany, not just horticulture. There
> were all kinds of mysterious things going on which, in his own beautiful
> way, he expressed in his art. Gorky always was sort of elaborating and
> weaving a lace-work of imagery into whatever he saw, which is very
> beautiful. And that was where his most characteristic development came
> from.[16]

Gorky's work had a visionary power which left them convinced that he was on a solitary path.

Gorky gradually became absorbed in moving the canvases, talking, listening to the comments of his fellow artists. Then his artist neighbour Peter Blume breezed in. It was the kind of exchange Gorky had been missing. He calmed down, reverted to talking as an artist. Noguchi 'didn't feel that I was leaving him all alone, with Peter there', and they said good-bye.

Gorky confided in Blume his great fear that he would never be able to paint again, although doctors reassured him he would. He was practising drawing with his left hand, and was intrigued, for the results were 'less skilful' than his right, and, he believed, 'more truthful'.

After his friends had left, Gorky had to unstrap and remove the heavy leather halter with his left hand in order to rest. He then had to remove the bandage on his stoma, clean himself and wrap it round his stomach again. That night, Dr Weiss's threat of lobotomy must have preyed on Gorky. His mind must have raced, wondering whether Weiss had told Agnes. Gorky had seen Sirun's father trapped, isolated from his family, in the Watertown asylum surrounded by tragic and incoherent mental patients. In his vulnerable state of mind, perhaps he feared that same fate lay in store for him. His family had fled from him. He was alone and felt abandoned and betrayed by everyone, especially the woman he loved.[17]

Next morning, David Hare rang to invite him over for lunch. They talked about painting and had a long conversation about Cubism. David knew he was upset but said Gorky conversed very coherently with him.[18] Gorky knew that he must get a housekeeper and a nurse. Levy had telephoned Gorky's sister-in-law Esther, 'I think we've got to do something.' She drove up from New York to visit:

He had this huge collar and arm in a sling and she'd left. I went up and he was emotional, of course. He was weeping. There was no one to care for him. He thought he smelled. There was this man in agony and I didn't know what to do for him. This human being who seemed to be . . . Not because he was a famous painter. I had no imagination to know what to do.[19]

Gorky had given up trying to persuade his wife to come back, but he told Esther that 'he wanted the children'. She found him 'very coherent'.

Esther left that evening, and called Virginia 'to speak to Aggie'. Her mother answered and she told her that she had seen Gorky and he was terribly upset. Agnes must get hold of him. Mrs Magruder told Esther to keep her nose out of what wasn't her business.[20]

Agnes had meanwhile written a letter to Ethel Schwabacher who received it on 22 July 1948.[21] She informed them of the break-up and apologised for upsetting them. She admitted that the separation had been a long time coming and now she had finally given in to the doctor's urging to leave with the children. She had foreseen that he would move back to the studio and given notice to the tenant. She made the startling charge not only that Gorky was of unsound mind, but had been so for a long time. She did not give his cancer or accident as a reason but considered that he was overburdened by having a family. The letter was a strange mixture of emotion and control in which she appeared to blame herself for taking on too much, for not loving him enough and needing to care for the children. But her calm and reasoned explanations made Gorky's distress appear groundless. She made no mention of Matta, or of her confession, and the jealousy she might have unleashed. She left no doubt that she had taken an irrevocable decision and the marriage was ended.[22]

53

Goodbye My Loveds

Gorky wandered around the empty house at night. 'Even among friends, I feel alone,' he had written to his sister.[1] But he could not speak to her any more. Yesterday in New York, when Jeanne Reynal had helped him to bed in her house, he had struggled, unable to take off his halter with his left hand. She had leant forward to help him and he snarled, 'Only a wife should do this!'[2]

Gorky heard a car drive up to the house. Suddenly his old friend Saul Schary, with whom he had painted the waterfall, appeared on his doorstep. A couple of weeks ago he had bumped into Agnes in Milford while he was shopping. She had said, 'Gorky's in hospital. Why don't you go and see him?'

Schary was surprised. He had not seen them though they lived very close because he 'didn't approve of Agnes' and 'didn't like what was going on'. Schary was kindly and unpretentious, not one of the fashionable set. Why was he in hospital? Schary had asked.

'He broke his neck,' she replied.

Schary waited. That evening, when his own wife was in New York, he thought of visiting Gorky and drove over after dinner. He was surprised to find him all alone. It had been a few years since they had met.

'He was upset, I could see that. His eyes – Gorky had dark eyes – there was a curious kind of blue glaze over them and his face was kind of splotched, red and white,' Schary observed. They exchanged news, but Gorky worried Schary. 'He was very agitated. I didn't know all of this trouble had occurred. He had this bad operation, the cancer of the

471

rectum. He had difficulties with his wife . . . On top of that he got this broken neck.'

Gorky brought out a book on Leonardo, a birthday gift from Agnes. They leafed through the beautiful reproductions and discussed the paintings. Schary sensed something in his friend. 'As we were talking, he must have felt a little guilty toward me.'

'You know, Schary, I made a terrible mistake getting in with these Surrealist people,' Gorky said. 'The husbands sleep with each other's wives. The wives sleep with each other. And the husbands sleep with each other. They're terrible people. I never should have let Agnes get mixed up with them.'

Schary sympathised. Gorky found it easy to talk with him and be honest. Schary had been at his first wedding party and had pleaded with Gorky to marry 'a nice Armenian girl'. He felt sure that Gorky had never felt at ease in the New World. 'Gorky was an exile in this country and never really understood this country very well. He never understood the people, what an American was.'[3]

Gorky had shown Schary the other side of himself, the black angel, often telling Schary that he was a 'black one', that he was born unlucky. Schary recalled seeing Gorky sing in 'his minor off-key' way as he accompanied himself in a wild dance, silhouetted against the night sky on his terrace in Connecticut.

Schary sat talking until about eleven. As soon as he left, Gorky became frantic. He looked around the house, which was so different from his studio in New York. There was an empty space where the picture of Matta he smashed had hung. None of his own work was around. Gorky had given the painting he had made of his mother and himself to Levy to exhibit.[4] She no longer kept him company, as she had in the long dark nights of the studio. He had also let Julien take away his favourite large pencil and charcoal drawing of her. 'A most marvellous drawing,' Julien had said.

Before midnight, Gorky called Kay Sage to cancel their lunch appointment the next day to consult the psychoanalyst Allan Roos. Then he called Julien Levy to ask him if he could find him a woman to cook, manage the house and keep him company. Levy thought Gorky was talking about a woman for sex.

'Oh, come on, Gorky, don't talk like that. I've never heard you talk

nonsense like that.' He pointed out that Gorky 'had plenty of friends and there were lots of girls who were in love with him'. He promised to call someone in the morning.[5]

Almost as soon as Julien had put the receiver down, Kay Sage called him to say that she had spoken to Gorky, who sounded crazy or drunk. She told him that he was calling his friends, and asking each one a different favour. He had called her with 'a weird message'. Julien replied that he had 'an even weirder message'. Sage had called a third friend who had also received an odd call from Gorky. Julien later reflected that Gorky was more used to offering help than asking for it. Sage thought his behaviour seemed 'suicidal'. But she didn't want to drive all the way to his house. She said she would call Peter Blume and ask him to go over.[6]

Gorky felt literally and figuratively unable to hold up his head. He had nothing to live for. He couldn't take care of himself; and he was afraid he might be committed, his brain cut up. Yet he could not even paint to contain his terror. His fears became confused with the excruciating pain in his head. He could not bear to be an object of pity in the hands of strangers and doctors. And he must have felt that even his own family had no further use for him. He closed his eyes to rest.

On 20 July 1948, the morning sun streamed into the house in Sherman, lighting up every corner. Something had changed in the night. Gorky walked out with the dog. The birds were singing, each blade of grass and leaf was etched in the early light. The earth smelled fresh. The morning was clean. Everything looked strangely normal. He was like a stranger who had already left the place. He wandered over to the pine trees and the empty children's swing.

When the telephone rang, he rushed to pick up the receiver but it was not Agnes. Schary had left his glasses the night before: could he come to pick them up? Gorky told him to come straight away.

When Schary arrived, he found the screen door open and walked in. Gorky was sitting a few feet away from him in the sunlight, hunched over the telephone.

'Yes, my dear.' He listened quietly. 'No, my dear.' Gorky hardly spoke, taking in the voice at the other end.

'Goodbye, my dear.'

Gorky replaced the receiver and turned to face Schary. His face was drawn and haggard with anxiety. His eyes were dead. He walked towards

Schary holding his glasses, and said, 'Schary, Agnes has left me. And my life is over. I'm not going to live any more!'

Schary blurted out encouragement, 'talking fast, trying to cheer him up'. He tried to counter his despondency. 'Your work is beginning to sell. You have two children. You owe it to them to stay alive.'

But somehow everything he mentioned was out of Gorky's reach: his wife, his children, his painting. 'He was sitting there with this thing around his neck.'

Gorky heard the words of his old friend, but it was too late. He said, 'Don't worry, Schary. I am going to act as a man does.'

For almost two hours Schary struggled to change Gorky's frame of mind. At last, Gorky looked at him, and said casually, 'Schary. Would you please leave? I have to do something.'

It was late morning, getting on for noon. It occurred to Schary that Gorky had to take care of his stoma. Schary stood up and Gorky walked him out to the car, parked on the land behind the house. Schary opened the car door and got in, while Gorky came around to the driver's seat. For a moment they stayed still. Gorky looked at his friend, behind the steering wheel, crumpled and uneasy. Their eyes met. Schary was about to start the car. Gorky bent towards him.

'Gorky picked up my hand which was on the car and he took it in both his hands and he kissed it and he said, "Goodbye, Schary."'

From an Armenian, this was a sign of respect and love, for an elder. Schary stayed to get his breath back. Before driving off, he watched Gorky turn and walk back into the house. He noticed, 'Gorky had a slouch when he walked. But this particular morning after he left me, he walked with very rapid short steps into the house. As though he'd definitely made up his mind to do something and he was going to do it.'

Gorky walked into the house first. His last abstract painting was on the easel. He took hold of a knife and plunged it through the canvas, ripping through pale colours.[7]

Then he walked out of the door, down through the open fields and under the trees. Zango trotted by his side. The sun had moved overhead. Gorky had never stopped walking, away from the soft sand by the lake, over rocky passes, from his village, his country, the city of New York, and this last

corner of Connecticut with its gorges and hemlocks. His children were in Virginia, Maro and his chubby Natasha; Mogooch, young and beautiful.

He reached the shed just above the stream. The water rushed over the stones. Drops glinted in the harsh sun. Huge lumps of stone lay about near the stonecrusher.

He walked into the shed with its open side. A place to sit in bad weather, to look out at the countryside, think and dream. There was a musty smell of old wood, a few empty crates. Up there it hung from a beam, the noose he had prepared. He stepped on a crate and tested the strand of rope. The length had to be right for him. It would not take long. His neck was already broken.

The sun was at its highest point. The innocent white loop hung from a beam. The rope was a curving simple shape he might have drawn himself. It waited. He thought of something and looked around, reached for an empty crate. He found a piece of chalk in his pocket. Bending down, he scored the soft chalk into the rough wooden surface. White dust particles flew into the sunbeam.

'Goodbye my loveds,' translating from Armenian, '*Eem seereliners.*' The chalk broke and part of it flew out of the open door.

He reached up with his left hand and found the buckles of the halter. One by one he undid them and took off the stiff harness for the last time. The dog watched at his feet.

He climbed onto the crate and reached up his hand. He pulled the noose over his face, stood for a moment and drew a breath. Then with all his strength, he kicked away the crate from under him.

PART VI
THE GIFT

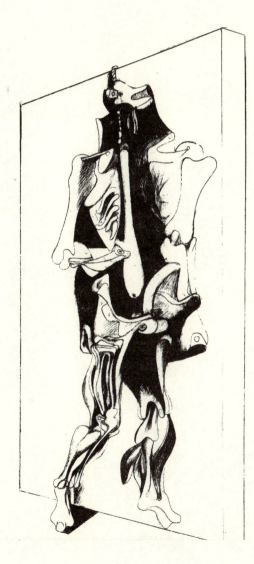

54

Summer Funeral

After leaving Gorky, Schary drove three blocks, a quarter of a mile, to Peter Blume's house. Blume was shaving.

'Peter,' he said, 'Gorky is talking about suicide. I wish you would take Ebie over there. Keep talking to him and see if you can get him out of this suicidal mood.'[1]

'Oh, he's been talking about it for twenty-five years. He wouldn't do it.'

Schary looked at Blume, blue-eyed, chiselled nose, wavy golden hair, grooming himself in the mirror. He felt a coldness from him. 'Peter, if he's ever gonna do it, he's gonna do it now, because he's got plenty of reason to.'

Blume said, 'Oh. I'm going down to take a swim.'

'Peter, I wish you wouldn't take that swim. I wish you'd go down and talk to him.' Schary watched Blume sling a towel over his shoulder and stride down to the pool at the end of his garden.

Schary returned to his house, about six miles away. The phone was already ringing. It was Blume.

'Schary, do you have Gorky with you?'

'No.'

Blume said, 'Well, I'm over at Gorky's house and he's nowhere around. Wait. If I find anything, I'll call you.'

Kay Sage called the Cowleys for news. She raised the alarm and asked them to go over to the Glass House, but warned, 'Don't go alone!'[2]

The Cowleys drove over to the Glass House immediately. The back door was open, as always. They looked through the house but found no one. All

479

four of them combed the rooms and searched through the grounds, calling for Gorky.

Blume was shocked when he came across a rope hanging from the door of the woodshed, and another from an apple tree behind the house. The women searched the house for clues, a note. Blume and Cowley scoured the outbuildings and further into the woodland.

They set off for one of Gorky's favourite places, a hemlock gorge with a waterfall half a mile from the house. They scrambled around searching and calling, but no reply. Wandering back, they crossed a side road where Gorky's little dog ran out, barking at them. They turned and followed the dog, which stopped barking as soon as they were behind him and trotted ahead towards the stone crusher. It led them to an old shed, open on one side.

Gorky was hanging there, his feet only a few inches from the ground. His shirt had slipped up. His trousers had dropped down his emaciated body. They could see the bandage around his abdomen. He looked like wax. Peter Blume said:

> He had strung this clothesline over the rafters, had made a noose, and then stood on the box, just an ordinary box, which he had kicked out from under him . . . actually, when he was hanging, his feet could almost have touched the ground. He was so close because the rope, a single clothes-line, had become very much stretched by the weight of his body.[3]

The spectre of Gorky hanging there was to haunt them for the rest of their lives. His harness was lying at his feet. The men found a crate on the ground. And Gorky had written, 'Goodbye my loveds' in white chalk, Blume reported. Cowley said there was a piece of broken chalk on the ground. Blume recalled the state troopers later searching for the chalk. 'They wanted to be sure that it was a suicide and not a homicide.'

They hurried back to the house. The dog stayed whimpering by the shed. Schary had arrived. They phoned Agnes. She had to return to Sherman again; this time to bury him. 'I certainly didn't think I was going to leave him until the last minute. And even then I knew he was going to die. I didn't think he was going to live.'[4]

Everyone involved recalled exactly where they were the moment they heard of Gorky's death. Noguchi heard it on the radio and called the Lams.

Muriel Levy was in New York still trying to arrange for Dr Roos to go and see Gorky in Ridgefield. 'I hung up the phone planning to go and get the train back. And the phone rang and it was Kay Sage, calling and saying that Gorky had hung himself.'⁵

Agnes flew back with her father, leaving the children with her mother in Virginia. They went down to the funeral parlour in New Milford. She walked in to see Gorky alone, surprised at how beautiful and untroubled he looked after his terrible death. On the telephone during their final exchange he had sounded 'very calm'. He had told her quietly, 'I have read your diary. I am going to free you.' Then he had hung up. When she had called him back, there had been no reply.

There were funeral arrangements to be made. Muriel recalled that Agnes did not express grief or shock, and talked about herself with detachment 'just like a character in a novel', noting particularly 'that her dreams were everything that Freud could have desired'. Agnes later related that she was numb, that it took a long time for the tears to release her.

The *New York Times*, on Thursday, 22 July 1948, carried a small entry on page 23:

<div align="center">

GORKY'S COUSIN ENDS LIFE
Artist Hangs Himself in Barn on His Connecticut Place

</div>

Sherman, Conn., July 21
Arshile Gorky, a painter with a studio in the Spring Lake district of this town, hanged himself today in a barn on his property after telephoning a neighbour and one of his art students that he was going to take his life. He was 45 years old.

Mr Gorky was born in Russia and was a first cousin of Maxim Gorky, the writer. He came to this country in 1924 and formerly was on the faculty of the Grand Central School of Art in New York, where he also had been a student.

Even at the end, Gorky's assumed identity meant more to the press than his artistic achievement.

Agnes wanted to have him buried in the woods he had loved but she was not permitted. Since he had taken his own life, the pastor in Sherman refused him both a funeral service in church and even burial in consecrated ground. Agnes and the Commodore called on several priests, but all refused the suicide a burial. Finally an Episcopalian minister, Father Day, agreed to

say a prayer outside the church and bury him outside the main cemetery.

Agnes notified Gorky's sisters. Vartoosh recalled, 'I was going up to see him and instead I had to go to his funeral.'[6] The Armenian relatives talked to Agnes on the telephone and found the American restrained attitude to his violent death chilling, when Agnes told them, 'He wanted it this way.'[7]

Meanwhile friends arrived at the house. Isamu Noguchi, Wilfredo and Helena Lam drove down early to support Agnes. Everyone's reaction to Gorky's death was extreme. Julien Levy would never recover from the shock and guilt of having caused the accident which had contributed to Gorky's injury and perhaps ultimately to his death.[8] However, he held Agnes responsible for deserting Gorky when he most needed help.

They drove off to the cemetery in Sherman, next to the neat little wooden church where Gorky was not admitted. He was only grudgingly given a spot on the slope farthest away from the church.

Gorky's funeral took place on a cloudy summer's day. A small group had already assembled. Gorky's niece Florence and her husband Mike Berberian arrived by bus from Massachusetts. They said that they looked for Gorky's widow but couldn't see her. Vartoosh and Moorad had driven up by car. Vartoosh stood with heavy lidded eyes next to her relatives forming a bewildered group of about eight Armenians all in black, set apart from the other mourners. They felt strange standing in a graveyard instead of in the church. Vartoosh knew the familiar words of the Armenian service would not be spoken for her brother; 'Whoever loves his own life will lose it; whoever hates his own life in this world will keep it for life eternal.'

As they waited on the slope of the cemetery, Florence and Mike saw Agnes for the first time. 'And she walked through a field holding a sheaf of flowers in a low cut black dress and sandals. There was a balding man next to her. She looked beautiful. Very dramatic.'[9] They were transfixed by the young woman their uncle had loved and kept secret from them until his funeral. Vartoosh felt close to Agnes, after the honeymoon meeting in Chicago, their exchange of letters and gifts. She came forward, weeping, to kiss her sister-in-law, who also recalled that she 'embraced his relatives'. Florence remembered, 'Agnes said, "Hello." Nothing further was said. The body was lowered into the earth. The priest buried him. He just said a prayer. I think that was all because he had committed suicide.'

Each group was shocked by the conduct of the others. The Armenians stared in disbelief at what seemed to them like inappropriate behaviour and

lack of respect. Mike exclaimed years later, 'They were all smiling. Nobody in that ceremony was sad. They were having conversations about all sorts of things.' Vartoosh and Florence were the only two who cried. Wilfredo Lam was 'very struck by the presence of Gorky's Armenian family who were dressed all in black and who wept ceaselessly'.[10] Muriel Cowley disapproved of them; 'It wasn't the American way.' Commodore Magruder said, 'Some national types show their emotions.' Muriel Levy watched from a distance and later reflected, 'I remember the funeral distinctly, more about Mogooch than anything else. I took a bunch of yellow nasturtiums. It was a very pleasant summer day.'

Vartoosh wept and lamented her brother in Armenian. Her picture of Gorky was still of a healthy young man, strong and vigorous. She had last seen him in 1941, just after his wedding, singing at his marriage feast in her house. She had no image of his dreadful physical condition at the end. Suddenly she could not accept that her beloved brother was in the wooden casket before her. Gorky had not only been the person she had felt closest to all her life, but also her hope for the future. His fame would vindicate the misery of their childhood and the death of their mother, the injustice to all the Armenians. Vartoosh, seeing the priest and the dry-eyed strangers, looked around for a familiar face, and recalled running away down the hill to the only person she recognised.

'Schary, where are all his friends? I don't know anyone here. Why aren't Gorky's friends here?'[11]

In seven years Gorky had left his family behind and taken up with an alien set, and she was hurt by their apparent aloofness. She grasped that something had gone fundamentally wrong in Gorky's life but couldn't identify it.

The funeral was not quite over. Julien Levy described it:

The skies darkened and it started to rain, first a drizzle but soon a chilling downpour. We stood huddled on a hillock somewhat removed from the grave, the Blumes and Saul Schary and I. Yves and Kay had not come. 'I don't take much stock in funerals,' said Kay. The Admiral, Agnes's father, stood joking and sharing a nip of whiskey from a flask with the minister, Father Day, who when the gathering of mourners was complete, moved downhill, staggering slightly, to read the brief service. It was audible only to

the little knot of close family, Gorky's sisters and their husbands. Agnes was conspicuous in her black widow's weeds, pale and potent as in some Gothic romance. The rain increased.

Suddenly the scene became macabre. Agnes, dripping wet, hovering over the grave, insisted that it be filled with earth to the last shovelful. The gravediggers grumbled, the mourners drifted uncomfortably away and then moved nervously to the shelter of the cars. The few who remained fixed by her widow's commanding stare waited for the last spadeful to fall and the last sod to be placed.[12]

It was the moment when Armenian mourners throw a handful of earth and say, 'May the earth rest lightly on you.'

Agnes felt she had succeeded in giving him a dignified burial. She commented, 'Of course I waited till the last spadeful.' Muriel witnessed it too. 'I remembered Mogooch as they were filling the grave, getting in there and stamping down the dirt.'

Afterwards Agnes's father took her home. She remembered that she saw Gorky's sisters but was too overwrought to act, torn between Gorky's family and her father who disapproved of them.[13] Florence had a different memory: 'Moorad and Vartoosh had come by car. We came by bus. We all went home together. We weren't invited back to the house or anything. We were none the wiser about his death. We just left the cemetery and went straight home.'[14] Forty-five years later, Vartoosh wept as she remembered that day. 'I just could not believe it. Why didn't they call me? I would have looked after him. Why would my brother kill himself? I still don't believe he did it.'

Agnes's close friends went to the house – Jeanne Reynal, Sonia Sekula, the Lams. She offered them a painting as a remembrance. Jeanne wanted his last work. Wilfredo chose a small unsigned canvas and on the way home Helena asked him if it would not have been better to take a signed one. He replied that he 'only wanted a souvenir of Gorky'.[15]

'I thought that Gorky was a victim rather than a victimiser,' Noguchi reflected. 'He is the classical example of the tragic hero, the one who is crucified.'[16] Muriel Levy believed, 'His abandonment was the last straw. Mogooch was only part of the picture. You'd have to be a saint or martyr to survive all these things. Nobody could.'[17] Malcolm Cowley remarked, 'He

felt very deeply. With his feeling for tragedy, I wasn't surprised he ended his series of misfortunes, that he committed suicide.'[18]

Gorky's defiant death would enhance his myth. The mystery of his identity and origins, always a difficult matter in his lifetime, would be complicated and fictionalised by those who might gain or lose by it.

Gorky's suicide deeply shocked the artists who knew him and was endlessly discussed. Matta proved a true Surrealist who thought of suicide as an act of liberation. When he visited Lionel Abel's home, 'He spoke very freely about the suicide a few days afterwards.'[19] Duchamp tried to tamp down the scandal he knew was about to burst and continue for years to come. The news of Gorky's suicide was to create shockwaves not only in America but also in Europe.

In Paris, André Breton was sitting in a café with friends, including Sydney Janis, when news reached him of Gorky's suicide. The death of the man he had come to love and respect, whom he considered one of the greatest painters in America, devastated him, and it enraged him to think that his protégé and collaborator Matta had contributed to the chain of events that ended in Gorky taking his own life. Frederick Kiesler had immediately written him an account of the events.[20] When Matta telephoned Breton from New York to explain that he had merely followed the Surrealist precepts, allowing himself to be guided by his unconscious desires, Breton yelled down the phone, 'Assassin! murderer!' Believing that Gorky had been betrayed by the two people closest to him, he immediately resolved to expel Matta, and have him condemned by the Surrealists.

Matta was surprised. 'After all, the Surrealists who were attacking me told me that Sade was a greater man than Jesus Christ.'[21] Oddly this much-repeated phrase of the Surrealists had been written by Agnes in a letter to Jeanne Reynal three years before in very different circumstances.[22]

Matta had been the heir apparent to Breton in New York, head of a movement with his new review, and now found himself condemned on all sides. Even those not personally involved appeared to have had enormous respect for Gorky as an artist of integrity.

In Paris, Breton heard different accounts of Gorky's suicide, then drafted a letter of condemnation. He summoned a full and extraordinary meeting of the Surrealist circle in 'the upper room of the café in Place Blanche'.[23] It

decreed: 'By decision taken in Paris on 25 October 1948 Matta Echaurren is excluded from the surrealist group for intellectual disqualification and moral ignominy.'[24] Breton wrote that Matta had surrendered to the 'Vertigo of Eros' with Arshile Gorky's wife. Each member was asked to sign. This sowed discord among the members and split them. Some refused. Victor Brauner defended Matta. Breton leaned on the young poet Alain Jouffroy, 'Faites moi confiance!' Brauner was excommunicated for his refusal, accusing Breton of imposing bourgeois morals upon them.

Breton, meditating on the photo with Gorky in the Connecticut countryside, composed a poem, 'Farewell to Arshile Gorky'.

> How big you are with your arms opened
> Your voice an eagle's nest
> When you sang to yourself the old Russian songs
> You had received as your share the pure line

His image was of Gorky surrounded by nature.

> I see you again with your rod of fables
> Among the stars and the flowering trees
> I tear myself from your destiny
> How they clung to you dear Arshile
> Ah he loves fire where is his house burn it.[25]

The entire poem was published in the new Surrealist review *Neon, No. 4*. It also contained a thinly veiled accusation and played its part in the Gorky legend.[26] Agnes called it 'that dreadful poem'. However Breton's 1945 introduction, 'Eye-spring', proved the most incisive commentary on Gorky, and was frequently republished. Jouffroy later wrote a *roman à clef*, based on his conversations with Breton and especially Matta.[27]

Breton was not to be publicly reconciled with Matta until a decade later at a ritual, *The Execution of the Testament of Sade*, held in 1959.[28] While Breton intoned Sade's text, the artist Jean Benoit in macabre costume with a giant phallus protruding, appeared dragging a coffin and stripped. Following Benoit's lead, Matta grabbed a red-hot iron and branded his naked chest with the word 'Sade'. The theatrical gesture apparently satisfied the ageing Breton.[29]

After the funeral, Agnes had to take charge of practical matters over the next few weeks. 'I had to clear up the house. We had $60 in the bank. Gorky had all his canvases and brushes in a drawer in his room. The best paper, canvas, paints he had kept against a rainy day. They were stored in Union Square. I got $500 from the art supply store.'[30]

Later she went with the children, Jeanne Reynal and Urban Neininger to the house bequeathed by her great-aunt in Maine. Matta also spent part of that summer in Maine and confided in Lionel Abel that he was in love.[31] Matta proposed to Agnes that they live together. She considered his proposal so seriously that she went to consult Marcel Duchamp.[32] He cast doubts on whether Matta could cope with Gorky's children, when he had rejected his own. Jeanne urged her to accept, offering to take charge of the children, which Agnes declined. Matta's career in New York was clouded by the affair and he left for Chile. Julien Levy organised a small commemorative exhibition of Gorky's work. The show ran from 16 November to 4 December 1948, and concentrated on his mature works.[33]

The insurance claim for Gorky's accident which had begun during Gorky's lifetime was to be concluded in December.[34] The *New York Times* reported from Bridgeport, Connecticut.

> Mrs Agnes Magruder agreed today to accept $11,000 from Julien Levy, New York art gallery owner, in settlement of a $20,000 damage suit arising from the death of her husband, Arshile Gorky, Russian-born artist. Mr Gorky was a cousin of Maxim Gorky, the writer.
>
> Mrs Gorky contended that her husband's suicide last July 21 was attributable to injuries suffered a month earlier when Mr Levy's automobile, in which he was a passenger, was involved in an accident. The artist became melancholy and morose as a result of the injuries, she asserted, and his mental depression caused him to take his life.
>
> The settlement was announced by counsel as a jury was being selected in Superior Court to try the case.[35]

It was not Julien Levy but the insurance company that paid the claim, as Agnes pointed out. Her lawyer had advised her not to make too large a claim because she and Julien were both vulnerable; his drunkenness at the time of driving and her infidelity might be cited as contributory factors. Moreover, Gorky's wife had been reported stating that he committed suicide as a result of 'mental depression'. She denied doing this but thought her

lawyer might have done so. It was Dr Weiss's version. Taken up later and distorted, several writers claimed that Gorky was 'insane' at the time of death, which was not contested. Agnes penned a cheerful note to Ethel Schwabacher that thanks to the settlement she and the children were now much better off and would set out for the warmer climes of Europe.[36] This was a sum Gorky could not have dreamt of realising. Ironically, in less than five months after his death, his wife and children were financially independent.

Levy fought and largely succeeded in keeping part of Gorky's work against the monthly sum he had advanced him. He kept 'all the late work since 1945 except what was in Gorky's studio – including rolled-up paintings to work on in Sherman of which three are now in Museums', Agnes stated. Within months the Julien Levy Gallery was closed down. His son Jerrold had offered to continue the business but he was only nineteen. Levy isolated himself in Connecticut. He sank into depression and alcoholism. He and Muriel separated. He recovered in 1966 to publish the best-illustrated book on the artist.

Gorky's first wife, Marny George, wrote, 'By a strange cycle of fate, the tie renewed in an unexpected way. Very shortly after hearing of his death I found that I too had cancer. I too had a colostomy operation. . . . (many personal symbols in his last paintings have an unbearable clarity for me).' She asked that her words not be used until after her death.[37]

Agnes corresponded with Gorky's sisters Vartoosh and Satenig. They came to New York to see her and their nieces. She gave Vartoosh portraits Gorky had done of her and other work. Satenig came up with her daughter Florence and was very touched to see Gorky's children for the first time. She refused Agnes's offer of Gorky's work, upset by hearing little Maro weeping, 'Don't give Daddy's things away.' Agnes pressed her to take seven drawings; however, she categorically refused the oil paintings.[38]

Agnes then left for Italy, leaving the girls, aged five and three, in a Swiss boarding school for a period. Natasha remembered that they were desperately unhappy.[39] Agnes then decided to live in Europe. Eighteen months after Gorky's death in a letter to Vartoosh she announced her forthcoming marriage in Paris to Jack Philips. She said that she would regret giving up her married name, but was pleased to be called by the nickname Gorky had given her. She had not seen the tombstone on Gorky's grave but thanked Vartoosh for erecting it.

In the neat cemetery of Sherman it is hard to find his grave. Bright sunshine; the air is cold. Frosted grass and leaves. In the distance on a slope two cypresses bend and meet. A simple headstone reads: 'Arshile Gorky Adoyan'.

55

Life After Death: The Gorky Legend

The fall-out after Gorky's suicide cast a deep shadow over the post-war art world. Both in private and public the repercussions persisted. His close friends felt that he had taken an honourable way out to preserve his dignity. Gorky was appreciated as a sensitive and courageous man who had been pushed beyond human endurance, 'more sinned against than sinning'. Some thought him a martyr to the indifference of the brittle Surrealists – a man seduced, pressed into service and then baited. Others thought that coming from a closed integrated society in Armenia, he had been at odds with the fragmented, unstructured society of the New York art world and become its scapegoat. The materialist New World had initially offered him the security and freedom to develop his talents, but had subsequently pulverised his acute sensibility.

His suicide, like his art, became the conclusion of one era and the opening of another. He closed the book on Cubism and opened it on Surrealism combined with Abstract Expressionism. Gorky had sustained the psychic tremors of two World Wars, the Great Catastrophe (as his countrymen called the Armenian Genocide) and the Depression. Their cumulative effects would fracture the human psyche, undermine society and splinter the arts. He had struggled to restore an integrity and passion to American art, integrating via Armenia both Europe and the Orient.

Thirty years after his death, I heard disaster stories about Gorky's paintings in New York. Dealers were convinced that his pictures had self destructed. Several burned in fires. In 1957, *The Orators* was damaged by fire. In 1961, *The Calendars*, belonging to Nelson Rockefeller, was burned in

the Governor's House, Albany, New York. A plane crashed transporting some paintings to the Los Angeles Museum show. In Allan Stone's Gallery paintings fell off the wall so often that the staff were afraid to hang them. A truck delivering his work crashed on its way to the gallery. When the artist Wayne Thiebaud bought a Gorky and wanted to take it home, Stone insisted on sending it to him separately. In Gorky's house in Sherman, Connecticut, phantom visits by a tall man in overalls had driven several people away. The glass wall had shattered. During my research in New York, I was startled by the phrase 'the Gorky curse'.

The body of work left by an artist can be interpreted as a composite self-portrait. Each work adds to the fusion of conscious and unconscious images, different tensions, breaking points and resolutions which make up the total of the artist's universe and his relationships. To the biographer the art reveals what has been hidden in an incomplete life story. Gorky began in the twenties with explicit solid images, portraits, still lifes, landscapes; then in the thirties shifted to a Cubist space and objects within a schematised conceptual framework. With thick impasto and textured surfaces he introduced a mythic sense and cosmology which hinted at the sculptural heritage of Armenia. During a period of public patronage in the mid to late thirties he invested personal and poetic attributes, even to the aeronautics industry which he was instructed to glorify. He escaped into a personal and psychological sphere, implicit with images and objects painted in flux and transformation that reflected his own flight from chaos. With a love-affair, marriage and children, barriers were broken down, allowing his unconscious to expand into a more fertile and fluid universe of exuberant colours. However, in the mid to late forties, the scarred landscape of his body began to distort his relationships with others and with himself. He distilled his work, making it spare and sober; his colour palette was restrained, his forms lost their fullness, drooped, tapered, escaping out of the picture space. This cumulative portrait is of a man of only forty-six at the height of his artistic powers, a fugitive from ill health and despair.

In 1951, after an uneasy silence, with his gallery closed and his widow away in Europe, Gorky's work finally appeared in a large Memorial Exhibition at the Whitney Museum. It was the first time many artists saw his work, and recognised its quality. He was exactly what the younger artists needed. He

had integrated Picasso's space with Miró's figuration, amplified Kandinsky and elevated Surrealism with his innate painterly gift. Later, they called him the father of the New York School. In 1962, a decade later, the Museum of Modern Art in New York exhibited *Arshile Gorky, Paintings, Drawings, Studies*. In 1965, the Tate Gallery in London held a major exhibition, *Arshile Gorky: Paintings and drawings*. In the mid 1960s the tide began to turn. In 1981–82 the most comprehensive retrospective took place at the Guggenheim Museum, with a catalogue by Diane Waldman which was a milestone. In 1995–96, *Arshile Gorky: The Breakthrough Years* was shown at the National Gallery of Art, Washington DC, in Albright-Knox Art Gallery, Buffalo, New York, and the Modern Art Museum of Fort Worth, Texas.

Apart from his paintings he left an important legacy of drawings which had been the basis of his art. Few of his American contemporaries could rival the high standard of draughtsmanship or his inventiveness in old master to neo-classical styles, or the Abstract Surrealist drawings.

However, for at least fifteen years after his death there was a lull in the market for Gorky's work. Sydney Janis took over from Levy's gallery. Gorky was seldom exhibited. Prices were low compared with those of his contemporaries. Gorky's fellow artists De Kooning, Pollock, Gottlieb and others paid tribute to him, protesting to Janis that since he was 'one of the first six of that generation' prices should be raised. The push towards Abstract Expressionism in America would have been impossible without his momentum, yet he was often excluded from the limelight. The state patronage for the new Action Painting was calculatedly selected to dominate the world as the new International Art. Gorky, an individualist, had been saluted for integrating European painting but his breadth in incorporating the figural with abstract was labelled 'transitional'. It was only twenty years later, when the art world saw the collapse of Action Painting, that he was reinstated as an innovator.

In 1984–85, the Calouste Gulbenkian Museum exhibited Vartoosh Mooradian's collection in Lisbon and Paris. The Mooradians refused to exhibit their collection in the same show as that of Agnes Gorky. Then, in 1989–90, an important exhibition was organised at the Sala de Exposiciones de la Fundacion Caja de Pensiones, in Madrid, which then travelled to the Whitechapel Art Gallery, London. No major exhibition of Gorky's paintings has been shown in a national museum in France, Germany, Italy,

Belgium or Holland. Not a single work hangs in the National Gallery of Armenia, where Gorky is a national hero and a symbol of artistic freedom for artists during the repressive Soviet era.

The impact of his death on his family was to separate them even further from one another. His sister Vartoosh never accepted Gorky's way of dying. She reasoned that together they had lived through far worse horrors as children. She blamed the people around him for their neglect and raged at herself for not being at her brother's side during his distress. Each morning she paced through her little flat, lifted photographs of her dead husband, son and brother, talked to them and kissed them. She bequeathed her estate to the Diocese of the Armenian Church of America with the hope that one day it would be restored to their people.

Gorky had disappeared from his children's lives in their early years, just as he and his sister had lost their father. He carried out his last words to his wife: 'I will give you your freedom.' His emotional legacy was fraught but the artistic one later became princely, as he had always predicted. Agnes and her daughters swapped homes between Italy, Spain and England. She had two more daughters from her second husband, Jack Philips, divorced him, and remarried Alexander Fielding who subsequently died. At the time of writing, she lives in London. Her eldest daughter Maro, and her husband Matthew Spender, live near Florence; Gorky's other daughter Natasha lives in London. The estate was divided between them. The girls grew up without real links to their Armenian ancestry. Natasha attempted to rediscover her father and her roots through my research, helping with enthusiasm.

<div align="center">❀</div>

Ironically, in New York's Museum of Modern Art, Gorky's two most poignant works, *Summation* and *The Diary of a Seducer*, hang opposite Matta's painting, *Vertigo of Eros*. Matta's friends related that he accepted no responsibility for Gorky's death, which he called 'a sacrifice'. Matta was observed to have been 'broken up' by Agnes's refusal to marry him, after their summer together in 1948. Shocked by the extent of the moral disapproval in New York, he felt ostracised. She saw him off on a trip to South America, and he later settled in Italy, then France. He remarried twice, but remained on good terms with Agnes. His twin sons died young, one by suicide and the other of cancer. Many members of the Surrealist

group committed suicide: Kay Sage, Victor Brauner, Kurt Seligman. Matta is one of the last surviving active artists of the original Surrealist group.

The perception of Gorky changed with each decade after his death. The early biographies, by Ethel Schwabacher in the fifties, and by Harold Rosenberg in the sixties, were followed by the publication of the letters, by Karlen Mooradian, which focused attention onto Gorky's Armenian background. Although literature on Armenian history and culture was published in Britain and the US, most writers did not take much trouble to research it. When the focus on abstract art, colour field painting and minimalism waned and figural art returned, Gorky's canvases began to be appreciated again both by critics and artists. In the 1980s, the *Catalogue Raisonné* by Jim Jordan and Robert Goldwater was a welcome addition to Gorky scholarship. Books by Julien Levy, Melvin Lader and Harry Rand made original and varied assessments. The *joie de vivre* of the young artist so apparent in his miraculous mature paintings, they interpreted in terms of his passionate love affair, happy family life in the countryside and growing recognition. Commentators had rich pickings when free-associating for erotic imagery. However, later paintings, which could no longer disguise the black hole in his emotional life that sucked in his energy, attracted little or no acknowledgement or serious consideration.

Two events in the nineties changed the climate of opinion; the establishment of the independent and democratic state of Armenia and a wave of new research into Armenian Genocide history and literature. There was a swing away from America as 'the melting pot' to a more widespread interest in immigrant cultures. Attention to the survivor experiences, shared by other ethnic groups, began expressing itself in music, literature and the arts. But this awareness was slow to affect the scholarship on Gorky. Two American writers made Gorky's Armenian experience central to their appreciation of him: Richard Tashjian in terms of his 'ethnicity', and Peter Balakian, who discussed the Genocide as central to Gorky's experience in an American arts magazine.[1] It was the first airing of this crucial issue. Incredibly, almost half a century elapsed before even Armenians woke up to this glaringly obvious point. The Armenian Diaspora all but ignored a genius, who had epitomised their national struggle, because he had shed his name and was too modern.

From a rural Christian community Gorky had adjusted to a post-industrial free-market society in New York. He had come from a

community which revered sacred and folk art, into a materialist one which traded in art as a glorified consumer product. Gorky evolved a personal humanity in his work and turned his attention to the collective by embracing the history of art, whereas most American modernists either negated the past or adopted a foreign primitive art. His dogged optimism spurred him to express his joy in human achievement yet he also invented covert narratives and cultural containers for the evil of the wars and the genocide he had witnessed.

For a long time his work was judged by old-fashioned criteria, until new media of video animation emerged and his drawings which had seemed hermetic were described as 'animated abstraction'.[2]

A majority of leading American artists were immigrants, but Gorky's history as a child fighter and a survivor of a mass murder was unique. Having overcome a traumatic childhood and mutism, through drawing, his art mirrored his personal achievement in liberating deeply hidden memories and violent conflicts to project them onto a more public platform. But the role of memory in Gorky is less a childhood recollected in tranquillity and more an invasion of suppressed disturbances which explode in his art. Primo Levi despaired because others could not share his witness to the Holocaust. Gorky tried to free himself from a clampdown on collective injustice and guilt. He secretly had to process the Catastrophe in order to go on living. Catastrophe became his way of life. Finally, feeling abandoned by his American family and friends, the Armenian boy went to join his mother. As though climbing the poplar tree menaced by swooping crows, he murdered his split-off personality.

His art is at last being viewed in its universal dimension and only just beginning to be properly investigated and unveiled. Breton had believed him to be 'the first painter to whom the secret has been completely revealed'. The multi-faceted nature of his talent and his personal struggle made him an inspiration to other artists. His close friend De Kooning praised him as a great artist of purity and passion, 'in the grand style'. Gorky never compromised in art or in life, leaving a legacy in his work of the greatest joy and the deepest tragedy. Gorky's words about a friend's paintings aptly describe his own: 'They take us to the supernatural world behind the reality where once the great centuries danced.'

Appendix

Appendix of letters alleged to be by Arshile Gorky for which no originals exist

		Arshile Gorky Adoian	The Many Worlds of Arshile Gorky
1.	3 July 1937	pp. 251–53	pp. 252–54
2.	6 January 1939	pp. 258–59	pp. 260–61
3.	14 January 1939	pp. 259–61	pp. 261–63
4.	26 September 1939	pp. 263–65	pp. 263–65
5.	3 September 1940	pp. 263–65	p. 265
6.	24 November 1940	pp. 265–68	pp. 266–69
7.	25 February 1941	pp. 268–69	pp. 269–71
8.	9 February 1942	pp. 275–77	pp. 276–77
9.	20 March 1942		pp. 277–78
10.	14 September 1942		pp. 278–79
11.	July 1943	pp. 277–78	pp. 280–82
12.	26 January 1944	pp. 279–80	pp. 282–84
13.	14 February 1944	pp. 280–82	pp. 284–86
14.	20 March 1944	pp. 282–83	pp. 286–87
15.	22 April 1944	pp. 283–85	pp. 287–88
16.	December 1944	pp. 285–87	pp. 288–90
17.	6 January 1945	p. 287	p. 290
18.	14 June 1945	pp. 287–90	pp. 291–92
19.	25 June 1945	pp. 290–92	pp. 292–95
20.	3 June 1946	pp. 292–94	pp. 296–98
21.	11 October 1946	pp. 295–98	pp. 299–309
22.	2 November 1946	pp. 298–99	pp. 309–10

Appendix

23.	6 January 1947	pp. 300–2	pp. 312–13
24.	17 January 1947	pp. 302–3	pp. 314–15
25.	17 February 1947	pp. 303–5	pp. 315–17
26.	4 May 1947	pp. 305–10	pp. 317–21
27.	24 November 1947	pp. 310–11	pp. 321–22
28.	6 January 1948	pp. 311–13	pp. 322–24
29.	2 February 1948		pp. 324–25

On 4 July 1945, Gorky penned an astonishing letter to Vartoosh which has never been published. In it he wrote:

This much is certain. This is the first letter I have written in Armenian in two years.

If Gorky had not written to Vartoosh since 1943, who wrote the letters which were edited by Karlen Mooradian? Three are published for 1945, 6 January, 14 June, 25 June. They do not include the one above which I have read in his Armenian handwriting. Gorky's last letter in Armenian to Vartoosh was one of the most beautifully decorated.

In June 1955, Mooradian published his first article on Gorky in *Armenian Review*, a Boston-based journal of Armenian studies. He then began to interview artists and friends, family and distant acquaintances, completing a massive stockpile of reminiscences in 1966. It is clear that Gorky's views and ideas at second-hand became source material for a series of 'letters', which began to appear in English in *Ararat*, another Armenian review, in 1968 and 1971, unchallenged.[1] Emboldened by the acceptance of these letters, Mooradian published his first book.

In 1978 and 1980, he produced two volumes on his uncle's life and work. The first, *Arshile Gorky Adoian*, jumbled names the artist had always kept separate, Manoug (Vosdan) Adoian and Arshile Gorky. The book comprised a chronology, an account and discussion of Gorky's life and work, and a large selection of letters, 29 of which I believe to be forgeries, published in the Armenian review, *Ararat*. In a footnote Mooradian wrote that 80 letters written to Vartoosh had disappeared, approximately 40 mailed to Armenia, and another 40 to Chicago. However he claimed, 'Fortunately, the 100 letters preserved by Vartoosh survive to shed light on Gorky's ideas and thoughts'. Since they came from Vartoosh no one questioned their authenticity.

The Many Worlds of Arshile Gorky, a second book of interviews, reproduced the letters. The strategy worked except that some interviews and 'letters' were suspiciously alike, for instance a discussion on Cubism. These first aroused my suspicion. I later found many instances of unpublished recollections which had been shaped into letters in the same manner. Gorky was supposed to have written

497

steadily to his sister throughout his life until a month before he died. In the second volume, two further additions were purportedly written in 1948, the last one dated three days before his suicide.

Karlen was saturated by his mother's obsession with her brother, quoting his opinions, phrases, ideas. When he decided to write a book about his famous uncle, he talked to her on the telephone and always recorded their conversations. Many of the invented letters lyricised his childhood or pointed to memories Gorky shared with his sisters. It was this gap which Mooradian tried to fill: he succeeded in drawing attention to Gorky's roots at the price of distorting the artist's character and personality. Mooradian supplied his own Armenian perspective on Gorky, but he was not fluent in the language and his view of the history was idiosyncratic. His library, which I examined, contained mostly English-language books which would have been available to anyone. The forged letters projected a shadowy double on Gorky which swamped the real artist – nationalistic, rigid, steeped in history, and opposed to psychiatrists, Surrealists, Americans. Mooradian cast a misanthropic and suspicious view of the world onto Gorky. Yet, even as late as 1992, I was asked to amend the entry in the Art Institute of Chicago's books by Anselmo Carini.

Writers and art historians were grateful for these letters appearing thirty years after his death, and almost every publication on Gorky since their publication has quoted from the dubious letters. The original letters were stored at the Chicago Art Institute, 1969–1984, banned from being shown to scholars, exhibited or photographed.[2] Mooradian systematically refused all requests. No scholar insisted on checking them. In any case, the letters were supposedly in Armenian. Some authentic letters were photographed and published to lend credence to the forgeries. To confuse matters further, all the letters appearing in *Ararat* were later translated from English into Armenian and published in an Armenian art review in Yerevan, conveniently providing Mooradian with an Armenian text that he could not have written himself.

It is a mystery whether Vartoosh knew of Karlen's invented letters. If she had, presumably she would not have let me look at her original letters or encouraged me to write a book. I never had an opportunity to ask her. And the letters were suddenly spirited away after her own death.

Notes

1. The Angel of Birth

1 Gorky's elder sisters pieced together this description from family accounts.
2 H. F. B. Lynch visited Armenia twice, in 1893–94, and in 1898. *Armenia Travels and Studies* (London, 1901, reprinted Beirut, 1965), vol. II, p. 92.
3 Noel Buxton, 'Armenia', *Ararat*, p. 229.
4 Azad Adoian, interview with author, 1992.
5 Arshile Gorky, 'My Murals for the Newark Airport: An Interpretation'.
6 Gorky's eldest half-sister, Akabi Amerian, interview by Karlen Mooradian, 1964.
7 Yervant Lalayan, *Azgagrakan Handes*, vol. II, Book 20, No. 2, 1910, author's translation. I am indebted to Hratch Tchilingirian for bringing to my notice the exemplary and extensive fieldwork by this anthropologist who published in Armenian and German.
8 Azad Adoian, interview by author, 1992.
9 Ado Adoian, interview by Karlen Mooradian, 1966.
10 Satenig Avedissian, interview by Karlen Mooradian, 1966.
11 Lalayan, *Azgagrakan Handes*, Vaspurakan, 7, Tiflis, 1911, p. 70.
12 Akabi Amerian, interview by Karlen Mooradian, 1964.
13 Satenig Avedissian, interview by Karlen Mooradian, 1966.
14 Moses of Khoren, *History of the Armenians*, Book 1, Ch. 31.
15 *Mythologie, Armeno-Caucasienne et Hetito-Asianique*, p. 7.

2. Hayrig, *Father*

1 W. Lewellyn Williams, *Armenia: Past and Present, A Study and a Forecast* (London, 1916).

2 Kertzo Dickran, *Varak* (California, 1990), pp. 61–2.
3 Libby Amerian Miller and Vartoosh Mooradian, interviews by author, 1993, are the source of this and the following account of Sima's fate.
4 Clarence D. Ussher, *An American Physician in Turkey* (Boston, 1917), p. 125.
5 Noel and Harold Buxton, *Travels and Politics in Armenia* (London, 1914), pp. 43–4. Also described in Ussher, pp. 125–9.
6 Ittihad ve Terraki, Hovannisian, *The Republic of Armenia* (Berkeley, 1971–82), vol. I, p. 10.
7 Robert Mirak, *Torn Between Two Lands* (Cambridge, Mass., 1983), p. 53.
8 Kertzo Dickran, *Varak*.
9 Mirak, op. cit.
10 Yenovk Der Hagopian, interview by Karlen Mooradian, 1965.

3. The Village School

1 Ado Adoian, 'Song of a Single Person', *Hayreniki Tzayn*, No. 27, 7 July 1971, Armenia, translated from the Armenian by author.
2 Azad Adoian, interview by author, 1992.
3 Ado Adoian, interview by Karlen Mooradian, 1996.
4 Vartoosh Mooradian, 1991, and Azad Adoian, 1992, interview by author.
5 Azad Adoian, interview by author, 1992.
6 Ado Adoian, interview with Karlen Mooradian, 1996.
7 In Aintab, Kaiseri and other Armenian provinces only Turkish was spoken and Armenian was taught secretly.
8 Paregham Hovnanyan, written memoirs in Armenian, unpublished, Yerevan, 1991, translated by author.

4. Pilgrim

1 *Vosdan* is also a noun meaning 'fatherland', 'home' and 'hearth'.
2 H. F. B. Lynch, *Armenia*, vol. II, pp. 123–4.
3 The church, now destroyed, was typical of the Armenian church style in this region. The monastery had several names besides *Charahan* (Demon Seizer), or *Sourp Nishan* (Holy Cross). It was also known as the Monastery of Yegishe, the Monastery of Vard (Prince Badurik), *Petelivank*, *Dira Sirbaran*, *Chagar Sourp Nishan* (Kurdish for 'call the Saint'). Y. Lalayan, *Azdagrakan Handes*, Vol. 2, No. 2, Book 20, 1910, *Ethnographic Journal*, Tblisi.
4 Karlen Mooradian, *Arshile Gorky Adoian* (Chicago, 1978), p. 100.
5 J. M. Thierry, *Monuments Armeniens du Vaspurakan* (Paris, 1989), pp. 330–1 gives a contemporary survey.
6 Yervant Lalayan, *Azdagrakan Handes*, Book 44, 1911.

7 Noel Buxton, 'Armenia', *Ararat*, p. 35.

8 Isabella Bishop, *Journeys in Persia and Kurdistan* (London, 1891 and reprint), vol. II, pp. 35–7.

9 *Ibid.*

10 Ado Adoian, interview by Karlen Mooradian, 1966.

11 H. F. B. Lynch, op. cit., p. 130.

12 Ado Adoian, interview by Karlen Mooradian, 1966.

13 Gilt thrones on which sat the king surrounded by his courtiers, groups of musicians and dancing girls, armed soldiers, wrestlers, lions, wild beasts and birds of many colours, were described by tenth-century historiographer, Thomas Ardsruni, *The History of the House of the Ardsrunis* (in Armenian), (Tiflis, 1917), pp. 481–2. French translation by M. Brosset. *Collection d'historiens armeniens*, Saint Petersburg, 1874, p. 238. Quoted by Sirarpie Der Nersessian, *Armenian Art* (London, 1978), p. 83–4.

14 For more information on Aghtamar see Sirarpie Der Nersessian, *Aght'amar. Church of the Holy Cross* (Cambridge, Mass., 1965), Sirarpie Der Nersessian and H. Vahramian, *Aght'amar*, Documenti de architettura armena, 8 (Milan, 1974).

15 *Agha* was a Kurdish title to denote rank also used by Armenians.

16 Ado Adoian, interview by Karlen Mooradian, 1966.

17 Yenovk Der Hagopian, interview by Karlen Mooradian, 1966.

18 The *khatchkar* had developed since the eighth century into a unique form of monumental sculpture with fine examples in the churches and monasteries of Armenia. See Patrick Donabedian and Jean-Michel Thierry, *Armenian Art* (New York, 1989), pp. 123–34.

19 Paregham Hovnanyan, memoir in Armenian translated by author.

20 Azad Adoian, interview by author, 1992.

21 *Ibid.*

22 Christopher Walker, *Armenia: The Survival of a Nation* (London, 1980), pp. 209–10.

23 Clarence D. Ussher, *An American Physician in Turkey*, pp. 163–4.

24 Many intellectuals knew they were treading a knife edge. Leading writers like Hovhannes Toumanian, and the ethnographer Yervant Lalayan, visited Van, transcribed oral history and poetry before the Armenian provinces disappeared. Lalayan founded a museum of antiquity and ethnography in Van whose collection was later transported to Erevan for safety. Composer and pioneer ethnomusicographer Komitas collected folk songs besides his analytical and theoretical work on church music.

25 Kevork Kondakian, interview by Karlen Mooradian, 1966.

26 Azad Adoian, interview by author, 1992.

27 *Ibid.*
28 Liberty Amerian Miller, interview by author, 1993.
29 Vartoosh Mooradian, interview by author, 1990.

5. Van

1 Vartoosh Mooradian, interview by author, 1990.
2 Kevork Kondakian, interview by Karlen Mooradian, 1965.
3 H. F. B. Lynch, *Armenia*, vol. 2, p. 83.
4 Lynch wrote, after visiting the schools, that there were eleven in Van with a total of 2,180 pupils, of whom 800 were girls. Six of the schools were attached to churches and the others were privately run. 'All these schools, with the single exception of Yissusian, are situated among the gardens. This last, of which the name signifies that it is dedicated to Jesus, is attached to the ancient churches of Diramair and Sourp Paulos in the walled city and close to the foot of the rock'. *Ibid.*, p. 96.
5 *Ibid.*, p. 99.
6 *Ibid.*, p. 97.
7 *Ibid.*, p. 107.
8 Reproduced in *Arshile Gorky*, Galerie Marwan Hoss (Paris, 1993), p. 49.
9 H. F. B. Lynch, op. cit.
10 Vartoosh Mooradian, interview by author, 1990.
11 C. Ussher, *An American Physician in Turkey*, pp. 37–8.
12 Vartoosh Mooradian, interview by author, 1990.
13 *Ibid.*
14 *Ibid.*
15 Satenig Avedissian, interview by Karlen Mooradian, 1965.
16 Raymond H. Kevorkian and Paul B. Pabouchian, *Les Arméniens dans l'Empire Ottoman à la Veille du Génocide* (Paris, 1992), pp. 550–4.
17 Henrik Mooradian interview by Karlen Mooradian, 1965.
18 Saul Schary, interview by Karlen Mooradian, 1966.
19 Ado Adoian, interview by Karlen Mooradian, 1966.
20 Yenovk Der Hagopian, interview by Karlen Mooradian, 1966.
21 Satenig Avedissian, interview by Karlen Mooradian, 1965.

6. Rainbow Line

1 Arshag Mooradian, interview by Karlen Mooradian, 1965.
2 Vartoosh Mooradian, interview by author, 1990.
3 Clarence D. Ussher, *An American Physician in Turkey*, p. 155.
4 Teaching of Vanetzi Catholicos Khrimian Hayrik. Lynch, vol. II, p. 86.

5 Manya Ghazaryan, *Armenian Carpet* (Erevan, 1998), pp. viii and x, cites that in AD 943 al-Masudi wrote about *vordan karmir*; red made from worms gathered around Mount Ararat. *Vord* means 'worm' in Armenian.

6 Vartoosh Mooradian, interview by author, 1990.

7 *Ibid.*

8 Christopher J. Walker, *Armenia* (London, 1980), p. 195.

9 *Ibid.*, pp. 194–5.

10 Vartoosh Mooradian, interview by author, 1990.

11 According to Vartoosh Mooradian, Levon Shagoyan was related to Manoug: by his maternal grandfather's sister, Mariam, mother of Shagoyan and Nazeli. Known as 'the Pasha', he was a legendary leader who later escorted a group of Khorkomtzis on foot to Iraq where they founded a village. Dr Boghosian, interview by author.

12 Clarence D. Ussher, op. cit., p. 220. See also Viscount Bryce, *The Treatment of the Armenians in the Ottoman Empire 1915–16* (Beirut, 1988), pp. 32–79.

13 Walker, op. cit., pp. 199–200.

14 Vartoosh Mooradian, interview by author, 1990.

7. The Heroic Defence of Van

1 Vartoosh Mooradian, interview by author, 1990, is the source of all her quotes.

2 Azad Adoian interview by author, 1992.

3 Dates given are according to Gregorian calendar used throughout Turkey, Armenia, Russia and Transcaucasia. Add thirteen days for European date.

4 Clarence D. Ussher, *An American Physician in Turkey*, p. 236.

5 *Ibid.*, pp. 237–8.

6 Viscount Bryce, *The Treatment of the Armenians in the Ottoman Empire 1915–1916* (Beirut, 1988); 'The American Mission at Van: Narrative printed privately in the United States by Miss Grace Highley Knapp (1915)', p. 15 corroborates accounts by Clarence D. Ussher and Ernest A. Yarrow.

7 *La Défense Héroique de Van (Armenia)*, Editions de la Revue Droschak (Geneva, 1916), p. 59.

8 De Nogales, *Four Years Beneath the Crescent* (London, 1926), p. 74. He summed up the situation, pp. 66–7: 'From the peak of the long narrow cliff, which seemed the crest of an overhanging wave about to break upon the shore, volleys from the Ottoman artillery, which gave the Armenians no rest by day or night, thundered and lightened ceaselessly, with almost clock-like regularity ... Aram Pasha and his Armenians were in possession of almost the whole of the walled city and the suburb of Aikesdan; while we were masters of the castle and

of the outskirts of the city, forming thus an iron ring which tightened every day as our isolated or simultaneous attacks stiffened.'

9 Vartoosh Mooradian, interview by author, 1990.

10 De Nogales, op. cit., p. 66.

11 Clarence D. Ussher, op. cit., p. 253; *ibid.*, next quote.

12 Vartoosh Mooradian interview by author, 1991.

13 *La Défense Héroique de Van*, pp. 74–84.

14 Daniel Varoujan, the national poet, was arrested and executed on 24 April 1915 by Young Turks. He went to the gallows with this poem in his pocket.

15 *La Défense Héroique de Van*, p. 36.

16 *Ibid.* Account of American missionary, Ernst A. Yarrow, p. 7.

17 Viscount Bryce, op. cit., p. 15.

18 *Ibid.* Letter from Sbordone and reply from Jevdet, p. 41.

19 *La Défense Héroique de Van*, translated from *Ashkhadank*, Armenian newspaper of Van, 17 April 1915, *ibid.*, pp. 83–4.

20 Ernest A. Yarrow, *ibid.*, p. 6.

21 De Nogales, op. cit., p. 68.

22 Clarence D. Ussher, op. cit., p. 244.

23 Viscount Bryce, op. cit., p. 36, and Clarence D. Ussher, op. cit., p. 264.

24 De Nogales, op. cit., p. 84.

25 *Ibid.*, p. 70, and following quote.

26 Kertzo Dickran, *Varak* (California, 1990), p. 93.

27 Richard Hovannisian, *Armenia on the Road to Independence, 1918* (Berkeley and Los Angeles, 1967), p. 56.

28 Clarence D. Ussher, op. cit., p. 282.

8. Beat the Drum

1 Unless otherwise stated, the author's interviews with Vartoosh Mooradian are the source of her account in this chapter.

2 *La Défense Héroique de Van* (Geneva, 1916), p. 89.

3 Richard G. Hovannisian, *Armenia on the Road to Independence, 1918* (Berkeley and Los Angeles, 1967), pp. 51–2.

4 *Ibid.*

5 Viscount Bryce, *The Treatment of the Armenians in the Ottoman Empire 1915–1916* (Beirut, 1988), p. 45.

6 Liberty (Amerian) Miller interview by author, 1992.

7 Clarence D. Ussher, *An American Physician in Turkey*, p. 312.

8 Souren Aprahamian, *From Van to Detroit* (Ann Arbor, 1993), p. 65.

9 Akabi Amerian, interview by Karlen Mooradian, 1965.
10 Clarence D. Ussher, op. cit., p. 314.

9. City of Death

1 Unless otherwise stated, the author's interviews with Vartoosh Mooradian are the source of her account.
2 The town was the agricultural centre of the *gubernaia* (province) of Yerevan, and insignificant compared to Van, Tiflis or Baku. Smaller than Van, its population was 15,000, equally divided between Armenians and Tartars. The entire population of Russian Armenia was only 700,000. This number swelled daily with the influx of refugees and until the population reached one and a quarter million by the end of 1916. Richard Hovannisian, *Armenia on the Road to Independence*, p. 92.
3 Hovannisian explains how by 1917 the Russian armies occupied virtually the whole of historical Armenia, the front line being pushed as far west as Erzinjan; they captured the Black Sea port of Trebizond. *Ibid.*
4 Azad Adoian interview by author, 1992.
5 Diana Der Hovannesian and Marzbed Margossian (trans. and eds.), *Anthology of Armenian Poetry* (New York, 1978); *The City Sings*, Yeghishe Charentz (1897–1937), p. 203. Charentz became Minister of Culture during the Republic; he was imprisoned and died in gaol.
6 Maxim Gorky and Valery Bryusov (eds.), *An Anthology of Armenian Poetry*.
7 Valery Bryusov, 'Armenian poetry and its integrity throughout the centuries: a historical and literary essay', op. cit., Russian translation by Bryusov; cited in Shahen Khatchaturian and Lucy Mirzoyan, *Martiros Saryan* (Leningrad, 1987), p. 113.

10. The Face of Famine

1 Christopher Walker says of this victory: 'Had they failed, it is perfectly possible that the word Armenia would have henceforth denoted only an antique geographical term.' *Armenia: The Survival of a Nation* (London, 1980), p. 254.
2 Azad Adoian, interview by author, 1992.
3 Vartoosh Mooradian, interview by author, 1992.
4 Richard Hovannisian, *The Republic of Armenia* (Berkeley, 1971–82), vol. 1, p. 138.
5 Eleanor Franklin Egan, 'This to be said for the Turk', *Saturday Evening Post*, 122 (December 1919), quoted in Hovannisian, op. cit., p. 127.
6 V. A. Mikaelyan, *The Peasantry of Armenia in the Period of Struggle for the Victory*

of the Soviet Order (1917–1920) (Erevan, 1960), quoted in Hovannisian, op. cit., p. 128.

7 *Ibid.*

8 Richard Hovannisian, *The Republic of Armenia*, vol. 1, p. 134.

9 US Archives RG 867.48/1216, quoted in Hovannisian, op. cit.

10 Liberty (Amerian) Miller, interview by author, 1992.

11. Second Flight

1 Most of this account is based on the author's interview with Vartoosh Mooradian, 1991.

2 US Archives, RG 256, 867B.48/15; ARA Bulletin, no. 12 (June 1919), pp. 18–20. Britain, FO 608/78, File 341/1/1, quoted in Hovannisian, *The Republic of Armenia*, vol. 1 (Berkeley, 1971–82), p. 139.

3 Lilyan Chooljian, interview by author, 1992.

4 Hovannisian, op. cit., pp. 460–1.

5 Lilyan Chooljian, interview by author, 1992.

6 Hagop Hovnatanyan (1806–81) is the best Armenian portrait painter of this period whose work has a resonance in Gorky's portraits: 'This painter, who won fame as "the Raphael of Tiflis" ... interested not so much in the appearance of his sitters but to their inner character, concentrating on the face and hands and particularly the twinkling eyes which seem to look inwards ... achieves a static balance between colour and linear constructions and imbues his portraits with spirituality and meaning. The main sources are the medieval Armenian manuscript illumination and folk art.' Shahen Khatchatrian, *Armenian Artists, 19th–20th Centuries* (New York, 1993).

7 James L. Barton, *Story of Near East Relief, 1915–1930* (New York, 1930).

8 Yves Ternon and J./C. Kebabdjian, *Arménie 1900* (Paris, 1979), p. 110.

9 I am grateful to Philip Mansel for background on this period and to Pars Tuglaci who identified *Vartan Pasha Vartanian*, the novel in the Turkish language.

10 Christopher. J. Walker, *Armenia: The Survival of a Nation* (London, 1980), p. 99.

11 St Gregory, Constantinople, built in 1391, had been tiled in 1733. John Carswell, *Kutahya Tiles and Pottery from the Armenian Cathedral of St James, Jerusalem* (London, 1972), vol. 2, p. 59.

12 *Ibid.*, vol. 1, p. 15.

13 *Ibid.*, vol. 2, pp. 18–19.

14 Discussed in Robert Mirak, *Torn Between Two Lands, Armenians in America, 1890 to World War I* (Cambridge, MA, 1983).

12. Ellis Island

1 The main source for Vartoosh Mooradian's account is the author's interview, 1992.
2 Satenig Avedissian, interview by Karlen Mooradian, 1966.
3 Florence Berberian (daughter of Satenig), interview by author 1992.
4 The source of this account is Lucille and Dawn (daughters of Hagop), Adoian's interview by author, 1992.
5 By 1923, the Ku Klux Klan had a vast membership, and books advocating racism were widely published and read. A three-tiered hierarchy of white Americans was headed by the so-called 'Nordics', then the 'Mediterraneans' and 'Alpines'. Any perceived mixture was termed 'mongrel'.
6 Charles (Ashot) Adoian, interview by author, 1992.
7 Robert Mirak, interview by author, 1995.
8 Arshag Mooradian, interview by Karlen Mooradian, 1995.
9 Mischa Reznikoff, interview by Karlen Mooradian, 1966, is the main source of his account.

13. The Watertown Years

1 Vartoosh Mooradian, interview by author, 1990.
2 Kooligian's (Christian name not known) interview with author, 1992, is the source of his account.
3 Kevork Kondakian, interview with Karlen Mooradian, 1965.
4 *Handbook of the Museum of Fine Arts*, Boston, 1920, 1921, 1925.
5 Mischa Reznikoff, interview by Karlen Mooradian, 1966.
6 Azadouhi (Libby) Miller (daughter of Akabi), interview with author, 1992.
7 Satenig, interview by Karlen Mooradian, 1965, is the source of her account.
8 Akabi Shaljian, from Aykesdan, Van.
9 Ethel Cooke, interview and correspondence with Karlen Mooradian, 1966, are the source of her account.
10 Ethel K. Schwabacher, *Arshile Gorky* (New York, 1957), Mrs Edward M. Murphy to Elaine de Kooning, 1951, p. 28.
11 Founded in 1914 by Douglas John Connah, previously proprietor of the New York School of Art or the Chase School (later to become the Parsons School).
12 Carter Ratcliffe, *John Singer Sargent* (Oxford, 1983), p. 116.
13 R. A. M. Stevenson, 'J. S. Sargent', *Art Journal*, 50 (March 1888), pp. 64-9.
14 Liberty (Amerian) Miller, interview by author 1992.
15 Acquired by Mrs Nat Austin, Cat. Rais., No. 5, p. 129.
16 Ratcliffe, op. cit., p. 58.
17 Academic and neo-classical bas-reliefs and paintings in civic style were unlike

his bold earlier portraits. Sargent had modelled the Danaides bearing amphora on dancers from the Ziegfeld Follies. 'Very ladylike', quipped Bernard Berenson.

18 The rest of Murphy's account is from Karlen Mooradian's interview, 1956.
19 *Handbook of the Museum of Fine Arts* (Boston, 1920).
20 Michael Berberian, interview by author, 1992.
21 Jim Jordan and Robert Goldwater, *The Paintings of Arshile Gorky*, Cat. Rais., No. 3 (16" × 12"), oil on board, p. 18.
22 *Handbook of the Museum of Fine Arts* (Boston, 1920).

14. The Big Apple

1 Mischa Reznikoff, interview by Karlen Mooradian, 1966.
2 Katherine Murphy, interview by Karlen Mooradian, 1966.
3 Robert Henri, George Luks, William Glackens, John Sloan, Everett Shinn, Arthur B. Davies, Maurice Prendergast, and Ernest Lawson. Henry Geldzahler, *American Painting in the 20th Century* (New York, 1965), p. 18.
4 *Ibid.*, p. 16.
5 Raphael Soyer, interview by Karlen Mooradian, 1966.
6 Henry Geldzahler, op. cit., p. 16.
7 Mark Rothko, interview by Karlen Mooradian, 1966, is the main source of this account, part of it published in Mooradian, *The Many Worlds of Arshile Gorky* (Chicago, 1980).
8 When her son Karlen came to write his book on Gorky, she opposed any mention of politics, insisting that he should steer clear of it. No doubt this attitude developed in later years, when she feared her politics had harmed Gorky.
9 Liberty Miller, interview by author, 1992.
10 Charles (Ashot) Adoian, interview by author, 1992.
11 Lucille Adoian, interview by author, 1996.
12 Yenovk Der Hagopian's interview with Karlen Mooradian is the main source for his account.
13 Ethel Cooke, interview by Karlen Mooradian, 1966.
14 Cat. Rais., No. 29, p. 155.
15 Cat. Rais., No. 4, p. 128.
16 Carter Ratcliffe, *John Singer Sargent* (Oxford, 1983), p. 66.
17 Stergis M. Stergis, interview by Karlen Mooradian, 1966, is the main source of his account.
18 Ethel Cooke, interview by Karlen Mooradian, *ibid.*
19 Haroutune Hazarian, interview by Karlen Mooradian, 1966.

15. Grand Central School

1 Quoted in Karlen Mooradian, *The Many Worlds of Arhile Gorky* (Chicago, 1980), p. 95. Revington's account is also based on unpublished excerpts of their interview.
2 Cat. Rais., No. 6, p. 131.
3 Cat. Rais., No. 7, pp. 133–4.
4 Mischa Reznikoff, interview by Karlen Mooradian, 1966.
5 Copy After Frans Hals, *Lady in the Window, Portrait of George Yphantis*, No. 7, pp. 132–3, *Self Portrait at the Age of Nine* (1913), *Portrait of Girl* (c. 1926–9), *Portrait of Mrs Nat Austin*.
6 Cat. Rais., No. 8, p. 133, is also of a Rodin subject.
7 Stergis M. Stergis, interview by Karlen Mooradian, 1966.
8 Warren McCulloch, interview by Karlen Mooradian, 1966.
9 Arthur Revington, interview by Karlen Mooradian, 1966.
10 Cat. Rais., No. 28, p. 154.
11 Liberty Miller, interview by author, 1992.
12 Reprinted in Ethel K. Schwabacher, *Arshile Gorky* (New York, 1957), p. 21.

16. Papa Cézanne

1 Satenig Avedissian, interview by Karlen Mooradian, 1965.
2 Mischa Reznikoff, interview by Karlen Mooradian, 1966.
3 Roger Fry, *Cézanne, A Study Of His Development* (London, 1927).
4 The main source of this account is Saul Schary's interview by Karlen Mooradian, 1966.
5 Stergis M. Stergis's interview by Karlen Mooradian is the source of his remarks.
6 Raphael Soyer, interview by Karlen Mooradian, 1966.
7 Will Barnett, interview by author, 1990.
8 Vaclav Vytlacil, interview by Diane Waldman, *Arshile Gorky 1904–1948, A Retrospective* (New York, 1981).
9 Quoted in Karlen Mooradian, *The Many Worlds of Arshile Gorky* (Chicago, 1980), p. 94.
10 Mr and Mrs McCulloch, interview by Karlen Mooradian, 1966.
11 Arthur Revington, quoted in Karlen Mooradian, *The Many Worlds of Arshile Gorky*, p. 96.
12 John Rewald, *Paul Cézanne, Correspondence* (Paris, 1937), p. 222.
13 Edmund Wilson.
14 Co-wrote with H. L. Mencken.
15 Arshag Mooradian, interview by Karlen Mooradian, 1965.
16 Shnorig Avedissian, interview by Karlen Mooradian, 1965.

17 Arshag Mooradian, interview by Karlen Mooradian, 1965.
18 Svennigen Herluf, interview by Karlen Mooradian: 'He was an exciting teacher. A wild Russian. He was a modern painter. He liked Cézanne, Modigliani and men like that. He loved more a still life.'
19 Willem de Kooning, interview by Karlen Mooradian, 1966, is the main source.
20 Balcombe Greene, 'Memories of Arshile Gorky', *Art Magazine*, special issue: Arshile Gorky, vol. 50, no. 7 (New York, March 1976), p. 109.
21 Diane Waldman, *Willem de Kooning* (New York and London, 1988), p. 32. Excellent discussion of Gorky's influence on de Kooning.
22 Cat. Rais., No. 58, p. 181.
23 Ludwig Sander, interview by Karlen Mooradian, 1966.
24 Melvin P. Lader, *Arshile Gorky* (New York, 1985), p. 24.
25 Statement from Satenig Avedissian in Whitney files.

17. Beautiful Sirun

1 This account is based on recollections by Ruth French (Sirun Mussikian) in interviews and correspondence with Karlen Mooradian, 1965–81.
2 Account based on Mischa Reznikoff's interview by Karlen Mooradian, 1966.
3 Balcombe Greene, 'Memories of Arshile Gorky', *Art Magazine*, special issue: Arshile Gorky, vol. 50, no. 7 (New York, March 1976), p. 108.
4 Saul Schary, interview by Karlen Mooradian, 1966.
5 There is a series of nudes and women's portraits with an unnamed sitter or sitters. Jim Jordan writes, 'of the problematic images that I also date to this period are *Reclining Nude* (69) and *Seated Woman with Vase* (70). *Reclining Nude* which at first appears to have been studied from a living model makes references in both composition and technique to the Matisse nudes of 1928 and 1929 . . .'
6 Cat. Rais., No. 39.
7 Karlen Mooradian, *The Many Worlds of Arshile Gorky* (Chicago, 1980), p. 124.
8 Lucille Adoian, interview by author, 1992.
9 Mrs Chaim Gross, interview by author, 1992.
10 James Johnson Sweeney, *Stuart Davis* (New York, 1945), pp. 22, 34.
11 Henry Geldzahler, *American Painting in the 20th Century* (New York, 1965), p. 146.
12 Stuart Davis, 'Arshile Gorky in the 1930s: A Personal Recollection', *Magazine of Art*, vol. 44, February 1952, pp. 56–8, is the main source for his recollections.
13 Mischa Reznikoff, interview by Karlen Mooradian, 1966, is the source of his account.
14 Stuart Davis, op. cit., pp. 56–8.
15 Libby Miller, interview with author, 1992.

16 Vartoosh Mooradian interview by author, 1992, is the source of her remarks.

18. A Dangerous Muse

1 Alfred Barr, letter to Karlen Mooradian, 30 March 1966.
2 Henry Geldzahler, *American Painting in the 20th Century* (New York, 1965).
3 Willem de Kooning, interview by Karlen Mooradian, 1966.
4 Diane Waldman, as deputy director of the Solomon R. Guggenheim Museum, curated the first major US Gorky retrospective in 1981, and wrote the excellent catalogue: *Arshile Gorky, 1904–1948*; this extract is from p. 29.
5 Sirun Mussikian (Ruth French), interviews and correspondence with Karlen Mooradian, 1965–81.
6 Arshag Mooradian, interview by Karlen Mooradian, 1966.
7 Sirun studied drama, became a successful actress and drama teacher. First she married a professor, then the distinguished architect Gregory Ain.
8 Raoul Hague, interview by Karlen Mooradian, 1996.
9 Yenovk Der Hagopian, interview by Karlen Mooradian, 1966.
10 Badrik Selian, interview by Karlen Mooradian, 1966.
11 Dorothy Dehner, interview by author, 1992.
12 Raphael Soyer, interview by Karlen Mooradian, 1966.
13 The forerunners were taught by Kenneth Hayes Miller and included George Bellows, Edward Hopper, Alexander Brook, Yasuo Kuniyoshi, Niles Spencer, Peggy Bacon and George Tooker. This later developed into the 14th Street school with the Soyer brothers Raphael, Moses and Isaac, Reginald Marsh, Isabel Bishop and Morris Kantor. In contrast to the American Regionalists who were elevating the life of the country and its surrounding myths Miller sent them out to look at the downside of New York, the streets around the Village and 14th Street. Reginald Marsh lived nearby as did Edward Hopper and several others. They ignored the glamour of 5th Avenue and the fashionable New York for the life of the working class, the Bowery, street life in all its forms.
14 Raphael Soyer interviewed by Karlen Mooradian, 1966, gave this account.
15 John Richardson, *A Life of Picasso, 1881–1906*, vol. 1 (London, 1991), p. 456.
16 Will Barnett, interview by author, 1992.

19. The Troubadour

1 Wassily Kandinsky, *Concerning the Spiritual in Art*, p. 57.
2 Cat. Rais., No. 90, p. 219.
3 Cat. Rais., No. 94, p. 223–24.
4 Anna Walinska, interview by author, 1992.
5 Mrs Chaim Gross, interview by author, 1992.

6 Rook McCulloch, interview by Karlen Mooradian, 1966.

7 The Burliuks' collaboration with Kandinsky continued when he invited them to exhibit with him. In the first and second exhibitions of the Blaue Reiter group they showed alongside the works of Goncharova and Larionov. Kandinsky also exhibited with them in Karo Bube exhibitions in Moscow in 1911 and 1912. The Burliuks were editors of the Futurist manifesto published in Moscow in December 1912 along with Kandinsky's poems 'Klange'. Burliuk's works had been selected by Kandinsky for a group show in Munich in the legendary exhibition of the Blaue Reiter group in 1911. An almanac by the same name was also published in which Burliuk made one of the most interesting contributions, called the 'Savages' of Russia. He argued that 'realism is nothing more than a species of Impressionism'. This view was guaranteed to commend him to Gorky. Despite its rhetorical argument for 'uniformity', Burliuk's seven points summarise important principles of composition in relation to planes. He pinpointed 'the relation of painting to its graphic elements, the relation of the object to the elements of the plane', giving the example of Egyptian profile painting, construction drawing, free drawing represented by Kandinsky, several viewpoints applied in the same work (a very important aspect of Gorky's later work), plane and its intersections, equilibrium of perspectives (once more an important concept in Gorky) and the law of colour dissonance.

8 *Blaue Reiter Almanac*, p. 173 (date ?).

9 Cat. Rais., No. 103, p. 230.

10 '1. *Still Life*, received 2–2–31, selling price $350.

 2. *Pears*, received 4–13–31, selling price $350. Exhibited Buffalo.

 3. *Composition*, received 4–13–31, selling price $350.

 4. *Fruit*, received 4–13–31, selling price $250, to John D. Rockefeller.

 5. *Still Life*, received 4–13–31, selling price $100.

 6. *Composition*, received 4–13–31, selling price $100.

 7. *Head*, received 9–12–31, selling price $450.'

11 Cat. Rais., No. 55, p. 178.

12 According to his wife Roselle Davis, he 'thought Gorky did a very good job'.

13 Cat. Rais., No. 145, p. 284. According to Jordan, 'the stamped date of Sept 21, 1931, on the stretcher, are pencilled labels noting inventory No. "7, *Head*, $450", and "Downtown Gallery, 113 W. 13th St., N.Y.C." which corresponds with the inventory on Gorky in the Downtown Gallery Papers, Archives of American Art', p. 285.

14 Lillian Kiesler, interview by author, 1992.

15 She purchased from the Eight as early as 1908, Robert Henri, Ernest Lawson, George Luks and Everett Shinn.

16 Robert Stern, Gregory Gilmartin and Thomas Mellins, *New York 1930, Architecture and Urbanism between the Two World Wars* (New York, 1987). For a few years she owned a private art club at 147th West 14th Street, where, since 1918, she had shown John Sloan, Stuart Davis, Edward Hopper, William Glackens, Reuben Nakian, Reginald Marsh, Ernest Lawson, Walter Kuhn, and Charles Demuth. 400 artists belonged to this club. In 1928 it was disbanded to make way for the museum. She wished 'to help create rather than conserve a tradition'. Her director, Juliana Force, and she hoped to gain for 'the art of this country the prestige . . . devoted too exclusively to the art of foreign countries and of the past'.

20. *Nighttime, Enigma and Nostalgia*

1 Vartoosh Mooradian, interview by author, 1992, is the source of her account.
2 Matthew Spender and Barbara Rose, *Arshile Gorky and the Genesis of Abstraction: Drawings from the Early 1930s* (New York, 1994), p. xv.
3 *Orestes*, 1947 (Private Collection), *Painting*, 1948, Museum of Modern Art and others.
4 *Arshile Gorky and the Genesis of Abstraction*, op. cit., Joseph P. Ruzicka, p. 22.
5 Melvin Lader is preparing the Catalogue Raisonné of Gorky's drawings.
6 Ferdinand Lo Pinto, interview by Mooradian.
7 Museum directors were sacked; artists persecuted. Kandinsky, Klee, Hausmann, Grosz and Heartfield became exiles. Many intellectuals died in concentration camps. Attacks on the Bauhaus School by the Brown Shirts, who termed it 'a home of cultural Bolshevism', was followed by the summary arrest of students. The director Mies Van Der Rohe closed the school that year.
8 Thomas Craven, *Modern Art; the Men, the Movements, the Meaning* (New York, 1934).
9 Dorothy Dehner, interview by author, 1992.
10 Untitled, c. 1933–34, pencil on paper, $11\frac{1}{2}$" × 9", Private Collection, in Diane Waldman, *Arshile Gorky, A Retrospective*, Solomon Guggenheim Foundation (New York, 1981), Fig. 60, and *Untitled* (head of a woman), 1932–34, pen and ink on paper, 25" × 19", Fig. 61.
11 Robert Waitman, *Report on America* (London, 1940).
12 David and Cecile Shapiro, *The Artists Union in America*, and S. Foner Philip and Schulz Reinhard, *The Other America: Art and the Labour Movement in the United States* (London, 1985), p. 93.
13 Under Edward Bruce, it was funded by the Harry Hopkins' Civil Works Administration and lasted a very short time.

14 National Archives Record Group 121, Entry No. 117, Box 4, cited in Ruth Bowman (ed.), *Murals Without Walls, Arshile Gorky's Aviation Murals Rediscovered* (New Jersey, 1978), p. 22.

15 Harold Rosenberg, interview by Karlen Mooradian, 1966.

16 The PWAP employed 4,000 artists in the pilot venture. Lump sums paid as weekly salaries were from $26.50–$42.50. Some 15,663 works of art were planned for production on public buildings over six months. Philip and Schultz, *The Other America*, op. cit., p. 23.

17 Lillian Olinsky Kiesler, interview by author, 1992.

18 Born in Germany in 1880, as a young man Hans Hofmann had travelled between Munich and Paris, in close contact with the new developments in modern art including the work of Matisse, Picasso and Kandinsky. He owned four works by Kandinsky. He saved many of his early works from being destroyed, by keeping them in his studio during the war. Hofmann first came to teach in America in 1930 at the University of California in Berkeley.

19 Mrs Kiesler said, 'Hofmann must have encountered Gorky and knew him personally by then. The school was on 57th Street and Lexington Avenue at that time. I first heard about Gorky in 1932, when Mr Hans Hofmann had first come to this country and was teaching at the Arts Students League.'

20 Frederick Childs, interview by Karlen Mooradian, 1965.

21 Peter Busa, conversation with the Mooradians, 1966.

21. Mayrig, *Mother*

1 Peter Busa's remarks are from interviews by Karlen Mooradian, 1966.

2 David Smith, *Atmosphere of the Early Thirties* (London, 1973), pp. 85–6.

3 Prophecy Coles, 'How my mother's embroidered apron unfolds in my life', *Free Associations*, no. 20 (London, 1990), pp. 49–73.

4 In Cat. Rais. Jordan suggests a connection with Egyptian funerary, p. 53.
 An interesting discussion by Haydn Herrera, 'Gorky's Self-Portraits: The Artist by Himself', *Art in America* (March–April 1976), p. 56. Gorky also admired the Pompeian frescoes in the Metropolitan Museum.

5 Thomas F. Matthews and Roger S. Wieck, *Treasures in Heaven, Armenia Illuminated Manuscripts* (Princeton, 1994), p. 50.

6 Talcott B. Clapp, 'A painter in a glass house', *Sunday Republican Magazine* (Waterbury, Conn.), 9 Feb. 1948.

7 Saul Schary, interview by Karlen Mooradian, 1966, is the source of his account.

8 Willem de Kooning, interview by Karlen Mooradian, 1966.

9 Karlen Mooradian, *The Many Worlds of Arshile Gorky* (Chicago, 1980), p. 165.

10 *Ibid.*, p. 148.

11 Author's note: After completing this manuscript I read the first thorough discussion of this theme – Peter Balakian's excellent article, 'Arshile Gorky and the Armenian Genocide', *Art in America*, February 1996, pp. 58–69: He writes, 'The 1915 Genocide reverberated in Gorky's inner life and was a moral and esthetic assumption for many of his best pictures' and 'Both portraits . . . disclose a single psychological process: the experience of a survivor confronting the nightmare of his past.'

12 Vartoosh Mooradian, interview by author, 1990.

22. Poor Art for Poor People

1 Archives of American Art, roll DC 113, frames 287–9, cited in Ruth Bowman (ed.), *Murals Without Walls* (New Jersey, 1978), p. 22.

2 28 February–28 March 1934.

3 See question mark in Cat. Rais. *Organisation*, No. 4, 1931 (165?), p. 549.

4 Mellon Galleries, Philadelphia, *Arshile Gorky*, exhibition catalogue, 1934.

5 Cat. Rais. Still lives acquired by Bernard Davis, Nos. 65, 66, 75, 77, 79, 80.

6 Liberty Miller, interview by author, 1992, is the source of this account.

7 Vartoosh Mooradian, interview by author, 1992.

8 Peter Busa, conversation with Vartoosh and Karlen Mooradian, 1974.

9 Willem de Kooning, interview by Karlen Mooradian, 1966.

10 Rosalind Browne and Roselle Davis both mentioned it.

11 Gaston de Havenon, interview by author, 1992.

12 Clement Greenberg, interview by Karlen Mooradian, 1966.

13 At least three other portraits of this period studied Picasso's African-inspired heads, Cat. Rais. *Man's Head*, No. 205, *Painting*, 206, *Composition No. 6*, No. 207.

14 I am grateful to Ruth Thomassian for information on Armenian photographs.

15 Cat. Rais., *Woman's Head*, No. 178, *Portrait of Ahko*, No. 179, *Pears, Peaches and Pitcher*, No. 15.

16 Koolikian, interview by author, 1992.

17 The Armenian writers returned from the Moscow First Congress of Soviet Writers to impose the decrees. I am indebted to Ronald Suny for his expert knowledge of this period in Soviet Armenia.

18 The account is based on Jacob Kainen's interview with author, 1992.

19 'One drawing was a figure which is male or female with cross-hatch, highly simplified. I sold it to Joseph Salmon. He sold it to Gertrude Stein Gallery on Fifth Ave. He acted like he liked Gorky but he didn't. Wouldn't tell me where

they sold it. I haven't seen it and never seen a reproduction. Profile, face is white, very rough cross hatching.' *Ibid.*
20 Only de Havenon who knew the artistic milieu but was not an artist himself interpreted this event in a different light.

23. Happy Tappy Girl

1 Marny George, letter to James Thrall Soby, 15 March 1951, Library, Artist's File, Whitney Museum of American Art, New York, is the source of her account.
2 Mischa Reznikoff, interview by Karlen Mooradian, 1966, is the source of his account.
3 Vartoosh Mooradian, interview by author, 1992.
4 Saul Schary, interview by Karlen Mooradian, 1966.
5 Cat. Rais., No. 124a, p. 256.
6 Azad Adoian, interview by author, 1992.

24. A Driving Force

1 Cat. Rais., No. 67, p. 191.
2 Cat. Rais., No. 78, p. 205.
3 Cat. Rais., No. 119, p. 250.
4 Lloyd Goodrich interview by Karlen Mooradian, 1966, is the basis of his account.
5 David and Cecile Shapiro, *The Artists' Union in America*, Foner & Schultz, *The Other America*, op. cit., p. 93.
6 Karlen Mooradian, *The Many Worlds of Arshile Gorky* (Chicago, 1980), p. 208.
7 Serge Guilbaut, *How New York Stole the Idea of Modern Art: Abstract Expressionism, Freedom and the Cold War* (Chicago, 1983), p. 19.
8 Text prepared in collaboration with Meyer Schapiro, 'Race, Nationality and Art, First American Artists' Congress', pp. 38–41. Republished in *Art Front*, no. 4 (1936), quoted in *ibid.*, p. 21.
9 Meyer Schapiro, interview by author, 1992.
10 Gaston de Havenon, interview by author, 1992.
11 Jeanne Reynal would write later in May 1944, 'That curious flat, long-fingered hand', *Archives of American Art*.
12 Ruth Bowman (ed.), *Murals Without Walls* (New Jersey, 1978), p. 23.
13 Marlene Park and Gerald E. Markowitz, *New Deal for Art* (Hamilton, NY, 1977).
14 Dorothy Miller, interview by Karlen Mooradian, 1966.
15 This account is based on Anna Walinska's interview by author, 1992.

16 The *New York Times*, p. X. 19.

17 Ethel Cooke interview and correspondence with Karlen Mooradian, op. cit.

18 Mischa Reznikoff, interview by Karlen Mooradian, 1966.

19 Mercedes Matter's interview by author, 1992, is the main source of her account.

20 Willem de Kooning, interview by Karlen Mooradian, 1966.

25. Dance of Knives

1 Ruth Bowman (ed.), *Murals Without Walls* (New Jersey, 1978), p. 25.

2 Saul Schary, interview by Karlen Mooradian, 1966.

3 Mural Project for Newark Airport with cover letter dated January 31, 1936, from Olive Lyford, assistant regional director WPA/FAP#1, files of the Newark Museum. Mrs Audrey MacMahon, director for New York and New Jersey.

4 'The early development of forms considered by inventors from the earliest records, to the successful flight of the first plane.

Modern development showing the phases through which plane design has passed since the first plane was built, to the present.

The mechanics of flying: the instruments, characteristic forms of aeroplane construction and flying, including related sciences such as meteorology and communication.

The activities on the field showing all the general daily routine in active life as seen about Newark Airport.' *Ibid.*

5 Peter Busa in conversation with Vartoosh and Karlen Mooradian, 1974, is the main source

6 Federal Art Project Gallery, 7 East 38th Street, New York.

7 La Guardia's visit was reported in the *New York Herald Tribune*, 28 December 1935. Busa gave an informal account of their exchange.

8 Jim Jordan, 'The Place of the Newark Murals in Gorky's Art', Bowman (ed.), *Murals Without Walls*, op. cit., p. 48.

9 Balcomb Greene, *Arts Magazine*, vol. 50, no. 7, March 1976, pp. 109–10.

10 Philip Foner and R. Schultz, *The Other America* (London, 1985), p. 93.

11 Mercedes Matter, interview by author, 1994.

12 Karlen Mooradian, *The Many Worlds of Arshile Gorky* (Chicago, 1980), p. 116.

13 Quoted in Ethel Schwabacher, *Arshile Gorky* (New York, 1957), p. 62.

14 Julien Levy, *Surrealism* (New York, 1936); *L'Imaculée Conception*, translated by Samuel Beckett, pp. 119–20, Julien Levy recalled that Gorky read the entire book in his office.

15 Carinne West, letter to Schwabacher, *ibid.*, p. 64.

26. Child of Eden

1 Cat. Rais., No. 191 (1935–37), p. 338. Anna Walinska associated receiving the present with Karlen's birth.
2 Vartoosh Mooradian, interview by author, 1992, is the source of her account.
3 Harry Rand, *Arshile Gorky, The Implications of Symbols* (London and New York, 1981), p. 78: 'Xhorkom wilfully misspells the name of Gorky's native village of Khorkom,' and 'He suppressed his Armenian identity by spelling his village's name unphonetically, perhaps fearing that some connection would be made between this remote village and his true ancestry. Although this is an unlikely possibility, it was not beyond Gorky to misconstrue appearance'. The village still exists but has lost its Armenian name.
4 Cat. Rais., No. 173 (38 × 48 inches, 96.5 × 122 cm.), p. 317, Whitney Museum of American Art.
5 Present were Sarkis Gasparian, Vahan Gasparian and Badrik Selian.
6 Vahan Gasparian, interview by Karlen Mooradian, 1966.
7 *Verelk* was edited by Badrik Selian: interview by Karlen Mooradian, 1966.
8 Cat. Rais., Nos. 150, p. 292, and 151, p. 293, private collections.
9 Agnes Gorky believed that it came from a poem by Lautréamont.
10 Jim Jordan: 'Nothing is presently known of the origin of this title which derives, presumably, from Armenian folklore. Use of the word "maize", however, could possibly indicate an interest in native American legend.' Cat. Rais., p. 293. Maize was not grown in Van but wheat and barley were used extensively and whole wheat, in particular, was used in sacred foods. I am grateful to the Rev. Vrej Nersessian for throwing light on Armenian myths and bibliography.
11 Cat. Rais., No. 167, p. 310, Hirshhorn Museum and Sculpture Garden, Smithsonian Institute, Washington, DC.
12 Cat. Rais., No. 149 (1936), p. 291.

27. Elevation of the Object

1 See Jim Jordan's excellent essay in Ruth Bowman (ed.), *Murals Without Walls* (New Jersey, 1978), pp. 47–62.
2 Frederick Kiesler had written an introduction for Gorky's catalogue at the Mellon gallery show, then was appointed to the WPA/FAP Design Studio with William Lescaze, Meyer Schapiro and Alfred Auerbach to survey locations for murals. Kiesler wrote a long article published in *Art Front* in the December issue, 1936, on Gorky's mural project. It was an open defence in the journal of art-as-a-weapon camp against a growing tide of opposition to Gorky.
3 'Form does not follow function, function follows vision. Vision follows reality.'

Kiesler and Gorky shared a biomorphic approach. Gorky was painting *Organization* with its dark, curving central motif and sticks with circular ball endings; Kiesler showed kidney-shaped tables which fitted into one another and lamps of chrome with the same ball-like weights. They developed a common language of forms.

The liberal, Kiesler was horrified by the agenda dictated by the Supervising Architect's office who set out a programme for artists: 'the first completely organized plan to co-ordinate painting, sculpture and architecture'. But he went on to make a point which had apparently missed the supervisors: 'Gorky's mural design is very realistic since he transplanted directly photographic details of aeroplanes or even one whole aeroplane and in the same naturalistic distortion of the camera shot, it won't help; it isn't abstract, but it looks like an abstraction and that alone doesn't fit into "the art of all great period." I wonder if Picasso would go on relief roll under such circumstances.' Kiesler, 'Murals Without Walls: Relating to Gorky's Newark Project', *Art Front*, 2, No. 11 (18 December 1936), pp. 10–11.

4 Jacob Kainen, interview by author, 1992.

5 The Museum of Modern Art, *New Horizons in American Art, 1936*, introduction by Holger Cahill.

6 The WPA Workers Project requested:

> We are preparing a national illustrated report that will include articles by project workers in all fields. We would like you to do a five hundred word piece on the work you have done for the Newark Airport Project interpreting the relationship of the forms in your mural to their aerodynamic sources. I think that it is also important that you explain the experimental significance of the abstract work that is being done on the project and the efforts that have been made to allocate the work.
>
> We will allow you three days of project time in which to write the article and hope that you can send it to Washington by Thursday of next week . . .
>
> Will you also send me a short autobiographical note and photograph of yourself for inclusion in our 'Who's Who Among the Contributors'.

National Archives and Record Service, Record group 69, Box 65.315 file November 1936. Reprinted in Bowman (ed.), *Murals Without Walls*, op. cit., p. 25.

7 A note from Francis Connor explains that despite the publication of bastardised versions of Gorky's text in Schwabacher and Rosenberg and others, this comes from a 'newly discovered holograph manuscript of Gorky's essay, "My Murals for the Newark Airport: An interpretation" (December 1936). Text prepared

for *Art for the Millions.*' Bowman (ed.), *Murals Without Walls*, op. cit., pp. 13–16. All the following quotations from Gorky are from this article.

8 Cat. Rais., No. 127, *The City* (c. 1935).

9 Cat. Rais., Nos. 141v and 141w, *Mechanics of Flying* (1936–37) in Newark International Airport Art Collection, the Port Authority of New York/New Jersey.

10 Cat. Rais., No. 141.

11 Hans Burkhardt interview with Karlen Mooradian, 1966.

12 Rosalind Browne (Bengelsdorf), interview by Karlen Mooradian.

13 Cat. Rais., No. 163. *Composition with Head* (c. 1936–37) ($76\frac{1}{2}"$ × $60\frac{1}{2}"$) (194 × 153 cm), and No. 164, *Still Life on Table* (c. 1936–37) (54" × 64") (137 × 162 cm).

14 See Ethel Schwabacher, *Arshile Gorky* (New York, 1957), pp. 55–9.

15 John Ferren, interview by Karlen Mooradian, 1966.

16 Delaunay had criticised Cubism for confining itself to line, but not colour. His discoveries in the 'movement of colour' were similar to the movement in musical tones. In music, chromatic scales of 12 tones were being used as a basis of composition. Delaunay wrote to Kandinsky, 'If Art relates itself to an *Object*, it becomes descriptive, divisionist, literary', Herschel B. Chipp, *Theories of Modern Art* (Berkeley, 1968), pp. 318–19.

17 John Ferren, Diary, AAA 371.

18 Even the format of the drawings has an echo as the left arm is emphasised in both and though certain shapes like the left shoulder and sleeve are crisply outlined, a softness in the shading of the face and shirt gives a range of textures. But the left arm and shoulder are exactly like the arm of the boy in *The Artist and His Mother*.

19 Conrad Marcarelli, interview by Karlen Mooradian, 1966.

20 Karlen Mooradian, *The Many Worlds of Arshile Gorky* (Chicago, 1980), p. 143.

21 Aristodemos Kaldis, *ibid.*, pp. 154–5.

22 Saul Schary interview by Karlen Mooradian.

The statement in Harry Rand, *Arshile Gorky: The Implications of Symbols* (London and New York, 1981): 'In 1942 Gorky visited Connecticut for the first time' (p. 84) is incorrect. Gorky visited it on numerous occasions between 1936 and 1942.

23 Cat. Rais., No. 236, *Landscape, Gaylordsville*.

24 Stuart Davis, *Magazine of Art*, February 1951, p. 58.

25 Federal employment and payment records, cumulative reports of New York City WPA/FAP, National Archives and files of the Whitney Museum of American Art.

26 Letter from Harry Cyphers, City of Newark Mayor's Office, 17 November 1936. Files of the Newark Museum.

27 The banks of the Seine became the theatre of a vast political charade, as France, Germany, USSR and Italy erected huge neoclassical pavilions confronting each other on the Trocadero. The Spanish Pavilion achieved instant notoriety by exhibiting the newly painted *Guernica* by Picasso, just as the civil war shattered the country. Gorky knew of Robert and Sonia Delaunay's commission to decorate the Air Palace and the Railways Palace with the help of fifty unemployed artists. The French artists illustrated air travel by building circular catwalks from which spectators could view two floating fighter planes suspended among vast chromatic circles. For the Railways Palace, 19,000 square feet were to be covered in a single mural which was based on machine parts: gears, wheels, signal panels, clocks in coloured rhythms under the supervision of Robert Delaunay, founder of Inobjective Painting in 1912.

28 Letter dated 1937, 18 possibly October or November.

29 Cat. Rais., No. 216 (1938).

30 Cat. Rais., No. 173.

28. *Argula*

1 Leonore (Portnoff) Gallet later came to own a substantial collection of drawings, and guarded her privacy, entrusting management of her collection to Knoedler's Gallery.

2 Elaine de Kooning, interview by Karlen Mooradian, 1966.

3 This account is from Liberty Miller's interview by author, 1992.

4 Karlen Mooradian, *The Many Worlds of Arshile Gorky* (Chicago, 1980), p. 256.

5 Diane Waldman, *Arshile Gorky* (New York, 1981), Pl. 90.

6 Cat. Rais., No. 210 and No. 149.

7 Rook McCulloch interview with Karlen Mooradian, 1966. This idea was later used in a 'letter', April 22, 1944, 'Curved lines define passion and straight lines structure.' Karlen Mooradian, *Arshile Gorky Adoian* (Chicago, 1978), p. 284, Appendix: Letter 15.

8 Agnes Fielding told me in conversation that 'argula' was the 'first word' Gorky thought he spoke and she believed it was meaningless.

9 S. Hoogasian-Villa and M. Kilbourne Matossian, *Armenian Village Life Before 1914* (Detroit, 1982).

10 Waldman, op. cit.: 'That Gorky knew and admired Miró . . . he incorporated a number of the Spaniard's images in his own canvases at an early date; the fanciful face that enlivens an otherwise orthodox Cubist Composition with

Head . . .; the recurring eye, pinwheel or star motifs . . . the bootlike form . . . the ladder forms ca. B . . .' p. 46. She writes, 'Gorky was committed to the medieval manuscripts and ancient tomb sculpture of his own Armenia', p. 45. Gorky's sources have often been restricted, even by such an excellent scholar. Many of his sources predate the medieval period and *khatchkars* (stone crosses) were commemorative, not merely used for burial.

11 *Painting*, 1938, two versions of *Battle at Sunset with the God of Maize*, 1936–37, Cat. Rais., Nos. 150 and 151; *Enigmatic Combat*, 1937, Cat. Rais., No. 176; *Tracking Down Guiltless Doves*, c. 1938–39, No. 220.

12 Elaine de Kooning interview by Karlen Mooradian, 1966.

13 Cat. Rais., No. 173.

14 I am indebted to Mr Anselmo Carini of the Chicago Art Institute, Works on Paper Department, for highly informative discussions on this and other drawings.

15 Karlen Mooradian, *Arshile Gorky Adoian*, p. 257, reprinted in *The Many Worlds of Arshile Gorky*, p. 259.

16 Karlen Mooradian. *The Many Worlds of Arshile Gorky*, p. 165.

29. The World's Fair

1 Arpenik Karebian, interview by Karlen Mooradian, 1966.

2 Curiously, when Lee Krasner was interviewed on Gorky she did not mention this holiday with him, perhaps because she was not with Pollock at the time.

3 Rosalind Browne, interview by Karlen Mooradian, 1966.

4 David Margolies, interview by Karlen Mooradian, 1966.

5 Letter to Vartoosh Mooradian, 12 October 1938.

6 Originally Julien Levy's Surrealist Pavilion.

7 William Lescaze told Karlen Mooradian that having admired Gorky's work since 1931 in galleries and the Newark mural airport, he chose him to design the mural.

8 William Lescaze, also designer of the Swiss Pavilion, was one of the few modern architects in the Fair; Frank Lloyd Wright and other Modernists had been excluded.

9 Letter dated 'March, Sunday', by Gorky. I believe the date, 1 March 1938, is incorrectly attributed by Karlen Mooradian. His evidence is an envelop postmarked 1 March. Letters and envelopes were often separated. Gorky had written on 28 February 1938 which he probably posted on the next day. The mural was completed one month before the opening, 30 April 1939, and he probably wrote this letter in March 1939.

10 Vosdan was favoured by Karlen Mooradian as being Shushan's choice; but no member of his family or friends ever used it in interviews.

11 Letter as No. 9.

12 Account based on author's interview of Art Muschenheim, son of William, 1996.

13 Such geometric motifs surrounded by the Helicline, a walkway ramp for viewing, and entrance, were undermined by towering neoclassical statues. People followed the Constitutional Mall down the colonnades, 150-foot pylons, along the Lagoon of Nations. A most popular site was the General Motors Building; queues waited for hours before the bold curvilinear structure by Walter Kahn, housing the *Futurama*, a scaled-down city and landscape which could be seen by taking a three-mile ride in the carry-go around.

New technology was displayed with every conceivable futuristic gadget. Mr and Mrs Modern went through the motions of compressing sixteen working hours into eight, 'to play, to live, to enjoy the fruits of labour'. There were also garish amusements, showgirls, parachute jumping, cinematic displays and light shows. Robert Stern, Gregory Gilmartin and Thomas Mellins, *New York 1930, Architecture and Urbanism between the Two World Wars* (New York, 1987).

14 F. A. Gutheim, 'Buildings at the Fair', *Magazine of Art*, 32 (May 1939), p. 288.

30. Blitzkrieg

1 Dorothea Tanning, *Birthday Party* (San Francisco, 1986), and interview by author, 1996.

2 Genevieve Naylor, interview by Karlen Mooradian, 1966.

3 Karlen Mooradian, *The Many Worlds of Arshile Gorky* (Chicago, 1980), Robert Jonas, p. 153.

4 Alfred H. Barr, *Cubism and Abstract Art* (New York, 1936).

5 'To the Editors', *Art Front*, vol. 3, no. 7, October 1937, p. 21.

6 Isamu Noguchi, interview by Karlen Mooradian, 1966.

7 Balcomb Greene, interview by Karlen Mooradian, 1966.

8 Cat. Rais., No. 229, p. 376.

9 Portnoff Collection ($5\frac{1}{8}$ by $8\frac{1}{8}$ inches).

10 Portnoff Collection (6 by $4\frac{1}{2}$ inches).

11 Willem de Kooning, interview by Karlen Mooradian, 1966.

12 Conversation between Vartoosh and Karlen Mooradian.

13 Isamu Noguchi, interview by Karlen Mooradian, 1966.

14 Gaston de Havenon, interview by author, 1992.

15 Philip Pavia, pp. 262–3.

16 Elaine (Fried) de Kooning interview by Karlen Mooradian, 1966.

17 Karlen Mooradian, *The Many Worlds of Arshile Gorky*, p. 134.

31. Fantastic Fancies

1 Georgio Cavallon, interview by Karlen Mooradian, 1966.

2 Peter Busa, interview by Karlen Mooradian, added, 'This was produced in *Direction* magazine in 1940. It came out in Connecticut. Nishinsky and Ernest Bloch also did one.'

3 See appendix for Gorky's unpublished letter on murals.

4 Georgio Cavallon, interview by Karlen Mooradian, 1966.

5 Cat. Rais., Nos. 72, p. 196, 73 (1929), p. 198.

6 *Organization II* (1936–37) Cat. Rais., No 175, pp. 320–1.

7 Cat. Rais., No. 250, p. 398.

8 Philip Mansell, *Constantinople, City of the World's Desire, 1453–1924* (London, 1995), p. 21.

9 Robert Jonas, interview by Karlen Mooradian, 1965.

10 Charles Mattox, interview by Karlen Mooradian, 1966.

11 He wrote a further undated letter in 1940 to Vartoosh, which has not been published, giving news of his work. He had gone to Buffalo to measure a wall in Mr Bell's aeroplane factory for a mural. He had completed sketches in a week. He was hoping to show the work at the end of the month to be paid $500 for the sketches and a further for the mural. He had also sent sketches to Washington in the hope of a $2,000 commission. He had no clients for pictures and was thinking of giving up his studio to go somewhere cheaper for a rent of $24 but was not hopeful.

12 Robert Stern, Gregory Gilmartin and Thomas Mellins, *New York 1930* (New York, 1987), p. 291.

13 In very abstract form they predominate in the early sketches for the Riviera Club mural. At least two have survived in Leonora Portnoff's possession. Pencil drawing 10 by 14 inches and $7\frac{1}{2}$ inches by $9\frac{1}{2}$ inches, of convex and concave rotating forms with an eye which suggests creatures rather than pure geometric forms.

14 Malcom Johnson, 'Cafe Life in New York', *New York Sun*, 22 August 1941.

15 'There is no proof that he based any of his own ideas on Kandinsky's theories. Nor did Gorky appear to know that many of Kandinsky's seemingly non-objective images represented specific objects that he had gradually disguised by abstraction that increased from one picture to another.' Melvin P. Lader, *Arshile Gorky* (New York, 1985), p. 67.

16 Letter from Jeanne Reynal quoted in *Graham, Gorky, Smith & Davis in the Thirties*, Brown University, Rhode Island, April 30–May 22 1977.

32. Seventh Love

1 This account is largely based on Agnes Gorky's recollections in interviews over a fifteen-year period.
2 Elaine de Kooning, interview by Karlen Mooradian, 1966.
3 Agnes's grandfather John Homes Magruder was a grocer in Washington, DC, selling fancy imported goods. Her grandmother Arabella Slough was the daughter of a general of the Western Territories; they had a daughter and son. Agnes's father entered the navy, and married Miss Hosmer, daughter of Sydney Hosmer, electrical engineer. The Hosmers claimed descent from a New England writer and divine, Thomas Hosmer. Most of this account is based on an interview with Esther Magruder, younger sister of Agnes.
4 Jane Gunther, interview by author, 1994.
5 Ethel K. Schwabacher, *Arshile Gorky* (New York, 1957), p. 84.
6 Arshile Gorky, letter to Vartoosh Mooradian, 27 May 1941.
7 Ethel K. Schwabacher, *Arshile Gorky*, letter from Gorky to Agnes, pp. 85–6.
8 *Ibid.*

33. Out West

1 Jeanne Reynal, interview by Karlen Mooradian, 1966.
2 Letter, 23 June 1941, Karlen Mooradian, *Arshile Gorky Adoian* (Chicago, 1978), pp. 269–70.
3 Isamu Noguchi, interview by Karlen Mooradian, 1966.
4 Letter to Vartoosh Mooradian, 20 July 1941.
5 Based on the author's interviews with Agnes Gorky between 1982 and 1997.
6 Manuel Tolegian, interview by Karlen Mooradian, 1966.
7 John Ferren, interview by Karlen Mooradian, 1966.
8 Jeanne Reynal interview by Karlen Mooradian, *ibid.*
9 The works included were listed as: *Portrait of My Mother*, 1921, charcoal drawing; *Portrait of My Sister*, 1923, oil; *Torso*, 1926, oil; *Still Life*, 1929, oil; *Still Life*, 1929, oil; *Mougouch*, 1933, pen and ink; *Composition*, 1933, oil, lent by Grossman, NYC; *Image in Xhorkom*, 1934, oil; *Xhorkom*, 1935, oil; *Composition*, 1937, oil; *Head Composition*, 1938, oil; *Portrait*, 1938, oil; *Painting*, 1938, oil, lent by the Museum of Modern Art; *Nostalgia*, 1939, oil; *Painting*, 1939, oil; *Berevano*, 1941, gouache; *Composition*, 1937, oil; *Enigmatic Combat*, 1937, oil, lent by Miss Jeanne Reynal.
10 Jeanne Reynal, letter, 5 April 1945, Archives of American Art, Washington.

11 Dorothy Miller, interview by Karlen Mooradian, 1966.

12 Postcard with postmark 'Virginia City, Nev. Sept 15. 1941'.

13 Vartoosh Mooradian interview by author, 1992.

14 Letter to Vartoosh Mooradian, 17 September 1941, from San Francisco.

15 His old friend Warren McCulloch, and another acquaintance, Percival Bailey.

16 Mrs Kelekian became Vartoosh's lifelong friend, then an executor of her will.

34. Blithe Spirit

1 Cat. Rais. (c. 1940), No. 242, p. 388.

2 From a letter to Vartoosh Mooradian by Agnes Gorky. The letter was shown to the author by Vartoosh Mooradian. It bears a handwritten note probably by Karlen Mooradian, postmarked '21 November 1941', and Vartoosh's explanation of Moorad's visit to New York on business.

3 The following remarks are from the author's interviews with Agnes Fielding.

4 Robert Mirak, interview by author, 1994.

5 Agnes Gorky Fielding, comment to author, 1997, after reading manuscript of this book.

6 Letter from Gorky to Vartoosh, 28 December 1941.

7 'Buy American Art Week' text, 1940, quoted in Serge Guilbaut, 'How New York Stole the Idea of Modern Art', p. 56.

8 Sam Kootz, letter quoted by Edward Allen Jewell, 'The Problem of Seeing', *New York Times*, 10 August 1941, p. 7. Kootz had published *Modern American Painters*, in 1930.

9 Ethel K. Schwabacher, *Arshile Gorky* (New York, 1957), pp. 81–2.

10 Oksen Sarian interview by Karlen Mooradian, 1966.

11 Arshile Gorky, *Camouflage*, Grand Central School of Art, New York, 1942.

12 Charles (Ashot) Adoian, interview by author, 1993. Gorky's family believed that on marrying an American heiress, he distanced himself from them.

13 Agnes Fielding, interview by author, 1993. In December 1997 she wrote, 'I knew Gorky meant Bitterness but he insisted it was his *real* name. I did not *know* it was not until Ethel's book came out in 1957.'

35. The Waterfall

1 Museum of Modern Art, statement written by Arshile Gorky, 1942.

2 He wrote to Vartoosh about *New Rugs by American Artists*, 'It is very nice to see it in that exhibition. It will be exhibited all over America's large cities. They will sell it and pay me when it is sold. Many magazine writers came to the exhibition. Agnes' Modern Museum director friend says that the photography of my original picture of that carpet will be published in *Town and Country*. When

it appears, I shall mail it to you. I have been working 15 hours a day for these past three weeks to complete one painting, and it is successful. It is an order.' Letter 15 July 1942

3 Letter from Gorky to Dorothy Miller, 26 June 1942.

4 Agnes Fielding, letter to Vartoosh, 17 June 1942.

5 *Ibid.*

6 Cat. Rais., No. 94, tentatively dated 1931. Art Muschenheim recalled this large handsome yellow and black abstract as hanging in his grandfather's dining-room. His father William had persuaded his grandfather to buy it and it was subsequently sold at his death. It contains elements of *Organization*, the *Khorkom* series, *The City* and even later murals of Ben Marden's *Riviera* (1940).

7 Dorothy Dehner, interview by author, 1994.

8 Mrs Chaim Gross, interview by author, 1994.

9 Agnes Fielding, interview by author, 1982.

10 Saul Schary, interview by Karlen Mooradian, 1966, is the basis of this account.

36. White Angels, Black Angels

1 Although he had given an interview proclaiming himself a Surrealist in 1941 to the *Saturday Evening Post* after completing the nightclub murals (see Bibliography).

2 Cat. Rais., No. 258 (1942) (30" by 26"). Schary recalled the earliest version of the *Waterfall* as the one which belonged to him, oil on board, signed by Gorky.

3 *Garden in Sochi* (1943) (31" × 31"), The Museum of Modern Art, not in Cat. Rais. See Guggenheim Catalogue, *Arshile Gorky* 1981, No. 125.

4 Ann Alpert (Pajarito), interview by author, 1992.

5 Lisa Phillips, *Frederick Kiesler* (New York, 1989), pp. 62–8. Cynthia Goodman's essay gives a clear account with photographs. In the building, Kiesler gave free rein to his ideas on 'design correlation', a continuous dialogue between all the elements present. A critic commented, 'what Kiesler has done essentially is to take the frames off the paintings, the paintings off the walls, and the walls away from the gallery ... Without either frame or wall, the spectator gets a clearer shot of the picture image and can see it immediately for what it is.'

6 Agnes Gorky interview by author, 1994, is the main source of her account.

7 Dorothy Miller, interview by Karlen Mooradian, 1966.

8 In June 1941, Hitler invaded Russia with his divisions, very close to Moscow; Leningrad was cut off and besieged. In June 1942, a new German offensive aimed at the Caucasus attacked Stalingrad in August, with the Fourth and Sixth Panzer Divisions.

9 Catholicos Kevork VI of Etchmiadzin had launched a fund-raising drive

among diaspora Armenians in collaboration with his counterpart outside Armenia, Catholicos Karekin Hovsepian of Cilicia. Hovsepian, a distinguished anthropologist, requested that Hazarian exhibit his fine collection of Armenian art from all periods to the American public.

10 Cat. Rais., No. 87 (30" × 11"), signed 'A. Gorky/1929'.

11 Cat. Rais., No. 149 (24" × 34"), signed 'A. Gorky/36'.

12 I am grateful to Shahen Khatchaturian, Director of the National Gallery of Art, Yerevan, for his account of Hazarian's recollections.

13 Badrik Selian, interview by Karlen Mooradian, 1966.

14 Cat. Rais., No. 150.

15 Letter to Vartoosh from Agnes Gorky, 20 October 1942, praising Gorky for giving two paintings to the Armenian War Relief, but she doubted whether they would be purchased as Armenians were not known for either buying art or liking modern art.

16 Badrik Selian, interview by Karlen Mooradian, 1966.

17 Letter, Agnes to Vartoosh, Wednesday ... surmised date, 6 May 1942.

18 Based on Peter Busa's taped conversations with the Mooradians, 1966.

19 Cat. Rais., Nos. 133 and 134.

20 9 December 1942–24 January 1943, *My Sister, Ahko*, Cat. Rais., No. 179 (19" × 15"), posthumously renamed *Portrait of Ahko*.

21 Agnes Gorky, interview by author, 1994.

22 Raphael Soyer, interview by Karlen Mooradian, is the main source for this account.

23 Cat. Rais., No. 31" × 22", signed A. Gorky. Dated incorrectly by authors as 1946, was corrected by Agnes Fielding (who was pregnant at the time) to 1943.

24 Peter Busa, interview by Karlen Mooradian, 1964.

25 Cat. Rais., No. 262, 1943, 38" × 25", The Hirshorn Museum and Sculpture Garden, Smithsonian Institute, Washington DC.

26 Quoted in Ethel K. Schwabacher, *Arshile Gorky* (New York, 1957), p. 102; Mary Burliuk, *Color and Rhyme*, 1949, is the main source for this account.

37. Skybaby

1 Julien Levy remembered Gorky tell him that he had seen a dog, called Pirate. Agnes Fielding denied that this was central to the painting.

2 Ann Alpert, interview by author, 1992.

3 Agnes Gorky's accounts are based on interviews by author, 1983–97.

4 Philip Pavia.

5 Agnes doubted this, yet she recalled that he visited once, vowing not to return

since they disagreed about their childhood memories. Her letter to Vartoosh, 20 March 1943, anticipates Akabi's visit after the birth; it did not take place.

6 Agnes Gorky, interview by author, 1995.

7 Jane Gunther, interview by author, 1992.

8 Undated letter to Vartoosh from the Gorkys, later dated 1 May 1943.

9 Letter to Vartoosh from Gorky, 17 February 1943, possibly the only letter he wrote that year.

10 Letter to Vartoosh Mooradian, 30 July 1943.

11 A. M. Janney, interview by author, 1992.

12 Letter to Vartoosh Mooradian, undated.

13 Bob and Mary Taylor interview by author, 1992, is the source of their accounts.

14 Peter Busa in conversation with the Mooradians, 1966.

15 André Breton and Philippe Soupault, *Les Champs Magnétiques* (Paris, 1920; revised ed., 1967), Philippe Soupault, interview by author, 1990.

38. Papa Breton

1 Dorothy Miller, interview by Karlen Mooradian, 1966.

2 Jeanne Reynal, letter to Agnes Gorky, 27 February 1942, Archives of American Art, Smithsonian Institution, Washington, DC.

3 Conflicting accounts have been published about the first meeting. Agnes confirmed 'that was the first night'.

4 Ann Alpert (Pajarito Matta), interview by author, 1994.

5 Cat. Rais., No. 281 (1944).

6 Sydney Janis, interview by Karlen Mooradian, 1966.

7 Yervant Lalayan, *Azdagrakan Handes*, op. cit.

8 Jeanne Reynal, letter to Agnes Gorky, 19 April 1944. Years later Lloyd Goodman would see the canvas unstretched, rolled up under Jean Hebbeln's bed.

9 James Johnson Sweeney, 'Five American Painters', *Harper's Bazaar*, April 1944.

10 Dorothy Miller, interview by Karlen Mooradian, 1966.

11 Agnes Gorky, letter to Jeanne Reynal, 5 May 1944, on which the following account is based.

12 The horses have a striking similarity to Urartian bronze horses.

39. The Glorious Summer

1 Letters of Jeanne Reynal to Arshile and Agnes Gorky, 12 April 1944, Archives of American Art, Smithsonian Institution.

2 Letter to Reynal, undated; inscribed 'June 1944'.

3 *Ibid.*

4 Jeanne Reynal letter to Agnes Gorky, 27 February 1942, Archives of American Art, Smithsonian Institution, Washington, DC.

5 Agnes Gorky, letter to Jeanne Reynal, *ibid.*

6 Agnes Gorky, letter to Jeanne Reynal, dated 'June? 1944'.

7 Most of this account based on Esther Brooks's interview with author, 1992.

8 Agnes Gorky, letter to Jeanne Reynal, undated; to author in conversation.

9 Agnes Gorky, letter to Reynal, undated.

10 Bob and Mary Taylor, interview by author, 1992.

11 Agnes Gorky, letter to Jeanne Reynal undated and inscribed 'Summer 1944'.

12 Jeanne Reynal, undated letter to Agnes, Archives of American Art, Smithsonian Institution, Washington, DC.

13 Jeanne Reynal, letter to Agnes Gorky, Archives of American Art.

14 Agnes Gorky, letter to Jeanne Reynal, 28 September, later inscribed 1944.

15 Letter, *ibid.*

16 Jerry Talmer, 'Watch that paint', *New York Post*, 1980, p. 13, quoted in Diane Waldman, *Arshile Gorky* (New York, 1981), p. 57.

17 Measured $69\frac{3}{4} \times 65\frac{3}{4}$ inches in the Peggy Guggenheim Collection.

18 Jeanne Reynal, letter to Agnes, 4 October 1944, op. cit.

19 James Johnson Sweeney, 'Five American Painters', *Harper's Bazaar*, April 1944, vol. 78, pp. 122, 124.

40. In a Biddy Whirlpool

1 Lionel Abel, interview by author, 1992.

2 Agnes Gorky, letter to Jeanne Reynal, undated; later inscribed 'N.Y. Dec, 1944'.

3 Letter, *ibid.*

4 Letter to Jeanne Reynal, undated.

5 Agnes Gorky written note to author, December 1997.

6 Based on Isamu Noguchi's interview by Karlen Mooradian, 1966.

7 Agnes Gorky, letter to Jeanne Reynal.

8 Anna Alpert, interview by author, 1992.

9 Letter to Jeanne Reynal.

10 Most of this account is based on Peter Busa's interview with Karlen Mooradian, 1966, and the recollections of Agnes Gorky.

11 Letter to Jeanne Reynal.

12 Muriel Streeter later married Levy. This account is based largely on her interview with the author, 1992.

13 Agnes in a letter to Jeanne Reynal refers to Peggy Guggenheim's disappoint-ment in not being able to have *The Liver*. Her final choice of *Painting* was praised for going a step further in that direction.

14 Agnes wrote that Julien was now very enthused by Gorky's work and convinced that he had always liked his earlier work which he had known since 1932. She believed that he was good at promoting the work and this arrangement would leave Gorky more time for his art.

41. Good Hope Road

1 Letter from Agnes Gorky to Jeanne Reynal, 10 January 1945.

2 *Ibid.*

3 Agnes Gorky, interviews by author between 1982 to 1998, are the main source.

4 Julien Levy, *Arshile Gorky* (New York, 1966), p. 30.

5 Letter from Agnes Gorky to Jeanne Reynal, 10 January 1945.

6 Levy, op. cit.

7 Letter to Reynal, 14 February 1945.

8 Jerrold adopted his stepfather Herbert Bayer's surname; Julien added it to Levy.

9 Lionel Abel, interview by author, 1992.

10 Meyer Schapiro, interview by author, 1992.

11 Ruth Francken, interview by author, 1990.

12 Cat. Rais., No. 292, *Water of the Flowery Mill*, 1944.

13 *The Leaf of the Artichoke is an Owl*, 1944; *Love of a New Gun*, 1944; *Pirate*, 1942; *One Year the Milkweed*, 1944; *The Sun, The Dervish in the Tree*, 1944; *They Will Take My Island*, 1944;

14 Agnes Gorky, three-page closely typewritten letter to Jeanne Reynal, April 1945. Much of this account is based on this letter and Agnes's recollections to the author.

15 *Ibid.*

16 *Ibid.*

17 *Ibid.*

18 Clement Greenberg, 'Art', *Nation*, 160 (24 March 1945), pp. 342–3.

19 Maude Riley, 'The Eye-Spring: Arshile Gorky', *Art Digest*, 19 (15 March 1945), p. 10.

20 Letter, Agnes Gorky to Jeanne Reynal.

21 Furtive secrets probably say more about Levy's fantasies than Gorky's. See Julien Levy's *Memoir of an Art Gallery* (New York, 1977), in which he describes visits to brothels and a Surrealist orgy as his initiation, pp. 164–72.

22 This and the following account are based on Agnes Gorky's letter, *ibid.*

23 Letter, *ibid.*

24 A celebrated event was the wedding of Surrealist groupie, stripper Gypsy Rose Lee, who chose a primate for her best man.

42. Rollercoaster Living

1 Much of this account is based on a letter to Jeanne Reynal, mid-April or May 1945, and on Agnes Gorky's recollections.

2 Stephen Miller, interview with Julien Levy, 1972, Archives of American Art, Smithsonian Institution, Washington DC., Microfiche Rolls 2886–2888.

3 Jonathan Bayer Levy, son of Joella and Julien Levy, said in an interview by the author, 'It was the weirdest bunch of people. *Peyton Place* syndrome. Sexual antics in a small town. Jealousies and liaisons. Husbands and wives. They were having affairs, or at the parties, one of them would slip off in the bushes. Half-drunk performances. For children it was hard to adjust.'

4 Letter to Jeanne Reynal, 10 January 1945.

5 This account is from Agnes Gorky's interviews by author, 1993.

6 Letter to Reynal, 10 January 1945.

7 Elisa Breton showed me these photos in Paris and told me how much Breton had loved Gorky as a friend for his warmth, honesty and exceptional talents, 1992.

8 Letter to Reynal, 10 January 1945.

9 *Ibid.*

10 *Ibid.*

11 *Ibid.*

12 *Ibid.*

13 David Hare, interview by Karlen Mooradian, 1966.

14 Agnes Gorky, letter to Jeanne Reynal, undated, later inscribed '1945, mid-April or May'.

15 Agnes Gorky's long letter to Jeanne Reynal mentioned Esther's visit and comically described the move: undated and later inscribed '45.5'. She had no memory of the visit in December 1997.

16 Letter, op. cit.

17 Letter, op. cit.

18 Gorky was placed in the context of other painters, Duchamp, Dominguez, Masson, Ernst, Tanguy, Paalen, Matta and Donati.

19 Letter to Reynal, undated, possibly June 1945.

20 Jeanne Reynal, letter to Agnes Gorky, inscribed 'April 1943'.

21 Letter to Jeanne Reynal, undated.

22 Muriel Cowley, interview by Karlen Mooradian, 1964.

23 On 7 June 1945 the Soviet Foreign Minister Molotov informed the Turkish

Ambassador to Moscow that the USSR demanded a revision of the Soviet Turkish border in the region of Kars and Ardahan. R. G. Suny, *Looking Toward Ararat* (Indiana, 1993), p. 225.

43. My Little Pine Tree

1 Florence Berberian, interview by author, 1994.
2 Account based on the letter from Agnes Gorky to Reynal, 23 August 1945.
3 *Ibid.*
4 Agnes Gorky, letter to Jeanne Reynal, September 1945.
5 Letter from Jeanne Reynal, 5 May 1945, Archives of American Art.
6 Agnes Gorky, letter to Jeanne Reynal, September 1945.
7 Arshile and Agnes Gorky, letter to Jeanne Reynal, undated, inscribed November 1945.
8 Agnes Gorky, letter to Vartoosh Mooradian, 1945.
9 *Ibid.*
10 Letter to Reynal, undated, inscribed November 1945, is the source for the following account.
11 Isamu Noguchi, interview by Karlen Mooradian, 1966.
12 Letter to Reynal, *ibid.*
13 Diego Masson, interview by author, 1993, is source for this account.
14 Letter to Reynal, *ibid.*
15 Letter to Reynal, *ibid.*
16 Agnes Gorky interview by author, 1982.

44. Burning Easel

1 Paul Resika, interview by author, 1993.
2 Cat. Rais., No. 300 (1945), 50 × 62 inches (127 × 157 cm).
3 1933, mural panels.
4 Harold Rosenberg, *The Anxious Object*, p. 106, written in 1964.
5 Harold Rosenberg, interview by Karlen Mooradian, 1966.
6 Clement Greenberg, *Nation* (24 March 1945), pp. 342–3.
7 James Johnson Sweeney, introduction to first Pollock exhibition at *Art of This Century*, 9–27 November 1943.
8 Clement Greenberg, 'Art', *Nation*, 3 November 1943, p. 565.
9 Lee Krasner, interview by Karlen Mooradian, 1966.
10 Philip Pavia, op. cit., p. 264.
11 Jeanne Reynal, interview by Karlen Mooradian, 1966.
12 Letter to Reynal from Agnes Gorky, 1946.
13 *Ibid.*

14 Letter to Vartoosh, 1946.

15 Letter to Jeanne Reynal, 5 February 1946.

16 Agnes Gorky, interview by author, 1993.

17 Letter to Reynal, 5 Feb. 1946; the following excerpts are from this letter.

18 Isamu Noguchi, interview by Karlen Mooradian, 1966.

19 Reynal letter to Gorkys, 1 February 1946, Archives of American Art.

20 Azad Adoian, interview by author, 1992. In 1948 Ado was imprisoned again for a further ten years.

21 Letter to Gorky from Ado Adoian, 1935.

45. Rearranged Body

1 Letter to Jeanne Reynal from Agnes Gorky, 5 February 1996.

2 Agnes Gorky, interviews by author between 1982 and 1997, are the source of this account.

3 Gaston de Havenon gave this account to the author in an interview, 1992.

4 Agnes Gorky wrote to the author in December 1997.

5 Interview, Agnes Gorky by author, 1991.

6 Letter to Jeanne Reynal from Agnes Gorky, 8 March 1946, is the main source for this account.

7 Letter to Gorky, 18 March 1946, Archives of American Art.

8 De Havenon, interview by author, 1992.

9 Ethel Schwabacher, *Arshile Gorky* (New York, 1957) pp. 115–16.

10 Letter to Reynal, op. cit.

11 Agnes Gorky wrote to the author in December 1997.

12 Recently it has become more widespread to manage without a bag.

13 De Havenon, interview by author, 1992.

14 Letter to Vartoosh Mooradian from Agnes Gorky, 22 March 1946.

15 Letter to Vartoosh Mooradian from Agnes Gorky, 30 April 1946.

16 *Charred Beloved No. 1*, 1946: *Charred Beloved No. 2*, 1946; *Landscape Table*, 1945; *Delicate Game*, 1946; *Portrait of Y. D.*, 1945; *Good Hope Road*, 1946; *Child's Companions*, 1945; *Hugging*, 1945; *Nude*, 1946; *Impatience*, 1946; *The Unattainable*, 1945; *Diary of A Seducer*, 1945.

17 Letter to Vartoosh and Moorad Mooradian from Agnes Gorky, 28 April 1946.

18 *Landscape Table*, 1945; *Delicate Game*, 1946; *Portrait of Y. D.*, 1945; *Good Hope Road*, 1946; *Child's Companions*, 1945; *Hugging*, 1945; *Impatience*, 1946; *The Unattainable*, 1945.

19 Letter to Mooradians, op. cit.

20 Clement Greenberg, *Nation*, 162 (4 May 1946), p. 552.

46. Life on a Leash

1 Agnes Gorky, interviews by author between 1983 and 1997.
2 Agnes Gorky, letter to Jeanne Reynal, undated, inscribed January 1946.
3 Agnes Gorky, letter to Jeanne Reynal, undated, inscribed summer 1946.
4 Wilfredo Lam, 'Memoir', unpublished, is the main source for his account. I am indebted to his son Eskil Lam for providing it and his first wife Helena who also shared her recollections with me. Agnes Gorky wrote in December 1997, 'we were introduced to Lam by the person now called Rosamond Russell then called Peggy Riley. She brought him to the studio.' December 1997.
5 Lowery Sims, *Rethinking the Destiny of Line* (New York, 1992), p. 55.
6 Wilfredo Lam, 'Memoir'.
7 Letter to Reynal, op. cit.
8 Gjon Mili, interview by Karlen Mooradian, is the source of this account, 1966.
9 Letter to Jeanne Reynal, op. cit.
10 *Ibid.*
11 *Ibid.*
12 Letter to Vartoosh Mooradian from Gorky, 12 August 1946.
13 Letter to Reynal, op. cit., is the source of the following account.
14 *Ibid.*
15 Letter to Reynal, postdated 'August? 1946'.
16 Letter to Jeanne Reynal from Agnes Gorky, summer 1946 (No. 7).
17 Arshile Gorky, letter to Vartoosh, op. cit. August 1946.
18 Letter to Reynal, summer 1946, is the source for the following account.
19 *Ibid.*
20 *Ibid.*
21 Julien Levy, *Arshile Gorky* (New York, 1966), p. 35.
22 Letter to Ethel Schwabacher from Agnes Gorky, 22 October 1946.

47. Catastrophe Style

1 Arshile Gorky, letter to Vartoosh Mooradian, 19 November 1946: 'This summer I completed many drawings. 292 of them. At no other time have I ever been able to draw this much, and they are truly excellent.'
2 Ethel Schwabacher, *Arshile Gorky* (New York, 1957), pp. 122–3.
3 Lent by Julien Levy, Cat. Rais., No. 115, Whitney Museum of American Art.
4 Schwabacher, op. cit., pp. 123–4.
5 Cat. Rais., No. 307, *Nude* (1946), (50 × 38 inches) (127 × 97 cm).
6 Arshile Gorky, *Garden in Sochi*, 26 June 1942, Museum of Modern Art (New York, 1942).
7 Lionel Abel, interview by author, 1993.

8 Letter to Ethel Schwabacher from Agnes Gorky, Virginia, 15 October 1946.

9 *Max Ernst, A Retrospective*, ed. Werner Spies (London, 1991), p. 327.

10 William Seitz, 'Arshile Gorky's *The Plough and the Song*', Allen Memorial Art Museum, *Bulletin*, 12, Fall 1954, pp. 4–15.

11 Alonzo Lansford, 'Concentrated Doodles', *Art Digest*, March 1947, p. 18.

12 Agnes Gorky, written notes, December 1997.

13 Ann Alpert, interview by author, 1992.

14 This account is based on Karlen Mooradian's interview with Yenovk Der Hagopian, 1966.

48. City Pastoral

1 Letter from Agnes Gorky to Vartoosh Mooradian, 4 May 1947. Agnes and the children spent the summer with her great-aunt Marion Hosmer, at Mainestay, Castine, Maine.

2 Vartoosh Mooradian, interview by author, 1990.

3 Vartoosh, letter to Gorky, 20 May 1947.

4 Gorky, letter to Agnes, 12 July 1947.

5 Gorky, letter to Agnes, 28 July 1947.

6 Gorky, undated letter to Agnes.

7 Letter from Jeanne Reynal to Agnes Gorky, 26 June 1947, Archives of American Art.

8 Margaret Osborne, interview by Karlen Mooradian, 1966.

9 Gjon Mili, interview by Karlen Mooradian, 1966.

10 Cat. Rais., No. 328 (1947), 60 × 72 inches (152 × 184 cm). Suffered fire damage in 1957, restored by Allan Stone Gallery.

11 Sydney Simon, 'Fifty Years of Painting by Peter Busa', *Art International II*, Summer 1967, reprinted in *Life Colors Art*, p. 51.

12 Letter from Arshile Gorky to Agnes, undated.

13 *Ibid.*

14 Agnes Gorky, interview by author, 1996.

49. Full-Blooded

1 *The Calendars* (1936–37), No. 314, 50 × 60 inches.

2 Greenberg, *Nation*, vol. 166, 10 January 1948, p. 52.

3 Lloyd Goodrich, interview by Karlen Mooradian, 1966.

4 Muriel Streeter (Levy), interview by author, 1992.

5 Letter from Arshile Gorky to Vartoosh Mooradian, 2 November 1938.

6 Jerrold Bayer's interview by the author is the source of his account.

7 Agnes commented in 1997 that she did not remember ever meeting them: 'They knew nothing about our life.'

8 Letter from Agnes Gorky to Ethel Schwabacher, 15 January 1948, is the source of the account.

9 *Ibid.*

10 'The Glass House' in *Life* magazine, 16 February 1948, vol. 24, pp. 90–92. Agnes remarked that he was not in the habit of hanging his work in the house while she lived with him. The article appeared on 16 February 1948, while the Whitney Museum was showing its annual exhibition of *Contemporary American Sculpture, Watercolors, and Drawings*, with a large crayon drawing of Gorky's, *The Betrothal*, 1947.

11 Jerrold Bayer had a very different view from his brother Jonathan.

12 Alexander Calder, interview by Karlen Mooradian, 1966.

13 Sandra Calder, telephone interview by author, 1992.

14 Agnes Gorky: note 1997.

15 *Soft Night*, 1947; *Agony*, 1947; *Calendars*, 1947; *The Making of Calendars*, 1946–47; *Betrothal 1*, 1947; *Betrothal 2*, 1947; *The Orator*, 1947; *The Beginning – Pale Grey*, 1947; *The Limit*, 1947; *The Opaque*, 1947; *Pastoral II*, 1947; *Year After Year*, 1947; *Four P.M.*; *Plough and the Song*, 1947.

16 Ethel Schwabacher, *Arshile Gorky* (New York, 1957), pp. 136–7.

17 Julien Levy, *Arshile Gorky* (New York, 1966), p. 30.

18 Letter to Ethel Schwabacher from Agnes Gorky, 2 March 1948.

19 *Art News*, March 1948, p. 46.

20 Clement Greenberg, *Nation*, Vol. 166, 20 March 1948.

21 *Ibid.*

22 Franklin Rosement, *The First Principles of Surrealism* (London, 1978).

23 Sydney Janis, interview by Karlen Mooradian, 1966.

24 Barnett Newman, interview by Karlen Mooradian, 1966.

50. The Crumbling Earth

1 Charles (Ashot) Adoian, interview by author, 1993.

2 Agnes Gorky, letter to Ethel Schwabacher, January 1953.

3 Ethel K. Schwabacher, *Arshile Gorky* (New York, 1957), p. 134.

4 Agnes Gorky, interviews by author, 1983–97, are the main source of her statements unless otherwise credited.

5 Muriel Levy's remarks are from her interview with the author, 1994.

6 Letter to Ethel Schwabacher from Agnes Gorky, March/April 1948.

7 Ethel K. Schwabacher, *Arshile Gorky*, pp. 138–140.

8 In December 1997, Agnes Gorky would 'contest the truth of Peggy's memory. She lived more than an hour away from our house – we did go to see her.'

9 Peggy (Margaret) Osborne, interview by Karlen Mooradian, 1966.

10 Helena Benitez Lam, interview by author, 1995.

11 Agnes Gorky explained that 'the reason was to give Gorky and me time to rest and be alone together. Gorky was not well and very upset by the children's noise etc. We both missed them terribly.' Written note to author, December 1997.

12 Agnes Gorky in a written note to author, 'I told him exactly why I had to go away for 2 or 3 days. He knew exactly when I was coming back.' December 1997. In earlier interviews, however, she said that she had made arrangements for the children's care, then had left without saying anything

13 Lionel Abel, interview by author, 1992. Matta and he were close friends and Matta spoke freely to him both at this period and later when they shared a house in the south of France. He wrote a book, *The Intellectual Follies: A Memoir of the Literary Venture in New York and Paris* (New York, 1984), based on their talks which Agnes Gorky (then Philips) privately disputed. This account is from the author's transcripts not from his book.

51. Darling Gorky

1 Julien Levy, *Memoir of an Art Gallery* (New York, 1977), p. 288; the remainder of his account is taken from his book.

2 Author's interview with Muriel Levy is the only source of her remarks. She wept as she recalled the events, speaking about them for the first time.

3 'I just couldn't believe it,' Agnes said years later, in interview with author. 'Last time I left, he'd burned the studio down! This time he was in hospital with a broken neck.'

4 Agnes Gorky objected to Lionel Abel's report in his book, *New York Follies*, that she had gone to Gorky's sick bed together with Matta: 'It was a lie. He didn't come with me.'

5 Peter Blume, interview by Karlen Mooradian, 1964.

6 Julien Levy, *Memoir of an Art Gallery*, p. 291.

7 Peggy Osborne, interview by Karlen Mooradian, 1966.

8 Genevieve Naylor, interview by Karlen Mooradian, 1964.

9 Jeanne Reynal, interview by Karlen Mooradian, 1966, is the source of her remarks.

10 Helena Benitez Lam in conversation with author, 1996.

11 This song was a big hit for the Andrews Sisters in 1938. The music (by Sholem Seconda) and the Yiddish lyrics by Jacob Jacobs were written in 1932: the hit version also had English verses.

12 Agnes Gorky's interviews with the author are the only source of this account.

52. Agony

1 Agnes Gorky, interview by author, 1981.
2 Lionel Abel, interview by author, 1992.
3 Julien Levy, *Memoir of an Art Gallery* (New York, 1977).
4 Agnes Gorky, written explanation to author, December 1997.
5 Jeanne Reynal, interview by Karlen Mooradian, 1966.
6 Agnes Gorky, letter to Ethel Schwabacher, January 1950.
7 Helen Sandow, interview by author, 1992. 'I introduced Gorky to him. I wish I never had. He overreached himself. Just because he shared a waiting room with a psychoanalyst he thought he was one too.' She later refused to help Ethel Schwabacher with her book. 'Those people could have helped him.'
8 Mina Metzger, interview by Karlen Mooradian, 1966.
9 Ethel Schwabacher, interview by Karlen Mooradian, 1966.
10 Jeanne Reynal, interview by Karlen Mooradian, 1966.
11 Muriel Levy, interview by author, 1992.
12 Agnes Gorky, written note to author, 1997.
13 Noguchi quoted in Karlen Mooradian's *Many Worlds of Arshile Gorky* (Chicago, 1980), p. 184.
14 Noguchi, interview by Karlen Mooradian. Just prior to this remark Noguchi had asked his interviewer to switch off his tape-recorder when questioned about Gorky's marriage. He then spoke into the tape-recorder, leaving his account on tape.

A lobotomy is an incision into the front lobe of the brain, in some cases prefrontal lobes were separated from the rest of the brain by cutting the connective nerve fibres. This was believed to sever the brain areas associated with emotion in an effort to reduce anxiety or violent behaviour.

15 Agnes Gorky explained to the author, 'The lobotomy is Gorky's fantasy. Dr Weiss had said that G. had never been a normal man, that he was too sensitive & precarious to bear the terrible thing I had done. Neither of us pretended to think he could. He never saw Gorky again because he would not stay anywhere where he or I could reach him.' December 1997.
16 Noguchi, in *The Many Worlds of Arshile Gorky*, p. 181–2.
17 Muriel Levy reported Reynal's conversation with Gorky. 'He said, "There's no doubt they can cure what's wrong with me." He was afraid. I inferred from what Jeanne told me that Gorky was afraid he was losing his mind and was afraid of being institutionalised.' Interview with author, 1992.
18 David Hare, interview by Karlen Mooradian, 1966.

19 Esther Brooks, interview by author, 1992.

20 Agnes later said that she 'could not speak' to her sister and never knew that she had seen Gorky or telephoned.

21 Agnes Gorky, handwritten note to author, December 1997, 'I wrote in severe distress while I waited in Virginia to know what was happening.'

22 Letter to Ethel Schwabacher from Agnes Gorky, 22 July 1948, reprinted in Schwabacher, *Arshile Gorky* (New York, 1957), p. 144. Agnes did not want this letter published by Schwabacher. The latter remonstrated with her for not informing them earlier so they could help. She sent the letter away for safe-keeping.

53. Goodbye My Loveds

1 Gorky, letter to Vartoosh Mooradian, 2 November 1938.

2 Jeanne Reynal, interview by Karlen Mooradian, 1966.

3 *Ibid.*

4 Agnes noted on this manuscript, 'Gorky had given this himself (so Levy claimed) to Julien at the beginning of his contract.' December 1997.

5 Interview with Julien Levy by Stephen Miller, Archives of American Art, 16 December 1972, p. 7.

6 Kay Sage was to commit suicide by shooting herself years later when she lost her husband and her eyesight.

7 Julien Levy, *Memoir of an Art Gallery* (New York, 1977), pp. 293–4. Agnes did not remember a slashed painting.

54. Summer Funeral

1 Based on Saul Schary's interview by Karlen Mooradian, 1966.

2 Malcom and Ebie Cowley, interview by Karlen Mooradian is the source of this account.

3 Peter Blume, interview by Karlen Mooradian, 1966.

4 Agnes Gorky, interviews by author between 1983 and 1997 are the source of her remarks unless othewise credited.

5 Muriel Streeter Levy, interview by author, 1992.

6 Vartoosh Mooradian, interview by author, 1990.

7 Azadouhi Libby Miller, interview by author, 1993.

8 He told Muriel of the outrage he felt that Agnes had come back, after walking out so many times.

9 Michael and Florence Berberian, interview by author, 1992.

10 Wilfredo Lam, 'Memoir'.

11 Vartoosh Mooradian, interview by author, 1990; corroborated by Schary and Levy.

12 Julien Levy, *Memoir of an Art Gallery* (New York, 1977), p. 294. Jonathan worked extensively on his father's book.

13 Agnes Gorky in conversation with author, December 1997.

14 Florence Berberian, interview by author, 1992.

15 Helena Lam, telephone interview by author, 1996.

16 Isamu Noguchi, in *The Many Worlds of Arshile Gorky* (Chicago, 1980), p. 184.

17 Muriel Streeter Levy, interview with author, 1992.

18 Malcom Cowley, in *The Many Worlds of Arhsile Gorky*, p. 121.

19 Lionel Abel, interview by author, 1992.

20 Alain Jouffroy, interview by author, July 1996. He recalled Breton's reaction. Agnes Gorky, interview and written comment to the author, 'Because of this Duchamp never spoke to Kiesler again.' December 1997.

21 Alain Jouffroy, interview by author, 1996.

22 Agnes Gorky, letter to Jeanne Reynal from hospital in Washington, 1946.

23 Alain Jouffroy, interview by author, 1996.

24 Tract Surrealist, II, 232.

25 *Neon, No. 4*, 1948, Reprinted in *André Breton, La Beauté Convulsive*, Catalogue, Centre Georges Pompidou. Translated by Denise Hare, reprinted in Harold Rosenburg, *Arshile Gorky: The Man, the Time, the Idea*.

26 Agnes Gorky in a written note to author: 'I did not see the poem until years later.' December 1997.

27 Alain Jouffroy, *Le Mur de la vie privée* ('The Wall of Private Life').

28 Annie Le Brun, *Jean Benoit* (Paris, 1996), pp. 30–42.

29 Alain Jouffroy, interview by author; Alain Jouffroy, *Une revolution du regard* (Paris, 1959), pp. 34–7.

30 Agnes Gorky, interview by author, 1993.

31 Lionel Abel, interview by author, 1992. 'Matta came to see me after he got back from Maine in the summer. He was ecstatic. Shortly after that he fell apart.' Agnes said, 'Lionel Abel years later published a libellous account of my behaviour with Matta which was entirely a lie. I could have sued him but I did not know about it until so late that I did not pursue it.'

32 Agnes Gorky, interview by author, 1981.

33 *White Abstraction*, 1934, lent by Agnes Magruder Gorky; *Garden in Sochi*, 1941, lent by Museum of Modern Art; *The Liver is the Cock's Comb*, 1944, lent by Jean Lamson Heblen; *The Pirate*, 1945, lent by Julien Levy; *Delicate Game*, 1946, lent by Jeanne Reynal; *Good Hope Road*, 1946, lent by Mr and Mrs John E. Abbott; *Soft Night*, 1948, lent by Mr and Mrs John Stephen; *Sculptured Head*, 1932, lent by Mrs David Metzger.

34 By way of explanation Agnes Gorky quoted her letter to Wolf Schwabacher after his accident on Monday, 29 June 1948. Julien had told her to make a claim for the highest sum without sending him to prison.

35 *New York Times*, 9 December 1948.

36 Letter to Ethel Schwabacher from Agnes Gorky, 9 December 1948.

37 Marny George, letter to James Thrall Soby, Artist's File, Library, Whitney Museum of Modern Art, 15 March 1951.

38 Florence Berberian, interview by author, 1992.

39 Natasha Gorky, conversation with author, 1982.

55. Life After Death

1 He criticised the *Breakthrough Years* catalogue for failing to 'produce an articulate, historically coherent statement about the Amenian Genocide – the event which most profoundly shaped Gorky's life'. He especially took the article, purportedly about Gorky's childhood, to task for its inaccuracies: 'Spender's account is woefully inadequate. It is hard to imagine a reader coming away from his essay with an understanding of the Genocide or of Gorky's life as a genocide survivor'.

2 Deanna Petherbridge, Professor of Drawing at Royal College of Art, commented: 'Gorky applied traditional methods of copying and transformation to contemporary works. They explore and establish a repertoire of shapes with a dazzling variety of line and imaginative use of materials from crayon to delicate wash. His late drawings have a figural vitality which I would describe as animated abstraction.'

Appendix

1 See Appendix: Letters alleged to be by Arshile Gorky.
'The Gardener from Eden', *ARARAT*, AGBU, New York, Winter 1968.
'Arshile Gorky: A Special Issue', *ARARAT*, AGBU, New York, 1971.

2 Anselmo Carini, Head of Works on Paper Department, Chicago Museum of Fine Art.

Chronology

1902–04

 22 April Manoug (Vosdan) Adoian born in Khorkom, Vari Hayotz Zor, province of Van, Western Armenia, in Ottoman Empire
His father Setrag Adoian (1863–1947) widower previously married to Lucy Amerkhanian (died 1896) leaving son
Mother Shushan Der Marderossian (1880–1919) previously married to Tovmas Prudian (died 1896), two daughters Sima (died 1908) and Akabi (1896). First daughter from the second marriage, Satenig (1901)

1906–09

 27 September 1906 Birth of daughter Vartoosh
 April 1908 Massacre of Armenians in Van
 July New Constitution. Birth of Azad. Setrag leaves for America
 1909 Ottoman massacres of Armenians in Adana, 30,000 dead

1910–12

 September 1910 Shushan, Manoug, and sisters Satenig and Vartoosh move to Van, Old City, where Manoug attends Yissussian School. Later family moves to Aykesdan, Garden City, where Manoug attends the

	Congregational American Mission
1911–15	School. Summer in Shadagh and Khorkom villages
1912	Russian diplomacy relaunches the Armenian Question

1913–14

January 1913	Military dictatorship of Young Turks gains power Triumvirate Enver–Talaat–Jemal Massacres in Adana
1914	Russo-Turkish accord anticipates the nomination of two inspectors to Armenian provinces
August 1914	Secret agreement of alliance between Germany and the Ottoman Empire

1915–17

January 1915	Defeat of Ottoman Army by Russia at Sarikamish
April–June	Start of deportation of Armenians. Revolt in Van. Heavy shelling
April	Beginning of the Siege of Van as prelude to Genocide of Armenians in Ottoman Empire. Manoug takes part in defence of the city. Thousands die in Van and surrounding villages Throughout the eastern provinces Armenians are sent on forced marches into the Syrian desert, wholesale massacres and torture
June	Russian army enters to liberate city retreat. Survivors from Van and surrounding villages are forced to flee Manoug and sisters on forced march across volcanic and rocky terrain 200km. north-east to Etchmiadzin
August	Arrive in holy city. Move to Yerevan
1916–17	Manoug attends Jemaran School. Works at carpentry in American orphanage
October 1916	Sisters Akabi and Satenig emigrate to US leaving teenage Manoug head of the family

1918–19

1918	Famine in Armenia. Turkey attacks Armenia
24 May 1918	Victory of Armenians at Sardarabad
28 May	Declaration of Republic of Armenia followed by civil unrest
August	Manoug's family flee to Shahab. Mother severely ill.

Return to Yerevan

Severe famine in Armenia. No relief gets through. 200,000 died from starvation

19 March 1919 Manoug's mother dies of malnutrition in Yerevan. Children move to Uncle Aharon

July Leave Yerevan for Tiflis and Constantinople Enter Haydar Pasha refugee camp

1920–21

January 1920 Boards ship for New York

February Arrives in Ellis Island. Goes to Watertown with Akabi and husband, Massachussets, then Providence to be reunited with father. Works in foundry.

1920–21 Attends local school. Leaves for Watertown. Works in Hood Rubber Company factory. Back to Providence, enrols at Technical High School, meets Russian Mischa Reznikoff

1922–25

September 1922 Changes name to Arshile Gorky. Enrols New England School of Design in Boston, part-time work washing dishes, lightning sketches in theatre, painting restoration

1924 Employed as assistant life drawing teacher. First known painting, *Park Street Church*

1925 Moves to New York City, stays with Badrik Selian, then takes studio at 47A Sullivan Street, Washington Square

1926–27

January Attends National Academy of Design to study with Charles Hawthorne only one month. Teaches at New School of Design, New York; students include Mark Rothko. Paints society portraits on commission

15 September Article in *Saturday Evening Post* announces Gorky as instructor at Grand Central School of Art

1927–29

1927 Meets Willem de Kooning

1928 Meets John Graham

1929	Starts love affair with Sirun Mussikian /Ruth French
	Meets Stuart Davis. Moves to 36 Union Square
24 October	Wall Street Crash

1930

12–26 April	Exhibits work in *Exhibition of Work of 46 Painters and Sculptors under 35 Years of Age*, Museum of Modern Art

1931

1 January– 10 February	*Improvisation* in Exhibition for the New School, New York (Katherine Dreier)
13 April	*Fruit* (Still Life with Apples) acquired by Mrs John D. Rockefeller from Downtown Gallery, New York
2–22 June	*Still Life*, exhibited in Downtown Gallery
7 December	Downtown Gallery, New York, exhibits lithographs
	Loses teaching job at Central School

1932

	End of affair with Mussikian
10 May	Vartoosh and husband Moorad Mooradian repatriate to Armenia
	Begins *Nighttime Enigma and Nostalgia* series. Meets Hans Hofmann and Isamu Noguchi

1933

20 December	Enlists in Public Works of Art Project and submits mural proposal. Suffers severe financial hardship.
	Spends Christmas with sister Satenig in Watertown

1934

2 February	First one-man show at Mellon Galleries, Philadelphia
	Fire in Akabi's house destroys about 12 paintings
	Involved in Artists' Union. Dispute with Stuart Davis
	Marries model Marny George. Marriage annulled

Summer	Completes many portraits in Akabi's house in Watertown
25 December	Vartoosh and Moorad return from Armenia

1935

12 February–22 March	Exhibits 4 paintings in *Abstract Painting in America*, Whitney Museum of American Art
March	Birth of nephew Karlen to Vartoosh. Mooradians move into studio
July	Applies to Emergency Relief Bureau. Establishment of Works Progress Administration/Federal Art Project
	Assigned to mural division starting with *Aviation* mural, Floyd Bennett Field. Collaborates with Wyatt Davis, photographer assigned for collages
September–October	One-man exhibition of pen and ink drawings at Boyer Galleries, Philadelphia. Delivers lectures at gallery
October–November	*Greek Torso* in group show at Guild Art Gallery, run by friend Anna Walinska attracts press notice
24 November	Gorky delivers lecture at gallery, 'Methods, Purposes and Significance of Abstract Art'
16 December 1935–5 January 1936	One-man show, *Abstract Drawings by Arshile Gorky* including *Nighttime, Enigma and Nostalgia* series at Guild Art Gallery receives *New York Post* critic's praise
	Falls in love with art student Mercedes Matter, daughter of artist Carles Matter
27 December 1935	Photo murals and project shown at Federal Art Project gallery, New York, Murals for Public Buildings, inaugural show, presented to Mayor La Guardia
	Gorky's mural chosen by Alfred H. Barr, Jr., director of Museum of American Art. Destined for Newark Airport

1936

16 March–4 April	Participates in group show, *Drawings, Small Sculpture, Watercolors*, at Guild Art Gallery

	14 September– 12 October	*New Horizons in American Art*, The Museum of Modern Art, Aviation: Evolution of Forms under Aerodynamic Limitations. Ten panels introduced, with one completed panel, a scale model with murals and photograph of large panels
	November	Mooradians move to Chicago. Gorky works on murals

1937

	9 June	Newark Airport Murals opens
	12 June– 31 October	Dallas Museum of Fine Arts, *Organization No. 2*
	12 December	Whitney Museum of American Art purchases *Painting*

1938

		Painted *Argula* and *Garden in Sochi* series Starts love affair with violinist Leonore Gallet Exhibition at Boyer Gallery, Philadelphia
	April	Completed charcoal drawing, *The Artist's Mother*
	May–June	Trois Siècles d'Art aux États Unis, Musée du Jeu de Paume, Paris, Composition (Painting)
	27 November 1938– 8 January 1939	*Annual Exhibition of Contemporary Painting*, Whitney Museum of American Art, *Oil Painting* (1938) Works on murals for the World's Fair
	9 November– 17 December	Société Anonyme, Twentieth Anniversary Exhibition: New Forms of Beauty, 1909–1936, *Forms in Pen and Ink*

1939

	January	Leaves WPA/FAP. Completes mural for Aviation Building
	20 May	Becomes citizen of USA. Tries for other mural commissions
	9 June	Reinstated to WPA/FAP

1940

	10 January– 18 February	Whitney Museum of American Art, *Annual Exhibition of Contemporary Art: Sculpture, Paintings, Watercolors, Drawings, Prints*, shows *Head Composition*
	8 November	Resigns from WPA/FAP Begins sketches for Ben

17 December	Marden's Riviera nightclub, Fort Lee, New Jersey Reinstated on WPA
27 November 1940– 8 January 1941	Whitney Museum of American Art, *Annual Exhibition of Contemporary American Painting*, shows *Oil Painting*. Acquainted with Roberto Matta Echaurren

941

	Falls in love with Agnes Magruder
10 March–3 May	The Museum of Modern Art, *New American Acquisitions*, shows *Argula* donated by Bernard Davis
July	Meets Jeanne Reynal who invites him to San Francisco Driven there with Agnes Magruder by Isamu Noguchi
9–24 August	One-man show at San Francisco Museum of Art, 21 works. Meets Léger
15 September	Marries Agnes Magruder in Virginia City, Nevada. Honeymoon in the Sierras. The couple visit the Mooradians in Chicago, return to New York
19 October– 7 November	*Art Exhibition for the Benefit of Armenian War Relief*, Art Students' League of New York, *Head* and *Summer in Sochi, Black Sea*
12 November– 30 December	Whitney Museum of American Art, *Annual Exhibition of Paintings by Artists under Forty*, shows *Painting (Garden in Sochi)*

942

25 January– 28 February	The City Art Museum of St Louis, *The Thirty-Sixth Annual Exhibition: Trends in American Painting of Today: Paintings by Émigrés*, *Still Life* and *Argula*
30 June–9 August	*Bull in the Sun*, rug at Museum of Modern Art, New York, *New Rugs by American Artists* Prepares camouflage course and publishes leaflet
Summer	Spends three weeks with Saul Schary in Connecticut drawing waterfall on Housatonic River
9 December 1942– 24 January 1943	The Museum of Modern Art, *Twentieth Century Portraits*, *My Sister Ahko*

943

Visits his family in Watertown for the last time

5 April	Birth of daughter, Maro
	Museum of Modern Art acquires *Garden in Sochi*, Gorky writes text
	Paints *Waterfall* series. Closely identified with Surrealism. Begins friendship with Matta
17 June–25 July	*Garden in Sochi* at The Museum of Modern Art, *Recent Acquisitions: The Work of Young Americans*
July	Spends summer on farm in Hamilton, Virginia, draws and paints prolifically
23 November 1943– 4 January 1944	Whitney Museum of Modern Art, *Annual Exhibition of Contemporary American Art: Sculpture, Paintings, Watercolors, Drawings, Shenandoah Landscape* (work on paper)
	The Museum of Modern Art, New York, Circulating Exhibition, *Twelve Contemporary Painters, Composition II* (work on paper)
	Growing friendship with Breton, Max Ernst, Marcel Duchamp and other European and American Surrealists

1944

February–December	*Abstract and Surrealist Art in the United States*, organised by Sydney Janis and San Francisco Museum of Art travelling show, shows *The Liver is the Cock's Comb*
April	Article by James Johnson Sweeney in *Harper's Bazaar*
	Gorkys leave again for Virginia for nine months
November	Returns to New York. Peggy Guggenheim acquires *Painting*. Contracted by Julien Levy Gallery
December	Moves to house of David Hare in Roxbury, Connecticut
	Friendship with André Masson

1945

January	Finds titles for new works with Breton
6–31 March	Solo show at Julien Levy Gallery, 10 paintings and drawings. Catalogue article by Breton, 'The Eye Spring: Arshile Gorky'
	Breton's *Surrealism and Painting* revised, includes Gorky

	Works on versions of *The Plough and the Song*
8 August	Birth of second daughter, Yalda, later renamed Natasha
September	Moves to home of Henry and Jean Hebbeln, Sherman, Connecticut. Neighbours with Yves and Kay Tanguy, Alexander Calder, Malcom Cowley, Peter Blume
	Increasingly suffers pain and exhaustion. No diagnosis
27 November 1945–	Whitney Museum of American Art Annual
10 January 1946	Exhibition of Contemporary American Painting shows *Journal d'un Seducteur*

1946

January	His studio in Sherman is burned with over 24 paintings, drawings destined for a new show, books and personal effects
	Move back to New York where he paints in a private ballroom, *Charred Beloved, The Plough and the Song*
5 February–13 March	Whitney Museum of American Art, *Annual Exhibition of Contemporary American Sculptures, Watercolors and Drawings*, shows *Anatomical Blackboard*, work on paper
6 March	Colostomy operation at Mount Sinai Hospital, New York
9 April–4 May	*Paintings by Arshile Gorky* at Julien Levy Gallery attracts favourable reviews
	Meets Wilfredo Lam
July	Convalesces at Hamilton, Virginia, and completes 292 drawings
10 September–	*Fourteen Americans* at The Museum of Modern Art,
8 December	New York, shows eleven paintings including for the first time *The Artist and His Mother*
November	Returns to New York
	Gives dinner for Joan Miró and Luis Sert
10 December 1946–	Whitney Museum of American Art, New York,
16 January 1947	*Annual Exhibition of Contemporary American Painting*, shows *Nude*

1947

Winter	Moves to Glass House, Hebbeln's conversion in Sherman with studio in the farmhouse
15–28 February	*Bloodflames*, Hugo Gallery, New York
18 February–8 March	*Arshile Gorky: Colored Drawings* at Julien Levy Gallery
Spring	Drawings for Breton's book of poems *Young Cherry Trees Secured Against Hares*
June–September	Completes large number of works in Union Square while wife and children summer in Castine, Maine
July–August	Galerie Maeght, Paris, Surrealist exhibition shows *How My Mother's Embroidered Apron Unfolds in My Life*
19 November 1947– 4 January 1948	*2nd Annual Exhibition of Paintings*, California Palace of the Legion of Honor, San Francisco, shows *Nude*
6 December	Whitney Museum of American Art *Annual Exhibition of American Painting* shows *The Calendars*
27 December	Death of father, Setrag Adoian (85) in Providence

1948

31 January–21 March	Whitney Museum of American Art, *Annual Exhibition of Contemporary American Sculptures, Watercolors and Drawings*, shows *The Betrothal*, crayon
16 February	Article with photographs of Gorky in the Glass House in *Life*
29 February–20 March	*Arshile Gorky* at Julien Levy Gallery: paintings and drawings
June	Children taken away by mother-in-law. Wife leaves to join children. Car accident. Hospitalised, placed in traction. Agnes returns
July	Gorky returns home. Children brought back. The family returns to New York. Gorky confronts Matta. Wife and children leave
22 July	Alone in the Glass House. Visit from Saul Schary. Commits suicide.

Select Bibliography

Aprahamian, Souren, *From Van to Detroit* (Ann Arbour, 1993).

Barton, James L., *Story of Near East Relief, 1915–1930* (New York, 1930).

Bryce, Viscount, *The Treatment of the Armenians in the Ottoman Empire 1915–1916* (reprinted Beirut, 1988).

De Nogales, Rafael de, *Four Years Beneath the Crescent*, trans. Muna Lee (London, 1926).

La Défense Héroique de Van (Armenia), Editions de la Revue Droschak (Geneva, 1916).

Hoogasian-Villa Susie and Kilbourne Matossian, May, *Armenian Village Life Before 1914* (Detroit, 1982).

Hovannisian, Richard G., *Armenia on the Road to Independence, 1918* (Berkeley and Los Angeles, 1967).

——*Armenia on the Road to Independence, Vol. I: 1918–1919* (Berkeley and Los Angeles, 1971).

——*The Republic of Armenia*, 2 vols. (Berkeley, 1971–1982).

Kevorkian, Raymond H. and Paboudjian, Paul B., *Les Arméniens dans l'Empire Ottoman à la Veille du Génocide* (Paris, 1992).

Mansel, Philip, *Constantinople, City of the World's Desires, 1453–1924* (London, 1995).

Mirak, Robert, *Torn Between Two Lands, Armenians in America, 1890 to World War I* (Cambridge, MA, 1983).

Movses Khorenats'i, *History of the Armenians*, translation and commentary R. W. Thomson (Harvard University Press, 1978).

Mythologie, Armeno-Caucasienne et Hetito-Asianique, Editions P. H. Heitz (Strasbourg-Zürich, 1948).

Suny, R. G., *Looking Toward Ararat* (Indiana, 1993).

Walker, Christopher J., *Armenia: The Survival of a Nation* (London, 1980).

In Armenian
Ardsruni, Thomas, *The History of the House of the Ardsrunis* (Tiflis, 1917), French translation, M. Brosset, *Collection d'historiens armeniens* (Saint Petersburg, 1874).
Lalayan, Yervant, *Azdagrakan Handes*, Vol. 2, Book 20, No. 2, 1910.

General
Stern, Robert, Gilmartin, Gregory and Mellins, Thomas, *New York 1930, Architecture and Urbanism between the Two World Wars* (New York, 1987).
Waitman, Robert, *Report on America* (London, 1940).

Armenian arts
Carswell, John, *Kutahya Tiles and Pottery from the Armenian Cathedral of St James, Jerusalem*, 2 vols. (London, 1972).
Der Hovannesian, Diana and Margossian, Marzbed (trans. and eds.), *Anthology of Armenian Poetry* (New York, 1978).
Donabedian, Patrick and Thierry, Jean-Michel, *Armenian Art* (New York, 1989).
Ghazaryan, Manya, *Armenian Carpet* (Erevan, 1988).
Khatchaturian, Shahen, *Armenian Artists 19th–20th Centuries* (New York, 1993).
Khatchaturian, Shahen and Mirzoyan, Lucy, *Martiros Saryan* (Leningrad, 1987).
Matthews, Thomas F. and Wieck, Roger S., *Treasures in Heaven, Armenian Iluminated Manuscripts* (Princeton, 1994).
Miller, Donald E., and Touryan Miller, Lorna, *Survivors: An Oral History of the Armenia Genocide* (California and Oxford, 1993).
Nersessian, Sirarpie Der, *Aght'amar. Church of the Holy Cross* (Cambridge, MA, 1965).
——*Armenian Art* (London, 1978).
Nersessian, Sirarpie, Der, and Vahramian, H., *Aght'amar*, Documenti de architettura armena, 8 (Milan, 1974).
Ternon, Yves, and Kebabdjian, J.-C., *Arménie 1900* (Paris, 1979).

Periodicals
Buxton, Noel, 'Armenia', *Ararat*, London, p. 229.
Gutheim, F. A., 'Buildings at the Fair', *Magazine of Art*, 32 (May 1939).

Works on Gorky
Bowman, Ruth (ed.), *Murals Without Walls, Arshile Gorky's Aviation Murals Rediscovered* (New Jersey, 1978).
Coles, Prophecy, 'How My Mother's Embroidered Apron Unfolds in My Life: a study on Arshile Gorky', *Free Associations*, no. 20 (London 1990).

Greene, Balcomb, 'Memories of Arshile Gorky', *Art Magazine*, special issue: Arshile Gorky, vol. 50, no. 7 (New York, March 1976).

Herrera, Haydn, 'Gorky's Self-Portraits: The Artist by Himself', *Art in America* (March–April 1976).

Jordan, Jim M., and Goldwater, Robert, *The Paintings of Arshile Gorky, A Critical Catalogue* (New York and London, 1982).

Mooradian, Karlen, 'A Special Issue on Arshile Gorky', *Ararat*, 12, No. 4. Fall 1971.

Spender, Matthew, and Rose, Barbara, *Arshile Gorky and the Genesis of Abstraction: Drawings from the Early 1930s* (New York, 1994).

Monographs

Ashton, Dore, Auping, Michael and Spender, Matthew, *Arshile Gorky, the Breakthrough Years* (exhibition catalogue) (New York, 1995).

Fundacion Caja de Pensiones and Whitechapel Art Gallery Catalogue, *Arshile Gorky: 1904–1948* (Madrid and London, 1990).

Jordan, Jim M., and Goldwater, Robert, *The Paintings of Arshile Gorky: A critical Catalogue* (New York, 1982).

Lader, Melvin P, *Arshile Gorky* (New York, 1985).

Levy, Julien, *Arshile Gorky* (New York, 1966).

Matossian, Nouritza, *Black Angel, A Life of Arshile Gorky* (UK, 1998)

Mooradian, Karlen, *Arshile Gorky Adoian* (Chicago, 1978).

——*The Many Worlds of Arshile Gorky* (Chicago, 1980).

Rand, Harry, *Arshile Gorky, The Implications of Symbols* (London and New York, 1981).

Reiff, Robert F., *A Stylistic Analysis of Arshile Gorky's Art from 1943–1948* (New York, 1977; Ph.D. dissertation, Columbia University, 1961).

Rosenberg, Harold, *Arshile Gorky: The Man, the Time, the Idea* (New York, 1962).

Schwabacher, Ethel K., *Arshile Gorky* (New York, 1957).

Spender, Matthew, *From a High Place, A Life of Arshile Gorky* (New York, 1999)

Waldman, Diane, *Arshile Gorky 1904–1948, A Retrospective* (New York, 1981).

Art

Ashton, Dore, *The Life and Times of the New York School, American Painting in the Twentieth Century* (London, 1972).

Ashton, Dore, Campbell, Lawrence, de Kooning, Elaine, Priem, Bernard, Tyler, Parker and Barr, H. Alfred, *Cubism and Abstract Art* (New York, 1936).

Breton, André, *Le Surréalisme et la Peinture* (New York, 1945, 1972) —— 'L'Adieu à Arshile Gorky', Galérie René Drouin, n.d.

Chipp, Herschel B. (ed.), *Theories of Modern Art: A Source Book by Artists and Critics* (Berkeley, 1968).

Craven, Thomas, *Modern Art; the Men, the Movements, the Meaning* (New York, 1934).

Ernst, Jimmy, *A Not So Still Life* (New York, 1984).

Foner, S. Philip, and Reinhardt, Schultz, *The Other America: Art and the Labour Movement in the United States* (London, 1985).

Fry, Roger, *Cézanne, A Study Of His Development* (London, 1927).

Geldzahler, Henry, *American Painting in the 20th Century*, Metropolitan Museum of Art (New York, 1965).

Guggenheim, Peggy, *Out of this Century* (New York, 1946).

——*Confessions of an Art Addict* (New York, 1960).

Guilbaut, Serge, *How New York Stole the Idea of Modern Art: Abstract Expressionism, Freedom and the Cold War*, trans. Arthur Goldhammer (Chicago, 1983).

Hunter, Sam, *Modern American Painting and Sculpture* (New York, 1959).

Janis, Sydney, *Abstract and Surrealist Art in America* (New York, 1944).

Jouffroy, Alain, *Une revolution du regard* (Paris, 1959).

Kandinsky, Wassily, *The Art of Spiritual Harmony*, trans. Michael T. H. Sadler (Boston, 1914).

——*Concerning the Spiritual in Art*, trans. and ed., Michael T. H. Sadler (New York, 1977).

Kootz, Sam, *Modern American Painters* (New York, 1930).

Le Brun, Annie, *Jean Benoit* (Paris, 1996).

Levy, Julien, *Surrealism* (New York, 1936).

——*Memoir of an Art Gallery* (New York, 1977).

Miller, Stephen, *The Mosaics of Jeanne Reynal* (New York, 1969).

Park, Marlene, and Markowitz, Gerald E., *New Deal for Art* (Hamilton, NY, 1977).

Phillips, Lisa, *Frederick Kiesler*, Whitney Museum of Modern Art (New York, 1989).

Ratcliffe, Carter, *John Singer Sargent* (Oxford, 1983).

Rewald, John, *Paul Cezanne, Correspondance* (Paris, 1937).

Richardson, John, *A Life of Picasso, 1881–1906*, vol. 1 (London, 1991).

Rose, Barbara, *American Art since 1900* (1967).

Rosement, Franklin, *The First Principles of Surrealism* (London, 1978).

Sandler, Irving, *The Triumph of American Painting: A History of Abstract Expressionism* (New York, 1970).

Sawin, Martica, *Surrealism in Exile and the Beginning of the New York School* (Cambridge, MA, and London, 1995).

Sims, Lowery, *Rethinking the Destiny of Line in Painting: The Later Work of Wilfredo Lam*, Catalogue, Americas Society (New York, 1992)

Smith, David, *Atmosphere of the Early Thirties*, ed. Garnett McCoy (London, 1973).

Spies, Werner (ed.), *Max Ernst, A Retrospective*, Tate Gallery (London, 1991).

Sweeney, James Johnson, *Stuart Davis* (New York, 1945).

Tanning, Dorothea, *Birthday Party* (San Francisco, 1986).

Tashjian, Dickran, *A Boatload of Madmen: Surrealism and the American Avant-Garde* (New York and London, 1995).

Waldman, Diane, *Willem de Kooning* (New York and London, 1988).

Articles on Gorky in his lifetime

Breton, André, 'The Eye-Spring', *Arshile Gorky Paintings*, Julien Levy Gallery, catalogue (New York, 1945).

Davis, Stuart, Janowitz, Harriet, Kiesler, Frederick, Cahill, Holger, *Arshile Gorky*, Mellon Galleries (Philadelphia, 1934).

'Fetish of Antique Art Stifles here', *New York Evening Post* (15 September 1926).

Greenberg, Clement, 'Art', *Nation*, 160 (24 March 1945), pp. 342–4.

——*Nation*, 162 (4 May 1946), pp. 552–3.

——*Nation*, 166 (10 Jan. 1948), pp. 331–2.

——*Nation*, 166 (20 Mar. 1948), pp. 331–2.

——*Nation*, 167 (11 Dec. 1948), p. 676.

——'Art Chronicle', *Partisan Review*, 15 (Mar. 1948), p. 369. 2 il.

——*Nation*, 17 (May–June, 1950), pp. 512, 513.

Guild Art Gallery, 'Abstract Drawings by Arshile Gorky: 16 December 1935–5 January 1959', New York.

Johnson, Malcom, 'Café Life in New York', *New York Sun* (22 August 1941), p. 15.

Kiesler, Frederick T., 'Murals Without Walls: Relating to Gorky's Newark Project', *Art Front*, 2, No. 11 (18 December 1936), pp. 10–11.

——, 'Between Murals Without Walls and Walls Without Murals', *Architectural Record* (February, 1937), pp. 10–11.

Lansford, Alonzo, 'Concentrated Doodles', *Art Digest* (March 1947), p. 18.

Sweeney, James Johnson, 'Five American Painters', *Harper's Bazaar* (April 1944), vol. 78, pp. 122, 124, 1 il.

Articles about Gorky

Balakian, Peter, 'Arshile Gorky and The Armenian Genocide', *Art in America*, February, 1996. pp. 58–108

Burliuk, Mary, *Color and Rhyme* (1949), pp. 1–2.

Davis, Stuart, 'Arshile Gorky in the 1930's: a personal recollection', *Magazine of Art*, 44 (February 1952), pp. 56–8.

Graham, Gorky, Smith & Davis in the Thirties, Brown University, The Bell Gallery, List Art Building, Providence, Rhode Island (30 April–22 May 1977).

Hooton, Bruce, 'One Who Saw First – Major Gorky Show', *Art World*, 5, No. 8 (18 April–16 May 1981).

Jouffroy, Alain, 'Arshile Gorky et Les Secrets de la Nuit', *Cahiers du Musée de Poche*, no. 2, June 1959, pp. 75–85.

Riley, Maude, 'The Eye–Spring: Arshile Gorky', *Art Digest*, 19 (15 March 1945), p. 10.

Rosenberg, Harold, *The Anxious Object* (USA, 1964, UK, 1965).

Seitz, William, 'Arshile Gorky's *The Plough and the Song*', Allen Memorial Art Museum, *Bulletin*, 12, Fall 1954, pp. 4–15.

Simon, Sydney, 'Fifty Years of Painting by Peter Busa', *Art International II*, Summer 1967, reprinted in *Life Colors Art*, p. 51.

Talmer, Jerry, 'Watch that paint', *New York Post*, 1980, p. 13.

By Arshile Gorky

Thirst, Grand Central School of Art Quarterly, New York, November 1926. Poem reprinted in Schwabacher, 1957.

'My Murals for the Newark Airport: An interpretation' (December 1936). Text prepared for *Art for the Millions. Murals Without Walls*, pp. 13–16.

Stuart Davis, *Creative Art*, vol. 9 (September 1931), pp. 212–17. Excerpt reprinted in Schwabacher, 1957.

Camouflage, Grand Central School of Art (New York, 1942), reprinted in Schwabacher, 1957, and Rosenberg, 1962.

Garden in Sochi, 26 June 1942. Museum of Modern Art (New York, 1942).

Breton, André, *Young Cherry Trees Secured Against Hares* (New York & London, 1946), illustrated by Gorky.

General Periodicals

Miller, Stephen R., 'The Surrrealist Imagery of Kay Sage', *Art International*, 26, no. 4 (Sept.–Oct. 1983).

Film

Windows to Infinity: The Life and Work of Arshile Gorky, 4 March 1979. Spotlight on Armenians Series, Armenian General Benevolent Union of America. Colour videotape.

Mural Without Walls, WNET Thirteen, Dateline: New Jersey. Colour videotape.

Acknowledgements

In addition to the people and institutions credited at the beginning of this book (p.vi), I am also grateful to many others for help and cooperation. I wish to thank firstly those members of Arshile Gorky's family who spent much time and trouble providing me with information about him: his widow Agnes (Mogooch) Gorky Fielding, for prolonged interviews and informal conversations over a fifteen-year period, as well as for documentation; his daughter Natasha Gorky, who was a generous host to me during my first interviews in Spain and who accompanied me to meet her aunt Vartoosh Mooradian in Chicago.

I thank the following for reading, discussing, making valuable suggestions and supporting me: Alain Adam, Hagop Adourian, Peter Balakian, Eileen Barker, Mary Ellen Barton, Stefania Bonelli, Ian Burlingham, Jonathan Burnham, Carmen Callil, Anselmo Carini, William Dalrymple, Melanie Friesen, Jude Galstian, Rolf Gehlhaar, Archbishop Yegishe Gizirian, Tina Hazarian, Garo Keheyan, Ruth Keshishian, Melvin Lader, Herman Lelie, Jonathan Bayer Levy, Philip Marsden, Satenig Matossian, Johnny Dewe Mathews, Claude Mutafian, Rev. Vrej Nersessian, Susan Pattie, Charles Pehlivanian, Deanna Petherbridge, Geoff Pine, Stephen Polcari, Lilly Richards, Ara Sarafian, Gary and Susan Lind Sinanian, Hratch Tchilingirian, Ruth Thomasian, Christopher Walker and Marina Warner.

I am grateful to Gillon Aitken, my literary agent, for his expert and judicious support; to Alison Samuel, my editor, for her skilled and sensitive editing, and for her calm constancy; to my friend Carol Burns for her phenomenal expertise in inspired suggestions, corrections and shaping this book during the past fifteen years of valued friendship; and to His Excellency Armen Sarkissian for his expertise, loyalty and faith in this book, and for the inspiration of his personal courage.

I thank His Holiness Karekin I, the late Catholicos of All Armenians, for his gracious guidance.

Black Angel

Thanks for permission to Archbishop Khajag Barsamian, Karekin Arzooma-nian and the Diocese of the Armenian Church of America, for the reproduction of excerpts from *Arshile Gorky Adoian* and *The Many Worlds of Arshile Gorky*, taped interviews conducted by Karlen Mooradian and Vartoosh Mooradian's correspond-ence.

Thanks to all those others who granted me interviews:

Arshile Gorky's family: Vartoosh Mooradian, Azad Adoian, Beatrik Adoian, Charles (Ashot) Adoian, Lucille Adoian, Dawn Adoian and Mike and Florence Berberian. And to Lionel Abel, Ann Alpert, David Anfam, Will Barnett, Aube Breton, Elisa Breton, Esther Brooks, Sandra Calder, Lilyan Chooljian, Rob Cowley, Dorothy Dehner, Ruth Francken, Mrs Chaim Gross, Jane Gunther, Gaston de Havenon, Ward Jackson, A. M. Janney, Alain Jouffroy, Shahen Khatchatrian, Lillian Olinsky Kiesler, Vivi King, Eskil Lam, Helena Benitez Lam, Jerrold Levy, Philip Mansel, Diego Masson, Mercedes Matter, Libby Amerian Miller, Stephen Miller, Robert Mirak, Art Muschenheim, Paul Resika, Milton Resnick, Meyer Schapiro, Chris Schwabacher, Muriel Streeter, Ronald Suny, Dorothea Tanning, Robert and Mary Taylor, Pars Tuglaci and Anna Walinska.

For help in my travels to Armen Aroyan and the group of May 1996 to historic Western Armenia; Archbishop Mesrob Moutafian, Istanbul; Zohrab Mirzoyan, Armenia; Françoise Dubarry; Marco and Judith Chiara; Martha Clarke; Eleanor Sebastian and Charles Frank, Jerrold Bayer Levy, USA.

ILLUSTRATIONS: Thanks to those credited in the plate sections, and many others who have assisted me. Every effort has been made to trace copyright holders, and the publishers will be happy to correct mistakes or omissions in future editions.

Index

Abbot, Berenice, 442–3
Abel, Lionel, 369, 379, 422–3, 485, 487
Abramson, Louis Allen, 295
Abstract Expressionism, xiv, 184, 340, 373, 401, 442, 452, 490, 492
Abstract Surrealism, 251, 296, 492
Abstraction, xii, 142, 174, 175, 188, 194, 198, 201, 204, 206, 209, 211, 227, 238–41, 243, 246, 265–6, 285–6, 291, 333, 341, 354, 374, 443
Académie Julien, Paris, 147
Action Painting, 289, 381, 492
Adana massacre (1909), 39, 108
Adeldjevas (Alcevas/Aljevas), 10, 18
Adoian, Abednago ('Krikor'; G's uncle), 9, 10–11, 13, 21, 22, 39, 40, 41, 49–50
Adoian, Ado (G's cousin), 9, 12, 23, 26, 27, 35, 52–3, 63, 90, 199, 200, 235, 236, 405–6, 417
Adoian, Akabi (previously Shaljian; G's stepmother), 131
Adoian, Arshalouys (Dawn), 120, 124, 144
Adoian, Azad (G's cousin), xvii, xviii, 12, 26, 27, 39–40, 52, 63, 90, 94, 235, 237, 392–3
Adoian, Baghdassar Ashot (Charles), 120, 121–2, 144, 323
Adoian, Baydzar (G's aunt), 39, 40
Adoian, Beatrice (G's cousin), 237
Adoian, George, 120
Adoian, Grandmother, 39
Adoian, Hagop (G's half-brother), 8, 50, 118, 120, 121, 123, 124, 127, 144, 173
Adoian, Heghiné (née Najarian), 120, 124
Adoian, Lucille, 120, 121, 124, 144, 173
Adoian, Lucy (née Amerkhanian; Setrag's first wife), 8
Adoian, Manoug Agha (G's paternal grandfather), 8, 9, 21, 39
Adoian, Mishag (Misaki; G's uncle), 9, 10–11, 122

Adoian, Satenig see Avedissian, Satenig
Adoian, Setrag (G's father), 10, 17, 18, 34, 45–6, 88, 107, 121–2, 181, 208, 213, 271, 323, 345, 394, 425, 433; appearance, 7, 119–20, 293–4; birth (1863), 9; death (1947), 447; first marriage, 8; G imitates, 17, 24; G keeps him a secret, 131–2, 180, 315, 323, 447; and G's birth, 7–8; G's preoccupation with, 293–4; G's and Vartoosh's view of, 114–15; leaves for America (1908), 22–3, 25, 36, 40, 51; lives with Hagop, 144; Lucille on, 120; marries Akabi, 131; meets G and Vartoosh in America, 119–20; quarrels with Krikor, 10, 21; and Satenig's wedding, 98; sends money back to his family, 46, 55, 95, 101, 114, 120, 406; storytelling, 366; work in America, 120
Adoian, Shushan (previously Prudian; née Der Marderossian; G's mother), 41, 45, 46, 48, 61, 71, 72, 73, 85, 106, 107, 124, 169, 272, 273, 345, 403, 441; appearance, 25, 50; background, 8, 32; Bible teaching, 433; change in G's attitude to, 275; death, 98, 99, 100, 119, 173, 198, 371; encourages G's art, 12, 47; farm work, 10, 12, 34, 39; first marriage, 40; forced march from Van, 79, 82, 83; G's birth, 5, 7–8; and G's education, 25, 32–3, 54; and G's refusal to speak, 10, 12, 13, 14; illness, 90, 93, 94, 95, 97–8; influences G, 23; and local myths, 15–16; personality, 9, 14, 23, 39; sewing, 55; and Sima's death, 21, 88; in Yerevan, 86, 87, 88, 89, 95, 97–8; yerk legacy, 424
Aghayan, 30
Aghtamar Island, Lake Van, Armenia, xvi, 3, 22, 27, 29, 34, 35, 36, 188, 215, 216, 217, 263, 378, 428
Aghtamar Seminary, 13, 19
Aharon (G's uncle), 55, 89, 94, 97, 100, 103, 427

Akantz, 71
Aknuni (an Armenian leader), 59
Albright brothers, 315
Albright-Knox Art Gallery, Buffalo, New York, 492
Alexander, Dr, 210
Alexander, Nohrabed, 30
Alexandropol, 104
Ali Bey, 20
Allan Stone's Gallery, 491
Amerian, Akabi ('Ahko'; née Prudian; G's half–sister), 8, 30, 42, 50, 52, 68, 144, 200, 213, 278, 322; appearance, 128, 223; in California, 394; emigrates to America (1916), 88; in Etchmiadzin, 85; fire in Watertown (1934), 220–21; forced march from Van, 79, 80, 82, 83; G moves in with, 127; greets G in New York, 118; on G's drawing, 23; on G's mutism, 14, 22–3; marries Mgrditch, 40; as midwife, 323; personality, 127; and Shushan's death, 119; in Van, 42; and Vartoosh's pregnancy, 236; and Vartoosh's wedding, 130, 131; in Yerevan, 86, 87
Amerian, Gurgen (later Jimmy; Akabi's son), 68, 79, 80, 82, 83, 86, 88, 118
Amerian, Mgrditch, 40, 50, 51, 88, 117–18, 303
Amerian, Tommy, 342
American Abstract Artists, 280, 286, 373
'American Art', 239–40
American Artists' Federation of Painters and Sculptors, 336
American Committee for Armenian and Syrian Relief in the Near East, 96, 100, 107
American Consulate, Tiflis, 102
American Federation, 267
American Mission, Aykesdan, 46–7, 48, 54, 58–9, 61, 66, 68, 72–5
American Scene, 183, 190, 201, 239, 320
Anahit (fertility goddess), 424
Anatolia, 29
Anrep, Boris von, 308
Antranig, General, 78
Antsevatsik princes, 51
Apostolic Orthodox Church, 8, 27, 29, 40, 86, 91
Aragatz, Mount, 103
Aragon, Louis, 396, 397
Aram Pasha, 68, 75
Ararat (an Armenian review), 497, 498
Ararat, Mount, 37, 82–3, 86
Arax Restaurant, New York, 277
Arax river, 83
Arcane 17, 372
Ardahan, 93
Ardos, Mount, 26, 31, 51, 428

Armenia: art, 188–9, 215; artistic renaissance (1920s), 258; at war with Georgia, 101; Eastern, 11, 105; famine in (1918–19), 95–8, 100–101, 203; First Republic declared (28 May 1918), 94, 102; funerals in, 447; G on, 143; graves, 217; illuminated Bibles, xii, 33, 73, 405; loss of autonomy (1930s), 225; myths, 15–16, 37–8, 193; and the Second World War, 334; Turkish blockade, 95; Vartoosh's repatriation, 199–200; Western, 11, 42, 83, 93, 96, 103, 391, 419, 425
Armenian Diaspora, 494
Armenian Relief organisation, 91
Armenian Review, 497
Armenian script, 378
Armenians: Adana massacre (1909), 39, 108; Apostolic religion, 27; and arms, 18–19, 22, 24, 30; carpet making, 56; costumes, 34–5, 50, 51, 273, 293, 348; deportations, 72, 103; as farmers, 11; folk songs/dances, 34, 51, 193, 246; genocide by Ottoman Turks (1915–20), xi, xii, 64, 71, 72, 77–9, 87, 91, 103, 108, 122, 127, 131, 155, 173, 185, 217, 275, 276, 284, 371, 391, 419, 441, 490, 494, 495; G's active involvement in American Armenian life, 155; the massacres of 1890s, 31, 32, 108; model of marriage, 319; the 'most progressive element in the Ottoman Empire', 55; Ottoman rule, 5, 11–12, 18–19; patriotism, 55; religiosity, 55; revolutionary secret societies, 19; settlement in the Armenian republic, 391; steles, 37; treated as second–class citizens, 30, 59; values, 55; in Van, 42; the Van massacre (1908), 19–21, 23; victory at Sardarabad, 93–4; Vosdan massacres (1895), 31; work in America, 122–3, 125
Armory Show (New York, 1913), 142, 177, 192
Arnos, Mount, 50–51
Arp, Jean, 179, 285, 332
Arpenik (waitress), 277
Arshile Gorky: The Breakthrough Years (1995–96), 492
Art Digest, 425
Art Exhibition for the Benefit of Armenian War Relief, 334
Art Front journal, 227
Art Institute of Chicago, 425, 498
Art Nouveau, 434
Art Students' League, 152, 175, 176, 205, 209, 210, 211, 289, 299, 301, 334, 344, 372, 402
Artaud, Antonin, 396
Artemid, 41
Artists' Congress, 289, 290
Artists' League, 228
Artists' Union, 227, 248, 251, 252, 278
Ashtarak, 96

Index

Ashton, Dore xiv
Astor family, 314
Auerbach, Alfred, 260
automatic drawing, 325, 332, 396
Avakian, Alexander, 315
Avakian, Kohar, 315
Avedissian, Sarkis (Satenig's husband), 119, 208, 323
Avedissian, Satenig (née Adoian; G's sister), 8, 18, 22, 208, 221, 278, 322, 323, 394; appearance, 128; on the Bible under the tree, 12–13; birth of Shushanig, 128; emigrates to America (1916), 88–9; forced march from Van, 79; G's companion in his infancy, 14, 15–16; on G's early work in America, 125; and G's first drawings, 15; on G's horse, 49; marries, 98–9; meets Agnes, 488; miscarriage, 119; personality, 40, 89; and Sima's death, 21; smallpox, 14; in Yerevan, 86, 87, 88
Avedissian, Shnorig, 163–4
Avedissian, Shushanig (Lillian), 128, 154
Avery, Milton, 321, 355
Avery, Sally, 328
Aykesdan, Van, 46–7, 54, 61, 64, 65, 66, 70, 72
Azerbaijan, 90, 93, 104

Bach, Johann Sebastian, 206, 239, 285
Badurik, Mount, 37
Baku, 30, 94
Balakian, Peter, 494
Balkan states, 19
Ballets Russes, 135
Balzac, Honoré de, 388
Bandi Mahoun river, 82
Barbizon School, 133
Barnett, Will, 159, 190–91
Barr, Alfred H., 174, 183, 184, 239, 285, 325–6, 332, 342, 371, 382
Bartlett, Dr, 343–4
Bataille, Georges, 396
Batum (now Batumi), 93, 94, 105, 106, 123
Bauhaus, 290
Bayer, Herbert, 336
Bayer, Jerrold, 378–9, 440–41, 442–3
Baziotes, William, 331–2
Bekir, 70
Bellows, George, 176
Benoit, Jean, 486
Benton, Thomas Hart, 205–6; The Arts Life in America, 205
Berberian, Florence (G's niece), 120, 392, 482, 483
Berberian, Mike, 482, 483
Berg, Alban, 242
Bergri, 80

Bijur, Jonathan, 184
Bijur, Mrs (art teacher), 131, 146; Portrait of Mogouch, 146
Bijur, Nathaniel, 152, 170–71
Bitlis, 42, 58, 59, 72, 83, 86
Black Sea, 105–6, 334
Blavatsky, Madame, 285
Bliss, Lillie P., 174
Blue Four, 147
Blume, Peter, 403, 442, 458, 469, 473, 479, 480, 483
Bolsheviks, 90, 94, 101
Boltowsky, Ilya, 280
Bombshell Group, 321
Borchalou, 104
Bosch, Hieronymus, 349; The Garden of Earthly Delights, 418
Boston, 435
Boston, Mass., 118, 121, 129, 152, 200, 220
Boston Museum of Fine Art, 129–30, 133, 139, 141, 147, 152, 278
Boston Museum School of Fine Art and Design, 131, 132, 133, 136–7, 152
Botticelli, Sandro, 173
Boudaghyan family, 42
Boyer Gallery, Philadelphia, 240
Brancusi, Constantin, 249
Braque, Georges, 141, 166, 174, 179, 184, 188, 189, 190, 333
Brauner, Victor, 486, 494
Breakaway Group, 141
Breton, André, xiii, 56, 175, 212, 265, 324, 331, 332, 341, 349, 352–7, 359, 367, 369, 370, 371, 372, 374, 376–7, 379, 380–1, 382–3, 387–9, 393, 395, 396, 397, 398, 402, 414, 416, 425, 430, 445, 451, 485–6, 495; Arcana, 362; Book of Hours of Elisa, 390; Les Champs Magnétiques (with Soupault), 350; Eternal Youth, 369; 'The Eye-Spring', 379, 380–81, 390, 486; 'Farewell to Arshile Gorky', 486; Nadja, 359; Portrait of the Actor A. B., 333; Le Surrealisme et la Peinture, 390; Les Vases Communicantes, 359; Young Cherry Trees Secured Against Hares, 385, 388, 389, 418, 422
Breton, Aube, 386, 389, 402
Breton, Elisa (née Caro), 362, 370, 376, 385, 387, 393
Bridgewater, 440, 442
Britain: in the Second World War, 320; in secret league with Turkey, 18
British Museum, London, xii
Brookline College, Massachusetts, 327
Brooklyn Museum, New York, 194
Brooks, Esther see Magruder, Esther

563

Browne, Byron, 278, 279, 280, 341
Browne, Rosalind, 252–3, 263, 278, 279
Brueghel, Pieter, the Elder: *Seasons*, 349
Bryusov, Valery: *The Anthology of Armenian Poetry*, 92
Burchfield, Charles, 174
Burkhardt, Hans, 263
Burliuk, David, 91, 193–4, 225, 337, 338, 342
Burliuk, Mary, 338
Burliuk, David, 194
Busa, Peter, 184, 210, 214, 216, 222, 232, 249, 250, 256, 273, 275, 291, 335–8, 372–3, 431
Butcher Regiment, 64, 72
Buxton, Harold, 20–21
Buxton, Reverend Noel, 20–21

Cahiers d'Art, 171, 175, 184, 265, 274, 303
Cahill, Holger, 198, 220, 240, 241, 294, 313
Calas, Nicolas, 414, 430
Calder, Alexander, 391, 396, 409, 417, 434, 442, 443, 450
Calder, Sandra, 443
Calouste Gulbenkian Museum, 492
Cape Cod, 278, 319
Carini, Anselmo, 275, 498
Carlebach, Julius, 398
Carles, Arthur B., 209, 238, 245
Carlock, Merlin, 146
Carrington, Leonora, 332
Castine, Maine, 435
Caucasia, 93
Caucasus, 83, 91, 103, 130
Cavallon, Georgio, 291–2, 296
Cedar Tavern, New York, 400
Central Asia, 57
Cézanne, Paul, 130, 133, 140, 141, 143, 150, 151, 152, 154, 158, 159, 161, 164, 165, 166, 171, 174, 185, 188, 190, 195, 201, 215, 224, 225, 226, 231, 266, 292; *Portrait of the Artist's Mother*, 215
Chagall, Marc, 91, 285
Chagar Sourp Nishan monastery, 31–2, 33, 99
Chagli, Aykesdan, Van, 46
Chaliapin, Fedor Ivonivich, 315
Charentz, Yeghishe, 90
Chase, William Merrit, 133
Chatto (revolutionary leader), 51
Cheka, 236
Chermayeff, Serge, 312, 337, 380, 410
Chicago, 311, 314, 316, 386, 447
Chicago Art Institute, 275, 340
China Today magazine, 301–2
Chingli Mountain, 82
Chookjian, Felix, 146

Chooljian, Kertzo Dickran *see* Dickran, Kertzo
Chopin, François Fryderyk, 206
Chrysler Building, New York, 197
Church of the Holy Cross, Aghtamar Island, 34, 35–6, 56, 215
Churchill, Sir Winston, 393
Cilicia, 42, 107
Circle journal, 242
City Scene, 190
Claude Lorraine, 225
Cloisters, New York, 270
Cold War, 419
Colour Field work, 142
Columbia University Hospital, 392
Committee of Action, 221
Communist Party: Armenia, 199, 235, 236, 406; United States, 144, 204, 207, 248
Connah, Douglas John, 132–3, 140, 142
Connah, Jack Ferris, 135, 136
Connecticut, xvi, 52, 266, 329, 372, 378, 386, 396, 416, 440, 443, 472, 475, 488
Constable, John, 225
Constantinople (later Istanbul), 10, 19, 39, 43, 60, 72, 101, 106–8, 123
Constructivism, 192, 332
Cooke, Ethel, 131–7, 139, 141, 146, 147–8, 243
Copley, John Singleton, 137
Cornell, Joseph, 332
Corot, Jean-Baptiste-Camille, 223, 225, 349
Cossacks, 19, 82
Cowley, Malcolm, 391, 403, 442, 479–80, 484–5
Cowley, Muriel, 391, 442, 479–80, 483
Cowley, Robert, 391, 403, 442
Crane, Hart, 391
Craven, Thomas, 205
Cronin, Frank, 136
Crooked Run Farm, Hamilton, Virginia, 345, 360, 361, 413–14, 421
Cubism, xii, xiii, 56, 91, 141, 142, 165, 166, 174–7, 182, 184, 188, 189, 192, 194, 195, 197, 204, 209, 220, 222, 227, 250, 251, 262, 266, 291, 312, 334, 341, 420, 469, 490, 491

Dada, 192, 391
Dalí, Salvador, 211, 212, 280, 294, 318, 324, 332, 379; *The Persistence of Memory*, 201
Daniel Gallery, New York, 147
Daniel (Setrag's nephew), 120, 123
D'Annunzio, Gabriele, 281
Danton, Georges, 406
David, Jacques-Louis, 387
Davis, Bernard, 220, 233, 235, 256, 264, 307, 379, 411
Davis, Bessie, 186

Index

Davis, Mariam, 247
Davis, Roselle, 172, 221
Davis, Stuart, 164, 176–9, 186, 195–7, 204, 205,
 207, 209, 211, 220, 221, 225, 227, 228, 233,
 238, 239, 247, 248, 251, 260, 267–8, 286,
 289–90, 321, 431
Davis, Wyatt, 247, 248, 249
Day, Father, 481, 483–4
'Daybreak in Turkey' movement, 22
De Chirico, Giorgio, 164, 184, 201, 212, 243, 389
De Havenon, Gaston, 222, 234–5, 287, 288–9,
 292, 373, 407, 408, 410, 466, 467
de Kooning, Elaine (née Fried), 273–4, 290, 300,
 431, 451
de Kooning, Willem, xii, 109, 164–5, 184, 190,
 193, 202–5, 209, 210, 217, 221, 238, 241–4,
 246, 256, 270, 271, 273, 277, 280, 286, 288,
 290, 292, 295, 299, 300, 302, 325, 341, 350,
 369, 431, 439, 451, 492, 495; Black on White
 series, 244
De Stijl, 192
Degas, Edgar, 129, 130, 159, 190
Dehner, Dorothy, 176, 252, 327–8, 354
Delaunay, Robert, 179, 265, 285
Delaunay, Sonia, 265
Demuth, Charles, 152, 174
dépaysement, 349
Depression, 179, 185, 188, 194, 203, 205, 235, 239,
 248, 280, 282, 303, 323, 490
Der Garabedian, Dickran, see Dickran, Kertzo
Der Hagopian, Parsegh, 107
Der Hagopian, Yenovk (Enoch), 23–4, 30, 37, 53,
 107, 144–6, 154, 172, 188, 224, 342, 426–8
Der Marderossian, Hamaspiur (G's maternal
 grandmother), 32, 221
Der Marderossian, Nishan (G's uncle), 32
Der Marderossian, Yeva (Shushan's sister), 42, 59,
 85–6
Der Marderossian family, 31, 32
Der Sarkis (G's maternal grandfather), 32, 33
Deux Magots, Paris, 416
Dewing, Thomas Wilmer, 133
Diaghilev, Sergei, 135
Diarbekir, 58
Dickran (Der Garabedian), Kertzo, 19–20, 74, 90,
 101, 102, 107, 113
Dies Committee, 252
Dilijan, 103
Diller, Burgoyne, 250, 251
Diocese of the Armenian Church of America, 493
Diramayr Church, 80
Disraeli, Benjamin, 18
Doerner, Max, 304
Dostoevsky, Fyodor, 175

Dove, Arthur, 238
Downtown Gallery, New York, 194–5, 197, 198,
 205
Draper, Muriel, 275, 374
Dreier, Katherine, 192, 244
Dro, Commander, 101–2
Duchamp, Marcel, xiii, 201, 212, 244, 332, 356,
 369, 373, 379, 382, 383, 385, 387, 430, 485,
 487; Boite en Valise, 332–3; The Bride Stripped
 Bare by Her Bachelors, Even, 374, 417, 435
Dürer, Albrecht, 129

Eakins, Thomas, 141
Eastern Caucasia, 57
Ellis Island, New York, 113, 115, 335
Eluard, Paul, 175, 253, 354, 396
Emergency Relief Fund, 240
Emergency Work Bureau Group, 207
Emmanuel, Pierre, 360
Empire State Building, New York, 197
Engels, Friedrich, 315
Enver Pasha, 57, 60, 61, 64
Ereer, 61
Erevan (later Yerevan), 79, 80, 93, 94, 95, 96, 98,
 99
Erevan plain, 83
Erevan province, 95
Ermerur, 32
Ernst, Max, 201, 258, 271, 284, 294, 332, 341,
 369, 374, 379, 383, 389, 399, 400, 423, 442
Erzurum (Erzurum), 58, 59, 60, 72, 83
Etchmiadzin, 32, 83, 93, 108

fascism, 284
FBI, 236, 285, 302, 347
Fechin, Nikolai Ivanovich, 147, 152, 161, 162
Federal Arts Project, 243, 251, 267, 279
Federal Arts Project Gallery, New York, 249, 250
Federation of Anarchists, 396
Feininger, Lyonel, 147, 282
Felix, Fernando, 187–8
Ferenci, Sandor, 456
Ferragil Gallery, New York, 147
Ferren, John, 265, 311
Fielding, Alexander, 493
Fielding, Mogooch see Gorky, Agnes
57th Street Gallery, New York, 212
Finland, 289
First American Artists' Congress, 239, 240
First American Writers' Congress of Communist
 Party Writers, 239
First World War, 59, 89
Fishkill, Duchess County, New York State, 286
Fitzgerald, F. Scott, 162

Flushing Meadow, Queens, New York, 280
Focillon, Henri: *Life Forms in Art*, 175
Folk Art Museum, Harvard, 175
Force, Juliana, 221
Ford, Charles Henri, 385
France, 93, 142, 320; G's plans to visit, 387–8, 395, 418, 451; in the Second World War, 320, 355, 362–3, 396, 397
Frances, Esteban, 332
Francken, Ruth, 379
Franz Ferdinand, Archduke, 59
French, Ruth *see* Mussikian, Sirun
Freud, Sigmund, 151, 162, 201, 335, 430, 481
Freudianism, 369
Frick Collection, New York, 245
Fry, Roger, 158
Fuller, Buckminster, 197
Futurism, 193, 194, 332, 342

Gagik, King, 35
Galérie Maeght, Paris, 430
Gallatin, Albert Eugene, 179
Gallery of Living Art, New York, 179
Gallet, Leonore, 272, 303; appearance, 270, 271; her collection, 270, 287; G starts love affair with, 270; leaves G, 288, 291–2; in Paris, 274; as a violinist, 271, 288, 291
Gaudier-Brezska, Henri, 258, 354
Gauguin, Paul, 278
Gaulle, Charles de, 362, 397
George, Marny *see* Gorky, Marny
George, Vesper, 133
Georgia, 90, 101, 104, 131, 198
Germany, 142, 282; and genocide of Armenians, 79; Nazi, 205, 227; non-aggression pact with Russia, 289; Reichstag fire, 205; in the Second World War, 362–3, 382, 396; secret agreement with the Ottoman Empire (1914), 59
Giacometti, Alberto, 356
Glass House, Sherman, Connecticut, 391, 436, 440, 441–2, 448, 459, 460, 479–80
Goldwater, Robert, xiv, 494
Goncharova, Natalya, 142, 194
Good Hope Road, Connecticut, 376
Goodrich, Lloyd, 221, 238, 239, 325, 439–40
Gorky, Agnes ('Magooch'; née Magruder, later Fielding; G's second wife), xii–xv, 216, 300–306, 310–11, 313, 330, 337, 338, 355, 356, 363, 370–71, 373, 378, 386–7, 394–6, 410, 418, 435–6, 453–4, 463, 465, 492; appearance, 299, 300, 303, 313, 328, 451; attitude to marriage, 318–19, 451; and the barn fire, 403; birth of Maro, 342–3; birth of Yalda, 392; and Communism, 301–2, 307, 318, 347; counselling, 425, 449, 455, 456; early life, 301;

encourages G, 349; financial position, 487–8; and G's car accident, 458–9; and G's funeral, 481, 482, 484; G's jealousy, 384, 425, 449, 451; and G's operation, 407–10; and G's suicide, 487; leaves G, xiii, 455, 460, 465, 474, 482; letter to Ethel Schwabacher, 470; and Malta, 395–6, 453–4, 463, 465; marries Alexander Fielding, 493; marries G (1941), 313–14, 315; marries Jack Philips, 488; meets G, 300–301; personality, 303; pregnancy, 310, 329, 337, 378, 389; and Reynal, 308; San Francisco trip, 308, 309–10; told of G's suicide, 480
Gorky, Arshile (Manoug (Vosdanig) Adoian): ambition to become a painter, 123; appearance, xiii, 36, 50, 104, 113, 128, 130, 131, 132, 135, 137, 146, 157, 160, 189, 193, 203–4, 236, 240, 257, 307, 337, 379, 387, 393, 397, 408, 468; appointed assistant life drawing teacher, 139; arrival in New York, 115–18; birth (22 April 1902), 5, 7–8; breaks up with Sirun, 187–8; buried in Connecticut xvi, 488–9; cancer, xv, 398, 400, 405, 407–11, 415, 426, 431, 449, 453, 471–2; car accident and hospitalisation (1948), xiii, 456–9; departure of his father, 22–3; discards his name, xi, xiv, 8, 35, 91, 104, 125–6, 131–2, 217, 441; elected instructor at the Grand Central School of Art, New York, 150; emigrates to America (1920), 110; enrols at Boston School of Fine Art and Design (1923), 131; exhibits at MoMA, 183–5; father's death, 447; first identifies with Surrealism, 296; first known painting, 138–9; first marriage, 231–5; first one-man show (1934), 219–20; first solo exhibition in New York (1945), 376, 378, 379–82; forced march from Van (1915), xi, 79–80, 82, 83; funeral, 481–4; his grave, 488–9; handicrafts training, 55–7; leaves Armenia (1920), 110; manifesto, 322; marries Agnes (1941), 313–14, 315, 483; meets Agnes, 300–301; meets Breton, 352–3; meets Matta, 325; mother's death, 98, 101, 106, 173, 371; move to Van (1910), 41–2; paintings burnt, xiii, 134, 220–21, 402–4, 406, 407, 411, 490–91; his part in the defence of Van, 68–9, 71; personality, 24, 37, 47, 136, 156, 185, 383; starts love affair with Leonore, 270; starts love affair with Sirun, 167–8; suicide (22 July 1948) xi–xii, xiv–xv, 475, 480, 481, 485, 487, 490, 498; US citizenship (1939), 288
style
airy, floating quality, 296, 348; 'animated abstraction', 495; approach to his Cubist works, 189; calligraphic quality, 33, 153; use of colour, xii, xvi, 34, 139, 263, 264–5, 273, 291, 378, 439, 491; compared with Mir;, 292–3; fluidity, 420; influence of decorative tiles, 108–9; new abstract personal style, 374; plasticity, 263; process of transformation from one motif into another, 185; use of space, 366;

Index

spontaneity, 134, 135; synthesis of the Western and the Eastern, 92, 215; watershed in his style, 331
subjects
animism, xii, 372; bone form, 424–5; boot, 293; cockerel, 353–4; egg, 293; fantastic forms, 293; his father, 293–4, 433; group compositions, 96–7; horses, 49; landscapes, 13, 130, 152, 160, 166, 266, 347–50, 366–7, 368, 405; his mother, xii, 97–8, 198, 213–18, 223, 266, 274–5, 293, 312, 334; the plough, 342, 424; portraits, 133–5, 147–9, 152, 154–5, 161, 170–72, 174, 264, 287, 312, 328; religious themes, 154; sculpture, 143, 161, 313; shadowy male figure in his drawings, 23; steles, 37; still life, 152, 158, 159, 161, 165–6, 171, 174, 185; symbol of eternal life, 272–3, 400; wrapped–up figures, 36
techniques
use of black, 57; camouflage, 294, 321–2, 331; colouring techniques, 109, 134, 161, 295–6, 363; crayons, 348–9; cross–hatching, 202, 226, 274; designing the canvas, 241, 275; draughtsmanship, 160, 202, 203, 266, 365, 439–40, 492; drawing innovations, 109; drawing/painting continuum, 161; feeling for intrinsic geometry, 159–60; mastery of light, 147; new oil–paint technique, 261; overpainting, 226, 317–18, 340; paints straight on to canvas, 134; paints well out in front of him, 153; positive/negative space, 209; tonality, 134, 135, 139; transparent painting, 147, 340, 363, 420; treatment of surfaces, 26, 37, 257, 273, 274–5, 400, 491
works
Abstraction, 271; Abstraction with Palette, 198; After Khorkom, 257; Agony, 431, 433, 434, 435, 444; Alphabet, 45; Anatomical Blackboard, 404–5; The Antique Cast, 161, 202; Argula, 14, 272–3, 293, 307, 317; The Artist's Mother, 274–5, 277, 312; Aviation Mural, 247–51, 253, 255, 259–64, 265, 267–8, 280, 291; Battle at Sunset with the God of the Maize, 258–9; Beach Scene, 146–7; The Beginning, 414, 433, 444; The Betrothal, 424–5, 433, 434–5, 439, 444; Blue Figure in Chair, 198; Bull in the Sun, 327; The Calendars, 431–2, 439, 490–91; Charred Beloved I and II, 18, 74, 405, 422, 423; Child of an Idumean Night, 258; Composition, 243, 274; Composition with Head, 264; Composition no 1, 238; Composition no 2, 238; Composition no 3, 238; Creative Art article on Stuart Davis, 195–7; Dark Green Painting, 431; Days, etc., 434; Delicate Game, 411; The Dervish in the Tree, 365; Detail for Mural, 243; The Diary of a Seducer, 63, 399–400, 404, 411, 422, 493; Enigmatic Triptych, 243; Fireplace in Virginia, 419; Flowery Mill, 377, 378; Fruit, 195; Garden in Sochi series, 22, 185, 258, 291–4, 317, 325, 331, 333, 338, 342, 405; Good Afternoon Mrs Lincoln, 365, 425; Gray Painting, 269;

Greek Torso, 242; The Head, 197, 334; How My Mother's Embroidered Apron Unfolds in My Life, 365, 369, 377, 411, 430; Hugging, 411; Image in Khorkom, 257, 264–5, 325; Improvisation, 192; Khorkom series, 257, 259, 264, 271, 312, 334; Kiss, 219, 281; Lady in the Window (copy of Hals), 134; Landscape, Gaylordville, 267; Landscape in the Manner of Cézanne, 166; Landscape Table, 389, 411, 419; The Limit, 444; The Liver is the Cock's Comb, 352, 353–4, 355–6, 364, 371, 373, 378, 381; Love of the New Gun, 365; Making the Calendar, 433; Mannikin, 198; Man's Conquest of the Air, 279, 280, 283, 303; Mojave, 317–18; My Sister, Ahko (later Portrait of Ahko), 223–4, 337; Nighttime, Enigma and Nostalgia series, 26, 201–2, 206, 210, 219, 226, 227, 243, 244, 257, 292; Nighttime of Nostalgia, 219; 1934 (mural project), 207–9, 219, 221, 222; Nude series, 405, 422, 423, 425; Oil Painting, 269; One Year the Milkweed, 365, 369, 411; The Orators, 39, 431, 432, 433, 444, 447, 490; Organization, 238, 241–2, 250, 256; Organization No 4, 219; Painter and Model, 198; Painting, 184; Painting (1936–7), 257, 269, 274; Painting (1944), 365, 366, 371; Park Street Church, Boston, 138–9, 146; Pastoral, 432–3; Pears, Peaches and Pitcher, 224; Pirate, 340; The Plough and the Song, 17, 420, 421–5, 428, 432; Plumed Landscape, 432; The Poet and the Model (painting of a Rodin statue), 153; Portrait (1936–38), 271; Portrait of the Artist and His Mother, xii, 198, 213–18, 223, 293, 422, 472; Portrait of the Artist's Wife, 337; Portrait of a Girl, 171; Portrait of Libby, 154–5; Portrait of a Man with a Pipe, 328; Portrait of Myself and My Imaginary Wife, 222–3; Portrait of a Woman, 171; Reclining Nude, 171; Rocks in the Forest, 166; Seated Woman with Vase, 171; Self Portrait (lithograph), 198; Self-Portrait at the Age of Nine, 154; Self-Portrait (drawing), 287, 293–4; Shenandoah landscape, 351; Still Life (1931), 194; Still Life (Cat. Rais. No. 124a), 235; Still Life with a bunch of grapes (1928), 185; Still Life with Guitar, 166; Still Life with pitcher and aubergines, 220; Still Life with Skull, 226; Still Life on Table, 264; Summation, 78, 284, 431, 493; Summer in Sochi, Black Sea, 259, 271, 334; The Sun, 365, 378; Sunset in Central Park, 192, 194, 327; Terracotta, 432–3; They Will Take My Island, xvi, 365, 369, 378, 395; To Project, To Conjure, 365; Tulips, 152; The Unattainable, 389; Untitled, 202; Water of the Flowery Mill, 352, 380; The Waterfall, 52, 151, 329, 331, 333, 338, 340; Woman with Violin, 270; Woman's Head, 224; Year after Year, 444
Gorky, Marny (née George; G's first wife), 231–5, 312, 488
Gorky, Maro (G's daughter), 342–3, 344, 345, 346, 355, 356, 358, 359–60, 373, 376, 382, 387, 389–90,

393, 404, 410, 413, 415, 416, 440, 463, 475, 488, 493

Gorky, Maxim, xi, 91, 104, 131–3, 142, 150, 151, 481; *The Mother*, 131; *My Childhood*, 132; *The Anthology of Armenian Poetry*, 92

Gorky, Natasha (G's daughter), xiii, 391, 392–3, 404, 410, 411, 413, 415, 416, 440, 450, 475, 488, 493

Gotham Book Mart, New York, 390

Gottlieb, Adolph, xii, 321, 380, 439, 492

Gottlieb, Esther, 328

Governor's House, Albany, New York, 491

Goya y Lucientes, Francisco de, 78, 130, 399

Gradiva Gallery of Surrealist art, 324

Graham, John, 174–6, 178, 189, 201, 209, 225, 238, 239, 321, 328, 431; *System and Dialectics*, 286

Grand Canyon, 310

Grand Central Art Galleries, New York, 141

Grand Central School of Art, New York, 146, 147, 150–54, 168, 199, 289, 321, 481

Grand Central School of Art Quarterly, 156

Graves, Morris, 355

Greenberg, Clement, 222, 381, 400–401, 412, 439, 444–5

Greenberg, Herman A., 235

Greene, Balcomb, 165, 169, 211, 240, 251, 280, 286–7

Greenwich Village, New York, 159, 162, 168, 172, 187, 197, 211, 231, 252, 361, 402, 430, 466

Gregory, St, 45

Gris, Juan, 196

Gropius, Walter, 290

Gross, Chaim, 175, 193, 336

Gross, Mrs Chaim, 328

Grosz, George, 210

group drawing, 288–9

Grünewald, Mathias, 154, 326, 434–5; *Isenheim Altarpiece*, 433

Guggenheim, Peggy, 332, 341, 347, 355, 371, 374, 410, 423, 442

Guggenheim, Simon, 285

Guggenheim Exhibition, 206

Guggenheim grants, 294

Guggenheim Museum, 332–3, 399, 492

Guild Art Gallery, New York, 232, 242, 243

Gunther, Jane, 343

Hagop, Kosali, 26

Hague, Raoul, 187, 217, 289

Haji Bekir Kishla barracks, Van, 74, 75

Halpert, Edith Gregory, 194

Hals, Franz, 134, 142, 143

Hamid, Sultan, 19, 21, 39

Hamidiye, 19

Hamilton, Virginia, 344–50, 415–20

Harachtimagan, 155

Harding, Dr, 425

Hare, David, 332, 340, 352, 370, 371, 372, 376, 383, 386, 389, 393, 402, 422, 442, 451, 469

Hare, Jacqueline, 362, 370, 372, 378, 382, 386, 389, 393, 402

Hare, Suzy, 340, 352, 383

Harper's Bazaar, 355

Harput, 58, 72

Hassam, Frederick Childe, 133

Haweis, Joella, 336

Hawthorne, Charles, 142

Haydar Pasha refugee camp, Constantinople, 106–7, 109

Hayes Bickford Restaurant, Boston, 136

Hayotz Dzor district, Armenia, 19, 64, 428

Hayrenik newspaper, 121, 138

Hazarian, Haroutune, 148, 157, 334, 335

Hebbeln, Henry, 367, 390–95, 402

Hebbeln, Jean, 355, 367, 372, 383, 387, 390, 393, 394, 395, 402, 403

Hélion, Jean, 380, 382

Hemingway, Ernest, 391

Henri, Georges, 133

High Deco, 197

Hiroshima, 63, 392, 395, 400, 419

Hirschhorn, Joseph, 329, 342

Hitler, Adolf, 205, 227, 288, 289, 336, 419

Hochschild, Mrs, 404

Hofmann, Hans, 209, 245, 279, 381

Hogarth, William, 245

HOK (Hayasdan Oknoutian Komite) Progressive Party, 257

Holocaust, 495

Holty, Carl, 321

Hood Rubber Company, Watertown, 121, 127, 128, 129, 144, 145, 236

Hoover, Herbert, 100, 199

Hopper, Edward, 197, 205; *House by the Railroad*, 174

Hosmer, Marion, 459

Housatonic Falls, Connecticut, 52

Housatonic River, 329

House Un-American Activities Committee, 252

Hovnanyan, Paregham, 24, 30

Hovnatanyan, Hagop, 105

Howe & Lescaze, 280

Hugo Gallery, New York: *Bloodflames* (1947), 425

Hundred Million Dollar Appropriation, 100

Hunt, William Morris, 133

Hussian, John, 154, 224

Igdir, 83

Impressionism, 130, 133, 134, 138–9, 141, 143, 161

Ingres, Jean, 130, 164, 165, 173, 190, 210, 215, 216, 225, 248, 251, 304, 313, 326; *Les Baigneuses*, 171;

Comtesse d'Haussonville, 246; *Odalisque with Slave*, 327
Instant Art, 289
International Style, 280, 290
Iron Curtain, 236
Iron Winding Company, 120
Ishkhanikom, 29, 53
Issahakian, 30
Istanbul (previously Constantinople), 22, 101
Italy, 142, 355
Ittihad see Young Turks

J. B. Neumann Gallery, New York, 183
James, William, 369
Jamgochian (teacher in Van), 54
Janney, A. M., 345–6
Jannings, A. M., 361
Janowitz (later Janis), Harriet, 220, 233, 241
Janowitz (later Janis), Sydney, 189, 220, 222, 233, 241, 256, 353, 371, 442, 445, 485, 492; *Abstract and Surrealist Art in America* (1944), 354
Japan, 392
Jawlensky, Alexei von, 147
Jemal, 57
Jevdet Bey, 61, 64–5, 66, 69–70, 71, 72, 78
Jidatachian (of Van), 66
John Becker Gallery, New York (*Picasso Drawings and Gouaches*, 1930), 190
John Reed Club, 204, 207, 222
Johnson, Philip, 248
Jonas, Robert, 294, 321
Jordan, Jim, xiv, 251; *Catalogue Raisonné* (with Robert Goldwater), 494
Jouffroy, Alain, 486
Julien Levy Gallery, 376, 409, 410–11, 488, 492; *Arshile Gorky: Colored Drawings* (1947), 425, 443–5
Jung, Carl Gustav, 451, 456

Kahlo, Frieda, 286
Kahnweiler, Daniel-Henri, 396
Kainen, Jacob, 225–7, 261
Kaldis, Aristodemos, 266
Kanaker Hill, 94
Kandinsky, Wassily, 91, 147, 164, 183, 184, 192–3, 194, 196, 265, 273, 285, 296, 332, 412, 492; *The Art of Spiritual Harmony* (book), 192; *Compositions*, 192; *Improvisations*, 192
Karakanta, Kolkoz, 406
Karakilisa, 104
Karo Bube, 194
Kars, 59–60, 93
Kayané Ballet, 430
Kelekian, Dr, 315–16
Kelekian, Hampartzoum, 109

Kelekian, Mr (in Constantinople), 108, 114, 116
Kelekian, Mrs, 315
Kelekian, Dr Vergine, 107, 109, 110, 114, 116
Kemal, Mustafa (later Ataturk), 106–7, 441
Kent, Rockwell, 176, 239
Khanjian, Aghassi, 235
Khatchaturian, Aram, 430
Khojabedian, Vanno, 334
Khorkom, Vaspurakan, Western Armenia, xv–xvi, 3, 5, 17, 22, 26, 27, 29, 30, 37, 39, 41, 42, 43, 45, 49, 52, 53, 54, 63, 128, 257, 334, 345, 349, 434
Khoshab river, 38
Kiesler, Frederick, 197, 209, 212, 220, 260, 281, 332, 333, 410, 414, 415, 430, 485
Kinsey, Dr Alfred, 443, 449
Klee, Paul, 147, 164, 285, 290, 332, 333
Klhkani Teveri, 30
Kline, Franz, 174, 341
Knapp, Miss (missionary), 65, 70, 80
Knoedler Galleries, New York, 148, 215
Kondakian, Dadig (G's aunt), 13, 27, 38
Kondakian, Kevork (Shushan's nephew), 13–14, 21, 128
Kooligian (a lodger in Watertown), 130–31, 224
Kootz, Sam, 442
Koshab river, 26
Koshk, Western Armenia, 25, 26, 27, 29
Krasner, Lee (later Pollock), 278, 279, 355, 372, 373, 401
Kraus, Karl, 242
Kurds, 40, 85, 102, 348; Armenian fear of, 24; in eastern Turkey xvi; and the forced march from Van, 82; the Hamidiye, 19; illegitimate possession of Armenian property, 58; massacre of Armenians, 71; as nomads, 11; robbery by, 18, 30; taxation by, 11–12; in Van, 42
Kurvantz Island, 38
Kutahya tiles, 108–9

La Guardia, Mayor Fiorello, 219, 250
Lader, Melvin, xiv, 494
Lafayette Hotel, New York, 352
Lake Sevan, 94, 103
Lake Van, xv, xvi, 3, 5, 15, 16, 18, 23, 26, 27, 34, 35, 37, 38–9, 106, 200, 203, 263, 309, 334, 366
Lalayan, Yervant, 11
Lam, Helena, 451, 461, 462, 480, 482, 484
Lam, Wilfredo, 370, 414–15, 442, 451, 461, 467–8, 480, 482, 483, 484
Lamba, Jacqueline, 352, 355
Larionov, Michail, 194
Laurens, Albert Paul, 147
Lautréamont, 245
Lautréamont, *Les Chants du Maldoror*, 324

Le Corbusier, 324, 331, 383–4
Le Franc, Margaret, 243
The Leaf of an Artichoke is the Owl, 377
League of Nations, 419
Léger, Fernand, xiii, 164, 174, 177, 184, 192, 196, 243, 246, 250, 312, 313, 338, 412
Lenin, Vladimir Ilyich, 91, 237, 245, 315, 391
Leninism, 236
Lennox Collection, New York Public Library, 225
Leonardo da Vinci, 292, 472
Leonardo da Vinci School, New York, 265–6
Lescaze, William, 260, 279, 280, 281
Levi, Primo, 495
Lévi-Strauss, Claude, 369–70, 383, 398
Levy, Edgar, 238
Levy, Joella, 374
Levy, Julien, 176, 201, 211–12, 275, 324, 325, 336, 370, 373, 374, 378, 379, 380, 382, 386, 389, 395, 398, 402, 404, 409, 418, 422, 423, 431, 440–44, 449, 453, 455, 456–7, 460, 469, 472–3, 482, 483–4, 487, 488, 494; *Arshile Gorky*, 488; *Memoir of an Art Gallery*, 443; *Surrealism*, 253
Levy, Muriel, xv, 431, 440, 443, 448, 452, 453, 454, 456, 457, 462, 481, 483, 484, 488
Life magazine, 441–2, 446
Lincoln, Abraham, 163, 247
Lindbergh, Charles, 247
Llewellyn Williams, W., 18–19
Lo Pinto, Ferdinand, 204
Lori, 101, 104
Los Angeles, 310
Los Angeles County Museum, 189
Los Angeles Museum, 491
Lynch, H. F. B., 8, 35, 42, 43, 45
Lysles, Miss (model), 146

McCulloch, Mr, 160
McCulloch, Rook, 160–61, 193
McCulloch, Warren, 153, 321
McNeil, George, 252
Macy's department store, New York, 321
Magruder, Agnes *see* Gorky, Agnes
Magruder, Essie, 301, 318, 327, 343, 344, 345, 347, 360, 361, 364, 380, 389–90, 449, 452, 453, 470
Magruder, Esther, (later Brooks), 301, 347, 360, 361, 367, 374, 389, 469–70
Magruder, John, 301, 374
Magruder, Commodore John, 301, 302, 305, 308, 318, 323, 328, 344, 418–19, 481, 483
Magruder, Sandra, 389
Magruder, Vivi, (later Rankine), 374
Magruder family, 394
Mahari, Gourgen, 90
Mahari, Kourken: *Aykesdane Ayrevoum E*, 66

Maillol Aristide: *Ile de France*, 174
Maine, 487
Majestic Theatre, Boylston Street, Boston, 138
Malevitch, Kasimir, 142, 194
Man Ray, 212
Manet, Édouard, 134; *Olympia*, 171
Manhattan, New York, 299
Manoukian, Aram, 65
Manuel (architect), 35
Mao Tse-tung, 302
Marcarelli, Conrad, 265–6
Marden, Ben, 295, 319
Margolies, David, 217, 276, 278–9, 288
Marion (Agnes' great-aunt), 425, 426, 435, 436, 440, 449, 459, 487
Marx, Karl, 237, 245, 315
Marxism, 236
Masson, André, 201, 203, 271, 332, 372, 386, 396–8
Masson, Diego, 396, 397–8
Matisse, Henri, 157, 165, 166, 174, 183, 184, 273, 279, 285, 337; *Jeanne Femme*, 171; *Still Life with a Greek Torso*, 226
Matisse, Pierre, 373, 379, 380, 382, 461
Matta Echaurren, Ann (née Alpert; 'Pajarito'), 340–41, 352–3, 372, 426, 464
Matta Echaurren, Patricia, 372, 379, 423, 446, 452
Matta Echaurren, Roberto, xiv, xv, 324–5, 332, 333, 340, 355, 369, 370, 380, 383, 395–6, 416, 422, 430, 434, 444, 446, 450, 462, 485–6, 494; and Agnes, 452–4, 463, 465, 468, 470, 487, 493; ambition, 324, 452; appearance, 452; and automatic drawing, 325; and Breton, 324, 331, 341, 372, 385, 390; compared with G, 324–5, 331, 445, 452; friendship with G, 341, 379; G confronts, 464–5; G smashes his picture, 462, 472; lends Ernst money, 423; meets G, 324; Muriel Levy on, 452; remarries, 493; Surrealist sensibility, 331; *Le Poète*, 379; *Vertigo of Eros*, 493
Matter, Mercedes, 245, 246, 304, 307
Mattox, Charles, 247, 260
Matulka, Jan, 321
Mayakovsky, Vladimir, 91
Mayne, Nick, 252
Mehmed V, Sultan, 39
Meier-Graeffe, 151
Mekhitarist order, 43
Mellon Gallery, Philadelphia, 219–20, 347
Metropolitan Museum of Art, New York, 57, 141, 142, 157–8, 163, 175, 197, 209, 210, 211, 225, 349, 382; *Artists for Victory* exhibition (1942), 336
Metzger, Mrs (art student), 160, 211, 235, 308, 327, 465
Mies Van Der Rohe, Ludwig, 290
Mihran, Mr (teacher), 25–6
Milford, 323
Mili, Gjon, 415

Miller, Dorothy (later Cahill), 197–8, 240, 241, 261, 309, 313, 325, 326, 333, 351, 355, 356, 398

Miller, Kenneth, 174

Miller, Kenneth Hayes, 152

Miller, Liberty ('Libby') Amerian, 40, 80, 118–19, 127, 134, 154, 220, 223, 270–71, 322–3

Minotaure (Surrealist review), 324

Miró, Joan, xiii, 164, 174, 179, 183, 184, 190, 192, 194, 265, 271, 273, 290–93, 313, 318, 332, 350, 370, 389, 396, 399, 412, 421, 422, 443, 444, 492; *Flame in Space and Female Nude*, 292; *Still Life with Old Shoe*, 292–3

Modern Art Museum of Fort Worth, Texas, 492

Modernism, 151, 175, 206, 214, 290

Modigliani, Amedeo, 175

Moholy-Nagy, Lazlo, 212, 285

Moks region, 71

Mondrian, Piet, 164, 179, 241, 242, 251, 286; *Flowering Tree*, 166

Monet, Claude, 130, 133, 134, 150; *Sur la Cité à Trouville*, 139

Monticelli, Adolphe, 142, 143

Montoya, Carlos, 421, 422

Mooradian, Arshag, 54, 123, 185

Mooradian, Karlen (G's nephew), xiii, xiv, 236–7, 255–7, 264, 267, 288, 429, 440, 494; *Arshile Gorky Adoian*, 496, 497; forged letters issue, 496–8; *The Many Worlds of Arshile Gorky*, 496, 497

Mooradian, Moorad (G's brother-in-law), 129, 130, 144, 155, 179, 199, 200, 224, 235–6, 237, 257, 264, 295, 315, 318, 327, 482, 484

Mooradian, Vartoosh (née Adoian; G's younger sister), 22–3, 57, 73, 102, 103, 154, 163, 168, 173, 218, 223, 224, 246, 253, 255, 256, 265, 271, 287, 429–30, 440, 493; anger at her father, 115, 119; appearance, 128, 179, 315; arrival in New York, 115–18; and the *Aviation Mural*, 259; birth (1906), 22; birth of Karlen, 236–7; collection exhibited (1984–85), 492; and Communism, 144, 155, 179, 199–200, 257, 288; in Constantinople, 107, 108, 110; emigrates to America, 110; in Etchmiadzin, 85; on family prayer, 61–2; forced march from Van, 79–80, 82–3, 83; G and Agnes visit, 314–16; G writes enclosing sketches, 417; G's beating at the American Mission, 58–9; and G's birth-date, 8; and G's cancer, 410, 411, 418; and G's funeral, 482, 483; and G's grave, 488; and G's letters, xiii, 497, 498; on G's marriage to Agnes, 314; on life at Aykesdan, 46, 48; and Moorad, 129, 130; meets Agnes, 488; moves to Chicago (1936), 264; passionate belief in G's talent, 128, 170; personality, 40; repatriates to Armenia, 199–200; returns to America, 235, 236; and Shushan's death, 98, 100; and the siege of Van, 68, 69; weakening ties with

G, 394; works in America, 121, 127; in Yerevan, 86, 87, 89, 94, 97, 205, 208, 224

Morgenthau, Henry, 78

Motherwell, Robert, 325, 369, 442

Mount Sinai Hospital, New York, 407

Moush, 86

Moutoyan, Krikor, 100, 107

Mumford, Lewis, 210

Muradian, Arshag, 163

Mural Project, 207–9, 219, 221

Murphy, Katherine, 132–3, 136–40

Muschenheim, Frederick Augustus, 281

Muschenheim, Lisa, 281–2, 287, 302

Muschenheim, William, 281, 282, 285, 287, 302, 327

Musée du Jeu de Paume, Paris, 274

Museum of Man, New York, 398

Museum of Modern Art, New York, 183, 195, 202, 205, 239, 243, 244, 248, 285, 290, 292, 318, 327, 333, 351, 398, 493; *Arshile Gorky, Paintings, Drawings, Studies* (1962), 492; *Art of Our Time*, 285; *Exhibition of Work of 46 Painters and Sculptors under 35 Years of Age* (1930), 185; *Fantastic Art, Dada and Surrealism* (1934), 211; *The First Loan Exhibition: Cézanne, Gauguin, Seurat and Van Gogh* (1929), 174; *Fourteen Americans* (1946), 422; G first included (1930), 183, 192; *Horizons of New Art* (1936), 253, 261; *Painting in Paris* (1930), 184; *Painting and Sculpture by Young American Artists* (1943), 342; *Recent Acquisitions* exhibition (1941), 307; *Road to Victory* exhibition (1942), 336; *20th Century American Portraits* (1942), 336–7

Museum of Modern Art, San Francisco, 308, 312–13

Museum of Non-Objective Art, New York, 285

Mussikian, Sirun, 200, 216, 220, 222, 235, 254, 292, 328, 427; appearance, 167, 171, 172, 173; end of the relationship with G, 186–8; father's insanity, 180–81, 469; G sketches and paints, 170–71; on G's Union Square studio, 169; identifies G with her father, 186, 187; 'Ruth French' assumed name, 168; starts love affair with G, 167–8; stressful relationship with G, 185–6; on Stuart Davis, 176–7; taken to meet G's family, 172–3

Nagasaki, 392, 395

Nahkian, Reuben, 277, 289

Nancy (G's first love), 162, 166

Naples, 113

Nathan, George John, 162–3

National Academy of Design, New York, 141, 142

National Gallery of Armenia, 493

National Gallery of Art, Washington D.C., 492

National Gallery of Washington, 267

National Museum of Modern Art, Washington, 214

nationalism, 240

naturalism, 222
Naylor, Genevieve, 285
Nazism, 205, 209, 227, 320, 321, 332
Neininger, Urban, 313, 314, 345, 461, 462, 487
Neon (Surrealist review), 486
Nestorians, 42
Neue Sachlichkeit, 142
Neutrality Act, 289
Nevelson, Louise, 242
New Deal, 207, 240
New Milford, 458, 468, 471, 481
New Milford Hospital, 457
New School of Design, Boston, 142, 146
New School of Design, New York, 142–3, 146
New School of Social Research, 239
New School for Social Research, New York, 192
New York City, xii, 30, 118, 140–41, 150, 190, 201,
 207, 208, 290, 320, 436, 444, 494
New York Hospital, 342–3
New York School, 492
New York State Temporary Emergency Relief
 Administration, 207
New York Symphony Orchestra, 271
Newark Airport, 249, 250, 261, 263, 267, 268
Newark museum, 261
Newman, Barnett, 445–6
Nicholas II, Tsar, 89
Nikolaiyeff, General, 78
Nimrud Dagh, 34
Nishan, St, 32
Nogales, Rafael de, 66, 72
Noguchi, Isamu, 269, 286, 288, 289, 295, 303, 308,
 309, 310, 340, 352, 371–2, 395, 404, 407, 408, 431,
 466–9, 480, 482, 484
'non-objectivism', 285–6, 296
Norashen Church, Van, 74
Noravank Church, Van, 75
Norwood, Providence, Rhode Island, 144, 173, 323
Nova, Sayat, 338
Novalis, 369
Nuremberg Trials, 419

Oberlin College, Ohio, 425
O'Keeffe, Georgia, 174, 238
Olinsky, Lillian, 209
Olympic Art Exhibition (1936), 252
Onslow Ford, Henry, 324, 331
Oppenheim, Meret, 294
Orozco, José, 207, 210
Osborne, Bayard, 404
Osborne, Margaret La Farge ('Peggy'), 308, 356, 364,
 404, 421, 431, 450–51, 459, 465
Ottoman army, 21, 50, 57, 59, 60, 96
Ottoman Empire, 42; Armenian fear of Turks, 24;
Armenians as its 'most progressive element', 55;
Britain in secret league with, 18; decay of, 11;
genocide of Armenians (1915–20) xi, xii; military
dictatorship of Young Turks (1913), 57; new
constitution, 21–2, 39; Russia carves up, 19, 87;
secret agreement with Germany (1914), 59; as 'The
Sick Man of Europe', 18; 'Turkey for the Turks'
programme, 57–8; Turkish rule over Armenians, 5,
11–12, 18–19
Ozenfant, Amadée, 290, 374, 384

Palisades, Fort Lee, New Jersey, 295, 296, 303
Pantuhoff, Igor, 278
Paris, 106, 141, 190, 211–12, 265, 274, 321, 332, 342,
 362, 388, 416, 451
Parsons, Betty, 322, 442
Partisan Review, 239, 241
Patras, 113
Paul Cézanne Loan Exhibition of Paintings (New York,
 1928), 164
Pavia, Philip, 210, 211, 244, 289, 341, 401–2
Pearl Harbor, 319
Penn, Irving, 414
Peret, Benjamin, 396, 430
Pershing, General, 343
Persia, 80
Persian Empire, 11
Pétain, Marshal, 312
Philadelphia Press, 177
Philips, Jack, 488, 493
Picasso, Pablo, 12, 141, 164, 165, 166, 171, 174, 175,
 177, 179, 182–5, 188, 189, 190, 192, 196, 201, 209,
 210, 215, 232, 242, 243, 250, 265, 273, 274, 279,
 290, 313, 326, 332, 333, 336, 341, 350, 372, 373,
 389, 396, 399, 412, 422, 492; *Bottle, Playing Cards
 and Glass*, 174; *Les Demoiselles d'Avignon*, 285;
 Guernica, 78, 268, 284, 285, 333; *Portrait of Gertrude
 Stein*, 190; *Seated Woman*, 184; *The Studio*, 241; *Tête
 de Marin*, 223
Piero della Francesca, 129
Pierre Matisse Gallery, New York, 201, 243, 265, 273,
 292, 333, 370, 374, 379
Pilibosian, Khatchadour, 224
Pissarro, Camille, 130, 134
Poland, 288
Pollock, Jackson, xii, 205, 243–4, 278, 289, 310, 341,
 350, 355, 372–3, 380, 381, 401, 402, 430, 439, 442,
 449, 492
Pop Art, 206
Pound, Ezra, 391
Poussin, Nicolas, 225, 349
Precisionism, 152, 174
Preston, 396
primitive art, 175

Index

Providence, Rhode Island, 119, 123, 127
Provincetown, Cape Cod, 278–9
Prudian, Sima (Shushan's daughter), 8, 20, 21, 88
Prudian, Tovmas (Shushan's first husband), 40, 51
Public Works Aid Project (PWAP), 207, 219, 221, 222, 241
Purdy (of New York), 147
Purism, 290, 332, 384
Putzel, Howard, 332, 371
Puvis de Chavannes, Pierre, 228

racism, 239
Radio City Music Hall, New York, 205
Raffi, 30, 87
Raily [Bernier], Rosamond, 414
Rand, Harry, xiv, 494
Raphael, 173, 175, 249, 304–5
Ratcliffe, Carter, 147
Rauschenberg, Robert xii
Read, Herbert, 332
Realism, 135, 174, 216; American, 133, 142; French, 133; Russian, 142; Social, 183, 189, 221, 251, 265; Urban, 205
Rebay, Hilla, 285
Red Army, 337
Regionalism, 142, 176, 207, 209
Reinhardt, Ad, 321
Reis, Becky, 382
Reis, Bernard, 382
Rembrandt van Rijn, 129, 158, 225, 347
Remick, Helen, 137
Renaissance, 141, 305; American Renaissance style, 133
Republic Aviation, 249
Resika, Paul, 399
Revington, Arthur, 151, 153–4, 160, 166
Rexroth, Kenneth, 311
Reynal, Jeanne, 296, 308, 311–14, 345, 352, 355, 356, 358, 359, 362, 363, 367, 372, 382, 383, 390, 392–5, 398, 402, 404, 408, 410, 414, 418, 421, 430–33, 440, 443, 449, 451, 461, 464, 465, 466, 471, 484, 487
Reznikoff, Genevieve, 461
Reznikoff, Mischa, 125, 130, 140, 147, 152, 157–8, 167, 168, 172, 177, 178, 221, 232, 233, 238, 244, 285, 431, 461
Rhode Island, 119, 121, 460
Rhode Island School of Design, 130, 147
Ricordi, 270
Riemenschneider, Tilmann, 154
Rikers Island Federal Penitentiary, 291
Rivera, Diego, 207, 210, 222, 228, 286
Riviera nightclub, Fort Lee, 295–6, 348
Robinson, Theodore, 133

Rockefeller Government House, Albany, New York, 431
Rockefeller, John D., 195, 270
Rockefeller, Nelson, 490
Rockefeller Centre, New York, 210, 219, 222
Rockeller, Mrs John D., Jr, 174, 195
Rodin, Auguste: The Poet and the Model, 153
Roger Williams Park, Providence, 124
Romany Marie's, Greenwich Village, 197, 415
Romney, George, 245
Roos, Dr Allan, 456, 462, 472, 481
Roosevelt, F. D., 207, 240, 289, 393
Rosenberg, Harold, xii, 208, 400, 494
Rosenberg, Paul, 333, 374
Roslin, Toros xvi
Rostom (an Armenian leader), 59
Rothko, Mark, xii, 142–3, 174, 321, 328, 380
Rousseau, Henri, 285; The Dream, 189
Russia, 258; attitude to Armenians, 18, 19; carves up the Ottoman Empire, 19, 87; centralised, 225; non-aggression pact with Germany, 289; Realism, 142; renaissance in literature and art, 200; Russian poets and writers fascinated by Armenia, 92; in the Second World War, 320, 346; the Soviet dream, 199, 419
Russian Armenian Congress (Tiflis, 1917), 93
Russian army, 65; liberation of Van, 77; retreat from Van, 79
Russian Empire, 93
Russian Revolution, 151
Russian Tea Room, New York, 135
Russo-Turkish accord (1914), 58

Saccho, Nicola, 121
Sade, Marquis de, 485; The Execution of the Testament of Sade, 486
Sage, Kay, 332, 385–6, 443, 457, 458, 472, 473, 479, 481, 494
Sahag Bey, 70
Saint Exupéry, Madame de, 407
St Nishan Church, Khorkom, 13
St Nishan Monastery, 8, 23, 427
St Sarkis church, Yerevan, 86, 87
St Vartan, 27
St Vartan Church, 27
Sairt, 72
Sala de Exposiciones de la Fundacion Caja de Pensiones, Madrid, 492
Salon des Independents, Paris, 142
San Francisco, 308, 310, 313, 386
Sandow, Alexander, 206, 222, 233, 303, 321, 327, 407
Sandow, Helen, 124, 206, 222, 233, 234, 274, 303, 327, 407, 451, 465

Sandow, Ludwig, 277
Santa Fe, 310
Sarajevo, 59
Sardarabad plain, 93–4, 103
Sargent, John Singer, 133–5, 137, 139, 141, 143, 147;
 Oyster Gatherers of Cancale, 146–7
Sarian, Oksen, 321
Saroyan, William, 310
Saryan, Martiros, 91
Sbordone (Italian Consul), 70
Schanker, Louis, 280
Schapiro, Meyer, xiv, 239–40, 260, 289, 327, 379
Schary, Hope, 329, 330
Schary, Saul, 52, 158, 214, 216–17, 235, 248, 266,
 328–9, 330, 431, 471–4, 479, 483
Schnitzler, Max, 239, 241
Schoenberg, Arnold, 242
School of Paris, 183, 381
Schwabacher, Ethel, xii, 211, 271, 302, 303, 321, 325,
 327, 331, 348, 404, 409, 410, 421, 441, 444, 448,
 449, 450, 459, 465–6, 470, 488, 494
Schwabacher, Wolf, 410, 421, 441, 444, 449
Second World War, 411; Armenia and, 334, 419;
 D-day, 362; G's fear of being drafted, 328, 335;
 Hitler attacks Poland, 288; US enters, 319; US
 refuses to join, 289; victory over Germany, 382
Seitz, William, xiv, 424–5
Sekula, Sonia, 484
Selian, Badrik, 188, 258, 334, 335
Seligman, Kurt, 332, 382, 494
Sert, José Luis, 421, 422
Seurat, Georges, 274, 326, 390
Sevdiguin river, 50
Shadagh, 40, 50–52, 64, 71
Shagoyan, Levon Pasha, 59, 102
Shagoyan, Mariam, 102
Shahab *see* Shahar
Shahar, near Erevan, 94
Shahn, Ben, 210; *The Passions of Sacco and Vanzetti*,
 205
Shamiram canal, 46, 428
Shearer, Moira, 200
Sheeler, Charles, 152
Sherman, Connecticut, 391, 393, 394, 404, 422, 444,
 453, 461, 467, 480, 481, 482, 488, 489, 491
Shero (revolutionary leader), 51
Shoushan, 70
Simultaneous Art, 289
Sipan, Mount, 3, 12, 34, 41, 82–3
Siquieros, David Alfaro, 228
Sis, 58
Sivas, 72
Sloan, John, 175, 205, 211
Smiling True (film), 200

Smith, David, 176, 214, 260, 327, 328
Soby, James Thrall, 332, 341, 371, 382
Sochi, 334
Social Realism, 183, 189, 221, 251, 265
Société Anonyme, 192, 244
Soupault, Philippe, 350, 396
Sourp Paulos and Sourp Bedros church, Van, 43, 45
Soviet Union *see* Russia
Soyer, Moses, 141, 190, 210
Soyer, Raphael, 141, 159, 189–90, 210, 214, 328, 337,
 431
Soyer, Mrs Raphael, 328
Spain, 284, 396
Spender, Matthew, 493
Spock, Dr Benjamin, 344
Stalin, Joseph, 91, 199, 222, 225, 236, 237, 250, 315,
 327, 360, 391, 393, 397, 464
Stalingrad, 334
Stalinism, 336
State Printing Press, Yerevan, 90
Staten Island, 162, 166, 350
Stein, Gertrude, 162, 224, 391
Steiner, Rudolf, 285
Stergis, Stergis M., 147, 148, 149, 153, 158–9, 161–2
Stern, Hedda, 332
Stevak, Max, 221
Stravinsky, Igor, 360
Stuart, Gilbert, 137
Sullivan, Gerard, 267
Sullivan, Mrs Cornelius J., 174
Sun Yat-sen, Madame, 302
Surrealism, xii, xiii, xiv, 30, 33, 175, 201, 202, 211,
 212, 241, 258, 285, 294, 296, 312, 324, 331, 340,
 349, 350, 352, 354, 359, 369, 371, 372, 374, 379,
 381, 382, 387, 396, 397, 415, 423, 430, 452, 453,
 472, 485, 490, 492, 493–4; Abstract, 251, 296, 492;
 The First Papers of Surrealism exhibition (New
 York, 1942), 332; French, 222, 332, 342; G's text,
 326–7; Matta excluded, 485–6; poetry, 391
Surrealisme en 1947, Le catalogue, 430
Svennigen, Herluf, 164
Sweeney, James Johnson, 332, 355, 371, 382, 401

Talaat (Minister of the Interior), 39, 57, 64
Tanguy, Yves, 332, 385–6, 395, 416
Tanning, Dorothea (later Ernst), 284
Taparez, Mount, 82
Tashjian, Richard, 494
Tatars, 95
Tate Gallery, London: *Arshile Gorky: Paintings and
 drawings* (1965), 492
Tate Gallery, London, xi
Tatig (G's aunt), 272
Taurus mountains, 50

Taylor, Bob, 346–7, 349, 361, 364, 367–8
Taylor, Henry, 368
Taylor, Mary, 346–7, 349, 361, 362, 364, 367, 368
Technical High School, Providence, 123, 125
Telegraph Hill, San Francisco, 311
Terlemezian, Panos, 148
Thiebaud, Wayne, 491
Ticino's, Thompson Street, New York, 178, 232
Tiflis (later Tblisi), Georgia, 30, 42, 43, 90, 91, 93, 94, 101, 104–5, 106, 123, 144, 183, 194, 334
Tigris river, 50
Titian, 304
Tolegian, Manuel, 310–11
Tolstoy, Count Leo, 132
Tomlin, Bradley Walker, 439
Toprak Kala Hill, Van, 75–6
T'oros (tile artist), 108
Toscanini, Arturo, 281
Toulouse-Lautrec, Henri de, 356
Toumanian, Hovhannes, 30, 87, 91; *Anoush*, 104
Transcaucasia, 59, 85, 89, 93, 96, 104
Treaty of Berlin (1878), 18
Trebizond (later Trabzon), 58, 72
Tree of the Cross, Khorkom, 12–13
Trotsky, Leon, 91
Truman, Harry S., 392
Turkey: blockade on Armenia, 95; cuts off diplomatic relations with the USA, 96; eastern, xvi; Russia and, 199–200; seizure of Armenian territories, 391; *see also* Ottoman Empire
Turks, 305; costumes, 45; and the forced march from Van, 82; genocide by *see under* Armenians; illegitimate possession of Armenian property, 58; Kemalist, 101; treatment of Tovmas Prudian, 40; in Van, 42
Twachtman, John, 150

Uccello, Paolo, 137, 165, 196, 241, 326, 349; *Rout of San Romano*, 259
Unemployed Artists' Group, 207, 221, 227
United Nations headquarters, New York, 384
United States of America, 190; aims at cultural domination, 320–21; G's US citizenship (1939), 288; Mgrditch and Hagop leave for (1911), 50; Mishag and Krikor in, 10–11; political isolationism, 141; and the Second World War, 289, 319, 392; Setrag and Krikor leave for (1908), 22–3, 25, 36, 40; Turkey cuts off diplomatic relations, 96
Urban Realism, 205
Ussher, Reverend Dr Clarence D., 59, 70, 72, 74, 75; on the American Mission School, Van, 46–7; on Armenian bravery, 68; courage, 64; the forced march from Van, 82, 83–4; as head of the American mission, 54–5; letter of reference for G

and companions, 102–3; and massacres, 20, 71; in Yerevan, 88

Vahakn, 16
Valentine, Kurt, 333
Valentine Gallery, New York, 164, 190, 284, 292, 333, 374
Van, 8, 10, 11, 18, 22, 26, 29–32, 38, 39, 41–54, 58, 59, 60, 104, 105, 108, 114, 167, 203, 272, 273, 277, 323, 326, 348, 353, 366, 393, 424; Armenians in, 42; costumes, 417; dyers, 433; evacuation, 79; G moves to (1910), 42–3; liberation by the Russians (June 1915), 77, 78; the massacre (1908), 19–21; ploughs, 342; rebuilding of (1917), 89; retaken by Russians/Armenians, 86; rituals, 424; siege (1915), 65–74, 90, 93, 124, 275; stone monuments, 433; the Turks leave, 74–5; *vishaps*, 258; weddings, 354
Van Gogh, Theo, 200
Van Gogh, Vincent, xv, 143, 200, 220, 273
Vanalidg, 428
Vanzetti, Bartolomeo, 121
Varak Dagh, 34, 73, 366
Varak, 64, 65, 71, 73
Varakavar, Mount, 82–3
Vardanian, Mariam, 343
Vari Hayotz Dzor, Armenia, 5
Varoujan, Daniel, 69
Vart Badrik monastery, 27, 29, 34, 53
Vartan, St, 23, 33, 90
Vartananz, 32
Vaspurakan, 34, 35, 45
Velázquez, Diego de Silva y, 130, 134, 220
Vermeer, Jan, 216, 239, 349
View magazine, 354, 369, 385
Virginia, 345–50, 355, 358–69, 371, 372, 386, 389, 393, 405, 407, 414, 417, 420, 421, 428, 448, 460
Virginia City, Nevada, 314
Vlaminck, Maurice de, 285
Vosdan, 15, 31, 36, 86
Vosgian (G's godfather), 118
Vramian (an Armenian leader), 59
VVV (Surrealist review), 341, 352, 356, 382, 385, 389, 422
Vytlacil (an art teacher), 209–10

Waldman, Diane, xiv, 165, 184, 492
Waldorf Cafeteria, New York, 341
Walinska, Anna, 192–3, 242–4
Wall Street Crash, 173–4
Walters Art Gallery, Washington D.C., 327
Ward, John, 362
Warner, Marina xii
Warsaw, 346
Washington D.C., 267, 327, 360, 402, 404

Washington, George, 247, 280
Watertown, near Boston, 98, 118, 121, 127, 144, 145, 179, 180, 188, 199, 220, 224, 236, 278, 342, 350, 386, 447, 469
Weber, Max, 176, 294
Weiss, Dr Harry, 407, 410, 415, 449, 461, 464–7, 469, 488
West, Carinne, 253–4
Weyhe, Erhard, 176, 211
Whistler, J. A. M., 150; *The Artist's Mother*, 155
Whitechapel Art Gallery, London, 492
Whitelaw Reid Mansion, Madison Avenue, New York, 332
Whitney, Gertrude Vanderbilt, 176, 197
Whitney, Gloria Vanderbilt, 176
Whitney Museum of Modern Art, New York, 197, 214, 221, 238, 268, 271, 274, 351; *Abstract Painting in America* exhibition (1935), 238–9; *Annual Exhibition of American Sculpture, Watercolors, Drawings*, 404–5; *Annual Exhibition of Contemporary American Painting*, 257, 269, 325, 399, 400, 401, 402, 404, 422, 439–40; Memorial Exhibition (1951), 491; *Paintings by Artists under Forty*, 317
Widener Library, Harvard, 135, 205
Wilkes, Miss (English nurse), 343
Wilson, Thomas Woodrow, 114
Wood, Grant, 301

Works Progress Administration (WPA), 239, 240, 241, 248, 250–51, 252, 260, 261, 277, 279, 280, 281, 284–5, 288, 289, 291, 293, 294, 307, 320, 328, 336
Works Progress Administration/Federal Arts Project, 240, 248, 260
World's Fair (*International Exposition*) (1938), 268, 271, 277, 279–83, 287, 290, 291, 303
Wyatt, 256

Xenophon: *Anabasis*, 43

Yalta Conference (1945), 391, 393, 419
Yarrow, Ernest A., 58, 59, 70, 74, 78
Yeghus (Setrag's elder sister), 9
Yegishe, 23
Yegishe, St, 32
Yerevan Art College, 148
Yerevan (previously Erevan), xv, 86, 87, 91, 100–104, 106, 108, 200, 205, 224, 235, 237, 354, 391, 498
Yezidis, 83
Yissusean School, Van, 43
Young Turks, 21, 22, 39, 57, 58, 59, 60, 63, 78
Yphantis, George, 152

Zangezour, Armenia, 224
Zohrab, Krikor, 39